W9-CJM-822

The Nation's Mantelpiece

Claude Monet

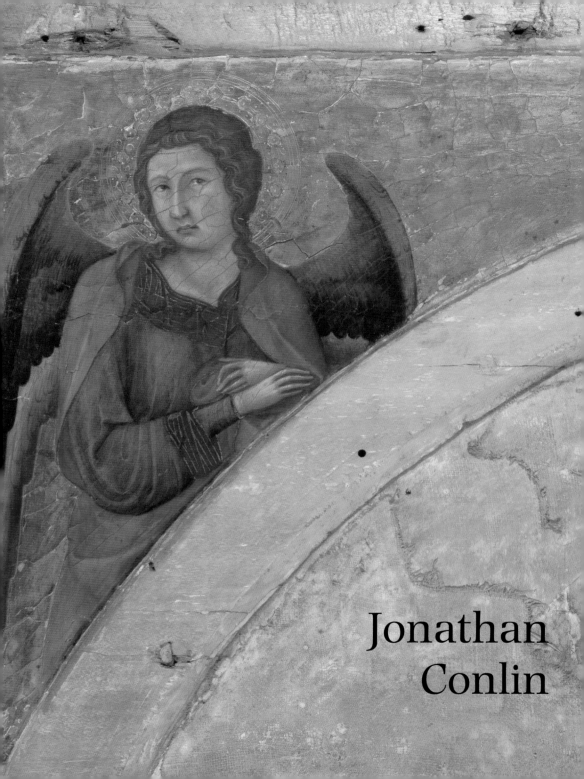

Jonathan
Conlin

The Nation's Mantelpiece
A history of the National Gallery

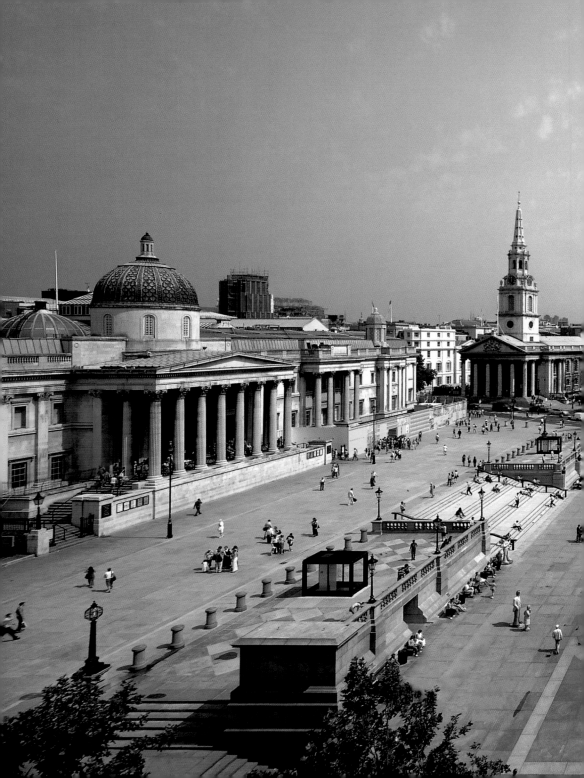

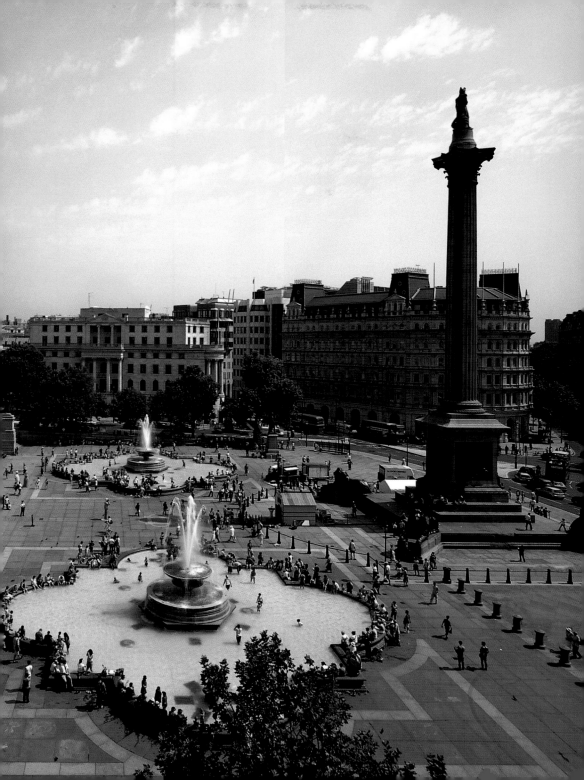

Contents

To my mother and my father

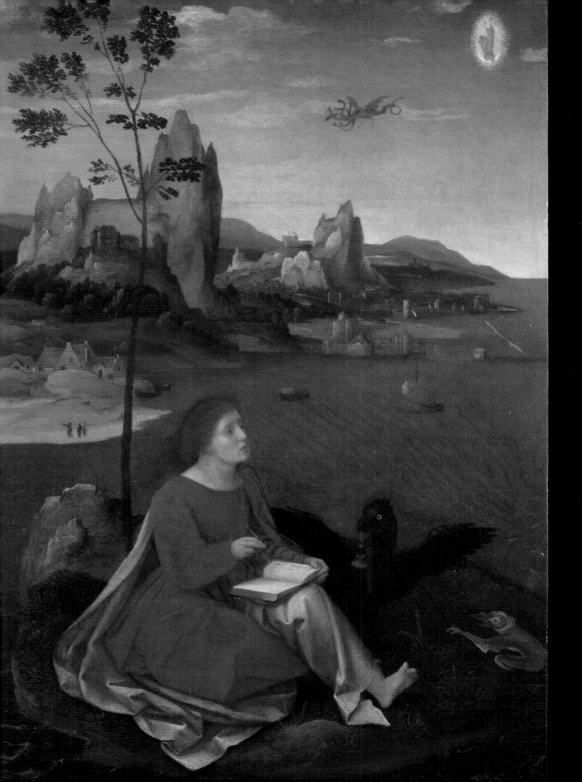

Acknowledgements

The idea for this book appeared seven years ago, when I was a Masters student at the Courtauld Institute. Sarah Hyde and John Murdoch's teaching provided the ideal grounding in museology and museum history, and I have continued to learn much from them both. I hope the book makes up for my being such a loquacious and trying student. At Cambridge Boyd Hilton gave the ensuing doctoral thesis his steadfast support, as well as the benefit of his unparalleled knowledge of the political background to the first phase of the Gallery's existence.

A Fellowship at Sidney Sussex College allowed a further period of research. For this, for their companionship, exemplary scholarship, professional guidance and many other gifts I thank the Master and Fellows of that foundation most warmly. At various points this project has been generously supported by the Arts and Humanities Research Council, by the Scoloudi Foundation (in association with the Institute for Historical Research) and by the Gulbenkian Foundation (UK Branch), whose grant commemorates the important and intriguing role Calouste Gulbenkian played in the Gallery's twentieth-century history.

This history would have been much harder to write had the Gallery itself not combined impressive archival resources with a highly professional staff, including Charlotte Brunskill, David Carter, Alan Crookham, Jessica Collins, Estelle Gittins, Matti Watton – but above all Elspeth Hector and Isobel Siddons, who went well beyond the call of duty. Head of Building Peter Fotheringham brought light to the darker corners of the Gallery's architecture, throwing in a guided tour of said corners for good measure. Isobel Drummond, Richard Younger and especially Belinda Ross were most helpful in tracking down illustrations. Among the staff of the other archives I visited, I would like to single out Iain Brown of the National Library of Scotland and Valerie Phillips of the 1851 Commission for special thanks. My summer campaigns in the archives would have been shorter and far less pleasant had Agnese and Flavio Valeri

Opposite: **St. John on Patmos**, Workshop of the Master of the Female Half-Lengths, 1525-30. Originally in the collection of Prince Ludwig Kraft of Oettingen-Wallerstein, this work passed with the rest of the collection to Prince Albert, and was presented to the Gallery at Albert's wish by his widow, Queen Victoria, in 1863.

as well as Bob and Sylvie Mayo not provided me with accommodation and support.

In tracing the Gallery's recent history I have learned much from Trustees, Directors, members of staff and others, notably Kathy Adler, Colin Amery, Caryl Hubbard, Erika Langmuir, Herbert Lank, Sir Denis Mahon, Neil MacGregor, Gregory Martin, Nicholas Penny, Sir Jacob Rothschild, Alistair Smith, Jon Snow and the 29th Earl of Crawford and Balcarres. I am grateful to them for sharing their experiences with me, either in formal interviews or more casual discussions. Taken as a whole their service to the Gallery has compassed more than seventy years. I hope that they can recognize the institution they have shaped in the chapters that follow. Responsibility for the views expressed in this book is, however, mine alone.

In preparing the book for publication the support of the Gallery's Director, Charles Saumarez Smith, has played a vital role, in some cases quietly solving problems before I was even aware they existed. Earlier drafts of this book benefitted from his careful reading, as well as that of other scholars whose work provided much-needed triangulation points by which to orientate myself as I navigated the treacherous waters separating history, art history, and architectural history, notably Peter Mandler, Andrew Saint and Giles Waterfield. Derek Beales, Belinda Beaton, Lawrence Goldman, Larry Klein and Martin Ruehl were beacons of encouragement when those waters got particularly troubled.

I have also benefited from discussions with a range of other scholars and experts, including Julia Armstrong-Totten, Harold Bartram, Ellinoor Bergveldt, Alex Bremner, Lorne Campbell, Viccy Coltman, Nuno Grande, Holger Hoock, Richard Humphreys, Rica Jones, Charlotte Klonk, Madeleine Korn, Gerry McQuillan, David Solkin, Geoff Swinney, Britta Tondborg and Christopher Whitehead. I am also grateful to Veronica Stebbing for producing an excellent index, and to Harold Bartram for a beautiful design. Alexander Fyjis-Walker of Pallas Athene was the first to laugh at the book – I hope he still sees the joke.

The dedication records my deepest debt.

Part I: History

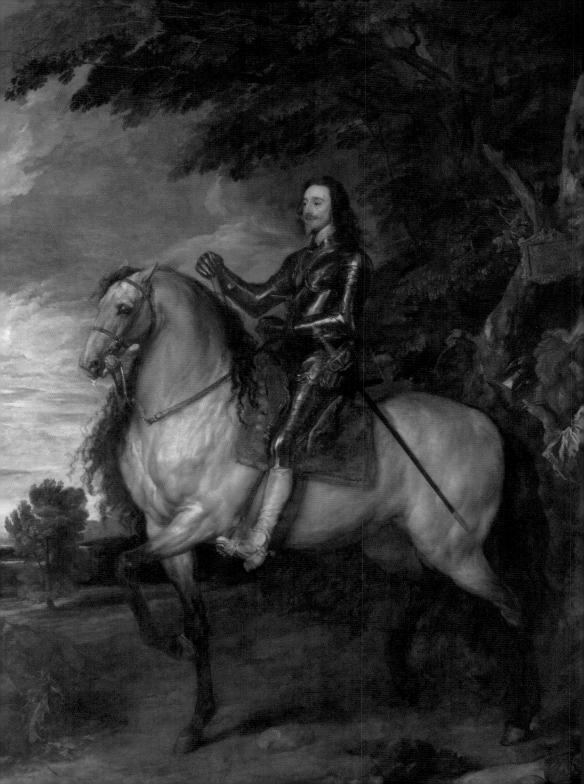

3

One: Origins

On the 4th of July 1649, parliament passed an act ordering that all the property of King Charles I, his wife and eldest son should be sold, the proceeds to pay off royal debts. Just five months earlier, Charles had stepped from the Banqueting Hall, where the gems of his extensive collection still hung, and been executed. Among the late King's goods were hundreds of European paintings, including the *Wilton Diptych*, Albrecht Dürer's self-portrait, Mantegna's nine *Triumphs of Caesar*, the Raphael Cartoons and many of Titian's finest works. Charles' deeply personal interest had been fed by magnificent gifts of paintings from King Philip IV of Spain and by his immediate entourage, which included collectors such as the Earl of Arundel and George Villiers, the first Duke of Buckingham. His generous patronage of Rubens, Orazio Gentileschi and Van Dyck changed London from what had previously seemed a cultural backwater into a magnet for European connoisseurs.

Between October 1649 and late 1651 this magnificent collection was dispersed in what has since been called 'the Commonwealth Sale'. What could not be sold to representatives of foreign powers was forced on reluctant creditors as part-payment for outstanding royal debts. Charles' plumber received Titian's *St. Margaret Triumphing over the Devil.*[1] The sale attracted no signs of public regret. If anything, the sales would have been welcomed by Puritan Commonwealthmen as a cleansing of the Augean stables, ridding the Court of so many painted invitations to popish idolatry and lasciviousness. Far from being accused of raping the kingdom of her artistic heritage, the Commissioners appointed to locate, inventorise and sell Charles' possessions – in effect, trustees of one of the finest art collections ever assembled – were criticized for not realizing enough from their sale.

The sale of Charles I's collection drew a line under the British monarchy as great collectors of Old Masters. Although an unexpectedly large number of works sold was

Opposite: Painted by the Court Painter, Anthony van Dyck, around 1637, this massive (over 3m tall) canvas of **Charles I on Horseback** is a monument to England's grand monarch. Thanks to the Civil War which broke out a few years later, it may also be one to hubris. Acquired by the Gallery at the Blenheim Sale in 1887, it remains a potent reminder of a great chapter in the history of royal collecting that closed with the King's execution in 1649.

3

Raphael's **Miraculous draught of fishes** was never intended to become a work of art in its own right, but rather served as a preparatory design for a series of tapestries commissioned by Pope Leo X in 1515 to decorate the Sistine Chapel. Seven of these designs, known as 'cartoons', were bought by Charles I in 1623. Held back from the Commonwealth Sale, they soon became highly revered national treasures. Still part of the Royal Collection, in 1865 they were lent by Prince Albert to the South Kensington Museum, and are still on loan to the Victoria and Albert Museum today.

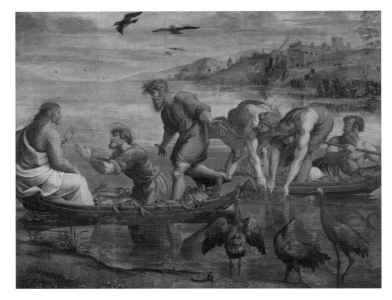

later recovered and restored to his son Charles II after 1660, the royal collection had lost its pre-eminence.[2] None of the king's more fortunate successors exhibited the same passion for pictures, or the deep purse required to satisfy it. Although romanticized in the nineteenth century as England's brilliant, if doomed experiment in courtly opulence, Charles I echoed down the succeeding centuries as a cautionary example, leading parliament and, to a lesser extent, the monarchs themselves to keep the court expenditure within relatively tight limits. At the same time, however, those works which Cromwell had decided to withhold from the sale were carefully preserved. Cherished reminders of this incomparable collection, they now inspired pride and regret rather than indignation. It was not long before tourists like the diarist Celia Fiennes were describing the Raphael Cartoons, for which Christopher Wren built special quarters at Hampton Court, as priceless works in which the nation at large had a stake. The cartoons were, English observers insisted, the very best examples of Raphael's oeuvre, and other nations supposedly envied England on their

account.[3] These remnants were reminders that, as the architect John Gwynn wrote in 1749, 'we had our age before France, and it continued thro' the latter part of Elizabeth down to the fatal Civil War, when the Frenzy of fanaticism excluded all that was just and beautiful.'[4] In this small way, Charles' collecting did provide England with the first Old Master paintings to inspire the beginnings of a national heritage discourse. As we shall see later in this chapter, however, royal stewardship of this heritage could attract criticism as well as respect.

The 1649 sale is a key date in the pre-history of the National Gallery. It ensured that the Gallery which would emerge 175 years later would be very different from Europe's other great museums. Almost all the great European galleries traced their origins back to royal collections that had been 'nationalized'. In France, this occurred as the result of a violent revolution: the royal collections were declared to be national property in 1792. Other European royals continued to hold and add to their collections well into the nineteenth century. Admittedly, they now had to be seen to make these paintings available to their citizens: the Royal (later National) Museum in Stockholm opened in 1794, Louis XVI's Bourbon cousins opened the Prado in 1819. In many cases this trend towards greater access had, however, started before the upheavals unleashed by the French Revolution, in the 1770s and 1780s. Indeed, Louis XVI's *surintendant des bâtiments*, the Comte d'Angivilliers, was in the middle of a project of reorganizing and opening up the French royal collections when the Bastille fell.[5]

The shadow of Charles I and 1649 ensured that the National Gallery would have to begin from scratch, without royal assistance. Its relations with the monarchy would be cordial, but not close. Those who dared hope that George IV, or perhaps Victoria, might cede the royal collection to the nation would be disappointed. When the Gallery Director requested loans from the Royal Collection to help fill up the rooms recently vacated by the Royal Academy in 1869, the Queen refused. Despite this fundamental difference between the London gallery and its Continental equivalents, Britons implicated in the project of forming an institution 'worthy of the nation'

would always cast an envious glance over the Channel. For all their associations with un-English despotisms and dirigiste, overcentralized governments, European galleries nonetheless seemed bigger, better and more richly endowed with great paintings. A national gallery had to keep up with these French, German and Italian galleries.

At the same time it had to reflect British pride in her constitution and the liberties which her citizens held to be the root cause of her military and commercial success. It was widely felt in the late eighteenth and early nineteenth centuries that British art and taste were failing to reflect that success. This led Bishop Robert Hurd to conclude, in his 1764 pamphlet on taste and polite education, that 'it must then be our own fault if our progress in every elegant pursuit does not keep pace with our excellent constitution.' Now that the civil strife of the seventeenth century was past, it was high time 'to apply the Liberty, we have so happily gained, to other improvements.'[6] But who could be trusted to police the arts, to ensure that their introduction from more 'polite' nations did not infect Britannia's sturdy and free (if unrefined) sons and daughters with debilitating foreign luxuries? Fulminating against Charles I's importation of 'foreign follies', and ridiculing the aristocracy's belief that the Grand Tour licensed them to guide taste, Hurd seemed at a loss.

In order to found a national gallery, notions of what such an institution should look like, what it should contain, who should administer it and, most importantly, what values it should inculcate in the people had to be invented. This chapter will explore the origins of the National Gallery in a network of eighteenth- and early nineteenth-century London institutions: the British Museum, exhibition societies, pleasure gardens, the Royal Academy, private galleries and the British Institution. These institutions served a variety of aims, some of which may seem to have little to do with forming a national collection of paintings. They were founded and administered by an equally varied collection of people, from professional artists and middle-class men of business to King George III. Some of the associations and societies behind these initiatives had very little

internal cohesion: at its inception the British Museum, for example, had trustees who included (among many others) the Archbishop of Canterbury, the politician and collector Horace Walpole, the President of the Royal Society and a number of Moravians.[7]

Nonetheless, it is important to consider these forebears. A history of the National Gallery that began at its foundation in 1824 would suggest that the idea emerged fully-formed from the mind of the Tory squire and connoisseur George Howland Beaumont, who donated his collection to the nation. In 1823 Beaumont became a Trustee of the British Museum, and informed Lord Liverpool's Tory government that he would give his collection to that institution, provided they purchased that of another connoisseur, the banker John Julius Angerstein. It has been suggested that the Gallery was a concession to a rising middle class that would subsequently take power and push through a Whig reform agenda in the 1830s: landed Tory connoisseurs had to have their monopolizing grip on art prised open, and then be further prodded into appreciating how the Gallery might serve to 'improve' the masses and yield improvements in manufacturing design by diffusing taste outside the salons of the titled.[8]

In fact, if we look back into the eighteenth century, it becomes clear that the connoisseurs' control of British art had been challenged long before, and that the economic and social benefits of widening access to paintings had been grasped at least fifty years earlier. John Gwynn's 1749 *Essay on Design* had urged the creation of a national pantheon, a public art academy and other projects, arguing that they would provide 'a national Ornament' and 'an Incentive to emulation' that would encourage public virtue, improve manufactures and boost the tourist industry.[9] The key debates that laid the rhetorical foundations for the National Gallery were not between social classes or political parties, but rather over how the polite arts could be supported in a commercial country, and what the crown or state's role in supporting them should be.

Some believed that the polite arts, which were defined in terms of moral virtues, were being held back by the selfishness

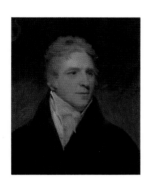

The founding benefactor **George Howland Beaumont** appears characteristically nervous and diffident in John Hoppner's portrait of 1803. A practising painter as well as a collector, his rather formulaic approach to landscape frustrated and amused his friend John Constable.

engendered by Britain's commercial success. Early in the century an aristocrat, the 3rd Earl of Shaftesbury, had written in his philosophical work *Characteristics* that a true public of the sort which could be entrusted with control of art ought to be restricted to 'disinterested' landed nobles. 'Disinterestedness' did not mean lofty indifference, but rather freedom from the ties of debt and interdependency which prevented their social inferiors from perceiving where the public interest lay. By the second half of the century, however, it was becoming clear that aristocrats were uninterested in forming a British school, choosing to collect foreign paintings without giving much thought to British artists or British audiences. It would be foolish to underestimate the importance of the aristocracy as connoisseurs and collectors. But they could appear uninterested in making their collections accessible to strangers. As for the monarchy, George III was widely distrusted, and closely identified with ministers who were felt to have sold out to French interests. In politics, imperial policy and in culture, 'the sense of the people' seemed to offer a way out, indicating a patriotic public open to new ideas and new men.[10]

The monarchy and the oligarchic political system seemed at odds with this 'sense'. Politicians and artists who sought its favour, like John Wilkes and William Hogarth, were outsiders who identified parliament, monarchy and the state in general with corruption. Their lack of deference and desire to champion and protect individual liberties led them to greet royal involvement in any area of public life with suspicion. This was true even when such interventions, such as the foundation of the Royal Academy in 1768, sought to address Britain's lack of an arts infrastructure. It seemed to them that the same state which proved so efficient at organizing the nation's resources for the century's many wars could not be trusted with the task of providing the institutions necessary to commemorate Britain's triumphs in great art. This meant that, however embryonic by today's standards, this cultural infrastructure provided a stage for a political debate by proxy: a debate between a new, centralized 'fiscal-military' state and a libertarian tradition which saw the state as the problem, not the solution.

While eighteenth-century Britain was remarkably precocious in developing a truly critical and self-conscious art public, such suspicions of court-focussed initiatives and state powers prevented it from establishing a national gallery until after the Napoleonic Wars ended in 1815. War on an unprecedented scale obliged the British oligarchy to match enemy success in mobilizing the people. Taxation was extended and service in volunteer militias and participation in patriotic societies encouraged. Rather than placing an increased burden on a 'loyal' core, the state was able to call on the support of religious, social, regional and economic groups previously seen as peripheral, or of questionable loyalty. This was possible thanks to the success with which the King and the aristocracy made themselves appear more 'national'. Founded nine years after the end of the war, the National Gallery was a monument to this mutual accommodation between 'the sense of the people' and state institutions, both of which had hitherto mistrusted each other.

The British Museum

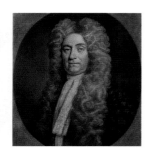

Sir Hans Sloane (1660-1753) was a successful doctor at a time when it was not unusual for practitioners to collect anatomical specimens, plants and other curiosities. In his case, however, collecting amounted to an obsession: to collect all branches of human knowledge in a single repository.

The British Museum had been founded during a similarly troubled period in the nation's history. The world's first free museum, it was established by Act of Parliament in 1753 and opened in 1759. Its establishment was important in three respects. To begin with, its foundation was a testament to the physician Sir Hans Sloane. Sloane had built up his collection of animal hides, skeletons, dried plants, shells, mummies and other curiosities into one of the sights of London, and by means of an ingenious will succeeded in posthumously thrusting it on the British state. His colourful cast of executors, referred to above, made it a difficult legacy to evade. That said, the government did manage to avoid having to pay for everything out of general taxation. Instead recourse was had to the decidedly un-Enlightened device of a national lottery, one so corrupt that a parliamentary enquiry had to be held. Nonetheless the British Museum Act committed parliament to the upkeep of the collection and provided a home for any further collections left to the nation by

public-spirited citizens.

Secondly, the Museum was a statement of confidence in the country's standing and pretensions. An institution intended to provide a single repository for all branches of knowledge, it reflected Enlightenment man's faith that the universe could be physically and epistemologically crammed into the files, books, spirit jars and display cases of a single building. Just eight years before it had seemed a struggle to hold the United Kingdom together, let alone a world's knowledge. The Jacobite Rebellion of 1745 had shocked many into questioning the nation's strength and cohesion. The establishment of a *British* Museum can thus be understood as a cultural promissory note. However dark the future seemed, it said, the strife-torn archipelago that Shaftesbury had called 'a very dubious circumscription' had a future.[11] In 1753 the House of Commons passed a bill ordering the nation's first census. Taken together with the British Museum's foundation that same year, we can perceive a drive to affirm the nation by rendering it both known and knowing.[12]

Finally, the British Museum was remarkable for being a museum intended 'not only for the inspection and entertainment of the learned and curious, but for the general use and benefit of the publick'.[13] Located in Montagu House in Bloomsbury, it was open, free of charge, to anyone with the time and inclination to visit it. Such openness was without equal in Europe, and appeared irresponsible to some of its Trustees. Dr. John Ward, for example, argued that unrestricted opening would necessitate the constant presence not only of the trustees, but of constables and armed soldiers to keep order.

Similar concerns led the Trustees to consider charging admission in 1774, 1784 and 1801, but in each case the majority ruled to retain free entry. Admittedly, the requirement that members of the public visit as a part of a guided tour, and the necessity of picking up a ticket for such a tour weeks in advance prevented casual drop-in visits before 1810 (when the policy was scrapped). The visiting hours, too, were inconvenient for those engaged in trade. Far from such policies being seen as a way of appropriating or restricting the Museum's knowledge on the basis of class, it was believed that visitors

Erected by a former ambassador to France, Ralph Montagu, in 1676, **Montagu House**'s wall-paintings and furnishings had drawn the admiration of diarist John Evelyn and other virtuosos. By the time it opened as the home of the British Museum in 1759, however, it was anything but *dernier cri*. Soon its opulent rooms were the subject of vicious squabbles among curators, as each sought to expand their fiefdoms at the expense of their colleagues'.

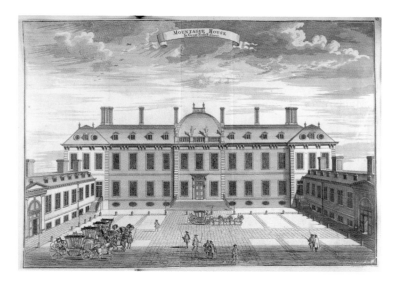

drawn from an educated elite were best qualified to ensure that the benefits were diffused across the country.[14]

The Museum's faith that all Britons could, whatever their class or education, be stakeholders in a priceless collection represented a leap in the dark. If its form marked clear progress in the direction of a national gallery, its content was disappointing. Although the Museum received important donations of antique sculpture in the eighteenth century, such as the Towneley collection, there were few paintings on display, apart from some portraits. And those took decidedly odd forms. 'I must not forget', wrote the author of one guide-book, 'an Egyptian pebble, which has been broke by accident, and discovered on both pieces, a lively picture of the poet Chaucer.'[15]

It was not long before voices were heard demanding that the Museum's lack of high art be addressed. In 1761 an anonymous author published a pamphlet entitled *A letter to the members of the Society for the Encouragement of Arts*, which stands as the earliest demand for a national gallery. The *Letter* began by repeating a familiar argument, alluded to above: that, although the country then abounded in 'riches, and science, and all the embellishments of human life,' these blessings could be lost 'if

In its witty play on the Biblical subject of Susanna and the Elders Thomas Rowlandson's pen and wash drawing of 1795, entitled **Connoisseurs**, satirizes the links between acquiring beautiful works of art and more rakish conquests.

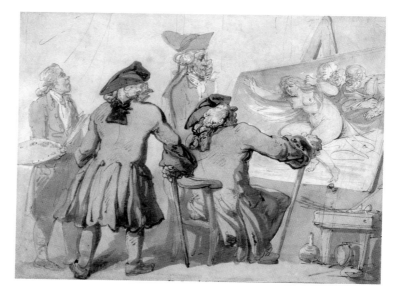

polite arts keep not equal pace.' Thus, while the British Museum was all very fine, the author expressed sorrow that

that noble institution, and fabric stand *alone*; and that we have not a public gallery, furnished with the best performances of the most famous artists. It surely were [of] no greater difficulty *for a nation* to complete a collection, than private noblemen... I could *devoutly* wish, that the monies sunk in procuring the *chaotic* productions of nature, with her *rudest* stores,.... had been expended in obtaining pieces, in which her comeliest proportions are best imitated... in the speaking *canvass* or animated *marble*.[16]

It is noteworthy that the first published appeal for a national gallery should have been addressed, not to the monarch or connoisseurs, in whose palaces the vast majority of Britain's paintings reposed, but to a six-year-old society of merchants, bankers and nobles whose main concern was improving the 'useful' rather than the 'polite' arts. Already we find traces of a vocabulary in which the nation is gramatically the subject, rather than what it was in so many European states: a predicated object which, if mentioned at all, was seen as

a passive, deferential and grateful recipient of royal or noble generosity.

The Society for the Encouragement of Arts, Manufactures and Commerce (SEAMC) had been established by William Shipley, a provincial drawing master, in London in 1754. The same concerns that the British Museum sought to assuage had also encouraged the foundation of a number of societies, hospitals and other institutions intended to render paupers, orphans and others on the fringes of society 'useful' to their country. Britain's population and morals were felt to be in decline. Social emulation, which had earlier been seen as the key to her transformation from 'Gothick' barbarity to polite refinement, was now felt by magistrates and commentators like Henry Fielding to have got out of hand. Rising wages and a flood of foreign goods on which to spend them were empowering the public, but this was a public made up of individual consumers intent on embellishing themselves, rather than on ensuring that their taste was commensurate with their station in an ordered society.[17] Instead of serving as a bulwark against the foreign fashions sapping the nation's strength, John Brown complained in his highly influential *Estimate of the manners and principles of the times* of 1757 that the existing leadership of the state was little 'accustomed to go, or even *think*, beyond the beaten track of private interest, in all things that regard our country'.[18]

Useful charities and societies like the SEAMC, Foundling Hospital and the Marine Society were established, run and in large part funded by merchants, stockbrokers, bankers and directors of international trading houses like the East India and Russia Companies. Their hands-on, practical patriotism, which sought among other things to reinvigorate the British armed forces, went a long way to counter Shaftesbury's contention that men of business were unable to perceive, let alone further the public good. This was not an exclusively middle-class project, however; if anything the appeal of such societies lay precisely in the opportunities they offered men of business to mingle with the nobility and other establishment figures who lent subscription lists a desirable cachet.

These organizations were highly innovative in their use of the polite arts as marketing opportunities to raise awareness and attract donations. The Foundling Hospital, established in 1739, took in unwanted or illegitimate infants and brought them up, providing them with apprenticeships or training as servants. It owed its success to its constant emphasis on public displays of useful charity. In 1753 it opened one of its kitchens as a shop 'where the children might work in public for all passers-by to see the virtue and utility of the experiment.'[19] Its public rooms were decorated by works of art on charitable themes, such as William Hogarth's *Moses brought before Pharoah's daughter*. Together with a sprinkling of Italian old masters, these works earned the Hospital a place in guidebooks to British art collections, attracting the curious and others who might otherwise have been wary of an institution that some critics believed encouraged extra-marital affairs.[20]

Set against this 'virtuous and useful' backdrop, the moral status of painting and painters also underwent re-evaluation. Products traditionally viewed as luxury commodities were now displayed in such a way as to inspire a virtuous ability to look through the showy medium to the noble attributes depicted. Painters who had struggled to avoid characterization as lowly craftsmen now appeared as gentlemen, as 'Governors' of the Hospital practising the highest genre of history painting. When the portrait painter Jonathan Richardson had tried to lay down the principles for 'the science of being a connoisseur' in his 1726 *Discourses*, his attempt to prove that the practising artist was qualified to comment on art had been defeated by the simpering tone of his writing. Only in the 1750s and 1760s, in the context of the Foundling and other spectacles of sympathy, did it become possible to visualize what Richardson had dimly perceived: the painter as 'A Brave Man, and one Honestly, and Wisely pursuing his Own Interest, in Conjunction with that of his Countrey.'[21] It was at the Foundling Hospital that a group of painters, sculptors and other practitioners of the polite arts would meet in 1759 to form the group that would eventually become the Royal Academy.

To those who ridiculed them connoisseurs could seem effete eunuchs. Behind the mask of priapic indulgence, it was suggested, they preferred the company of pictures and fragmentary statues to living people. As seen here, in a detail from Hogarth's **Sculptor's Yard** of 1753, absence (in this case, of limbs) did seem to make the connoisseur's heart grow fonder.

Viewing both Old Master and modern British art at the Hospital taught visitors to look beyond questions of connoisseurship (the distinguishing of individual artist's 'hands', for example) and appreciate the patriotic and moral purpose behind public art. Art appreciation had previously involved attempts to identify and collect fragments of an elusive aesthetic perfection located in times and countries remote from mid eighteenth-century Britain. This was a cosmopolitan effort, but not necessarily Enlightened: in the 1750s the follies of the gullible connoisseur had earned him a place in comedies by Samuel Foote, prints by Hogarth and particularly in *The Connoisseur*, a periodical edited by Bonnell Thornton. Here he was portrayed as prejudiced, yet easily led; articulate, but only in meaningless cant.

Amicable collision?

In 1760 the SEAMC hosted London's first free public art exhibition, attracting 20,000 visitors to a show organized by the Society of the Artists of Great Britain. Rather than either organization seeking to police the crowds, the Society of Arts called on the visitors to police themselves, announcing 'that all persons attending (by the indulgence of the Society) are expected to keep order.' In private art galleries the presence of the owner obliged those participating in discussion of art to flatter and defer to the aesthetic judgment of their host. At the SEAMC exhibition, the indulgent host is relegated to parentheses. Affrays such as that which saw a door-keeper called Morgan Morgan engage in fisticuffs with a visitor suggested that models of behaviour suitable to this new environment were still under negotiation.[22] At the second exhibition, in 1761, an admission charge of a shilling was imposed. Although this undoubtedly excluded many would-be visitors, the exhilaration of entering a space open to self-expression remained, and explains the popularity of these shows. In 1762 London played host to three such annual exhibitions, all of which wore their public-spiritedness on their sleeve. Whereas civic-humanist texts had visualized

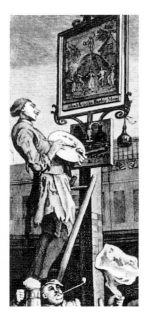

Hogarth's attitude to grand history painting wavered between aggressive attempts to surpass the achievements of the continental Masters and equally forthright attempts to propose a native aesthetics. Though the sign-painter-artist in this detail from his famous **Beer Street** of 1751 appears to be starving, Hogarth clearly identified with this much-maligned British art form.

public-spiritedness in terms of the heroic individual, acting on behalf of others, it was increasingly felt, to quote John Barrell, 'that the public spirit [needed] to be understood in terms of an ability to perceive, rather than act upon, the public...'[23]

The more the pretensions of public art exhibitions to serve the patriotic and moral good of the nation grew, however, the wider the gap between the rhetoric and reality of British art yawned. British painters were still embarrassingly poor relative to their European counterparts, and their output was over-whelmingly restricted to portraits and depictions of their patrons' families, houses and horses. According to classic aes-thetic theory, of the sort enshrined in the famous European academies, these were the lowest, least public genres of paint-ing. As the painter Joseph Highmore had sniffed in 1766, even 'children, servants, and the lowest of the people' could judge the success of a portrait.[24] Morally they seemed so many adver-tisements of wealth and vanity.

Spying an opportunity for satire, the journalist and wit Bonnell Thornton organized a spoof art exhibition in 1762, which was held at the same time as, and just around the corner from, the two other, serious exhibitions at the Society of Arts and Spring Gardens. Collecting 110-odd pub- and shop-signs from around the city, he hung them flat against the wall, print-ed a catalogue and advertized the opening of a 'Grand Exhibition of the Society of Sign-Painters'. Then he sat back and watched a crowd of genteel visitors arrive, pay their shilling admission fee and humiliate themselves in front of the exhibits, which included a bird in the hand, King Charles in his Oak, a nag's head, a buttock of beef, and a remarkably realistic portrait of 'a block, done from the life'. Two signs (listed in the catalogue as 'The Curiosity, and its companion') were hung with blue curtains, which, as any connoisseur would know, were hung over paintings of female nudes intended only for the male gaze. Except in this case when the visitor nervously pulled them aside, he or she was confronted with one sign bearing the words 'Ha! Ha!' and another 'He! He!'

The public response was fierce. A correspondent calling

himself 'A despiser of all tricking' wrote to the *Gazetteer* confessing that he

did not imagine any set of gentlemen would have been concerned in a senseless attempt at satire, and along with it, the most impudent and pick-pocket abuse that I ever knew offered to the public. The exhibition is really of signs, and those in general worse executed than any that are to be seen in the meanest streets. If there is any satire in this design it must be in humming their customers. Wit, or taste, there is certainly none... In fine, this mock exhibition is a most impudent and scandalous abuse and bubble: an insult on understanding, and a most pickpocket imposture. The best entertainment it can afford, is that of standing in the street, and observing with how much shame in their faces people come out of the house.[25]

The exhibition fad and the rhetoric of public-spiritedness had gone so far that people would queue up to pay a shilling to view the Sign-Painters Exhibition, apparently not believing that the exhibition could really be what it said it was.

The exhibition was a celebration of an art form which Thornton's associate, William Hogarth, believed to be 'truly English'. Far from seeking to embarrass their fellow artists exhibiting at the other two shows, Thornton's fictional 'Society of Sign-Painters' claimed to be 'animated by the same public spirit, their sole view [being] to convince foreigners, as well as their own blinded countrymen, that however inferior this nation may be unjustly deemed in other branches of the polite arts, the palm for sign-painting must be universally ceded to us.' It was, in its way, a highly patriotic exercise, and it had a point. The 'art' of sign-painting, its wit and inventiveness, really had been celebrated as quintessentially British by Addison, Steele, Fielding – even Shaftesbury himself. In cities without street numbers, signs not only served to encourage commerce, but operated as landmarks, rendering the city navigable to connoisseurs and illiterates alike. Here was an art form that was clearly British, and clearly useful.

But what of virtue? Signs advertised bawdy houses, taverns and other enterprises that served mankind's baser appetites. They were highly irrational, and in 1762 were in the process of

being banned by City authorities as a public nuisance, as obstacles in the way of a clean, well-ventilated streetscape. It was hard to see signs as a polite art form, therefore. Thornton was satirizing the form and rhetoric of the public art exhibition, ridiculing the eagerness of a paying public to adopt the connoisseur's pretensions to support projects that advanced the common good. The exhibition revealed the extent to which the rhetorical connections binding together public utility, refinement, and public art had become a self-supporting structure, in which anything could be displayed as 'art'.

In view of this, the exhibition seemed to be suggesting that Britons had best stick to viewing signs, rather than pretend to an understanding of higher art forms removed from the familiar world of trade and consumption. For all its humour, the exhibition questioned whether the institutionalization of art appreciation represented progress. Furthermore, it set up politeness and the polite arts as enemies of the national art form, which was irrational, crude and low. Thornton's inability to suggest what real British art should look like reminds us that, for all their importance, patriotic aesthetic renegades like Hogarth and John Wilkes could not go it alone. Their fight for a patriotic, useful national culture would be in vain if it ended in the collapse of a viable notion of the public.[26]

Vauxhall Gardens, the summer resort of middling- and upper-class Londoners located on the south bank of the Thames, afforded a more promising basis on which to found such a notion. Here, on payment of a shilling, visitors could perambulate the gardens, listen to music and view some of the hundred paintings on display, some of which illustrated incidents from Shakespeare's plays and popular novels like Richardson's *Pamela*. In a sense, Vauxhall Gardens was a multi-media museum. The main spectacle on view, however, was the crowd itself. Although contemporary accounts that speak of servants and butcher's boys parading round Vauxhall are undoubtedly exaggerated, the *frisson* of excitement generated by the Gardens was clearly rooted in a shared awareness that this was a place where people who would normally only meet across a shop-counter (if at all) mingled, where strangers one

Suffused with melting music, punctuated by affrays and alive with the *frisson* of unplanned encounters with all sorts of people, contemporary accounts struggled to do **Vauxhall Gardens** justice. Although this view of 1751 after Samuel Wale shows the Gardens' Great Walk by day, in fact Vauxhall was only open on fine nights during summer, when all London came by boat and carriage to taste its many delights.

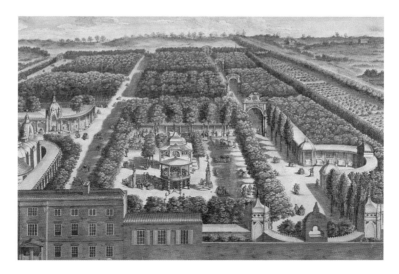

did not know and who could not be neatly classified promenaded without anybody in charge. Yet, as one account of circa 1780 maintained, Vauxhall promoted virtue also:

The manners of the lower order of the people have, by almost imperceptible degrees been harmonized by the mixing with their betters, and that national spirit of independence which is the admiration and astonishment of Europe in a great measure takes birth from the equality it occasions.[27]

The neatest explanation of this social polishing without police was, perhaps surprisingly, provided by Shaftesbury, an aristocrat. In describing what he termed 'amicable collision' he seems to have captured perfectly a concept of a deliberate mixing of different social ranks: a mingling that is more than just a litmus of British constitutional liberty, but is one which seems to function as an actual engine of liberty:

All politeness is owing to liberty. We polish one another and rub off our corners and rough sides by a sort of amicable collision. To restrain this is inevitably to bring a rust upon men's understandings. It is a destroying of civility, good breeding and even charity itself, under pretence of maintaining it.[28]

Foreign visitors found this mingling without surveillance or control astonishing, and French *philosophe* visitors like the Abbé Coyer were forced to agree that it must have something to do with the British constitution. In his *Nouvelles Observations sur L'Angleterre* of 1770 Coyer drew especial attention to the paintings on display at Vauxhall, including Francis Hayman's *The Humanity of General Amherst*, which celebrated the virtues of Seven Years War heroes. This was one of a series of four paintings commissioned by the gardens' impresario, Jonathan Tyers, in 1760-1. According to Coyer these paintings, located in a privately-run pleasure resort, had a very public message:

In our age nobody thinks of displaying models of patriotic virtue in places where the public has its diversions. They do so here. In the centre of Vauxhall there is a salon decorated with… paintings celebrating recent British victories, which seem to say to the spectators: to enjoy the right to amuse yourselves, do something similar.[29]

Hayman's programme of history paintings celebrated the mercy of the victorious British commanders, and arguably helped Britons overcome some of their innate fears about standing armies and imperial hubris by suggesting that imperial conquests were Providence's way of rendering the world (and armed conflict itself) more polite and sympathetic. Vauxhall thus played a role in domesticating and nationalizing the phenomenal successes of the Seven Years War, proving, to quote one guidebook to the gardens, 'that clemency is the genius of the British nation.'[30] The SEAMC also did its bit for the war commemoration effort, holding a competition in 1761 for designs of classical trophies and reliefs 'allusive to the Glorious Achievement of the British Arms During the Present War'. Among the entries was 'A Proposal for a Temple of Victory' which prefigures the Royal Academy's plan for a 'Dome of National Glory' discussed later in this chapter.[31]

By the late 1760s, therefore, a number of institutions had been established catering to a public appetite for entertainment and self-improvement. Spectacles of useful charity and sympathy at the Foundling Hospital allowed those unwilling or unable to disavow their stake in Britain's burgeoning

commerce the opportunity to experiment and familiarize themselves with a public-spirited rhetoric. Unlike the old cant of criticism, this was a patriotic language. Although the Sign-Painters' Exhibition suggested that this language, too, could be satirized, it was difficult even for those most suspicious of it to suggest an alternative. This public was not rigidly defined or supervised. Indeed, some of those charged with administering these institutions feared that they were casting the net too widely, failing to acknowledge a distinction between those whose claims to taste were founded on real education, wealth and rank from those whose politeness was a façade.

It also had a political aspect. Many of the merchants and company directors who visited the British Museum, attended art exhibitions and served as governors of useful charities did not have a vote, or, at least, would have to purchase estates outside London to qualify for one. The gentry whom they encountered in the course of their cultural activities could vote. Yet the public sphere which brought them together declined to classify them along these lines – by failing to observe such an important distinction it intimated that the circles of polite society and political society were misaligned. It is not surprising, therefore, that John Wilkes, the first politician to speak in parliament in favour of a national gallery, should have been eager to redress this imbalance; to widen the political franchise and empower public opinion so as to hold oligarchic ministers and the King who chose them to account.

John Wilkes and 'the public eye'

On April 26, 1777 Wilkes spoke in the House of Commons urging parliament to purchase the Houghton Collection, donate it to the British Museum, and provide funds to build a special gallery annexed to Montagu House. The Houghton Collection of paintings had been formed by Robert Walpole, Britain's notoriously corrupt Prime Minister, and included Rembrandt's *Abraham and Isaac* among other masterpieces. Owing to the insolvency of Robert's eldest son, the collection was being sold, much to the distress of his younger son, Horace. Wilkes argued

that by purchasing these works as the nucleus of a national collection parliament would fill a gap in the British Museum's collections and further the patriotic project of a national school:

The British Museum, Sir, possesses few valuable paintings, yet we are anxious to have an English School of painters. If we expect to rival the Italian, the Flemish, or even the French School, our artists must have before their eyes the finished works of the greatest masters. Such an opportunity, if I am rightly informed, will soon present itself. I understand that an application is intended to be made to parliament, that one of the first collections in Europe, that at Houghton, made by Sir Robert Walpole, of acknowledged superiority to most collections in Italy, and scarcely inferior even to the Duke of Orleans' in the Palais Royal at Paris, may be sold. I hope it will not be dispersed, but purchased by parliament, and added to the British Museum. I wish, Sir, the eye of painting as fully gratified as the ear of music is in this island, which at last bids fair to become a favourite abode of the polite arts. A noble gallery ought to be built in the garden of the British Museum, for the reception of that invaluable treasure.

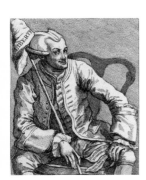

Hogarth's unflattering 1763 portrait of **John Wilkes** as a leering rake was based on a sketch made during one of the latter's many appearances in court. Although Wilkes' legal battles helped secure several of the civil liberties we enjoy today, such images have made it easy to dismiss him as an unprincipled opportunist – and ignore his interest in art.

He went on to criticize the Crown's management of the royal collection, drawing attention to George III's removal of the Raphael cartoons to his new, private residence of Buckingham House. Here his speech echoed earlier comments, emphasising their status as national heritage.

Such an important acquisition as the Houghton Collection, would in some degree alleviate the concern, which every man of Taste now feels at being deprived of viewing those prodigies of art, the cartoons of the divine Raphael. King William, although a Dutchman, really loved and understood the polite arts. He had the fine feelings of a man of Taste, as well as the sentiments of a hero. He built the princely suite of apartments at Hampton Court on purpose for the reception of those heavenly guests. The nation at large were then admitted to the rapturous enjoyment of their beauties. They have remained there till this reign. At present they are perishing in a late baronet's smoky house at the end of a great smoky town. They are entirely secreted from the public eye; yet, Sir, they were purchased with public money, before the accession of the Brunswick line, not brought from Herrenhausen. Can there be, Sir, a greater mortification to any English gentleman of Taste, than to be thus deprived of feasting his delighted view with what he most admired, and had always

considered as the pride of our island, as an invaluable national treasure, as a common blessing, not as private property? The Kings of France and Spain permit their subjects the view of all the pictures in their collections, and sure, Sir, an equal compliment is due to a generous and free nation, who gave their prince an income of above a million a year, even under the greatest public burdens.[32]

Wilkes' analysis was largely correct. George III admittedly made some important additions to the Royal Collection, acquiring the collection of Consul Smith in 1762, and commissioning a series of large history paintings from Benjamin West in the 1780s. Compared to its European counterparts, however, the British court was notable for not allowing artists facilities to study its art collections.[33]

Although Wilkes' speech was widely reported, parliament did not take the suggestion any further. The collection was purchased by Catherine the Great, and left for Russia in 1779, 'where it will be burnt in a royal palace in the first insurrection,' as Horace Walpole despondently observed.[34] Even those not personally involved in the sale felt its loss to be an indicator of declining fortunes – not only those of the Walpoles, but of the nation as a whole. As 'C.D.' wrote to *The European Magazine* in 1782,

the removal of the Houghton Pictures to Russia is, perhaps, one of the most striking instances that can be produced of the decline of the empire of Great Britain, and the advancement of our powerful ally in the North. The riches of a nation have generally been estimated according to as it abounds in works of art, and so careful of these treasures have some states been, that, knowing their value and importance, they have prohibited the sending of them out of their dominions.[35]

Rembrandt's dramatic portrayal of the angel's last minute intervention in his **Abraham and Isaac** was one of many masterpieces lost when the Houghton Collection was sold to Catherine the Great of Russia in 1779. The failure of Wilkes and others to convince the government to buy it for the British Museum would be lamented for years.

Compared to the silence which greeted the sale of Charles I's art, this reaction to the loss of a great collection in 1779 was recognizably modern in its focus on the movements of art as a test of national strength. Although heritage panics would take on far more dramatic forms in the following two centuries, we can clearly perceive the beginnings of a familiar argument: that one of a national gallery's functions was to serve as an

asylum for art, saving helpless paintings from kidnap and mistreatment by nefarious foreign powers.

But who could be trusted with guardianship of such 'national treasure'? As far as Wilkes was concerned, that trust belonged to parliament alone. In his speech he pointed out how three great agencies for preserving and displaying British art – the King, the British Museum, and aristocratic families such as the Walpoles – had fallen short of the standards which the public were entitled to expect: by excess of arrogance, meagre parliamentary funding, and insolvency respectively. Only through parliamentary support could the cause of great British art be reliably advanced and taste diffused among the people.

Wilkes' speech had been widely reported because he was a political celebrity. The son of a Clerkenwell distiller father and a non-Conformist mother, in the 1760s he had made his reputation as a king-baiting journalist. In his newspaper, the *North Briton*, he accused George III and Bute, his first Minister, of plotting to rob British citizens of their age-old liberties by levying unconstitutional taxes and silencing public opinion. In 1763 Wilkes had been charged with seditious libel and imprisoned in the Tower. Released to await trial, he fled to France and was outlawed. Five years later, having enjoyed the hospitality of Parisian philosophes and even gone on a Grand Tour to Italy, Wilkes returned – and was thrown in prison again. While there he was elected MP of Middlesex, only to have the result quashed. Wilkes kept winning new elections, however, until Parliament declared the man who had come a distant second in the poll duly elected.

Wilkes' colourful rhetoric and unremitting self-promotion as a victim of ministerial despotism had already made him a household name. This became painfully obvious when a quarter of the electorate petitioned the King in Wilkes' favour, protesting against his election being set aside. Wilkes eventually won the right to take his seat, but only after 'Wilkes and Liberty' riots had raged across the capital, apparently confirming the fears of those who saw British liberty as inherently tending to licentiousness. In the 1770s Wilkes went on to secure the right of the press to report parliamentary debates

(1771) and deliver the first speech (1776) in favour of franchise extension ever delivered in the eighteenth-century House of Commons.

Wilkes was a key figure in what has been called 'the commodification of politics' in Britain, as well as in the history of popular politics. In focussing on the many innovative forms of Wilkite agitation it can be easy to lose sight of the man himself. For all his rakish, wide-boy image and tub-thumping xenophobia, Wilkes was a man of the Enlightenment. Educated at Leiden University, where he befriended the young *philosophe* the Baron d'Holbach, Wilkes spent his European exile writing history and discussing the latest developments in political and aesthetic thought with the best minds of the age. His surviving correspondence includes lively exchanges with Denis Diderot and Johann Joachim Winckelmann on the subject of art and politics. Leader of the *Encyclopédistes*, Diderot penned a series of penetrating salon reviews for Grimm's *Correspondance littéraire* from 1759 onwards. Five years later in Rome, where he enjoyed the patronage of the Cardinal Albani, the Prussian emigré Winckelmann had published his seminal *Geschichte der Kunst des Alterthums* (*History of ancient art*).

Wilkes' discussions on art with Diderot and Winckelmann implicated him in a broad eighteenth-century debate on the progress of empires past and present: crudely put, that between the 'hard' Antique model of 'free,' virtuous and beautiful heroes dependent on an enslaved agricultural underclass and an emerging, 'soft' modern model in which all individuals had freedom, but chose to exercise it within a decentralized and apparently disordered commercial society whose aesthetic charms were less obvious. In contrast to Diderot's pessimistic reaction to signs of *anomie* in French painting, and Winckelmann's failure to establish a German academy free of court interference, Wilkes appears to have believed that it was possible for British culture to resist both the demoralizing effects of luxury and the dead hand of royal patronage.[36]

In arguing that Britain could have the best of all possible worlds – freedom, arts and commerce – Wilkes posited a 'win-win' situation where others, notably the philosopher David

Hume and painter James Barry saw painful trade-offs. Although Hume grudgingly admitted that the seeds of art needed liberty to germinate, after they had sprouted the young plants did better in the controlled environment of an Absolutist hot-house than in the *beau désordre* of the British garden. For Hume, big art needed a big state, and an audience of subjects, not consumers.[37] In his speech Wilkes seemed at first to agree: he made frequent allusions to the golden age of municipal improvement that was Periclean Athens; when, he said, Pericles 'boasted that every art would be exerted, every hand employed, every citizen in the pay of the state, and the city not only beautified, but maintained by itself.'

Far from presenting a plea for a command economy, however, Wilkes argued that in Britain such extreme measures were unnecessary, thanks to the public-spiritedness of individual Britons. Once parliament laid the foundations by purchasing the nucleus of a collection and providing it with a home, private donors would step forward to donate paintings, obviating any need for further expenditure from central taxation. Central government expenditure on a suspiciously *étatiste* institution is justified as a one-off exercise in 'priming the pump'. Another great rhetorical pillar of the national gallery had been constructed: the funding equivalent of what eighteenth-century quack inventors called 'a machine to go without horses'.

The academic prerogative

The monarchy was conspicuous by its absence from such visions. This was in stark contrast to the situation on the Continent, where a number of kings, princes and emperors were in the process of reorganizing their art collections. In some cases, notably that of the Austrian imperial collections at the Belvedere Gallery in Vienna, Enlightened curators like Christian Mechel were breaking new ground in the ways they classified and hung their collections. Hitherto the great galleries had sought to create rich spectacles by hanging works of different periods and school cheek by jowl. These made great demands on the viewer's knowledge and skill in picking apart

Previous pages: Sebastien Bourdon's **Return of the Ark** of 1659 was in Sir Joshua Reynolds' collection, and so was among the works he hoped the Royal Academy would purchase as a study collection, the nucleus of a national gallery. Although the Academy resisted the idea of a national gallery, Sir George Beaumont shared Reynolds' taste and vision. He acquired this painting and presented it to the National Gallery with the rest of his collection in 1827.

the resulting puzzle. Mechel, by contrast, wrote in a 1783 guide to his gallery that a properly arranged collection should be a 'visible history of art'.[38] Although this new type of hang doubtlessly made it easier for non-connoisseurs to understand how the art was arranged, access to such royal collections remained strictly controlled. It was easier for foreigners to visit than locals, another fact which suggests that, however 'Enlightened' in tone, such galleries' prime function was still the absolutist one of impressing foreigners with the splendour of the King. And, as Shaftesbury had noted in 1711, 'where absolute power is, there is no public.'[39]

Even if the forms it took were unsatisfying, it was arguably possible for something approaching a public to exist at the fringes of a powerful court. By paying for tickets deferential professionals and merchants eager to experience the polite arts could help rulers spread the cost of court opera, concerts and other spectacles. Some critical, public discussion could exist under Enlightened Absolutism. In Paris there were, for example, attempts to encourage published criticism of the Salon, to create French 'Wauxhalls' and other cultural initiatives aimed at 'le citoyen désinteressé'.[40] These struggled, however, to be more than parasites of court culture. In Britain, the roles were reversed: if anything, the court was a parasite of culture. Neither George I nor II had their own opera, but fitfully attended that at the Haymarket, often arriving in a sedan chair. Members of the royal family rarely experimented with a 'patriotic' self-image, except, as was so often the case for the Prince of Wales (George III's father), they saw it as a way of pursuing a family feud by other means.

When they did attempt grand audio-visual spectacles the results were inevitably less than grandiose. The performance of Handel's *Music for the Royal Fireworks* held by George II's command in Green Park in 1749 was particularly revealing in this respect. Unable to provide the necessary equipment himself, King George had to turn to Jonathan Tyers, the Vauxhall Gardens impresario, for help. In return, Tyers received the royal permission to put on a 'rehearsal' of the music several days before the real event. Tyers' show was so well marketed it

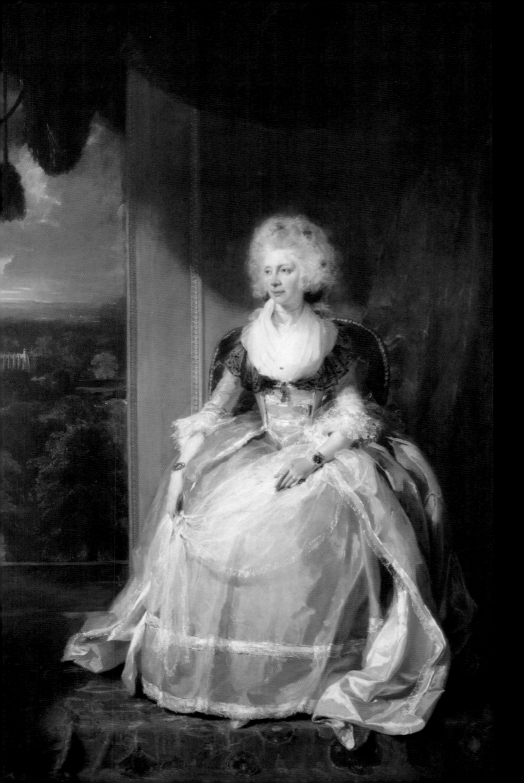

caused a traffic jam all the way back to London Bridge; the performance itself was magnificent. George II's show was entertaining, but for all the wrong reasons. First the fireworks failed to go off, then they set fire to the grand firework pavilion, causing its enraged architect, Signor Servandoni, to draw his sword on the King's Comptroller of Fireworks.

From his accession in 1760, George III seemed eager to draw a line under such spectacles of humiliation. At his coronation he declared that he 'revelled in the name of Briton,' and he displayed a strong desire to take a more assertive line in politics, in an attempt to cure the factionalism which had dogged it for so long, and which had been linked to 1750s fears of luxury and national decline. So many years of Whig Supremacy had caused nuanced political debate to atrophy. Aided by Wilkes' injection of 'Old Whig' revivalism, many observers chose to fall back on a tried and trusted explanation for the new policies of George III and his Scottish first minister, Lord Bute: the abuse of royal prerogative. Bute was supposedly misleading the King into overstepping the constitutional line, arrogating despotic powers of taxation and arrest to his corrupt cronies. Bute was also charged with selling out on British imperial interests in the Peace of Paris (1763), whose terms were felt to be suspiciously generous to defeated France.

When George III founded a Royal Academy of Arts in 1768, therefore, an act which might have been seen as catching up with more obviously 'polite' European countries (Louis XIV had founded the French Academy of Painting and Sculpture in 1648) was interpreted by some as another example of royal meddling. John Wilkes heard about the foundation while incarcerated in King's Bench prison, and wrote to his French friend Suard that the arts could never thrive 'under the inelegant, and banefull shade of the Northern heresy [i.e. Bute], which has been fatal to the eye in painting, to the ear in music, to the smell in incense.'[41] The founding members of the Academy had seceded from the Society of Artists of Great Britain after a dispute. By exploiting the court contacts of the architect William Chambers they succeeded in gaining George III's support for a new institution, despite the fact that the

Opposite: Painted in 1789 when the artist was thirty, Thomas Lawrence's portrait of **Queen Charlotte** pleased neither the sitter nor her husband, King George III. Exhibited at the Royal Academy in 1790, it remained in the artist's studio. In 1927 Director Charles Holmes resisted Trustee requests to 'eliminate' or crop the upper portion.

King had given a charter to the Society of Artists just three years before. Members of that Society felt sidelined, and a spokesman argued in the Wilkite *Middlesex Chronicle* that the new foundation was intended 'to shew the world that prerogative shall triumph over every law in every department of state.'[42]

Compared to earlier London art schools, which had actively avoided rigid structures and administrative alliances with connoisseurs, the Royal Academy was closely modelled on the highly regimented Paris Academy, and actively embraced a cosmopolitan, connoisseur approach to aesthetics. Epitomized in Academy President Sir Joshua Reynolds' annual discourses, this approach stressed the emulation of the Antique and of Old Masters; Michelangelo, Claude and Rembrandt above all. Eager to disassociate itself from a craftsmanlike or 'slavish' mimicry of life, it defined imitation as a quasi-philosophical ability to capture nature's 'central form'. In contrast to Hogarth's socially inclusive focus on native common sense, it could betray a rather un-Enlightened face in defending prejudice – at least, when that prejudice was in favour of the Antique and the painters Reynolds admired.[43]

The Academy's approach was also tamer, seeking to contain the threats posed by concepts of 'genius' and especially the sublime. Hogarth's 1753 *Analysis of Beauty* presented art as indulging an innate, almost animal, love of pursuit for its own sake. 'Pursuing is the business of our lives,' Hogarth had written, arguing that his serpentine 'line of beauty' worked precisely because of the eye's pleasure in being '*led a wanton kind of chace*'.[44] Art indulged human appetites, rather than demanding that they be repressed and denied. Reynolds suggested that true art was not a spring bubbling up from below, but depended on disinterested, non-commercial patronage from above, as well as institutional frameworks in which young artists could be preserved from dependence on the disordered, imperfect, commercial world outside.

There was nothing particularly new or unreasonable about this: since the 1750s those fearful of the moral effects of luxury had argued that culture should be institutionalized and

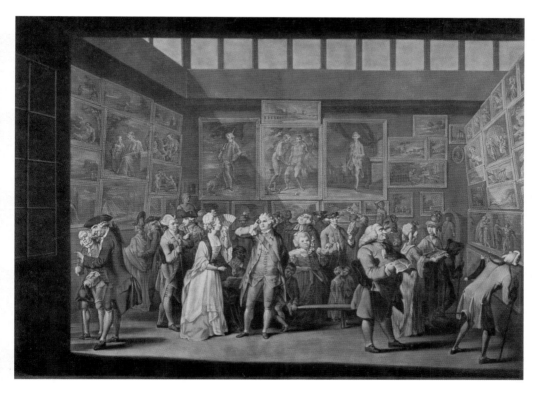

The **Royal Academy's annual exhibition** enfranchised all with eyes to see, especially at a time when art criticism was still in its infancy. This 1771 view by Michel-Vincent Brandoin shows how crowds consumed each other as well as the art on display. The squinting central figure in the tricorn hat may be John Wilkes. In 1771 the exhibition was held in rented quarters in Pall Mall. Although the Academy moved into more commodious quarters at Somerset House in 1779, the tradition of hanging paintings frame to frame was continued.

brought under the control of public-spirited 'police' (understood in the now archaic sense of 'administration' or 'regulation'). Reynolds and the Academy were, however, guilty of protesting a little too much. Their theory stated that history painting was the highest genre, and portrait a low one. Their annual exhibitions demonstrated that in practice they were only too happy to follow the market's priorities, which were exactly opposite. Instead of holding themselves aloof from the glittering effects popularized in commercial spectacles such as De Loutherbourg's quasi-cinematic 'Eidophusikon,' the Academy encouraged cross-fertilization. Such panoramic effects, which had been criticized as examples of 'French' frippery, were naturalized in the works of Turner, whose mannerisms was seen as the means by which a painter-genius focussed

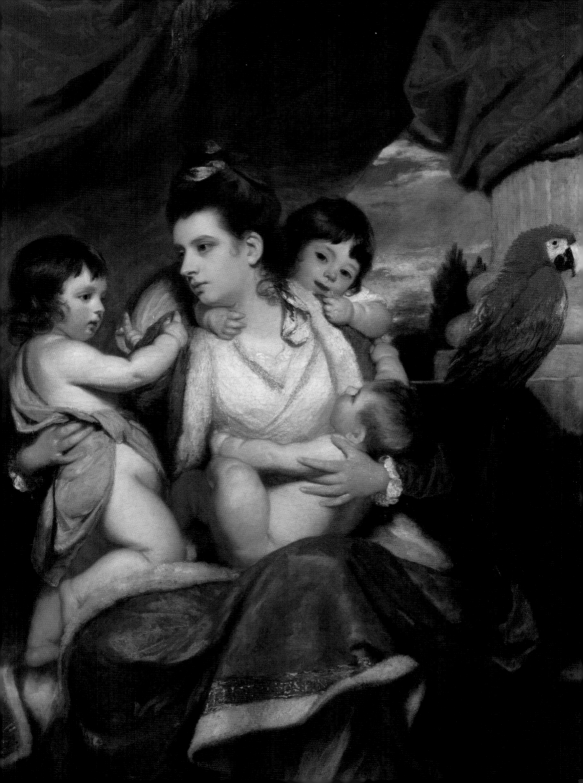

the viewer's mind on shared associations linking national character and landscape.[45]

This gap between rhetoric and policy was nowhere wider than in debates surrounding the question of forming a collection of Antique sculptures and Old Master paintings. One of the first arguments Wilkes made in his 1777 national gallery speech was that it was foolish to expect a British School of painters to emerge without first establishing a public gallery of art suitable for their emulation. It might have been expected that an Academy whose President used Rubenses from his own personal collection to illustrate his lectures would have been at the forefront of efforts to create a national gallery. Its reluctance suggests an institution wary of outward-looking projects, or rather one that preferred to define its educational role more narrowly.

In both his 1792 Academy lectures and his 1798 *Letter to the Dilettanti Society* the history painter James Barry criticized the Academy's lack of an art collection. Barry asked how a city amply provided with hospitals and other institutions designed to satisfy 'almost every want of humanity, both of body and mind' could lack a national gallery. Were the Academy to make a start

Opposite: Joshua Reynolds' 1773 portrait of **Lady Cockburn and her three eldest sons** was probably inspired by an engraving of another painting now in the Gallery, *Charity* by Anthony van Dyck. It is the only work to enter the collection twice, in 1892 (as NG1365) and again in 1906 (as NG2077). In 1892 it was bequeathed to the Gallery by Lady Hamilton (daughter of the boy kneeling at left). Her heirs objected that she had no right to alienate family heirlooms. The Trustees took legal advice and returned the portrait in 1900. Showing a respect for ancestors typical of period, the heirs sold Lady Cockburn the next day. It was subsequently bequeathed to the Gallery by Alfred Beit.

this beginning... would, with a generous public that only wants such an occasion of directing its energy, soon fructify and extend to a National Gallery, which... would... extend to the improvement and entertainment of the nation at large. There are many old famous pictures in this kingdom: whether any of these should be bestowed on this public gallery, or only lent to it for any given number of years, to be replaced by others, the end would be equally answered; and, by proper inscriptions on the frames, the public would know its benefactors, who would be paid in a glorious celebrity, proportioned to the utility and satisfaction they diffused.[46]

Barry shared Wilkes' belief that the public only needed a slight impetus before they would start donating works. Barry saw such a gallery as a means of encouraging social cohesion through the inscriptions identifying the public-spirited wealthy. Far from the Academy encouraging him in demands for a

national gallery, such rhetoric made him extremely unpopular, and expedited his expulsion in 1799. During their investigation into his conduct fellow Academicians ridiculed his eagerness to set up a gallery.[47]

Despite having ample means in the shape of the profits from their annual exhibitions (which drew an average of 56,000 visitors per year between 1799-1808), as well as a promising nucleus in the shape of Reynolds' collection, the Academy decided against purchasing it and instead funnelled profits into their pension plan.[48] In 1799 the art dealer Noel Desenfans published a pamphlet urging the creation of a national portrait gallery, which would preserve portraits which might otherwise be sold by their titled owners. Admission fees would fund commissions of new portraits from native artists, and incite patriotic Britons to earn a place in this 'Royal and National Establishment'.[49] Such a gallery might have compensated for the failure of the British state to purchase the great Orléans Collection (praised by Wilkes in his speech). This was purchased by a syndicate of British nobles in 1798 for £43,500 (and so was divided up).[50] Academy President Benjamin West showed little interest in Desenfans' idea, however. Six years later West and other RAs again opposed plans for a gallery, self-servingly arguing that a gallery would only confirm 'the prejudices in favour of old pictures,' claiming that a collection including foreign paintings could not be 'national'.[51] The Academy's published lectures and transactions stressed its position as one member of a pan-European network of academies pursuing a common goal of retrieving the aesthetic glories of Antiquity. Behind the façade narrow professional interests held sway, fuelling the Academy's vicious internal squabblings, which brought it close to collapse in the years 1800-3.[52]

This prevented the Academy from joining the bandwagon of 'national' rhetoric which enabled both the monarchy and the political elite to present themselves as patriotic, manly and courageous. In contrast to their portrayal in earlier conflicts – notably the Seven Years War – as treacherous, emasculate and pacifist, during the Napoleonic Wars King George III and the nobility underwent what Linda Colley has dubbed an

'apotheosis'.[53] Aided by his various illnesses, which stressed his fragility, George III became 'Farmer George': a benign pater-familias of worthy morals. Though low profile, his interest in Gothic architecture and pageantry contrasted the venerable age and stability of the British regime with 'the mushroom court of the Tuileries'.[54] The nobility's apotheosis took the form of monuments to victorious commanders such as Admiral Lord Collingwood in Westminster Abbey and St. Paul's Cathedral, a programme of sculptures which saw parliament spend £117,075 between 1798 and 1823 on a total of 36 sculptures.

This ambitious and unprecedented programme effectively turned these churches into a near equivalent of the French Pantheon.[55] The inclusion of ordinary seamen and soldiers in both royal parades and the monuments was also novel, and reflected a willingness to stress the role of the 'normal' citizen in an epic struggle. Unlike previous wars, the Napoleonic conflict was more than a squabble over distant colonies or borders. As Burke's *Reflections on the revolution in France* (1790) had intimated even before the conflict began, it was a struggle between two political systems. In so far as the war necessitated calling on the blood and treasure of a larger proportion of the nation's population than ever before, it was no longer enough for such propagandists to confine themselves to comparisons of constitutional theories: the British constitution had to be explained in terms of British manners, prejudices, history, topography – even landscape.[56] This is the context for 'national' projects of the period from 1793 right up to the 1830s, including the National Gallery.

The need to match her enemy's success in mobilizing hearts and minds explains why many of these projects echoed French architectural visions of the ideal state as a forest of grand Graeco-Egyptian obelisks, pyramids and temples. As early as 1798 a member of the French Museum Commission proclaimed that 'the true and lasting monuments' to the memory of 'our warriors' would be 'our museums'. If their breathtaking designs for national museums and libraries of the 1780s are anything to go by, architects like Étienne-Louis Boullée must

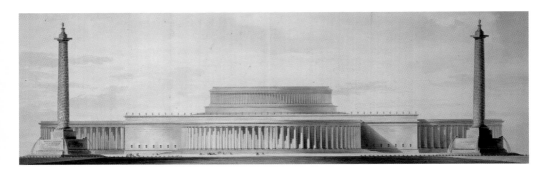

Late eighteenth-century designs for sublime (un-realized) libraries and museums by **Étienne-Louis Boullée** show that the tendency for architects to use such projects as an opportunity to foist 'signature buildings' on the public has a long pedigree. In Revolutionary France, the cult of reason brought forth many such monstrous visions.

have been delighted.[57] The transformation of the Revolutionary Louvre into the Musée Napoleon, filled with a dazzling display of art systematically looted from Europe by its great Director, Auguste Vivant Denon, encouraged this military-commemorative vision of the museum. The flood of British artists, connoisseurs and others that visited Paris during the Peace of Amiens (1802-3) were deeply impressed.

The competition for a dome of military glory, launched under the patronage of the Duke of Clarence in 1799, closely paralleled these French developments. The painter John Opie's design for a 'Temple of Naval Virtue', for example, took the form of a circular, top-lit building whose interior was to have been lined with large paintings of naval battles and portraits of heroes. Various other designs combining monuments with a national gallery were exhibited at Royal Academy exhibitions in the period 1798-1805, including projects by Thomas Hardwick and Joseph Gwilt.[58] The sculptor John Flaxman proposed his own 'Dome, or Gallery of National Glory' to the Royal Academy in March 1801, by which stage a special committee of the Academy appointed to develop Opie's ideas had met several times and petitioned the King in favour of the plan. Unfortunately for them George III's physical condition had deteriorated three weeks previously. The plan seems to have been forgotten in the resulting administrative backlog.[59]

The fact that the Academy did not pursue the matter further, or consider appealing to parliament seems characteristic of its unhappy, fitful attempts to establish itself as a body

advising the government or Crown on national projects. George III had suspicions that Benjamin West and his colleagues harboured Jacobin sympathies; that the Academy was royal, but not loyal.[60] The institution was internally divided between those eager for the Academy to advise parliament and the government on state art patronage and those who argued, like William Chambers, that it should stick to its last. For a few years around the turn of the century the former camp seemed to gain the upper hand. The Academy sought to advise government over the St. Paul's and Westminster sculpture pantheons, for example.

Although the Academy had some success in minor projects, such as securing import duty exemption for imports of works of art, these could seem highly self-serving. In 1797, for example, Academicians succeeded in having themselves exempted from Pitt's new Income Tax.[61] Far from trusting the Academy's judgment, in 1801 Pitt's administration appointed a 'Committee of Taste' made up of connoisseurs to decide on designs for the parliamentary monuments. This seemed to prove that the attempt to jump the national bandwagon had been a mistake, or, perhaps, that the Academy was ill-prepared for parliament's adoption of the role of commemorative maecenas. Despairing at the state's rebuttal of the Academy in favour of non-professional

The architect Joseph Gwilt produced this **design for a combined national gallery and war monument** in 1809. Top-lit galleries allowed the exterior to be totally given over to plaques honouring Britain's fallen heroes. Such juxtaposition seems odd today, but in the Revolutionary and Napoleonic era museums became sites for the celebration of victory and the forging of new national identities.

advisers like Sir Charles Long and Richard Payne Knight, Academician Joseph Farington had commented in his diary that 'the connoisseurs' had 'again got into their hands the direction of everything respecting the public monuments.'[62]

The Academy now retreated to lick its wounds, and would play little role in the foundation of the Gallery. They did, however, play an important advisory role in the administration of Dulwich Picture Gallery, which opened to the public in 1817. This consisted of a collection of 371 paintings originally formed in the 1790s by Desenfans, acting on commission for the Polish monarch, Stanislas Augustus. With the partition of Poland Stanislas was forced to abdicate, leaving Desenfans holding the paintings, which he left to his friend Francis Bourgeois on his death in 1807. Bourgeois' decision to donate the collection to Dulwich College was effectively a decision against the British Museum, which he disliked for its 'aristocratic' board and exposure to city centre pollution.[63] Sir John Soane's pioneering gallery building (1811-4) was erected at the site several miles south of Westminster. Although open to the public for free, this remote location inevitably limited access. It nonetheless kept the need for a central public collection before the eyes of government.

The British Institution and Beaumont

A more important institution for the purposes of our study is the British Institution, founded by a group of upper-class collectors and politicians in 1805. The BI organized temporary exhibitions of works borrowed from connoisseur collections, intended both to educate the public and improve the skill of native artists. In a way this institutionalized the precedent set by connoisseurs such as Francis Egerton, who in 1806 opened his Cleveland Row house to select members of the public on a ticket system, allowing them to admire the treasures of the Stafford Collection.[64] The Institution wore its patriotism on its sleeve, sponsoring competitions for paintings or sculptures commemorating victories, and trumpeting its public-spirited aim of creating a British School.

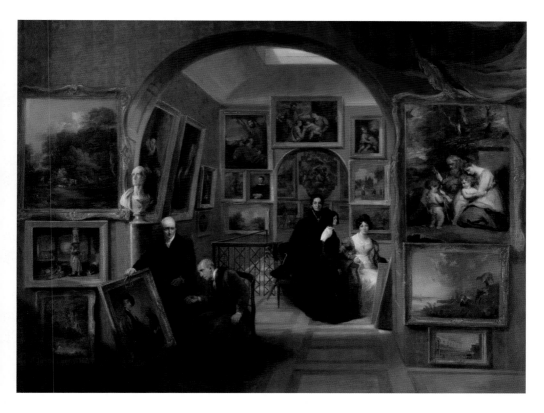

The British Institution's gallery at 100 Pall Mall was the epicentre of the Regency connoisseur's world. Here collectors mingled with leading politicians and society figures, admiring works of art borrowed from the great aristocratic collections. Britain's first temporary exhibitions of Old Masters were held here, including retrospectives dedicated to British ones such as Reynolds, whose *Self-portrait* (left) and *Holy Family* (right) are shown in this painting of c. 1825 by J. S. Davis among Canalettos and Cuyps.

The BI also represented a reaction against arguments which linked commerce and art. In the 1780s and 1790s printsellers such as Josiah Boydell had seemed to justify Wilkes' confidence in the synergies of trade and artistic advancement. Hailed at Royal Academy dinners as the greatest patron of the age, Boydell and his contemporary William Bowyer kept British artists busy producing engravings after famous Old Masters in private hands, as well as commissioning many new paintings of scenes from British history and literature. Available – for a fee – to the public both as a 'virtual' gallery of prints and as shows of 'real' paintings in various rooms in London, these collections served the Muses, Britannia and Mammon. By publishing collections of repro-

ductions after famed Old Masters in private collections (including the Houghton Collection), Boydell also created 'virtual national galleries,' gathering the finest paintings on British soil together – in engraved form.[65] Boydell donated several of his paintings to London's Guildhall, publishing a pamphlet in 1802 in which he presented the gift as the nucleus of a national gallery. With the closure of the European market as a result of the Napoleonic Wars, however, he ended up bankrupt.[66] As if emphasizing that the connoisseurs were now on the case, the BI set up its headquarters in Boydell's former showrooms in Pall Mall, and fulminated against his supposed debasement of public taste.[67]

There were important limits to this patronage. Prizes were aimed at encouraging British artists who respected the same Old Masters, predominantly seventeenth-century painters like Claude Lorrain and Guido Reni, who were represented in the collections of BI governors. Indeed, the BI organized a competition in which artists were to produce 'companions' to Old Master works on show in their exhibitions.[68] Although these works remained firmly in private hands, the national rhetoric of the BI shows presented aristocratic possessions as national heritage. Membership and governance, however, were hardly inclusive or democratic. To be a Governor (with a vote in electing the Directors) cost fifty guineas a year; extra votes could be purchased for fifty guineas, and Hereditary Governorships cost one hundred guineas. Women could become Governors and even vote, but practising artists were banned. The BI played a pioneering role in organizing the world's first temporary exhibitions of Old Masters, and used its 1813 Reynolds show and other retrospectives as a further means of controlling the British canon. The same can be said of its policy of buying religious and historical works by British painters for presentation to churches and institutions, including the National Gallery.[69]

There is no denying that such patronage represented an important investment in British art, past and present. In 1811 the BI paid three thousand guineas for Benjamin West's *Christ healing* (now destroyed), a record-breaking price for a work by any British artist, living or dead. Yet it was a patronage which

Opposite: One way in which the Directors of the British Institution sought to influence British artists was by buying paintings they deemed worthy of emulation to present to churches and public institutions. In 1827 they presented the Gallery with Parmigianino's *Madonna and Child with Saints*. Three years later they presented this work, Thomas Gainsborough's **Market Cart** of 1786, which they had bought the previous year for 1050 guineas.

did not seek to set British artists on an independent course: as the critic William Hazlitt put it:

> One independent step... an appeal from [the connoisseurs] to the public, their natural and hated rivals, annuls the contract between them [and the artist], which implies ostentatious countenance on the one part, and servile submission on the other... [The connoisseurs] are so sensible of your gratitude that they wish your obligations never to cease... There is something disinterested in all this: at least, it does not show a cowardly or mercenary disposition, but it savours too much of arrogance and arbitrary pretension.[70]

The Tory connoisseur Sir George Beaumont's patronage, both as an individual and through the BI premiums and purchases he controlled, was full of similar paradoxes.

A landed squire who found personal, political or commercial responsibilities difficult, Beaumont's retiring nature was perfectly suited to the connoisseur's world, where opinions were weighed in inverse proportion to the volume at which they were delivered. A landscape artist of no small merit himself, he enjoyed close friendships with John Constable, David Wilkie and other professional painters. But, as Constable noted, it was precisely Beaumont's slavish veneration for the Old Masters in his collection that caused both his own art and his appreciation of others' work to suffer.[71] Beaumont confessed to preferring the idealized nature of Claude to the real thing. His involvement with the artists he 'discovered' was often cyclical: an intense honeymoon period of aesthetic discussion regularly ended in disillusionment, and occasionally mutual disgust. At times Beaumont used the smaller BI premiums to pay off artists he had separated from, notably the young Benjamin Robert Haydon.[72]

Beaumont's efforts to protect his protégés from a broader public were prompted by fears that their taste would be corrupted, as he felt that of Turner had been. He wrote to the poet William Bowles that

> a strange taste prevails at present, this is the age of innovation in all ways, and our wiseacres of the present day have had the sagacity to

discover that in politics, poetry, and painting all that has hitherto been done is fit only for the flames – I hear the young genii are in the habit of calling Titian, Claude... the black masters warning each other with earnestness not to paint like them, this I dare say you will agree with me is a caution by no means called for, but the consequence is the art is now beginning again and at the wrong end, formerly before an artist ventured to dash and flourish he made himself master of the constituent parts, this was the practice of Gainsborough [and his contemporaries] as is manifest from their early works but now my little master with his pap spoon in one hand and his pallet knife in the other dashed away without knowledge or reason, and produced the most disgusting nondescripts.[73]

Modern British art was in danger of cutting itself off from both the British and Continental Old Master canon, rending the seamless garment of 'grand manner' painting in which Beaumont had wrapped his munificent gift to the nation. Beaumont had clearly hoped that the BI would use its patronage, its close links to government and its public exhibitions to ensure that the British School did not stray from the course plotted by Reynolds. British painting should remain locked into the international aesthetic economy, whose rigid hierarchy of artistic genres placed history at the top and portrait and landscape somewhere near the bottom. Above all, it should avoid the eccentricities of Hogarth's 'modern moral subjects' and Turner's quasi-historical landscapes, which mingled 'high' and 'low' genres.

Sniping between the Royal Academy and the BI, which culminated in a series of cruel satires on Beaumont, Knight and other BI Governors published anonymously in 1815-6, suggested that as an institution the BI was not strong enough, however. These satires suggested that behind the national rhetoric the BI was just a self-serving group of collectors who had come together to keep Old Master prices high.[74] Another institutional basis for preserving the connoisseur canon had to be found, one Beaumont could endow with his beloved art collection, safe in the knowledge that it would stand the test of time.

It took a national gallery.

IOANNES BELLINVS

47

Two: Possessed by the People, 1824-1914

The National Gallery was established in 1824 to serve in a number of roles: as a monument to military victories, as a means of improving British manufactures and as a way of preserving the connoisseur canon from dangerous innovations. Although these supporting arguments had been developed in the previous century under the aegis of private voluntary organizations, events during the Napoleonic Wars had given parliament and the people more confidence in the state's competence in such matters. A series of parliamentary grants had embellished London's great public spaces with monuments to her war heroes. The British Museum's earlier pretensions to universal knowledge had been replaced by an equally ambitious, if less Enlightened, appetite for new acquisitions that displayed British imperial achievement: artefacts captured from the French (such as the Rosetta Stone) or eased from the custody of allied powers by Britain's diplomatic leverage (the Elgin Marbles). A great power needed state collections to confirm its place in the world.

Some of the impetus for the foundation unsurprisingly came from the Continent. There artworks which had been looted by France and displayed in Napoleon's Louvre were returned thanks to the diligence of the Duke of Wellington, who on at least one occasion had to send troops to encourage Vivant Denon, the Louvre's Director, to release works to their original owners. Wellington's very English desire for fair play ensured that the Prince Regent's idea that Britain should appropriate some of Denon's loot as war booty was quietly quashed.[1] Yet in reality it would prove impossible to return to the *status quo ante*: in the case of many devotional paintings, their original owners – ecclesiastical foundations – no longer existed, having been dissolved during French occupation. For all the constitutional conservatism of the immediate post-war period, the new nationalisms forged during the Wars of Liberation ensured that the claims of the various Kings and princes to 'their' property

Opposite: Giovanni Bellini's portrait of **Doge Loredan** (1501-4) was just one of the many great fifteenth-century Italian masterpieces acquired by the Gallery's first Director, Charles Eastlake. Although the Trustees could be sceptical of the value of such 'curiosities' when acquired to fill 'gaps,' in the *Doge*'s case Eastlake clinched his case for purchase by pointing out the value of the work to native portraitists.

King Ludwig I of Bavaria's aggressive acquisitions and ambitious museum-building projects transformed Munich, drawing in architects, painters and collectors eager to design, decorate and fill the royal museums. Wilhelm von Kaulbach's **Ludwig I as Collector** (1848) was a design for one of the frescoes decorating the Neue Pinakothek. Among the collections he purchased was one of medieval paintings formed by Sulpiz and Melchior Boisserée, who are depicted immediately to his left.

were amplified by their subjects, who now claimed a share in 'national' property.

In the case of the German states, these subjects now cherished previously maligned medieval works of art as totems of a pan-Germanic community whose borders, however vague, were certainly not those drawn at the Congress of Vienna. Far from attempting to contain this threat, the rash of museum building seen in Berlin and Munich during the 1820s and beyond, notably the construction of Schinkel's museum and Leo von Klenze's Glyptothek and Pinakothek, showed that the leaders of the larger German states appreciated the museum's value as a means of promoting their policy agenda. Although these museums' fine architecture, impressive acquisitions and sophisticated rhetoric of public education did not translate into anything like the number of visitors seen in Trafalgar Square, they provided models for what a great national gallery should be. Keeping up with Berlin, Munich and, to a lesser extent, Paris, was a constant concern in London.

Such museums benefitted greatly from their liminal position between court and state, which guaranteed the generous support both of new Ministers of Education and monarchs, above all Bavaria's Ludwig I, whose feverish museum building

foreshadowed the follies of his better known, mentally disturbed successor Ludwig II. There were limits to the British state's willingness to follow their lead. In spite of the apotheosis undergone by the monarch and the state during the Napoleonic Wars, distrust of court and central government remained. Under the guise of 'Old Corruption' it exercised the minds of outspoken Radicals in the 1820s, both those in parliament like William Cobbett, as well as those outside, such as Thomas Wooler, whose newspaper *Black Dwarf* took a slide rule to the ranks of aristocratic sinecurists feeding off the state. To them, establishing a national gallery was tantamount to constructing a new drain on the English taxpayer, misappropriating yet more hard-earned private funds so that layabouts could sit on sofas looking at pretty pictures.

Even when the cholera epidemics of the 1830s succeeded in convincing such men that the state did have a responsibility to organize public works (like drains), the contrast with such 'scientific' projects of physical betterment made state provision of free paintings seem cruel, or, at best, irrelevant to the real needs of the masses. Increased government inspection and intervention in working conditions, sanitation and education during the course of the century did not extend to more generous support of the National Gallery. As for the crown, even when an exceptional individual like Prince Albert broke the mould of low-key Hanoverian patronage, their activism came at a price. In the 1850s Albert's ambitious proposals for Gallery reform and reconstruction fuelled suspicion that he was overstepping his constitutional powers – encouraging a reaction against change, even when it was clear that some change was necessary.

Fitting an institution with such un-English baggage into the nation was going to be difficult. The task was made harder by the fact that the resulting struggle took place under relentless parliamentary and public scrutiny. In addition to being administered by powerful Trustees, many of whom were important political figures, the Gallery depended on an annual parliamentary vote of the Commons just to stay open. Securing larger grants for acquisitions, building or an extra member of staff

Hullmandel's engraving compares the expanse of the French Louvre with the humble proportions of London's Louvre, otherwise known as **100 Pall Mall**. Here the Nation's collections were displayed in the former home of the banker John Julius Angerstein until slightly grander accommodation could be found.

was more difficult, and regularly implicated the Gallery in lengthy political debates. Even if the Gallery kept its head below the parapet, its unsatisfactory quarters, picture cleaning scandals and comparisons with grander foreign galleries were sure to attract public comment, usually derogatory. In contrast, other European galleries enjoyed the protection of the court, and received far less attention from the representatives of the people, who, in any case, resorted to such galleries in far fewer numbers. The National Gallery was, therefore, regularly dragged into broader debates on art, education and social policy.

This chapter and the next aim to provide the core political and institutional narrative, tracing the Gallery's development from its foundation up to its 150th anniversary in 1974. Later thematic chapters provide more detailed analysis of the formation of the collection, and consider how the institution sought to satisfy those who saw its prime role as tapping art's power to re-socialize and integrate disaffected sectors of society. Those familiar with institutional history as traditionally understood – a hagiography of diligent curators and munificent benefactors – might consider the range of sources and issues discussed here irresponsibly broad. Others may miss the Foucauldian approach synonymous with 'museology,' a discipline that continues to serve as a retirement community for once-fashionable theories no longer able to support themselves in mainstream academia.[2] In writing about the National Gallery the historian needs to take precautions against both the Stockholm syndrome of the former and the cynicism of the latter: to avoid the temptation to cast the Gallery as valiant champion against Treasury philistinism, or the tool of a hegemonic middle class attempting to indoctrinate and punish its social inferiors.

The National Gallery was willed into existence by Parliament on April 2, 1824, when the House of Commons voted to grant £60,000 to cover the expense of purchasing the art collection and Pall Mall home of the deceased banker John Julius Angerstein. The groundwork had been laid by three men: the Tory squire and collector George Beaumont, the Whig George Agar Ellis and Charles Long, Baron Farnborough, Tory

politician and favourite of George IV. Long had been the nearest thing Pitt's administration had to an arts minister, closely involved in administering the parliamentary grants for memorials to heroes of the Napoleonic Wars. Deputy President of the BI, and a Trustee of the British Museum, he had encouraged Beaumont to leave his collection to the Museum, and had him made a Trustee in May 1823. At a time when John Nash's development of Crown Lands into Regent's Park and Regent Street was concentrating minds on the benefits of central planning, Long's pamphlets on such improvements combined support for a national gallery with the insistence that efficient management of any such artistic project be entrusted to an aesthetic 'dictator' (Long himself), rather than to parliament.[3] This was in marked contrast to Wilkes' stance in 1777, when he had insisted on parliament's competence in this area. Until such time as his dictatorship began, however, Long was happy to steer the gallery plan through a sub-committee of the British Museum board, which considered plans to incorporate a gallery for pictures above Nash's new King's Library.

The purchase of the Angerstein collection had first been proposed to the Commons by Agar Ellis on July 1, 1823. Compared to Long and Beaumont, Agar Ellis was relatively unknown. Nominally a Whig, he was in the process of changing party allegiance. He helped to persuade the Tory Chancellor of the Exchequer, Frederick Robinson, to include the plan in his budget speech, delivered in February 1824. In life Angerstein had drawn on the advice of the President of the Royal Academy, Sir Thomas Lawrence, which gave the collection a cachet which Angerstein's own elusive origins might have otherwise denied it. Beaumont believed that his collection complemented Angerstein's, and appears to have made its purchase a condition for the donation of his own.

Prime Minister Lord Liverpool's role was limited. In refusing Lord Leicester's offer of his exclusively British collection in 1823, however, Liverpool had taken the important step of burying the notion, popular among Royal Academicians, that a truly 'national' gallery had to exclude foreign paintings.[4] His support of the 1824 plan demanded little thought, given the

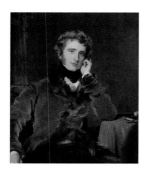

Agar Ellis, portrayed here by fellow Gallery Trustee Thomas Lawrence, was an active promoter of the Gallery scheme within parliament. A Whig who crossed over to the Canningite party and later served in Grey's Liberal cabinet of 1830, Agar Ellis insisted that access to the new Gallery be as easy and unrestricted as possible.

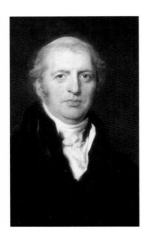

As Prime Minister **Lord Liverpool**'s political principles could be difficult to pin down, as the curious label of 'Liberal Tory' applied to him attests. In agreeing to the establishment of the Gallery and in resisting efforts to restrict its remit to British painting, however, he earned his place as one of the institution's founders. This portrait by Lawrence was exhibited at the Royal Academy in 1827.

modest amount voted. But his willingness to commit the state to the gallery's permanent support at a time of retrenchment suggests that there was indeed something liberal behind his 'Liberal Tory' administration: an acknowledgement that the unenfranchised nation whose support had helped win the war deserved, appreciated and could be trusted with opportunities to improve itself by indulging in an activity that had previously been the preserve of the leisured classes.

Robinson's budget speech began predictably enough by praising Beaumont's generosity, and by echoing Wilkes in insisting that once established, a gallery would inspire further benefactors to come forward. The cost of buying Angerstein's collection and his house could be justified to parliament as priming the pump. The repayment of an Austrian war loan, however, meant that in reality it would cost the public purse nothing. Nobody had expected the loan to be repaid, so the money represented a 'godsend'. Robinson reached his peak in promising that the result of all this would be

the establishment of a splendid gallery of works of art, worthy of the nation; – a gallery, on the ornaments of which, every Englishman who paces it may gaze with the proud satisfaction of reflecting, that they are not the rifled treasures of plundered palaces, or the unhallowed spoils of violated altars.[5]

Robinson thus erected another rhetorical pillar of the National Gallery, one which defused the revolutionary associations of the art museum and excused the relative weakness of the Gallery's collections. The absence of the glories of the Louvre and, later, of the German museums, could be celebrated as an indication of the unbroken rule of property in Britain.

The gallery opened in Angerstein's former home, 100 Pall Mall, on April 28, 1824, with the event almost totally unnoticed by the press. Robinson had stated in his speech that the Treasury would have the 'immediate superintendance,' and the Treasury had indeed appointed William Seguier, a trained artist-turned-dealer, as Keeper. It instructed Seguier that the Gallery was to be open four days a week from ten to five, to a maximum of 200 persons at any one time. Two other days

were set aside for artists wishing to copy.[6] When Agar Ellis visited it on May 5, he noted that one entered the Gallery 'freely without tickets, being the first attempt at a perfectly open exhibition in this country. Seguier, whom I met there, told me the experiment succeeded perfectly – and that all the people are very orderly and well-behaved.'[7] In January 1825 Seguier was able to inform the Treasury that 70,222 visitors had already attended, with 'no injury of any description' occurring to the pictures.[8]

It was unclear whether the gallery was an independent institution, or administered by the Paintings, Prints and Drawings sub-committee of the British Museum board. In March 1824 the Tory MP John Wilson Croker had argued in the Commons that the paintings would not 'civilize and humanize the public at large' if they were displayed as part of the British Museum, whose location was felt to be remote. They needed to be 'in the gangway of society'.[9] Writing in the *Quarterly Review*, Agar Ellis agreed:

There must be no sending for tickets – no asking permission – no shutting it up half the days in the week; its doors must always be open, without fee or reward, to every decently-dressed person; it must not be situated in an unfrequented street, nor in a distant quarter of the town. To be of any use, it must be situated in the very gangway of London, where it is alike accessible, and conveniently accessible, to all ranks and degrees of men ... to the indolent as well as the busy – to the idle as well as the industrious.[10]

Independent status seemed to be confirmed in July 1824, when Liverpool appointed a 'Committee of Superintendence of the National Gallery of Pictures in Pall Mall'.[11] All those on the Committee were also British Museum trustees, and five of them sat on the Museum sub-committee. If this Committee of Superintendence met before 1828, it did not keep minutes.

Until 1831, therefore, it was not clear quite what kind of institution had been established. If Beaumont or Liverpool had a view as to whether the gallery belonged to the British Museum or not, they took the secret with them to their graves in 1827. This created two vacancies on the Committee of

The Gallery's first Keeper, **William Seguier** (1771-1843, seen in this portrait by John Jackson, 1830), was a trained artist-turned-dealer who supplemented his £200 salary by also holding the posts of Conservator of the Royal Collection and Superintendent of the British Institution, and by restoring pictures. His was a career based on deference and clientage.

The Gallery's first home at **100 Pall Mall** might have been small, but domestic scale was not irreconcilable with grandeur. Frederick Mackenzie's view (c. 1830) shows the main gallery on one of the days assigned to artists wishing to copy. The painter at centre is shown overwhelmed by the treasures before him, which include Reynolds' *Holy Family*, Sebastiano's *Raising of Lazarus* and Titian's *Bacchus and Ariadne*. A modern visitor might have wondered why pictures of such different periods and schools were hung cheek by jowl.

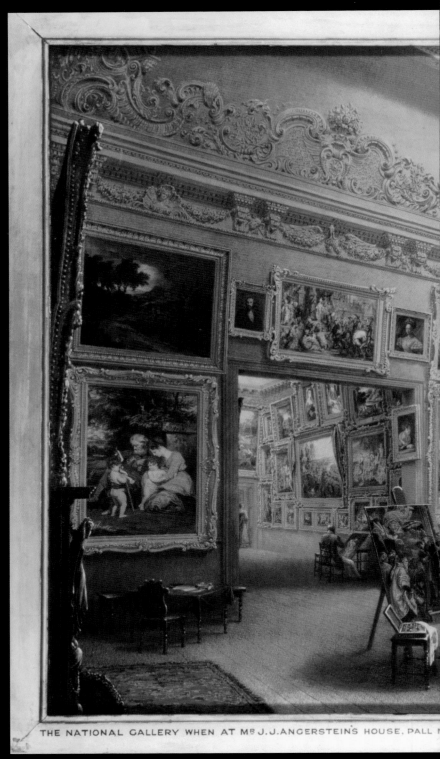

THE NATIONAL GALLERY WHEN AT M⁹ J.J.ANGERSTEIN'S HOUSE, PALL M

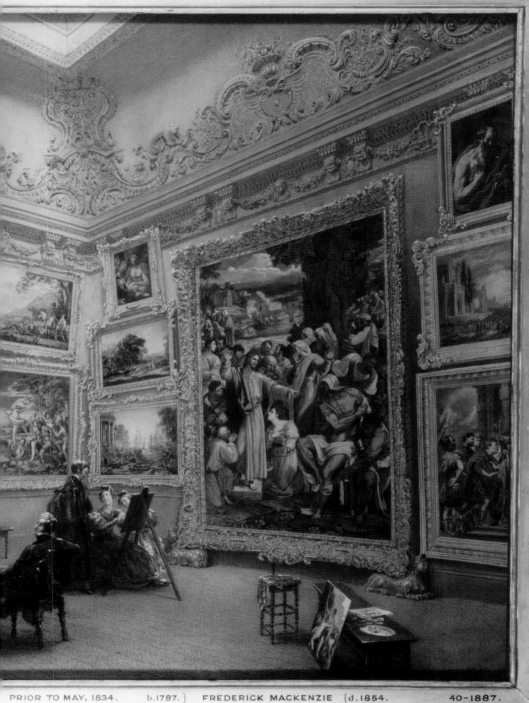

Superintendence which Prime Minister Canning filled with the Tory politician Sir Robert Peel and Agar Ellis. Crucially, neither man was a trustee of the British Museum, and, doubtless spurred by Peel's concern for procedure, the body now began taking minutes. In July 1828 the Treasury wrote to the Museum's Paintings sub-committee, informing them that previous correspondence concerning the National Gallery had been 'inadvertently addressed' to them. Faced with the secession of the Gallery, the Museum tried to rally its forces, asking the Treasury to insist that a certain number of Gallery Trustees be drawn from their own Board. For the most part, however, their reaction was one of relief that the damage had not been worse. The Museum was terrified that an independent Gallery would rob it of the Elgin Marbles and other sculptures.[12]

The Board of the National Gallery was very political and very aristocratic. The First Lord of the Treasury, the Chancellor of the Exchequer and the President of the Royal Academy were invariably appointed Trustees. The 4th Earl of Aberdeen, Sir Robert Peel and the 3rd Marquess of Lansdowne (appointed by Lord Grey in 1834) were collectors as well as politicians, and Peel confirmed the Board's connoisseur character when, during his short 'Hundred Days' ministry of 1835, he appointed Francis Egerton (later the 1st Earl of Ellesmere), George Granville (2nd Duke of Sutherland) and Spencer Compton (2nd Marquis of Northampton). Continuing the Angerstein connection between high art and high finance, he also added the bankers William Wells and Alexander Baring (1st Baron Ashburton). In the case of Lansdowne, Northampton and Baring, Trusteeships seemed a hereditary appointment: sons, nephews and brothers were appointed later in the century. Politically the board was evenly matched between Liberal/Whig and Tory. Conspicuous by its absence, however, was any sign of Radicalism, despite the fact that Radical MPs like Joseph Hume and William Ewart were closely involved in Gallery debates.

This was the body responsible for administering the Gallery. The Treasury laid down opening times and appointed the

The painter **Charles Eastlake** served as Keeper of the Gallery in the 1840s and later returned as its first Director in 1855. In just ten years his many purchases in Italy and elsewhere transformed the Gallery's collection into one of the most representative in Europe. Yet he also served as Secretary of the Fine Arts Commission and President of the Royal Academy – and as first President of the Royal Photographic Society. That he posed for this photograph by the pioneer Caldesi is therefore fitting.

Keeper, with whom it corresponded directly on matters such as salaries for the housekeepers and warding staff. For the most part, however, the Trustees were expected to take the lead, with the Keeper adopting a subservient, passive role. Of the three men who held the post in the years before the creation of the Directorship in 1855, only Charles Eastlake's tenure (1843-7) saw the Keeper adopt a more pro-active approach. Close links to Peel enabled him to secure a number of important acquisitions. Peel's connoisseur taste made it difficult to acquire early Italian works, however, and in 1847 the Prime Minister's support could not protect Eastlake from scandals surrounding picture-cleaning and the purchase of a suspect Holbein. Forced into resigning by such pressure, Eastlake was replaced by another painter, Thomas Uwins, who, like Seguier before him, saw his position as one of 'servant to the trustees'; in his 'uncertain and dependent position,' he wrote to a friend in 1851, 'I must obey their orders.'[13] These orders were rare and often unclear, however, producing a lack of direction whose consequences were made painfully obvious during a Select Committee investigation into the Gallery undertaken in 1853. The connoisseur/artist relationship was ill-suited to a national institution with a public charge to keep.

A monument to Reform?

At first glance the momentous political developments of the 1830s, not least the Great Reform Act, seemed to suggest that under the Whigs such inefficient and irresponsible institutions as the National Gallery would be rendered more accountable to the middle-class electorate. William Wilkins' Trafalgar Square building was indeed constructed between 1834 and 1838, in the latter part of the 'Age of Reform'. There was no doubting that it was a grand gesture, dominating as it did a new public space which would come to be known as Trafalgar Square on construction of William Railton's column in the 1840s. This gesture, however, could be interpreted in unsettling ways, as a promissory note to the people on the part of the state. For if the

state acknowledged its duty to provide free opportunities for the people's aesthetic education, surely it had thereby also acknowledged its responsibility to provide rather more basic tuition? Until 1838 it had been possible to see the Gallery as a one-off, without wider significance for state policy on education. Placed at the heart of the city, at the point where London's leisured, commercial and political classes met, the Gallery could now provide those with radical ideas for the reform of British government and society with a jumping-off point. From the 1880s to the outbreak of the First World War, it proved a useful target, too, for Fenians and Suffragettes looking for opportunities to shake the British government and public out of their complacency.

The Gallery was constructed on the site of the royal stables, a warren of narrow streets somewhat alleviated by the symmetry of William Kent's Royal Mews (1735). The idea of clearing this area to improve traffic flow and provide a grand ceremonial space was not the result of any grand Whig reform. It

Presented to parliament in 1826, this plan shows **John Nash's proposals for the rearrangement of buildings and streets at Charing Cross**. He proposed to house the Royal Academy in a Parthenon-like structure in the centre of what is now Trafalgar Square, with a long, thin National Gallery immediately to the north. Nash's subsequent fall from grace and ministerial sensitivity to grand public works projects put paid to this imaginative plan.

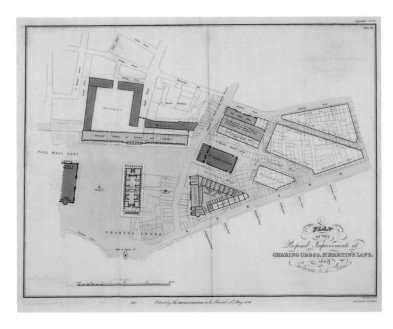

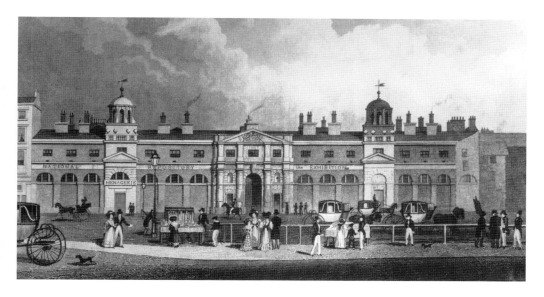

Erected in 1735 to designs by the master of English Palladianism, William Kent, the **Royal Mews**' charms were only truly appreciated when John Nash cleared away the buildings surrounding it in the course of his 1820s improvements of the area north of Charing Cross. Some Trustees thought it a promising and economical home for the National Gallery. It was in fact demolished to make way for Wilkins' Gallery.

had originally formed part of John Nash's plans for the development of Crown Lands along the axis running south from Regent's Park. Nash had the area around Charing Cross cleared in the 1810s and plans he presented to the Commons in 1826 show a large square with a Parthenon-like structure in the middle of it (intended for the Royal Academy) and, to the north, a long, thin structure intended to serve as 'a National Gallery of Painting and Sculpture'.[14] The Gallery's foundations thus lay in the rather grubby soil of a royal public-private partnership, rather than anything more pure. Indeed, after Nash's shady insider dealing in Crown leases led to his disgrace in 1828, the site was abandoned. The Select Committee charged with cleaning up after Nash recommended that the north edge of the square be let for shops, and the Gallery trustees agreed to their recommendation that the nation's paintings be accommodated in Kent's Royal Mews once its lessee, a zoo-keeper, had removed himself and his giraffe.[15]

Whereas Wellington as Prime Minister in 1828 had been unwilling to listen to Agar Ellis' ideas for building slightly more appropriate quarters for the Gallery, when Lord Grey took

power Ellis was himself appointed First Commissioner of
Works, that is, the Cabinet-level minister responsible for public
buildings, including the National Gallery. He began soliciting
designs from architects, a process which continued under his
successor, Lord Duncannon, who in 1832 appointed a commit-
tee which considered designs by William Wilkins, Sydney
Smirke and C. R. Cockerell – and carefully ignored one by
Charles Barry that an MP named Edward Cust was noisily advo-
cating. Far from being a regulated competition, as Cust rightly
pointed out there was very little guidance given to candi-
dates, and the subsequent unhappy developments proved
that he had been correct to criticize the confused lines of
control.[16]

Wilkins probably 'won' the competition thanks to his excel-
lent relations with Trustees (notably Aberdeen), his willingness
to play up to Peel's feeling for economy and, most importantly,
the publication of a pamphlet on state arts policy addressed to
Robinson (now ennobled as Lord Goderich), a Trustee and
member of Duncannon's committee. In it he dextrously com-
bined simpering requests that rising professionals like himself
receive more 'distinctions' with warnings that if the upper
classes did not learn to respect knowledge and the arts as wor-
thy objects of state support, then their 'government of prerog-
ative and privilege' would be replaced by that of the 'instructed
classes'.[17] It was a masterpiece of Janus-faced public relations.

Rather than being the climax of his career, however, the
construction of a building Wilkins claimed could successfully
house the National Gallery, Royal Academy and the Public
Record Office destroyed it. The Gallery ended up costing nearly
three times his original estimate of £33,000, and was widely
ridiculed from 1833, when a garbled version of the façade
appeared in the *Literary Gazette*.[18] Much of this was Wilkins'
own fault. His long, low, Grecian façade paid little respect to the
surrounding buildings, and the architect's combination of
pedantic antiquarianism and professional arrogance gave the
press a perfect target. Failing to keep his nerve, in 1834 Wilkins
sought to liven up his bare façade by adding various winged
Victories and a series of friezes celebrating the achievements of

Nelson and Wellington – sculptures originally intended for the Marble Arch. Although Peel's 1835 ministry put a stop to this scheme, some sculpture survived: the homeless Victories were inserted into niches, their spears replaced with paint brushes. They are still there today.

The Whig ministry only made the situation worse by similar failures of nerve, suggesting that they viewed the project as little more than a troublesome inheritance foisted on them by their Tory predecessors. In parliament, the nearest thing to a vision for the Gallery was provided, not by Whig ministers such as Althorp or Thomas Spring Rice, but by the Tory Sir Robert Peel, who in 1832 gave two short speeches justifying construction both as a counter-revolutionary gesture and as a means of improving the quality of British manufactures.[19] Spring Rice's piecemeal, hand-to-mouth financing of the project only provided malcontents like Cobbett with more opportunities to whinge about 'jobbery' and the wastefulness of ministers in 'flinging away the money of the nation in the purchase of useless fineries'. Although the Whigs had enough spine to resist Cobbett's offer to stop criticizing the new Gallery in return for Malt Tax abolition, they let Wilkins down time after time.[20]

Spectacles of improvement and advertisements for rather less worthy spectacles jostle in this 1836 scene of the Gallery's building site, entitled **Cross Readings at Trafalgar Square**. At right one sandwich man punches another on the nose, 'tipping the claret' as it was known in Regency slang. That the victim himself bears a large advertisement for claret is, quite literally, the punchline.

Privately, Whig ministers like Brougham, Melbourne and Grey harboured serious doubts. Althorp apparently said that 'if he had his way he would sell the National Gallery, and have nothing of the kind.'[21] Whether it was a craven fear of press accusations of 'jobbery,' Evangelical scruples about visual art or Benthamite scepticism about art's utility, the Whigs had plenty of ways of explaining why they failed to share Tory or Radical enthusiasm for the National Gallery. This is surprising, as Whig ministers included aristocrats with fine art collections, and, of course, several of them were active Trustees. Even Peel's vision, however, was compromised by a penny-pinching desire for economy that crossed party lines.

Such economy meant that the new Gallery, opened by Queen Victoria in 1839, was woefully inadequate. It had also resulted in the unhappy cohabitation of the Royal Academy and the National Gallery. Far from grasping this opportunity to develop as a national institution, the Academy's high-profile home attracted Radical parliamentary criticism of its private character.[22] Such criticism was met, notably under Martin Archer Shee's Presidency, with petulant declarations that their policies were nobody's business but their own. For our purposes this conflict is of interest because it seemed to place the monarchy and artistic Establishment on the side of the Academy, leaving the Gallery isolated, or, perhaps worse, in the Radicals' corner.

The Radicals used a series of House of Commons Select Committees to draw parliamentary and public attention to the value of museums as a counter-attraction to public houses (1834), as a means of improving manufacturing design (1836) and combating social exclusion (1841).[23] In turn, they helped bring about the foundation of the Government School of Design (1837) and the 1845 Museums Act, which empowered municipal authorities to fund the construction of museums by adding a half-penny on the rates. Sadly the School of Design lurched from crisis to crisis until its reorganization under Henry Cole in the 1850s, and the Act proved to be of little practical use, even after further enabling legislation (the 1850 Museum Act) had been passed. Nonetheless, these radical

initiatives created opportunities for parliamentary and press debate on the role of museums in Britain. They also laid the groundwork for the South Kensington Museum (established 1857) and the 1891 Museums and Gymnasium Acts, which led to an explosion in the number of municipal museums.

There were good political reasons behind the Radicals' interest in art institutions. With the removal of much government venality and waste, 'economy' had lost its power as a radical rallying cry by the late 1830s. For all their supposed radicalism, Radical MPs' advocacy of the working man was in many ways a ventriloquist act of limited appeal to those who would support Chartist extra-parliamentary agitation in the 1840s. The Radical Hume preferred Peelite free trade and minimal government to the proactive policies of factory, sanitary and poor law reform which the technocrat Edmund Chadwick was urging on both Whig and Tory administrations.[24]

Without any big issues to campaign on, their numbers thinned by defeats at the 1837 general election, the field of state art institutions offered Radicals a stamping ground, one which the mainstream parties were happy to cede to them, possibly as a way of keeping them occupied. Although the Radicals' interest in the National Gallery kept it in the headlines, their hectoring tone could create its own problems. The history painter Benjamin Robert Haydon, a fiery advocate of state art patronage and Academy reform, found Hume's 'very enlarged views' encouraging when he met the MP in 1833, predicting that Hume would be 'a useful lever for the cause of art'.[25] Six years later, Haydon was claiming that Hume's party 'care nothing for art, and only want to make it a stepping stone to pull down other institutions. Hume is such a heavy man that I fear he will be beaten.'[26] Coming from Haydon, hardly a shrinking violet himself, this statement offers a salutary note of caution.

Nonetheless, Radical initiatives helped establish two beliefs about the power of free displays of art that would become commonplace in any discussion of the National Gallery until the end of the century. The first was that Old Master paintings would improve the quality of British workmanship and in particular enable British manufacturers, such as the cotton

printers of Manchester, to compete in markets for high-margin, high quality goods dominated by French or German products. Seeking a way of explaining the 1830s slump in manufacturing that would exculpate Free Trade, William Ewart's 1836 committee on arts and manufactures concluded that exports were suffering because British workers had not been familiarized with art in the same way as French or German ones had: through museums and government design schools.

The Committee recommended that the National Gallery be rendered more accessible to working men through labels, cheap catalogues and the abolition of the summer recess, which saw the Gallery closed during the summer.[27] Although none of these steps were implemented until the 1850s, the committee enshrined the belief that greater state intervention in support of museums combined with free trade would result in more tasteful products and higher profits. As yet nobody challenged the assumptions that good taste could be 'caught' by visiting a picture gallery, or that once 'caught,' the market would reward it.[28]

The second article of faith established by these Radical MPs was the belief that free access to the National Gallery and other museums would wean the working classes off drink, rough pastimes and political radicalism. Joseph Hume regularly commented on the fact that working-class visitors had attended existing free museums in large numbers without causing any damage to the precious objects on display. After having failed to interest the Trustees in the project, Hume did his bit to facilitate such visits by publishing his own cheap guide to the Gallery in 1842. The following year he proudly told the Commons that, once taken home by the working man, this guide's very presence on the family's table would 'refine morals' by silently urging a repeat visit.[29]

Evangelicals enfranchised in 1832 and unleashed onto their local authorities by the Municipal Corporations Act of 1835 had in many cases used their new-found influence to shut down popular city and suburban sports such as cock fighting, bull baiting and football. Newly-established constabularies

Previous pages: One of the Gallery's earliest purchases, Poussin's **Bacchanalian Revel before a term** (1632-3) was acquired for £9000 in 1826 from the goldsmith Thomas Hamlet, along with a Carracci and a Titian. The artist's licentiousness caused Martin Davies some discomfort when he catalogued the French School in 1946. 'The compiler would be glad not to see Venus in that composition,' he primly noted in his discussion of another Gallery Poussin, entitled *Nymphs surprised by Satyrs*. He bowdlerized this painting's title as a revel 'before a term of pan,' even though, as Anthony Blunt correctly pointed out at the time, it is in fact a term of Priapus. Yet 120 years earlier neither the Trustees nor the House of Commons saw any cause to object.

gave them the foot soldiers needed to wage this war for 'rational recreation'. Yet if rational alternatives were not provided it could hardly be expected that frustrated cock fighting enthusiasts would do anything other than spend even more time in the pub. Initiatives to create public parks and endow museums demonstrated the willingness of local notables to address this need for 'counter-attractions'. It was difficult for them to see the public house and the public museum as anything other than a choice between the wide and narrow gate, between mutually exclusive paths to shameful sin and glorious redemption respectively. In the 1840s and 1850s the working classes began to develop their own leisure facilities, notably music halls. Some of these, such as Lambeth's Canterbury Hall, had their own art galleries.[30] The wall of respectability dividing such places from 'improving' ones like the National Gallery appeared impenetrable only to those looking on from above.

At times, Radical support of museums as a means of re-integrating the working classes into an otherwise 'classless' society could verge on the Benthamite. In the Commons debate on Ewart's 1845 Museums Act Joseph Brotherton stated that money spent on art museums would be money saved from the police budget. 'It was much better to cultivate a taste for the arts at the public expense,' he said, 'than to raise a large amount of taxation for the prevention and punishment of crime. In Manchester and Salford it cost £40,000 a year for the support of the police and for other arrangements to check crime and bring criminals to justice.'[31] Although few put it in such a utilitarian way, the 'social inclusion' case for museums found a welcome reception in both High Tory 'Young England' circles and in the writings of the Christian Socialist Charles Kingsley.

In 1848 the latter celebrated the 'equalizing' power of the National Gallery in a series of contributions to the Christian Socialist newspaper, *Politics for the People*.[32] As seen in novels such as Kingsley's *Alton Locke*, the Gallery was presented as a place in which individuals drawn from the extremes of society could mingle. Overcome by shared wonder at great masterpieces, here they would overlook petty distinctions in rank,

learning and dress, recognizing their common humanity. By joining in this appreciation, and by coming into their birthright as citizen stakeholders in the Gallery, those alienated from society would be welcomed back into the fold. Even those confronted with the horrors of the East End slums argued that facilitating access to museums was almost as important as granting access to clean water and education. To those seeking to reconnect Britain's 'two nations' of rich and poor, art represented 'a social bridge of no ordinary size and strength.'[33]

If Radical involvement could create positive consensus on the Gallery's social utility, however, it could also drag the institution into more contentious territory. Radicals such as Ewart and Thomas Wyse supported a central board of education run by a Cabinet minister. They wished to extend the powers of the Committee of Council of Education, by which Whig ministers Spring Rice and Lansdowne had taken the first faltering steps towards central funding for school construction and centralized teacher training in the late 1830s. Together with a series of Select Committees and legislative proposals by the Whig Lord John Russell and Tory James Graham, their proposals made 'national education' a focus of fierce debate in the 1830s and 1840s. The way in which the Radicals pointed to the centrally-funded, 'secular' National Gallery as a model for a state education system threatened to render the Gallery highly suspicious to those inside and outside parliament who fiercely supported decentralized, voluntarist, denominational education.

For the two main voluntary school societies, the Anglican National Society and the non-Conformist British and Foreign School Society, state schools were anathema, threatening to replace religious tuition with either an eviscerated Christianity of the lowest common denominator or a Benthamite syllabus designed to make children into 'useful' automata. One of the leaders of National Society resistance, the young William Gladstone, published his 1838 book *The State in its relations with the church* as a plea for a more organic, Coleridgean kind of 'national education' within a revitalized, High Anglican confessional state. Although Gladstone's vision was totally at odds with Whig moves towards toleration (or, rather, indifferentism),

it also found the National Gallery a useful precedent.[34] The book drew public ridicule from Macaulay and anxious confusion from Peel.

Whether the notion invoked Bentham, Coleridge, or a horrible concatenation of both, it was clear that bracketing the National Gallery and 'national education' made the former a target for all those concerned at Victorian government growth. This made it easier for philistine provincial MPs of all parties and none to oppose parliamentary votes for the Gallery. 'It was not,' as the High Churchman Robert Inglis opined in the mid-1840s, 'the surest mode of enlightening the people in Christian doctrine, to make them skilful judges of the merits of a statue or picture.'[35] The art critic Anna Jameson saw the trend to 'diffuse' taste among the middle and working classes as doomed to cheapen art:

Anna Jameson published numerous guides to picture galleries, large tomes that were nonetheless aimed at a broad, middle-class audience. She was among those who sought to draw attention to early Renaissance art, including the neglected Sienese School. 'We are far from that intelligence which would give to such objects their due relative value as historic monuments,' she noted in her 1842 guide to the Gallery, 'but we are making progress: in the fine arts, as in many other things, knowledge comes after love.'

I utterly deny the principle... that a work of art is excellent in proportion as it is intelligible to people in general. I cannot help thinking that if we diffuse, by means of national galleries, cheap prints, art-unions, and so forth, the mere liking for pictures, as such, without diffusing at the same time that refined and elevated standard of taste which is the result of cultivation and discernment, and education, we are likely to be deluged with mediocrity; every man, woman and child will turn critic, and art and artists together will be essentially *vulgarized*.[36]

Few people denied that increasing the number of viewers would change the course of British art. For those who had invested money and loyalties in a connoisseur canon this was a threat rather than an opportunity.

Until the appointment of Eastlake to the new post of Director in 1855, Trustee acquisition policy was in keeping with Beaumont's legacy. Aberdeen, the only one of the original Trustees alive in 1853, told the Select Committee of that year that 'hitherto it has been merely like the collection of a private gentleman, and nothing more.'[37] During his Keepership Peel prevented Eastlake from acquiring works required to make the collection serve as a 'visible history of art,' describing such specimens as 'mere curiosities' tangential to the core mission of the gallery: the collection of supreme works of art.[38] This

Peelite taste was an offshoot of a broader economic and social consensus, one which took in Radical MPs such as Hume and Christian Socialists like Kingsley. According to this consensus the duty of central government was to uphold a fixed 'gold standard' and otherwise avoid sending its citizens mixed messages – avoiding interventions which might delude them into looking to the state or their class rather than themselves for a quick fix to poverty or unemployment. In fiscal policy, Peel and Lord Overstone sought to keep to this gold standard by means of legislation, notably the 1845 Bank Charter Act. A self-made banker, Overstone was an active Gallery Trustee from 1850 onwards. At the 1853 Select Committee he was careful to point out the distinction between a Gallery enshrining the morally-improving canon of 'intrinsic merit' and one which merely sought to collect specimens of art from every historical period.[39]

Far from the National Gallery enjoying the fruits of this consensus in the peace of the 1850s 'Age of Equipoise,' however, the decade saw it pass through an unsettling period of reform, centred around the 1853 Select Committee on the National Gallery, which undertook a thorough review of its administrative structure, site, arrangement, acquisitions policy and accessibility. This review, and the reforms implemented in its wake were made all the easier by the fact that the Trustees and staff of the Gallery stood aside, awaiting instructions rather than developing their own policies. This was symptomatic of the creeping paralysis which had set in at least five years before, as the Gallery's ad-hoc administrative 'system' ground to a halt.

Thanks to the generous donations of men like hackney-carriage magnate Robert Vernon, who donated his collection of modern British paintings in 1847, by 1853 the Gallery had 393 paintings: 224 had been donated, 99 bequeathed and 70 purchased. Yet with only five rooms to hang them in, these paintings could not be arranged by school or period, and Vernon's munificent gift had to be shown first in the donor's own home, and then in the Gallery's dark ground floor rooms. Accusations of overcleaning, first made by the collector William Coningham in 1847, had continued to fester even after Eastlake had resigned as Keeper. Hume had moved that cleaning reports

Opposite: Alongside less coy paintings of dogs, children and landscapes by British artists such as Edwin Landseer and William Etty, hackney carriage magnate Robert Vernon's 1847 gift to the National Gallery also included this work by Claude-Marie Dubufe, entitled **Surprise** (c. 1827). Dubufe thus became the first living foreign artist to be represented in the collection, his work especially popular among Victorian copyists working in the Gallery.

be placed before the Commons, only to find that none were kept, as the cleaners viewed their materials and methods as a professional secret.[40] With Eastlake gone, Hume sniping at them from the Commons, Uwins' weakness and the suspense of wondering what Select Committees appointed in 1848 and 1850 to consider Gallery accommodation would determine, the Trustees froze. They did not purchase a single painting between 1847 and 1851, when Eastlake returned, this time as an ex-officio Trustee. A moratorium on cleaning was imposed.[41]

The Golden Age

The Committee's recommendations regarding gallery administration were considered by the Trustees in February 1854. Rules regarding the frequency of Board meetings, quorum and collective responsibility for decisions were finally laid down. Cleaning reports were to be compiled every summer detailing the work undertaken during the summer closure, and the Keeper was to give an annual report to the Treasury.[42] Gladstone still considered the Board to be 'in a state of suspended animation,' however, and toyed with the idea of abolishing it and placing the Gallery under Prince Albert's control.[43] Although he dropped this extraordinary idea, he overhauled the entire administration again by means of a Treasury minute in March 1855. The minute created the post of Director, and even empowered him to purchase works without Trustee support. It also instructed him to prepare 'historical catalogues' and keep dossiers on each painting. Most importantly, it established an annual purchase grant of £10,000. Whereas before the Trustees had run the gallery, the minute now determined that their role was simply to 'keep up a connexion between the cultivated lovers of art and the institution, to give their weight and aid, as public men, on many questions in art of a public nature that may arise, and to form an indirect though useful channel of communication between the government of the day and the institution.'[44]

Gladstone's minute closely followed Eastlake's recommendations to the 1853 Committee, and it seemed to follow

naturally that he should be appointed the Gallery's first Director – especially as Uwins had had the good sense to retire on grounds of ill-health. Instead Eastlake was Gladstone and Prime Minister Aberdeen's third choice, and very possibly fourth. The Scottish antiquarian James Dennistoun, the historian Francis Palgrave, and the artist William Dyce, erstwhile Director of the Government School of Design, were all sounded out before Eastlake, who was offered the post only after the first two had refused. Rumours even abounded that Prince Albert had invited Gustav von Waagen to London in order to offer him the post.[45] Interestingly, neither Palgrave nor Dennistoun were artists, a bold step at a time when it was still felt that Keepers and Directors needed hands-on experience of painting. If anything, the common thread uniting these men was their historical work: Palgrave, Dennistoun and Eastlake had all published important books or articles on medieval and Renaissance art and history. Both Dyce and Dennistoun had also published accounts of how they believed the Gallery's problems should be solved, highlighting the need for an acquisitions policy that addressed those lacunae which prevented its collection from offering a 'complete collection' of works from all periods and schools.[46]

Eastlake's qualifications eventually prevailed. In addition to being a practising artist and President of the Royal Academy, Eastlake had considerable administrative experience as Secretary of the Fine Arts Commission, the body appointed in 1842 to determine how Barry's Palace of Westminster was to be decorated. A fluent German speaker, Eastlake and his wife Elizabeth were both scholars with excellent connections to German experts: men such as Gustav Waagen and J. D. Passavant, who either headed highly respected German museums or had been responsible for landmark monographs that laid the foundations for art history as an academic discipline. Eastlake's own study, *Materials for a history of oil painting* (1847-69) is still in print.

Although privately Eastlake felt that the Trustees did not really appreciate his efforts, once appointed the Director soon set out on what would become a series of exploratory forays

Previous pages: Eastlake had difficulties getting Veronese's **Alexander and the Family of Darius** back to London in 1856. While the Austrian authorities who administered the Veneto did, eventually, grant an export licence, this delay, combined with rumours that it was a copy, gave Eastlake's enemies inside and outside parliament plenty of time for sniping. Their scrutiny revealed that various douceurs had been paid to the owner's family and servants, including six pounds to the cook. As one MP observed, it seemed 'that there was a goose to be cooked, and that, therefore, this sum was paid for cooking the British goose.'

Opposite: Duccio's **Virgin and Child** of about 1315 was purchased by Eastlake in 1857, one of several important works formerly in the Lombardi-Baldi collection at Florence. The first Duccio to enter the collection, it came complete with two wings (not shown) depicting St. Dominic and St. Aurea. When closed these wings reveal a complex geometric pattern on the reverse, which itself contains a rebus directing the observer on which order they are to be opened.

around Italy.[47] On these tours Eastlake reconnoitred possible purchases, especially less familiar works by early Renaissance painters whose altarpieces could still be extracted relatively easily and cheaply from monasteries and churches. The 1855 minute enabled Eastlake to acquire a phenomenal series of works in a very short time, without Trustee interference. In 1857 alone he purchased over 40 works, a fantastic number if one considers that 70 had been purchased in the previous 33 years. The quality of works like Bellini's *Madonna of the Meadow*, Gaddi's *Coronation of the Virgin* and Uccello's *Battle of San Romano* was truly outstanding. At the same time a special act passed in 1856 enabled the Director and Trustees to sell off unwanted pictures, beginning with the majority of the Krüger Collection, a group of fifteenth-century Westphalian panel paintings which Gladstone had acquired two years before without consulting the Gallery at all. These 37 works raised a paltry £249.[48]

Just three years into his first five-year term, Eastlake was able to inform Gladstone that the Gallery's need for early Italian paintings had been 'in a great measure supplied'.[49] That was just as well: the Gallery minutes for the years 1855-60 show Eastlake facing increasing competition from German museums, as well as resistance on the part of Italian states to the removal of their artistic heritage abroad. Even the Austrian authorities administering the Veneto made difficulties over the export of Veronese's *Family of Darius before Alexander* in 1856. Douceurs intended to expedite its removal backfired badly when a pair of Liberal MPs accused Eastlake of paying bribes; accusations which led to the Commons taking the petty step in 1858 of cutting funding for Otto Mündler, the Gallery's Travelling Agent.[50] Eastlake had also been accused of overcleaning works during his Keepership. As Director he took care to have many of his purchases cleaned by Italian restorers like Molteni and Baldi before they travelled to London.[51]

Such purchases underlined the need for more space. Expansion on the Trafalgar Square site was impossible until the barracks, workhouse or Academy moved away, and for the moment none of them would move. A wonderful new site

Queen Victoria commissioned William Charles Ross, her Miniature Painter in Ordinary, to paint this portrait of **Albert** in 1840, the year of their marriage. Just two and a quarter inches high, it is the Gallery's smallest painting.

beckoned at South Kensington, where the Commissioners of the Great Exhibition of 1851 had purchased a large estate in cooperation with Derby's Conservative government. Indeed, in moving the vote of £150,000 for these land purchases in December 1852 the Chancellor of the Exchequer Disraeli had specifically spoken of how desirable it would be to relocate the Gallery to Kensington, where there would be space to arrange the pictures properly, away from the pollution of the city centre.[52] The Commissioners and especially their head, Prince Albert, saw a relocated National Gallery as the centrepiece of a new complex of technical, patent and scientific institutions intended to unleash the synergies of science and art.

Far from rendering the Gallery less accessible to the working-man, many of the witnesses giving evidence to the 1853 Select Committee argued that the distance would act as a moral filter. The Spanish art expert Richard Ford believed that access had been made too easy: Liberal MPs had supported free admission without considering 'the evils to which that leads; they would not mind a little test, or a little check, I think, if it were explained to them that the property we have got is being deteriorated from want of some restrictive precautions.'[53] William Dyce stated that, though he would 'be very sorry to appear to doubt the advantage which the generality of people derive from seeing works of art,' he believed that 'an extreme view of it is taken in this country which is not warranted by the example of other countries, where they admit the common people less frequently than we do.'[54] Perhaps due to an inbuilt museum inferiority complex, the very popularity of the Gallery could be a source of shame.

On November 16, 1853 Gladstone, who had succeeded Disraeli as Chancellor on the fall of Derby's ministry, recommended the relocation of the Gallery at a meeting of Aberdeen's cabinet. He and President of the Board of Trade Earl Granville wrote to Albert the same day to inform the Prince of its approval. To quote the latter, 'Mr. Gladstone put the question well to the Cabinet as to the transfer of the National Gallery to Kensington Gore Estate. He was well supported by Lord Lansdowne [a Trustee], and Sir Charles Wood.

After some discussion it was unanimously agreed to.'[55] Gladstone, however, noted that 'the cabinet are somewhat apprehensive with regard to the immense outlay which is likely to be required in connection with public buildings and the sites for them'.[56] Uncowed, Albert drew up a rough plan of how he wanted the estate laid out: a propylea or ceremonial gateway would give way to a central 800 by 300 foot gallery with two internal courts, itself surrounded by 'colleges of art and science, museums of industrial art, patented inventions, trade museums and etc'.[57] On his instructions this plan was sent to the architects Thomas Donaldson, James Pennethorne and C. R. Cockerell, who thus got a second chance at designing a National Gallery. Designs were also submitted by Henry Cole and Richard Redgrave, and may well have been forthcoming from Leo von Klenze as well. For Albert, the plans bid fair to realize in London the sort of cultural quarter which Ludwig I of Bavaria had created in Munich as the setting for his Glyptothek and two art galleries (the New and Old Pinakotheks).

Instead plans for 'a Pinacothek at Kensington Gore' were abandoned in 1856.[58] Technically speaking the credit for killing the plan must go to Lord Elcho, an otherwise undistinguished Conservative MP who served as Trustee of the National Portrait Gallery.[59] Styling themselves 'The National Gallery Reform

Among the designs commissioned by Prince Albert for a campus of science and art at South Kensington **Charles Cockerell**'s design (1853) stands out. This bird's eye view looks south from the southern edge of Hyde Park, roughly where the Albert Memorial stands today. Visitors would have passed through an elegant propylea or gateway to enjoy the gardens, concert hall and National Gallery beyond.

In the 1850s Conservative **Lord Elcho** was the chief parliamentary spokesman for a gaggle of connoisseurs who felt shut out by the German scholarship that underpinned Eastlake's phenomenal achievements as Director. In 1857, for example, he criticized the Pisani altarpiece as overpriced and overrestored. In later life Elcho became a defence hawk, urging the expansion of the militia and helping establish the National Rifle Association.

Association,' Elcho, the Liberal MP William Coningham and extraparliamentary allies such as the Irish connoisseur Morris Moore claimed that the relocation was a plot by Albert's technocrat toadies to transform a shrine to 'excellence in art' into a scientifically-arranged omnium gatherum of painting, archaeological specimens and applied arts.[60] If the nation's paintings were gradually being destroyed by the dirt brought in by the unwashed hordes of Trafalgar Square, then at least they were suffering in the line of duty: it was 'not the number of years that a masterpiece is preserved' that mattered, *'but the number of eyes that see it'*.[61]

In the 1850s the British Museum, South Kensington Museum and National Portrait Gallery showed themselves willing to experiment with decorative, if not 'themed' interiors, artificial lighting and a focus on historical authenticity over connoisseurship. Writing in the *Art Journal* in 1853, the former Director of the Berlin Gallery Gustav von Waagen argued that the interiors of the National Gallery should echo those of the churches and palaces for which the paintings had originally been painted.[62] Rather than welcoming such initiatives, which at very least suggested a way of attracting more state funding, Elcho and his allies perceived them as a threat to the Gallery's core values. The fact that Russell, Palmerston and Gladstone gave in to this small, hysterical group suggests that their suspicions might have been shared. Certainly their failure to heed Albert's demands that they resist reminds us that, for all his organizational effort, the Prince Consort was still the prisoner of a constitution which, as Walter Bagehot had observed, looked to the Crown purely for 'the seasonable addition of nice and pretty events'.[63]

Instead of realizing Disraeli's 1852 vision of cooperation between science, manufacturing design and fine art, plans for a Gallery at South Kensington proved abortive. In addition to Elcho, some of the blame for this must fall on Henry Cole, the indefatigable campaigner and public relations impresario whose name will always be associated with the museum he established at South Kensington in 1857, renamed the Victoria and Albert Museum in 1899. Cole had started out in the 1820s

as a humble copying clerk in the Public Record Office who spent his free time on the fringes of the Utilitarian circle around Jeremy Bentham. The first of what would be a series of well-publicized campaigns for improvements to the public service began in 1837, when he succeeded in convincing a well-disposed MP to request a select committee to investigate the records service. Blazing a trail he would retrace in his subsequent campaigns to reform the Post Office, Government School of Design and other art institutions, Cole's stage-managed committee deliberations were accompanied by pamphlets, petitions and collarings of high officials. Having outmanoeuvred and worn down all opposition, Cole's reforms were pushed through, and he moved on to the next campaign.

Cole's energy won the admiration of Prince Albert, but led others to suspect him of empire building. In the early 1850s Cole insisted that institutions intended to improve manufacturing design ought to pay for themselves, and promised that his design school and museum at Kensington (the Department of Science and Art, or DSA) would serve as beacons of good taste. Instead, Cole's Kensington complex was a warren of hastily-erected, leaky iron buildings. A virtue might have been made of their functionality. Instead they were gradually covered with elaborate decorative schemes that did little to improve public taste, not least by overwhelming the many excellent works of decorative art Cole acquired for the museum. Beyond Kensington, Cole's 1861 conversion to 'payment by results' made drawing lessons a miserable chore for generations of schoolchildren taught by DSA-trained masters.

Having erected his first 'iron museum' in 1856, Cole and his architect Francis Fowke subsequently bolted on further galleries (1857) to house the Sheepshanks Collection, and, later (1857-61), the Turner and Vernon pictures from the National Gallery's collection. These works remained on loan at South Kensington until 1869. But Cole's eagerness to play host to the National Gallery's paintings masked a broader reform agenda. Around the time of the planned handover of the new South Kensington galleries to the National Gallery Cole organized a petitioning campaign, urging the Trustees to introduce

Henry Cole started out as a gifted lobbyist for measures to improve manufacturing design. His energy would transform the Museum of Manufactures (1852) housed in temporary quarters at Marlborough House into the museum now known as the Victoria and Albert. The quintessential Victorian busybody, Cole's campaign to introduce evening opening and other reforms at the National Gallery led the latter's staff to fear that he would 'swallow them up'.

The **Turner and Vernon Galleries at the South Kensington Museum** (1857-61) were designed by Henry Cole's architect, Royal Engineer Francis Fowke, to house National Gallery paintings that could not be shown at Trafalgar Square. Fearing that Cole might take them over, the Gallery Board successfully insisted that these rooms had a separate entrance. They epitomize the Cole approach to museum architecture: stripped-down, yet tarted-up, infinitely expandable, ultimately disposable.

gaslight and evening opening. He was at the forefront of those wanting to merge the National Gallery's paintings, the British Museum's drawings and his own museum's applied arts into one 'National Museum of Arts,' to be built at South Kensington.[64] He also had his eye on the National Portrait Gallery, another institution then housed in unpopular, substandard accommodation.[65]

Just before the handover Cole tried to get National Gallery Keeper Ralph Wornum to agree that the Vernon and Turner Galleries would be under DSA control, with the same evening opening arrangements and admission fees charged in his museum. Wornum had been Librarian at the DSA before coming to the Gallery in 1855, and knew the thin end of a wedge when he saw one. The resulting inter-departmental squabbles would be of little interest were they not indicative of the degree to which Cole's administrative appetite and manipulation of public opinion created a climate in which art galleries and art education in general were met with suspicion, or at least bemused scepticism.[66]

If Cole was out to swallow the National Gallery whole, he did not let the abandonment of plans to relocate it to South Kensington slow him down. In 1857 he and his ally, the painter Richard Redgrave negotiated the gift of a large collection of British paintings by the Leeds cloth merchant Joseph Sheepshanks. The deed of gift identified the collection as the nucleus of a 'National Gallery of British Art'.[67] This implied that the National Gallery's remit should be limited to foreign Old Masters. In a marked change from their earlier hostility to 'unscientific' arrangement, the Cole camp's scheme for the adaptation and reorganization of the Gallery as a 'a Salon Carré, a tribune for our choicest treasures' was published in *Cornhill Magazine* under the title 'National Gallery Difficulty Solved'.[68] Although the Gallery clearly did see itself as a tribune, Trustee William Russell and others were adamant that British paintings belonged alongside their Continental Old Master rivals, 'as a matter of national pride' if nothing else.[69] Cole's proposals, including those for artificial light and evening opening, were firmly rejected by the Trustees.

As a young artist in the 1820s **William Boxall** had bravely attempted to support himself producing history paintings before turning to portraiture. Boxall was 66 years old when he was appointed Director, and at Gladstone's insistence remained in post until he was 74. Dogged by depression and ill-health, he nonetheless succeeded in acquiring a number of important works, including Michelangelo's *Entombment*. This self-portrait is one of several of his paintings subsequently donated to the Gallery.

As we shall see in chapter five, the years 1855-85 under Directors Eastlake, Boxall and Burton were arguably the Gallery's heyday in terms of acquisitions, in particular the first decade under Eastlake, who died in 1865. His successor, the artist William Boxall, was a much less energetic and knowledgable figure, chosen only after the much better-qualified candidates J. C. Robinson (Keeper of the Museum of Ornamental Art at South Kensington) and Austen Henry Layard had declined. Layard, who combined service as a Liberal MP and diplomat with a phenomenally successful career as archaeologist, later served as a Trustee and bequeathed his collection of early Italian art to the Gallery. Although Boxall's travels on the continent enabled him to secure a number of important Italian works, in most cases he was clinching negotiations begun by Eastlake. Otherwise he found his activities limited by what he felt to be ridiculously high prices, and by greater legal obstacles to export imposed in the wake of the Italian *Risorgimento*.[70]

Having enjoyed good relations with Disraeli, Boxall found it more difficult to deal with the Liberal administration after 1868. An attribution scandal surrounding the newly-acquired Michelangelo *Entombment*, renewed pressure from Cole to introduce gas lighting and finally the debate over the reconstruction of the Gallery were more than Boxall could cope with. Admittedly, he was also faced with rehanging the Gallery after the long-awaited departure of the Royal Academy to Burlington House in 1869. By 1871 he was pleading ill-health, and, after the painter George Richmond refused the post, was persuaded to stay on for a lacklustre second term by Gladstone. Boxall and Richmond went together to inspect the large collection of Dutch paintings that had been formed by Sir Robert Peel and which was then being offered to the state for £75,000 by his heir. The Chancellor of the Exchequer, Robert Lowe, moved for an extraordinary grant in the Commons that March, completing a remarkably uncontentious purchase that included Hobbema's *Avenue at Middelharnis* and Rubens' *Chapeau de Paille*.[71]

In addition to the five rooms released by the Academy's departure, Boxall also witnessed the Gallery's first expansion northwards, onto the site formerly occupied by the parish

workhouse. Here seven new rooms were constructed between 1868 and 1876 to designs by Edward Middleton Barry, the third son of Charles, architect of the Palace of Westminster. The main focus of this suite was a domed gallery with four galleries running off it. In addition to a rich decorative scheme by the firm of Crace and Sons, these galleries featured lunettes

The orgy of ornament in the **new suite of rooms opened in 1876** is a monument to architect E. M. Barry's defiance of pennypinching Treasury mandarins and the Gallery's desire for functionality. Director Frederick Burton complained that Barry seemed intent 'to render the new galleries as unsuitable as possible to pictures by sacrificing the lights, the walls and I don't know what else to his architectural crotchets.'

E. M. Barry's complex would
have housed both the
National Gallery and the
National Portrait Gallery in
Neo-Roman splendour,
dominating Trafalgar Square
as Wilkins' low Greek never
could. Like many of the
designs entered in the 1866
government competition,
it seems more like one of
the town halls of the period,
such as Cuthbert Brodrick's
at Leeds (1858), than a
museum.

sculpted by E. M. Wyon. The contrast with the much simpler
interiors of the Wilkins block is still striking, and the dome
seems a rather delayed and displaced attempt to compensate
the visitor for Wilkins' lacklustre effort. The Barry rooms pro-
vided the gallery with a grand space in which to display the
Gallery's masterpieces, inviting the visitor to explore one of the
three avenues laid out before him. But this preparatory space
for orientation is curiously located, set away from the main
axes of the building. Subsequent expansion of the Gallery has
not done anything to find a satisfactory role for the Barry
rooms, except for a short period during the Second World War,
when they provided a venue for public concerts.

This is hardly surprising, as Barry's original designs were for
a total rebuild of the Gallery in a rather heavy Imperial Roman.
Coming after a series of botched public competitions for the
new Foreign Office, the Royal Courts of Justice and a Gallery
rebuild, the commission for the new suite seems to have been
the last in a chain of compensatory concessions by a series of
First Commissioners of Works with radically different views.
Briefly, Barry was given the National Gallery commission in
compensation for being ousted from the Royal Courts of Justice

Known as 'Layard of Nineveh' for the enormous winged bulls and other Assyrian artefacts he unearthed in Ottoman Turkey in the 1840s , the archaeologist and diplomat **Austen Henry Layard** greatly enriched the British Museum's collections before becoming a Trustee of the Gallery in 1866. Prime Minister Lord John Russell had hoped to appoint him Director, but plans for him to hold the post in conjunction with that he already held as Under-Secretary at the Foreign Office proved impractical.

project, which went to George Edmund Street, who had received that commission in compensation for failing to secure the Foreign Office. Although the Tory First Commissioner Lord John Manners had initiated a National Gallery design competition in 1866, the results were inconclusive. Even after Manners got a bill purchasing land for Gallery extension at Trafalgar Square through the Commons in 1866, Trustees Austen Henry Layard and William Gregory nonetheless tried to pass a motion that would have allocated the Burlington House site to the Gallery, rather than the Academy.[72] They lost the vote, however, and designs from fourteen architects for a new gallery on Trafalgar Square went on show in the Royal Gallery, Westminster Palace in January 1867. No official winners were declared, with the judges simply stating that E. M. Barry's design for the new Gallery and Murray's scheme for the adaptation of the existing building showed most merit. The expansion question rumbled on, Manners' prevarication contrasting with the courage and imagination of his colleagues, who chose this moment to redesign and expand the British electorate by means of the Second Reform Act.

The designs submitted to the competition are of interest on two counts. First, because they included a solitary Gothic scheme. George Edmund Street's entry was an oddly domed cathedral of art, whose rather more exciting interior would have offered a quasi-mystical environment for art-viewing (see illustration p. 391). The fact that the idea of a national gallery in the 'national style' was still considered ridiculous, despite the convincing arguments Street advanced in his pamphlet of the same year, is curious.[73] The others submitted were noteworthy only on account of their homogeneity. Earlier competitions, such as those of 1832 and 1853, had seen a range of styles: Wilkins' Greek, Cockerell's Wren Revivalism and Barry's Italian Palazzo. Now all was heavy Neo-Roman, with an effusion of columns and rotundas more redolent of a bank than an art gallery. Indeed, some designs rested on single-storey plinths like Soane's Bank of England, and the architects included several who had made their reputations in constructing the Royal Exchange and City banking houses. They seemed unaware of

important Continental developments in museum architecture, such as Gottfried Semper's Dresden art museum.[74] Instead their designs prefigure the decadent fussiness of Sidney R. J. Smith's Tate Gallery (1894-7).

The fall of Derby's Conservative ministry in 1868 saw Gladstone become Prime Minister for the first time. He appointed Layard First Commissioner, perhaps the best qualified individual ever to hold the post, and certainly the best disposed to serve the Gallery's interests. Layard drew up an ambitious scheme to relocate the Gallery to Crown land on the Embankment, in a building that would include space for the Raphael Cartoons, the British Museum's prints and drawings, and a gallery for contemporary European art. Unfortunately, Layard found his position undermined by the Treasury and proved remarkably thin-skinned when faced with petty accusations of corruption directed against him in the Commons. He appeared relieved when Gladstone arranged to have him appointed ambassador to Spain, replacing him with Treasury mandarin Acton Ayrton.[75] Ayrton had no interest in the arts, being appointed mainly to keep him from quarrelling with the Chancellor. Although Layard had managed to start work on Barry's gallery extension, Ayrton kept the project on a tight budget and tried at least once to have it dropped.[76]

Hanging the new Barry rooms fell to Boxall's successor as director, the Irish painter Frederick Burton, appointed in 1874. Burton's two decades in office represent the tail end of the Gallery's golden age of collecting, which effectively ended with a bang in 1885, when an unprecedentedly generous Treasury grant of £87,500 enabled the purchase of two works from the Blenheim Sale: Raphael's *Ansidei Madonna* and Van Dyck's *King Charles I*. Like Eastlake, Burton was a Germanophile, having left a successful practice as a society portraitist in Dublin for Munich, spending most of the 1850s copying, studying and restoring the Bavarian royal collections and producing endearing scenes of village life in the *altdeutsch* style. Given his lack of publications and absence from London during the key debates of the 1850s, the appointment was a surprise.

Burton widened the Gallery's collecting remit in surprising

The Irish-born painter **Frederick Burton**, shown here in a portrait by Ruskin, had spent several years earlier in his career in Munich, where he could admire the museums endowed by King Ludwig I at first hand. He served the Gallery well as Director for twenty years, although Trustees such as Layard complained of his laziness – a reflection of increased Trustee activity, rather than any inactivity on Burton's part.

ways. In 1888, for example, he eagerly accepted Lord Savile's offer of 66 reduced-size copies of the Hermitage's Rembrandts and the Prado's Velázquez, arguing that 'a collection of really good copies of works of celebrity elsewhere would form a valuable complement of our gallery.'[77] The idea had been mentioned in passing during the 1836 and 1853 Select Committees, and Edmund Chadwick had even proposed it to Albert in 1857 as part of his bare-faced campaign to secure a knighthood.[78] Burton was the first, and last, Director to consider the idea. In the same year he also secured a number of Graeco-Roman mummy portraits which had featured in an exhibition organized by the Egyptologist Flinders Petrie. Although several of his Trustees argued that such works belonged at Kensington or in the British Museum, Burton insisted that they were part of the story he was trying to tell at the National Gallery.

For all this willingness to expand the parameters of the collection, it would appear that Burton and the Trustees were nonetheless taken rather by surprise when the sugar magnate and philanthropist Henry Tate wrote to them in October 1889 offering to donate his collection of British art, on condition that they build new quarters in which to display them within three years. Rather like Robert Vernon before him, Tate was a shy man, almost totally unknown to the Trustees, who again found themselves somewhat embarrassed, both by the size of the collection and by the paintings in it, which Trustee William Gregory described as 'representatives of a bad period of English art'.[79] The offer was refused, on the grounds that Tate's insistence that his paintings be displayed separately from the rest of the collection would prevent the Gallery from exhibiting them in chronological order, among those British works it already possessed. The Trustees even suggested that Tate offer them to Cole's South Kensington Museum instead.[80]

Tate then went to the Chancellor of the Exchequer and offered to donate £80,000 towards the cost of building a gallery. George Goschen's dilatoriness in finding a satisfactory site, however, frustrated Tate to the point where the offer seemed to be withdrawn. A change of government in 1892 saved the situation: William Harcourt, Goschen's Liberal

This unattributed nineteenth-century work is a copy of Murillo's **The Infant Virgin** from the Louvre. In 1888 Trustee Lord Savile gave this and other copies after Velázquez and Rembrandt. Director Frederick Burton was happy to put them on show, and hoped the Gallery would form a copy collection, to assist students and others unable to travel to foreign museums and view the originals. This idea was never followed up and all the other 65 copies donated by Savile are, tellingly, now lost.

replacement, proposed the site of disused Millbank Prison, and construction began in 1894. Although the Tate Gallery was an annexe of the National Gallery, and did not secure its own board of trustees until 1917, its development is another story, which has already found its historian.[81] The movement of pictures back and forth between Trafalgar Square and Millbank, however, is a revealing guide to how the Gallery's trustees saw the relationship between British and European, Old and Modern masters. Formal separation was not achieved until the National Gallery and Tate Act of 1954, which clarified the remit of both collections.

The 1885 Blenheim Sale was a turning point in the Gallery's fortunes. The annual purchase grant was suspended for several years to compensate for the special grant. The purchase itself required a supplementary vote of the Commons, which came up for debate in March 1885. A number of MPs from both sides of the house argued against it, citing the expense of naval re-armament, high unemployment and the ongoing war on

terrorists in Afghanistan. All these competing claims on the government purse would make regular appearances in debates on the Gallery right up to the First World War.

The limits of the cultural nation

To be fair, those who raised them had a point. German and American industry was overtaking Britain's, and even a man of Gladstone's stature could not resist the inexorable mission creep which shackled both parties to imperial commitments abroad and, later, welfare ones at home. There seemed a decline in Britain's industrial spirit, as successful millocrats and entrepreneurs opted against reinvesting their capital in favour of exporting it – ironically enough, to help finance the very American and colonial infrastructure that powered Britain's economic competitors. The gospel of museum betterment had been based on a classless vision which saw the Gallery as a place where fine art reformed society one individual at a time, rather than providing one class with a means of indoctrinating the others. It had also been seen as fostering manufacturing wealth in a free-trading world, inspiring improvements in design and empowering consumers to recognize and reward tasteful products. From the 1880s onwards all of these tenets were under attack. Appeals for protective tariffs, the collectivization of the working class and a more informed knowledge of unemployment were an assault on the Peelite view of the economy as a cyclical, character-building machine, one too intricate for government meddling to be anything other than presumptuous meddling in an inscrutable, divine order.

Although the 1867 and 1884 reform acts had brought working men considerably closer to the franchise, those critics and museum reformers who claimed to have the educational and aesthetic needs of such men most at heart, notably Henry Cole and John Ruskin, seemed unable to move with the times. They felt franchise extension and demands for greater state involvement in public welfare to be irrelevant, if not counterproductive to the project of teaching the masses. Rather than seeing the museum's duty as introducing the working man into

Opposite: Raphael's **Madonna and Child with St. John the Baptist and St. Nicholas of Bari** (1505) was one of just two works bought at the 1885 Blenheim Sale, the other being Van Dyck's *King Charles I on horseback.* The Director and Trustees were disappointed not to have acquired others. 'They are one and all of the highest order,' Director Frederick Burton wrote to Prime Minister William Gladstone, 'not merely curiosities of art and valuable as illustrating its history and development, but representing it at the supreme moment of its culmination in Italy and Flanders.'

the classless, homogenizing environment of respectable art-viewing, they saw its task as being to isolate the working class-es as a distinct audience. Ruskin argued that there should be a separate National Gallery of 'useable,' second-rate art arranged to impart fixed lessons to them, 'so that they might look at a thing as their own, not merely as the nation's, but as a gift from the nation to them as the working class.'[82]

The words 'merely' and 'gift' show how far Ruskin was from seeing the Gallery's works as a national resource in which all Britons had a stake; instead the working classes were outside, grateful for any aesthetic charity the gatekeepers of culture might extend to them. Although much praised both then and now for their progressiveness, many of Cole's access initiatives, such as evening opening by gaslight, were designed as oppor-tunities to distill, rather than dissolve, social rank. The working and middle class were each to have their own times to visit, free from the other's presence. This ultimately pessimistic (com-pared to Kingsley's) view of museum outreach was shared by the Liberal technocrats of the Social Science Association (SSA), who discussed 'art for the people' at their 1885 Birmingham conference. Whereas the powers of art to bridge any educa-tional or social gulf had previously seemed limitless, those interested in slums and social exclusion, such as the novelist Walter Besant, now argued that there was a working-class residuum beyond art's reach.[83]

This residuum was presumably the same underclass of 'habitual offenders' which the SSA proposed to contain with new, 'scientific' legislation whose questioning of the presump-tion of innocence belied its 'liberal' rhetoric.[84] Behind initiatives to bring art closer to the people, notably the opening of 'slum museums' in Whitechapel and elsewhere, was a rigid, often highly patronizing pedagogic drive, which produced a curious mixture of progressivism and fatalism.[85] William Morris' 1890 novel *News from Nowhere* is particularly telling in this respect: although the Utopia sketched by Morris is a Ruskinian paradise of creative craftsmen freed from slavery to money and machines, it has no room for a National Gallery. Indeed, for Morris Trafalgar Square was synonymous with immiseration,

Trafalgar Square had seen its fair share of Chartist demonstrations in the 1840s, but the scenes witnessed on **'Bloody Sunday'** (13 November 1887) were particularly troubling. Trade unionists and socialists clashed with hundreds of police and Life Guards just steps from the Nation's treasure house. In the wake of the unrest Burton gave directions 'that our police should have the fire-hose always in readiness to play upon any mob that might choose to pay their addresses to the N.G.' Walter Crane produced this stylized image to accompany a poem by Morris commemorating Alfred Linnell, one of the casualties of the riots.

unemployment and the triumph of state violence over rights of free speech and free assembly. In the 1880s economic decline forced hundreds of unemployed to sleep rough in the Square. They would have been among the thousands of protestors that Morris addressed on the morning of November 13, 1887, just hours before they clashed with 1,500 policemen and 350 Life Guards assembled on the square – in what came to be known as the 'Bloody Sunday' riots. Although this collection of fellow Socialists, unemployed and Irish Home Rulers was successfully dispersed, Morris would write afterwards that the severity displayed by the authorities that day proved 'that slaves have no rights'.[86]

The Blenheim Sale revealed other cracks in the nation represented by the National Gallery. Whereas the charge that expenditure on the National Gallery cheated Britons who lived outside London had long served to lend a certain dignity to philistine opposition, once picked up by Irish Home Rule MPs it acquired new meaning and urgency. Recently released from Kilmainham gaol, William Redmond MP appeared in the House of Commons in July 1885, to argue that as the purchase had been funded by general taxation the newly acquired Blenheim paintings should go on tour – including to Ireland. From its foundation in 1854 the National Gallery of Ireland had been

the National Gallery's poor relation, scrabbling with its Edinburgh rival, the National Gallery of Scotland, for crumbs from the sale of the Krüger Collection, for example. Redmond now stated that Ireland would no longer rest content with 'cast-off pictures': 'if there were any more good pictures in the market which could be bought for £70,000 or £80,000 they ought to be purchased for Ireland.'[87] He claimed that the Liberals had secured the support of Irish MPs for the purchase by making promises to send the Raphael Ansidei Madonna on tour to Dublin – only to claim later that it was not the done thing to send paintings on tour. This, as the National Gallery Loan Act of 1883 had made only too obvious, was disingenuous: that Act had empowered the Trustees to loan paintings in precisely the way Redmond proposed.

If Ireland couldn't have its fair share of the National Gallery, might Irish terrorists decide to destroy it? One MP warned the Commons that 'if pictures of so costly a description were to be purchased, and put into the National Gallery, some ruffian might walk in and blow to nothing in a moment those valuable pictures.'[88] The previous year Fenian terrorists had launched a series of attacks in which bombs were placed in railway stations and public thoroughfares, timed to explode within seconds of each other. One of these attacks saw an attempt to bomb Trafalgar Square.[89] Although the 18 slabs of dynamite placed near Nelson's Column failed to detonate, Her Majesty's Inspector of Fortifications was charged with advising the National Gallery on security.[90] Railings were erected and one of the pedestrian passages through the ground floor of the building was boarded up. The police presence in and around the building was also increased, and included officers in plain clothes.

If the cost of the *Ansidei Madonna* set a new record for Gallery acquisitions, the price in short and medium turn fallout was arguably much greater. With vindictive pettiness, the Treasury cut the annual purchase grant entirely to 'compensate' for its unwonted generosity. Although they had promised in the meantime to consider further extraordinary grants for particularly important works that might come on the market,

Burton and the Trustees found their appeals fell on deaf ear
Indeed, as Trustee William Gregory put it in a memorial to th
Treasury in 1888, if the Gallery was to continue to justify i
reputation as a 'teaching gallery' it would need to buy works t
lesser-known masters – precisely those whose importanc
would hardly be appreciated by Treasury or parliament. To ac
insult to injury, when the Gallery tried to include such appea
in its annual report, the Treasury censored them, as being of
controversial character'.[91] Without even a recourse to publ
opinion, the Gallery had to adopt the curious tactic of 'rentin
Reynolds' *Countess of Albermarle* from Agnew's until such tin
as it could buy it. Although a purchase grant of £5,000 wa
conceded in 1889, a £55,000 'extraordinary' grant towards th
purchase of Holbein's *Ambassadors* and other works at th
Longford Sale in 1890 led to another cut. It is astonishing t
record that only in 1954, almost seventy years after th
Blenheim Sale, did the annual purchase grant reach the pre
Blenheim Sale figure of £10,000 (approximately £580,00
today).[92] For Burton and his successors, this cut was a sevei
handicap. On Burton's retirement in 1894 Prime Minister Lo
Rosebery made the Director's position even more uncomfor
able, redefining his powers by means of a Treasury minute.

The 'Rosebery Minute' shifted the balance of power betwee
Director and Trustees. It argued that the system put in place t
Gladstone's 1855 minute had left the Trustees 'debarred fro
the exercise of any real power... an anomaly which should,
possible, be removed'. This was hardly fair. Although Eastlal
had been a powerful Director, Boxall and Burton had been le
assertive. As *The Times* noted during the 1869 attribution scar
dal, 'It used to be the director, but both speakers and writei
seem now to hold the trustees as responsible.'[93] Rosebery ther
fore believed that the Minute was in tune with this new cor
sensus. It also reflected a belief that the Gallery's days of activ
collecting were (thanks to American buyers pushing up price
behind it. There seemed no need for a Director able to purcha
on his own authority.[94]

The Minute determined that Burton's successor would t
'chief executive and administrative authority of the Gallery

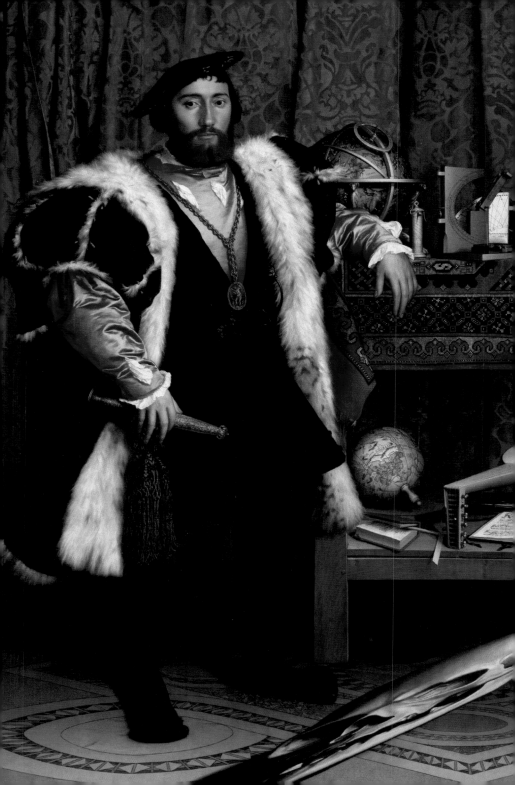

Hans Holbein's **Ambassadors**
(1533) was acquired from
the Longford Castle collection
in 1890 with help from a
special Treasury grant,
supplemented by donations
from Alfred de Rothschild,
Lord Iveagh and Charles
Cotes. The Earls of Radnor
held on to other masterpieces
that the Gallery would later
struggle unsuccessfully to
secure in the 1970s, notably
Holbein's portrait of Erasmus
and Velázquez' *Juan de Pareja*.

When it came to taking any decision, 'whether on the acquisition of new pictures, the preservation of those already in the Gallery, or the management of the institution,' however, he would merely have a vote on the Board, who would collectively decide what course to take. As if to ensure the Director's total isolation, the Minute directed that the Keeper and Secretary would now serve under the Board, rather than directly under the Director. The 1902 'Lansdowne Resolutions' limited the Director's powers still further, closing loopholes which had allowed the Director to make small purchases abroad on the understanding that he would secure retroactive Trustee approval. Although the Treasury refused to accord the resolutions any binding status, the resolutions and the Rosebery Minute survived in practice until the Second World War.

This grab for power by the Trustees might have made sense if the Board had been strengthened by the addition of men with a professional interest in art, or rather the new type of art connoisseurship associated with German scholars ('art history' did not yet exist). But it wasn't. Compared to the Trustees who served during the Gallery's first fifty years, those who served in the latter decades of the century and after were less politically experienced. Whereas the Board had previously cut across party lines, in the years 1880-1910 several previously Liberal Trustees crossed over to the Conservatives. Non-landed Trustees, including the self-made chemicals magnate Sir Charles Tennant and the banker Alfred de Rothschild, did not alter the picture. Ensconced in their country houses, which in the case of Rothschild's Halton boasted a bowling alley and circus ring, these Trustees were buying up Reynoldses and Gainsboroughs almost as quickly as aristocratic Trustees like the 5th Marquess of Lansdowne were selling them.[95] At the same time their flamboyance heralded the beginning of the end of what Lady Frances Balfour would later look back on as 'good society,' a time when 'certain things were not done, certain people not received'.[96]

The appointment of Rothschild and Lansdowne as Trustees in 1892 and 1894 represented a fundamental shift in the make-up of the Board, and set a pattern which would be followed for

Max Beerbohm's caricature
shows Alfred de Rothschild
'Roughing it at Halton,' his
luxurious country estate in
Buckinghamshire. Such
satires immortalized Alfred as
the definitive *fin de siècle*
dandy and hypochondriac, a
Fabergé Humpty-Dumpty
afraid to break, despite hav-
ing all the King's doctors and
all his own footmen standing
by. As Trustee Rothschild
humiliated and amused staff
by turns.

the next century. The second-oldest of the three sons of Lionel
Rothschild, Alfred inherited a large fortune and excellent social
and political connections. These removed the need to work very
hard at banking, or anything else. Although he and his elder
brother 'Natty' exercised a certain amount of influence over
British foreign policy in the period up to 1914 – Rosebery mar-
ried Alfred's cousin – there seemed surprisingly little of the
business-diplomacy synergy which had made the House of
Rothschild great. The years 1880-1918 saw the family lose
their previously pre-eminent position in international finance,
partly due to the risk-averse indolence of fourth-generation

playboys like Alfred, but mainly by a failure to invest in America or patch up quarrels between the family's three main banking hubs. This did not prevent Alfred from enjoying what the family's biographer has described as 'the life of a *fin de siècle* aesthete, at once effete and faintly risqué'.[97] The Gallery's later history would see other larger-than-life characters serve as Trustees, notably Sir Philip Sassoon and Sir Joseph Duveen.

Lansdowne introduced what would become another stock-character on the board: the aristocrat driven to increasingly honorific public positions as colonial governors or company chairmen by *noblesse oblige* and a hunger for salaried employment born of thousands of acres of worthless land in Scotland or Ireland.[98] Like his near-contemporary Rothschild, the young Lansdowne had shown little academic or political spark, but acquitted himself well enough in minor political office under Gladstone to serve as Governor-General of Canada and Viceroy of India between 1883 and 1894. Converted to Conservatism by Gladstone's support of Irish Home Rule, he later served as War and Foreign Secretary under Salisbury, his career ending spectacularly in 1917, when he went public with his highly unpopular views in favour of a negotiated peace with Germany.

Lansdowne had little interest in art, and probably did not grieve overmuch when declining estate revenues obliged him to sell Rembrandt's *Mill*, which secured the record price of £100,000 in 1910. He shared many characteristics with equally important Trustees who served after him, who included another Viceroy of India (Curzon) and the 27th and 28th Earls of Crawford. Lansdowne and Curzon were both involved in plans to reform the House of Lords in the wake of the 1910 Parliament Act. Curzon and the 27th Earl of Crawford both served as ministers in Lloyd George's cabinet. Party leaders had no interest in discussing reforms that might lend the Lords greater authority or credibility, however, nor in according such titled ministers anything more than a decorative role.[99] This did not mean that as Trustees they were uninterested in Gallery business or ignored by the Treasury.[100] They were probably the most influential Trustees to serve on the Gallery's Board in the next eighty years.

'Lansdowne was acidly polite and glacially genial at best,' Keeper Charles Collins Baker noted. Philip de Laszlo's portrait of **Henry Petty-Fitzmaurice, 5th Marquess of Lansdowne** captures the hauteur which made him such a forbidding Trustee. Like his boardroom ally Alfred de Rothschild, Lansdowne had sought to promote Anglo-German relations around the turn of the century. His 1917 proposal that Britain seek a negotiated peace with Germany would end his political career.

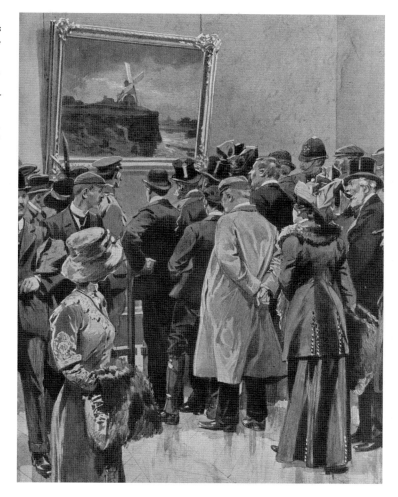

When the 5th Marquess of Lansdowne decided to sell his famous Rembrandt, **The Mill**, in 1910 he was careful to inform his fellow Trustees and offer them first refusal at the same price he had been offered. At £100,000, however, there was no question of the Gallery being able to do anything about it. The painting was shown at the Gallery in 1911, before it left for America. As this illustration from the *Illustrated London News* shows, hundreds came to say goodbye.

The ease with which plutocrats and decayed aristocrats mingled in High Victorian society was made visible in the way Rothschild and Lansdowne cooperated on the board, painfully visible to Edward Poynter, who served as Director in succession to Burton from 1894-1904. The choice of Director in 1894 fell to Gladstone, as it had in 1855, 1866 and, arguably, 1874 as well. Again he selected a painter, although the tide of opinion against

artist-directors was now running so high that it even spilled into the press, where the critic D. S. MacColl argued that only Poynter's rival Sidney Colvin (Keeper of Prints and Drawings at the British Museum) possessed the requisite knowledge. 'The study of the older schools of painting has,' Colvin wrote, 'become in recent times a branch of archaeology pursued like other branches of archaeology by specialists...' Poynter, he added, was not only a painter, but an Academician, which was worse. 'Among modern developments, it is the Academy that seriously threatens the National Gallery... [Poynter's] work is academic, and its quiet and harmless academicism leads by easy stages to very barbarous developments.'[101]

Those references to 'modern developments,' to the Academy, and indeed the very fact that the appointment aroused such debate clearly demonstrate the extent to which the art world had fragmented, making the Directorship into a prize or bully pulpit eagerly sought by members of rival camps. Earlier renegades like Turner or Haydon had signally failed to foment anything like such a debate in the British Establishment. The former found the Academy a cosy enough berth. The latter committed suicide. It even seemed that Millais and the other prodigal sons of the Pre-Raphaelite Brotherhood could find a way back to the Academy fold. By 1888 Millais himself was fulminating in the *Magazine of Art* against 'a band of young men who, though English, persist in painting with a broken French accent...'[102] This was a pointed reference to French-trained artists such as Whistler, whose 'Nocturnes' and 'Arrangements' were introduced to a paying public at Coutts Lindsay's Grosvenor Gallery in Bond Street between 1877 and 1890. In addition to its summer exhibitions of contemporary art, the Grosvenor also held winter exhibitions dedicated to Gainsborough and Van Dyck.[103]

Although it is important not to exaggerate the Grosvenor Gallery's role as an 'anti-RA' space, its aristocratic cosmopolitanism and 'art for art's sake' decadence were enough to make it a challenge to the Academy's claims to represent the best of the British School. Yet the problem for the RA was not simply that Academicians (including Poynter himself) weakened such

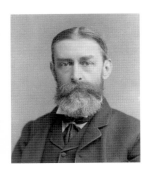

Born into an artistic family resident in Paris, **Edward Poynter** studied painting there with Whistler and others, a Bohemian episode commemorated in Du Maurier's famous novel *Trilby* (1894). He made a name for himself in London by painting large classical machines, and in 1894 was appointed Director on his strength as an artist. His efforts to continue filling 'gaps' in the collection were frustrated by Rothschild and other Trustees who wanted to focus on acquiring masterpieces.

claims by exhibiting at the Grosvenor, but that the Gallery's denizens saw the very project of a national school immortalizing British character as ludicrous. This fed into criticism of the Academy's control of the Chantrey Bequest, an endowment fund originally established to fund acquisitions of British paintings and sculptures for the National Gallery.

The Academy had used the fund to purchase works by their own Academicians, who produced large, over-loaded works illustrating quaint or touching incidents from history or romance. D. S. MacColl succeeded in convincing Lord Lytton to move that a Lords committee investigate the Academy's management of the Bequest in 1904. Although this Committee failed to wrest control from the Academy, it provided Poynter and MacColl with an excellent set-piece, which saw the former's camp criticize MacColl's taste as 'unpatriotic'.[104] Clearly, despite the *entente cordiale* enough francophobic suspicions survived to make such chauvinism a useful stick with which to belabour new tastes. Ironically, a closer look reveals that Poynter found his attempts to fill gaps in the early Italian schools stymied by the ultra-conservative tastes of Rothschild and Lansdowne.

Poynter had an ally on the Board in the shape of George Howard (9th Earl of Carlisle), then the most senior Trustee and a talented artist in his own right. A Grosvenor Gallery aesthete, he left estate management and social activism to his wife. He resented the Rosebery Minute and did his best to help Poynter. As their correspondence shows, however, the pair could do little to stop the opposing triumvirate.[105] As Rothschild saw it, he had to oppose 'the acquisition of inferior works which were really unworthy of the National Collection... many of which in his opinion had lowered the standard of excellence which ought to be maintained.' It would be much better to save up and buy masterpieces, which, he rather fancifully claimed, would attract generous grants from the Treasury. Even when Rothschild was unable to attend Board meetings physically, he made his views known. Later that same month he telegraphed from Monte Carlo that he did not want the Gallery buying any pictures from dealers.[106] The next year he, Lansdowne and

Annibale Carracci's **Three Maries** (c. 1604) was part of the famous collection of the Duc d'Orléans, which came on the market after the French Revolution, and was bought by a syndicate of British noblemen. This painting entered the collection of Lord Carlisle. The 9th Earl was a leading Trustee, and in 1912 his widow, Rosalind, gave the Trustees the option to select works from the collection. 'In the old days the "many" did not care for art, and pictures were fitly housed in the stately private houses' she wrote to the Keeper, 'but today the People have come to their heritage, and are learning to "hunger and thirst" after Art, wherefore the treasures should belong to them.'

Tennant promulgated their own policy on the respective claims of Trafalgar Square and the new Tate Gallery, which had opened as the 'National Gallery of British Art' in 1897. In stark opposition to Howard they laid down a set of principles making it clear that the latter gallery was to be the poor relation, left with the pre-Reynolds and post-Landseer paintings the Trustees thought were worthless.[107]

By means of the Rosebery Minute – which Alfred probably influenced – and Lansdowne's 1902 Resolutions, the pair had ensured that finding candidates for the post of Director would be difficult. Their resistance to Poynter's suggestions for acquisitions led him to conclude 'that we shall never buy another picture of importance.' While he seemed able to cope, his successor Charles Holroyd was broken down by it. A Slade-trained painter-etcher, Holroyd had served from 1897 as first Keeper of the Millbank Gallery. The only explanation for the appointment of such a nonentity probably lies in the fact that, as the Earl of Carlisle had predicted, no decent candidate could be found willing to work under the conditions created by Rothschild and Lansdowne.[108] The critics Claude Phillips and even Roger Fry were interviewed, but were doubtless too controversial; Fry in any case took up a post at the Metropolitan Museum in New York before the matter was decided. As it was, Holroyd was appointed only in 1906 after an interregnum of over a year. The portrait of him by his friend Charles Holmes in the latter's autobiography shows a pathetic figure, leaving board meetings on the verge of tears.[109]

The twenty five years prior to the outbreak of World War One saw several important architectural developments: the construction of two new galleries and the domed central hall (1889), that of Ewan Christian's Italianate National Portrait Gallery immediately behind the Barry Rooms (1891-5) and finally the opening of six new galleries behind the west wing (1909-11), mirroring the layout of the Barry Rooms of 1876. Few could forget the disastrous public competitions of the 1860s, and so the design of both Gallery extensions was entrusted to the Office of Works. The NPG's architect was appointed by the building's donor, William Henry Alexander.

The decision to build the NPG's first purpose-built home on a narrow site immediately behind the Gallery seemed to hark back to 1860s ideas of merging both institutions.[110] Though an odd choice, Ewan Christian did indeed manage to design a building that fitted in so well that many would later assume that its east range was part of Wilkins' Gallery. Otherwise, however, NPG Director George Scharf was adamant that new and old Galleries should be divided by very solid walls. In the face of opposition from Layard and other National Gallery Trustees Christian resigned himself to leaving the tower he originally intended for the main entrance off his final plans. Whereas the 1889 extension and central hall emulated the opulent style of the Barry Rooms, the interior decoration of both the NPG and the 1911 suite at the National Gallery was much more restrained.[111]

'Art has never been their fetish'

Priced out of the market by Henry Clay Frick, Benjamin Altman, P. A. B. Widener, J. P. Morgan and other American buyers, the Gallery could salvage little from the country house sales held with increasingly frequency in the early years of the century. A Raphael *Madonna* from Panshanger was sold to Widener for £116,500 in 1913; the next year Frick paid £82,400 for the Earl of Abercorn's Raphael, *Paolina Adorno*.[112] One million pounds worth of art was exported in the year 1909-10 alone.[113] Some of the works sold, such as the Colonna Raphael, had been on loan at the Gallery for almost thirty years. In addition to the agricultural depression caused by cheap Canadian wheat, landed aristocrats were being pushed into selling their art by increased death duties and new super-taxes. Yet they seemed unwilling to explore the possibility of seeking exemption by identifying themselves as guardians or trustees of private property that was also national heritage.

Perhaps this was because they were frightened by Irish Land Reform. Steps towards 'trusteeship' or 'virtual nationalization' of landed property were certainly evident there. Indeed, the rights of tenants were strengthened by central government to

such an extent in the 1880s and 1890s that landowners were
first reduced to the status of guardians, without power to set
rents, and then were effectively bought out. But a lack of imag-
ination may have played a part, too. Although it was possible
for landowners and statesmen like the Conservative Attorney-
General Sir John Holker to appreciate that the public might be
stakeholders in matters of sanitation, transport infrastructure,
and defence, paintings were another matter. In the 1877 debate
on Sir John Lubbock's bill to protect ancient monuments
Holker observed that

> as to interference with the rights of property, he quite admitted that
> where there was a great public necessity – arising, for example, from
> sanitary considerations or from the need of communications between
> one part of the country and another – private rights must give way.
> But was there any such necessity in the present case? He thought not.
> He feared there was a growing desire on the part of the [Liberals] to
> make private rights subservient not only to public necessity, but also
> to public convenience... If they adopted the principle of the Bill in this
> respect, where was its application to cease?... Why not impose restric-
> tions on the owners of pictures or statues which might be of great
> national interest? If the owner of the "Three Marys" or of
> Gainsborough's "Blue Boy" proposed to send it out of the country,
> were they to prevent him, on the ground that the matter was one of
> national concern?[114]

The Duke of Westminster's *Blue Boy* did leave the country; sold
by Duveen to Samuel F. Huntington of California in 1921 for
£148,000, the Duke having resisted Isabella Stewart Gardner's
offer of £40,000 in 1896.[115]

With the introduction in 1894 of heavier death duties by the
Liberal Chancellor William Harcourt, however, some
Conservatives underwent a conversion to heritage. A. J. Balfour
tried to argue that the tax would harm the national interest, in
that the new duty would force landed owners to sell works of
art ('items of national wealth') which they had magnanimous-
ly shared with the public by opening their stately homes.[116] In
fact, the great houses largely closed their doors to the public in
the last decades of the nineteenth century, choosing to batten
down the hatches rather than capitalize on the 1830s and 40s

country house cult. There was almost no sign of a concerted opposition case against Harcourt; as a party the Conservatives were uninterested in defending aristocracy.[117] In any case, it was hard to counter Harcourt's complacent justifications for the refusal to extend tax relief to masterpieces. If, as he put it, 'England was the richest country in the world,' then surely he was correct to suggest that there was nothing to worry about.[118]

Whereas Balfour's motives could presumably be trusted, those of some of the other MPs willing to explore the idea of extending tax exemption for heritage objects looked decidedly suspect – not least David Lloyd George's. When Salisbury's Conservative government considered giving tax relief to owners of 'objects of national scientific and historic interest' in 1896, Lloyd George proposed an amendment making any relief conditional on the granting of public access.[119] If this was intended to be an invitation to play the trustee role, it met with a frosty reception. Thirteen years later Lloyd George's 'People's Budget' massively increased Harcourt's death duties, and his Limehouse speech seemed to be a declaration of class war.

Harcourt's 1894 duties were only one step in a series of acts, initiated by Gladstone back in the 1880s, by which estate and legacy duties were altered, first so that settled property paid its fair share, and later, as taxation started to be differentiated for the first time, as a soft revenue target. In so far as the Inland Revenue had usually undervalued works of art when confronted with them, such increases would only bite if systems of assessment were improved. Unfortunately for the aristocrats, from 1888 onwards the Inland Revenue's Legacy Duty Office called on the services of William Michael Rossetti as art valuer. Brother of the Pre-Raphaelite artist, Rossetti was a radical republican who had sympathized with the abortive Paris Commune. He could be trusted to squeeze the rich – in 1891 he earned the Revenue an extra £7,000 just by re-valuing Sir Richard Wallace's collection.[120] Wallace was certainly not the only National Gallery Trustee to receive such treatment.

Without funds of its own, and with a Director unable to show leadership, the Gallery's acquisition policy was effectively outsourced to a new body, the National Art Collections Fund,

founded in 1903 by D. S. MacColl, Claude Phillips and Christiana Herringham. Thanks to the campaigning efforts of the NACF, the National Gallery was able to acquire Velázquez' *Rokeby Venus* for £45,000 in 1906 and (with the help of a mystery donor) Holbein's *Duchess of Milan* for £72,000 in 1909. Thus the critic who had made Poynter's life so difficult now came to the rescue of his successor. MacColl had originally intended to form a society of 'Friends of the National Gallery,' in conscious imitation of the network of rich industrialist patrons which Wilhelm von Bode used so effectively to enrich the network of Berlin museums under his control.[121] As MacColl put it later, 'I had in mind, besides the growing expense of Old Masters, the absolute blank in that collection of modern painting; Ingres, Delacroix, Millet, Daumier, Monticelli, Manet, Degas, Whistler were in my mind.'[122] Although it quickly grew to accept its role as rescuer of national treasures, originally the NACF was not just about acquiring the things institutions like the National Gallery and other institutions couldn't buy – it was also about presenting them with the things they wouldn't. This may explain why some of the organization's founders soon drifted away, or perceived its eventual focus on masterpieces as a successful hijack attempt by the Establishment. 'I don't think the Nat[ional] Art Collections Fund can do both jobs, old and new,' Herringham wrote in 1903.[123]

At the inaugural meeting of the NACF in July 1903 MacColl and Fry were clear on one thing: the new institution would not 'combine with the National Gallery to buy pictures'.[124] It wasn't clear whether they really wanted to combine with the great British public either, which could only be counted on to support the purchase of familiar masterpieces which, MacColl argued in the *Saturday Review*, were the government's bag anyway. After its successful intervention in raising money for the *Rokeby Venus* MacColl hoped that the NACF would buy Whistler's *Old Battersea Bridge* for the National Gallery. He must have known that a public appeal in favour of such a contentious work would be hopeless: the Holbein appeal had worked because it was 'safely protestant' (Holbein was also 'British') – a Botticelli would have been 'too catholic'.[125] Such frustration can only

Opposite: For Henry VIII, Holbein was useful as both a painter and a diplomat. Both roles came together in his portrait of **Christina, Duchess of Milan**, painted to help Henry decide if she was a suitable wife. This painting would have joined the exodus to America had it not been for a mystery donor who agreed at the eleventh hour to contribute the missing funds. The secret of her identity is still kept by the National Gallery, which has a sealed envelope containing her name, labelled 'To be opened by one without scruple'. Offers from several unscrupulous historians (including the author) to open it have been rebuffed.

have confirmed the millenarian in MacColl. This eschatology continued to motivate the institution he founded: an insistence that the battle for the nation's heritage was already over (bar one final push), combined with a slightly hysterical indifference to the inevitable triumph of American plutocrats. Seen from this perspective, once 'lost' from our shores works of art ceased to exist, or would, MacColl darkly hinted, disappear in a Sardanapalan bonfire at the next financial crash. An epic battle 'already half-decided,' American wealth on 'a wicked scale' – MacColl's father, a Free Church minister who had died long before, must have looked down on his son and been well pleased.

Whereas MacColl opposed the introduction of protective tariffs on the grounds that they would do little other than 'raise the fortunes of the new trust magnates,' the usual grounds of opposing restrictions on art exports lay in free trade libertarianism. This held even as foreign states banned art exports, as Italy did by its Nasi Law in 1909. The Trustees upheld the sacred rights of property in the so-called 'Curzon Report' of 1913. This summarized the deliberations of a committee of Gallery Trustees chaired by George Nathaniel Curzon, appointed by the Treasury to 'enquire into the retention of important pictures in this country and other matters connected with the national art collections'. The committee considered the idea of creating a list of works prevented from leaving the country, of funding increased museum purchase grants by the proceeds of a 10-20% duty on art exports, or from a French-style duty on all art sales. A further idea considered was the hypothecation of death duties on art, which would address the charge of Treasury hypocrisy in refusing to increase the Gallery's purchase grant at the same time as it collected large sums from assessing art for legacy and other duties.

The Curzon Committee's findings were largely against any restrictions on sale. Although it admitted that other nations had increased dealers' and museums' predations on British collections by closing their borders to exports, the Committee refused to see their actions as setting any precedent. Of course Italians had a right to protect themselves from the loss of their

Previous pages: Velázquez' **Toilet of Venus** (c. 1647-51) is called the *Rokeby Venus* after Rokeby Hall in Yorkshire, where it hung before the Gallery acquired it in 1906 for £45,000. The campaign to 'save' it for the nation was the first organized by the three-year-old National Art Collections Fund. Attacked with a hatchet by Suffragette Mary Richardson on March 10, 1914, the *Venus* survived and in September 1943 it attracted 36,826 visitors to Trafalgar Square, the highest attendance recorded for any of the 'One Picture Shows'.

art treasures, it argued, for in their case the works involved were

national in character and origin or are intimately associated with [their] history. Here, on the other hand, the great majority of our Old masters are exotic and were brought into this country by almost exactly the same means by which it is now sought to take them out. If the ancestors of a nobleman in England purchased his masterpiece abroad two centuries or less ago, it is difficult to contend that the picture has now become so English that the law can be legitimately invoked to prevent it from ever going abroad again. Further, there are conditions which would render such an invasion of the rights of ownership particularly harsh and invidious at the present time. To place upon owners the burden of very heavy taxation and then to deprive them of what are in many cases the sole means of meeting it would be almost a refinement of cruelty, and would arouse against the Government the legitimate resentment, at the very moment when it ought to conciliate the sympathy and to secure the co-operation of the class to whom these masterpieces belong.[126]

Instead of empowering the Director to place paintings on a register of protected works, the report urged that the Director contact owners before they went to market, asking them politely to grant the state first refusal. The government was urged either to increase the derisory annual purchase grant of £5,000 to at least £25,000, or to ring-fence the proceeds of estate and legacy duties levied on art for acquisitions. The idea of a one-off purchase fund of £1m was rejected. All in all, the Curzon Report did little other than provide extensive evidence of how serious the problem of art exports had become.

From the 1880s onwards the National Gallery seemed to get the worst of both worlds. It entered the market for works by British painters (including honorary Britons like Holbein and Van Dyck) just as they became fashionable with American buyers. Ironically, high prices only seemed to convince some Trustees, Rothschild in particular, that these inflated masterpieces were just what the gallery needed. Exposed to the haemorrhaging effects of this new transatlantic trade in art, those who urged limits on art exports received sententious sermons on the benefits of free trade from the same politicians

who were ditching this Gladstonian heirloom in their haste to build dreadnoughts and tariff walls. Campaigns to purchase masterpieces at risk of sale abroad, however, necessitated the use of a rhetoric of national benefits that attracted the attentions of disaffected groups. These took the Gallery as a stand-in for the Establishment; the same Establishment which had signally failed to fund or house the Gallery adequately. The attacks by Mary Richardson and other militant Suffragettes in 1914 on the *Rokeby Venus* and other National Gallery paintings represent the lowest ebb in the Gallery's history.

The Suffragettes' campaign against property had previously been aimed at the windows, horses, vehicles and country houses of political figures, rather than works of art. Delivering what he termed 'the philosophy of bomb throwing,' the Prussian mastermind of Joseph Conrad's 1912 novel *The Secret Agent* had indeed been sceptical of iconoclasm's effectiveness as a means by which to *épater les bourgeois*:

You anarchists should make it clear that you are perfectly determined to make a clean sweep of the whole social creation. But how to get that appallingly absurd notion into the heads of the middle classes...? ... Of course, there is art. A bomb in the National Gallery would make some noise. But it would not be serious enough. Art has never been their fetish... There would be some screaming of course, but from whom? Artists – art critics and such like – people of no account. Nobody minds what they say.[127]

Mary Richardson slashed Velázquez' painting seven times with a small hatchet on March 10, 1914. The Gallery was closed for a fortnight, only for another attack to occur on May 22nd, in which five Bellinis were assaulted.[128]

The attacks caused 'screaming' among more than artists and art critics. MPs and Colonel Blimpish correspondents to *The Times* demanded that the perpetrators be transported to South Africa, Western Australia, or even more unpleasant places.[129] Whereas most mainstream papers echoed such reactions, *The Suffragette* celebrated the success of the attack, and closely followed Richardson's subsequent movements in and out of prison. This ballet was choreographed by the 1913 'Cat and

As this image recording **the damage to the Rokeby Venus** in 1914 attests, Suffragette Mary Richardson was not dubbed 'Slasher Mary' for nothing. Using a small axe head secreted up her sleeve, she was able to smash the glass and then repeatedly cut the canvas. The Gallery no longer grants requests to publish images in their collection recording the damage. This image had to be created digitally, therefore, based on period news photographs – a painstaking process performed by Lars Kiel Bertelsen of Aarhus University as a 'act of art'.

Mouse Act,' by which Suffragettes on hunger strike were temporarily released until such time as they had recovered enough strength to be recommitted. In an essay entitled 'Venus, the Bishops, and a Moral,' Dr. Ethel Smyth censured the hypocrisy of those who 'whine at an attack upon the picture of a beautiful woman, while beautiful womanhood is being defaced and defiled by the economic horror of sweating and by that other horror of prostitution'. The *Rokeby Venus* would, by Richardson's attack, be 'a sign and a memorial of women's determination to be free'.[130]

The anger and disruption caused by the attacks was probably greater than that caused by any other Suffragette atrocity. The force-feedings and violence expended on militants in prison and during street demonstrations had lost much of their propaganda value by early 1914, which may explain Christabel Pankhurst's approval of Richardson's plan. Subsequent analysis of the attacks would discover evidence of proto-feminist subversion of high art and connoisseurship in Mary Richardson's actions. There is little evidence for such a theory: in her autobiography 'Slasher Mary' states that the attack represented 'my protest from the financial point of view' – an

Attacks on paintings at the
National Gallery and Royal
Academy terrified the
Trustees and led MPs to
demand exemplary
punishment of offenders
such as Mary Richardson.
Deportation to South Africa
was suggested by one MP.
Although the Trustees did
explore the possibility of
putting up glass screens in
the Gallery, the solutions
proposed by W. K. Haselden
in this 1914 cartoon were
probably seen as too extreme
to be seriously considered.

attack on property, in other words.[131] If we must find a deeper
meaning, it may be more rewarding to look, not exclusively at
Richardson's feminism, but also at her interest in Futurism.
Futurist manifestoes such as that published by Marinetti in
1909 saw the burning or bombing of art museums as a neces-
sary cleansing of the Augean Stables, whose contents were
supposedly holding art back from its destiny. Marinetti, who at

the time of the attacks was holding Futurist 'concerts of nois-es' around the corner from the Gallery in the Coliseum, can only have approved.[132]

In response to the threat of further attacks, the Gallery was closed for three months. It reopened on August 20th. Across the Channel, German forces captured Brussels. Though the Suffragettes' campaign had ended the previous week, the First World War had begun. The paintings were now at risk of attack by much more than hatchets.

Three: Opulence and Austerity, 1914-1974

In contrast to the panic induced by the Suffragette attacks on the paintings, the National Gallery faced the onset of the First World War resolutely. By October most of the important paintings had been evacuated to an Underground tunnel at Aldwych. Although half of the building would be commandeered by the Admiralty in 1915, the Trustees refused the Treasury's demand that they close entirely, citing the large number of British and Imperial servicemen who visited. They also tried to resist government attempts to use the gallery for recruitment: although they succeeded in keeping placards off the façade, they buckled under pressure to exhibit a portrait of Kitchener.[1]

The writing and publication of his report into the loss of the nation's art treasures abroad had done nothing to dim Curzon's enthusiasm for Gallery work. Whereas the pre-War interventions of Alfred de Rothschild and Lord Lansdowne had sometimes seemed to bring Gallery business to a standstill, Curzon's activity as Trustee was more positive. The former viceroy's eye for detail and inability to delegate could make him a difficult colleague, however. The Director, Charles Holroyd, was hardly in a position to stand up to him. The outbreak of war found him in even worse physical and mental shape then ever, imploring the Trustees to sanction the removal of the paintings to the country, so that 'if London is taken... I should not have to tell lies about them, even to Germans.'[2]

Curzon was effectively running the Gallery, aided by another new Trustee, Robert Witt, a successful solicitor who had published a guide to picture appreciation in 1902 and helped establish the NACF the following year. The lengthy interregnum after Poynter and Holroyd's unhappy tenures convinced the Trustees that they should be in charge, not critics or 'experts'. Experts might be useful for identifying and filling gaps in the collection's holdings of secondary works. But it was felt that the Gallery needed to focus on acquiring a limited number of

Opposite: Vincent Van Gogh's **Chair** of 1888 is just one of a group of French masterpieces acquired by a special fund established in 1924 by Samuel Courtauld. Other Courtauld Fund works include Van Gogh's *Sunflowers* and Degas' *Young Spartans Exercising*. The Fund was set up in such a way as to ensure that the Trustees had little or no influence on which particular works were acquired – which was probably just as well, seeing how the Board had treated Hugh Lane when he generously offered his collection of similar masters a decade before.

Stymied in his political pro-
jects, notably that of reform-
ing the House of Lords, the
former Viceroy of India
George Nathaniel Curzon
found a partial release for his
administrative appetite in
running the National Gallery
and organizing the 1913
Curzon committee on art
exports. In meetings with
staff Curzon was, as the
Keeper Charles Collins Baker
noted, 'almost invariably
the Pro- Consul addressing
servants: intolerably and
contemptuously.'

universally recognized masterpieces, a belief fuelled by a series
of headline-grabbing sales of famous works from British collec-
tions to American collectors. Hence the Trustees had kept the
whole thorny question of Board/Director relations out of the
Curzon Report. Dysfunctional though it was, they were happy
with the status quo. One even compared it to the British consti-
tution: 'a sort of balance of three minds – a powerless Director,
a council, and the Treasury behind holding the purse strings'.[3]
In 1916 the Trustees attempted a sort of *coup d'état* by lining up
Witt for the Directorship.

In a surprising twist that is difficult to explain, Witt and the
Trustees were outsmarted in the summer of 1916: instead of by
Witt the post was filled by the painter and National Portrait
Gallery Director Charles Holmes, who leveraged his excellent
contacts at the Treasury. He succeeded in having the
Directorship made into a Civil Service post, which strength-
ened the incumbent's position, and in having the Trustees'
term of office restricted by Treasury minute to seven years,
rather than life.[4] Although he had been discreet about his can-
didature, Robert Witt was highly disappointed not to have been
chosen.[5] Holmes marked a definite turning point in the run of
National Gallery Directors: the last practising painter, he was
also the first Director with prior experience of museum admin-
istration.

Holmes was also a publicist: the first Director to publish a
celebration of trout fishing, as well as his memoirs. Although
he was close to Fry, Ricketts and other progressive artists of the
Cézanne-revering sort whom the Trustees reviled, Holmes'
tastes were catholic. The author of the first monograph on
Hokusai to be published in English (1899), Holmes suggested
that oriental art should be included in the National Gallery,
owing to its present and future influence on British artists.[6]
Perhaps worryingly, he never seems to have argued with his
Trustees over acquisitions – only over cleaning and hanging,
which he held to be the sole preserve and responsibility of the
Director. Holmes was able to expand into a new suite of six
rooms opened in 1917 – a much more restrained reflection in
the west wing of the Barry Rooms in the east.

Dubbed 'the Cockney Gent' by the great art expert Bernard Berenson, **Charles Holmes** was certainly different from the eminently forgettable Directors who served immediately before and after him. Although he did paint and exhibit occasionally, Holmes had entered the art world late, having earlier worked in publishing. A keen amateur fisherman and boxer, he knew when to play the Trustees and when to jab.

Holmes also set up a Reference Section on the ground floor in which less important paintings could be stored, while remaining accessible to scholars. For the most part, however, he stuck to the cluttered frame-to-frame hang in the main galleries. Holmes reputedly possessed an uncanny ability to identify which of the paintings from the Reference Section would fit any space that opened up, no matter how small or close to the floor. The art expert Bernard Berenson complained in a letter to his American patroness that 'the cockney gent who now misdirects the National Gallery has had the truly original idea of hanging pictures so low that to see them you have to lie flat on your belly.' 'It gives me a tummy ache,' he added.[7]

The arrival on the Board of Witt and the 27th Earl of Crawford tightened the bond between the Gallery and the National Art Collections Fund (NACF) they had helped to establish in 1903. This relationship would remain close for the next fifty years at least. As we shall see, overlapping membership of both boards enabled certain forceful Trustees, notably Witt and Arthur Lee, to play one institution off against the other – to capitalize on the institutions' natural desire to work in tandem. Wartime taxation and the death of countless heirs had increased the pressure on landed owners to liquidate their art treasures. In 1910 legislation had passed allowing objects to be accepted in lieu of estate duty. Crucially, however, the same legislation did not provide a fund from which to recompense the Revenue for the foregone tax – and so it could not be used until the establishment of the National Land Fund in 1946. In 1919 the Trustees came up with the idea of a 1 or 2% stamp duty on all art sales, hypothecated to a special purchase fund. The Chancellor, Horne, rejected the plan when it was put to him in 1921, however.[8] As for the annual purchase grant, it was still only seven thousand pounds. Even after singing the Gallery's praises at its centenary in 1924, however, Prime Minister Ramsay MacDonald refused to improve its financial situation.[9]

Yet these were years in which sale rumours hovered around the country's most important art treasures. The Gallery and government were so convinced that the Earl of Pembroke's *Wilton Diptych* was about to be sold that a special grant was

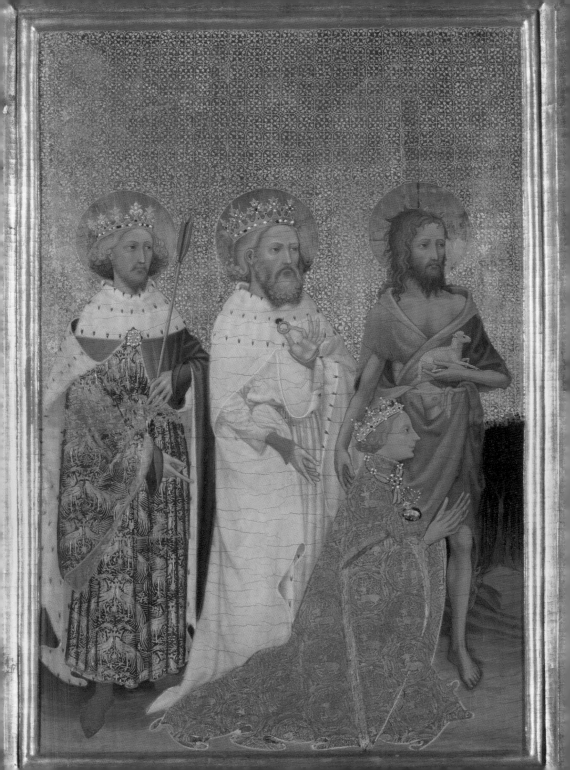

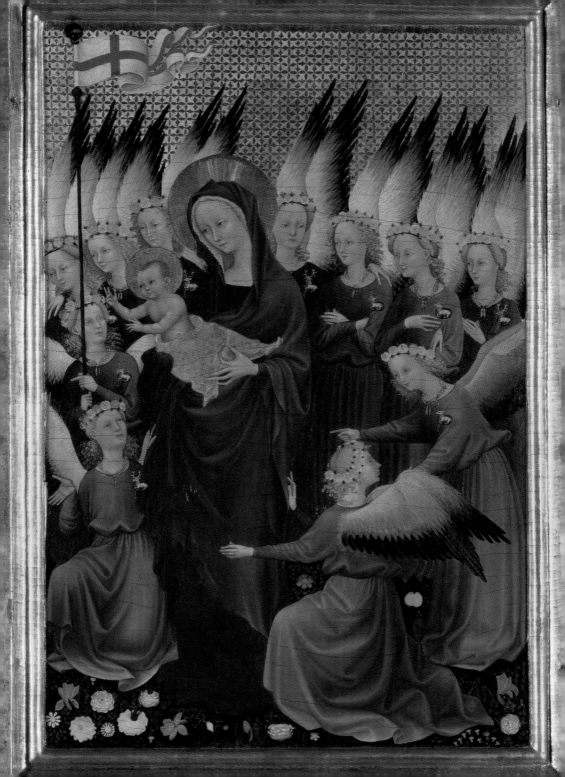

made in 1918. The sale did not in fact occur until 1929. But the greatest fear was that the Bridgewater Titians (a set of six allegorical paintings) might go. Here again, the sale did not occur until later, the Gallery acquiring *The Death of Actaeon* in 1972. Such threats made the sale of 'redundant' Gallery paintings to raise funds for acquisitions of allegedly more valuable works seem a necessary evil. Special government grants or public appeals were impossible in wartime. Curzon and the Trustees therefore prepared two versions of a National Gallery Sale Bill in 1916.[10]

Their natural concern was that such an action would discourage donors and testators from giving works which might be sold. The version of the bill which would have facilitated the sale of some of the Turners bequeathed by the artist in 1857 was dropped. It was determined that some Turners could nevertheless be sold by designating them as 'unfinished' – 'unfinished' canvasses not having been mentioned in the artist's will. Instead Curzon settled on that version which would allow only the sale of works bought with government funds. The main target was the Peel Collection of Dutch works: Cuyps, Ruisdaels, Rembrandt's *Philips Lucasz.* and Rubens' *Drunken Silenus*. In order to avoid the painful publicity of a public sale, Curzon proposed a complex scheme of dubious legality by which a syndicate of dealers would agree not to bid for two of the Bridgewater Titians (thus keeping the price low for the Gallery) in return for unimpeded access to the others as well as the pick of the Gallery's unwanted pictures.[11]

Although Prime Minister Asquith had doubts, the bill was introduced in the Lords by Trustee Viscount D'Abernon in November, in what was his maiden speech. The bill progressed well, despite some opposition. This was largely thanks to Lansdowne playing on their Lordships' fears. Ever since the first abortive attempts to protect national monuments through legislation (back in the 1870s) large landowners had feared that heritage might be used as an excuse for placing statutory restrictions on their power to sell their own paintings and other property of historic interest. Now Lansdowne reassured them that it would not be necessary for government to take that

Previous pages: The Gallery finally acquired the 14th-century **Wilton Diptych** from the Earl of Pembroke in 1929 after several false alarms. Rumours of impending sale had started in 1914, when Trustee Robert Benson noted that 'the Wilton Diptych is perhaps the most important picture to the Nation in private hands.' The painting was acquired with the help of several wealthy businessmen, including Samuel Courtauld and the press baron Viscount Rothermere.

In 1921 the Duke of Westminster sold Gainsborough's portrait of Jonathan Buttall (c. 1770) to Samuel F. Huntington of San Marino, California for a staggering £148,000, roughly equivalent to £3m today. As with Rembrandt's *The Mill*, the **Blue Boy** was given a farewell exhibition at the National Gallery, whose Director Charles Holmes was moved to scrawl 'Au Revoir' on the back. Cole Porter was moved to write a song, 'Blue Boy Blues' lamenting its fate.

power, provided they allowed the Sale bill to pass.[12] It did pass the Lords, but went no further. Although Lewis Harcourt had been contacted about introducing it in the Commons, the bill never made it, both because it was felt it would never pass and because the Bridgewater Sale failed to materialize. There was no lack of nerve on the part of the Trustees or Charles Holmes, who felt it to be 'a desperate, but fully considered effort to avert an imminent catastrophe'.[13]

The idea of a sale bill continued to circulate for a number of years afterwards – a telling witness to the power of the dealers and of the Gallery's NACF-fuelled 'rescue' agenda. The sale bill, the 1922 exhibition of Duveen's greatest prize – Gainsborough's *Blue Boy* – in the National Gallery and Duveen's appointment as a Trustee in 1929 indicate the extent to which each fed off the other. Dealers earned profits and the NACF earned contributions the same way: by insisting that there were only a limited number of art treasures remaining in the country, and that no price was too high to secure them. In other words, both clung to a mercantilist understanding of artistic greatness with the same fierceness with which the Bank of England clung to the Gold Standard. Both camps reacted nervously to the popularity of Impressionist works, which seemed to propose an alternative aesthetic currency.

The symbiotic relationship between dealer and patriotic connoisseur had been keenly observed by Henry James in his 1911 novel on the subject, *The Outcry*, which ends happily when its aristocratic owner is harried into donating a rediscovered masterpiece to the National Gallery.[14] Great art was a scarce resource, and sales were gambits in a zero-sum game that was fast running out of pieces. By 1922 a Trustee was even arguing that there were only ten outstanding works of art left in private hands.[15] While some owners, like the Duke of Northumberland, argued that sales were aiding the British economy by injecting American dollars, others argued that both they and the dealers were as much war profiteers as those who dealt in eggs or sugar.[16]

As if that wasn't enough, several of these 'profiteers' were offering to provide the funds needed to save the Bridgewater

Titians and other works in return for peerages. National
Gallery paintings were undoubtedly a more worthy beneficiary
of such bribes than Lloyd George, who famously employed an
agent to raise an estimated £1-6m for his own political war-
chest by hawking baronetcies door-to-door. Although donors
like Tate had been honoured before, this had always been a
pleasant surprise. From 1916 to the mid-1920s the correspon-
dence of Gallery Trustees and staff is full of chatter about who
might be interested. Although several candidates are not iden-
tifiable, Van den Bergh (margarine), Sir John Ellerman (ship-
ping), and Edmund Davis (mining) do appear.[17] Davis even
promised to bequeath his entire collection in return for a
knighthood.

'Save the Old Masters from their friends'

Profiteers and peerage-hunters thus joined lazy aristocrats in
the rogues' gallery of figures identified with the National Gallery
between 1914 and the outbreak of the Second World War. The
anti-semitism fashionable in the period made the 'Jew dealer' a
particularly powerful bogeyman. Some, notably the Bloomsbury
art critic Clive Bell, felt that with friends like these, the National
Gallery had no need of enemies. 'Save the Old Masters from their
friends' ran the title of Bell's 1922 *Vanity Fair* article on the
Gallery. Bell argued that what he called the 'treasurers' of art
had incapacitated and incarcerated art in a frame of vulgar
High Society gilt. For them 'a picture is an asset, a national asset
or a private, something that redounds to the credit of a nation or
raises the social prestige of an individual... something to pos-
sess, not something to enjoy.'[18] Bell's comment reflects the
ambiguous position of those professional curators, writers and
others who depended on museums and journalism for their
livelihoods. The publicity of heritage campaigns seemed to offer
them a broader middle-class audience that would (unlike the
great noble collectors and dealers) acknowledge their consider-
able expertise. Yet in so far as such campaigns focussed on estab-
lished Old Masters this audience seemed deaf to their attempts
to include new artists in the canon.

Holmes compared the dashing Trustee and Minister for Air **Philip Sassoon** to 'the hero in a novel by Disraeli: young, rich and clever'. As Chairman he invited Trustees to meet at his London residence before meetings, where they lunched off gold plates. He also held a series of important temporary exhibitions there, exhibitions which, like his country house at Port Lympne, Kent were thronged with the very best inter-war society had to offer.

But did the idea of returning great art to the people offer any viable alternative? In the wake of the massive post-war franchise extension trustees recognized the need to argue publicly that state expenditure on rescuing paintings benefitted the whole nation, 'especially the poorer sections of the community who suffer most [from heritage loss]'. Philip Sassoon's 1922 speech to the Commons continued:

The trustees are not particularly concerned with the owners of these works that they have in mind. They are not the people whom they wish to protect. It is the general public, the man and woman in the street, who have no other power of gratifying their taste for art except by visiting our museums and national galleries, whose interests they wish to protect before it is too late. The principle is already established. The nation has in the past made very considerable grants for the purpose of acquiring art collections.

In private, however, they recognized that such rhetoric belonged to the past. Curzon argued in favour of a quasi-chivalric, royal-sponsored society of 'friends of art' (complete

with decorations). This was necessary because the government could not be expected to continue to give special grants of the sort Sassoon advocated:

As the great masterpieces rise in value and as the House of Commons becomes more democratic, so will it be increasingly difficult to obtain the consent of the representatives of the working classes to an expenditure, which some of them will be found to denounce as an abuse of the funds of the taxpayer, and as of interest only to a small section of the population of London.[19]

Such concerns discouraged the acquisition by the Gallery of anything outside the recognized canon. The dealer Hugh Lane's offer to lend his collection of nineteenth-century French works by Monet, Renoir and others had been eagerly accepted by Holroyd in 1906. In place of thanks Holroyd was soundly rebuked by the Trustees, who believed that he had been duped into allowing Lane to use the Gallery as a showroom for his dubious wares.[20] And there was no doubt in the minds of trustees such as Rothschild and his ally Lord Redesdale that they were shoddy ones. 'I should as soon expect to hear of a Mormon service being conducted in St. Paul's Cathedral,' the latter wrote, 'as to see an exhibition of the works of the modern French Art-rebels in the sacred precincts of Trafalgar Square.'[21]

When they did go on show – in the Tate – the ebullient Margot Asquith went to see them with yet another Trustee, R. H. Benson: 'we met Ld Lansdowne and Ld Redesdale,' she breathlessly wrote Curzon, 'We had great fun! I think the pictures grotesque but of course this is for all of you to judge I only wondered if you realized that Lane tho' a real artist and a fine judge is an astute dealer.'[22] The debate over the relationship of what was called 'modern French' art to the older works displayed in the National Gallery is discussed more fully in chapter five. What should be stressed here is the extent to which the Impressionist school was believed to be 'a ramp' set up by speculators.[23] The industrialist and collector Samuel Courtauld held other views, and in 1923 gave the Gallery a £50,000 fund to spend on acquiring examples of these maligned artists' works. At the same time he realized that such a fund would only work

Opposite: Trustee Alfred de Rothschild protested that Renoir's **The Umbrellas** (c. 1881-6) and the other Impressionist works collected by the dealer and connoisseur Hugh Lane 'would disgrace the one-armed man who chalks on the flagstones of the streets'. He and several others on the Board misinterpreted Lane's generosity in first loaning and then bequeathing the collection to the Gallery as an attempt by a wily dealer to storm the citadel of high art. Impressionism was a fad got up by dealers, and they weren't about to let the Gallery's standard slide. Fortunately they were overruled.

if the Trustees were kept off the special board charged with deciding what to buy. It took seven years and several governments to pass before Courtauld was made a Trustee, however, and the Gallery's lukewarm response towards Courtauld-funded aquisitions like Van Gogh's *Chair* may well have lost it the bequest of the great paintings in his own collection (now the Samuel Courtauld Trust, Courtauld Institute Gallery).[24]

The Trustees had done their level best to snub Lane, too, rejecting his offers to loan his 39 paintings in 1907 and 1914. When he went down with the *Lusitania* in 1915, however, it was discovered that he had bequeathed his collection to the National Gallery, or, should it fail to construct a suitable gallery within a certain space of time, the City of Dublin. As Joseph Duveen offered to fund a 'modern foreign' gallery behind the Tate in 1916, however, Dublin's chances seemed slim.[25] Unfortunately there was also a later codicil which Lane had signed, but, crucially, not witnessed. This left the collection to Dublin, and both Lane's relations and Irish MPs insisted that it should be honoured. 'The Board was so much against the pictures,' Holroyd wrote to Curzon shortly after Lane's death, 'that I presume they will hand them over to Dublin with pleasure.'[26]

Instead the Trustees dug in their heels, beginning what would become their longest-running dispute over a bequest. The quarrel quickly became political: by refusing to cede the pictures to Ireland the British government was accused of adding yet another insult to the injuries she had inflicted on that unhappy island. Demands for repatriation of artefacts to Ireland had already embroiled the British Museum in a legal tussle over the Broighter Hoard, discovered in County Derry in 1896. There was an ongoing dispute with the Italian authorities over paintings from the Layard Bequest left in the collector's Italian villa, tighter export restrictions having been imposed in 1909.[27] The 1911 Mond Bequest (43 paintings) was the focus of another dispute with the chemical magnate's son, the Liberal MP Alfred Mond. Although Curzon and the Trustees came to an agreement regarding the Mond Bequest on their own, the government settled the Layard dispute, on terms which the Trustees

Opposite: Lucas Cranach's **The Close of the Silver Age** | (c. 1527-1535).was part of the bequest of chemicals magnate Ludwig Mond (1840-1909). With a large fortune and the guidance of fellow German J. P. Richter, Mond and his deep purse had been perceived during his lifetime as a threat rather than an opportunity. His generous offer to lend his Raphael *Crucifixion* in 1893 was refused.

found distasteful.[28] The Trustees took their duty to cling on to every disputed painting seriously, and feared – justifiably – that the government could force them into ceding the Lane Bequest to the newly established state of Ireland as a political gesture. Such tenacity was further driven by an awareness that the age of such great bequests was over – as indeed it was. A final settlement to the Lane dispute was reached in the 1950s.[29]

The Gallery's troubled relationship with Lane and the bequest pointed up the challenge of finding Trustees sympathetic to both the Old Masters of Trafalgar Square and the more modern works housed in their annexe – the Tate, or to give it its official title, the National Gallery of British Art, Millbank. With the establishment in 1917 of a separate board for the Tate, the Gallery trustees took a crucial first step towards the separation of the two institutions. The history of the Tate will be considered here in the context of the negotiations over the division of paintings between Trafalgar Square and Millbank.

By their opposition to any such accommodation with 'modern French' art Alfred de Rothschild and Lord Redesdale made the Gallery Board a stand-in for the 'barbarian' Establishment, and their fulminations against Cézanne fed a certain smugness among the Bloomsbury Group. John Maynard Keynes' breathless account to Vanessa Bell and Duncan Grant of how he single-handedly wangled the Treasury into granting £20,000 for purchases at the 1918 Degas Sale in Paris was typical. His role in the Sale reassured his pacifist friends that his government work was not the sell-out they claimed it to be.[30] It wasn't the full story, however. Curzon and Charles Holmes are owed equal credit for the plan, and the latter's choices (much maligned by Keynes and Bell) are worth re-evaluating.

More broadly, such incidents draw attention to the curiously one-sided approach of Roger Fry and Bloomsbury to the question of how the Gallery could be made more accessible. In focusing so intensely on getting unrepresented artists into the Gallery, they lost sight of the more important goal of getting unrepresented classes in as well. In their elitism, Bloomsbury spokesmen like Clive Bell joined Curzon in seeing the advance of mass democracy as detrimental to the cause of great art, as a

threat, rather than an opportunity. In concluding that great art required an enslaved underclass, however, Bell went much further.[31]

In marked contrast to the mid nineteenth-century consensus, free admission was no longer seen as much of a shibboleth. Starting in 1880 a charge of sixpence had been levied on those wishing to visit on Artist's Days, when the Gallery was less crowded. In 1922 the Trustees doubled the number of paying days to four to help raise funds for acquisitions. As Coalition Chancellor in 1919 Austen Chamberlain had been eager to revive his earlier idea that the Gallery's purchase grant be supplemented by a hypothecated export duty of 20%, owners being compensated for this restriction by the exemption of their masterpieces from assessment for death duties. The Trustees had stated a preference for an auction tax, but then changed their minds. Finally they accepted the Treasury's offer to remit them the proceeds of extra paying days. These two extra days dispensed with the 'artist' label, which had in any case long since worn thin: the artists who did use the Gallery regularly were professional copyists, not the Rembrandts of tomorrow.

Meanwhile willingness to increase paying days seemed to pay off at the Treasury. At the same time as they accepted the paying days idea the Trustees had shown the Treasury a list of paintings of national importance which they felt had to be guaranteed against sale abroad. This was the first of what would be a series of 'Paramount Lists,' over whose contents the Gallery and Trustees would wrestle for the next fifty years. Paramount Lists were schedules of specific paintings of heritage value which the Treasury had supposedly promised to purchase if they were ever threatened with export. The idea of such a list was to some extent a development of the list of 'missing' artists Prince Albert had instructed Eastlake to prepare in 1853 – except that the lists targeted specific paintings rather than artists and focussed exclusively on paintings already in Britain.

The NACF had first formulated such lists in 1909, and the 1913 Curzon Report included similar ones (prepared by

Trustees Herbert Cook and R. H. Benson) in an appendix. After the first Treasury commitment in June 1922, further lists were negotiated in 1927 and 1930. The Treasury's undertaking with respect to these ten-strong Paramount Lists was valued at £780,000. In order to establish this arrangement as a long-term commitment, however, parliamentary approval was needed. The Treasury told the Trustees on October 23, 1922 that they were prepared to propose a vote establishing a National Purchase Fund which could be drawn on for the purpose of acquiring these named works.[32] This would have set down both the Gallery's targets and the Treasury's financial commitment in a straightforward fashion, and prevented much of the subsequent ill-feeling caused by attempts (on both sides) to redefine both. That very day the Coalition government fell.

The new Conservative government of Bonar Law instituted a government economy drive as a sop to Viscount Rothermere's 'Anti-Waste' campaign, which had fuelled middle-class concerns at what they considered excessive taxation. The Geddes Committee on national expenditure was given the task of balancing such concerns with the fear that a Labour government in waiting would see any serious welfare cuts as justifying a 'socialist' capital levy.[33] In their third interim report the Committee praised the Gallery's doubling of fee-paying days, and concluded that all national museums should charge fees on weekdays.[34]

Muirhead Bone argued in the *Burlington Magazine* that the paying days 'formed part of a definite Treasury plan to make all the National Museums and Galleries earn part of their grants' – by threatening to remove the grants entirely in cases of non-compliance.[35] In reality, the Gallery had volunteered to double paying days, seeing acquisitions as more important than access. It was a dress rehearsal for the position they took in the 1970s, against the backdrop of much fiercer public debate. Unwittingly they thereby led first Geddes and then the Chancellor of the Exchequer Stanley Baldwin to urge charging across the board. A clause enabling the British Museum and its dependent institutions (including the Natural History Museum) to charge for admission was added to a Fees

Previous pages:
Desperate to raise funds to secure the Bridgewater Titians from sale abroad in 1916, the Gallery framed a sale bill that would allow them to sell works off. The First World War was raging, so the government could not be expected to help. Selling works seemed the only way out, and the sale of unwanted pictures from the Krüger Collection in 1857 provided a precedent of sorts. 'Superfluous' Dutch works such as David Teniers the Younger's **Rich man being led to hell** (c. 1647) were the favoured targets for sale. As the Acting Director noted at the time, 'pictures are only great pictures for so long as their reputation endures.'

(Increase) Bill in 1923. The clause was eventually removed in the face of protests. During the debate Ramsay MacDonald had argued that 'the Government cannot economise by shutting off the treasures of the nation and allowing them to be enjoyed only by a small class of the nation'. This comment from the Leader of the Opposition did little to enliven a debate that was remarkably low-key compared to Victorian trumpeting of free access as a shared right or a means to social harmony. The Gallery cut the two extra days from April 1924. It insisted, however, on keeping the remaining two days even after the Tate opted to abolish all paying days the following year.[36]

The failure of Baldwin's bill notwithstanding, the question of admission charges was made the topic of a Royal Commission on National Museums and Galleries appointed in 1927 under the chairmanship of D'Abernon – the first parliamentary investigation into museum policy in more than sixty years. This was appointed to consider whether charging could be introduced without affecting these institutions' educational mission, as well as to consider ways of handling the conditions linked to bequests. Its interim report began by staking a firm claim to greater state expenditure: the national museums and galleries 'began by being the first educational institutions which the Government thought proper to assist,' it noted. 'They are now the last.' For the most part, however, it was intended to remind the public how much these great collections owed to private donations – in the hope of encouraging more.[37]

Where Gustav Waagen and other German museum directors had previously been consulted about best practice, now the Director of New York's Metropolitan Museum, Edward Robinson, was called. From a shaky start back in 1872 the Met had started attracting large donations of art and cash from wealthy Manhattanites in the 1880s. In the following forty years it expanded at the rate of one new wing every decade. From the start benefactors had been encouraged by means of a 'Fellows' or 'Friends' system, which rewarded them (depending on their level of generosity) with one of a number of carefully ranked titles. Apart from an annual municipal grant covering

maintenance and some building costs, it received no government funds. By 1927 it nonetheless enjoyed a $1m budget and a staff of 500. It charged 25¢ two days a week, and put on free concerts and lectures. It also had the power to lend abroad and sell. Its expert staff were called 'curators,' a title unknown at Trafalgar Square (although the warders had been called 'curators' in the previous century). In 1925 the Met appointed its first female curator. The National Gallery's first came in 1979.[38]

Of course, comparing the Metropolitan and the National Gallery is not strictly speaking fair, as the former collected Greek, Roman, Egyptian and Asian sculpture and artefacts as well as European paintings. The Museum of Fine Arts Boston, the institution founded in 1876 and endowed by the collector Isabella Stewart Gardner (under Berenson's tutelage) was a closer match. The separation of display and 'reference' or study collections it pioneered was also cited as a model of best practice by the Royal Commission. The 'Boston system' allowed masterpieces space to breathe in the public galleries, with lesser works being stored compactly in a facility accessible to scholars. Holmes' creation of a 'Reference Section' in 1917 had done little to relieve overcrowding. Ten years later the National Gallery was still showing one hundred paintings in a single room.[39]

The Commission thus served to point out ways in which British museums needed to play catch up not only in financial terms, but also in their technical, educational and administrative operations. Several of its recommendations – evening opening, cheap guides, lectures and tea-rooms – were similar to ones made by Cole or even the great 1853 select committee. Yet the target audience had changed. Rather than Ruskin's 'happier carpenter,' the needs that were to be fulfilled were those 'of the business man, and now of the business woman'.[40] Even though the decline of Sabbatarianism made it a possibility for the first time, extending weekend opening further (to include Sundays) was not felt to be worthwhile: the target audience went home to the suburbs at the weekends. The Commission did, however, roundly reject admission charges. It also considered the idea of an arts minister.

In this scene from the 1920s the Gallery lecturer **Stewart Dick** discusses a painting suspended a couple of feet off the floor. Even after several extensions and the creation of a 'Reference Section' Holmes still hung works frame-to-frame.

Calls for a Minister for the Arts had a history stretching back almost a century, to Charles Long's 1825 appeal that he be appointed 'dictator' of state arts policy. The mushrooming of new departments under Lloyd George during the war had made this seem more than a possibility.[41] In 1902 a Board of Education had been established, and the eponymous author of the great 1918 Fisher Education Act had been eager to bring the National Gallery and similar institutions under its control. This the Commission rejected. It would 'inevitably tend in the direction of the Continental system of bureaucratic control – unsuited, as we think, to the national character...' Muddling through, as the *Times* noted cheerfully in a leading article, was the British way. The Royal Commission did recommend the establishment of a standing committee that could advise government on the relative needs of national and regional museums. A permanent Museum and Galleries Commission was duly set up in 1930.[42]

The 1927 Commission was an enthusiastic advocate of the 'kinetic' use of resources, intended to compensate for the his-

torically contingent allocation of fine art resources by loans and special exhibitions.[43] Whereas the National Gallery had been circulating block loans of British paintings to provincial galleries since the 1880s, it did not lend foreign works and had no powers to lend abroad. The late 1920s saw London (notably the Royal Academy) play host to a series of large international loan exhibitions, however, and the Gallery's refusal to reciprocate was conspicuous by the time of the 1930 Italian exhibition held at Burlington House. From 1929 Ramsay MacDonald began pressuring Trustees to agree to a National Gallery Loan bill. Although they rejected the idea twice in two years, a third vote in July 1930 left the Board hung: five for, five against.[44] The Trustees moved their argument elsewhere: when Ormsby-Gore, a Trustee and member of Cabinet, introduced a bill in the Lords in 1931, fellow Trustee Crawford opposed it. After a lull MacDonald tried again in February 1934. Another parliamentary debate saw the bill pass in April 1935, albeit with a wrecking amendment restricting it to British works painted after 1600.[45]

MacDonald's push for a loan bill was a result of diplomatic pressure from Mussolini, Stresemann, the Dominions and his own Foreign Office. All saw travelling temporary exhibitions as having great potential to promote international understanding. In the world of British politics their appeal was the same, whether one's vision of a 'new world order' was stolidly empire-focussed (as with Beaverbrook's 'Imperial Preference Campaign') or extended to the artificially sweetened League of Nations. The Italian Exhibition had been excellent propaganda for Mussolini, and Trustee squabbling over whether to lend the Titian *Vendramin Family* (it went) could appear embarrassingly hide-bound. Movement and exchange, the kinetic use of resources, held the key to world peace. 'Shuttle diplomacy' did not seem to have done the dashingly handsome Foreign Secretary Anthony Eden any harm. How could it be harmful to the *Rokeby Venus?*

Opponents of international loans such as Crawford argued that it was not worthwhile putting valuable Old Masters at risk of damage in transit or in one of the Continental museum

Previous pages: The greatest of the large international loan exhibitions, the Italian Exhibition held at Burlington House in 1930, was also the most notorious, both for the risks taken transporting paintings and for enabling Mussolini's Fascist regime to launder its reputation in the wake of the invasion of Ethiopia. The decision whether to lend this recently-acquired Titian of **The Vendramin Family** (1540s) to the show was controversial. The 27th Earl of Crawford was in no doubt: 'Frankly and without any disguise I stand for Britain first, and I regret that we should denude ourselves in order to boost a movement which is political in its fundamentals.'

David Lindsay was just one of a long line of Earls of Crawford conspicuous for their importance as collectors and as supporters of British art museums. Like his son (also David) the 28th Earl, Lindsay was a keen observer of the political and social scene, even as death duties and waning political influence obliged him, as it did so many other aristocrats, to sell cherished collections of books and paintings.

'death-traps'.[46] He was not blind to the great opportunities such shows gave scholars to study original works side-by-side. A Renaissance scholar in his own right, Crawford was able to appreciate their value. He suspected, however, that their diplomatic value had led officials to ignore evidence that international travel harmed paintings. The apparent enthusiasm with which the Dutch and Italians lent their best works to London should not, he argued, be taken as imposing a reciprocal obligation. Works lent to London and other European capitals had indeed been damaged. The political value of 'exhibition diplomacy' had weighed so heavily with curators' political masters that this had been hushed up. To Crawford the pressure placed on the Gallery's Trustees both to accede to Irish claims on the Lane Bequest and to pass the National Gallery Loan Bill was ominous. Appointed Trustees were being urged to compromise their duty to protect the public's pictures by elected politicians who had no such formal responsibilities.

The loan question contributed to a crisis in the internal relations of the Gallery which had been building since the 1894 Rosebery Minute. Broadly speaking, this dispute surrounded questions of expertise, of whether the critic and curator's knowledge of 'art history' (the phrase was a novelty) should trump the Trustees' less formal connoisseurship. Chapter five will return to this story in greater detail. Although Holmes had been strong enough to fight the Board to a standstill for a few years in the 1920s, by 1932 a disputed Chairman election caused the simmering pot to boil over. A Trustee (Ormsby Gore) and the Keeper (Collins Baker) resigned, the King's name was drawn into the dispute, and the Treasury decided to impose its own 'watchdog' Trustee on the board to keep the peace. The press lapped it up.

Dealing with Joe

One idea the Prime Minister proposed to solve the crisis was to create 'a more democratic board' by appointing non-aristocrats as Trustees. In reality, however, that decision had already been made, and the 'commoner' Trustees appointed in the previous

Arthur Lee (left) had a colourful career in the army, in diplomacy and in politics before he married money and settled down to a life of collecting art and running Royal Commissions. Childhood neglect and other issues related to his marriage made him a rude and at times hysterical Trustee, so hungry was he to have his connoisseurship and his 'discoveries' validated.
Augustus Daniel (right) was a pliable former Trustee Lee installed as Director in 1929. A nonentity, this is the only image that survives of him.

decade had been among the greatest trouble makers. Chief of these was Arthur Lee, a self-made adventurer who had married money and served as one of Lloyd George's more toadying ministerial acolytes in the war. Betrayed by the Welsh Wizard, in the 1920s Lee kept himself busy working on government commissions, collecting paintings, and advancing pet projects such as the institution now known as the Courtauld Institute. His bullying of the Keeper C. H. Collins Baker caused the 1932 scandal and his years as Trustee (1926-1933) coincide neatly with the period of greatest Gallery in-fighting. This period also included the unhappy Directorship of Augustus Daniel, a self-effacing non entity who had served as Trustee since 1925 – long enough for colleagues to realize that, if they made him Director instead of an 'expert,' they could do pretty much whatever they pleased. Appointed Director in 1929, Daniel did next to nothing for two years, but by 1931 had switched sides and become a thorn in the Trustees' side, if a very small one.[47]

Another layman added to the board was none other than Joe Duveen, the world-famous art dealer. In terms of collecting, the late 1920s and 1930s are best understood as the age of Duveen. Starting in 1917 Duveen had masterminded the family firm's first nervous steps into picture-dealing. It took patience, credit and judgment to groom prospective American clients, gently weaning them off Victorian furniture and Barbizon paintings and introducing them to European aristocracy and the treasures they had, until recently, owned. In the face of Duveen's masterful charm, hard-nosed bankers, property developers and war profiteers became dizzy: unclear in their minds whether Joe was a friend who also happened to deal in art or vice versa. Joe had an extensive payroll of spies, 'restorers' and scholars, notably Bernard Berenson, who ensured he always knew where his next clients and next purchases were.

Thanks to their help Duveen Brothers was instrumental in the export of many of the greatest paintings 'lost' in this period to American plutocrats such as Samuel H. Kress, Henry E. Huntington, Milton Kress and P. A. B. Widener. While real output remained depressed by the government's stubborn focus on

'Duveen was regal,' Clark observed of the infamous dealer **Joseph Duveen**. Duveen made fabulous profits selling art and furniture from British aristocratic collections to American plutocrats, driving prices up against British galleries and museums – who nonetheless appointed him to their boards. This in turn gave Duveen access to privileged information and lent him cachet stateside. As Clark put it, 'in London he might be a clown; in New York he was a king.'

the return to gold, Duveen's boundless optimism epitomized the sleek, increasingly cartelized (if not monopolized) world of inter-war enterprise. As with the bullish stock market, nobody knew or cared how Duveen got away with his huge markups. This man, Joe Duveen, was made a Trustee of the National Gallery in 1929. It was a landmark decision, hotly contested, and still controversial eight years later, when he unsuccessfully sought a second term.[48]

Equally colourful characters now entered through the breach. The following year the Prince of Wales arrived on the Board: a dandy with an almost total ignorance of art, one almost wonders if he was appointed to keep him out of trouble for a few hours a month.[49] In 1932 came the socialite and biographer Evan Charteris, followed in 1935 by Anthony Eden. Carry over Philip Sassoon, the fabulously wealthy socialite and evanescent Minister for Air, who had been appointed back in 1921, and one can safely say that the Board as constituted in 1932 was the most socially glittering collection ever seen in Trafalgar Square. Unlike the boards of the British Museum or similar institutions, membership had become a highly coveted badge of acceptance on society's 'A' list. It was the ultimate realisation of that over-egged, heavily ormulu'd model of Trusteeship pioneered by Alfred de Rothschild, whose pompous memoranda, telegrams and board-room put-downs had first humbled Poynter in the 1890s. To aristocrats intent on public service, notably Crawford's son Lord Balniel (appointed 1935) these people could be downright embarrassing – but fascinating, too, and such good company.

Those in the know – and both the 27th Earl of Crawford and his son Balniel (who succeeded as 28th Earl in 1940) certainly had their ears to the ground – found the fact that Duveen had been allowed onto the board painful, not least because they knew three important Trustees owed him money.[50] 'The Art world must be the most corrupt of all worlds,' wrote Balniel in his notebooks, 'but, if Trustees of our galleries are to become suspect of having personal dealings with people like Duveen, it is really serious.'[51] Although it is hard to pin-down rumours of more deleterious effects of this appointment, there is little

doubt that Duveen regularly interrupted negotiations for purchase out of a desire to ensure that the Gallery, like his other clients, bought exclusively through him. As a Trustee he had access to the 'Paramount Lists' which the Treasury and Trustees were still negotiating. Knowing what pictures were on this list and how they were valued was invaluable intelligence to a dealer who needed to know in advance if the authorities would prevent a sale going ahead.[52]

This is not to deny Duveen's generosity in funding a modern gallery for foreign pictures at Millbank and a Duveen Room in Trafalgar Square (opened 1930), or his donation of works such as Hogarth's *The Graham Children*. A witty *raconteur* and sharp negotiator, Duveen knew how to leverage such gifts. At times the results were positive – as when he invited other art-lovers to emulate his generosity, to support new artists and campaign for the implementation of the Royal Commission's recommendations. But they could also be disastrous – as when he used his position as donor of a new Gallery for the British Museum's Elgin Marbles to bribe workmen to have the marbles cleaned with copper scrapers until they were restored to their 'original white'.[53]

As the 27th Earl of Crawford put it, Duveen's generosity was 'a very handsome insurance... against any agitation to tax the sale of works of art'. As a Trustee D'Abernon, who had come to an arrangement with Duveen to sell his family's collection, was careful to oppose proposals for new duties – such as the proposal by Chancellor Austen Chamberlain, mentioned above, for a 20% export duty, hypothecated to the Gallery's purchase grant.[54] Those not linked to Duveen argued that giving him gongs was one thing – but in permitting him to buy a seat on the board they allowed him to appropriate their status to his own marketing ends. They seemed to be right: his involvement with the National Gallery helped him win over his most challenging and rewarding client, the American banker Andrew Mellon.

It was out of a desire not to interfere with Mellon's own negotiations that Duveen kept out of the greatest untapped source of fine art: Russia. Although Soviet Russia's sales of

Opposite: Criticism of Duveen should not blind us to his generosity in donating works such as William Hogarth's charming **Graham Children** (1742), which he gave in 1936. The Gallery had been aware of it since 1930, when it was shown in an exhibition of conversation pieces held at Sassoon's townhouse. One could call such impromptu gifts princely – were it not for the skilful way Duveen had of turning them to his own advantage. Gift or not, in its dealings with Joe the Gallery always paid one way or another.

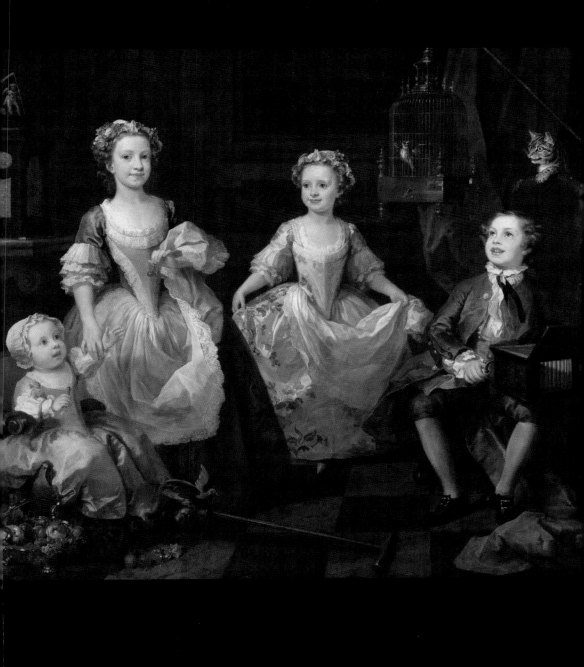

paintings and artefacts to Armand Hammer and Mellon are well-known, the National Gallery's attempts to acquire Hermitage paintings have been overlooked. It was largely due to the 1924 journey of the art expert and alpinist Martin Conway that the potential wealth of the Soviet's hoards had become clear. Conway published his *Art treasures in Soviet Russia* the following year, revealing that the great Hermitage collections had not been lost or destroyed in the Revolution but had, if anything, been enriched by the addition of confiscated private collections. As early as 1924 D'Abernon, then serving as Ambassador to Germany, had informed the Foreign Office, Prime Minister and Charles Holmes that the Soviet had opened an art-trading house in Berlin, intending to use it to sell state art treasures to the west. An epochal purchase of £1m worth of paintings was discussed, but nothing happened.[55] The government had only just recognized Soviet Russia, and the Zinoviev letter suggested that the regime was intent on destabilizing Britain. For the country's first Labour ministry to be seen negotiating with Communists would have been suicidal.

By the time the second Labour ministry was in power the Soviet's need for hard currency had become more urgent. In January 1928 Stalin's inner cabinet had issued a directive on 'measures to increase the export and sale abroad of objects of art'. A dedicated 'Antikvariat' agency was charged with its implementation, but faced competition from various other art-exporting entities run by the finance and trade ministries for the chance to sell the most valuable artefacts. Each sent raiding parties to the Hermitage and other museums armed with long lists of treasures for requisition. If the first of the Five Year Plans was to be a success, Russia needed foreign technology such as tractors and electricity generating equipment. Yet it had little to offer in exchange other than ore, matches and other commodities. As Conway and, later, Witt, noticed, the Communist regime recognized the value of great museums as tools for indoctrination. Parties of workers were taken round the Hermitage and other museums to impress on them the full extent of pre-revolutionary exploitation.[56]

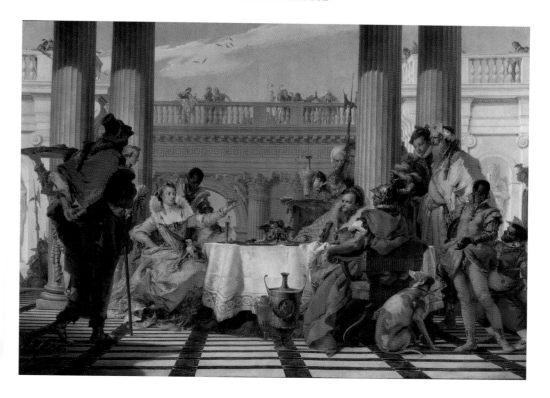

Tiepolo's **Feast of Cleopatra** (1743-4) was one of thousands of works sold abroad by Stalin in the pursuit of much-needed hard currency during the first Five Year Plan. The Gallery's negotiations with the Soviet were at an advanced stage in January 1933, when the painting arrived at Trafalgar Square. One by one the Trustees came to look at it, including Prince Edward (later Edward VIII). Not known as a connoisseur, he 'thought it a big thing and telling (or decorative).'

But this did little to halt the sale of 2,880 paintings from the State Hermitage Museum alone between March 1928 and October 1933. Among the works sold to Andrew Mellon (and now in the National Gallery of Art, Washington) are Raphael's *Alba Madonna*, Botticelli's *Adoration of the Magi*, Rembrandt's *Joseph accused by Potiphar's Wife*, and Jan van Eyck's *Annunciation*. At first curators at the Hermitage tried to rescue the finest works from this feeding-frenzy, but from 1929 onwards they were totally sidelined, as falling profits from sales led to a step-change in the speed of operations. When it came to public museums like the National Gallery, interested in making up for the loss of the Houghton Collection to Catherine the Great in 1779, the Russian authorities were willing to offer steep discounts.[57]

Sir Robert Witt was a success-
ful solicitor, as well as one of
the most important of the
twentieth-century Trustees.
In 1916 he tried, unsuccess-
fully, to be appointed Director.
As Chairman of the NACF he
enabled the two entities to
cooperate closely, notably
when the Gallery tried to
acquire works from the
Hermitage in the early
1930s. He also created a
unique collection of images
of paintings. Although he
originally thought of
endowing the Gallery with
the Witt Library, instead
it went to the Courtauld
Institute.

In 1930 the board had decided to start by negotiating for a
Tiepolo: *The Feast of Cleopatra*.[58] Dealing personally with Nikolai
Ilyin, head of the 'Antikvariat,' the Trustees offered £40,000,
but insisted that they would have to see the painting first.
Initially Ilyin refused to bring it to London, offering instead to
invite a Trustee deputation on an all-expenses-paid trip to see
it. In July 1931 Witt went to Russia, and was very impressed
with the painting, as well as with Giorgione's *Judith* and
Rembrandt's *Danaë*. Duveen followed in September 1931, and
agreed. Telling the NACF board that the Trustees had decided to
go ahead (they hadn't), Lee and Witt arranged for the NACF to
contribute half of the cost (which had now come down to
£25,000). Lee also checked that the King did not mind them
buying art from a regime that had executed his relations and
stolen their property. He didn't.[59] The only Trustee to question
the ethics of the purchase was the 27th Earl of Crawford. 'I do
not like buying such things from Russia,' he wrote to Daniel,
'later on we might be charged with trading upon the distress of
that unhappy country'.[60]

Even when Treasury restrictions on currency movements
seemed to throw up an insurmountable obstacle, Witt kept in
stride: he arranged with the Managing Director of the engi-
neering firm Metropolitan Vickers (MetroVick) for the Tiepolo
to be 'bought' with £25,000-worth of turbine machinery – the
Gallery would then pay MetroVick and no money would cross
international borders. After much prevarication, the govern-
ment agreed, and as far as the Russians and their middlemen
were concerned, the deal was closed. The Tiepolo arrived at
Trafalgar Square in January 1933. Yet when the Trustees filed
in to see it, they decided not to buy it – driving Lee and Witt to
distraction, and Ilyin to his sickbed. Having kept his views
secret up until that point, Daniel appears to have tipped the bal-
ance of opinion against the painting by circulating reports in
which Gallery staff claimed that it was not in fact painted by
Tiepolo. Given the excellent provenance of the work (with
which they were familiar), this slander was probably motivated
by a desire to frustrate Lee and Witt.[61] The painting was soon
snapped up by the National Gallery of Victoria, Melbourne.

Undeterred, the Trustees now considered a Rembrandt land-scape. By 1934 however the Russians had lost their appetite for hard currency and the Hermitage was spared further raids, thanks to a brave personal appeal by one of its curators to Stalin. The window of opportunity had closed.[62]

The above, highly simplified account gives little hint of the extent to which these negotiations were caught up in, and hindered by, much broader political and economic questions. First among these was the question of where the National Gallery's money was going to end up. In March 1931 D'Abernon's successor as British Ambassador to Germany was told that proceeds from the Berlin Antikvariat sales were going to support the Nazi Party. The information came direct from a leading political figure, Kurt von Schleicher, who later became Chancellor.[63] This was almost certainly misinformation, and the Russians later reassured the Gallery that its money would be spent in Britain. Nonetheless, dealing with 'Bolshies' was never going to be easy: in 1927 British police had raided Arcos (the Soviet trade delegation in London) and in 1933 MetroVick employees working in Russia had been arrested, charged with treason, and subjected to show-trials.[64]

Economic depression and the suspension of bank payments in 1931 not only caused the Treasury to fear the drain of specie abroad, but led the press to call for the protection of British markets from dumping by the Russians, who were believed to use slave labour to undercut foreign competitors. Chamberlain duly introduced tariffs in 1931, copying America's Smoot-Hawley Act of the previous year. Trade with Russia, even of antiquities, was hardly a vote-winner, as the contentious purchase of the *Codex Sinaiaticus* for the British Museum from the Russians had shown.[65] MetroVick, by contrast, was eager to expand its Russian operations. Its offer to help barter Tiepolos for turbines was, as the Cabinet well knew, part of its attempt to keep economic channels with Russia open.[66] The potential profits of trading with Russia seemed limitless. If the trade demanded hefty 'loss leaders' in the shape of large export credits, 'frozen' debts and the odd diplomatic incident, so be it.

An unresolved loan bill, secret deals with Communist Russia

The 27th Earl of Crawford thought **Kenneth Clark** 'a very arrogant little chap, but as clever as a monkey' when he was appointed Director at the tender age of 31. Had it not been for the war Clark's tenure would probably not have been remembered as particularly distinguished. The wealth and confidence that made him a success with the board alienated the staff, who relished the scandals that punctuated his reign with unmasked glee.

and internecine strife: this was the rather forbidding prospect confronting the thirty-one year old Kenneth Clark when Ramsay MacDonald appointed him Director in 1934. Clark had seemed too young to some, and the post had first been offered to Ellis Waterhouse and W. G. Constable, a critic and expert on British art who had entered the Gallery as an Assistant Keeper in 1923.[67] Lord Lee, however, wanted Clark to be Director of the National Gallery and Constable to be Director of the Courtauld Institute which Lee had just established with financial backing

from the industrialist and Trustee Samuel Courtauld. In a characteristic display of pique Lee told the Treasury that he would close the Institute down unless he got his way. The threat worked.[68] The previous three Directors and their staff had often been treated by the Trustees *de haut en bas*: as 'boys', 'butlers', 'servants' or 'lackeys'.[69] Yet here was a Director who was wealthier than some of the trustees, the gilded scion of a Paisley textile fortune who had spent childhood holidays estivating at Monte Carlo and on yachts, whose father gave him an hotel as a wedding present. His career seemed charmed: an apprenticeship with the great scholar Berenson had been followed by the Keepership of Western Art at the Ashmolean – and now this.

In the first volume of his autobiography Clark referred to this period as 'the Great Clark boom'.[70] The first couple of years at the Gallery went well: in 1934 the Gallery was opened exceptionally at 7am in order to allow those attending the FA Cup Final to enjoy the paintings before kickoff. This was a remarkable and well-publicized gesture, suggesting a flexible Gallery attuned to the needs of new audiences.[71] In 1934 Clark

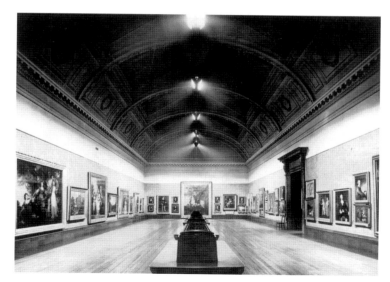

The Gallery was most appealing to visitors on rainy days, precisely those days when it was next to impossible to appreciate the pictures properly by natural light. Yet artificial light came late, so late that the Gallery was able to go straight to electricity, leaping gas-light and arc-light entirely. Clark marked **the introduction of lighting in 1935** with the Gallery's first press conference and with experimental evening opening. Although many paintings were still hung above each other, under Clark the hang was much less cluttered compared to Holmes' day.

also secured funding for a Scientific Adviser, Francis Rawlings, who established a 'Physical Laboratory'. Rawlings' pioneering work using x-rays to analyze paintings laid the foundation of the Gallery's Scientific Department. The landmark introduction of evening opening (until 8pm) three nights a week in 1935 was, thanks to Clark, well-advertised through a press-launch (a novelty) and posters on the Underground. Henry Cole, who had fought so doggedly for this back in 1860, would have been delighted, and intrigued – the Gallery had leapfrogged gaslight and gone straight to electricity. The great promoter of circulation would have been fascinated by Clark's trip to Alexandra Palace to investigate the potential uses of television as a medium of diffusing Old Master paintings. Sadly, this proved a disappointment – for now.[72]

Things seemed to start going wrong in 1937-8. Clark's charm had worked wonders with the Trustees and especially with donors: Mme Yznaga agreed to bequeath her collection, Courtauld lent more paintings, including the first Cézanne ever shown at Trafalgar Square, and in April 1934 the secretive Armenian oil-magnate Calouste Gulbenkian offered Clark the loan of his collection – and intimated that it, his money and his 5% of Iraqi oil production could one day be the Gallery's. When it came to the staff, however, Clark was a condign failure, giving the impression of being haughty and uncaring. When his Keeper died, he neglected to offer condolences to the widow. He left his paychecks uncashed in his desk drawer – which may have contributed to the accountant's decline into suicidal despair.

When it emerged that the same man had been embezzling funds, Clark found himself hauled before the Public Accounts Committee of the House of Commons, where his ignorance of Gallery administration was painfully obvious.[73] Soon after came the even more damaging discovery that four panel paintings Clark had led the Trustees to acquire as Giorgiones were in fact by a much less important master named Previtali. Challenged on these issues, Clark was evasive. In one letter he argued first that the panels' 'chief qualities are imponderable, and incapable of precise definition' by experts, and then that

Opposite: The social success of Clark and his wife Jane gave the Director ample opportunities to woo potential donors. One of them was Emilie Yznaga, a resident of Paris keen to leave her small collection of French eighteenth-century art to the National Gallery without paying French taxes. The Gallery's weakness in eighteenth-century art had been overlooked for years in the belief that the Wallace Collection somehow made up for it. The Yznaga bequest of works such as Louis-Léopold Boilly's monochrome **Girl at a window** (after 1799) was therefore especially welcome.

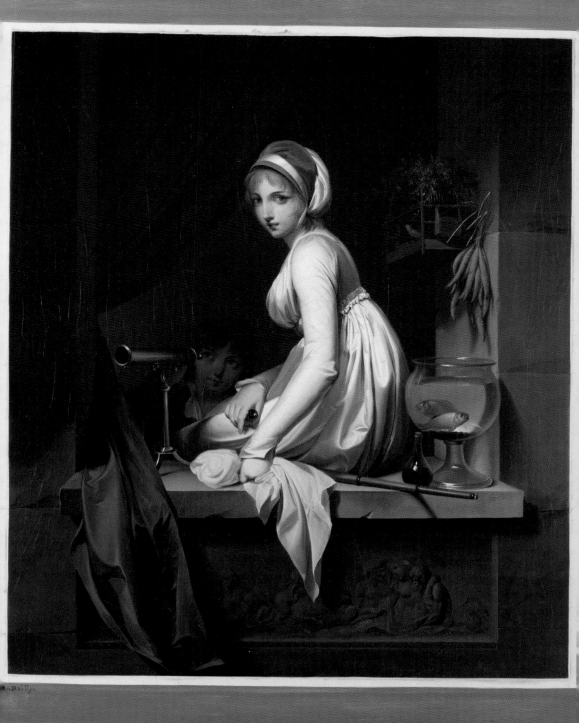

Martin Davies entered the Gallery as an attaché in 1930, and rose through the ranks to become Director thirty-eight years later. A consummate scholar, 'Dry Martini' had little time for distractions. A colleague later recalled that 'the only strong emotion which he experienced was hatred – intense and lasting hatred – of Kenneth Clark.'

'the Gallery does not as a rule buy the kind of pictures which require expert opinion.'[74]

Indeed, Clark seems to have been so focussed on the 'masterpiece' that he could argue that an annual purchase grant was 'a snare,' precisely because it led Trustees to buy secondary works needed to fill gaps. In 1939 Clark proposed selling such secondary works to raise funds for purchases.[75] Both at the time and in his autobiography Clark could be surprisingly diffident when discussing his record at the gallery: office had been thrust upon him too young and, though a disappointment in several other respects, he was prepared to stand by his record of acquisitions. To D. S. MacColl, who regularly chided him and his wife for being stuck-up, he revealed sterner stuff. 'As long as the present attacks persist,' he wrote, 'I shall stay until I am kicked out; and it will be damned hard to kick me. You can tell any of your friends who wish to see me gone that their wisest course is to let me alone.'[76]

By 1938 relations between Clark and the staff were so bad that Balniel intervened, confronting the Keeper, Harold Isherwood Kay, and Assistant Keeper Martin Davies and recording their side of the story. The unpleasant picture that emerged suggests that Davies, who confessed to being physically sickened by the sight of Clark, had convinced Kay that the Director was infringing on his powers as Keeper. Davies planned to get Kay and himself transferred to the Tate – a remarkable statement, given Davies' scholarly interests and eventual Directorship of the Gallery. For the moment the pair backed down, and fortunately for Clark the war soon separated him from the paintings and from Davies.[77]

One serious accusation can, however, be isolated from the ramblings patiently recorded by Balniel. This is the charge that:

The Director's policy seemed to be to popularise the Gallery, whereas the prestige of the Gallery could only be enhanced by its becoming an institute of scholarship, to which the world would look. The staff should have as their primary purpose a scholarly objective: and publicity and the popularizing of the gallery should take second place.[78]

This overreaction on Davies' part suggests that his opposition

was founded on more than personal hatred of Clark. It may also reflect Davies' desire to make the Gallery the preserve of serious art history.

His touchiness reflects the extent to which this was still an embattled concept. In fact Clark's great career as a popularizer was still a long way off. He had yet to navigate a path between the detailed connoisseurship of Berenson, which could descend into a 'parlour game' of attributing works by comparing photographic details of painted hands or ears, and the intellectual categories of Fry, which vanished into abstraction. Neither was the way to popularize anything.[79] The only indication of the path Clark's career would take was, perhaps fittingly, an easily over looked work which had something of the parlour game and the profoundly intellectual about it: the book *One hundred details from pictures in the National Gallery* of 1938. This collection of black and white photographs of unfamiliar corners of well-known paintings had bite-size commentaries ('conversations,' Clark called them), but also a serious purpose: to 'encourage us to look at pictures more attentively, and show us some of the rewards of patient scrutiny'. 'Re-reading it,' he would later write in his autobiography, 'I recognize for the first time the sound of my own voice.'[80] This book was Clark's first experiment with a personally engaged approach to art appreciation. Had it not been for the war, it might have been the only indication that behind the supercilious façade of the young Director lay the power to reach out to new audiences.

'Not a picture shall leave this island'

As another European conflict grew ever closer in these years plans for another evacuation were drawn up. Although the zeppelin had aroused similar sorts of fears in 1914, in the 1930s it was the bomber that concentrated people's minds: it was believed that any declaration of war would be immediately followed by a massive bombing raid on London that would cause horrendous damage and six-figure casualties. If Cassandras such as Baldwin were right in declaring that 'the bomber would always get through,' then the old boltholes of Home

Counties country houses and a disused bit of tunnel at Aldwych would no longer do. Thanks to Francis Rawlins, who was a railway buff, detailed plans for evacuation by rail to distant corners of Wales were in place in time for a rehearsal to be held on September 27, 1938, just as Neville Chamberlain was meeting with Hitler at Munich. After Chamberlain returned with 'peace in our time,' the paintings came back – although Clark had little faith that this peace was anything more than a temporary reprieve. The second, real evacuation was set in motion on August 23, 1939, and completed twelve days later, with the paintings stored in Penrhyn Castle, the National Library of Wales Aberystwyth, University of Wales Bangor, and Arthur Lee's home in Gloucestershire. The next day war was declared.

In October the US government suggested that, in view of the fact that Britain would probably be invaded, the Gallery should

be shipped to America, where they generously offered to look after it. After discussion it was concluded that America would probably try to make too much capital out of 'saving' the Gallery, and it was left to Churchill to slam the door as only he knew how: 'Bury them in the bowels of the earth,' he wrote to Clark, 'but not a picture shall leave this island.'[81] The eventual concentration of all the paintings inside a Welsh mine, the creative use of the empty galleries for Myra Hess' lunchtime concerts and the One Picture shows held from 1942 are among the best-known incidents from the Gallery's history.

The historian approaches war-time folk memories gingerly, nervously aware of the important role the Gallery played in raising morale. The National Gallery entertained thousands of displaced servicemen and -women as well as native Londoners denied access to theatres, concerts and other pleasures. In fact, to use the word 'entertainment' seems almost to demean the Gallery concerts and exhibitions – which symbolically kept the fragile flame of civilization burning. The 28th Earl of Crawford (as Balniel was now known) wrote movingly of the effect of the first painting shown in January 1942, Rembrandt's *Margaretha*

During the War the Gallery selected one painting a month from among those evacuated to the Welsh slate mine and sent it back to Trafalgar Square. The first was Rembrandt's **Margaretha de Geer**, here admired by a serviceman. With other sources of entertainment closed, thousands came to commune in front of a single painting, including many who had never visited before, when the entire collection had been on display.

de Geer: 'Crowds flocked to visit her, and it was pathetic to see how hungry, after so long, people were for the real thing. She has done for painting what Myra Hess did in those early weeks for music.'[82] The Gallery was bombed twice in October 1940, causing its closure until October 1941. The One Picture shows had to be suspended in February and March 1944 during another period of heavy bombing. Wartime memories of the gallery nonetheless stressed its role in providing evidence of continuity and survival. People made use of it to flaunt a refusal to let the enemy disrupt their 'normal' life. It is one of the curiosities of wartime London that they did so by looking at and listening to things that had been peripheral to that pre-war life.

Critics of blockbuster temporary exhibitions have complained that they cause visitors to neglect permanent collections, causing them to orientate their visiting around shows marketed as one-off, see-it-and-die extravaganzas.[83] The One Picture shows were the ultimate blockbusters: whereas previously the Gallery had displayed masses of paintings for the few, now a few paintings drew the masses. The mingling of different ranks before the nation's *lares et penates* was the realization of Charles Kingsley's Victorian vision of the equalizing power of the Gallery. As we saw in chapter two, during the 1850s Kingsley had celebrated the easy mingling of rich and poor in front of beautiful art as offering visitors a foretaste of heaven, that 'fairyland made real'. Wartime visitors to the Gallery found a similar vision of future happiness, except they wanted their 'fairyland' at the end of the war, rather than in the world to come. Temporary exhibitions elsewhere in the building, like the RIBA's 'Rebuilding Britain' (1943), confirmed this trend to see the Gallery not only as an escape from the present, but as a promise of a more egalitarian future.

The concerts were a testament to the single-mindedness and drive of the pianist Myra Hess, who was motivated in part by a desire to provide for unemployed musicians. Funds were collected at concerts for the Musicians Benevolent Fund. The same idea lay behind Clark's use of government contacts to secure resources for his War Artists' Advisory Committee, which kept

The free lunchtime concerts organized by the pianist **Myra Hess** during the war were intensely moving experiences, etched in the memories of many of those who attended, sitting on one of the chairs laid out under Barry's dome or on the floor. The concerts raised funds for the Musician Benevolent Fund. The flame of professional music guttered, but did not go out.

painters painting and, crucially for Clark, out of the armed forces. In choosing his artists Clark was still very much the Fry acolyte, and this (combined with his general manner) led some artists to associate his control of the new patronage with 'a hothouse atmosphere of museum cranks and didactic favouritism'.[84] Men like Henry Moore and Stanley Spencer were certainly not those who produced works appealing to the common man. Clark's mellifluous commentary for wartime exhibitions and documentaries devoted to their work somehow managed to gloss over the perhaps rather curious idea of sending

these men to immortalise imperilled 'Olde England' and the bravery of the armed forces. The critic Eric Newton memorably compared it to 'asking T. S. Eliot to write a report on the Louis-Farr fight'.[85] Whereas Myra Hess passed up the opportunity to expand the public's musical horizons, sticking to a limited repertoire of classics, Clark succeeded in mixing 'golden oldies' with more controversial modern work in the temporary shows he put on at Trafalgar Square – including one dedicated to Paul Klee. He and Crawford also made sure that proposals to hold dances and stage plays and ballet in the Gallery were refused. There were limits.[86]

Meanwhile, in a secret location near Blaenau Ffestiniog, protected by over two hundred feet of rock, the paintings were better cared for than ever before: inside the slate mine they enjoyed air-conditioning in six special brick huts constructed on the floor of the caves – and the intense scrutiny of Martin Davies, who bore the strain of immuration in a Welsh mountainside remarkably well. With the evacuated library at hand, no public and, above all, no Clark, Davies set about cataloguing the pictures, work which produced a raft of post-war publications that set new standards for art historical scholarship.[87] By separating this dysfunctional pair, the war enabled the Gallery to achieve the seemingly impossible: to combine great, if highly introverted, scholarship with equally remarkable public relations work that looked outwards. These achievements were, it could be argued, of an order that was not seen again at Trafalgar Square until the 1980s.

This balance was dependent on a willingness to take risks with masterpieces that a less heroic age might consider tantamount to reckless endangerment. In 1932 the Earl of Crawford had opposed lending the gallery's finest works to Parisian or Italian museums for fear they might suffer a few knocks in transit. Yet in 1942 Clark succeeded in drawing his and the other Trustees' attention to a *Times* reader's plea that a few works be brought back to London and put on show. He convinced them to reconsider their January 1940 resolution not to bring paintings back. The idea had seemed fairly reasonable, back then: massive raids on London had not rendered the

Kenneth Clark was not a regular visitor to **Manod, the Welsh slate mine** where the paintings sat out the war. His work organizing gallery events, on committees and for the Ministry of Information admittedly kept him in London – which suited Martin Davies just fine. Here Clark examines a Cranach from the Royal Collection, one of the many works from other collections that were also given asylum at Manod.

city uninhabitable. At that time, however, Lord Bearsted had insisted that returning pictures would be off-message when the government was trying to keep evacuees from flooding back into London.[88]

But by 1942 the 'phoney war' was a distant memory. Although the Americans had finally joined in, victory still seemed far off. Clark somehow convinced Lord Balniel and the other Trustees to change their minds. The first picture shown – Rembrandt's *Margaretha de Geer* – had been bought from Balniel's father (the 27th Earl of Crawford) the previous year. Clark must have been very persuasive indeed. Forty-three paintings were shown in all between January 1942 and May 1945, largely favourites: Hobbema's *Avenue at Middelharnis*, the *Rokeby Venus*, Botticelli's *Venus and Mars*, but also less 'classic'

The **wartime canteen** organized by Lady Gater was a great success, especially among service-men and -women, and personnel from Whitehall ministries. It raised £10,000 pounds for charitable causes in 1942 alone. Though set up in response to unique circumstances, it ensured that a permanent Gallery restaurant would be established after the end of the war.

Previous pages:
Hobbemma's **Avenue at Middelharnis** is the master's signature work, and was one of 77 works acquired in 1871 from a collection formed by the former Conservative Prime Minister Sir Robert Peel. Peel, who died in 1850, paid a dealer £800 (£35,000 today) for the picture. One of the Gallery's most beloved works, the *Avenue* was admired by 12,477 visitors when it was 'Picture of the Month' in November 1942.

works like De Hooch's *Courtyard in Delft* and El Grecos. Once started, the large public following deluged Clark with comments and requests for specific paintings.

Detailed, month-by-month visitor figures allow us to gauge the public's enthusiasm for these paintings. Five works were seen by more than 30,000 people: a group that included the *Rokeby Venus* (the most popular work among those shown) and Gainsborough's *Artist's daughters*, but also Bellini's *Agony in the Garden* and even a Lane Bequest picture, Renoir's *Umbrellas*. The majority of the one-picture shows drew around 22,000. These attendances broke down to a daily average of 600-1000 visitors. Even in 1944, where there were no interruptions, the annualized figures were a third of what they had been in 1937. If one considers that nearly 11,000 visited the Gallery during a four week period in February/March 1942 when there was no painting on display, one has to conclude that many attended the Gallery for other reasons: the concerts and Lady Gater's canteen. The picture of the month was dependent on these other 'draws' for between a third and a half of its visitors.

For wartime, however, such attendances were considered impressive enough for visitor statistics to be used as propaganda.[89] Clark's gallery work was fitted around his work making films at the Central Office of Information, and so the shows also came to be included in propaganda films such as *Britain can take it*.[90] Although the organization Mass Observation was monitoring private conversations and morale, in the absence of the letters written to Clark requesting specific paintings we are unable to assess how people actually felt in front of the paintings. In terms of the class make-up of Gallery visitors, the only sources we have are a few scattered accounts (or 'follows') by Mass Observation volunteers recording the appearance, behaviour and very occasionally the remarks of visitors to the temporary exhibitions and concerts. These suggest that the audience was mainly middle-aged and middle class. Nonetheless, reports of visitors spending an average of thirty minutes in one room during one particular show of contemporary art suggest that those who did come viewed intently – even if one of them told her friend she thought the Matisse was 'a horrible pink'.[91] The fact that annual visitor figures rose from around half a million before the war to nearly one million in 1947 suggests that the shows did tap into a new audience that remained loyal.

Mr. Five Percent

Meanwhile, behind the scenes, Clark had also been active in encouraging the would-be benefactor Gulbenkian to develop his ideas for a Gulbenkian Annexe at the National Gallery. As noted above, this idea had begun simply, with the loan of a few of his paintings to Trafalgar Square. The war made its realization seem at once more remote and yet more compelling a prospect, not least because the strategic value of Gulbenkian's 5% of Iraqi oil production had rapidly increased. The result was a series of events that saw the Gallery caught up in much broader political and economic struggles, as much with Britain's allies as with her foes.[92]

By the outbreak of war plans for the Gulbenkian Bequest seemed on the verge of realization. In July 1937 Clark officially

The Armenian millionaire **Calouste Sarkis Gulbenkian** was dubbed 'Mr. Five Percent' for his personal stake in Iraqi oil production. By 1942 he was convinced that the National Gallery was the ideal home for his 'children,' a collection of paintings, coins, rugs and other arte-facts that came with a massive endowment to buy more. Sadly, it was not to be.

informed the Gallery Trustees as well as Prime Minister Chamberlain of Gulbenkian's offer. All heartily welcomed the plan. Clark began working out the details of the settlement, spurred by Gulbenkian's desire to minimize tax liabilities. By early 1938 Clark was informing the National Gallery Board that the gift was 'almost a certainty'. The Board and Office of Works agreed to cede a site behind the Gallery's west wing, an area originally earmarked for Gallery extension. They also agreed to Gulbenkian's choice of architect, the American William Delano, whose plans for a $600,000 annexe are discussed in another chapter.

The building was to have ground-floor galleries for display of Gulbenkian's collections of Greek coins, Islamic and Egyptian artefacts, and French decorative arts; Houdon's statue of Diana was to guard a staircase leading up to a suite of seven galleries for the paintings, which would in turn communicate directly via a bridge with the National Gallery's north-west corner. The onset of the Second World War did little to dampen Gulbenkian's enthusiasm. As Clark observed in a letter to Delano in 1942, Gulbenkian was 'not naturally an optimistic man, but I suppose has more belief in the continuity of the capitalist system than we have'.[93] This enthusiasm even seemed to survive the classification of Gulbenkian as an 'enemy alien' under the 1939 Trading with the Enemy Act – a classification he earned as a result of his continued residence in Vichy France. In May 1942 he wrote announcing that he wanted to buy more works to show in the Gallery. As his gift to the British nation was so certain, why couldn't he pay up front to buy works for display in the National Gallery until such time as his annexe was built? Clark promised to consult Keynes. Helpfully, the great economist had become a Trustee the previous year.[94]

In contrast to the larger corporate entities which together formed the Iraq Petroleum Company (IPC), 'Mr. Five Percent' (as Gulbenkian was known) had opted to receive his eponymous cut in cash, rather than in kind. He thus depended on his business partners to collect his 5% in oil pumped from fields around Mosul, refine and sell it on his behalf. His formidable staying-power in the unforgiving world of Big Oil was a function of his

success in co-opting would-be competitors into the IPC cartel, as well as in ensuring that successive regimes ruling in Mesopotamia – be they Ottoman, Turkish or British – gave the IPC exclusive privileges in return for small royalties. In addition to aiding exploration and exploitation of new oil fields, co-operation offered higher profits than the competitive price-cutting Gulbenkian had witnessed early in his long career. By 1940, such lessons and such a superannuated teacher (Gulbenkian was seventy) seemed outdated, however. Hence the enthusiasm with which Gulbenkian's partners shut off payments to him when he was declared an 'enemy alien,' and their reluctance to compensate him for lost income when the Custodian of Enemy Property unfroze his assets in July 1943.

Early in 1944 he asked Clark to intervene at the Foreign Office on his behalf, suggesting that he was being deliberately targeted by his partners in the Anglo-Persian Oil Company (a major shareholder in the IPC) with close links to the British government. The Foreign Office should be reminded that it was 'largely, or to some extent at any rate, due to Mr. C. S. Gulbenkian's foresight and exertions extending over half a life time, that Iraq oil is today available to our armed Forces.'[95] This argument was less than conclusive, but it was timely. Although the Treasury noted the quality and number of Gulbenkian's oil paintings, what interested them rather more was the oil production. As R. A. B. Mynors of the Treasury observed in an internal memo of March 1944:

The upshot of this ... [is] that, although such a man can never be depended on, the prize is so great that it is worth making a gesture to keep him sweet even at some expense; and the only gestures within reach (apart from, shall we say, a peerage!) are generally over his supply of funds, and a declaration by His Majesty's Government that we never regarded him as an enemy, for that rankles more than anything. Lord Keynes now tells me that the disposal of Gulbenkian's assets is believed to be imminent, the trustees being Clark and Lord Greene, and (more important) the endowment is to be given not in cash but in the form of his shares in Iraq Petroleum. The present distribution of holdings in Iraq Petroleum Company, and the state of oil politics in the Near East, would give such an acquisition political

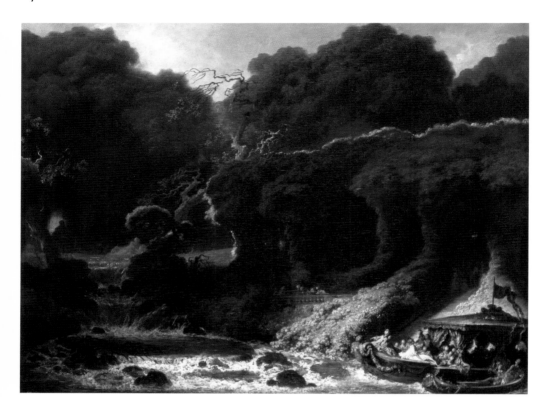

Fragonard's **The Fête at Rambouillet or the Island of Love** (c. 1770) was one of the paintings the National Gallery lost when Gulbenkian changed his mind about leaving his collection to London, a decision which Director Philip Hendy's snubs made that much easier to take. Thus the Gallery lost a fine collection, a fine building and a massive endowment that could have stemmed the flood of art treasures to America.

value on a different plane from the Old Masters, and it is the more worth our while to take some risks in order not to lose touch, if possible, with our slippery benefactor.[96]

British government holdings in Anglo-Persian would be increased, strengthening both as they faced the prospect of a post-war world where American power and American oil firms would loom larger than ever before.[97]

As far as the Gallery was concerned the main attraction of an endowment yielding an estimated £400,000 a year (in fact, by 1955, it was £5m, £87m in today's money) was different, but similar in its goal of shifting the Anglo-American balance of power. For the Gulbenkian fortune had the potential to plug the

art pipeline to America, or even reverse its flow. Resistance would be useless. As Clark explained to Foreign Secretary Anthony Eden: 'Mr. Gulbenkian's Gallery would be so much richer than any other Gallery in the world that it was of the greatest importance for the National Gallery to keep some sort of control of its funds. Otherwise the National Museums would be faced with a rival with whom they could not possibly compete.' Sadly, Eden and the Trading with the Enemy Department refused to undertake what Mynors called 'a mammoth exercise in whitewashing' in order retroactively to reclassify Gulbenkian.[98] The Gulbenkian project might nonetheless have succeeded, had there not been a change at the helm of the Gallery.

Before the war was over Clark had decided that the task of rehanging and reconstructing the Gallery should pass to a new Director, freeing him to focus on his writing. Clark's replacement, the forty-five-year-old former Leeds City Art Gallery Director Philip Hendy was in some respects a surprising choice. After working as a guide lecturer and assistant to the Keeper at the Wallace Collection Hendy had caught the eye of the trustees of the Isabella Stuart Gardner Museum, who commissioned him to catalogue their collection. As curator of the Museum of Fine Arts, also in Boston, from 1930 to 1933 Hendy had made himself conspicuous by using purchase funds to acquire relatively modern art by Matisse and Braque. In Boston, at Leeds and at the National Gallery Hendy's passion for such artists could lead him to adopt extreme measures in an endeavour to shock the public into admiring newer artists and reassessing the basis of their respect for the established Old Masters. In some ways his 'shock tactics' only appeared as such due to the conservatism of the 1950s, and especially the highly introverted state of the Gallery at the time. Combined with the leftist politics which probably secured him the post and the result was a recipe for friction with the Board. His twenty-three year tenure earned Hendy the distinction of being the longest-serving Director. When one considers that the Trustees only just failed in having him dismissed in 1951, this is a remarkable achievement in itself.[99]

It was also bound to have repercussions for the Gulbenkian

Snowdon's witty portrait has **Philip Hendy** backed by two visitors stooping to admire the Samuel van Hoogstraten peepshow (c. 1655-60), as if bowing to the Director's towering physical presence. The longest-serving Director, Hendy seemed to lose energy towards the end of his term, justifying his continued presence to his long-suffering staff by claiming that he had to stay on to keep the V&A's John Pope-Hennessy out.

project. To Hendy Gulbenkian represented a throwback to pre-war capitalism at its most unscrupulous. The idea of a French-style building housing paintings alongside furniture and other decorative arts was anathema to a Director whose wartime work at Leeds' Temple Newsam Museum had seen him strip out period furnishings. A Gallery memo claims Hendy also opposed giving up the ground behind the gallery to what he saw as a rival institution – and even ascribes to him the view that the Gallery already had enough paintings.[100] Hendy encouraged the National Gallery of Art in Washington to move in on Gulbenkian, who, snubbed, ordered his collection transferred to Washington in 1950. Although the Gulbenkian Collection returned to Europe in 1955, it and the fortune went to Lisbon instead of London. Bureaucratic scruple and politics had foiled what Crawford called 'the greatest potential benefaction ever received by the world of art'. The Gulbenkian National Gallery remains the most intriguing counterfactual in its history.[101]

Hendy's resistance to the Gulbenkian plan was of its time.

Pandering to slippery benefactors must have evoked painful memories of Duveen, and seemed hopelessly regressive in a post-war society where millionaires would not exist. In this new world, culture would be patronized by trade unions and government. Philanthropy had been the ransom paid by the pre-war *rentier*, and both were now to be extirpated: a 1948 survey found that a majority of Britons felt that charitable giving would be redundant in this new society – health, education and the arts would be provided by Bevin's new National Health Service, 'RAB' Butler's secondary moderns and Keynes' CEMA (renamed the Arts Council in 1945).[102] Britons would 'win the peace' the same way they had won the war.

Before the war Keynes had argued in *The Listener* that Britons needed to overcome their nervousness about Fascist use of the arts to glorify their regimes. The view that art and patronage were the preserve of private individuals and local voluntary groups belonged to the past. The cultural cringe which felt that German and Italian initiatives could never work in Britain was a product of a capitalist 'Treasury view' which failed to recognize that art patronage was 'an immemorial function of the State'.[103] By 1945 much had changed, as a second *Listener* piece by Keynes introducing the rebranded Arts Council made clear. Art and its appreciation now represented an economic market that needed management. Such management was carefully contrasted with the control identified with pre-War Fascist regimes: it was British, precisely because it had come about in a 'informal, unostentatious way – half-baked if you like'. Indeed, Keynes didn't even mention the word 'culture'.[104]

At first glance CEMA's agenda had indeed resembled that of the One Picture shows. Both were part of an attempt to rescue high art and high culture from the 'highbrows'. *Out of Chaos*, a short film about the wartime National Gallery produced in 1944 noted the presence of young 'arty' figures in the crowds attending the One Picture shows, but dismissed them as 'the sort of people who were commonly seen in the Gallery before the war'.[105] The wartime 'Art for the People' exhibitions put on by the British Institute for Adult Education under CEMA's aegis

had shown art by the people. Exhibitions of amateur work by London firefighters and air raid wardens had been put on in Trafalgar Square. Although Keynes declared in the 1945 *Listener* piece that the Arts Council wanted every part of Merry England to be merry in its own way, the terms of this invitation had shifted. This was now a licence to appreciate the best professional work that London could offer, not a licence to be creative oneself. The reaction of Keynes and Trustees like Crawford to 'Art for the People' had been one of embarrassment, swiftly followed by cancellation of the programme.[106]

Reconstruction

Such visions soon gave way to the reality of continued rationing, austerity and export-drives. As described by its newly appointed Assistant, Cecil Gould, the gallery in 1946 was a depressing prospect:

During the raids on London only one exhibition room had been totally destroyed. But all the skylights in all the exhibition rooms had been damaged by shrapnel. None of them had preserved more than about

Gallery staff cheerily laugh a defiance in this wartime photograph taken in a **bomb-damaged gallery**. What with the phenomenal success of the lunchtime concerts, canteen and One Picture exhibitions the Gallery had a very good war indeed. When it came to allocating resources for postwar reconstruction, however, the Gallery found itself at the end of the queue.

a quarter of their glass. The missing areas had been boarded over. Naturally no redecoration had been done since before the war – in most cases long before it. The ancient Lincrusta wallpapers, with their patterns in relief, which featured in most of the rooms, were now heavily stained where water had come through the holes in the roof. When I arrived at the Gallery some of the rooms on the west side were so badly damaged that they were unsafe. Accordingly the Ministry of Works had built temporary tunnels, called 'tunnels of love' by Philip Hendy. These curious constructions zigzagged past the central [radiator] islands in two or three rooms in succession until others were reached which had not been so badly damaged.[107]

The poor state of the west wing galleries greatly limited the number of rooms available to display the collection upon its return from Wales.

In view of the popularity of the Gallery during the war, and out of respect for the British tradition of 'muddling through,' one might have expected Hendy to have had the west wing galleries patched up and to have displayed as many paintings as possible in those galleries that could be opened. By harnessing the press interest generated by the rehang, Hendy might have been able to squeeze more money out of government. In matters of cleaning, he could have followed Clark's low-key approach. Instead he introduced an eccentrically spartan hang, rejected a 'make do and mend' policy and fought an international campaign in favour of new scientific cleaning methods. His inability to delegate and his fluency in mandarinese alienated staff, Trustees and several prospective donors. His focus on acquiring works of the 'modern French' school as well as his desire to replace what little architectural grandeur Trafalgar Square possessed with 'clinical functionalism' could give the impression that he did not like grand art and grand museums much.[108]

It could be a very progressive-looking austerity, however. One of the charges levelled against the Director by his Trustees was that he spent too much time away from the Gallery attending international conferences and writing articles. To his credit, Hendy did much to raise the Gallery's profile among the international museum community, not least as President of the

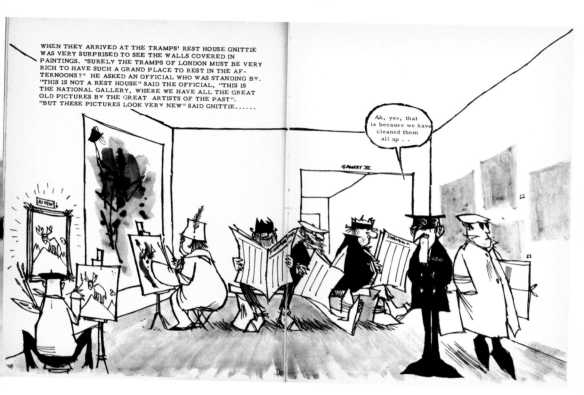

The 1954 Exhibition of Cleaned Pictures organized by Philip Hendy came almost exactly a century after the great 1853 Select Committee investigation into over-cleaning. Cleaning scandals have erupted at regular intervals in the Gallery's history, with the same arguments emerging each time. Where other Directors ran for cover, Hendy relished the challenge, and used the show to trumpet a great leap forward in the 'science' of cleaning – inviting this humorous rebuttal from **Private Eye**.

International Council on Museums (ICOM) between 1959 and 1965. Like its 1920s predecessor, the Office International des Musées (a branch of the League of Nations), ICOM was one of a number of international bodies established in a post-war mood of peaceful cooperation. His cleaning policy and views on display were applauded in such circles, and he felt, perhaps justly, that the promulgation of such views should not be hindered by a board of amateurs or by day-to-day administration. In 1947 and in 1966 he sought in vain for a clarification of the Trustees' powers, even trawling the Gallery's records for evidence that they could not be trusted to make wise choices regarding acquisitions.[109] It was admittedly rather inconsistent of the Trustees to begrudge Hendy the right to defend his

THE OFFICIAL EXPLAINED TO GNITTIE WHAT HE MEANT . . .

"Many people" he said "wonder why the paintings of Old Masters often have that dark, musty, out-of-date look. The answer is simple. Because they were painted before the invention of electric light".

"But the coming of new cleaning techniques, such as the detergent and the vacuum cleaner, has changed all that. Many of the world's most famous galleries, including of course our own, have taken advantage of Science to make their pictures as bright as new".

A famous old master, the Goya Wellington, awaits treatment from a specialist

"One natural by-product of this process, of course, is that many new pictures have been discovered. One Italian gallery, which recently cleaned up a fourteenth century Giotto, found no less than seven other old masters underneath - a Renoir, two Fra Angelico's and four Picasso's".

Removal of Surface Dirt

"Conservatives in the art world often argue that cleaning destroys the whole basis of Art-Worship. "Why shouldn't we see these pictures as they were originally painted?" they cry, or even "Why should the filth of ages not be allowed to remain?" The answer given by such eminent authorities as Sir Filter Henpeck is simple: 'Would you allow your home to remain uncleaned, year after year?' Of course not".

Application of Daz

"Of course cleaning has one apparent disadvantage, in that it causes many famous paintings to disappear altogether. But this is no bad thing. For less pictures mean higher prices. And higher prices mean that many galleries which might otherwise have to shut up shop can now sell off their paintings, and thus remain open".

The Window Test!

And finally - the picture, just as it was when the artist first thought of it.

policies in Gallery publications, notably the catalogue to the 1947 exhibition of cleaned pictures.[110]

This exhibition provided the public with an opportunity to look back over a century of controversies over the cleaning of Gallery pictures, and invited them to judge for themselves whether the Royal Academy and other critics were right. Hendy made an already daring show even more audacious by making the exhibition a showcase of how science could unveil the 'truth': paintings were shown half cleaned, with famous faces like Velázquez' *Philip IV* peering out of 'windows' punched in their dirty prisons. Backed by a battery of new machines and analytical tools, the picture cleaner had, it was suggested, left the foggy realms of taste behind. Indeed, the

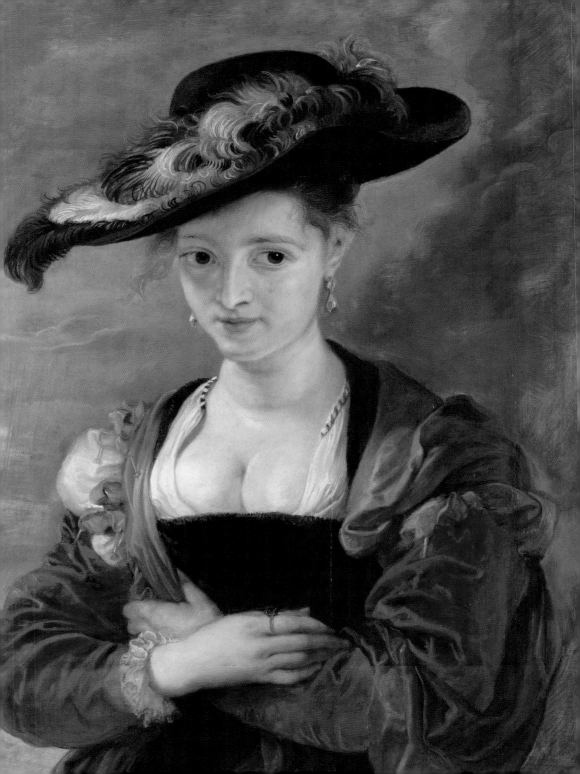

only taste at question was the self-serving, retrograde taste of those who preferred dirty paintings. Painters who criticized the work of his favoured restorer Helmut Ruhemann were, Hendy proposed, really acting in self-defence: they feared that if the full chromatic richness of Rubens and other Old Masters were uncovered, then their own muddy canvasses would be shown up. These artists were maligning the greats in the same terms as they had 'true' modern artists like Cézanne or Matisse: as gaudy or tawdry. This masterstroke not only threw his critics beyond the pale of art, it made schools of painting which many had thought antithetical appear as close allies: 'It is the re-emergence of these pure blues [during cleaning] which has made Ruisdael and Koninck, who had come to seem conventional painters, to re-emerge themselves [sic] once more as pioneers of modern landscape painting'.[111] Broadly speaking press reaction to the exhibition and the scientific commission appointed to investigate Hendy's cleaning (the Weaver Report) was supportive of the Director's position.[112] The Conservation Department Hendy had established in 1946 survived its baptism of fire.

Although the National Gallery has enjoyed a bit of a respite from cleaning scandals, picture cleaning remains a contentious subject, whose technicalities are beyond the present writer's ken. Given the importance of Ruhemann, Hendy and their 1947 show in the history of conservation, however, it seems worthwhile to mention two particular cases: one reassuring, one not. The first is that of Rubens' *Chapeau de Paille*, a work acquired in 1871 as part of the Peel purchase. Hendy gave orders for Ruhemann to clean it shortly before going on holiday in 1947. Crawford and fellow Trustee and art historian T. S. R. Boase were shocked by his breezy report that it had taken three hours – a remarkably short time. They believed the blue sky had become too mauve, and that the picture had not been improved by its cleaning. In fact, the reason it had been so easy was because Clark had secretly had it cleaned during the war, panicked at the change in tonality, and had Ruhemann put a tinted varnish on it.[113]

Less encouraging is the transfer from panel to canvas of

Opposite: Sir Robert Peel so admired Peter Paul Rubens' **Chapeau de Paille** (1622-5) that he commissioned Thomas Lawrence to paint an equally luscious portrait (1827) of his wife. Acquired along with the rest of Peel's collection in 1871, Kenneth Clark had the Rubens cleaned shortly before the war. Shocked by the vibrancy of the result, he had a toned varnish put back on top, which Hendy had removed a few years later.

Bellini's *Madonna of the Meadow*, entrusted to an American restorer named Richard D. Buck in 1949. Hendy had brought him over in order to give the Gallery paintings the benefit of the advanced conservation methods he and Trustee Alan Barlow had witnessed during a tour of the United States the previous year. Unfortunately Buck seems to have had very little experience of working with panel paintings. Working from the back, when Buck reached the gesso ground of the painting he was delighted to come across preparatory underdrawing in a wonderful state of preservation. It was decided that a photograph of this would be just the thing to impress the press with the wonders scientific conservation could uncover. In order to render the drawing clearer Buck applied a substance, forgetting that he had previously applied another chemical to the other (front) side that would react with it. In several areas the intervening paint layer 'floated off' and had to be replaced. First Hendy understated the extent of the damage, then, just before he left, had Buck submit a fuller account to the Trustees. This explained that he had neglected to inform them of the real damage the previous year because he feared it might jeopardise the 'good work' he and Hendy were promoting.[114] Hendy's scientific showmanship had got the better of him. He understandably had some difficulty securing the renewal of Ruhemann's contract in 1948, 1951 and 1953. As noted above, he was very nearly terminated himself.[115]

Under Hendy relations with the Tate were poor. The 1944 Massey Committee into the respective functions of the National Gallery and the Tate had attempted to clarify their collecting remits and establish a consensual system of exchange. It confirmed that the Tate should collect British art of all periods and modern (defined as less than a century old) European art. Yet in labelling it a 'source of supply' for the Gallery, it suggested that the Tate's subservient position should be maintained. The best of both collections would eventually be 'promoted' to Trafalgar Square. As his contributions to the cleaning debates showed, Hendy believed that Cézanne and Renoir were already part of the Old Master tradition – only a thin layer of discoloured varnish and Academy prejudice separated the two.

Opposite: Giovanni Bellini's **Madonna of the Meadow** (c. 1500) was yet another of the fabulous works acquired by Eastlake in the late 1850s. The painting served in the front line as one of the 'Pictures of the Month' during the Second World War. It survived the German bombers, but was seriously damaged by the restorer Richard D. Buck in July 1949. Although the Director Philip Hendy initially covered up the extent of the damage, the Trustees were eventually told.

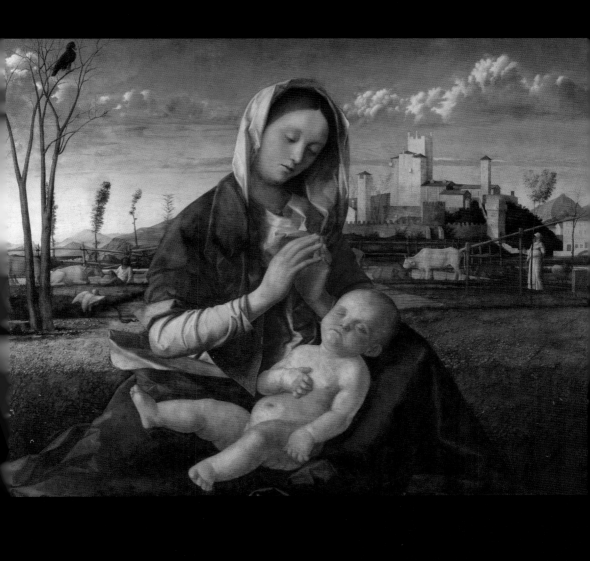

The economist **Lionel Robbins** was probably the greatest of the Trustees to serve in the last century. 'You have performed a miracle,' Hendy wrote to him in 1966, 'and made the N. G. constitution work'. Robbins' handling of the Treasury, media, ministers, his fellow Trustees – of Hendy himself – was deft, even if the position he took over admission fees seems less than firm when viewed with the benefit of hindsight.

The Tate did not have many examples of this school, however, so Hendy's demands for the transfer of their modern French works to Trafalgar Square were deeply resented, fuelling the Tate's desire for total independence.[116]

This came in 1955 with the National Gallery and Tate Gallery Act, but at a cost: the criteria for transfer or loan between the two were not clarified, and continued to be a source of strife.[117] In an attempt to get loan powers through without the fuss surrounding the abortive attempts of 1930 and 1935, loan powers were tacked on to this bill. The Board was now in favour, and loan clauses survived several wrecking attempts. These parliamentary debates were less than heated, but are noteworthy as containing the first signs of a reaction against Hendy's policy of hanging masterpieces with generous spaces separating them. Perhaps oddly, critics in the House of Lords argued that this smacked of both American-style showmanship and an 'over-precious' type of display.[118]

Such criticisms did not prevent the Treasury from approving large special acquisitions grants. In 1960 and 1964 grants for modern French works were secured. That Hendy was able to weather such criticisms and secure such grants was largely due to the arrival of the economist Lionel Robbins on the board in 1952, and particularly to his inspired Chairmanship, which began two years later. A Middlesex farmer's son, after service in the First World War Robbins had toyed with guild socialism before entering the LSE in 1920. Called by Keynes onto an advisory panel of economists formed in 1930 to consider unemployment, he had signalled what would become a characteristic free-trader's scepticism towards Keynesian deficit financing. His interest in the visual arts had been stirred by the painter Clive Gardiner, and from the late 1930s he had served on a number of boards, including the 1950 Waverley Committee appointed to consider restrictions on the export of works of art.

Robbins was arguably the most effective Trustee the Gallery ever had. He epitomized the postwar shift in Trustees away from gilded bearers of freshly minted titles towards professors and mandarins such as Alan Barlow and Viscount Massey, from the plutocracy towards 'the intellectual aristocracy'. Noel

In July 1960 the **Trustees** gathered together for this group portrait, vaguely redolent of Leonardo's *Last Supper*. At left are Hendy (standing) and Henry Moore (sitting). At centre the 28th Earl of Crawford sits at a table with John Witt (with glasses) and Robert Cecil, 5th Marquess of Salisbury (leaning), Oliver Lyttelton (standing) and Denis Mahon (in profile) behind. At the extreme right is the art historian Brinsley Ford.

Annan, who coined that particular phrase, was made a Trustee in 1978. Artist trustees were also introduced at this period. Of course, Presidents of the Royal Academy had served as Trustees in the early years of the Gallery, and Eastlake and Poynter had combined the role of PRA with the Directorship. The relationship between the two institutions had always been troubled however, and William Llewellyn's appointment in 1933 was the last time a PRA served on the Board.[119] The new artist Trustees appointed from 1941 onwards – William Coldstream and Henry Moore – were part of that alternative artistic Establishment which Clark had founded through his wartime projects and through CEMA/the Arts Council. As Trustees they had little influence, and were sometimes underappreciated by their colleagues.[120] One unusual candidate for the Board in 1974 was former TUC General Secretary Vic

Feather – even if he did not become Trustee, the suggestion highlights the massive power of the unions.[121]

Although very little of it took place in the public gaze, Robbins' lobbying was so effective that Treasury officials began muttering about the Gallery co-opting departments and turning them into spokesmen for their demands, either for the often delayed reconstruction of the west wing, for a special acquisitions grant, or for the development of the Hampton Site. This skill seems to have caused the Treasury to raise their game, notably after 1960.[122] Up until this point the Treasury's role had been simple: unless 'got at' by someone with a direct line to Downing Street, they simply said no to the Gallery's requests. There was no internal policy that could be tracked over time. After 1960 it is no longer unusual to find Treasury memoranda revealing an understanding of past grants and policy decisions rivalling that of the Gallery itself.

Officials could think several moves ahead and manoeuvre the Gallery into revealing which one of a series of 'equally vital' projects was most important – in effect, whether reconstruction should or should not come before acquisitions.[123] Whatever the outcome, deciding between these priorities was never going to be easy, or go down well with the public. The Treasury's success in out-sourcing such painful decisions to Trustees exploited the so-called 'arm's length principle,' under which semi-autonomous state institutions like the National Gallery were supposed to have room to set policy free of pressure from elected officials and their political agendas. This principle became a convenient noose, with which the Trustees made an excellent attempt at hanging themselves in 1971-4, over the introduction of admission charges. Unpopular or difficult decisions made in Whitehall were made to appear the work of an 'amateur' Board. Even if the Trustee system seemed ever more anomalous in a post-war technocracy of planners and experts, the Treasury did not want it any other way. This explains Hendy's inability to interest the government in any reform of the Trustee system.

Special acquisitions grants were set-pieces of Trustee-Treasury wrangling. The question of export restrictions had

been considered by a committee of experts appointed by the Chancellor in 1950. Crawford, Robbins and the Courtauld Institute director Anthony Blunt had been among the members of this committee (named the 'Waverley Committee' after its chairman), which published its report in 1952. The committee was charged with finding a replacement for the existing, ramshackle system of export review. This was itself cobbled together using controls granted under the Import, Export and Customs Powers (Defence) Act 1939 and Defence (Finance) Regulations Act 1939, neither of which had been intended to address the art export question. Although export duties and a register of embargoed works were again rejected the Committee did create an export review panel empowered to stay the export of works of art which met any one of a set of three criteria. The Waverley criteria were phrased in the form of questions: was the object 'so closely associated with our history and national life that its departure would be a misfortune?' Was it of 'outstanding aesthetic importance'? Was it of 'outstanding significance for the study of some particular branch of art, learning or history'? In the report the second test received the least attention.

If a museum was able to raise a matching sum within a fixed period, the prospective exporter was compelled either to accept their offer or take the object off the market. 'We think that the State has a clear right to forbid the export of objects which it regards as of national importance,' the committee concluded, 'but we think that it has the equally clear duty to see that particular individuals are not unfairly treated as a result.'[124] Although it was no longer possible to slip important works out without a licence, the Waverley system arguably gave the alarm too late, when bidding had already raised a masterpiece's price, and then allowed too little time: two or three months were to be allowed, the committee advised, 'only in quite exceptional circumstances'.[125] In so far as it was largely advised by Hendy and other directors of national museums, it also drew resentment from regional museums who felt that their needs were unrepresented.[126] More promising developments came in the field of estate duty reform. Under the terms

of Finance Acts passed in 1953 and 1956 the National Land Fund established by Hugh Dalton in 1946 could now be tapped to compensate the Revenue for revenue foregone when works of art were accepted in lieu of estate duty.

Thanks to Crawford and John Witt (the son of Robert Witt), the Board continued to enjoy close relations with the NACF. Hendy himself was clearly nervous about the tendency to acquire works that were perceived to play well with the great British public. He freely acknowledged that the French works he felt were most needed were also those unlikely to have the broad appeal of familiar Old Masters. Indeed, he was frank enough to tell the Treasury as much.[127] Coming from central government, however, grants such as that of just over £30,000 pounds for the small El Greco *Adoration of the Name of Jesus* could send mixed messages at a time when ministers were preaching wage restraint and cutting back on benefits. The acquisition coincided with rallies by pensioners against 'RAB' Butler's budget, which was felt to make life harder for the elderly. 'If they can afford to throw away public money like that,' their leader observed, 'they can afford to give us what we are asking.'[128]

William Hickey's *Express* column spoke for many journalists and ordinary members of the public when he asked how such a sum could be spent on a 'luxury... when purchase tax is being put on household utensils, when rents are rising, when the credit squeeze is on, when markets are becoming difficult for our salesmen who earn us our foreign currency.' The purchase grant was yet another symptom of the 'Whitehall mind which considers that as it has our money, it can decide what shall be done with it.'[129] A very different note had been struck by Robbins at the NACF dinner earlier that year. His speech's main targets were knee-jerk appeals for 'economy' and the government's use of punitive taxation to eliminate 'the forms of private wealth which in a former age were the main supports of art and culture'. Yet he had also used it to float a trial balloon (one gleefully seized by the press) regarding 'nationalization' of key works, on which he argued that £15m could be spent without fear of diverting labour or machinery from the

Opposite: Just 21⅔ by 13 inches, El Greco's **Adoration of the name of Jesus** (late 1570s) cost the Gallery dear in 1955, and not just in financial terms. Dubbed 'the so little picture that cost so much' by the *Aberdeen Press and Journal*, the acquisition came at a time when the government was preaching austerity. In his *News Chronicle* column Percy Cudlipp fumed: 'what right has Mr. Butler to contribute £30,100 towards the cost of buying a painting for the National Gallery and then tell us we should think before buying a kettle?'

government's export agenda.[130] At this time he also encouraged the Trustees to consider admission charges, which William Emrys Williams believed would convince the public of museums' financial plight.[131] Ever willing to consider new possibilities, Robbins also mooted corporate sponsorship – the first time this had been suggested.

On rare occasions when government art policy was put into words, as with the 1962 Conservative Party document *Government and the arts*, any extension of tax relief was rigorously ruled out in terms that, as the collector and Trustee Denis Mahon put it, were 'all too typical... of the pseudo-progressive "consensus" attitude' which saw any reforms as pandering to tycoons, snobs and the rich 'at the tax payer's expense'.[132] Together with the rather older excuse that tax concessions to museums represented the thin end of a wedge, this consensus proved an insurmountable obstacle well into the 1970s.

The Waverley system and the consensus against tax reforms ensured that the Trustees' only recourse was to lobby for special grants. These became more urgent after a resolution of the long-running dispute over the Lane Bequest was brokered in 1958. Under this agreement the Gallery agreed to lend paintings to Dublin, securing a Treasury guarantee in 1959 that special funds would be provided to buy new paintings to fill the resulting gaps. All in all, the Gallery did remarkably well in the years 1954-61, securing five special grants in addition to £125,000 over five years to fund Lane replacements. The acquisition of a pair of Renoir *Dancing Girls* reviled as merely decorative led to a reaction of sorts, however. Responding to press and to a lesser extent Royal Academy criticism, Treasury officials now noted 'a feeling that the general public is perhaps ceasing to applaud special grants as such'. Macmillan was particularly sceptical, and even asked for a memo on sale powers to be prepared. Although this proposal went nowhere, the Prime Minister's insistence that special grants should have as their first aim 'to keep what is in England' remained in force for the next forty years.[133] The Renoirs were the last special grant given to fund a purchase abroad. In a related shift several of the special grants made in the 1964 were made only after the Gallery

Opposite: **The Duke of Wellington** sat to Francisco de Goya in 1812, shortly after British forces entered Madrid. He does not seem to have been much taken with the result. The Trustees had first singled it out as being of paramount significance in 1927, although when it was finally acquired with the help of a special Treasury and Wolfson Foundation grant in 1961 some felt it would have been better going to the Portrait Gallery.

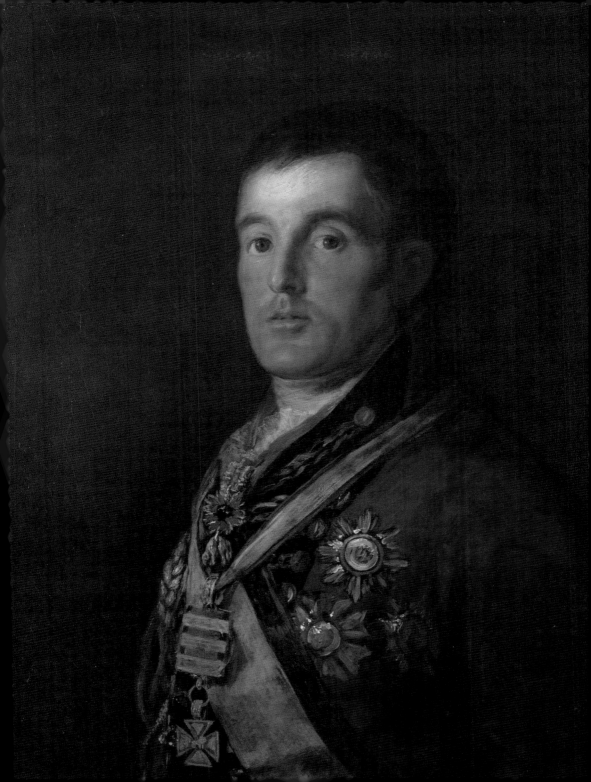

had first found private benefactors, like the property developer Max Rayne, who were willing to contribute seed money towards acquisitions.

'The Duke is safe'

As Hendy commented on *Panorama* in 1963, the Goya thieves had 'really been rather sweet', borrowing the painting to make a political point, rather than stealing it for personal gain. In the end only one of them, **Kempton Bunton**, turned himself in. He was acquitted of theft, having only 'borrowed' the painting, but was sent down for three months for stealing the frame.

That the first work acquired in this way – Goya's portrait of Wellington – should have been stolen from the Gallery fourteen days after going on display was regrettable. Given its subject, the allocation of the work to the Gallery rather than to the National Portrait Gallery had seemed curious. When the loss was announced one of the first letters Hendy received was from Keynes' brother Geoffrey, Chairman of the Portrait Gallery Trustees, informing him that they had not stolen it. All in all, Hendy's reaction was cool. A report into gallery security revealed that the culprit had hidden in a gallery toilet at closing time, stolen the painting and made his escape via an internal courtyard which had been opened up to the street at the rear of the Gallery in the course of on-going reconstruction work.[134]

In 1956 a young Irishman had stolen a Berthe Morisot from the Tate in protest at the retention of the Lane Bequest. At first, therefore, it was thought that it might have been a prank organized by art students upset at Hendy's cleaning. Soon anonymous letters began arriving from the thief, however, the first of which began by noting that while 'the Duke is safe - his future [was] uncertain.' Subsequent notes made it clear that the theft was, in a way, a continuation of the 1955 pensioners' campaign, which had made so much of the 'waste' of public funds on the El Greco. Thus the thief expressed a willingness to return the painting provided OAPs were provided with free TV licences. It was 'an attempt to pick the pockets of those who love art more than charity'.

The thief's prose might have been littered with spelling errors, but these only make his coinages and wit shine out more brightly. 'We ask that some noncomformist tupe of person with the sportitude of a Butlin and the fearless fortitude of a Mongomery start the [ransom] fund for 140,000. No law can touch him. Propriety may frown – but God must smile...' In

Ransom notes have, as a genre, generally put the lie to the rule that brevity is the soul of wit. The Goya thieves were more expansive, and reached for greatness, especially in their third communication, '**Com 3**'. Yet in 'Com 4' they somehow felt the need to apologize: 'The person who wrote the other letter apologises for using Montgomery of Alameins name in his 3rd comm. The spelling in 3rd Comm. was not deliberate. one of our friends is illiterate.'

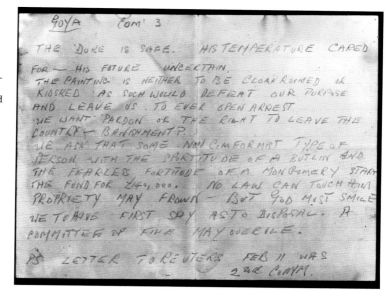

another letter he wrote that 'The yard are looking for a needly in a haystack, but they havnt a clue where the haystack is.' Sensing a kindred spirit the comedian Spike Milligan placed an advertisement in the *New Statesman* offering to be an intermediary. The painting seemed to be everywhere. Its supposed ashes were found in the left luggage at Victoria Station. A Mrs. Rosa Alexander anxiously wrote in that she had seen it for sale in a shop at 34 Waterloo Street (it turned out to be a poster: a hoax by the shopkeeper).[135] Sean Connery was rather less shaken when, as James Bond in *Dr. No*, he found it hanging in the criminal mastermind's lair. In fact the painting had been removed from its frame and stuffed in the back of a wardrobe in Birmingham. Two years on the thief, Kempton Bunton, handed himself in to the police. In a way he had the last laugh: as he had intended to return the painting he could only be charged with stealing the frame, and was sentenced to just three months' imprisonment.[136]

Considering that Wellington was still absent without leave, the success of the 1962 NACF campaign to collect sufficient

funds to save Leonardo's cartoon of *The Virgin and Child with St. Anne and St. John the Baptist* is remarkable. The £800,000 drawing, owned by the Royal Academy, was acquired after just four months' intensive activity. The campaign's indefatigable leader, the Earl of Crawford, repeatedly came up against the same question: 'Would the Cartoon... be safe in the National Gallery from the restorer or from the thief?'[137] Apart from the dauntingly large sum demanded by its owner, the Royal Academy, the fact that it was a drawing rather than a painting also created an obstacle. It seemed proper to exhibit it as part of the British Museum's Prints and Drawings Department.[138] In so far as the purchase price was to go to the Royal Academy, the appeal threatened to dredge up old antagonisms between RA and Gallery. It was pointed out that the cartoon would not be 'missed' because the introspective, self-serving Academicians had rendered access to it so difficult.

Somehow these many problems were overcome, and the crowds gathered at the Madonna's shrine in Trafalgar Square were felt by many to be a throwback to the wartime One Picture shows. This time, however, there were money boxes in the gallery, 'presided over,' Crawford later wrote, 'by relays of beautiful young women, who, with various techniques and infinite patience, distributed our pamphlets and persuaded visitors to leave their contributions.'[139] Posters and collection boxes were displayed in regional museums; reproductions were sold in large numbers, notably by the *Sunday Times*. Over a thousand schools held bake sales or other events to raise money. Crawford had initially hoped he would be able to depend on large donations from millionaires and corporations. As it turned out the largest single donation was a mere thousand pounds.[140]

Here was a campaign that lived up to years of NACF rhetoric: Britons of all ranks really did feel themselves to have a stake in Old Masters. Instead of depending on large private donors who either insisted on peerages or were otherwise unsavoury, it was discovered that the NACF could count on the people. Although Hendy and the Gallery staff remained curiously aloof from the campaign, there is no doubt that it went a long way to stay the

Leonardo's **The Virgin and Child with St Anne and St John the Baptist** (c. 1500) is clearly a full-size preparatory drawing for a painting, but it would appear that it was never used. It entered the Royal Academy's collection in the eighteenth century, only to be put on the market in 1962 to raise funds. This was a controversial decision, and aroused an age-old antagonism between the Gallery, a public institution, and the Academy, a quasi-private one that nonetheless claims stewardship of British art and artists.

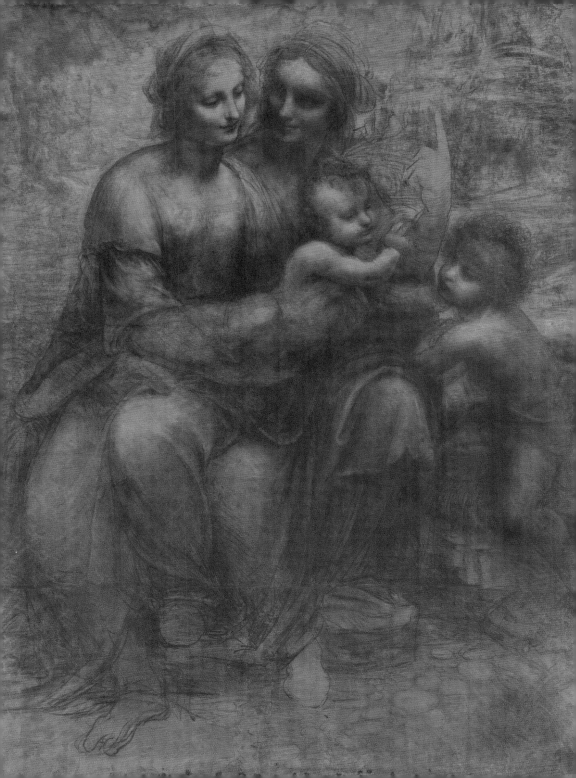

Treasury's reaction against special grants.[141] Indeed, the Treasury had initially refused to consider a grant. In the end they matched the public's contribution.

The other focus of negotiations between Gallery Trustees and the Treasury concerned plans to develop the site immediately to the west of the Gallery, called the Hampton Site after the department store which had formerly stood there. It is now covered by the Sainsbury Wing. The Canadian High Commission had initially leased the site from the Crown Estate with a view to building offices on it, but by 1957 they had dropped that idea and the Gallery began lobbying for the government to take over the lease. Witt, Robbins and Hendy lined up to make public promises that they would not need to build on the site for a considerable time.[142] Privately they promised the Treasury that they would hold back other requests for assistance on condition the lease was acquired. On this basis the lease was taken over and in 1958 the Chancellor pledged that after 25 years the site would be theirs to develop.

Within two years the Trustees, assisted by the Trustees of the Portrait Gallery, were demanding that the site be developed much sooner. Unlike Old Masters, portraits could be shown without top light, allowing the possibility of a new, multi-story Portrait Gallery with a relatively small footprint. In return the National Gallery wanted to demolish the Portrait Gallery and extend over it. Long term planning of this kind must have seemed audacious at the best of times, and the Treasury was highly doubtful whether either institution really needed more space. 'The only result would be to enable them to bring fresh pressure on the Treasury for enlarged purchase grants with which to fill it,' one official wrote.[143]

Macmillan and his latest Chancellor, Selwyn Lloyd, announced the acceptance of this master plan to the Commons in October 1961. A £1m Portrait Gallery would be built on the Hampton Site, followed by further phases involving extensions of the National Gallery to the north and over the former Portrait Gallery, which would be demolished.[144] Lloyd and the Conservatives left office in 1962 and 1963 respectively, but in 1964 plans for a four-phase reorganization of the entire site

were prepared by Ministry of Public Buildings and Works architect William Kendall. As we shall see in chapter six, these ambitious plans were only partly realized – the Northern Extension opened in 1975 was a slightly altered version of Kendall's Phase I. The long delay was due to inter-departmental Whitehall wrangling. In 1966 this was made worse by the intervention of local government in the shape of the City of Westminster and Greater London Council (GLC) planners. These suggested that the streets around the Gallery be widened, creating a complex of new traffic arteries which would have left the Gallery stranded on a glorified traffic island.

That both the Kendall and GLC plans went unrealized was due to two colourful individuals who typified the 1960s shift away from 1950s conservatism. The arrival of Jennie Lee as the nation's first Minister for the Arts under Wilson in 1964, and that of Roy Strong at the helm of the National Portrait Gallery in 1968 changed museum politics forever. Austerity and veneration were replaced by fun and celebration. Derided by Strong as a 'champagne socialist,' Lee's background in fact lay in the grittiest part of the Labour movement: the Independent Labour Party. Her appointment was, as her biographer has noted, a token of Wilson's respect for her deceased husband 'Nye' Bevan, whose institutional and political legacy she fought to protect. Her presence in cabinet secured Wilson's left, and in return she extracted record sums for the arts. In the absence of any great love or familiarity with fine art Lee focussed on encouraging a young and diverse audience. Although museum Directors gleefully exchanged stories of the gaffes she occasionally made on her many visits, the media-savvy ones like Strong knew enough to make sure that they ticked the right boxes.[145] They filled their institutions with flashy temporary exhibitions and specially primed crowds of inner-city schoolchildren. In a rare nod to Lee's priorities, the Gallery included a 'room for teenagers' in their extension plans. They also agreed to hire female warders and open on Sunday mornings.[146] Sadly, Strong's successful campaign of obstructionism in 1970-1 killed off plans to relocate the Portrait Gallery to the Hampton Site. This ensured that a Northern Extension intended as the

first step in the transformation of the entire site ended up being a grumbling appendix to Wilkins' building.

At a time when Strong and the Metropolitan's equally youthful and dynamic Thomas Hoving were setting the pace, the 1968 appointment of Martin Davies to head the Gallery in succession to Hendy seemed retrograde. Davies was 68, and had been at the gallery since 1932. 'Buggins does it again' was the press reaction to rumours of his appointment. Jennie Lee tried to prevent it.[147] Although Davies could delegate radio and television appearances to his Keeper Michael Levey, he could not delegate himself out of the Chairmanship of the Directors' Conference, and was conspicuously pliant, or simply incoherent, on the question of charging. 'I have no time,' he remarked in a speech to the 1971 Museums Association Conference, 'to accumulate examples against attractiveness of a faith that entry into museums must be paying.'[148] In contrast to Clark's charm and Hendy's command, Davies could seem decidedly unmagnetic. Previously this had could have been overlooked as a minor handicap: in the age of Clark's landmark television series *Civilisation: a personal view* (1969), personalities were important.

'Mr. Heath would be proud of me'

The admission charges episode, a central one in the Gallery's history, began with Paymaster-General David Eccles' announcement on October 27, 1970 that the government aimed to collect £1m per annum in charges. In 1936 Clark had thought of asking the Treasury to abolish the two paying days, arguing that 'the charge of 6d. was a considerable barrier to the full public enjoyment of the Gallery.' The Trustees had decided to postpone such an approach until their full purchase grant was restored, and charges were retained until November 1945, when Hendy succeeded in having them removed.[149] Thus in 1970 the Gallery had been free for a generation, and many opponents of charges genuinely believed that it had always been so.

For Eccles, an admission charge represented a token

In the late 1950s **Lord Eccles** (known as 'smarty-boots') had been something of a friend to the arts, in his role as President of the Board of Trade in Macmillan's cabinet. As Paymaster-General in Heath's government, however, he was in charge of implementing Mrs. Thatcher's new museum charges, and became something of a whipping-boy of the left, and even for some among his own party. In this 1970 *Daily Telegraph* cartoon by Nicholas Garland Heath congratulates him, promising that 'one day your work will hang in all the best museums!'

"'PAH! WHAT DO THEY KNOW OF ART— ONE DAY YOUR WORK WILL HANG IN GALLERIES ALL OVER THE COUNTRY!'"

contribution by the visitor towards the cost of an ambitious building programme releasing art from the paternalist grip of highbrow Trustees and their friends. Their Victorian ideal of free access, Eccles opined, was patronizing or downright irrelevant to this public, who could easily afford to pay fees that represented much less than a packet of cigarettes or a pint of beer.[150] As well as empowering them to demand museums that satisfied their needs, Eccles and Heath believed that charging would incentivize museums to render the collections more accessible.

Eccles was a master tactician. At times he could appear to be on the Gallery's side, as a Cabinet lightweight who needed to bring some money to the big boys' table if he wanted to get something the Gallery wanted in exchange. Meetings 'starting with a panatella and ending with a gin,' saw both sides apparently in agreement, for example, that the activist Committee Against Museum Admission Charges (CAMAC) was an etiolated group that could be safely ignored.[151] Yet in initially refusing the Trustees' request for a free day, and in painting the Gallery Board as Victorian dinosaurs Eccles revealed his hard side. Had

anti-inflation measures not delayed the introduction of charges from 1972 to April 1973, Eccles' skill suggests that they could have been introduced peacefully.

The delay enabled opponents to link new museum charges with charges for school milk and meals as one of the '3 MS' associated with the new Secretary of State for Education and Science, Margaret Thatcher ('Milk Snatcher'). It was precisely as part of this package that they became such a contentious topic. After referring to her as so right-wing that she made Enoch Powell look like 'the Fidel Castro of Tory politics,' Labour MP for Swansea West Alun Williams noted in the House that, having already 'stunt[ed] the physical growth of our children by starving their young bodies of milk,' she was now out 'to stunt the growth of their minds'. The most outspoken opponent in debate was a Conservative backbencher who manfully resisted his party's three-line whip: Jeffrey Archer. 'Genuine interest is often captured by just dropping into a gallery,' he remarked, noting that fees would prevent this. 'No whip will make me crawl into any corridor.'[152]

Davies and the Trustees seemed unable to join the fight against charges. The former was prepared to accept charges of up to 5 shillings.[153] The Gallery failed to pin the government down on the fundamental question of whether the fees were being imposed on them or not. This surprised Eccles. As he observed in an unguarded moment, the Trustees' apparent reluctance to test the 'arm's length principle' and reject charging surprised him: 'They seemed to like their chains.'[154] According to the MP Andrew Faulds, the bill should have been called 'the Museum Trustees (Facilitation of Financial Blackmail and Devaluation of Powers) Bill'.[155] On November 20, 1973 Thatcher suggested in the Commons that fees could be given back to museums as a direct incentive to attract people through the turnstiles. This left museums like the Gallery the option of foregoing charges and stoically accepting the loss of an extra revenue stream. They decided not to take it.[156] They also neglected opportunities to coordinate with other Galleries such as the Tate and go public with arguments against charging.

Keeper **Michael Levey** (kneeling), Director **Martin Davies** (standing, left) and Chairman of Trustees **John Witt** tally up the coins and notes deposited in the collecting box for Titian's *Diana and Actaeon*. This arresting scene was staged to raise the media profile of the campaign to save the work for the nation, and may have helped convince Edward Heath that the Treasury should make its own contribution.

This portrait of a recumbent Gallery becomes less lurid if one steps back from the insistence that the Gallery had 'always been free'. The Gallery had charged on at least two days a week for almost half of its history. Since 1945 the Trustees had been willing to consider charging at regular intervals, without seeing it as a matter of principle. It should also be noted that the Trustees had other important issues to contend with. In the course of the debate over charging Robbins and Witt had struggled to get their choice for Davies' successor through (the Prime Minister wanted John Pope-Hennessy), and were attempting to secure a special grant for a Titian which Curzon had attempted to purchase back in 1916: *Diana and Actaeon*. They were also eager to urge tax reforms on the Treasury. Here little had been achieved since the pre-1914 discussions. A clause in the 1956 Finance Act allowed works to be accepted in lieu of estate duty and enabled the Treasury to offer a '*douceur*' (a reduction in the taxable assessment) for works sold to public museums by private treaty. In 1970 the Gallery had been arguing for years

that gifts of money should enjoy exemption, and that donors in cash or kind should be able to offset the value of their gifts against Income Tax (the American system). Robbins believed that all these projects would be jeopardized by a strong anti-charging stance, as he pointed out in a masterful paper on the 'political economy of the arts'.[157] The Trustees decided that there were things more important than free access.

As Robbins put it in a speech in the Lords, when it came to a face-off with the Treasury, one could only commit hara-kiri once. 'In my judgment – perhaps I am over-optimistic – in general, trustees have more chance of getting their way with ministers if the disputes do not take place in public.' Indeed, the Titian grant went through only because Heath overruled Eccles.[158] At a certain point further parliamentary debate seemed academic: even before the bill received its third reading government had already ordered turnstiles and tickets. Charges of ten pence per person, except on Wednesdays, were introduced on New Year's Day 1974: OAPs were free, and 3-17 year olds 5p, but the normal tariff was doubled in the tourist months of July and August. These charges were abolished by Hugh Jenkins on March 7th, as one of the first acts taken by Wilson's second government. In so far as they had raised a meagre £8,324 in two months, they were clearly falling short of their target of £170,000 in a year.[159]

Even if charges had been defeated, morale in the Gallery in 1974 was low. The country as a whole seemed stuck in a rut. Soon the British government would be forced to go cap in hand to the IMF. The country was placed on a three-day week. A former curator recalls that one day in spring 1974 he was heading home for the day when he came across a scene that stuck in his memory.[160] It was the accountant, dutifully tallying up the day's admission fees, struggling to count all the pennies and five pence pieces in his poorly-lit office, putting up with the gloom out of respect for a recently-introduced rule intended to help save electricity. Spying the curator, he looked up and smiled:

'Mr. Heath would be proud of me.'

Part II: Themes

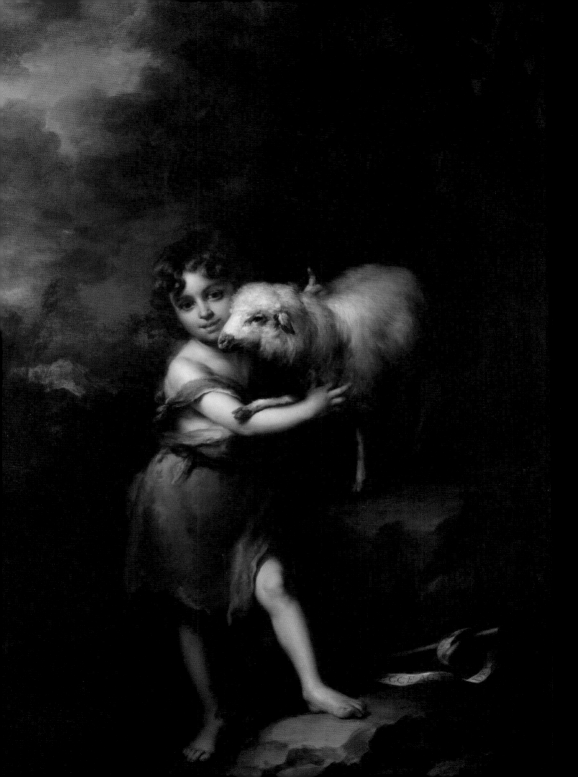

Four: The Experiment

In announcing the establishment of the National Gallery as an independent institution, Agar Ellis' 1824 *Quarterly Review* article insisted that conditions of access be looser than at the British Museum. There was to be no admission fee, 'no asking permission' and above all no distinctions drawn between social ranks. It was to be open 'to the indolent as well as the busy – to the idle as well as the industrious'. The gate to art was to be wide and lightly patrolled, and many were to enter by it. The novelty of these notions was such that even Ellis himself betrayed a certain degree of nervousness in the first few days – his diary records that he went along to 100 Pall Mall a few days after the opening, and was relieved to find that what he called 'the experiment' worked.[1]

This nervousness was based on ignorance of who would actually turn up. Would the gallery succeed in reaching an audience other than the titled loungers who had thronged the British Institution? Could that wider audience be trusted to show respect to the art, the institution, and the Trustees who acted as gatekeepers? Would the lowering of barriers between the appreciation of the connoisseur and the commercial activities of the city outside diffuse or demean culture? Answering these questions would be impossible without benchmarks or criteria for measuring the success or failure of the Gallery.

Records of visitor numbers were kept from the beginning, and continue to be cited as a measure of the Gallery's success. It was possible, however, for large crowds to be seen as an indication of failure. In the mid-nineteenth century Gallery staff and Trustees found the sheer number of people attending worrying, believing that quantities of visitors were lowering the quality of the individual visitor's experience. In a characteristic example of Britain's museum inferiority complex, the contrast with the much less crowded European museums became a source of embarrassment. At the 1853 select committee William Dyce stated that, though he would 'be very sorry to

Previous page: Richard 'Dicky' Doyle was an illustrator who contributed regularly to *Punch* from its inception in 1841. This scene from the National Gallery illustrates **Doyle's diary for the year 1840**, when he was 15. It shows the popularity of Murillo's newly purchased and saccharine *Infant St John with the Lamb* (c. 1660-5). Doyle himself preferred Rembrandt's *Franciscan Friar*, which the Duke of Northumberland had presented in 1838, while he criticized Rubens' *Brazen Serpent* (to the left of the Murillo) for 'the extreme grossness of the female figures'.

Opposite: Bought in 1840, Murillo's **Infant St John with the Lamb** (c. 1634-5) was an instant hit with the public, perhaps because of its resemblance to keepsakes of the time. The Trustees spent £2,530 (£110,000 today) that year on this painting and Guido Reni's *St Mary Magdalene*. Although both were 'safe' artists, the purchases were nonetheless debated in parliament, underlining the challenges faced by staff and Trustees in acquiring works without a discretionary purchase fund.

appear to doubt the advantage which the generality of people derive from seeing works of art,' he believed that 'an extreme view of it is taken in this country which is not warranted by the example of other countries, where they admit the common people less frequently than we do'.[2]

Such concerns were founded on ignorance of who these 'common people' were. Although Henry Cole was an important nineteenth-century pioneer of visitor surveys, classifying and measuring audiences and their levels of appreciation was always going to be extremely difficult. A century on from the Gallery's foundation the expansion of state education and the

E. F Brewtnall's 1872 *Illustrated London News* scene shows **a party of 'mechanics' or working men** listening to one of their betters explaining a painting to them, some respectfully, others less so. Although the latter sometimes wondered why there were so many working-class visitors and complained of the 'miasma' they gave off, the crowds of different ranks were ultimately welcomed as a sign that the Gallery was doing its job.

For some looking at the people looking at the pictures was as interesting as looking at the pictures directly. Charles Compton's 1855 painting **A study in the National Gallery** celebrates the power of a single painting – in this case Francesco Francia's *Pietà* (c. 1511-7, acquired 1841, illustrated p. 223), – to arrest the attention of a particular visitor, creating a pocket of intimate communion in the eddying throng.

rise of a professionalized museum service made it possible to isolate certain types of visitor. Curators could still be mystified or even worried by the sheer numbers of people thronging the galleries, however. Three-quarters of these were, an influential report noted in 1928, 'persons of whom nothing is known'.[3] They used the galleries in many different ways: for picnics, for romantic assignations, as a day-care centre for children, as a refuge from the rain and a place to read newspapers and sleep. Although the range of activities tolerated within the Gallery has narrowed since 1945, this has been somewhat compensated for by the introduction of restaurants and improved shopping facilities. The introduction of lectures in 1914, and the establishment of a dedicated Education Department in the 1970s have provided the Gallery with opportunities to organize visitors' activities and suggest new ways of appreciating the paintings.

In his landmark book, *Culture and Anarchy* (1867), the

Lessons from "Old Masters':
From its foundation the
National Gallery has been
especially popular with
children, to the perennial
frustration of those who
came seeking peace and
quiet – and who believed that
the Gallery should exclude
them, as the British Museum
and Dulwich Picture Gallery
did for many years. But there
were no activities organized
for them until Clark became
Director. In addition to
lectures such as that shown
here, Clark organized a series
of special Christmas Lectures,
modelled on the scientific
ones held at the Royal
Institution.

Victorian social critic Matthew Arnold defined culture as 'a pursuit of our total perfection by means of getting to know... the best which has been thought and said in the world... turning a fresh and free thought upon our stock notions and habits...'[4] Culture was, Arnold argued, being neglected in favour of other national projects – enlarging markets, Disestablishment, technological innovation, widening the franchise – that encouraged exclusive devotion to false idols of profit, toleration, progress and democracy. In their pursuit of these British society had fragmented into separate groups each going their own way, visualizing the world as one driven by 'mechanical laws'. In justifying their narrow perspectives they had come to question the validity and relevance of notions of 'right reason' and the state. 'Reason' was seen as dependent on individual opinion, and the state as a potential despot to be kept weak, rather than as a defence against the anarchy that threatened to result from the atomization of society.

Seen in Arnoldian terms, the National Gallery serves culture by collecting and displaying the best that has been painted in western Europe over the past eight centuries. The

next chapter will address how 'the best' was judged, and by whom – and how the collection shaped the canon of western European painting. But discrimination and collecting on their own were not enough: the National Gallery's art is not treasure to be hoarded – it, like Arnold's culture, has to be 'made to prevail'. But, Arnold had warned, before the best could be made to prevail the nation had to learn how to perceive itself as a whole.

In view of the apparent tardiness of the Gallery in this field – the Education Department was still embryonic in 1974, at the close of the period to be considered here – the history of the Gallery's educational mission could be told as one of callous neglect. It becomes more interesting, and also more valuable, if it is seen in terms of social perception. The 'masses' visiting or neglecting to visit the Gallery can be divided up in any number of ways. Far from simply reflecting existing models of social division, the Gallery's outreach consistently targeted 'new' groups. As if to tame them the rhetoric often spoke of such visitors in the singular: 'the typical representative of group X'. In the nineteenth century it was the working man. Later the new 'businessman- and -woman' of the new suburbs. Later still the state school child and disaffected teenager, more recently still the Looked After Child (LAC) and 'school-phobic'. Such 'untouched' audiences could appear unsettling, but also more 'open,' being free from established prejudices. They required a level of guidance different from that afforded art-lovers and collectors such as those who worked in the institution or sat on its board.

How could the Gallery be sure they were on target? On one level, 'prevail' could simply be understood in terms of exposure. The Gallery had to become the solution to a logistical problem: how to move as many bodies past the paintings without damaging them. It is on this level that visitor numbers are valorized, and at times the results can seem unsatisfying. Seen from a different angle, a refusal to look closer at large crowds could betray an admirable desire to let the art do its own outreach free from bustling initiatives. Even if such an approach left the galleries thronged with apparently insensitive visitors, the exercise would be justified by the presence among them of

one person whose life was changed. For much of its history the Gallery adopted this approach to access, successfully defending it against those with more sophisticated proposals intended to produce better (or at least more visible) results.

The technical terms used to define the parameters and measure the success of such experiments change over time, along with the people who organize them: political grandees in their respective sets, Improvers and their Select Committees, social critics and their reviews, curators and the *Museums Journal*, museologists and their surveys. As we shall see, each sought to discredit its rivals, and in many cases sought to present them as unsophisticated, uncaring, or both. In fact, these ways of seeing the gallery's educational mission exchanged ideas and personnel on a regular basis. Apparently progressive and genuinely well-meaning projects to integrate new sub-sets of visitor have had their trade-offs. Over 400,000 more people visited the National Gallery during the Great Exhibition of 1851 than during the Festival of Britain a century later. Between 1841 and 1881 annual visitor figures never went below a figure equivalent to 20% of London population. In 1921 and 1931 it was 7%. Despite improvements in transport, mass tourism, better accommodation and more masterpieces on display it only reached 20% again in 1971.

That the development of policy within other arts institutions such as the Arts Council has been seen in terms of a struggle between 'raisers' and 'spreaders' suggests just how familiarized we have become to such trade-offs. The former argue that culture is best advanced by supporting professional practitioners (often London-based) and great collections (often London-based) that uphold an inherited aesthetic 'gold standard'. Look after them, and the taste of the masses will improve as a matter of course. 'Spreaders' believe that culture is best advanced by encouraging people to explore their own creativity as practising artists in amateur groups. Look after them, and audiences for great performances will take care of themselves. If such work leaves professionals and great collections relatively less pampered, that is a risk worth taking for a more participatory and egalitarian culture. Such a culture may even forge

Opposite: This **Self-portrait at the age of 63** is one of four self-portraits by Rembrandt in the National Gallery. It dates from 1669, the year of his death, and is one of his last works. It was acquired in 1851, along with Van Eyck's *Portrait of a Man*, which may also be a self-portrait.
1851 was also the year of the Great Exhibition, when the number of visitors at the Gallery passed the one million mark for the first time.

new aesthetic standards different from those espoused by elite institutions. True culture involves accepting the possibility of unleashing creative destruction of accepted norms. One which Ruskin hoped to destroy was that which saw art and creativity as leisure-time activities, removed from the world of work.

Raymond Williams put it well when he wrote in 1958 that the question was 'whether the known gold will be more widely spread, or whether, in fact, there will be a change of currency.'[5] That he uses the word 'spread' to describe a position we would identify with that of a 'raiser' suggests that a more sophisticated vocabulary may be required. Williams pointed out the extent to which initiatives understood in terms of 'communication' were in fact one-way transmission. Although Eastlake was able to imagine how state culture might spawn a new aesthetic standard or 'currency', for the most part all agents involved in Arnold's project have tried to put this out of their minds.[6] For all his disdain of the middle classes and efforts to improve the life of the working man, Ruskin remained a Tory paternalist. There was never any question that the art treasured in the National Gallery was the best. In Williams' terms, therefore, the National Gallery was 'dominative' in its refusal to question that the art it contained was 'the best'. It was only twenty years later that such terms came to be explicitly applied to the Gallery.

On January 12, 1972, the author John Berger walked into the National Gallery and cut the Venus' head out of Botticelli's *Venus and Mars*. What the gesture lacked in physical impact (it was a set made to look like the interior of the Gallery, and a reproduction of the Botticelli) it more than made up for in being transmitted to millions of BBC2 viewers tuning in for the first of a four-part series entitled *Ways of Seeing*. The series and book pioneered a deconstructive and occasionally cynical approach to the museum which has informed much museum history written since, locating the museum among a 'carceral archipelago' of institutions by which we are classified and coerced. Foucauldian 'museology' is part of the Gallery's history, and that is how it is considered here. It should now be just about possible to resist the tendency to see all prior advocates of

John Berger's 1972 series **Ways of Seeing** analyzed the ways in which images of all kinds are perceived and manipulated. As a television documentary it remains unsurpassed, and lost nothing of its impact for being something of an *ad hominem* attack on Gallery staff – as well as the paintings. The series began with this sequence of Berger cutting Venus' head out of Botticelli's *Venus and Mars*.

museum education as inhabiting a false consciousness.[7]

In any discussion of how culture is brought to a public there are bound to be elements of that public that are sidelined. Public is defined here as those Britons who were not practising artists or collectors, who visited the Gallery in order to relax and take their minds off work and other responsibilities by looking at art. Three groups will therefore be excluded, beginning with the artists. The Gallery was intended from the start to serve as a training resource for painters, and in the first fifty years it was used as such. By the 1880s, however, it was recognized that referring to the two weekly paying days as 'Artist's Days' was slightly ludicrous. Instead of providing room for apprentice painters to set up their easels, they were largely serving to keep a series of perennial 'students' in work churning out copies of Landseer's *Dignity and Impudence*.[8]

The Gallery was also intended to impress tourists with Britain's artistic treasures, and to provide connoisseurs (or

Several of the Gallery paintings most beloved of Victorian visitors are no longer at Trafalgar Square, having been transferred to the Tate, which opened in 1897 as an annexe of the Gallery but later achieved total independence. Edwin Landseer's **Dignity and Impudence** (1839) was probably the most popular Gallery painting in the second half of the nineteenth century, and remained there until 1929. Together with other crowd pleasers such as Frith's *Derby Day* (1856-8) and Rosa Bonheur's *Horse Fair* (1855), it was left to the Gallery by the pharmacist Jacob Bell in 1859.

'amateurs') with a place to study. Both groups were a constant presence in the gallery, especially on Artist's Days, and their importance was recognized by the staff, who regularly took distinguished foreigners and scholars around the Gallery. In nineteenth-century Paris and Berlin the museums were mainly at the service of tourists and amateurs. The public was let in on sufferance, with free access just one day in the week in many cases. Such policies were fuelled by the close links between museums and the court, which heightened fears of unruly visitors while denying even loyal subjects much of a stake – the art wasn't really 'theirs'. In London the position was very different: visiting amateurs like Waagen often felt excluded by the hordes of the unwashed, and Gallery staff refused to hang works selectively for fear of censure from a public who wanted all their property on display.[9]

Rational Recreation

Such a generous interpretation of the public's rights did not mean that the early years of the Gallery's social mission were unproblematic. In the 1820s and 1830s leisure time was an unsettling notion to the middle class. Evangelicals felt the duty to account to God for every minute spent on earth especially acutely, and the standardization of working hours brought about by new technology emphasized this economy of time. Confronted by evidence that their superiors and inferiors did not allocate time to particular activities as religiously, they were torn between conflicting desires. On the one hand such observations confirmed that Christ's kingdom was not of this world, and petted their sometimes smug sense of being set apart by God. On the other they were tempted to provide more than just a moral example to their fellow men, to use the power accorded them at local and national level by the reforms of the 1830s to regulate leisure activities. The 'Rational Recreation' movement was born, and much of its attention was focussed on regulating or outlawing 'rough sports' and 'licentious' activities which had hitherto provided opportunities for London's rich and poor to mingle: cockfights, pleasure gardens and fairs.

Aeron Hoven's painting of **A room hanging with British pictures** (c. 1857) shows a genteel party admiring the Gallery's collection of Turners, including (centre) *The decline of the Carthaginian Empire* and *Ulysses deriding Polyphemus* (left). Owing to lack of space Turner's bequest first went on show at Marlborough House in 1857, and Hoven's painting probably records one of the rooms there. As at Trafalgar Square, there are no labels. Visitors had to buy a guide if they wanted to know what they were looking at.

Although its institutions – voluntary groups like the Lords' Day Observance Society and the Society for the Prevention of Cruelty to Animals – used a rhetoric of national moral improvement, as Hugh Cunningham has shown it was ultimately the product of a struggle over leisure within the middle class.[10] Much lampooned at the time, the Rational Recreation movement provided a moral aspect to the 1830s project of encouraging the working classes to devote their leisure time to self-improvement through museum visiting. Lord Ashley, an Evangelical, was the first MP to support the National Gallery as an alternative to the public house.[11] There was a good deal of Utilitarianism, too, in the suggestion that longer opening hours would reduce crime and so pay for themselves. That the National Gallery was seen as so important in advancing all

In 1832 the Society for the Diffusion of Useful Knowledge began publishing **The Penny Magazine** as a means of providing working men with reliable information drawn from a range of scientific fields. Reproductions of Gallery paintings such as Correggio's *Ecce Homo* were accompanied by articles gently encouraging them to improve themselves by visiting their Gallery.

Opposite: Artists such as Correggio, Guido and the Carracci were perceived as safe purchases in the years before the creation of the post of Gallery Director in 1855, when Trustees felt particularly exposed to attacks from parliament. Correggio's **Ecce Homo** (c. 1525-30) was acquired in 1834. Speaking in the Commons, Trustee Sir Robert Peel said that the ultimate proof of their desirability was that 'gentlemen possessed of valuable pictures would be proud to exhibit them'.

these projects is curious, as Bentham, the Evangelicals and Whig educationalists like Lord Brougham all had reservations about the visual arts. 'Diffusing' a love of art and a good taste could appear like a distraction from more important and more scientific projects.

Nonetheless Brougham's Society for the Diffusion of Useful Knowledge (established 1825) did print full-page reproductions of Gallery paintings in its *Penny Magazine*. At the time John Pye's series of engravings after Gallery paintings was only just in the process of being published, at prices prohibitive for all but the wealthy. The provision of woodcut reproductions costing just a penny must have had a remarkable impact. The accompanying articles encouraged the working man to ignore the forbidding façade and take visual possession of artefacts to which he had an equal right with the 'highest in the land'. He (and it was always he) was advised to be suspicious of works he could appreciate at first sight. Instead of proceeding quickly he was

to select any of the celebrated pictures for an experiment upon himself... quietly examining the picture, the figures seem almost to breathe and live; passions of the most apposite kind speak in their faces. That which at first he perhaps ill understood, becomes full of intelligence; and he will probably quit its examination with a strong feeling of reluctance.

Some accounts were moralizing. Hogarth's *Marriage à la mode* was construed as portraying the ruin that would only cease when all classes 'learn to seek for happiness in the exercise and cultivation of the higher qualities of their nature'.[12]

Useful knowledge was not gained without effort or difficulty, and even those working-class autodidacts who took advantage of the opportunities afforded by the *Penny Magazine*, museums and Mechanics Institutes could take positive pleasure in the distance such activities put between them and the public-house culture of their peers.[13] This encouraged a tendency to see a visit to the museum (however casual) as an epochal moment in the working man's life. Once inside, a man was 'saved' from the public house and all it stood for.

John Leech's 1843 *Punch* cartoon entitled '**Substance and Shadow**' juxtaposes painted paeans to status and wealth with real-life victims of poverty, malnutrition and exploitation. The paintings seem based on the sort of art seen at Royal Academy exhibitions. The Academy charged admission, however, and so never drew the poor as the Gallery did. What kind of state, Leech seems to ask, provides paintings when its people cry out for clean water and sanitary housing?

CARTOON, Nº 1.

Interestingly, this attitude was also prevalent among Radical MPs such as Joseph Hume, seen as the voice of the working man in parliament. Hume and William Ewart were closely involved in organizing the 1841 Select Committee on National Monuments, which argued for free public access to cathedrals, museums and other monuments. Whereas admission charges led working-class visitors to jostle each other and generally treat artefacts as a show, Hume argued that free admission 'would be beneficial for the admission implying a degree of self-control would to that degree operate as an education... the more the public were occupied in visiting these public buildings the more probability there would be that they would obtain a perfect control over their characters.'[14]

The Gallery itself was disengaged from this project. There were no labels on the pictures. One had to pay a shilling for the flimsy official guide, which listed paintings, their artists, their size and donor – but gave no indication of when the artist had lived, the date of the painting or what it represented. Labels

were only introduced in 1856, after pressure from William Ewart in the Commons. These gave artist and title – dates were added in 1932.[15] The picture dealer George Stanley, a witness at the 1836 Select Committee on Arts and Manufactures, argued that labels were a waste of time, because those visitors who would not spend money on the official guide would probably be of the sort who would not gain anything from knowing the title or artist.[16] While the National Portrait Gallery's exhibits had labels from the day it opened in 1857, at Trafalgar Square there was a definite blindness to visitors' basic needs, equally evident in the absence of toilets. Yet it could also reflect the extent to which the Gallery existed to cultivate taste, rather than a knowledge of art history. Labels and guidebooks were seen as pettifogging obstructions to proper enjoyment by Dickens, for example. In an 1858 *Household Words* essay Dickens satirically accused such aids of robbing the visitor of the right to make his own aesthetic judgments.[17]

Affordable and informative guides only appeared in the 1840s, thanks to the efforts of Hume and especially Henry Cole, who published a range of guides (including ones costing one penny) under the pseudonym 'Felix Summerly'. Summerly's guides were obviously aimed at the working man, yet politely asked leave 'to add a word or two to a certain class of visitors here' before addressing him directly:

Because you are delighted with Constable's *Corn Field* or Hogarth's *Marriage à la Mode*, which speak to your comprehension, do not assume that you are entitled to toss up your head in disdain at Sebastian del Piombo, whose mysteries you have not yet fathomed. Thank God, rather, you are able thus far to sympathize with art, and pray for grace and understanding to march a step further. Exercise a little modest forebearance towards works which some part of the world have looked upon with reverence and emotion for three hundred years. Believe me, too, you are not able to digest all that is in the National Gallery, in a single or even many visits. Come here at least a dozen times in a year. Begin with a study of the English painters; then pass on to Rubens; and then to Murillo. You will afterwards chance to find some beauties in Correggio, and even take an interest in Francisco Francia, before you have done with the Gallery. But above all, whenever you visit these works of creative genius, which make

Previous pages: **The Toilette** is one of a series of six paintings by William Hogarth (1743) which have been in the collection since its foundation in 1824. They tell of a disastrous marriage of convenience between a wealthy industrialist's daughter and Earl Squander's impecunious son. Here the former is shown at her levée, flirting with the Lawyer Silvertongue, who will eventually kill her husband and be hanged, driving her to take poison. The moral message was not lost on the *Penny Magazine*, which described hers as 'an embittered life in the vain pursuit of pleasures that can only be won as the solace of honest exertion'.

Opposite: 'Every work of art would become a source of feeling, reasoning and thought to them.' So promised the Radical MP Joseph Hume on April 6, 1841, rising in the Commons to move for a select committee to consider working-class access to museums. Acquired that same year, Francesco Francia's **Virgin and Child with St. Anne and other Saints** and its matching lunette **Pietà** (1511-7) seemed to herald the arrival of 'Christian Art' – a new way of feeling and thinking about the people's pictures.

their authors more divine than mortal, come in a spirit of lowliness and reverence, and you will assuredly depart all the wiser and better for doing so.[18]

The path to God-given sympathy with art outlined here is not historical, but begins with celebrations of British landscape or character (seen as 'easy') and eventually reaches the 'Christian Art' of Francia, which is presented as the most challenging, and presumably most rewarding. Such a wayward course was if anything facilitated by hanging practices. As discussed in the next two chapters, until the 1920s works were still hung frame to frame as size dictated – although rooms were allocated to specific schools (Italian, French, etc), there was little sense of following a path through the building, and the visual impression must have been overwhelming.

Summerly's tone can appear gratingly patronizing, but a scan of guides aimed at the middle class clearly shows that they adopted the same preachy tone. Art appreciation was not supposed to be easy for anyone. If members of the working class bothered to read such guides, they certainly were not put off. Visitor figures and descriptions of the gallery by middle-class visitors suggest that they attended in large numbers. From a mere 60,000 in 1830, annual attendance figures rose over tenfold to 696,000 by 1845. By 1859 there were 962,128, which the Keeper calculated as being equivalent to ten every minute. Asked to describe what class of visitor he saw during his visits, the stonemason-turned-critic Allan Cunningham told a 1841 select committee that they were 'Men who are usually called "mob", but they cease to be a mob when they get a taste.' In 1853, the Trustee Lord Monteagle complained that the gallery was so crowded with working-class people that the smell and the dirt were almost overpowering. There was no suggestion, however, that anything much could be done about it.[19]

The Keeper, Thomas Uwins, gave the 1853 Select Committee an account which is almost comic in the impression it gives of a hapless, unsettled public servant massively outnumbered by working-class people, people who seem more at home in the gallery than he does:

I have seen that many persons use [the Gallery] as a place to eat luncheons in, and for refreshment, and for appointments. There are room-keepers, who are very vigilant and attentive to everything that goes forward, and who check any improprieties. Scarcely a day passes that I do not visit the Gallery myself, and I have observed a great many things which show that many persons who come, do not come really to see the pictures. On one occasion, I saw a school of boys, imagine twenty, taking their satchels from their backs with the bread and cheese, sitting down and making themselves very comfortable, and eating their luncheon. I saw the impropriety of the thing, and the room-keeper would have observed it, if I had not.

Uwins saw the boys' teacher and stopped them eating,

– but it required that interference on my part to stop it; it was supposed to be a place where such a thing could, without impropriety, be done. On another occasion, I saw some people, who seemed to be country people, who had a basket of provisions, and who drew their chairs round and sat down, and seemed to make themselves very comfortable; they had meat and drink; and when I suggested to them the impropriety of such a proceeding in such a place, they were very good-humoured, and a lady offered me a glass of gin, and wished me to partake of what they had provided; I represented to them that those things could not be tolerated. And on frequent occasions I have perceived a quantity of orange-peel in different corners of the place, which proved that oranges, among other things, are eaten; and eating, no doubt, goes forward sometimes.

A more reliable source on visitor behaviour is probably John Wildsmith, an attendant who spent far more time than Uwins in the public areas of the Gallery. In contrast to the latter's histrionics he reported that the 'mechanics' came 'in order to see the pictures, and not to see the company'. 'Some of them take a very great interest in the pictures,' he added.[20]

Uwins clearly had problems explaining the unwritten (for it was unwritten) regulation that food and drink were not to be consumed in the Gallery. He could not even imagine the need for the rule to be framed as such. When one considers that several of the larger London gin-palaces of that time had picture galleries, the drinking of gin in the National Gallery seems less inappropriate than at first appears.[21] Uwins, Waagen and other members of the infant curatorial profession were falling victim

to their own ignorance: of the ease with which working-class people were manoeuvring among a range of cultural spaces, most of which combined 'improving' or educational content with drinking and other 'low' activities. Gallery paintings may well have been among those Old Masters 'staged' at Vauxhall Gardens and, later, at music halls by 'poses plastiques' (*tableaux vivantes*) troupes like that of Professor Keller.

Here the unquestioned nostrums of Rational Recreation hampered outreach. It was assumed, for example, that improvement had to be provided for the working class, that entrepreneurs would not provide the people with their own working-class leisure resorts. As noted above, it was also assumed that, once 'caught' by art, the working man and his family would never return to less noble leisure pursuits. In their failure to perceive either the range of entertainment venues open to 'mechanics' or their subjects' relaxed attitude to the decisions this variety imposed, advocates of 'improvement' showed how effective they were at indoctrinating – themselves.

'The workman's paradise'

In 1824 the founders had agreed that the National Gallery should be a place where all classes would mingle. The degree to which this succeeded unsettled many who felt that it was empowering visitors to call themselves judges of art. Landseer's 1834 guide to the Gallery, a weighty 424-page tome aimed at a very different market from Summerly's, complained that 'we elevate anybody and everybody (even the uneducated) to the status of being able to criticize art: Ergo we are all qualified – all critics in beauty.'[22] For the most part, however, those who listened in on the 'childlike' comments of the working man and his family did so with delight, positively relishing their freedom from the 'cant of criticism'. Spontaneity born of ignorance could be a source of wonder. A typical example of this is an anecdote related by Matthew White Ridley in the Commons in 1834, when the purchase of the Londonderry Correggios was being debated. He claimed to have overheard one sailor in the Gallery point at a ship in a Dutch marine painting and remark

to a friend: 'Damn it, damn it, Jack, see how well she sails!'[23] The striking thing here (apart from the swearing) is that this outburst was relayed by Ridley as proof that the Gallery was working, despite the fact that the comment suggested an inability to go beyond the subject to consider the more connoisseurial details of style and handling. The Gallery paid the price for such complacency ten years later, when a lame watch-finisher named William Adams destroyed a painting of *Leda and the Swan* – precisely because he could not see anything more than a swan and a woman having sex. Tellingly, the incident was almost never discussed, and MPs continued to assert that the Gallery's crowds had never caused any damage whatsoever.

The novels and journalism of Charles Kingsley afford the most ambitious and challenging accounts of how great art could overleap the barrier of visual illiteracy. His 1848 contributions to the penny paper *Politics for the People* hailed the British Museum and National Gallery as 'the workman's paradise,' as equalizing spaces. Here as in his later novel *Alton Locke* (1850), the Gallery was presented as a space in which individuals of different ranks could discover that class was but a 'paper wall'. It enabled them to reconnect with their common humanity through shared wonder at representations of God's work and glimpses of His heavenly reward for the patient Christian. Kingsley's account of a street urchin in the Gallery relates

how first wonder creeps over his rough face, and then a sweeter, more earnest, awe-struck look, till his countenance seems to grow handsomer and nobler on the spot... and reflect unknowingly, the beauty of the picture he is studying... He begins, and rightly, to respect himself the more when he finds that he, too, has a fellow feeling with noble men and noble deeds.

In another contribution he invited the widowed slum-dwelling visitor to recognize his deceased wife and lost children in the happy faces depicted in the paintings, and to find a foretaste of 'the *world to come* – that fairy land made real,' in the landscapes painted by 'loving, wise, old Claude, two hundred years ago...'[24]

Kingsley and his ally F. D. Maurice were both 'Christian Socialists,' members of a diverse group of writers and church-

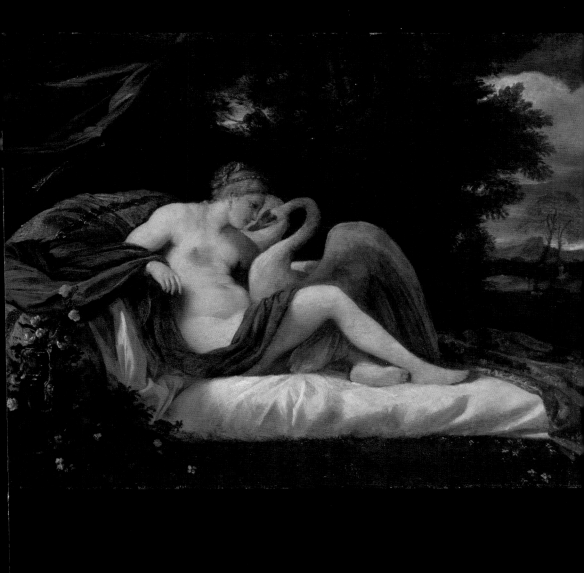

men who dallied with Chartism in 1848 and later helped start the co-operative movement. Their goal was to make the working class 'understand themselves as spiritual beings belonging to the Divine Order'.[25] In contrast to the Evangelicals who had promoted Rational Recreation, they refused to understand all men as neatly divided between the elect and the damned, arguing that Christ's kingdom already existed. To join it, however, men had to be helped to see Christ in one another's humanity. Although the East End slums and Chartist agitation led them to advance various projects for social reform, they did not see such unrest as the product of any physical or economic deprivation, or, indeed, the elite's suppression of the people's democratic rights. What the poor needed was fellowship and leadership from the clerisy, who had abdicated their responsibilities in favour of the 'iron laws' of political economy. As seen in his well-known fable, *The Water Babies*, Kingsley believed that together knowledge of salvation, contact with beautiful objects (and people) and manly struggle could not only redeem the lost, but help them to become more beautiful themselves. Pedagogic systems were an obstacle rather than a means to both understanding and wonder.

Although few may have put it so imaginatively, the fact that so little was done by way of pedagogy at the Gallery suggests that Kingsley's views were shared. Until the 1850s there was little sense that the Gallery was intended to teach art history. As we shall see in chapter five, the very discipline or phrase 'art history' simply did not exist. The Gallery existed to instill taste, understood as aesthetic and to some extent moral judgment. This explains the virulence with which the members of the National Gallery Reform Association opposed the move of the Gallery to South Kensington, a move they understood as involving a repackaging of the paintings as de-moralized 'specimens' arranged either historically or according to some pedagogic system dreamt up by Henry Cole.

'Excellence,' the Reform Association feared, would be suborned to the utilitarian ethos of Cole's Department of Science and Art. Reclassified as a moment in a history of art made visible, a Gallery painting would no longer perform the moral and

quasi-spiritual role it had previously specialized in. Admittedly, it might now form part of a series of works that helped the visitor trace developments in style and learn to distinguish between different artists – but something precious would nonetheless be lost. As Trustee Lord Overstone put it to the 1853 Select Committee, all issues boiled down to one question:

everything connected with the National Gallery is dependent on your clearly setting down what you are going to aim at; if you merely aim at presenting before an uninstructed public a collection of a few pictures, which either from the sentiment and feeling and devotion thrown into them shall excite the moral feelings, and exercise a moral influence upon the public, that is one thing, and if that be the only great object you aim at, it should be distinctly understood. If it is to be a great school of art, in which the public mind of all orders and classes is to be trained up [in]... the knowledge of amateurs..., then you must purchase on different principles.[26]

Although vexed by the meddling Elcho and his Reform Association, it would seem that Overstone and his fellow Trustees shared their concerns. Though they did not hinder Eastlake from arranging the collection in a more 'scientific manner,' they did not want the pursuit of 'knowledge' to drive out 'moral influence'.

Cole's use of visitor surveys, statistics and variable admission fees at his South Kensington Museum made his model even less appealing. Interrogating visitors, if only to assist the project of bringing art to the masses, was seen by many as an invasion of personal privacy. On one level it seemed a shame, if not positively dangerous, to attempt to dissect the experience of art appreciation. Christ-like artistic geniuses were not to have their wonder-working paintings put to the test. Many members of such committees seem to have shared with the Liberal Charles Baring Wall an awareness 'of the extreme difficulty of distinguishing the motives by which visitors are attracted to public exhibitions,' and were unprepared 'to undertake so difficult an analysis, or to recommend that any restrictions should be resorted to with regard to the admission of visitors'.[27]

Appearing before an 1861 Select Committee stage-managed

by Cole, Gallery Keeper Ralph Wornum firmly refused to answer questions asking what classes attended his Gallery, and at what times. Upholding the classless, Kingsleyan vision of the Gallery, he would not be rattled, even when his questioner suggested that he had somehow been remiss in not collecting the necessary data:

> Q: Mr Cole, from the Kensington Museum, when examined, stated that he had [undertaken visitor surveys], and I thought you might have turned your attention to that?
> A: No, I look at all classes alike, I do not know one from the other: they are all mixed together.[28]

Though this doubtless appeared retrograde at the time, such resistance was soon justified. By the 1880s Cole's statistically-informed initiatives were seen to have failed. The South Kensington Museum retained only traces of the 'art and science' mission its founder had developed in the 1840s.

Walter Stanley Jevons, a Benthamite social reformer who helped run Owens College, was the sort of person one might have expected to mourn the passing of Cole's pedagogy. Instead his 1883 collection of papers entitled *Methods of Social Reform* lampooned the South Kensington museum for pretending to 'tell you to a unit the exact amount of civilising effect produced in any day, week, month or year'.

> The persistent system of self-glorification long maintained by the managers of the South Kensington Museum seems actually to have been successful in persuading people that the mere possession and casual inspection of the contents of the South Kensington courts and galleries has created aesthetic and artistic tastes in a previously unaesthetic people.[29]

Jevons' views were also shared by those taking part in the discussion of 'art for the people' at the 1883 Social Science Association Conference in Birmingham. Both Jevons and ssa speakers such as Walter Besant saw the effectiveness of the objects on display as limited by their sheer profusion and, significantly, by the degree to which the museum ripped them out

This 1872 image from the *Graphic Supplement* of **'Holiday Folks in the National Gallery'** is full of stock characters familiar from many other written accounts of the Gallery's work maintaining social harmony: the country gent (far right), the awed if scruffy East End family and the Greenwich pensioner (left). At the extreme left are two ladies who seem to have wandered off a fashion plate.

of their original context in order to array them as historical specimens.

Besant argued that, for all the labels, evening opening and statistics displayed, the Kensington system had tried to avoid painful realities: first that a large proportion of the working class were beyond the reach of art (as well as religion, virtue, or 'knowledge of any kind'), and secondly, that simply displaying art was not enough. Expecting the average working man and his family to appreciate art without the assistance of lectures or catalogues was tantamount to expecting them to carry away a knowledge of Assyrian history from looking at cuneiform inscriptions. He urged that educational efforts be focussed more tightly. 'We have to do,' he said, 'not with the very poor at all, but with the respectable poor – the families of skilled mechanics, *employés* in regular work, workmen in breweries, ship-yards, and factories, independent handicraftsmen, clerks, cashiers, accountants, writers, small shopkeepers....'[30] Such people hardly had the education and leisure requisite to gain something from a visit to a gallery. Though it was constantly

argued that contemplation of beautiful things would create an 'artistic sense,' Besant insisted that in reality 'an occasional visit to a collection of paintings cannot create an intelligent appreciation of art'.[31]

A crisis of faith

Such arguments had been around during the 1850s debates, but were now linked to a broader crisis of confidence in museums. The troubled career of John Ruskin prefigures this change. In the 1850s Ruskin had taught working men at Maurice's Working Men's College. At this point his theological and social views placed him firmly alongside Kingsley in the Christian Socialist camp. To those who feared that art education might give workers ambitions above their allotted station, Ruskin stated in 1857 that his work at the college aimed not at 'making a carpenter an artist, but [at] making him happier as a carpenter'.[32] The critic who had broken a lance for Turner and devoted hours to cataloguing the artist's bequest to the National Gallery took a lively interest in Gallery acquisitions, urging the addition of early Italian Renaissance works to the nation's 'treasure-house'. Up until 1860 his writings expanded on the perceptive genius of such artists, inviting readers to benefit from their insights into a divine universe.

After 1860 he appeared to realize that there were limits to this transference: that the degree to which any given audience could follow or share in such insight was historically contingent on the society in which they lived. At first this seemed to be limited to perception of art – but as Ruskin's crisis of faith deepened he became sensitized to such an extent that the natural world itself seemed to be fading behind a man-made veil.[33] He thus devoted himself to changing society. Rather than praising artistic vision, his lectures now lambasted bourgeois blindness. His establishment of a model community under the aegis of his Guild of St. George provided him with opportunity to experiment, although it nonetheless became difficult in some cases to divine just what changes he was advocating. In terms of museums, Ruskin's frame of reference also seemed to

narrow. Like Cole, Ruskin's approach to museum display had always been highly didactic. In the end it led him to postulate a clean divide between museums for 'teaching' (aimed solely at the working classes, consisting of lesser works) and for 'treasuring' (aimed at the middle and upper classes, consisting of masterpieces). Whereas the National Gallery was clearly one of the latter, those museums Ruskin helped establish later in his career at Sheffield and elsewhere were in the former category.

Up to this point nobody had noticed that museums can be boring. Only after 1880 does one find references to what we now call 'museum fatigue' – but which then was called 'museum horror'. This museum malaise appeared in spite of – or because of – a massive boom in museum foundations in the forty years to 1920, a boom facilitated by the 1891 Museums and Gymnasiums Act. This act went much further than Ewart's 1845 and 1850 Acts in allowing municipalities to fund museums through borrowing and by insisting that museums open without charge not less than three days a week. The

Henry Edward Tidmarsh's watercolour shows how the **'New Italian Room'** looked in the 1890s. The easternmost of the Barry Rooms opened in 1876, the room had been decorated with a stencilled frieze commorating great British artists, yet was hung with Italian works such as Raphael's *Ansidei Madonna* (centre, on a temporary screen) – an indication of how little cooperation there had been between architect and Gallery staff.

period also saw the massive physical expansion of the British Museum, National Gallery and other central collections. Far from serving to bolster curators' professional pride, their newly-established organization (the Museums Association, established 1889) was characterized from its inception by despair at low funding levels and a failure to define aims.[34] Around the turn of the century critics such as D. S. MacColl, Roger Fry and Frank Rutter had some successes organizing campaigns against 'hidebound' institutions such as the Royal Academy and the National Gallery, advocating the inclusion of controversial artists' work in these great public collections. Such 'progressive' agendas did not, however, extend to considering how such art could be made accessible to the masses. The struggles to defend ancient monuments and paintings from developers and American millionaires only confirmed a tendency to focus on acquisitions rather than outreach. As the *Daily Express'* cartoonist suggested in 1906, rescue campaigns passed over the heads of the man in the street. At the same time the NACF's heritage rhetoric could be interpreted as suggesting that little needed to be done – that the masterpieces it helped to save were already part of the 'mental furniture' carried about by Britons of all classes.

The debate leading up to the introduction of Sunday opening in May 1896 shows the extent to which the high energy and expectations invested in the Gallery's 'improving' mission had leached out. The rise of German and American industry, rising union unrest and set-piece confrontations such as the 'Bloody Sunday' riots in Trafalgar Square corroded confidence in social harmony. Apparently unable to see parliament as anything but a collection of employers trying to introduce Sunday labour on the sly, in 1884 2,412 trade and friendly societies actually petitioned in opposition to opening. They argued that it represented the thin end of a wedge, rather than an attempt by the state to provide them with opportunities to enjoy their property at a time convenient for them and their families. The numbers put forward by both the friendly societies and the Sabbatarian non-conformist groups were, as Lord Dunraven showed in an 1884 article in *The Nineteenth Century*, highly

'I see this 'ere Rokeby Velasquez has been secured', remarks the man with the newspaper. 'Got 'im, have they?', his companion replies, 'I thought it was one of them aliens [foreigners] was at the bottom of that tunnel mystery.' Leaders of campaigns to 'rescue' works such as Velasquez' *Rokeby Venus* insisted that such works were, as Trustee Robert Witt put it, 'familiar friends' which 'fill the background of our minds'. This 1906 Will Owen cartoon from the *Daily Express* gently hints otherwise.

suspect: many petitioners were Sunday school children dragooned by their teachers, or friendly society members responding to what we would now call 'push polls'.[35]

The debate seemed to pit the Grand Old Men of Liberalism against a younger generation. Elements of the trade union movement took great solace from claiming Lord Shaftesbury and Gladstone as their champions. If there was any common ground, it was that the benefits of Sunday opening were far from clear. As Shaftesbury observed in the 1885 debate, 'that multitudes would throng to these Exhibitions was possible, but then they would consist of easy, comfortable people, who could go to them on any other day. But would they attract any of the frequenters of the gin-palace and the pot-house?' He invited Lord Thurlow, who supported opening, to accompany him on a walk around London's East End slums and ask himself if opening the National Gallery would 'transform' them 'into lovers of science and art, and would induce them to leave the joys of the gin-palace in order to spend their time in looking at statues and pictures?' A striking about turn, this, coming from one who had been the first to make the case for the Gallery as alternative to the gin palace back in 1832.[36]

For all those concerned evening opening seemed a way of avoiding the whole troublesome issue. The Working Men's Lord's Day Rest Association (led by Shaftesbury) petitioned the Gallery in 1885 asking for evening opening until 10pm three nights a week. Those who supported it in the Lords, such as the Marquess of Lothian, shared Shaftesbury's scepticism. 'He was not,' Lothian observed, 'one of those who placed great reliance on the educational influences of Art, [but] he thought it very desirable that the public should have increased means of participating in an innocent and refined pleasure.'[37] The Trustees had delayed the installation of gas lighting in the face of Cole's 1860 campaign by raising what turned out to be valid concerns about the effect of gas on paintings. They had failed to act, however, after an investigation by the chemist Faraday declared gas to be safe, and even after the Royal Academy introduced it next door. When the Academy moved out of their wing of Trafalgar Square in 1868, the Gallery was able to open up a

new suite of galleries. But first they removed the gasoliers. South Kensington went on to introduce electric light in 1880, followed by the British Museum in 1890. But the Gallery refused to countenance the idea, insisting in 1880 that the 'class of the public in whose favour the proposition has presumably been made would the least avail themselves of it if put into practice.' The idea of broader access through longer opening hours was now seen as 'a doubtful experiment', not least because of the 'riff-raff' (as J. C. Robinson called them) who might take advantage.[38]

All in all, therefore, the second half of the century seemed to see the Kingsleyan vision of social salvation fade. It became ever harder to imagine how the Gallery might serve the culture defended by Arnold and Ruskin. As noted in chapter two, the vision of socialist culture advanced in William Morris' *News from Nowhere* (1890) had no place for a national gallery, or, indeed, the state – even the organic one outlined by Arnold. Admittedly, art in Nowhere was no longer lodged on the trivial side of a work/play divide, and active creativity was shared by all. But the people inhabiting this Utopia seem curiously unaware of themselves as a people. In a similar way the nearly contemporary and equally influential work on *The Renaissance* by Walter Pater can also seem to be advancing a model of art appreciation located at the vanishing point of the cultural vectors outlined by Arnold. The Oxonian's writings on art are closely

High unemployment in the 1880s meant that hundreds of London's poor had no option but to sleep rough in public places, above all Trafalgar Square, where one policeman counted more than four hundred using it for this purpose on a single night. What with this, civil unrest and Fenian bombs in the Square, the Gallery was on the front line, and strongly opposed evening opening, fearing **rough sleepers** might enter.

identified with the *fin de siècle* decadence of Oscar Wilde and other artists who paraded a healthy disdain for institutions and audiences alike. This may have caused his importance for twentieth-century ways of seeing to be neglected.

Pater made the Arnoldian means, the 'free spontaneous play of consciousness,' into an end in itself. As with Arnold, he saw culture as reconnecting us with our best, most unified and balanced selves, but he did not, as Arnold did, see this as the preliminary to future action. The aim of engaging with art was the same as that of engaging with any other part of the world: to rouse us to a life of constant and eager observation. Pater nonetheless came up with an important justification of the Gallery's educational utility when he argued that 'the chief use in studying old masters' lay in the fact that artistic qualities and characteristics were 'written larger, and are easier to read [in them] than the analogues of them mixed, confused produc-tions of the modern mind.'[39] He managed to distill into words a fog of long- and deeply-held notions of old art as inspirational not because of its survival, its good taste or historical signifi-cance, but because out the passionate elements of a universal human nature. Although it had almost no impact on the Gallery at the time, Pater's approach was highly influential on Kenneth Clark and Michael Levey. The former noted in his 1961 edition of *The Renaissance* that Pater overtook 'in the candour and subtlety of his analysis, all the critics of his time and [drew] level with the ideas of our own day'.[40]

Arnold, Ruskin, Morris and Pater were all interested in exploring how culture could serve man's best interests. Several of them saw the 'bustle' and art historical knowledge of muse-um curators as counter-productive in this regard. All were dis-affected by national politics, and Ruskin and Morris believed the only real changes could be made on a local level, as 'exper-iments'. Between its establishment in 1888 and the First World War the London County Council (the LCC) implemented a number of social policies that linked urban rejuvenation with what have been called 'universalist notions of evolutionary socialism'.[41] The predominant Progressive Party numbered Independent Labour Party members such as John Burns

among its councillors. The LCC's army of blue- and especially white-collar workers were remunerated according to a 'fair wage' policy. Women were enfranchised to vote in LCC elections, and played a major role in the context of LCC-controlled museums such as the Horniman.

Even after the Progressives fell from power in 1907, the LCC continued to take dramatic steps introducing object-based learning to the classroom – or, rather, by making London museums an extension of the classroom. Teachers were seconded to museums to assess their collections' value as illustrative material. They then lectured to groups of local school teachers who would then guide their pupils round the museum, leading them in activities such as drawing and handling objects. Many schools developed their own museums, encouraging students to play at being curators themselves. Although the Trustees did agree to let LCC school parties visit the Tate outside normal opening hours, the National Gallery did not take part in such schemes, and only appointed a Schools Liaison Officer in the 1970s. As with Cole's educational projects, cooperation with civil servants was feared as a preliminary to a takeover. In the 1890s the Gallery privately feared 'Councilization'.

The introduction of museum lectures and classes during the twenty years either side of the 1918 Education Act was focussed on children – and relatively young children at that. The Kindergarten movement developed in nineteenth-century Germany had first been linked to museum learning in the essays of Jevons and other social scientists writing in the 1880s. The strong emphasis placed on children was such that by 1938 a Carnegie Trust report into museums could hail art galleries as furthering 'the visual education of the child and even the adult'. The museum could offer new teaching methods a bridgehead into schools. Although it was hoped that inspired children would drag their parents along on a repeat visit, the rise of state education was felt to have created a generation gap so wide that it could be hard to perceive the adult audience standing on the wrong side. If children were 'better educated than their parents' and 'more capable of absorbing knowledge,'

Previous pages: Bought by Eastlake in 1860, **An Allegory of Love** by Benvenuto Tisi (also known as Garofalo) was not formally added to the Gallery collection until 1932, perhaps because of its licentious nature, perhaps because it was immediately sent on loan to the National Gallery of Scotland. Established the previous decade, both the National Galleries of Scotland and Ireland fought for such loans, even though the works lent were ones the Trustees thought inferior.

then showing round groups of adults who just turned up was 'wasteful of the talents of trained instructors'.[42] Even Adult Education groups such as the Workers' Educational Association seem to have walked away from museums.

The introduction of lectures at the National Gallery in 1914 was the product of neither Ruskinian ideas of adult education nor the new theories of educationalists. Instead the driving force had been a campaign for museum lectures launched by Lord Sudeley in 1910. A retired naval officer who had turned to politics, Sudeley's campaign was couched in strappingly patriotic terms that would have cheered Kingsley and made Arnold wilt. He believed that too little had been done to render the national collections useful in providing 'Instruction in the fullest meaning of that term, Education, and the Intellectual recreation of the public'. 'Until the system of popular lectures was started ten years ago,' Sudeley wrote in 1921 (just a year before his death), the only way of obtaining such knowledge 'was by the dreary process of reading labels and guide-books.'[43] In an address to LCC teachers he stated that museum guides taught 'classical ideals,' instilling a spirit that 'insisted on unselfish obedience to law and order, [that] inculcated, as one of the highest duties of the citizen, the duty and beauty of physical fitness, it taught a lofty patriotism, and a single-minded devotion to the good of the state.'[44] Wrapping the museum in a cross between the flag and a toga was Kiplingesque, but stripped it of the 'treasure house' aura. That said, Sudeley does not seem to have played any part in shaping the style or content of the lectures he helped to bring about.

Twice-daily lectures were given at the Gallery from April 1, 1914, three years after they had been introduced at the British Museum. The lectures were interrupted when the Gallery's first lecturer, Kaines Smith, went to war, resuming in 1919. They were held at times convenient for those on their lunch hour (12 and 2). Saturday lectures were introduced in 1930, and Clark added a dedicated first-floor lecture room equipped with an 'epidiascope' (slide projector) in 1935.[45] Although there were no official lectures for children, teachers could, of course, take their pupils round on their own. Kaines Smith's 1921 *Looking at*

Tramps and vagrants found the Gallery's open door policy particulary welcoming, as this 1925 view by Stanley Anderson shows. Until the opening of Hawks' suite of Gallerys in 1911 the seats had been rather uncomfortable. With the introduction of upholstered benches and 'radiator islands' in the centre of the public rooms, however, sheltering in the Gallery became a much more inviting prospect. The tramps seem to have stopped patronizing the Gallery at some point in the early 1970s.

pictures suggests that his lectures shared many characteristics with Summerly's guides. There is the same encouragement to build on an appreciation for 'easy' anecdotal works like Frith's *Derby Day*, to ignore the 'cant of criticism' and feel part-owner-ship in the works. A focus on sentiment is, if anything, insisted on even more strongly. 'Inspiration, aim, effort are what mat-ter, and these are all sentiment,' Smith wrote, 'all else is clever-ness, a good thing in itself, but not enough alone.'[46] Where Smith differs from early Victorian guides is in what he does not mention: there is no suggestion that art can change the viewer or society as a whole.

The eclipse of outreach was never clearer than in 1921, when the doubling of what were now simply called 'paying days' was hardly noticed. Despite strong evidence that few young artists were taking advantage of free access on these days to study undisturbed, the Director, Charles Holmes, opposed free access across the board. The Gallery should not forget that its mission was to 'a limited number of geniuses,' rather than 'a few thousand people who were not geniuses'.[47] It

took two years for the *Burlington Magazine* to respond, with a tepid complaint by the engraver Muirhead Bone about the 'alienation' created by the move. The magazine was soon back to refereeing Fry, Bell and MacColl's wearisome tiffs about significant form in Cézanne's *Bacchanales*.[48]

When an increase in the incidence of museum admission fees was proposed in March 1923, the Parliamentary Secretary to the Board of Trade cited the doubling of paying days at the Gallery in support of the measure: 'It has not been found to reduce the number of visitors,' he stated, 'and has brought in a really appreciable contribution towards the upkeep of the institution.' Although Labour leader Ramsay MacDonald objected to a measure that would allowed the 'treasures of the nation... to be enjoyed only by a small class of the nation,' for the most part the debate in and out of Westminster remained low-key.[49] Clearly there was less political as well as social capital invested in access, compared to fifty years either side.

F. W. Thomas' visit to the Gallery in 1925 as part of the 'Low and I' feature in *The Star*, was a boring chore, enlivened only by the attempt to imagine how the Gallery might liven itself up by imitating the marketing methods used by that other great 'picture palace': the cinema.[50] One member of the 1927 Royal Commission who was also a Trustee, Robert Witt, appeared willing to consider the idea of adding an organ, organ preludes being a prominent feature of cinematic performances. Yet the note of hesitation in his exchange with Tate Keeper Charles Aitken is clear:

Witt: 'I should very much like to provide music. I have not thought of an organ. It is a little like the cinema.'
Aitken: Would not it be a good thing if it were like the cinema in that it draws thousands and thousands of people?[51]

In addition to free concerts the Commission had also advocated the establishment of evening opening, museum restaurants, improved rest-rooms, shops and temporary exhibitions. While Holmes had held a few concerts in 1922, for the most part he and the Trustees did not see these needs as urgent. There were,

David Low and F. W. Thomas visited Trafalgar Square in 1925 looking for material for one of their regular *Low and I* columns. Low included a courting couple among his vignettes. In poor weather the Gallery was one of the few free (yet respectable) places where couples could meet. As recorded in the poem 'Love in the National Gallery', one of the most popular trysting places was next to Turner's *Crossing the Brook* (1815):

*My mother's the difficult sort,
 and he'd a mamma of his own,
And so we were able to court at
 the public collections alone.
Ah! many the vows that we
 swore, and many the kisses
 he took
As we sat with one eye on the
 door, and the other on
 "Crossing the Brook".*

Holmes argued, plenty of tea-rooms and restaurants in the vicinity. He failed to appreciate that such facilities were being advocated as a means of keeping visitors in the Gallery longer. Although the Trustees formally refused the suggestion in 1928, in June 1934 they agreed to establish a refreshment room. The Treasury refused funding.[52]

Publicity and Propaganda

Despite such proposals for reform, the Commission achieved little, other than diagnosing a serious outbreak of museum fatigue (now called 'exhibition terror') among the museum-visiting public.[53] It was only in the 1930s that this mood of museum malaise which had dominated since the 1880s started to clear. In particular under Clark's Directorship, the Gallery reflected the optimistic internationalism of the great block-buster exhibitions. In retrospect it can seem difficult to imagine how the Fascist regimes' abuse of touring exhibitions could have been applauded, let alone seen as a way of sponsoring world peace. Ormsby Gore's 1931 speech to the Commons nonetheless reflected a widespread optimism that encouraged access initiatives like evening opening. The blockbuster travelling exhibitions, he observed,

are a real delight to ever-increasing thousands of people of all classes and in all walks of life. Unhappily, most of our museums are only open for a few hours in the day. Most of them close at four or five in the afternoon, and the vast mass of the public who care about these things, but who are at work all day except just on a Sunday afternoon, have little or no chance of ever seeing them. One of the great values of these exhibitions is that invariably they are open till late hours in the evening under specially favourable conditions. The appreciation of art is a growing democratic movement, and we should recognize that fact by assisting the public to see pictures in this way... We have centred in the League of Nations a body calling itself the Committee of Intellectual Co-operation. Is it not high time that apart from the purely intellectual co-operation of the philosophers and the scientists, there was active co-operation in the art world? I believe that that can do more, perhaps, than anything else to bring countries to a closer understanding of each other.[54]

Conspicuous by its absence is the commonplace which saw the Gallery as especially important for the working class. Ten years previous Sudeley's *Nineteenth Century* essay had fleetingly referred to galleries' appeal 'to number of workers in industrial life who find great benefit from studying the triumphs of the past and thus gathering wisdom for their own work'.[55]

This constituency had entirely disappeared by the time of the 1927 Royal Commission, which urged evening opening and more lectures as means of addressing 'the needs of the business man, and now of the business woman,' which had, it noted, never been properly identified before.[56] The rise in the number of 'black coated' (white-collar) workers in London from 262,000 in 1871 to almost a million in 1911 had passed museums by, as had the change in leisure habits created by suburbanization and the Garden City movement. The late nineteenth-century debate on Sunday opening had remained rigidly focussed on the industrial working class, and the 'working man' at that.

Until very recently, the history of lavatories at the National Gallery has been an unhappy one. In the early years the need for such facilities was clear: Uwins reported in 1853 that the corners of the galleries were 'swimming in water' – visitors with young children had no choice but to let them relieve themselves on the spot. In March 1856 some ladies got together a petition for a toilet, but Eastlake feared the ongoing costs of water and cleaning. 'If a glass [i.e. a mirror] would satisfy them that might be easily provided,' he told Wornum.[57] Lavatories were introduced in 1917, but failure to expand and refurbish them regularly ensured that they remained cramped and noisome. The importance of such provision for female visitors can hardly be exaggerated. Without decent facilities available in the centre of London expeditions into town had to be kept short. Even when parish councils awoke to this need at the very end of the nineteenth century, they encountered stiff resistance from those, including women, who feared that public lavatories ('German abominations') would become the haunts of 'public women' (prostitutes). Spying an opportunity, the new shopping emporia of the West End used lavatories, restrooms and restaurants as a means of luring customers.[58]

In 1931 Clark urged the establishment of a 'Rest-room' next to the lavatories (the former was not, as now in America, a euphemism for the latter) 'for women visitors who may be affected by "museum fatigue"'. The Office of Works refused to consider such requests, however, and Clark was still having to

raise the matter ten years later, when he noted that such a facility had been 'turned down because it would be used by tramps etc.' 'This,' he went on, 'is the sort of objection which can be made to any amenity. The present lavatories are out of date, and the ladies lavatory is a disgrace. It is the subject of frequent complaints and has been reported by sanitary inspectors.' Again, little was done.[59]

Clark had rather more success with evening opening. In the late 1920s and 1930s the Gallery had come to realize that weekend opening was an irrelevance to that mass of people who retreated to the cultural desert of 'Metroland' on Friday afternoon. They required evening opening. When the Treasury approved evening opening in 1935 it was strictly on an experimental basis, however, and its continuation after the initial trial period was dependent on satisfactory visitor statistics. Although Holmes had not been above issuing leaks to the press to score points off his Trustees, Clark now worked the media as no Director ever had before. In 1934 he had unsuccessfully asked the Treasury to fund a 'Liaison Officer' – effectively, a press and public relations officer.[60] Denied professional assistance, he and Assistant Curator MacLaren liaised with the BBC, *The Listener*, the dailies and London Underground to trumpet the new initiative. The Gallery even held its first Press View. The introduction of evening opening until 8pm three nights a week from April 1935 was presented to the press as being aimed directly at office workers. Starting the following year 6:30pm lectures were introduced. Such innovations went a good way towards addressing the frustration of both the 1927 Royal Commission and 1938 Carnegie report at museums' stubborn refusal to appeal to the public through advertising, signage, less cluttered displays and changing exhibitions – in a word, propaganda.

In the 1920s and 1930s 'propaganda' served to denote a new type of advertising, one that replaced endless repetitions of a product's name with more sophisticated ploys founded on the new American science of 'behaviourism'.[61] Thanks to the pioneering work of Jack Beddington at Shell-Mex, such forms of 'propaganda' could themselves be marketed as the saviour of

art: corporate sponsorship seemed more willing to sponsor 'challenging' work by Epstein, Graham Sutherland and Paul Nash than the state. The National Gallery encouraged such work. Clark opened an exhibition of Shell-Mex posters in 1933, and, much earlier, even the self-effacing Holroyd had allowed himself to be called in to approve Epstein's sculptures on the British Medical Association building – an extremely contentious commission in 1908.[62]

Bringing Epstein back from the wilderness into which his BMA sculptures cast him was one of the many services Frank Pick of the London Passenger Transport Board performed for British art patronage. He helped the National Gallery's propaganda work by having his staff design and display posters gratis. These started in 1910 with a poster that simply listed London museums and their opening hours, illustrated with small black and white vignettes. From 1919 posters solely advertising the Gallery began appearing, including large reproductions of paintings. In 1923 came the first experiment with text. Entitled 'Worthies in the National Gallery,' a poster illustrated with 11 portraits from the Gallery's collection had a text which highlighted art's power to preserve the real presence of unknown men. Not only were the identities of the sitters known, however, but the 'moral' they supposedly illustrated was decidedly obscure. 'By what wayward chances and for what diverse reasons are they now brought together?', it asked. 'To form a cautionary tale to those who by like chances and for like reasons must go to see them, and meditate on their fame.' Under Clark the posters fortunately dispensed with such dark, incoherent mumblings. The paintings selected for reproduction were, interestingly, not popular or particularly familiar paintings.

While Clark and Pick cooperated closely, and would work together at the Ministry of Information during the War, the latter could be painfully frank about the limitations of propaganda. He viewed the gallery posters on the underground as a failure, proving that the Gallery could not compete with big business. What mattered was what went on inside the Gallery. More temporary shows were needed, for which the press could provide publicity. 'He emphasised the fact that the public is not

Frank Pick of the London Passenger Transit Board was a pioneer of design who made the tube a forcing ground for new talent. He also helped museums like the National Gallery by designing a series of free posters. The first appeared in 1919, followed in 1923 by this remarkably unappealing invitation to visit the 'Worthies' of Trafalgar Square'.

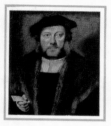

WORTHIES IN THE
NATIONAL GALLERY
TRAFALGAR SQUARE

"Some are born great, some achieve greatness,
and some have greatness thrust upon 'em."

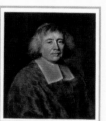

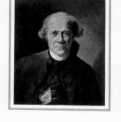

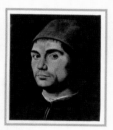

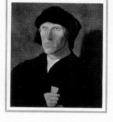

THAT these men are real none can question
who sees them thus surviving their
mortality. So little is known of them that they
are become hardly better than characters of
fiction. On each one's face there is written a
book. By what wayward chances and for what
diverse reasons are they now brought together
here? To form a cautionary tale to those who
by like chances and for like reasons must go
to see them, and meditate on their fame.

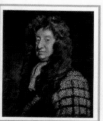

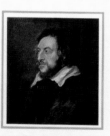

EDMUND BUTTS.
Dr. FUCHSIUS.
ANTONELLO.
JOHN HAY, 1st MARQUESS OF TWEEDDALE.

BATTISTA FISTA OF MANTUA.
DUCREUX.
CARDINAL DE RETZ.
THOMAS 2nd EARL OF ARUNDEL, K.G.
and others unknown.

This colourful, semi-abstract London Underground poster by **Robert Scanlon** (late 1950s) is typical of the livelier images adopted postwar. 'When did you last see your Picassos?' ran the strapline on another. Designs by Scanlon, Unger and Bassingthwaite presented museums as vibrant places, as opportunities to escape postwar austerity.

at all interested in works of art as such, but only for their content, value or historical associations, and that articles on the exhibitions should be written with these facts in mind.' Clark could not have disagreed more. As he would write eight years later, 'with pictures the important thing is our direct response to them... We do not want to know *about* them; we want to *know* them, and explanation may too often interfere with our direct responses.'

Yet Pick's advice had only confirmed that which Clark had received in 1936 from Echoes, a PR agency. They urged the Gallery to make all publicity efforts event-based: drawing attention to new acquisitions, new hangs, links to other temporary shows and a 'picture of the week' (a strategy developed at the V&A).[63] Despite the lack of space for temporary exhibitions, Clark did seek to follow this advice by putting on small temporary shows of loaned works related to paintings in the permanent collection, such as that of a Daddi *Marriage of the Virgin* and a Duccio *Crucifixion* from the Royal Collection, held in 1937. When he announced this show to the Trustees he also argued that the paying days should be eliminated – the first Gallery Director to argue that charging represented 'a considerable barrier to the full public enjoyment of the Gallery'.[64]

Pick's comment that the public was uninterested in 'works of art as such,' that they were only interesting as unusually old and expensive objects depicting historical personalities must have led Clark and the Trustees to wonder if propaganda really was a way of increasing public appreciation of the paintings. New technologies such as colour lithography, radio and television, which Clark experimented with the following month, seemed to offer a wonderful opportunity to diffuse culture. Indeed, Clark had got the idea for his 1938 book *One hundred details from paintings in the National Gallery* from a 1937 TV quiz show in which contestants won points by recognizing details from famous paintings.[65] The 1945 Dartington Arts Enquiry gushed that modern printing methods 'could do for the visual arts what the gramophone has done for music... making knowledge and appreciation of the masterpieces possible to all, incalculably widening the range of general experience and to a

considerable extent forming popular taste.' Reproductions would increase the demand for direct contact with originals, boosting gallery attendances.[66]

Unfortunately, as had been discovered in the 1830s and 1840s in the context of textile design, new technologies seemed to undermine good art, replacing taste with an insatiable appetite for variety and novelty. In a mass consumer society technology seemed to shorten the life of works of art. A. V. Broadhurst of the Music Publishers Association told the 27th Earl of Crawford's 1925 Committee on Broadcasting that radio shortened the life of songs.[67] Crawford's opposition to loan powers in the 1930s was founded on the belief that the hunger for ever more temporary blockbuster exhibitions was shortening the life of Old Master paintings. In 1937, Clark was unwilling to consider televising paintings because the bright lights and 'crowds of exciting people' milling around made him fear for the paintings' safety. How could the Gallery paintings, seen as symbols of an enduring European civilization, survive this onslaught?

In the years around 1930 a string of publications appeared discussing the problem of culture in a democratic society, in a conscious return to a question adumbrated by Arnold in 1867. Clive Bell's 1928 *Civilisation* (published in cheap Penguin paperback) combined Pater's 'aesthetic ecstasy' and Roger Fry's 'significant form' to formulate a vision of the world his Bloomsbury associates had hoped the holocaust of the First World War would create. True civilization, which had nothing to do with comfort, property or technological advancement, could only be created in a society in which a group of artists were supported by a majority made up of slaves. Those who felt that inequality was intolerable should, he opined, have the courage to admit that 'you can dispense with civilization and that equality, not good, is what you want. Complete human equality is compatible only with complete savagery.'[68] F. R. Leavis' 1930 essay on 'Mass Civilization and Minority Culture' agreed that the uncritical celebration of technology and the novelty of the choices it made available to a mass audience were actually narrowing the spectrum of production and

creativity, centering cultural authority on 'the taste of the bathos' and cheap sentiment. This taste found authority in sheer numbers, reviling as 'highbrow' the taste of that true elite of men capable of 'unprompted, first-hand judgment'.[69]

Although published much later, Richard Hoggart's *The Uses of Literacy* (1957) was founded on his childhood in the 1920s and 1930s and in many respects shared this perspective. Hoggart's 'candy-floss' culture was one of high output and low expectations. It encouraged an easy-going attitude that refused to pass judgments on quality. On the rare occasions when it was confronted with values or cultural forms which did make claims to superiority it fought back by accusing would-be 'improvers' of being patronizing, hypocritical, or puritanical. It didn't want to be improved. It wanted to be left alone. Yet Hoggart found little comfort in the white-collar workers who liked Picasso because they thought it was the go-ahead thing, or in a middle class he felt had 'opted-out' of their duty of cultural leadership. It was the same 'doing as one likes' mentality and middle-class 'distrust of themselves as an adequate centre of authority' Arnold had identified back in 1867.[70]

'Are we building a new culture?'

Clark's position on culture and democracy was not far removed from that of Bell. In an echo of Lord Reith's policy towards BBC programming, he argued in an 1945 *Cornhill Magazine* essay that the people did not know what they really wanted, let alone needed. 'No doubt it will be necessary to tempt the people with scraps,' he wrote in 1945, 'but they must not be spoon fed or they will never learn to feed themselves, and will soon become too lazy even to open their mouths. We cannot compete with the cinemas and we should not try to.'[71] For all the pessimism which underlay his work as communicator, Clark was energized by the possibilities created by the war: six years in which the tide of mass culture had been halted, six years to use the massively swollen State machine to lay the foundations of a healthier post-war culture.

Clark was an ally in Keynes' takeover of CEMA in 1942.

'The failure of the nineteenth century democracies to maintain the grandeur and dignity of the State is, in my judgment, one at least of the seeds of their decay,' Trustee **John Maynard Keynes** wrote shortly before the Second World War. As one of the Bloomsbury Group earlier in the century Keynes had found it easy to join in criticism of the artistic Establishment. CEMA gave him the chance to remodel state arts policy from the ground up, with mixed results.

Although the National Gallery was not funded by the Arts Council, the latter's origins during the Second World War are inextricably linked with the Gallery's history. Not only was Clark head of CEMA's art panel and Keynes a Trustee of the Gallery, but in the absence of the vast majority of the collection Gallery space was handed over to temporary shows which Clark either organized under CEMA's aegis or which were closely related to the vision of a national culture it propounded.

Clark shared Keynes's belief that a culture of discrimination, preservation and appreciation was preferable to one of inclusiveness, enthusiasm and participation. Although CEMA later insisted that its slogan was Ivor Brown's 'The Best for the Most,' a look at its 1942 publication *The Arts in War-time* (reputedly penned by Keynes himself) cites a couplet taken from Herbert Farjeon's prologue to the opening performance of *She Stoops to Conquer* at the Theatre Royal Bristol, stating that this represented the 'almost official motto': 'Making it our endeavour, first and last, / To serve the present and deserve the past.' Although 'spontaneous, intelligent comments' by audience members were welcome, culture in CEMA's eyes was an enduring tradition whose merits were beyond discussion.

This 'culture' was identified with the 'civilisation' Britain was fighting to protect. Yet, as Bell and Leavis had suggested, a lot was lost if 'civilisation' was allowed to become a synonym for 'culture': the former was less dynamic, more vague and too easily associated with the triumph of science or consumer affluence. It was also less participatory. *The Arts in War-time* skated over the cut in funding for Bill Williams' 'Art for the People' shows, noting that CEMA wanted to be associated with the greatest works, 'and with the national collections'. Although the shift in emphasis was to a certain extent camouflaged by Keynes's rhetoric and back-stairs manipulation, the contrast with the participatory ethos of both the Minister of Education of the time (Earl de la Warr) and of the Pilgrim Trust who provided the funding is striking.

Williams' travelling exhibitions dated back to 1935, and, together with those organized by the National Council on Social Service in the 1930s, had brought shows of professional

and amateur art to galleryless towns, putting on displays in electricity and gas showrooms, factories and cafés. The NCSS specialized in exhibitions intended as a form of social welfare provision in areas hit by industrial depression. Artworks were interpreted by lecturers who travelled with the show, and who encouraged viewers to draw and paint themselves, in the same way as CEMA's 'music travellers' (another program axed by Keynes) had both put on performances and started local amateur groups. Clark believed that such shows were giving a false impression of what the authorities considered to be great art, and replaced tours of original works with tours of framed reproductions of Gallery and other Old Master paintings. He did not see any need for guide lecturers – if the art was truly good it would speak for itself. Like Clark, Keynes was 'worried lest what one may call the welfare side was to be developed at the expense of the artistic side and of standards generally.'[72]

In his *Picture Post* article of 1943 entitled 'Are we building a new culture?', Williams had painted a glorious picture of the future his Army Bureau of Current Affairs and CEMA were building. The article featured pictures of female munitions factory workers putting on their own amateur ballet performances, captioned 'Nine workers dance for all the other workers.' Such projects inspired a hope

that the day may come when the art treasures of the country, released from the Chained-Bible stage in which they so often remain to-day, will be exhibited in those places where the community works and eats and waits for a train. If art is made truly accessible it may become attractive and intelligible to the man-in-the street.[73]

The large and heterogeneous audience for the One Picture exhibitions combined what had seemed good 'propaganda' (marketing) in the 1930s with a vision of a classless postwar Jerusalem useful as propaganda in the modern sense of the term.

In a surprisingly short space of time, however, Williams was co-opted by Keynes's vision of CEMA, and turned from a 'spreader' to a 'raiser,' being rewarded with a Gallery Trusteeship in 1949. By contrast CEMA's first Secretary (Mary Glasgow) fought for the original vision, arguing that the Arts

Council should resist pressure to fund concerts and art exhibitions directly, as this came 'from the highbrows in Parliament and elsewhere who look to the Arts Council for the maintenance of exclusive artistic standards'.[74]

Labour's 1945 manifesto, *Let us face the future*, had seemed to underpin CEMA's approach to culture in proposing that the authorities provide concert halls, theatres and civic centres 'so as to provide our people full access to the great heritage of culture in this nation.' A closer look at the views of the Labour ministers who laid the foundations of the NHS and a planned economy, however, suggests that the highly-centralized metropolitan focus on defending high standards was not necessarily shared. If Clark and Keynes looked to Arnold, Aneurin Bevan and Anthony Crosland looked to Morris. Labour's technocratic focus on economic issues and planning, Crosland wrote in *The Future of Socialism* (1956), represented the legacy of a joyless, puritanical Fabianism. Although the Webbs and their Blue Books had won a posthumous triumph, 'now the time has come for a reaction: for a greater emphasis on private life, on freedom and dissent, on culture, beauty, leisure and even frivolity.'[75]

Far from seeking to broaden access to the nation's art heritage, such socialist visions could, as with Morris, see the National Gallery as an irrelevance, if not a painful memory of how pre-War free-market society had abused art. Bevan's *In Place of Fear* (1952) saw the museum as complicit in a competitive system which had put 'virtues of contemplation and of reflection... at a discount.'

It is essential to realise that most of the glories of art were produced for social and not for private contemplation. Occasionally a rich collector who had bought them as an investment might leave them as a legacy to a museum, in which case they are immured in museums and art galleries, where they look reproachfully down on the long processions of sightseers, who can catch, in such a context, only a small glimpse of their beauty.[76]

In the 1840s the frescoes commissioned for the new Houses of Parliament from William Dyce and other artists had been

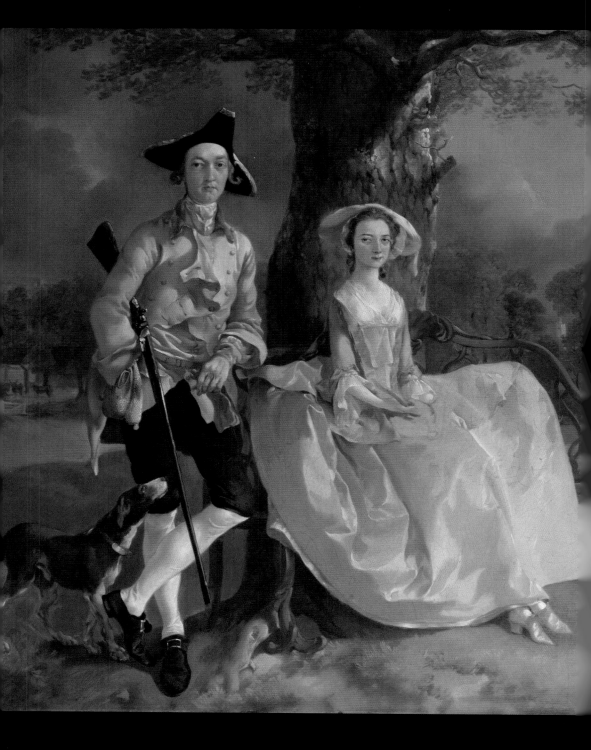

intended as a 'people's history'. A century on Bevan's working man viewed these same frescoes very differently. 'It is not the past of his people,' 'they were shut out from this.'[77]

Labour MPs shared the view that the party's patronage of the art should face the future, not seek to 'deserve the past'. This was made clear in wartime parliamentary debates on protecting Britain's art heritage from export abroad. 'It is more art that we want in life,' one noted, 'real living art, rather than gathering together the remnants of a by-gone age, perhaps beautiful in their way, and signs or examples of what we should do now.'[78] Putting it even more pithily, another MP asked whether those seeking to defend Britain's heritage realized 'that unless snobbish Americans buy the furniture of aristocratic houses, we shall not be able to pay for a Ministry of Social Security?'[79] Just because Americans wanted Old Master paintings to give their vulgar commercial society a veneer of 'culture' did not mean that we had to cling to them. In so far as Labour envisaged Britain as Greece to America's Rome, it was highly fitting that this should happen.[80] That such attitudes were shared outside cabinet and parliament was shown by the public outcry opposing the rescue from export of the El Greco *Adoration of the Name of Jesus* in 1955, and by Kempton Bunton's theft of the Goya fourteen days after its rescue in 1964. Both purchases were seen as symptomatic of the neglect of more important commitment to benefits for OAPs – as a betrayal of the Welfare State, not as the cultural arm of that project.

Clearly the 1930s gap between highbrows and lowbrows had widened. The Oxbridge 'intellectual aristocracy' never had it so good. As *Encounter* noted in 1955, 'Never has an intellectual class found its society and its culture so much to its satisfaction.'[81] As the dilatory progress of post-war refurbishment at Trafalgar Square demonstrated, central government did not see the construction of arts infrastructure as a priority.[82] As Charles Landstone has argued, the dispersal of the wartime audience was partly an inevitable result of the closure of shelters and relocation centres. The Arts Council focus on London and the defence of professional standards clearly

Previous pages: John Berger used the magic of television to hang a 'No Trespassing' sign from the tree in Thomas Gainsborough's **Mr. and Mrs. Andrews** (c. 1750) in his 1972 series *Ways of Seeing*. In 1971 the image was used to advertise Sotheby's Special Reserve brand cigarettes. It has since been used to sell the Renault Mégane saloon car. Reasons enough to drive anyone to reach for their gun.

played a role. Roy Shaw, its third Secretary-General, was another working-class boy who entered the Council from a career in adult education. As with Williams, the mandarins turned him against a community-focussed culture, something he later called 'a cod's head culture for the poor'.[83] But some blame must fall on the non-Bevanite mainstream of the Labour Party. While the Conservatives accepted the Welfare State and planning, Labour in turn accepted a definition of 'modern civilisation' rooted in personal choice.[84]

In effect, the perennial 'raise or spread' dilemma of improvement had re-emerged in reverse. Although Crosland denied there was a conflict between raising living standards and spreading culture, his idea of solidarity through consumption made it difficult to see it as anything but a choice of one over the other. Certainly the hidebound attitude of the 1950s Labour Left towards youth culture, television and other unfamiliar aspects of the 'affluent society' prevented Labour from developing a clear strategy. Echoing Hoggart's language, socialists tended to dismiss consumers and viewers as unwitting victims of manipulation, inhabiting a world of 'make believe'. Not having a television almost became a badge of membership in New Left circles, as old puritan nostrums harking back to the days of Rational Recreation reemerged.

The party's *Leisure for Living* manifesto of 1959 looked forward to a time when it would be second nature for someone to buy 'an oil painting of real merit for half the price of a television set'. It was as if the medium really was the message – rather than simply being a device that could relay good and bad programming. At its worst such policies seemed not just confused, but unwilling to question the party's assumption that it was the state's duty to provide culture, defined in old-fashioned 'high culture' terms.[85]

Part of this may have been down to fear of the success of Fascist regimes in using museums to create a dynamic national culture. Although such methods continued to find support among museum experts, for Bevan and Roy Shaw national culture was to have nothing to do with encouraging 'group' or 'undisciplined emotions' of the sort they blamed for causing

the war. Art was a way of broadening the individual's 'repertory of feelings', a gamut of emotions that were felt rather than acted upon.[86]

As Director Philip Hendy did not fit well into the post-war Oxbridge mandarinate celebrated by Noel Annan's *Our Age*. Although he never evinced much interest in broadcast media, he did carry on Clark's work of improving facilities at the gallery, even though space was very much at a premium. Building on the success of the wartime canteen, a restaurant was established in 1955. In December 1944 Clark had put on the first educational programme aimed at children: Christmas Lectures modelled on those at the Royal Institution. Hendy increased the frequency of such activities and reintroduced evening opening until 9pm in 1960. In 1956 he introduced a Schools Scheme, involving loans of colour prints of Gallery paintings with short explanatory texts.[87]

Although the results appeared antiseptic to his Trustees, Hendy's redesign of interiors of the west wing galleries represented a genuine attempt to make the building's marble columns and lofty galleries less forbidding. Both his acquisitions and the gadgetry of his cleaned picture show can also be seen as a form of outreach: they suggested links with contemporary art and science celebrated at the Festival of Britain.

This detail from a 1952 **Underground poster** designed by Hans Unger is typical of the less reverential posters produced after the war.

Hans Unger and Lewin Bassingthwaite's Underground posters reflected the changed mood with dynamic interpretations of the Gallery's façade and contents. Although the text accompanying Unger's 1952 poster still referred to ideas of the 'poor man's gallery,' it did inject a new note of alliterative, shoulder-shrugging chumminess:

We hear much about the street being the poor man's art gallery, but, in fact, most of London's public art galleries art are free. If you like looking at pictures or looking at the people who look at pictures or merely like to sit undisturbed and think how much less pleasant it is outside, you can do so for nothing, or next to nothing. Once there, you are equally welcome, whether as a connoisseur of Caravaggio, a fan of Frith or a would-be lover of both if only you could tell either from the other.[88]

A 1949 poster, written in an older idiom, had solemnly remarked that to know the gallery's paintings 'took time'. In an echo of Cole's 'Summerly' guides of the 1840s, it advised the neophyte to start by looking at Michelangelo's *Entombment* and the *Wilton Diptych*, 'and go again and again'.[89] Although separated by a mere three years, the contrast in tone is clear: instead of stressing effort and telling would-be visitors how to use the gallery, the 1952 text suggests three equally valid and enjoyable ways of using the same space, and celebrates the muddling of attributions.

Civilisation and its discontents

For all the contrast it offered to pre-war attitudes, this mildly complacent and patronizing mood irritated Jennie Lee, and as Britain's first Minister for the Arts her 1964 *Policy for the Arts* vowed not to let the Bevanite vision go down without a fight. Lee blamed the failure of this vision on philistine press comment and on the failure of reconstructed communities to encourage 'habits of neighbourliness and cooperation'. In a corrective to CEMA's own wartime rhetoric, she insisted that the vast majority of 'working people' had not yet been brought into contact with the art. 'People who had never known what they

were missing did not press for galleries.' Fortunately a more confident younger generation ('more hopeful material') had arrived. The aggressive aspects of that youth culture which had appeared in the 1950s were not a threat to culture, but an opportunity. Such energies could be 'directed... into making Britain a gayer and more cultivated country.'[90]

Privately the Gallery staff found Lee's enthusiastic misattributions and complaints about the rock cake served in the restaurant bemusing and irritating by turns. Although it can be hard to square with her career as an outspoken scourge of trimmers within the Labour movement, Lee did not see the museum as a temple to be defended from marketing methods pioneered in the cut-throat world of business. Although Roy Strong found her 'a bit clogged up with *vieux jeu* socialism,' the two clearly enjoyed a symbiotic relationship. Appointed Director of the National Portrait Gallery in 1968, Strong took the idea of museum-visiting as experience to a new level, organizing shows that courted and explored celebrity. Whereas the development of the celebrity in the 1920s had been seen as a threat to enduring historical values, Strong's 'Elizabethan Image' show at the NPG suggested that the notion could be timeless. According to Strong's diaries, Hendy never acknowledged his existence. 'No one at the National Gallery can have welcomed the sudden glamourous renaissance inaugurated by the young Director of the poor relation, which had produced phenomena-like queues around the corner into Trafalgar Square...'[91] Even less biased observers noted how ineffectual Martin Davies' 1971 Museum Association speech was when compared to Strong's 'Martinis with the Bellinis' speech (as the press dubbed it) the previous year.[92]

Whatever Lee's policy lacked in discrimination, it more than made up for in generosity. Strong knew Lee was where the money was – and was prepared to play up to her 'diversity' and 'gaiety' mantras. The Gallery certainly was not. In April 1966 the police visited in response to rumours that 'men were picking up girls on the premises'. As its Establishment Officer sternly noted in 1968, '"Beatniks" and their associates we will not tolerate.' Admittedly, this was a response to an outbreak of

Kenneth Clark's *Civilisation* (1969) proved that colour television - a novelty associated with tacky American gameshows – could be used for improving ends. Directors Michael Gill and Peter Monagnon pursued an exhausting itinerary, visiting eleven countries and using 117 locations. Clark felt that the reason for the series' success was simple: 'the average man was pleased when someone spoke to him in a friendly, natural manner about things that he had always assumed were out of his reach.'

drug dealing and other 'offensive behaviour' in the Gallery. The Chairman of Trustees found the Gallery ill-equipped with powers to regulate 'the behaviour of certain unkempt young persons whose manners and whose presence in the state they choose to display [themselves in] excited the repugnance of himself... the whole Board and of all respectable visitors to the Gallery.' Quite what this behaviour was is unclear, but anecdotal evidence suggests that circulation (notably on the steps) could be blocked by groups of stoned hippies. A notice was put up which reserved to the Trustees the right to refuse admission, while the attendants' uniforms were made to look more like those of police officers.[93] Apart from that and a sit-in or two, it would appear that the counter-culture ignored the 'squares' of Trafalgar Square.

Perhaps as a result of this, attempts to use the Gallery to explore issues of the body and sexuality in this period could

prove startlingly incoherent. Lorna Pegram's 1970 BBC documentary *A Venus Observed* focussed on the *Rokeby Venus*, exploring its provenance, the Suffragette attacks, and the line between fine art and what one ten-year-old boy interviewed primly called 'filth'. The documentary cut rapidly between interviews with a practising artist, an anatomist at St. Mary's Hospital, a psychologist outside a Soho sex-shop, a pub in Rokeby, the Gallery's shop assistant and Victor Lyons of the Playboy Club, who just had time to explain why Velázquez' Venus was a Bunny rather than a Playmate before the show ended with footage of plump housewives working out at the Buxted Park Health Hydro (to the sounds of *I'm your Venus*). To modern eyes, the show is vaguely redolent of *Monty Python's Flying Circus*. A closer look reveals that, for all its enthusiasm and range, only two women were given the opportunity to speak.[94]

Thankfully the Gallery's own efforts at organized educational activities for children were somewhat better organized. Thanks to the efforts of one of the curators, Alistair Smith, the Gallery laid the foundations of a dedicated Education

One of the ways Jennie Lee attempted to rejuvenate the Gallery's image was by insisting that the new Northern Extension have a room for teenagers. By the time it opened in 1975 Lee was no longer Minister for the Arts, and the room became a **smoking room** instead. Director Michael Levey felt it was important to have a room without paintings to which visitors could repair in order to savour the paintings as if at one remove, through recollection.

The foundations of the Gallery's Education Department were laid in the 1970s. **Activities for younger schoolchildren** were laid on, and the new Northern Extension provided cloakrooms and lunchrooms.

Department in the mid-1970s. This was roughly a decade later than the V&A, where Trenchard Cox and Michael Kauffmann had been pioneers. A Schools Liaison Officer was appointed, for example, who used the GLC's school dinner vans to distribute information outlining a new range of specialized activities. A room was set aside for school parties to eat their packed lunches in. Feeling that primary school children represented more of a *tabula rasa*, the first activities (quiz sheets) were aimed at 'making them... concentrate and look very carefully... very often in a certain order, an organized order dictated by the composition of the painting.' The picture trails also provided opportunities to engage imaginatively with works of art, by naming the dog in Piero di Cosimo's *Mythological subject*, for example.[95]

Meanwhile lectures for adults were made less 'art historical' by the first audio-visual displays in the lecture room. A pre-recorded sound-track was linked to an automatic slide projector, the displays being designed to highlight 'process,' encouraging visitors to view paintings as crafted artefacts, rather than art historical specimens. This partly compensated for the Gallery's failure to introduce sound guides before 1995. Acoustiguides were introduced at the Science Museum in 1961, and at the NPG next door in 1966.[96] 'Bats' with explanatory texts were introduced in 1972. Later the first wall-labels were introduced according to a set format. Instead of the strip-labels, which only gave artist, title, dates and provenance, curators drafted short texts explaining the subject and providing more background information on the commission and the artist. There was a deliberate attempt to identify and dispense with the many foreign loan-words that feature in the art-historical vernacular.

Under the Directorship of Martin Davies, however, 'Education' and access issues came a distant second to art historical scholarship. This made it easy for John Berger's 1972 television programme *Ways of Seeing* to present the Gallery as an institution stuck in the past. Berger's observations pointedly addressed examples drawn from the Gallery's collection, including the *Madonna of the Rocks*, Bronzino's *Allegory of Time and Love*, the Leonardo *Cartoon*, Holbein's *Ambassadors* and

Gainsborough's *Mr and Mrs Andrews*. Berger was certainly not the first to suggest that the museum decontextualized art, that museums had a chilly, quasi-religious atmosphere or even that the mass diffusion of reproductions might potentially change or devalue the way people looked at art inside them. The 1945 Dartington Enquiry had noted that reproductions in schoolrooms 'can destroy a child's appreciation of original paintings, if they are allowed to become an alternative to them.'[97]

He was the first to suggest that museum obscurantism was 'nostalgic' rather than just the product of inertia, that it represented 'the final empty claim for the continuing values of an oligarchic, undemocratic culture'. In the same way as advertisers used images to feed our individual insecurities, so museums and 'the National Cultural Heritage' exploited the artifically-preserved aura of fine art in order to 'make inequality seem noble and hierarchies seem thrilling'.[98] Bevan's writings, quoted above, foreshadowed such arguments. Berger seemed unable to suggest a replacement for the culture he attacked, to suggest how we were to engage with art once we had been informed of its manipulation. All the purposes to which we were putting great art were abuses, mainly of ourselves. Berger didn't create a new currency, he made all art into dirty money.

Although *Ways of Seeing* consisted of only four half-hour shows, they were broadcast twice, issued to art colleges as 16mm film and the accompanying book (1972, still in print) went through many editions.[99] It was in an important sense a riposte to Kenneth Clark's *Civilisation: a personal view* (1969), which did even better commercially; syndicated abroad, it even earned the honour of translation onto DVD. Berger cast Clark as one of the 'few specialized experts who are the clerks of the nostalgia of a ruling class in decline'.[100] Like most of Clark's contemporaries (and especially the fourteen individuals whom it saved from committing suicide) Berger failed to notice the pessimism of *Civilisation*.[101] As a visual Cook's tour of European sights which commercial jet aircraft and the package holiday would soon bring within the reach of the lower, middle and working classes, the series was sensational. As one of the first series broadcast by David Attenborough's new channel, BBC2, it

Opposite: Bronzino's **Allegory of Time and Love** (c. 1540-50) was purchased by Eastlake in 1860. A regular visitor to the Gallery, Terry Gilliam particularly admired this painting. The large foot that stamps down at the climax of Gilliam's opening sequence for *Monty Python's Flying Circus* is a copy of Cupid's right foot.

reassured the naysayers that switching to colour broadcasting (seen as 'American') did not have to involve lowering standards.[102] Far from presenting civilisation as secure, however, Clark regularly emphasized its fragility from the very first episode, tellingly entitled 'By the skin of our teeth'.

Unable to see art as anything but a minority pursuit, Clark even doubted whether such shows or even museums were on the right track:

I believe that those of us who try to make works of art more accessible are not wasting our time. But how little we know of what we are doing. We are at the very bottom of the hill, and I am not even sure that we are trying to climb it by the right path. In plain language, I am not sure that museum art and a museological approach, however extended and skillfully contrived, will ever bring about a healthy relationship between art and society. It [sic] is too deeply rooted in cultural values which only a small minority can acquire.[103]

Berger may have kicked down a door that was already open.

These rival visions of the museum's educational work set the stage for the 1971-4 debates on admission charging. Although neither seems to have taken direct part, Berger and Clark's programmes were often cited in these discussions. Eccles invited such references by justifying new admission charges as the ransom for high art's release from the highbrows. As his ally van Straubenzee put it, opponents of charging 'do not want the increased numbers coming and, in a somewhat superior way, want to retain their galleries as oases just for art lovers like themselves.'[104] This must have seemed a better tactic than presenting charges for museum visitors as simply the cultural equivalent of the new NHS charges.[105] Eccles echoed both Bevan and Berger in admitting that a love of art such as had supported the Gallery with donations and visitors was often an artificial response to a bourgeois hunger to display one's 'distinction'. The concept of 'cultural capital' had recently been developed by a French sociologist named Pierre Bourdieu, who highlighted the extent to which museums pandered to a bourgeois desire to flaunt taste as a positional good.[106] Eccles went even further in accusing museums of

patronizing and 'talking down' to the lower classes. Free access, he argued, accentuated both their poverty and their dependence on the state's generosity in granting them access to heritage. Here he was echoing, perhaps unwittingly, the points made by Alma Wittlin in her 1970 book *Museums: in search of a useable future.*[107]

While Eccles' arguments could sometimes sound slick, those of his opponents could sound like throwbacks to a bygone Victorian age. Jennie Lee argued that the museum's attitude to its visitors should be Christ-like: 'suffer them to come unto ye'. She suggested that a free day would not help, because working-class people would not attend on that day because of the 'shame'.[108] In the Lords, Robbins' speech echoed Kingsley's description of the street urchin transfixed by the Gallery's art:

If you go into the National Gallery and observe the way in which people are enjoying themselves – it is a pleasurable experience to see people enjoying themselves in a way which does no harm to anybody – one thing that strikes one most is the spectacle, here and there, of some young person suddenly transfixed with the beauty which has dawned on him for the first time in his life. I do not want to deter that person. There is the possibility that even the smallest charge may deter him.[109]

Once again, it was believed that the art itself was powerful enough to overleap gaps within society – in this case, a generation gap which concerns about the permissive 1960s culture had deepened. The tendency of museums to become what the Libral peer Lord Beaumont of Whitley called a 'snogging shop for adolescents' was an abuse to be tolerated, because a boy waiting for his date might one day wander up to a painting and discover what the gallery was really about.[110]

The 'experiment' proposed by Agar Ellis a century before was still ongoing. By the mid nineteenth century it had freed itself from the restrictive and at times Utilitarian assumptions of Rational Recreation and 'useful knowledge,' achieving a real transcendence in the vision of Kingsley. Although this vision faded in the later years of the century, the Gallery successfully resisted the arguments of those who saw it as of limited

Neil MacGregor had no
experience of working in
galleries when he was
appointed Director in 1986,
and the media jumped to the
conclusion that he had been
selected by the Trustees in
the belief that he would be
more pliable than a museum
insider. MacGregor was
indeed happy to go along
with the Trustees' ideas on
enriching the décor, remov-
ing one cause of poor Board-
Director relations. While
other museums embraced
Thatcherite consumerism
with greater or lesser degrees
of enthusiasm, MacGregor's
lectures, exhibitions and
television series reminded
ordinary visitors that the
Gallery's paintings were
part of national life because
they spoke to common
human emotions.

relevance to issues of poverty, economic decline and the atom-
ization of society. The Second World War and the One Picture
shows represent the realisation of its mission to a nation per-
ceived as fundamentally classless, even while they confirmed a
tendency to view the art contained in the Gallery as token of a
'civilisation' rather than 'culture'. Clark's success in gaining
acolytes came almost in defiance of his deep-set personal
doubts regarding the social reach of the elitist museum culture
Berger and other critics associated him with. Only in the very
different economic and social conditions of the 1980s were
similar levels of confidence in outreach achieved. This was
mainly due to Neil MacGregor, who combined a salvationist
philosophy of outreach, deeply influenced by Kingsley, Ruskin
and Clark, with new types of exhibition that seemed to estab-
lish a real connection with visitors.[III]

Looking at it from the perspective of a Matthew Arnold or Raymond Williams, however, the experiment failed to reinject spiritual energy into the state or invite those outside the elite to propose a replacement for the aesthetic 'currency' in which the nation's treasure was denominated. That does not mean that those inside the elite – Trustees and their fellow collectors, Gallery staff – were not obliged to change these valuations, often in response to pressure from those they perceived as outsiders: artists, art experts, critics and, eventually, art historians. As the next chapter will demonstrate, here the challenges were even greater.

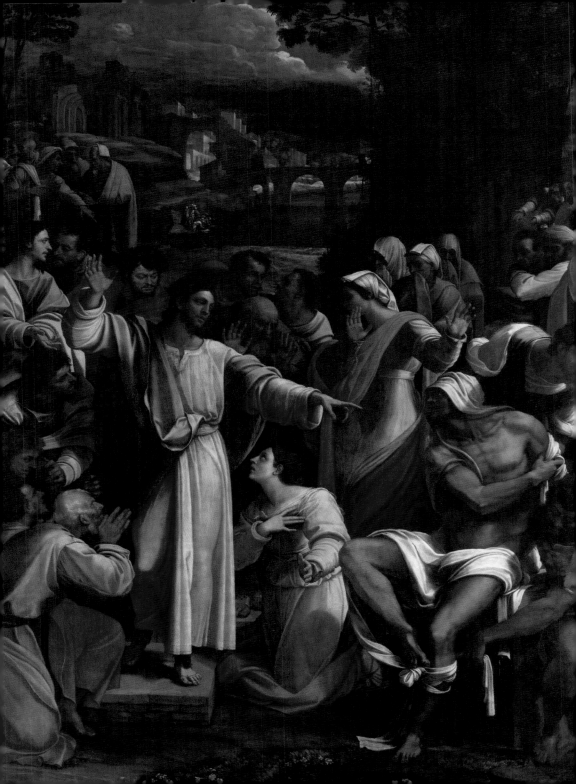

Five: A special feast

Compared to the Louvre and the Metropolitan, the National Gallery's collection remains a relatively small one, consisting of just over two thousand paintings. For almost a century, however, its defenders have persistently replied to this charge of weakness by citing the balance and quality of the collection: every major school of European painting is evenly represented, and represented by a select group of masterpieces, rather than by an exhaustive catalogue of second-string masters.[1] At the same time the concept of a 'small yet balanced' collection has served to emphasize the collection as an organic whole, one whose limbs have developed gracefully. Other museums often consist of discrete collections crudely knitted together into unhappy conglomerates, monuments to sudden shifts in the political and financial balance of power. That of the National Gallery was formed from scratch, at an even pace, half by government purchase, half by donation and bequest.

It would be possible to tell the history of the Gallery's collection (perhaps the Gallery as a whole) as the process by which this balanced, representative collection was formed. One might trace the key stages by which holdings of Sienese or Netherlandish paintings were built up, thanks to generous bequests or savvy Directors. There would be the satisfaction of watching particularly beloved pieces of this jigsaw, such as Holbein's *Ambassadors*, fall into place. There would also be the frustration of discovering that great works such as Bellini's *Agony in the Garden* could have been bought for one-twentieth of the price paid fifteen years later – relieved, of course, by the awareness that they were destined to end up at Trafalgar Square. One might rank the Directors by their success in such terms, judging them according to the number of pieces they managed to add to the puzzle.

Yet there seems to be something cruel, if not rather self-serving, about challenging past Keepers and Directors to compete in this way – for they, unlike us, did not have the box to

Opposite: Sebastiano del Piombo's **Raising of Lazarus** (1517-9) had been part of the Orléans Collection, which went on sale in London in 1798. Insurance broker John Julius Angerstein spent heavily at the sale, adding to a collection his heirs sold to the nation in 1824. The Angerstein Collection was the foundation of the people's collection, and *Lazarus* literally the Gallery's first painting, inventorized as 'NG1'.

look at. Each was trying to make the pieces fit in a different way. The balance between admiring a work for its 'intrinsic merit' and admiring it as an excellent document of one moment in art's historical development shifted. Eastlake's rhetoric of 'specimens' 'illustrating' a particular school marked one extreme:

> When pictures described in early writers or in original documents have come to light... in modern times and have been unquestionably identified, the historic value of such specimens as characterizing periods in art, outweighs or enhances any considerations respecting their intrinsic qualities.[2]

As that slippery 'outweighs or enhances' shows, adopting a clear position on the matter could be difficult.

Eastlake's subordinate, Keeper Ralph Wornum, argued in favour of a more balanced approach: by acquiring works that were both masterpieces and illustrations the Gallery could ensure that both the layman and the connoisseur would find 'a special feast prepared for him'.[3] Although none felt they had finished, each Director had an idea of a complete collection in his mind, and used that to guide his decisions. At some points a new Director would scatter the pieces and start assembling them in a new way. Inevitably some no longer fit. Over 4,500 paintings have been transferred to other institutions. Some were even sold.

A second problem with the jigsaw approach lies in the fact that Directors rarely enjoyed a free hand in acquisitions, or in related decisions regarding the acceptance or non-acceptance of gifts and bequests. Trustees, Chancellors of the Exchequer and other 'non-professionals' had important roles in determining whether funds would be made available. This depended in part on whether they liked the picture themselves, or whether they thought the public, artists or art experts would. Half of the collection was donated, so here the Gallery's role was limited: while on the one hand gifts could be refused outright, or solicited by a canny Director or Trustee, on the other, works the Gallery felt to be of insufficient merit occasionally had to be accepted, for fear that rejection would cause offence, imperilling future generosity.

Large gifts and bequests, such as those of Vernon, Turner and Mond, came bundled with painful conditions; above all that paintings acquired *en bloc* be hung together as a monument to the donor's taste, separate from other Gallery paintings of the same schools. By 1890 the Treasury was warning the Trustees about the risk of the Gallery becoming a conglomerate of collections.[4] In the absence of government funding, American museums like the Metropolitan were especially at risk in this regard, and even today the donor's shadow looms large there.[5] In some cases gifts did not so much fill gaps in the collection as create them: drawing attention to schools or masters that the Gallery itself had neglected. In 1848 the collector William Coningham gave the Gallery two works ascribed to the fourteenth-century painter Gaddi – a pointed, if generous, gesture given the pamphlet he had published the previous year, lambasting the Gallery for only buying 'spurious pictures of Correggio, of Guido, of Vannucchi [del Sarto], and of Poussin, and doubtful Claudes'.[6]

One can only fill those gaps one is aware of, and it is impossible to achieve a balanced representative holding of a school one does not believe to exist, or to be worthy of representation. In considering whether or not to purchase a specific painting, Directors, Trustees and the collectors who donate or sell works are thus dependent on the education in appreciation given them by art experts or the market. At the time of the Gallery's foundation a worthy artist was indicated by his presence in great noble collections, or by having been held up for emulation in Reynolds' Royal Academy lectures. Seventy years later the development of art history as an academic discipline in Germany had moved the goalposts: the most admired Old Masters were now the subject of scholarly monographs, and in some cases the artists chosen were very different from those cherished by Beaumont and his circle. A century later and the great temporary exhibitions saw scholarship linked to patriotism, with paintings cherished as illustrations of heroic artists' incorporation of national character.

By 1891 art history (*Kunstgeschichte*) had become such an established part of the German higher education system that

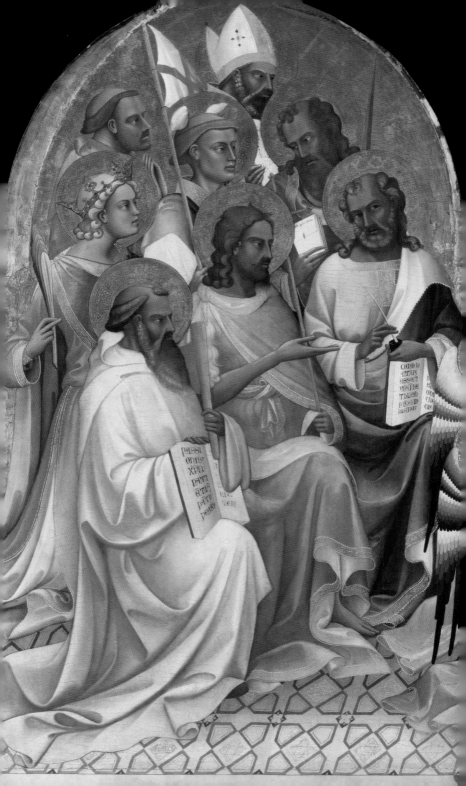

art historians such as August Schmarsow could write books with titles such as *Art History in our Universities*. It was self-evident that museum Directors had to possess specialist knowledge of a sort practising painters were unlikely to have. As the 1894 struggle between 'specialists' and painters for the Directorship showed, this was not the case in Britain. Although a close friend, Trustee George Howard was not impressed by Sidney Colvin's argument that the post was 'the prize of the profession,' a full-time job demanding 'the long habit of comparative study,' familiarity with scholarly publications and talent for 'getting gifts and bequests'. Howard believed that only painters and dealers could assess the true value of a picture – and that the post did not demand all the appointee's time. The painter Edward Poynter was duly appointed, and became President of the Royal Academy two years later.[7]

Only with the foundation of the Courtauld Institute in 1932 did it become possible to study art history at degree level in Britain. In 1934 Kenneth Clark became the first National Gallery Director to be appointed exclusively on his strength as a scholar, and the first to keep office hours. As the *Burlington Magazine* noted in 1933, 'England is just a hundred years behind Germany in recognizing art history as a subject requiring special training and education' – even the label 'art historian' seemed 'clumsy and not altogether accurate'.[8] The teleology of professionalism has led art historians to trace the history of other great public collections as the 'emancipation' of disinterested academic expertise from the negative influences of aristocratic dilettantism and art dealers' commercialism.[9] In a British context such an approach can blind one to the many *marchands amateurs* who played very important roles in advancing knowledge of art: men such as James Buchanan, Charles Fairfax Murray and J. C. Robinson. Part of the funding for the Courtauld came from a dealer, Joseph Duveen. Attempting to identify a clear professional pedigree can also discourage an exploration of the literary and even scientific influences which shaped the emerging discipline of art history.

The history of a great collection maps the history of connoisseurship and art history.[10] The Gallery's nineteenth-

Opposite: The MP William Coningham was one of the Gallery's greatest critics in the 1840s and 1850s. His gift of two paintings (c. 1407-9) of **Adoring Saints** attributed to Taddeo Gaddi in 1848 was generous, but also a way of drawing the Trustees' attention to their failure to buy *quattrocento* works. Coningham acquired them at the 1845 sale of the Cardinal Fesch collection. Now known to be have been painted by Lorenzo Monaco for the Camaldoese monastery of San Benedetto fuori della Porta a Pinti, Florence, the wings were reunited with the missing central panel in 1902.

Elizabeth Eastlake (*née* Rigby) possessed a knowledge of the history of art at least as great as her husband, National Gallery Director Charles Eastlake. She survived his death in 1865 and was un-impressed with his successors Boxall and Burton. 'There is no first-rate Connoisseur now in England,' she wrote to Gladstone in 1894, 'Sir Frederick Burton has never been one.' 'But,' she sniffed, 'it is easy to secure good pictures at inordinate price.'

century history is particularly rich in this respect. The Gallery was fortunate to have in Charles Eastlake a Keeper and Director who, along with his wife, played a key role in introducing German and Italian scholars and their works to a British audience. In almost every case these men pursued their scholarly writing alongside a wide range of literary activities: as poets, novelists or travelogue-writers. Several were politically active, and so arrived in London as exiles escaping persecution for their roles in the revolutions of 1848. Among these were Gottfried Semper, Théophile Thoré, G. B. Cavalcaselle and Gottfried Kinkel. Semper's role in mid-century debates surrounding architectural polychromy will be discussed in the next chapter. Like Semper, Cavalcaselle was another art expert facing a death sentence at home, and together with Joseph Crowe spent much of the 1850s short of food, writing books on Netherlandish and especially Italian painting that remained highly influential for the next century.

For the most part, however, the Gallery was not at the forefront of developments in connoisseurship, art history or art theory. Had J. C. Robinson become Director in 1862 or 1871, or Roger Fry in 1914, things might have been different. Yet it is precisely the absence of a figure like Berlin's Wilhelm von Bode – of a colossal, all-powerful museum 'dictator' – that makes the history so interesting. In so far as the National Gallery was never taken hostage by a single scholarly camp, its acquisitions policy seemed open to interpretation and influence by a number of interested parties. One way to approach this story is to consider specific acquisitions drawn from different schools and historical periods. What criteria were at work here? Whose criteria were they? What vision of a 'complete collection' was each acquisition intended to serve?

The works considered here range over most of the schools represented in the Gallery, and are chosen partly for the interest of their own provenance, but for the most part because the discussions surrounding their acquisition and reception illuminate a point at which understanding of the western European canon changed. The Graeco-Roman portrait, the Manet and the Cézanne are particularly instructive in exploring the edges

of this canon, defined as much in aesthetic as in chronological terms, as the interface between archaeology and art history and between art history and art theory. In these cases the attention given to these particular schools bears little relationship to their weight in the current collection – but it does reflect deep concerns voiced at the time about the nature of the Old Master canon as a whole. As with the British School, whose works were transferred back and forth between Trafalgar Square and the Tate in the twentieth century, the question here was not exclusively one of acquisitions policy, but of assessing where a dividing line should be drawn: between 'modern' French and 'classic' British art that spoke to the European canon and another sort, that didn't.

Astonishing the natives

The first painting to be considered here is one from the collection of John Julius Angerstein purchased en bloc in 1824 for £54,000: *Seaport with the embarkation of the Queen of Sheba*, painted around 1648 by Claude Gellée. Claude painted a number of similar seaports, several of which are also in the Gallery's collection. His landscapes were widely admired in the eighteenth century for the harmony of their colouring and their careful composition. According to the hierarchy of genres laid down by the seventeenth-century French academic tradition, which remained highly influential in Georgian England, landscape was an inferior genre. In contrast to scenes of classical history, it was felt to demand little of its viewers – both in the sense of leaving itself open to criticism by the impolite and unlettered, but also in the sense of not inspiring the educated viewer to emulate the virtue of Antique heroes. Claude redeemed his work by a sort of pictorial *deus ex machina*, adding small figures who act out episodes from classical or biblical history that can seem to have little bearing on the scene as a whole.

Angerstein's taste for Claudes was shared by Beaumont, whose 1828 gift included the four from the Altieri Collection. Claude and Poussin were then the most admired French

A self-made man of obscure origins, insurance broker **John Julius Angerstein** formed a fabulous collection that greatly increased his public profile. Among those who advised him was the painter Thomas Lawrence, who painted this posthumous portrait in 1824, the year his collection was purchased by the nation.

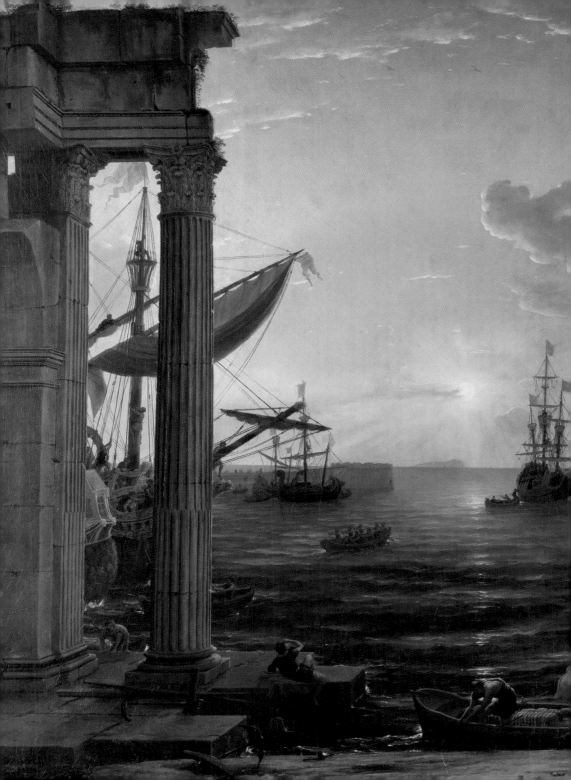

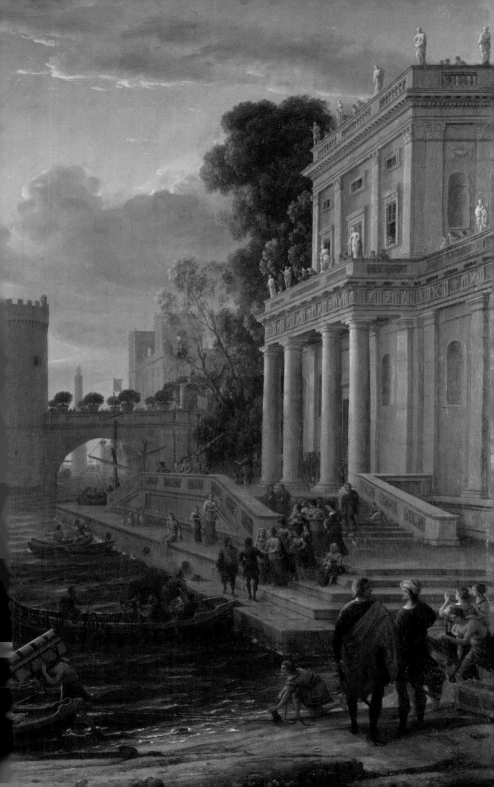

masters. Although it remained a commonplace that he was the acme of painters, Raphael was celebrated as the herald of a golden age, his predecessors being almost totally neglected, although his near contemporaries Correggio (fl. 1494-1534) and Titian (c. 1487-1576) were also highly admired. The darlings of the British Institution canon were the Italians (esp. Bolognese) of a generation born fifty to seventy-five years later: Ludovico and Annibale Carracci, Guercino and Guido Reni. Thus the 35 Angerstein pictures were a focussed collection, with twenty dateable to within the fifty years 1600-1650. Angerstein had been a wealthy man, but his obscure origins and poor education doubtless fuelled a desire to concentrate on the approved masters, as suggested by his advisor, President of the Royal Academy Thomas Lawrence. The Academician Joseph Farington described the collector as being 'much respected for his good heart and intentions, but defficient [sic] in Education, and very much embarrassed on all occasions when He is required to express himself.'[11] Indeed, in the absence of any personal claims to distinction in such matters the collection Angerstein formed was seen as Lawrence's creation. As Francis Haskell noted, the extent of the flood of art into England unleashed by the French Revolution was such that it became almost too easy to satisfy accepted appetites – or in the case of aristocrats like the Duke of Bridgewater, to create an appetite for the great masters where none had been before.[12]

Collecting the right Old Masters and lending them to the new temporary exhibitions at the British Institution was understood as virtual patronage. With the Continent closed to young artists, spending money to bring art to England for their improvement was a patriotic act. Questions of who actually owned the art, or whether it was in a public collection or not were largely not asked: somehow, all benefitted. With the help of the intrepid dealer William Buchanan, Angerstein was able to acquire works that had originally been part of Charles I's collection, but which had been sold by Cromwell after 1649: Correggio's *Mercury instructing Cupid before Venus* and Rubens' *Minerva protects Pax from Mars* (also known as 'Peace and War'). Seen in the broad, perhaps rather millenarian terms of

Previous pages: Claude's **Seaport with the embarkation of the Queen of Sheba** (c. 1648) was part of the Angerstein collection. The Gallery's founding benefactor, George Beaumont, shared Angerstein's admiration of the artist, seeing his work as being as much a guide to landscape designers as to painters. Claude provided a focus for Beaumont's discussions with William Gilpin, Uvedale Price and other theorists of the picturesque. Beaumont later made his bequest of his collection conditional on the state purchasing Angerstein's.

Napoleonic Europe, Angerstein was indeed to be congratulated in returning these works to their 'home'. His acquisition of the massive Sebastiano del Piombo *Raising of Lazarus* was particularly applauded, as the painting had been highly admired when it hung in the Louvre, owing to a belief that Michelangelo assisted in painting it. In fact, Michelangelo had only provided the design.[13]

Buchanan may have pandered to Angerstein's appetite for such applause in offering the collector works he felt would create 'a fuss in the papers' and 'astonish the natives'. The Glaswegian son of a wealthy hatmaker, Buchanan had entered the international picture trade on a purely speculative basis by 1803. In that year he wrote to an associate of his plans to import '30 or 40 of the most celebrated works which Italy can produce, and these I have thoughts of offering to the Nation as a beginning to a National Gallery'. Lacking any connections among Academicians (he later bribed a few), this offer was turned down. Further letters note his frustration that bigotry and the RA President's prejudices were so strong 'that very fine pictures of Perino del Vaga, Fra Bartolommeo, and *early* pictures of the greatest masters pass unnoticed'.

Perino and Fra Bartolommeo were of the same style and period as Raphael, yet it appeared that 'names which are not fashionable and well known here go for nothing.' Unfazed, he offered them to the Americans, who also refused them. Buchanan also organized a buying expedition into Spain, but found little interest at home for his wares, which included the painting we now know as the *Rokeby Venus*. Thereafter he became much more successful at giving his clients what they wanted: in his offers to the Gallery he stuck safely to the Carracci and their ilk, being called a 'Jew without money and without scruples' by Trustee James Graham for his pains.[14]

The extent to which Angerstein's taste was shared by the founding Trustees is shown by the works acquired in the years up to Charles Eastlake's appointment as Keeper (1843) and beyond. Without an annual purchase grant or a strong Keeper, consensus was needed in each and every case, which made it impossible to bid flexibly at auctions or buy abroad. The first

Following pages: Peter Paul Rubens visited London in 1629-30 as an envoy for Philip IV of Spain. In presenting Charles I with this painting of **Minerva protecting Pax from Mars** he was sending a diplomatic message on the benefits of peace. Spain and England had been at war since 1625, and peace negotiations were under way. Sold abroad at the 1649 Commonwealth Sale, it was brought back by the dealer William Buchanan in 1802. Although he failed to interest either the government or Angerstein, he did succeed in selling it to Lord Gower, later Duke of Sutherland, who presented it in 1828.

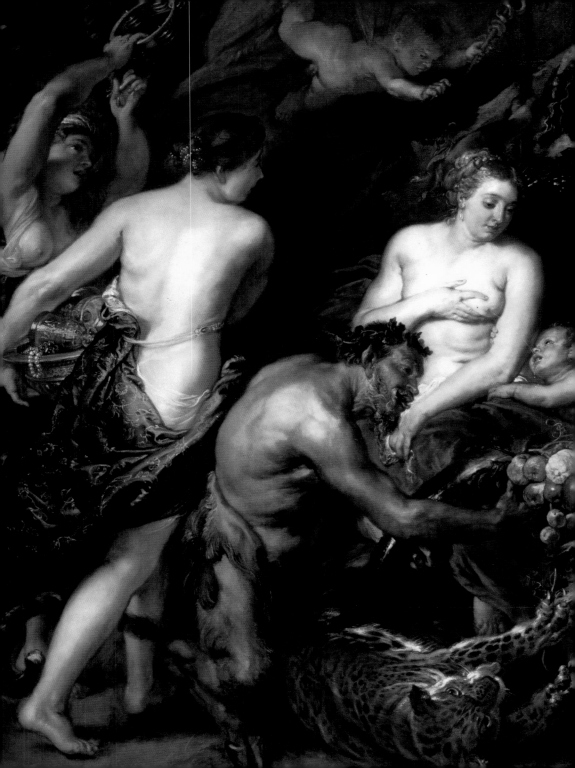

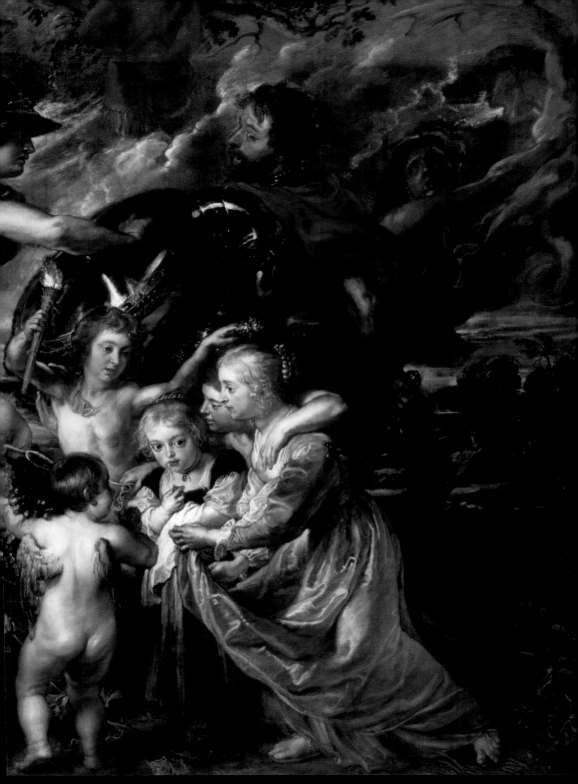

A Fellow of Exeter College, Oxford, **Holwell Carr** hastily acquired a degree in divinity when a lucrative living in the College's gift opened up, at Menheniot in Cornwall, in 1791. Carr hired a curate and never went near his parish, choosing to spend his time and salary collecting art and disputing attributions with other connoisseurs at the British Institution. His will left his collection to nation, stipulating that this portrait (1828) by John Jackson be placed beside it.

Opposite: In 1654 Rembrandt's mistress Hendrickje Stoffels was summoned before the Council of the Reformed Church in Amsterdam and banned from receiving the Eucharist for living 'like a whore' with the artist. This painting of **A Woman Bathing in a Stream** of the same year may be a response to this incident. It was bought in 1829 by the connoisseur Holwell Carr and formed part of his 1830 bequest.

purchases recommended by the Trustees in 1825-6 were works by Correggio, Titian, the Carracci and Poussin. Lawrence's correspondence with Trustees such as the Duke of Aberdeen is characterized by learned discussion of the School of the Carracci and the challenges of dating its works.[15] In this regard there was little to distinguish the Gallery from the private collections of the Trustees: Aberdeen himself, though not a collector on any great scale, owned two Annibale Carraccis and observed to the 1853 Select Committee that the Gallery's collection had up until that point been 'merely like the collection of a private gentleman, and nothing more'.[16] Until the 1850s it was difficult to imagine what that 'more' might be. And even if late Georgian connoisseurs could be a back-biting bunch, there's no masking the generosity with which such 'private gentlemen' donated their beloved treasures to the nation. Gentlemen the likes of Reverend Holwell Carr, absentee vicar and heiress-hunter, whose 35-strong bequest (1830) consisted of Titians, Claudes, Guercinos – but also Rembrandt's *Woman bathing in a stream*.

Lawrence's role as advisor to Angerstein and as one of the founding Trustees emphasized the Gallery's goal of improving the native school of painting. To some of his artist contemporaries, however, it could seem a threat. The fond connoisseurial embrace, which had supported the fledgling British school through the difficult war-years, now threatened to become a permanent choke-hold. Whereas its links to the Royal Academy might have been expected to fuel Benjamin Haydon's persecution complex, that the more stable John Constable should have opposed the Gallery's foundation is surprising. In a letter of 1822 to his friend Canon Fisher, Constable had started with criticism of the British Institution's connoisseurs for being too focussed on copying established masters, concluding from this that 'should there be a National Gallery (which is talked of) there will be an end of the art in poor old England, and she will become, in all that relates to painting, as much a nonentity as every other country that has one.' 'The reason is plain,' he added, 'the manufacturers of pictures are then made the criterions of perfection, instead of nature.'[17]

As a patron and collection George Howland Beaumont took a close personal interest in his artistic protégés, encouraging them to use paintings from his collection as models. Constable made use of his Claudes, while Beaumont lent a young David Wilkie Dutch works by Jan Steen. Unsurprisingly Wilkie's **Blind Fiddler** (1806) betrays the influence of such Old Masters. Presented by Beaumont along with the rest of his collection in 1827, Wilkie's work was later transferred to the Tate.

Constable's **Cornfield** (1826) is closely related to studies the artist painted during a stay at Beaumont's Coleorton estate, where he was able to take his patron's Claudes up to his bedroom for closer study. Although their relationship was close, Beaumont presumably did not think the artist's work worthy of inclusion in his munificent gift of paintings to the nation. Instead the Gallery's first Constable was presented by a body of subscribers after his death in 1837.

Constable's own *Cornfield* entered the Collection in December 1837, presented after a group of 113 subscribers had raised the three hundred guineas needed to buy it. The gift was intended as a memorial to the artist, who had died earlier that year, and affords an excellent opportunity to consider the position of the British School within the Gallery. Was it doomed to remain subservient, or could it challenge the masters of other European schools? In 1837 the Gallery possessed seven British works: Angerstein's collection had included Hogarth's *Marriage à la Mode* series, but these were seen as curiosities, and no Hogarths were bought again for sixty years. Although painted by a living contemporary, David Wilkie's *Blind Fiddler* represented the result of Beaumont's encouragement of his protégés to paint new Old Masters – in this case, a reheated version of a seventeenth-century Dutch tavern scene. 'Connoisseurs think the art is already done,' as Constable put it.[18]

Wilkie summed up Beaumont's career, and his vision of the British artist's position within the Gallery, in a letter to the latter's widow written shortly after Beaumont's death in 1827. Here Wilkie hailed Beaumont not only as a latter-day Lorenzo

de' Medici, but as a painter whose 'rich and deep tone of colouring' represented a rare vestige of a 'golden age of British art' founded on respect for Old Masters. Now that this respect was enshrined in a national institution, a new generation of British artists were confronted with a choice:

It is a question of practical and vital importance to modern art. Whether its productions are to aim at a place among the established masters or be produced upon a principle which [Beaumont] well knew would form a perpetual system of exclusion.[19]

This 'perpetual exclusion' had seemed painfully close to realisation in 1823, when Sir John Fleming Leicester had offered his collection to the nation.

Leicester had prepared the ground by opening his Hill Street house to London's genteel in 1818, operating a ticket system on Mondays between 1 and 4pm. There he had 54 paintings on display – unusually, all of them British, and almost exclusively landscapes. His agent, the dealer William Carey, published a pamphlet defending this choice by arguing that those truly able to judge art solely by '*intrinsic excellence* alone' must recognize the merits of the British School. The only way such a School would be encouraged was 'by the noble spirit of an independent imitation of their principles,' applied in the production of works that reflected native characteristics such as 'domestic affection.' Finally, by happy coincidence, a painting depicting the model of a *Modern Picture Gallery* (that looked rather like the one in Hill Street) appeared in the 1824 Royal Academy show.[20]

Leicester's campaign was defeated by Lord Liverpool's insistence that, if there was to be a Gallery, 'the old Masters must find a Place in it, and more particularly the larger Pictures, which are not adapted to private Collections'. As with Buchanan, Leicester's offer was not totally disinterested – he was short of funds and eager for a peerage – but it arguably did sow the Gallery idea in Liverpool's mind.[21] Even if Fleming had been an important patron of the much-abused Turner, owning ten works, including *Sun rising through vapour* and *The Building of Carthage*, it is doubtful whether his concept of the British School was revolutionary. Indeed, he appears to have bowed to

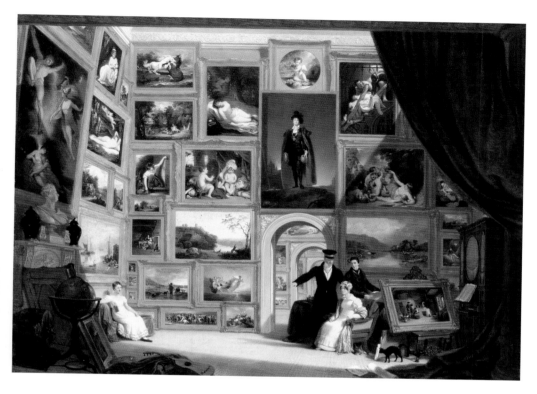

W. T. Witherington's painting of **A Gallery Hung with British Pictures** was exhibited at the Royal Academy in 1824. Although not based on any recorded interior, it was commissioned by Sir John Fleming Leicester to record the collection of British paintings he exhibited in his Hill Street home, a collection he had unsuccessfully offered to Prime Minister Lord Liverpool as the foundation of a truly national Gallery – that is, one that excluded foreign works.

pressure from Beaumont in withholding the Turners from display in his Gallery. Leicester's collection was eventually dispersed, Turner buying back several of his works which eventually entered the Gallery as part of the artist's bequest in 1857.

Most visitors to Hill Street would have recognized the same traits which they sought in Old Masters, what Douglas Hall has characterized as 'eclecticism, elegant quotation, generalisation, neo-classicism seen through a fine cloud of sentiment'.[22] The subscribers to Constable's memorial seem to have shared this feeling: having initially opted in favour of presenting *A view of Salisbury Cathedral*, they hesitated and selected the *Cornfield* instead, arguing that it was more likely to appeal 'to the general taste'. The artist had indeed had a weather eye on such matters. 'I do hope to sell this present picture,' he wrote at

the time of painting it, 'as it has certainly got a little more eye-salve than I usually condescend to give to them.'[23] By this he was referring to sentimental details such as the drinking boy and the donkey and foal. There was, however, another sort of 'eye-salve' in the composition: its strong compositional resemblance to one of Beaumont's Claudes that Constable had copied in 1800 and 1823: the *Landscape with Goatherd and Goats*. During his second six-week stay with Beaumont the artist had taken the painting up to bed with him every night, writing that a copy he had made of it 'contains almost all that I wish to do in landscape'. In a more aggressive homage Turner would insist in his will that his *Sun rising through vapour* be hung in the Gallery next to Claude's *Seaport* and *Mill*.[24]

Thus by the late 1830s the struggles between modern British artists and Beaumont seemed a distant memory. Turner did not represent 'a permanent system of exclusion'. Carey's 'domestic affection' offered native artists a rich sentimental seam to mine, and a tradition that could be extended back into the previous century. Even if they seemed more redolent of the 'sweet' Murillo than of the truly great Michelangelo, the scruffy children that populated the landscapes and genre scenes of Gainsborough, William Collins and William Mulready had an Old Master pedigree.

That said, the Trustees never thought of actually buying any until the 1860s, and even then their acquisitions did not stray beyond the 'classic' English school of Reynolds and Gainsborough portraits that would later reach stratospheric prices. The Trustees had agreed with Eastlake's view 'that a sufficient number of pictures of the English School are sure to be presented or bequeathed in time'.[25] Latter-day Leicesters, such as Robert Vernon, who donated his collection of British paintings in 1847, received little thanks for their gifts (again, no peerage). But at least they were accepted, if poorly (and separately) housed until 1876. Many would-be donors of individual British works were told that the Trustees were prevented from accepting them by a regulation forbidding the display of works by living artists – such a regulation was never formally laid down and was only fitfully observed.[26]

Previous pages: Turner's **Sun rising through vapour** (1807) was among the thousands of paintings and watercolours bequeathed to the gallery on the artist's death in 1856. In 1818 he had sold it to Sir John Fleming Leicester, whose later offer to donate his collection to the nation was declined. Turner bought *Sun rising* back from Leicester's executors and stipulated in his will that it must forever hang next to Claude's *Seaport* and *Mill*.

There is little doubt that the Gallery inspired many important young artists, particularly in its first fifty years. By the late nineteenth century, however, the Gallery's paying or 'Artist's Days' were mainly attracting **professional copyists** reproducing popular works for the trade. The female copyist became a stock character, eternally aged, yet somehow immortal at the same time.

Vernon represented a new breed of mercantile collector put off Old Masters by the disdain of connoisseurs and a belief that modern British art represented a safer moral and financial investment than Guercinos. Their taste for 'domestic affection' was expressed in an admiration for Mulready's scenes of village schoolyards, Landseer's dog-paintings, and anyone who could paint banditti. A middle-class appetite for illustrated annuals and keepsakes, together with the patronage of the Art Unions, literally kept a generation of British artists alive. Eastlake, Uwins and Boxall had all pumped out slightly soppy scenes of brigands or Italian peasants at some point in their careers. The London Art Union's *Art Journal* also provided them with opportunities to write art criticism, some of which led directly to the first publications on the history of English art.[27] The authorities' toleration of the predominantly middle-class Art Unions has led some to conclude that the connoisseur aristocracy abdicated responsibility for guiding the British School.[28]

In fact, an eye for skill and a penchant for tracing Old Master pedigrees, however strained, meant that Landseer's dog paintings could find a welcome among the cognoscenti. Beaumont, who did not consider his own Landseer worthy of donation to the Gallery, would doubtless have been taken aback to discover that Landseer's *Dignity and Impudence* (bequeathed by the pharmacist Jacob Bell in 1862) was the most popular painting among late nineteenth-century copyists in the Gallery – and quite possibly among the majority of visitors. It remained on show at Trafalgar Square until 1929. Only under Hendy did the representation of the British School constrict to the 'classic' core of Hogarth to Turner, the number of rooms allocated to it being halved to just two between 1939 and 1954.[29] The table of the most frequently copied works shows how popular the soppier paintings of children were with the middle class, who kept the often suspiciously aged 'student copyists' in business. Originally intended for artistic training, by the late nineteenth century 'Artist's Days' were therefore becoming an embarrassment. From 1890 the Gallery ceased reporting which works were popular, and it became rare for anyone to attempt to justify the Gallery as a training facility.[30]

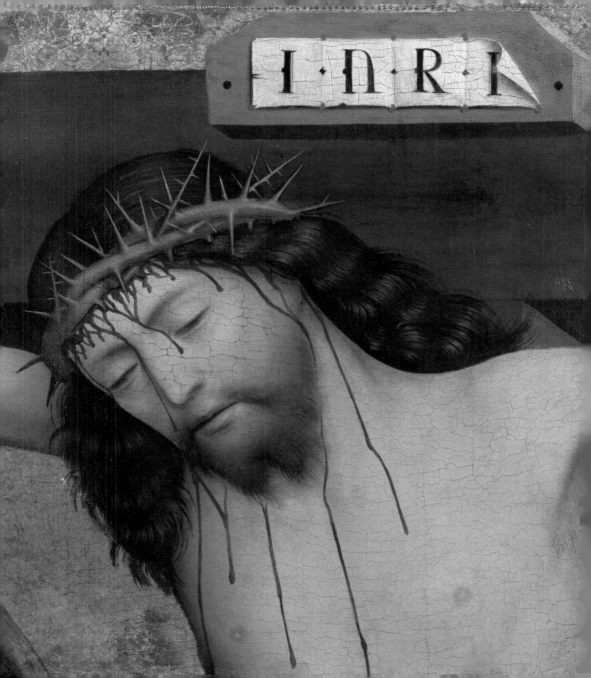

The discovery of sacred art

If the Trustees were somewhat discomfited by the Vernon Gift, the arrival of the Krüger Collection seven years later was even more disconcerting. Of the total of 64 works acquired *en bloc* from Carl Krüger for £2,800, 17 remain in the collection, the rest passed to other public collections or was sold, raising a paltry £249 pounds in 1857. The purchase was very much Gladstone's idea, and he even kept one of the paintings – possibly the *Head of Christ crucified*, by an unknown painter later dubbed the Master of Liesborn – in his office at the Treasury.[31] It occurred at a time when the administration of the Gallery was still under review in wake of the 1853 select committee. Eastlake was not involved, nor were the Trustees. Instead Gladstone was advised by the artist William Dyce, whose willingness to help out was a direct function of his belief that Gladstone would soon appoint him to the new post of Director. The purchase was one of a number of projects linking the two men with the 'Christian Art' movement of the 1840s and 1850s: a movement that sought to reinvigorate the Anglican church through the revival of ritual, music and art associated with pre-schismatic Christian Europe. Rather than seeing the Renaissance as the dawn of a golden age, writers on Christian Art could sometimes portray it as the beginning of the end. The Renaissance's celebration of human rather than divine knowledge and beauty was perceived as a fetischism fatal to art.

Thanks to the publication of Alexandre Rio's *De la poésie Chrétienne* (1836), the rediscovery of *quattrocento* painters such as Fra Angelico was linked to the French Catholic revival led by Montalembert. In exchanging his earlier admiration for the seventeenth-century master Carlo Dolci in favour of Fra Angelico and Perugino, by 1838 William Gladstone had come to see the history of Christian Art as a recapitulation on a broader scale of mankind's struggle with sin. Although some admirers of Christian Art could seem to be arguing that the sensual rot that set in with Raphael was terminal, Gladstone's vision of art history was more positive. It helped him find a way out of the political and personal dilemmas posed him by events

Opposite: Chancellor of the Exchequer William Gladstone negotiated the purchase of Carl Krüger's collection of fifteenth-century Westphalian pictures himself in March 1854. The Gallery was reeling from the Select Committee investigation of the previous year, and Gladstone felt no need to consult the Trustees, even Eastlake. This **Head of Christ Crucified** attributed to the Master of Liesborn (c. 1470-80) was one of the few Krüger paintings the Trustees did not sell off when they returned to power.

of the 1840s: the conversion of his close friend Henry Manning to Catholicism, as well as the apparent triumph of a Macaulayesque 'progress' that was snapping the ties linking Church and State.[32]

Of course, Gladstone was not a published authority on art like his contemporaries, the Germans Friedrich Rumohr, Franz Kügler and Gustav Waagen, whose landmark works on Raphael, the Van Eycks and others saw a new emphasis on historical documentation and rigorous comparison of works. It is important to remember, however, that for many the rediscovery of fifteenth-century Italian and 'German' (Netherlandish, as it often turned out) painting was about more than keeping abreast of developments in a new field of scholarship – of reading new monographs (in the original German, or, perhaps, Lady Eastlake's English), of following the latest skirmish of 'attributionism' or admiring the latest translation of Cennino Cennini's thirteenth-century *Handbook for Artists* – important as all those activities were. The pioneer British collectors of Christian Art included several priests, such as the Reverend Walter Davenport Bromley and the Reverend John Fuller Russell, who were out of this academic loop.[33] The appeal to such men, as well as to the popular critic Anna Jameson, was only partly that they served as a window on a 'dark' age or showed what Eastlake called the 'germs of a perfect development'. The main appeal lay in a perceived relevance to nineteenth-century needs, a need to trust 'in the progressive spirit of Christianity to furnish us with new impersonations of the good – new combinations of the beautiful'.[34] The supposed 'child-like' simplicity, sweetness and sincerity Anna Jameson admired in such works can seem cloying today. Doubtless a future age will find our equally strong assumptions – that all Watteaus are melancholy, for example – equally amusing.[35]

The Krüger purchase was an attempt to create 'an English Boisserée,' an equivalent for the collection of fourteenth- and fifteenth-century paintings formed by a group of three collectors from Cologne at the turn of the century. The Boisserée Collection had been purchased by the Bavarian King in 1827 and later installed in Leo von Klenze's Pinakothek. The

Opposite: Formerly in Prince Albert's own collection, Stefan Lochner's **Sts. Matthew, Catherine of Alexandria and John the Evangelist** (c. 1445) is one of two Gallery paintings formerly owned by the Boisserée Brothers, doyens of *altdeutsch* art from Cologne who started collecting when the Rhineland was under French occupation. The Boisserées took their collection on tour after the Wars of Liberation, transforming previously reviled 'Gothic' art into a symbol of Germany's cultural rebirth – and laying thefoundations of German art historical scholarship.

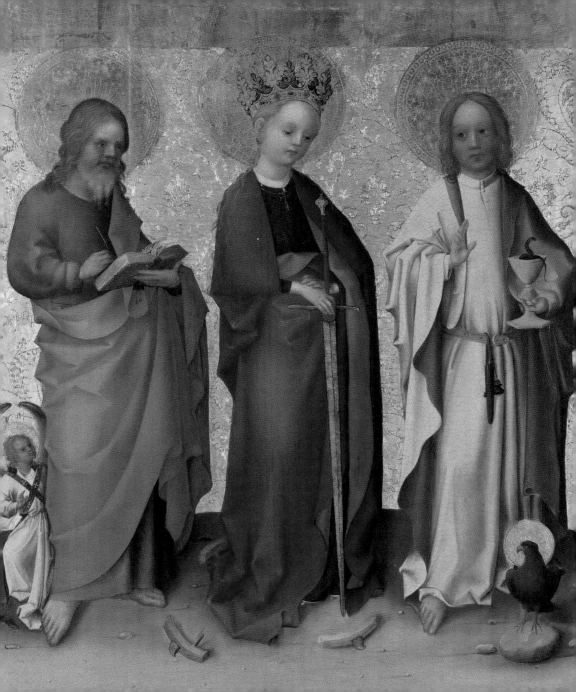

brothers Sulpiz and Melchior Boisserée appear, holding one of their triptychs, in a cartoon (*Ludwig I as collector*) for a fresco that originally graced the Neue Pinakothek. Inspired by the sight of looted Van Eycks and Memlings in the Napoleonic Louvre, and greatly assisted by the forced secularisation of Rhenish monasteries under French occupation, the brothers had formed a large collection at a time when such art was disdained as Gothic rubbish. Before selling the brothers had taken their collection on tour around Germany, where it inspired a generation of poets, painters and patriotic students with heady visions of what wonders German civilisation could achieve, granted peace, unification and freedom from impious French despotism.

Once in Munich the Boisserée Collection was admired by British tourists, Anna Jameson among them. In her 1853 review for the *Quarterly Review* Elizabeth Eastlake even used the phrase 'the Boisserée movement' to describe the growth of interest in early Renaissance art.[36] As far as antiquity was concerned, London had nothing to be ashamed of: the Elgin Marbles, however poorly housed in the British Museum, easily rivalled the Aegina Marbles. But London's Pinakothek did not have, in the words of its future Keeper, 'the shadow of an equivalent' of the Boisserée Collection.[37] The expatriate Briton Edward Solly had, admittedly, formed an impressive collection – but this was sold to Prussia in 1821, where it became the focus of Schinkel's Museum. There had also been an impressive collection of *altdeutsch* paintings in London – that of Karl Aders – but in 1838 Aders failed in his plan to interest the government in purchasing it for the National Gallery.[38] Only when Eastlake became Keeper in 1843 did the Gallery begin to buy the odd early Netherlandish work. But even then the acquisition of the questionable 'Holbein' seems to have shaken Eastlake's confidence in his knowledge of this school.[39]

When Gladstone asked him to inspect the Krüger Collection shortly after its purchase Dyce appears to have been rather taken aback, sensing (accurately) that this purchase would not be the making of him. He sought to stall Gladstone, arguing that there was no need to reach a decision immediately, as 'the

Jan Mostaert's **Head of St. John the Baptist** (early 16th century) was bought by Karl Aders as a work of Hubert van Eyck in 1831. Aders' collection at Euston Square had drawn the admiration of Constable, Carlyle, Blake and other distinguished visitors, but the Gallery passed up several opportunities to acquire the collection in the 1830s, and even today its Netherlandish holdings are weak. This painting was one of a total of thirteen Netherlandish works bequeathed by Mrs. Joseph Green, including Gerard David's *Lamentation* and *Adoration*.

It was as a Holbein that Gallery Keeper Charles Eastlake acquired this **Man with skull**. The resulting public furore over this 'libel on Holbein' led to his resignation from the Keepership in 1847. In 1993 dendrochronological analysis indicated that one of the panels on which it is painted was taken from a tree that was still growing in the year of Holbein's death; the painting is now tentatively described as 'Style of Nicolas Neufchâtel'

Opposite: The Gallery's three van Eycks were all purchased by Charles Eastlake, either as Director, or as in the case of the **Arnolfini Portrait** (1434), during his earlier Keepership. This was some compensation for the Gallery's earlier failure to acquire the important early Netherlandish collection of Karl Aders.

stock of work by early masters ought to be very considerably increased before the public exhibition of any works which are chiefly valuable in relation to the history of art, is hazarded.'[40] Eastlake and Wornum had drawn up a very extensive *Plan* of 'missing' masters for submission to the select committee of 1853. Of course, in the case of many early *altdeutsch* painters, there were not even names to add to such a list, so little was known of them. In the case of the 'Holbein' Eastlake had argued that such a work should be considered for its historic value, rather than as an illustration of a particular master's *oeuvre*. Gladstone adopted a similar line in 1854 when urging the acquisition of another worryingly early work (a Masaccio), telling Uwins that it should be bought 'by its *subject* and not by its name' as 'the judgments of a public body in such matters are severely criticized'.[41] In the 1750s Hogarth had satirized dealers who protected their daubs from criticism by coating them in thick yellow varnish – a century later 'historical interest' seemed to afford the ultimate protection from hostile reattribution.

The Krüger purchase has been described as 'the unluckiest purchase in the National Gallery's history', but this seems rather harsh.[42] Before they were sold off Eastlake offered the unwanted works to the National Gallery of Ireland, and an exchange with Berlin was considered.[43] At the time of writing three of the paintings are on display, and further research has suggested that rather than being examples of the rather exiguous 'Westphalian School,' the panels from the Liesborn altar are in fact related to the better-known centre of Cologne. The Gallery's holdings of the Netherlandish School remain relatively weak (52 works), and it is indeed remarkable that, as the Gallery's current curator has observed, there are only 'nine deliberately planned purchases [of Netherlandish works] from Government grants, seven of which were made between 1842 and 1865'.[44]

There would be even fewer, had it not been for Prince Albert and his impecunious relation, Prince Ludwig Kraft Ernst of Oettingen-Wallerstein, yet another collector who had been inspired by the Boisserées and also sold *altdeutsch* paintings to

the King of Bavaria. Forced to abdicate, Prince Ludwig had attempted to sell his collection in London, exhibiting it in Kensington Palace, but to no avail – the Gallery declined to purchase it in 1844.[45] When he was unable to repay his cousin Albert a £3,000 loan secured on the paintings, they became the Prince Consort's, and were offered to the Gallery at his wish by Victoria in 1862 (after his death). In this way the Gallery acquired its first (and last?) Stephan Lochner – the artist who, judged by the Boisserées' understanding of art history, represented the pinnacle of *altdeutsch* achievement.[46]

The Krüger purchase left a shadow over one school: two, if one considers that the artists understood as *altdeutsch* or 'German' in this period are those now catalogued as German and Netherlandish. But out of the confusion and reform of the Gallery a new Director would appear who made the years 1857-65 a golden age in the Gallery's acquisitive history. Although it began inauspiciously with the first National Gallery Sale on February 14th, Eastlake's first of many summer tours of Italy made 1857 an *annus mirabilis*: Pollaiuolo's *Martyrdom of St. Sebastian*, Duccio's *Madonna and child with Saints*, Filippino Lippi's Rucellai Altarpiece, Fra Angelico's *Adoration of the Kings* (now attributed to Zanobi Strozzi) and Uccello's *Battle of San Romano* were just some of the 36 works acquired in Florence. Among the works Eastlake later acquired back in England was Giovanni Bellini's *Agony in the Garden*, acquired in 1863 at the sale of the Reverend Davenport Bromley's collection, which also yielded Pesellino's *Trinity*. Thanks to the efforts of these earlier collectors, Eastlake could to some extent compensate for his inability to overcome Peelite reluctance to bid for *quattrocento* works in the 1840s. Even if as Keeper he had not been empowered to bid at the sale of Cardinal Fesch's collection back in 1845, others like Bromley and Coningham had, and in several cases Eastlake bought these works from their sales in the 1850s and 1860s.

How had Eastlake gained the extensive knowledge that enabled him to make such coups as the Bellini *Agony*, and how had he developed his concept of art history? A pupil of Haydon, Eastlake had travelled widely around Europe in the 1810s and

Opposite: Filippino Lippi's **Virgin and Child with Sts. Jerome and Dominic** (c. 1485) was painted for the Rucellai family chapel in San Pancrazio, Florence. Eastlake bought it from the family in 1857 – the Gallery's *annus mirabilis*. Austen Henry Layard's parents had rented part of the Rucellai Palace in the late 1820s, and this painting is recorded as having hung above his bed. This can only have helped inspire the future Trustee with a love of early Renaissance art.

1820s, familiarizing himself with great collections and working as a painter of banditti scenes in Rome, where he met Beaumont, Rogers and other first generation Trustees (some of whom bought his work) as well as German scholars and painters of the Nazarene School. He admired the works of Giotto and Fra Angelico in Padua and Florence long before they were put on the English tourists' map by Francis Palgrave's 1842 *Handbook for travellers in North Italy*.

Eastlake's theories of art's historical development shared this questioning spirit. In 1829, a year before he returned to settle in London, Eastlake submitted a piece 'On the philosophy of the fine arts (a fragment)' to the *Quarterly Review*. This proposed the study of art historical development along the same lines as the Frenchman Georges Cuvier had traced in his study of natural history. 'Nature aims at distinctions,' Eastlake wrote, 'and attains it not merely by strongly marked differences, but by imperfect approaches to each leading type, which serve to give it value.'[47] Eastlake borrowed familiar concepts from the English aesthetic tradition, such as Reynolds' idea of 'central form' and Hogarth's sinuous 'line of beauty,' but hinted at a more dynamic, if not evolutionary, historical model. As if sensing that he had gone too far, Eastlake at the last minute asked the *Review*'s editor not to run the piece.

He was on dangerous ground. Brought to London by young scientists who often had revolutionary leanings, comparative anatomist Geoffroy Saint-Hilaire's new theories of transmutation were causing fierce debate. According to established theories the earth experienced long periods of stasis in which creatures remained within a rigid hierarchy. This order was punctuated by short shocks of divinely-ordained creative destuction. Saint-Hilaire's theory by contrast posited a world in which all creatures were adapting themselves continually. To members of the political elite wrestling with the Great Reform Act the idea that the universe was one in which reform never ceased was a particularly forbidding one. Such debates infiltrated the British Museum, where Peel was among those Trustees seeking to ensure that the fossils were not rearranged in series, as demanded by the new rogue theories.[48]

Both Eastlake and his wife's later publications, however, continued to discuss the study of art in terms of comparative anatomy. In an 1840 review of J. D. Passavant's landmark study of Raphael, Eastlake observed how Raphael's apparent eclipse of Perugino and other predecessors (his painting over their frescoes, for example) was not destructive, but demonstrated that 'each progressive improvement in imitation was by slow degrees engrafted on the traditional types.' Lady Eastlake wrote in 1854 that the education of 'the professed critic in art' was 'essentially the same as that of the student in exact sciences'. Far from seeing art history as the study of dessicated specimens, however, Charles Eastlake argued that while the general character of art remained fixed, 'new human feelings demanded corresponding means of expression, and it was chiefly reserved for painting to embody them.'[49]

Eastlake was not alone in seeking to provide an overarching narrative in which to place the discoveries of the great German scholars. Lord Lindsay's *Sketches of Christian Art* (1847) is another publication of the 1840s credited with drawing attention to pre- and early-Renaissance Italian art. By contrast the work Lindsay intended to serve as the 'key' to his history, *Progression by antagonism* (1846), is rarely referred to – perhaps because it is seen as irrelevant rambling.[50] A focus on Ruskin and the tranference of German art historical scholarship (which as yet had few pretensions to grand systems) may have encouraged this neglect. Whatever its cause, it has made it easy for twentieth-century scholars of art history to belittle Victorian appreciation of early schools as so much swooning over a 'keepsake Middle Ages, or a coloured vignette Renaissance'.[51]

In the 1830s Eastlake's personal correspondence shows him to have been among those critical of the Gallery's purchases of the Carracci and *seicento* Italians. Of course, Eastlake was not the first to admire earlier Italian art. Back in the 1790s the Liverpudlian collector William Roscoe had published the first English biography of Lorenzo de' Medici, and William Young Ottley had bought works like Botticelli's *Mystic*

Nativity from the Aldobrandini, Colonna and other Italian families.[52] Ottley's great drawings collection was purchased by Thomas Lawrence in 1823, and there had been several attempts to persuade the government to buy it for the Gallery in the 1830s. But the first public appeals for a strictly chronological hang and the acquisition of early works for historic rather than aesthetic or artistic interest first appeared in the highly-influential *Edinburgh Review* only in 1834 and 1847. These reviews, as well as those of George Darley in the *Athenaeum* from 1834, can appear insubstantial compared to the tomes published or translated by the Eastlakes.[53]

Yet the influence of German scholarship on the National Gallery's collection, either through Eastlake or the Prince Consort, was only possible thanks to a preparing of the ground by early Victorian salons. Those centred around Richard Monkton Milnes and Sarah Villiers, Countess of Jersey, were particularly important in encouraging a more historically aware appreciation for Italian art. Milnes hosted Rio on his trip to London, introduced him to Gladstone and got Darley to review his book. He was also friendly with William Coningham, who, several years before launching his attacks on the Gallery had made a name for himself as a collector of Sebastiano, Raphael – but also Mantegna and Crivelli.[54] Although the authors of the *Edinburgh Review* pieces are not figures familiar to art historians – one, Edmund Head, was a Governor of New Brunswick, the other, Thomas Lister, an author of 'silver fork' novels – their Villiers connections link them.

Head's 1847 piece argued that the Gallery

should secure for the enjoyment of the people pictures capable of affording pleasure to all, by their intrinsic excellence;... But it has yet another function, which more particularly belongs to a public institution - that of gathering together, and arranging in order, such productions as go to illustrate the history of the art itself... works which are not always attractive in themselves, though as a series they are highly instructive to artists and amateurs.[55]

Here Head distinguishes between that canon of art whose 'intrinsic excellence' affords pleasure to all, and a de-canonized

Opposite: Painted on canvas, Sandro Botticelli's **Mystic Nativity** (1500) is his only signed work. An apocalyptic conflation of Christ's first and second comings, it partly reflects the shock of the 1498 invasion of Italy by French forces. Part of the Aldobrandini collection before being brought from Italy by William Young Ottley, it was one of a total of nine works bought in 1878 from the son of William Fuller Maitland of Stansted Hall, Essex, a collector of early Renaissance Italian and modern English paintings. Among the others was an *Agony in the Garden* then thought to be by the young Raphael (now attributed to Lo Spagna).

historical collection of works. The paintings which form the latter may have little value in themselves, but once arranged in a certain order they become legible as a history of art for educated amateurs. It is important to note that there is little evidence here of one model being privileged above the other.

The Peel Purchase

Consideration of such journalism allows one to identify a period of approximately forty years (from the late 1830s to the 1870s) in which the study and appreciation of art was evenly balanced between reverence for individual genius and interest in the character of a historical period. From the 1870s onwards writing on art returned to its roots in German Romanticism, its gushing hagiographies of troubled, creative geniuses now serving as primers for the formation of a grittier national character. The best-selling works of late nineteenth-century German art writing were Hermann Grimm and Julius Langbehn's biographies of Raphael and Rembrandt (original editions 1872, 1890). The former argued that it was only the *selfmade-großen Männer* (the self-made great men) who made history worth studying. The authority of the Old Masters was also used as a stick to belabour the pernicious influence of 'sickly' French Impressionism on modern art. Drawing a distinction between such writing and art history is difficult. Grimm was Professor in Art History at Berlin for almost thirty years.

Try as they might to defend 'serious' art history from this onslaught, all European art historians and museums were affected, and the majority made their peace with it. By hosting great temporary shows commemorating the anniversaries of the birth of Rubens, Rembrandt and other artists European museums tapped a powerful source of public enthusiasm. In the long-term, however, the cult approach could be used to further Fascist political agendas. By the 1920s and 1930s German museums were encouraged to acquire works by great Teutonic masters by selling or exchanging non-German works – even Raphaels. In the end, as with the 1930 Italian show at Burlington House, curators' concerns regarding the integrity

With a smile compared by one MP to 'the glint of a silver coffin lid,' **Sir Robert Peel** built his career as statesman on rigorous attention to detail, and by introducing a series of reforms which many in his party saw as betrayals of Tory principle. At home among his art collection Peel unbent, as this sketch by Jemima Wedderburn shows.

(in every sense of that word) of their collections were side-lined.[56] The National Gallery's shift away from the acquisition of illustrative 'specimens' and towards a focus on big-name masterpieces in the late nineteenth-century should be understood in this European context.

Other than the acceptance of the bequest of a reduced copy of Rembrandt's *Nightwatch* by Gerrit Lundens, little had been done for the Dutch School in 1857.[57] This despite the fact that still-lifes and domestic or tavern interiors of the Dutch Golden Age had remained popular with collectors throughout the intervening period. The common description of them as 'cabinet pictures' suggested that they were prized for different reasons than the great Italians: as unchallenging, smaller-scale decoration for less 'public' rooms where the collector spent his hours of relaxation. Frequently copied or imitated with slight variations, and located well down the Academic hierarchy of genres, still-lifes or tavern scenes could seem lacking in moral and aesthetic aura.

Yet there seems to have been a boom in Dutch art on the London market in the 1840s, partly owing to the willingness of

one collector to pay high prices: Prime Minister Sir Robert Peel. Anna Jameson's account of his collection, rendered in a style a later age might associate with a lifestyle magazine, has the stern statesman waxing uncharacteristically lyrical about how his Dutch paintings provided him with an oasis of calm after a busy day at the office. Repaying a confidence with interest, she observed: 'it is as if the owner had intended to comprise within the smallest space the largest amount of excellence and beauty and invested wealth.' 'Not only is there not one mediocre picture in the collection,' Jameson gushed, 'but there is not one which is not of celebrity and first rate.'[58]

Invested wealth there certainly was. Buchanan wrote to another collector in 1841 that Peel had 'within these last two years given prices for a few Dutch pictures, which Dutch pictures were never sold at before'.[59] In what would become a rather unfortunate pattern in the Gallery's history, complaints that the Gallery urgently needed to bolster its Dutch holdings only seemed to appear once that school was seen to be reaching record prices. The following year Anna Jameson wrote in her *Handbook to London Galleries*:

We are as yet most poor in the fine masters of the Dutch School. There is not a single specimen of Hobbema or Ruysdael. The specimens of V[a]ndervelde are insignificant; and of the beautiful conversation-pieces of Terburg [Ter Borch], Gerard Douw [Dou], Netscher, Metzu [Metsu], Ostade, Frans Mieris and their compeers, not one.[60]

No Jan Steen and only two Teniers, she might have added.

Indeed, although Teniers, Rubens and Rembrandt had featured in the collections of the British Institution connoisseurs, there had been only a handful in the Angerstein, Beaumont and Holwell Carr collections. Beaumont's only Dutch landscape (apart from a unique and uncharacteristic Rubens) was by Jan Both, who specialized in Italianate scenes. In 1837 a Rubens had been bought, although the subject (*The Brazen Serpent*) was felt to make it 'disgusting'. The purchase of the 55-strong Peel Collection for £75,000 by special government grant in 1871 more than addressed this need. Jameson, had she been alive, would have been pleased to find four Hobbemas, includ-

ing *The Avenue at Middelharnis*, two Ruysdaels, ten Vanderveldes (by Adriaen and Willem), a Ter Borch, a Dou, three Netschers, two Metsus, two Ostades (Adriaen and Isack) and a Mieris. Still no flower-pieces, and still no Vermeer, an artist whose spectacular posthumous career only began in the 1870s thanks to a series of articles by Théophile Thoré.

Eastlake was a difficult act to follow, and his successor has perhaps been slightly underappreciated. William Boxall acquired Pieter de Hooch's *A woman and her maid in a courtyard*, from the sale of Baron Delessert's collection in March 1869. Together with Rembrandt's *Portrait of an 83-year old woman*, purchased in 1867, this suggested that he was alive to the need to build up the Dutch part of the collection. 'When Boxall does make up his mind to buy a picture I think that his judgment and taste may generally be relied upon,' Layard wrote to fellow-Trustee William Gregory in 1870, 'the difficulty is to screw him up to the buying point.'[61] Boxall was spooked by rising prices, but appears to have held his nerve in this case, despite the fact that the Delessert Sale saw another de Hooch reach a massive 150,000 Fr. (over £6000) far outstripping Dou, whose window-frame scenes (notably *The Poulterer's Shop*) had been extremely well received at the 1857 Manchester Art Treasures Exhibition.

It had taken well over a century for de Hooch's works to sell at prices similar to Vermeer, Dou and Van Mieris. Even then his later works were more admired for their greater finish, although to a later age they seem to have exchanged poise for pose.[62] In his retrospective account of his career the London-based dealer Nieuwenhuys identified the Smeth van Alphen sale (Amsterdam, 1810) as marking the turning point in the artist's fortunes, the point at which George IV, Wellington and Peel began to collect. Nieuwenhuys and John Smith were Peel's chief suppliers, a third, lesser-known dealer supplying him with his slightly earlier de Hooch in 1833.[63] In the 1870s Thoré sought to sideline de Hooch in order to limit the implicit challenge to Rembrandt and Vermeer. He argued that de Hooch's skill was due to having worked in Rembrandt's studio, and in some cases reattributed de Hoochs to Vermeer.

At the National Gallery, however, de Hooch received little

Opposite: Pieter de Hooch's (1660-1) **Courtyard of a house in Delft**, was acquired by Director William Boxall in 1869. De Hooch does not appear to have been considered a particularly important master, and a third de Hooch was almost sold in 1916. Yet 15,061 visitors came to see this painting when it was 'picture of the month' in June 1942.

favourable attention until our own times. The artist came to attention again in 1894, when Poynter was seeking to convince the Treasury to resist Trustee demands that the Gallery focus exclusively on 'masterpieces,' pressure that led directly to the Rosebery Minute. When the Chancellor, William Harcourt, critiqued the acquisition of what he felt to be unimportant Dutch masters (*'little curios'*) Poynter replied that 'de Hooghe is to me such an exceptionally charming artist that I should always like to add a good one to the Gallery when there is a chance of getting one.'[64] When Holroyd took that chance in 1916, acquiring *A Musical Party*, it only seemed to expedite his unhappy departure. Critics such as D. S. MacColl, Claude Phillips and others took it as proof that neither he nor the Trustees could be trusted to buy sensibly. At that time Trustees and curators were drawing up lists of what paintings to sell in order to fund the purchase of the Bridgewater Titians – and the de Hooch seemed, for the editor of the *Burlington* at least, a capital place to start. Although de Hoochs were not on Holmes' or Curzon's lists, otherwise they were dominated by Peel Purchase works, especially 'superfluous' Cuyps, Teniers and Wouwermans.[65] Banquo's ghost turned up, with a near-perfect sense of timing, in 1917 when the Trustees were offered the chance to buy back some of the Krüger panels the Gallery had sold sixty years before. They resisted.[66]

The Treasury compensated for the large Peel purchase grant by suspending the Gallery's annual purchase grant. It also dropped the hint in an official Treasury Minute that 'in these circumstances it appears likely that some modification in the Administration of the Gallery, as settled in 1855, may be advisable.'[67] As Layard despaired in 1872, 'the tendency now is to put an end to expenditure in these matters, and to leave them to private enterprise, as Dillwyn [a Radical Welsh MP and industrialist] once said "like Cremorne" we must chiefly depend hereafter upon gifts and bequests.'[68] For the Gallery to be advised to model its financing on one of London's pleasure gardens was indeed serious. The idea of leaving purchasing policy in the hands of Germanophile experts ticking off 'missing' masters had never been fully realized. But now there was a

marked tendency to reject 'scientific' collecting, with new priorities increasingly set 'outside,' by the market and connoisseurs. On Boxall's departure there was a suggestion that the Directorship be abolished. His successor, Frederick Burton, turned down (admittedly due to lack of funds) the offer of Eastlake's precious notebooks – truly the Sibylline books of the Gallery. Otto Mündler, the great Director's loyal aide, now took himself (and *his* notebooks, another invaluable resource) off and began working for another Great Director: Berlin's Wilhelm von Bode.[69] The Golden Age was clearly over.

Eastlake and his Travelling Agent Otto Mündler scoured Italy for acquisitions. The latter described how Eastlake's desire to cover as much ground as possible led him to dispense with the usual formalities when calling on dealers or others who invited the pair round to inspect their pictures. Eastlake would circle the room's pictures, then 'depart with a wordless bow, leaving those present greatly surprised and bitterly disappointed.' Once safely outside he would scribble in **notebooks** such as this one, which records observations made during a visit to Arezzo on the 10th and 11th of September 1858.

As ex-Director of the Berlin Museum and a scholar who compiled an exhaustive guide to *The Art Treasures of England* (1854), Gustav Waagen cut an impressive figure in the London art scene of the 1850s. The role played by him and other German scholars at the 1857 Manchester Art Treasures Exhibition was so important that it has been called 'a German exhibition'.[70] Yet the state of the Berlin Gallery showed not only Waagen's limitations, but those of the otherwise much admired Prussian system of museum administration. At first control of acquisitions policy lay in the hands of an 'Artistic Commission' made up of practising painters. This body showed Peelite scruples in refusing to consider purchasing Bellini's *Doge Loredan* at the 1839 Beckford Sale, arguing that such works were not useful to trainee artists.[71] When the system was streamlined in 1843, funds that could have been spent on paintings were diverted to fund pet projects developed by the all-powerful Intendant, Ignaz von Olfers, a former diplomat more interested in collecting casts and copies than originals. As for private gifts, only five of the 345 works acquired in the gallery's first forty years were donated. Only after 1870 did Berlin overcome what the Gallery's historian has called 'the Prussian inferiority complex of the Waagen era'. This renaissance occured because the imperial court, parliament and private donors seized on Berlin museums as an opportunity to show off new-found industrial and political might. To show it off to foreigners and scholars, one should add, as visiting hours made it difficult for normal Berliners to attend.[72]

The mighty Wilhelm von Bode has become synonymous with this expansion, which cast its shadow over National Gallery acquisitions until the First World War. Bode's impressive output of monographs and scholarly articles tracked the market closely from the start, beginning with his Vienna University PhD thesis on Frans Hals (1870), an artist then neglected (he is missing from Jameson's list), but destined to become one of the most sought-after Dutch masters in the Edwardian period. Von Usedom, Berlin's Intendant, gave him a job in 1872, ostensibly helping build up a collection of copies of famous paintings. Instead he was given 100,000 Marks and

sent to Italy to buy originals, the first of a series of grants that kept rising in size, as did the normal annual purchase grant. In 1886 he got 2m Marks to spend at the Blenheim Sale – and in 1901 he got the same again to buy works for a new museum devoted to the Renaissance: the Kaiser-Friedrich Museum (now the Bodemuseum). Supposedly controlled by the *'Kultus-minister,'* Berlin remained very much a royal gallery, and Bode enjoyed excellent contacts at court. This helped secure government funds. When government grants began to decline in frequency in the 1890s, court connections helped Bode encourage his stable of private collectors, new men hungry for decorations and titles.

Bode's 1872 Italian tour had been a disappointment, which he blamed on Eastlake and his English agents cornering the market. He therefore turned his attention to Britain itself, which he toured in 1879, taking Waagen's *Art Treasures of Great Britain* as his guide. The mid-1880s marked the beginning of what seemed to certain more hysterical observers to be a systematic pillage of Britain's art treasures. In fact, Bode could show great awareness of, and sensibility for, English *amour propre*.[73] Although somewhat frustrated in his plans at the Blenheim Sale, he nonetheless secured two important Rubens and in 1894 carried off Rembrandt's *Anslo and his wife*. In contrast to Eastlake, Bode was not a 'gap-filler'. Whereas his colleague Julius Meyer's 1878 catalogues were exemplary in their careful analysis of sources and willingness to question attributions, Bode's 1891 ones dispensed with scholarly circumspection, removing any material that did not flatter his self-image as an 'ingenuous connoisseur'.[74] Whether spending thousands on acquisitions or defending his own attributions, Bode was a big name hunter.

'Archaeology' vs. 'Connoisseurship'

Compared to Bode, Frederick Burton could appear ineffectual, if not dopey. Bode loved telling stories at his expense, much as Layard enjoyed ridiculing his apparent unwillingness to scout out purchases on the continent, update the catalogues, attend

Opposite: This 'ugly old fellow with a lined face' caught Frederick Burton's eye during a visit to Flinders Petrie's exhibition of the **Egyptian mummies** he had recently excavated at Er Rubayat. Such portraits were, he told his Trustees, 'intensely individual in character – just such faces as you may see now in Italy or Greece'. He felt they marked the first stirrings of western art, and so belonged in the National Gallery. Although visitors clearly enjoyed them as much as Burton, the heads were later transferred to the British Museum.

auctions – anything that might detach him from his favourite armchair at the Athenaeum.[75] Although he showed his distance from Eastlake's approach in refusing to draw up lists of painters unrepresented in the collection, Burton did acquire a number of great works, including the first genuine Holbein, the first Vermeer and Leonardo.[76] He also acquired a 1st-century Roman Period encaustic portrait on limewood from a mummy excavated in 1888 near the village of Er-Rubayat, Egypt; this is no longer in the collection, having been given to the British Museum in 1994.[77] Although such a transfer now seems obvious, it clearly did not seem so in 1888, when several such portraits were acquired. Two more, 2nd-century, portraits arrived with the Mond Bequest in 1924, and another in 1943, presented by Major R. G. Gayer-Anderson Pasha, a member of the Egyptian Civil Service whose eponymous museum of Pharaonic art is one of the sights of Cairo. The Er-Rubayat heads were put on display in the vestibules of the central hall, next to a Margarito (late 13th century) acquired by Eastlake and fresco fragments by Spinello Aretino (late 14th century) that Layard had presented in 1886. Guidebooks preferred the mummy portraits to these 'expressionless' later works, finding 'a strange modernness about them, a sense of life and freedom... so full of character, [they] would be more at home in the Royal Academy, or even the New English Art Club.'[78]

Burton and key Trustee benefactors such as Layard, William Gregory and John Savile saw these mummy heads, not as curiosities, but as important documents that marked the start of the European story the National Gallery was supposed to tell. Burton had seen them at an exhibition held (where else?) at the Egyptian Hall by their excavator, the archaeologist Sir William Matthew Flinders Petrie. The first individual to hold a chair in Egyptology in Britain, Petrie was a pioneer who introduced a new standard in the documentation of archaeological digs. Like Layard, who had made his name excavating Nineveh, Petrie knew the importance of timely publication, and he rushed his account of the excavation into print.[79] Donating seven of his artefacts to the National Gallery obviously helped with publicity. To ensure acceptance, and secure permission to

buy more, Burton made his case for inclusion to the Trustees in July 1888:

> The method was handed down through Byzantine Art to the earliest Italian we know of, as may clearly be seen in Cimabue's works, and in the Sienese Madonnas, aye, even in Lorenzetti's frescoes. When I saw these things, which illustrate an unbroken succession in the art of painting, I thought how valuable they are in that respect, and how desirable a few specimens of them would be for the N.G... I consider these things as appropriate and desirable for a Gallery that pretends to be historical as any early Italian fresco or other work. They belong to European Art, and show the method which had already become traditional in it from the time of the Hellenic painters. Rude and summary as the worst of them are, they have a certain style about them...

Trustees Sir Richard Wallace, George Howard and Viscount Hardinge were initially sceptical. The South Kensington Museum collected similar works out of an interest in the technique of encaustic painting, suggesting that such portraits were examples of 'craft' rather than art. Burton's arguments persuaded the board, although Hardinge insisted he spend no more than a hundred pounds.[80] Burton was delighted with what he got, writing to Gregory that 'There is one head amongst them – an ugly old fellow with a lined face – that would not disgrace Moroni in its vitality and its workmanship.' Coming from such an ardent admirer of Moroni and North Italian art in general, this was high praise indeed.[81]

Burton's acquisition of the heads suggests that he could and did take the initiative on occasion. It also highlights an ongoing interest, which Eastlake had shared, in the roots of the European tradition in a 'Byzantine,' post-classical past, one that provided a link, however tenuous, with Antiquity. Layard's own collection showed a similar interest in 'Byzantine' art, greatly enriching the Gallery's holdings of *trecento* painting, for example. In the 1920s Martin Conway encouraged the Gallery to consider acquiring Russian icons of a similar period, in the wake of his own discoveries in Communist Russia. Although one token icon (*The Transfiguration*) was acquired in 1926, later attempts to add icons were not encouraged – and this one, too, eventually passed to the British Museum.[82]

By the 1890s 'archaeological' had become one of a number of pejorative adjectives used to dismiss 'German' art history as dry and obscure. When George Howard wrote to Gladstone regarding the choice of a new Director in 1894, he argued against the appointment of a critic. 'It is true that archaeological criticism has become more voluminous,' he wrote, adding that while 'the archaeology of the schools may be interesting' only practising painters had the 'training of the eye which in this case is the all important matter.'[83] The approach pioneered by the great Italian scholar Giovanni Morelli in the 1870s may have encouraged a dismissive attitude, Morelli's followers having simplified the master's methodology to the point where it could seem to demand little more than classifying painters by their handling of hands or ears.[84]

J. C. Robinson thus spoke for the majority of art lovers when he complained in an important 1895 article that Germany was 'robbing us of the very springs and bases of connoisseurship, the noble art treasures which our fathers and grandfathers endowed us with, whilst we waste our money on second-rate curiosities only, or worthless trash.'[85] In a hysterical turn, Robinson's jeremiad seemed to be arguing that the very appreciation of art, the 'old-established English taste and art culture' was somehow being removed along with the paintings that taste had admired. Instead of protecting our heritage by better funding of museums, Robinson continued, we had allowed our taste to be perverted by fads, including that for a 'superabundance of art learning,' brought to our shores by 'plodding, industrious, and specialising Germany.' Adopting a sneeringly mercantile tone, he observed that 'the supply of knowledge in this special field has, indeed, outstripped the demand in the fatherland, and the German art doctor has already been driven to fields and pastures new.'[86] The great English collectors, he pointed out, had had little use for books.

Now Hals and Rembrandt, the idols of German 'art learning,' were causing Britons to hold their *lares et penates* cheap:

In the realm of painting we have of late years, for instance, gradually witnessed the almost complete supersession of Italian sixteenth- and seventeenth-century art by the once comparatively unconsidered

A giant among Victorian art experts, **J. C. Robinson** was a dealer and curator who greatly enriched the Renaissance collections of what is now the V&A, though he received little thanks at the time, partly because of his tendency to argue with his superior, Henry Cole. In 1857 he set up the Fine Arts Club, whose *conversazioni* and exhibitions encouraged collectors to pool their resources, promoting greater understanding of the history of fine art.

Dutchmen. Annibale Carracci, Guido, Guercino, Salvator Rosa, and even Claude and Poussin – a single Rembrandt or Franz [sic] Hals would now buy up a whole gallery of these dethroned deities.[87]

Robinson's deities are similar to those admired by Beaumont and his circle, which is surprising, as it is clear that Robinson was a pre-eminent connoisseur of a much broader range of artists. Having started out as curator of the Museum of Manufactures in 1854, Robinson's greater knowledge of fine art combined with his activities as a dealer had led to clashes with his superior, Henry Cole. Cole succeeded in having the upstart demoted to 'Art Refereee' in 1863, and dismissed four years later.

As a dealer advising Sir Francis Cook and others Robinson had handled many *quattrocento* works, his purchase of Piero della Francesca's *Baptism* in 1860 being just one of his many coups.[88] Indeed, he gave El Greco's *Christ driving out the money changers* to the National Gallery the same year as he published the article noted above. His rant, though uncharacteristic in some respects, nonetheless speaks to the way in which the very knowledge and 'science' of art history could be perceived as part of a German threat to British collections and taste, rather than just a neutral bystander. The use of monographs and exhibitions to claim Rembrandt as the greatest ever *German* artist did indeed help create a situation in which a landed Trustee, the 5th Marquess of Lansdowne, could, as we have seen, sell Rembrandt's *The Mill* for a record £100,000 in 1910.

The acquisition of Velázquez' *Toilet of Venus* (*The Rokeby Venus*) in 1906 amply demonstrates how scholarship, great exhibitions and the masterpiece cult could transform a highly uncharacteristic work by an artist of a 'problematic' school into a fiercely defended heritage object. At the Gallery today the Spanish School is even smaller than the German one, with just 52 works, compared to 451 Dutch and 972 Italian. The *Venus* (c.1648) is an unrepresentative work, as the artist painted very few full-length nudes, and the original commission was clearly a private one for a cabinet picture, of the sort that the patron might have reserved for his own enjoyment. Absent from the

Opposite: Piero della Francesca's **Baptism of Christ** (1450s) was one of J. C. Robinson's many coups as collector, and was purchased from him by the Gallery in 1861, a year after he acquired it. Robinson lived for the chase and relished his buying expeditions to Italy for the South Kensington Museum. 'Florence has not had such a raking out as this within the memory of man,' he boasted to his then boss Henry Cole in 1859.

Titian models Velázquez may well have been imitating, the reflected gaze of the model's face establishes a sense of complicity in voyeurism that led to demands in some quarters that the Gallery have the mirror painted out. From Mary Richardson's attack in 1914 to the adolescent attention given it in the 1970 documentary discussed in the previous chapter, the *Rokeby Venus* has become an icon. Although the works 'rescued' later in the century (with the exception of Stubbs' *Whistlejacket*) were less adventurous, the acquisition showed that in matters of taste, a retentionist agenda did not necessarily imply a Robinsonian return to a default setting.

Troublingly Catholic, yet somehow 'isolated' from other European Schools, a taste for Spanish art was redolent of Charles I and his ill-fated collection. In contrast to the impact of the 1649 and 1779 (Houghton) sales on British holdings of other schools, nobody seemed particularly eager to get 'their' Spanish art back. The *Venus* was bought in Spain by the artist George Wallis, Buchanan's agent, who shipped it to London in September 1813. As in the Rhineland with *altdeutsch* art, French occupation (1808-12) and secularisation of religious orders (1835) flooded what passed for a market with Murillos, Zurbaráns and Velázquez. Although Buchanan may have hoped to sell the *Venus* to the Earl of Wemyss, 'a lecherous old dog' with 'a particular rage for naked beauties and plenty of the ready to purchase them with,' he found little interest in Spanish masters. 'Of the Spanish school,' Wallis wrote to Buchanan, 'we have no idea whatever in England... This School is rich beyond idea, and its painters are all great colourists.'[89]

Things began to change in the 1820s and 1830s, thanks in part to Wilkie and David Roberts' paintings celebrating the derring-do of simple peasants in the Carlist wars. Interest in Spanish art and travel really took off in the 1840s, however, thanks to the activities of British authors who published a series of reviews, travel guides and histories. Richard Ford's *Handbook for Travellers* (1845) and *Gatherings from Spain* (1846) were highly influential, as was William Stirling's *Annals of the Artists of Spain* (1848) – the first English book on art to have photographic illustrations, in the form of 36 Talbotypes.

Stirling's *Velázquez and his works* (1855) was even published in German translation (1856), showing that the flow of art historical knowledge was not all one way.

Edmund Head had also travelled extensively in Spain, publishing reviews of the above works as well as a *Handbook of the History of the Spanish and French Schools of Painting* in 1845. Not above the odd display of spite, Ford described Head as 'a learned dry antiquarian'. In fact, all these works including his own were antiquarian in approach, in keeping with the Spanish works on which they were based, notably Juan Agustin Ceán Bermudez' *Diccionario histórico de los más ilustres profesores de las bellas artes en España* (1800).[90] It took later studies by German scholars such as J. D. Passavant (1853) and especially Carl Justi (1888) to place Velázquez in his European cultural context.

At the National Gallery, Murillo reigned supreme in the 1840s. As the cartoonist Richard Doyle noted, his *Peasant Boy* and *Infant Saint John with the Lamb* were the among the most popular works with the masses, perhaps due to their similarity to saccharine Art Union prints. His *Good Shepherd* was besieged by visitors to the 1857 Manchester exhibition.[91] Murillo was also the star, along with Velázquez, of the 'Galerie Espagnole' (1838-48) in the Louvre, an impressive collection formed for Louis-Philippe by Baron Taylor.[92] The exhibition did much to rouse interest in the School as a whole, but largely failed to alter the consensus of opinion which saw Spanish art as a sultry nocturne occasionally lit up by superstitious visions. When Louis Philippe's gallery went on sale in 1853 Uwins purchased Zurbarán's decidedly Gothick *St Francis in Meditation* for £265. Possibly Uwins' best acquisition, it was warmly received by Ford and Stirling. Eastlake's record, both as Keeper and Director, was remarkably poor in this area: a mere three acquisitions, interestingly all Velázquez, including the *Boar Hunt*, and a *Dead Soldier* now catalogued as 'Italian School (?), 17th century'. Boxall and Burton did not achieve much more, although Trustees John Savile and William Gregory made several important donations in the 1880s and 1890s, including a large collection of copies after Velázquez in the Prado.[93]

Interest in Velázquez had not been spurred by historians alone, however, but also by artists who felt that his work offered valuable lessons to artists confronted by Impressionism. Previous rediscoveries by artists had seemed to involve the latter travelling back to a simpler age. Velázquez seemed to the artists of the 1890s to have travelled forward, displaying powers of perception and technique that were fully up to contemporary challenges. He was arguably the first Old Master described as having 'preconceived the spirit of our own day'. It was said by the painter and art-critic R. A. M. Stevenson (1847-1900), whose 1895 book on Velázquez was, according to the critic Frank Rutter, 'the bible for art students in the late nineties'. Stevenson's book hailed Velázquez as a true impressionist, defined as 'an attitude to painting in which every part of a composition was treated in relation to the whole' – in contradistinction to the French Impressionists he saw as mannered.[94]

As a contribution to the project of returning Velázquez to the art historical canon Stevenson's book was highly ambiguous, contrasting the master's true technique with the rote-learned colour-schemes, shortcuts and 'decorative conventions' he believed characterized most Western art, past and present. In so far as it was these conventions which enabled art experts to make their attributions, this sub-optimal art got the sub-optimal historians it deserved. More conversationalist than connoisseur, Stevenson was reluctant to shoulder the social responsibilities that went with the post of Roscoe Professor of Fine Art at Liverpool. One 1892 letter neatly captures the irritation Edwardian critics (and, later, the Bloomsbury Group) felt with the rituals that had formed around polite art appreciation. In it Stevenson complained of being expected to

Opposite: When Francisco de Zurbarán's **St Francis in Meditation** (c. 1635-9) from the collection of the late French King, Louis-Philippe came on the market in May 1853, Keeper Thomas Uwins recommended that the Trustees buy it. Although it only cost £256, the purchase is nonetheless doubly remarkable: first because the Board was then in a state of suspended animation after a series of scandals, secondly because the work is such a contrast to the 'safe' works by Correggio, Murillo and others they usually bought.

talk mild gossip about Botticelli, Burne-Jones and Frith – actually Frith – at garden parties and afternoon teas. And then there were a lot of pedagogue duffers who talk about 'schools,' and attributions to this and that master – and queried about dates, and the cinque-cento, and that rot – and their wives, who wishes [sic] to uplift the working classes by means of art...

It is interesting to note that *quattrocento* artists like Botticelli were now fully integrated into this shallow table-talk. The very name 'Botticelli' in particular took on an almost kabbalistic power among self-described aesthetes. From being the solution, these artists had now become part of the problem.[95]

The Impressionist challenge

Impressionism and modern French art were yet another challenge facing the Old Master canon in the years up to and including the First World War. 'Modern French' was a portmanteau term, stretching from artists who had been dead for over fifty years to those still alive, from Beaux-Arts and Barbizon to Post-Impressionism and Fauvism. It therefore included Ingres (d. 1867) and Corot (d. 1875) and Manet (d. 1883), but also Renoir (d. 1919) and Monet (d. 1926) – both Théodore Rousseau (d. 1867) and the *douanier* Henri (d. 1919). The familiar line has it that the National Gallery was 'late' in acquiring such works, a small coterie of blinkered aristocrats 'inside' the Gallery turning a deaf ear to open-minded, progressive critics 'outside'. In fact, if one stoops to analyze acquisitions in terms of a 'race', the British stable performed rather well: tied with the Metropolitan Museum, New York, for the first Monet acquired (1915), and several lengths ahead for Gauguin (1917, Luxembourg: 1923, Met: 1939). Monet, Pissarro and other Impressionists had moved to London in 1870 to escape the Franco-Prussian War, and the first non-Salon exhibition of their work was held in that city, not Paris.[96] Admittedly Redesdale's 1914 memo on the Lane loans, quoted in chapter three, suggests stubborn conservatism, an impression Keynes and the Bloomsbury set actively encouraged.

Suspicions of 'Victorian values' ran so deep in Bloomsbury that even when the Establishment's bastions did respond to their blandishments the motives of those involved (Curzon, Holmes and Courtauld) were assumed to be less than disinterested – and as such were snobbishly impugned.[97] This was particularly true of the Degas Sales of 1917-8, at which Holmes and the V&A's Eric MacLagan bid for the Gallery, aquiring the

Opposite: Director Charles Holmes purchased Paul Gauguin's **Vase of Flowers** (1896) at one of the sales of Degas' collection, held in Paris 1918. Although much maligned by the Bloomsbury Group for failing to acquire a Cézanne, Holmes' purchases actually appear quite inspired in hindsight. During the sale Holmes coolly ignored hissed demands that he stop bidding on lots earmarked for the Louvre, as well as the more impressive sound of German guns shelling the city.

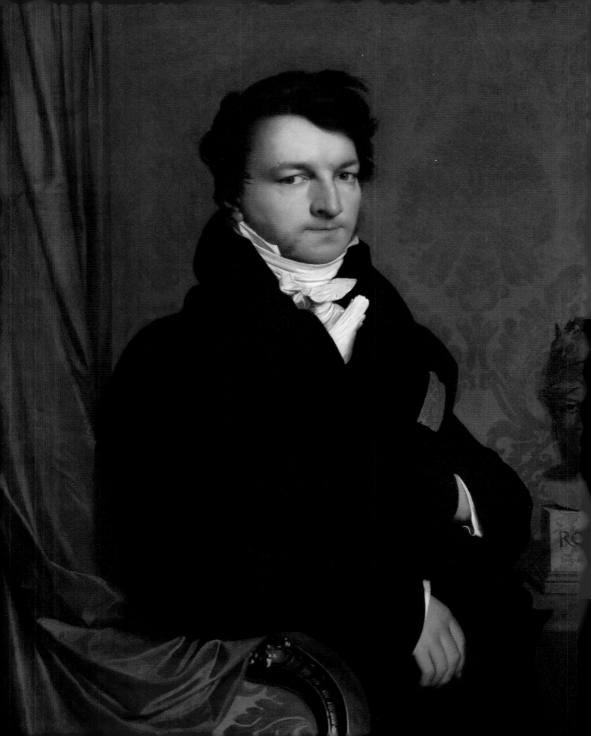

fragmentary Manet *Execution of Maximilian*, his *Woman with a cat* (later transferred to the Tate), a Théodore Rousseau landscape, four Ingres (including *Angelica saved by Ruggiero* and *Monsieur de Norvins*), Gauguin's *Vase of flowers*, two Delacroix portraits, and an uncharacteristically expansive Corot landscape. D'Abernon and Duveen later presented a Degas *Head of a Woman*. Manet's *Execution* had been hailed as 'the only historical picture of impressionism' by R. A. M. Stevenson when it had been shown at the International Society of Sculptors, Painters and Gravers show at Prince's Skating Rink in 1898.[98]

In 1917 Roger Fry drew Holmes' attention to the sale; later the painter Duncan Grant also spotted the catalogue at Fry's studio, and drew Keynes' attention to it. Keynes was then working for the Treasury, and his account has it that Chancellor Bonar Law agreed to a government grant 'as a sort of joke,' in bemused response to a plan by which the money would represent a partial in-kind repayment of export credits.[99] Had this Keynesian wheeze in fact worked, it would indeed have resonated with the original purchase of the Angerstein Collection in 1824 – both representing artistic windfalls from wartime debts nobody expected Britain's ally to repay.

In fact the £20,000 government grant consisted of real money remitted to the British embassy in Paris, and was as much the product of Holmes and Curzon's efforts.[100] Keynes did not approach the Chancellor directly, but asked Holmes to ask Curzon to do so. Holmes then joined an official delegation including Chamberlain and Keynes en route to Paris. Despite the *frisson* created by the German's long-range gun, Big Bertha, which began shelling the city halfway through, bidding at the sale was fierce. Holmes displayed grit, if not brashness, in continuing to bid for a Delacroix that was wanted for the Louvre. Although Chamberlain had privately joked prior to the sale that he might not sign a cheque for an El Greco Holmes hoped for, the Director nonetheless fought hard, if in vain, for it. When the second part of the Degas Collection (consisting of the artist's own works) came up for sale in 1918, Holmes wrote to Keynes asking him to help secure a grant. Once again, prices were expected to be low. Holmes described the sale as an

Opposite: Ingres' portrait of **Monsieur de Norvins** is dated 1811-12, when the sitter was Chief of Police of the Roman State. Infra-red photography indicates that it may have originally included a bust of Napoleon's son, the King of Rome, in the top left-hand corner. This would presumably have been painted out following Napoleon's fall in 1814. The portrait was acquired at the Degas Sale along with another Ingres, *Angelica saved by Ruggiero* (c. 1819-39).

opportunity to acquire works of 'a great artist who we shall inevitably have to buy some day'. Trustee Robert Witt was also clear that a 'big effort' had to be made, and Curzon wrote to Bonar Law again, asking for three thousand pounds of the sum left unspent in 1917, to be spent on the works of an artist 'now regarded as one of the greatest of modern masters'. Unfortunately prices again exceeded expectations, obliging the Gallery to forego works they had earnestly wished to acquire, notably Degas' *Portrait of the Bellelli Family*, now in the Musée d'Orsay.[101]

Fry, Keynes and their Bloomsbury allies savaged Holmes and through him Curzon for failing to buy these works. An anonymous correspondent claimed in the *New Statesman* that Holmes had been ordered not to buy any nudes or ballet subjects, in obedience to Curzon's 'aristocratic' taste.[102] The episode burnished Keynes' reputation among Bloomsbury friends, who felt he had sold out in joining the Treasury. Vanessa Bell told him that 'your existence at the Treasury is at last justified.'[103] Keynes clearly derived a certain amount of satisfaction from sharing Bloomsbury's 'advanced' taste. While they were in Paris Holmes had noted how his taste for Cézanne lent Keynes an aura of complacent superiority which left him open to the wiles of dealers.[104] As the lively account of the sale in his autobiography makes clear, Holmes was doing the best he could under difficult circumstances. His room for manoeuvre was restricted by his Trustees. This explains his decision to concentrate on 'certain Capital works of a size and importance suited to a public Gallery – not mere scraps or sketches'.[105] Whatever he chose, he would face a grilling back home. 'Everyone,' the painter Charles Ricketts told him at the time, 'is dying to see you make a little mistake.'[106] His main targets at the sale had been works of the nineteenth-century Academic and Romantic traditions, in particular Ingres and Delacroix, whom he wished to see represented in all 'phases of their genius'. In that regard the Gallery did well out of the sale. In so far as Delacroix' *Schwiters* and the Corot display the influences of Lawrence and Constable, Holmes' choices foreshadow recent interest in a common Anglo-French tradition of landscape and portraiture.[107]

Previous pages: Edouard Manet's **Execution of Emperor Maximilian** (1867-8) had caught the eye of R. A. M. Stevenson and other critics when shown at a London skating rink in 1898. After Manet's death in 1883 it was cut up. Degas acquired these fragments and mounted them on a single canvas, which the Gallery purchased after his death in 1917. As it happens the focus of the painting, Emperor Ferdinand Maximilian of Mexico, does not appear – the figure at left is one of the generals executed alongside the Emperor in 1867.

The Gallery's greatest sin in Vanessa Bell's eyes was in not following Keynes' own example in buying Cézanne. Fry found in Cézanne the perfect realisation of the 'constructivist' tradition in art he first noticed in the course of his Berenson-influenced studies of the 1890s. Building on Berenson's view of art history as the story of how representational 'problems' were resolved, Fry believed that Cézanne had solved that of 'how to use the modern vision with the constructive design of the older masters.' Such beliefs had clear precedents in R. A. M. Stevenson's advocacy of a technique which viewed the world as 'unconnected flat *panes* of colour, like *mosaic,* free of the 'knowledge that any objects exist.' Fry had kept himself aloof from the 'New Art Criticism' of D. S. MacColl and others, which loudly championed French Impressionism around the turn of the century. 'Cézanne and Gauguin are not really Impressionists at all,' Fry wrote in 1908. 'They are proto-Byzantine rather than Neo-Impressionists.'[108] They bridged the chaotic eddies of Impressionism, making 'of the Impressionist vision something that should have the architectural completeness of early art.'[109] Although examples of Cézanne's work had first been shown in London by Durand-Ruel in 1905, Fry's 1910 Grafton Gallery show of French Post-Impressionists marks the point at which the artist came to prominence in Britain.

Holmes' review of the 1910 Grafton show demonstrates that he was broadly supportive of Fry's campaign. In his own landscapes as well as in his writing (his work on Hokusai had appeared in 1899), Holmes stressed eastern influences rather than formalism, arguing that 'the art of the Post-Impressionists may perhaps be most easily addressed from the Oriental side.' Hence his proposal that a small Oriental collection be added to the National Gallery. He particularly admired Van Gogh, whom he accurately predicted would become 'a considerable figure, perhaps the most considerable figure of the movement.' He disagreed with Fry, however, in finding Cézanne, 'a humble follower of the more famous Impressionists,' to be an incompetent let down by 'consistent personal clumsiness of touch'. Among the works on display at

the Grafton the future Director singled out the *Dame au Chapelet* for comment, describing it as:

A failure. If the intensity of vision and the technical science of a Rembrandt are needed to make a great picture from such a subject, any well-trained art student could make a good study from it. Cézanne's ill-success proves, if any proof were needed, that his heaviness of hand was due to sheer want of competence.[110]

It is interesting to contrast this with a later Gallery Director's 1960 defense of the same painting, which he had acquired for the Gallery seven years before. In the intervening period the Courtauld Fund's two Cézannes had been shown at the Tate, and Courtauld's own *Mont Saint Victoire* had been lent to Trafalgar Square. The artist's reputation was secure from assault by all but the most retardaire Academicians.[111] In his 1960 Home Service talk Hendy praised the painting in terms that reveal how he saw such acquisitions fitting in to the Gallery, and how the public might influence collecting policy. All this makes the talk worth quoting at length:

She is the subject of the picture; but the theme is not the spirit of the old woman, the sense of her past and of her tenuous future, as it is with *Margaretha Trip*. Rembrandt's theme is the almost invisible. Cézanne's is much more difficult to describe because it is wholly visual... no form was true to him if it was not absolutely clear, not only in itself but in its relation to all other forms within the picture space... one must not say that design is even half of Cézanne. To him Nature was nothing without design, and design was equally nothing without nature... Cézanne belongs to the great tradition of the past.
 In the context of the twentieth century he is an 'Old Master'. His place is in the National Gallery. And there is the tragedy. The National Gallery was once a great pioneer. It played a leading part in bringing back into public esteem, on to a level with Raphael and Titian and Rubens, the great painters of the earlier Renaissance... But it has not been equally perspicacious at the other end of the history of painting; it failed to see the significance of the great French school of the nineteenth century... Why is the non-representation of Cézanne in [the Gallery] not recognized as a matter of importance to the public, a deficiency to be remedied? In our democracy the National Gallery can be no better than the nation wants it to be. This is not only our business... it is your business as well.[112]

Opposite: Paul Cézanne's **Old Woman With A Rosary** (c. 1896) is allegedly a portrait of a former nun who escaped her convent. Although Cézanne had died in 1906 his art was still somewhat controversial when Gallery Director Philip Hendy acquired this work in 1953 for £32,200. Two Trustees, the 7th Duke of Wellington and the Earl of Pembroke and Montgomery, formally objected to its acquisition.

Such commentary shows the extent to which Fry's vocabulary had come to predominate in British art writing and discourse by the 1950s. While at the Metropolitan in New York before the Great War Fry had displayed Sebastiano next to Manet and Rubens next to El Greco, foreshadowing Hendy's iconoclastic hang at the Gallery forty years later. Hendy, for example, hung the *Rokeby Venus* between the two de Hoochs discussed above.[113] Hendy shared Fry's belief that Cézannes belonged in a collection of Old Masters. Hendy's troubled negotiations over transfers to and from the Tate (1952-5) were a function of this. Several National Gallery Trustees felt it was premature to rob the Tate of some of its most important works, such as Seurat's *Bathers at Asnières*.[114]

For Daniel in 1932, and later for Clark as well, it had been a commonplace to state that 'we at the NG cannot buy modern.'[115] That changed under Hendy. His acquisitions policy was driven by the need to find 'replacements' for the Lane Bequest pictures which were sent to Dublin on long term loan under the 1959 settlement.[116] His priorities even influenced the acquisition of more traditional Old Masters. When Prime Minister Macmillan complained that Hendy was only buying 'fashionable' French Impressionists, Robbins reacted by urging the Count Lanckaronski's Uccello (*St George and the Dragon*), as if to compensate.[117] Hendy's mission was frankly educative – perhaps overly so at times. He was probably the last Director to go cap in hand for a special grant to the Treasury while admitting that the pictures he hoped to buy would not be popular with the public.[118]

While it must be said that some of his purchases, such as the Renoir *Dancing Girls* (acquired in 1961) and Cézanne's *Les Grandes Baigneuses* (acquired 1964), were questionable, at least such purchases challenged the commonplace that such grants could only be used to buy works in England that were at risk of imminent export.[119] In 1946 the Trustees had decided that pictures located abroad could not be included on Paramount Lists. Macmillan's weary yet pithy response on Boxing Day 1960 to one too many Hendy appeals for Impressionists combined healthy scepticism with patriotic conservatism. 'You must

Opposite: Acquired in January 1959 with the help of a special Treasury grant, Paolo Uccello's **St. George and the Dragon** (1460) is unusual in being painted on canvas rather than wood – the oldest painting on canvas in the Gallery. The 28th Earl of Crawford doubted whether it was even by Uccello, describing the princess as 'an elegant, elongated, fanciful visitor from the gothic North, [who] finds no relatives among the clumsy, dumpy little women of Renaissance Urbino.'

decide', he minuted his Chancellor, Selwyn Lloyd, 'but 1) when did these economists and tycoons [i.e. the Trustees] discuss these ideas? Only when these pictures became fashionable. 2) I think the point... is decisive. To keep what is in England is first priority.'[120]

The Age of Duveen

What had seemed like an assault on the National Gallery's masterpiece canon ended up confirming its belief that the very best works of every school 'spoke' to each other. Regrets had occasionally been expressed from the 1850s onwards that Renaissance altarpieces and English portraits in the National Gallery could not be seen in their original context, leading some to wish that galleries be made to mimic palace or church interiors. From the years around the First World War by contrast it was felt that Impressionists and Post-Impressionists 'belonged' in a museum. In so far as Fry and his school saw Post-Impressionists as addressing aesthetic problems first raised by Duccio, their arrival in the Gallery involved a certain detachment from the historical view of paintings, from seeing them as windows on a *Zeitgeist*. When Clark was publicly criticized over the acquisition of four small allegorical panel paintings he believed to be by Giorgione (later given to Previtali), the Director did not take the fall-back position of arguing that the panels' importance as historical documents compensated for the lack of attribution. This was the line Eastlake had taken in the similar case of the suspect 'Holbein'. Instead Clark stated that the panels 'were bought as beautiful expressions of the Giorgionesque spirit and not as guaranteed authentic pictures'.

It is striking how eager Daniel, Clark and other Gallery staff of the interwar period were to distance themselves from Eastlake's 'scientific' collecting policy. The very word 'expert' became pejorative, associated with scholars like Berenson who were in the pay of dealers like Duveen. Connoisseurial knowledge was now a commodity, a paper currency consisting of certificates of authenticity issued by scholars and retired museum Directors such as Holmes in return for retainers. Unreliable

Opposite: These four **Scenes from Tebaldeo's Eclogues** (c. 1505) are painted on two wooden panels that probably formed the doors of a cabinet. Their acquisition as Giorgiones by Clark in 1937 gave his many enemies the perfect opportunity to exact revenge for what they perceived as superciliousness. Clark was not the first Director to fall victim to 'attributionism' and whether as Giorgiones or under their current attribution to Andrea Previtali, the panels retain their disturbing beauty.

scholarship drove out good by a sort of Gresham's Law.[121] In the same letter in which he defended the Giorgione panels Clark argued that the authenticity of a work could not be made the subject of expertise. 'It is the essence of such works that their chief qualities are imponderable.' Even if experts were honest, the Gallery had no business consulting them 'because the Gallery does not as a rule buy the kind of pictures which require expert opinion.'[122]

Duveen was at the centre of this web of experts, and as such the Sassetta *Scenes from the life of St. Francis*, purchased from him in 1934 afford an insight into how he affected acquisition policy. The Sassetta panels were excellent examples of the Sienese School, one which the Victorian discovery of the *quattrocento* had largely neglected. Although Poynter and the banker, collector and Trustee Robert Benson had been alive to the poor state of the school's representation, they had not been able to do much.[123] That the Sienese School of Duccio, Ugolino, Simone Martini and Sassetta (fl. 1427-1450) was fairly well known by the 1920s was largely thanks to the efforts of the American scholar Robert Langton Douglas, whose *History of Siena* appeared in 1902, followed closely by the 1903 *Burlington Magazine* article which relaunched Sassetta. The School seemed curiously disconnected from the great Florentine School. Despite Douglas' efforts to emphasize Duccio and Sassetta as colourists, the School was felt to be 'Neo-Byzantine,' and as such had drawn the attention of Fry. Duveen himself had never shown much appreciation.[124]

The six panels (and one now in the Musee Condé, Chantilly) had been commissioned for the church of a Sienese convent suppressed during the Napoleonic period. After passing through the hands of various local notables they had been sold to Count Demidoff by 1840, at which point the chain of ownership becomes unclear. Duveen acquired them from Emmanuel Chalandon of Lyon in 1925, and 'sold' them to Clarence Mackay of Long Island. Mackay never paid for them, however. A Gatsby-like figure who came to a sticky end, the sources of Mackay's reputed fortune are mysterious. Realising that his great client would never pay, Duveen used him as a

Opposite: One of a series of six panels by a Sienese artist Stefano di Giovanni (called Sassetta), **St. Francis Giving Away His Clothes and St. Francis Dreaming** (1437-44) was purchased from Clarence Mackay of Long Island in 1934. Trustee Joe Duveen bought the panels without consulting the board, and then asked them to pay him back. Thanks to several private donors, that was just about possible. Duveen generously waived the last £4,000 owed, then changed his mind. At some point in the negotiations it became clear that the panels in fact belonged to Duveen himself.

front, hanging hard-to-shift works like the Sassettas on the walls of his sumptuous New York apartment (furnished at Duveen's expense) and then inviting likely clients to admire his taste. Even after £4,270 worth of heavy restoration, the panels could not be sold.[125]

In 1934 Clark convinced the Board to offer Mackay £35,000 for the panels. Duveen then appeared, candidly admitted that he had Mackay's butler in his pay, and that the offer had been intercepted. Though Clark was much scandalized by this, it was probably academic, in so far as the panels were (as Duveen admitted the next day to Sassoon) Duveen's in all but name. Duveen nonetheless told the Gallery that Mackay might accept £48,000, and Clark set about trying to raise the difference from the NACF (which pledged £10,000) and his small stable of friendly millionaires, which included Guinness and the press-baron Viscount Rothermere. Duveen's involvement clearly put a number of them off, however, and so when Duveen sent a telegram saying that he had purchased the panels, the Board decided to let them go. Clark was still £6,000 short, and in any case the paintings had not been popular with all Trustees. In a characteristic display of magnanimity, Duveen telegraphed a clarification: what he meant to say was that he would let the Gallery have the panels for £43,000 without obligation. Clark and the Board agreed, but Clark sensed that something was wrong about the deal and remained privately nervous about its repercussions.[126]

The Board had been in the position of being the victim of Duveen's generosity before, and it had been a painful experience. Negotiations for Holbein's *Edward VI as a child* ('the Hanover Holbein') broke down when Duveen (backed up by D'Abernon) interposed himself. Although the purchase was not complete, Duveen asked the Gallery to step aside, claiming that he planned to buy it and then hold a public subscription to 'rescue' it for the Gallery. Instead it was bought by Andrew Mellon and is now in the National Gallery in Washington.[127] The reason the Trustees rounded on Holmes in 1927 for accepting Duveen's 'spontaneous' offer of a Correggio (*Christ taking leave of his mother*) from the Benson Collection was that in

Giorgione's **Allendale Nativity** (1500-1505) was another of the masterpieces in the collection of Cardinal Fesch in the 1840s. Although the great Bernard Berenson later claimed it was in fact the earliest known work by Titian, this theory did not find wide acceptance. By the 1920s it was in the collection of Robert Benson, a Trustee, and the Gallery had hoped to be given the chance to acquire it. Instead Benson sold his whole collection to Duveen in 1927. The *Nativity* was in turn bought by Samuel Kress, who presented it to the American National Gallery in 1939.

doing so Holmes had allowed the slippery benefactor off the hook. In addition to being an important collector Benson had been a Trustee of the Gallery, and both the Treasury and the 27th Earl of Crawford believed that this gave the Gallery sufficient leverage to demand an opportunity to select some works from his Estate. The Benson Collection, which Duveen had purchased whole, included stunning pieces such as Giorgione's *Allendale Nativity*, many of which were donated to the National Gallery, Washington, by Samuel Kress, Duveen's client.

In the 1890s Benson had also been an important collector of Sienese works, and thanks to the efforts of his adviser, Charles Fairfax Murray, his collection included four predella panels from Duccio's *Maestà* (1308-11) needed to complement the two from the same altarpiece already in the collection.[128] In offloading the Correggio, a relatively unimportant, not to say unattractive, picture by a master already well-represented in the Gallery Duveen had escaped, while the gesture only helped his

campaign to become a Trustee.[129] Two years after the Sassetta affair had been 'closed,' Trustees with their own obligations to him were still hinting darkly about a 'debt,' Charteris attempting to parlay it into a renewal of Duveen's Trusteeship. When this failed, Duveen himself rang up Clark. To quote Clark's account, Duveen said he wanted £4,000: 'no public recognition – hates publicity – just £4,000. Very much hopes it *will* be legal (in rather a menacing voice).' The debt, if it was one, was never paid.[130]

The age of Duveen seemed to mark the point at which private collectors ceased to consider leaving their collection to the Gallery *en bloc*. The Salting Bequest of 1910, which helped bolster the Gallery's holdings of a long list of secondary masters, was the last such bequest to be handed over without legal challenges from customs authorities or relations. And Salting had been an exceptional collector, whose constant bargaining and semi-reclusive lifestyle marked him out from his peers.[131] As Holmes noted in 1921, the idea of appointing collectors as Trustees in the hope that they would remember the Gallery in their wills had failed spectacularly in the case of Alfred de Rothschild and Benson.[132] From 1904 onwards there was a shift to asking millionaire businessmen to contribute towards acquisitions in life. In that year an embattled Poynter had appealed to the Treasury for a special grant to secure Lord Darnley's Van Dyck (*The Stuart Boys*) – and been told that the Treasury would match any funds collected from private donors. The concept of 'matching funds' had been invented.[133]

Opposite: This **Still Life** by Jan Davidsz. de Heem (c. 1664-5) entered the collection as part of the Salting Bequest in 1910. The Gallery long seemed nervous of buying still lifes, and so here the role played by benefactors has been especially important, benefactors such as Trustee Lord Savile, who gave examples by Chardin, Harmen Steenwyck and Jan van de Velde in 1888.

In addition to involving the Gallery in the sale of peerages (as described in chapter three) this confirmed the shift towards an acquisition policy focussed on securing a limited number of securely-attributed works at the top of the market. Robert Witt spoke for the majority of the Trustees when he wrote in 1933:

We believe that the most successful recent purchases for the Gallery have been those which, like the *Wilton Diptych*, have taken the form of outstanding masterpieces at substantial prices, and both expert and popular opinion has acclaimed both the selection and the outlay.[134]

Rothschild typically went further in arguing that public

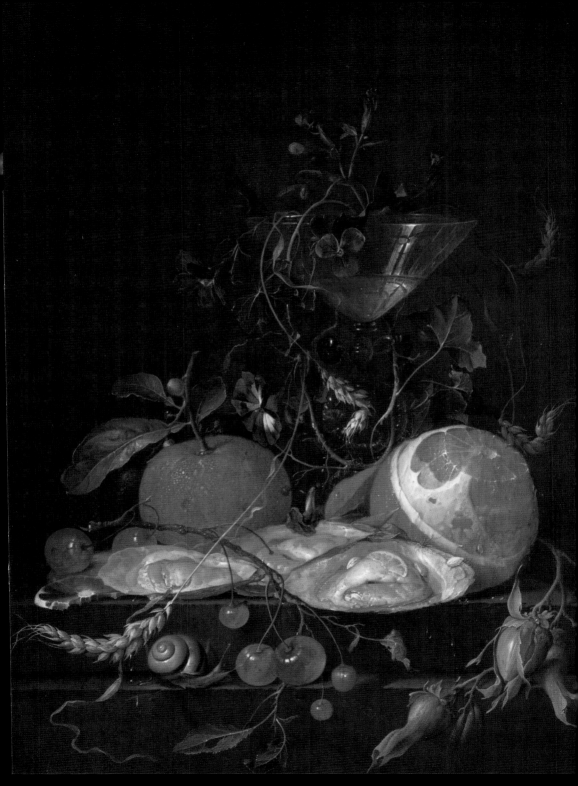

opinion trumped that of so-called experts, for whom he invariably exhibited disdain.[135] High prices were a sign of quality.

Sir Herbert Cook, who joined the Board in 1923, was one of the last Trustees to be appointed in the hope of an eventual bequest. Herbert's grandfather, Sir Francis Cook, had built up the family's wholesale haberdashery firm, and his impressive art collection had been shaped by J. C. Robinson. As a connoisseur Herbert Cook had been close to Benson, and like him was a pillar of the Burlington Fine Arts Club, (established 1856) organizing important loan exhibitions under its aegis and preparing a scholarly monograph on Giorgione in 1900. At his death in 1939 his collection included Jan van Eyck's *Three Maries*, Rembrandt's *Portrait of Titus as a boy* and Titian's *La Schiavona*. Clark and the Trustees believed that verbal pledges made during Cook's lifetime entitled them to first refusal and markdowns. Unfortunately, Cook's son thought differently, and an ugly tussle ensued, in which he accused the Gallery of seeking to coerce him by one means or another. Although the son did donate the Titian in 1942, Robert Witt's bullying and Clark's vague threats of using wartime legislation to ban export were probably counter-productive.[136]

A broader view?

Opposite: Titian's **Portrait of a Lady** (c. 1511) was presented to the Gallery by Sir Francis Cook in 1942 in memory of his father, Herbert Cook, a former Trustee and noted connoisseur. In one of his last interventions on the Gallery Board, Arthur Lee demanded that it be labelled a portrait of Caterina Cornaro, produced in a joint effort by Titian and Giorgione. Clark pointed out that there was no evidence to substantiate this theory, and defended his right as Director to decide how paintings were labelled.

It can take many years for changes in taste and understanding of the canon to become perceptible. It may therefore be premature to comment on the situation after the Second World War. The Gallery's priorities under Hendy are touched on above. Two other trends, however, are conspicuous enough to be worthy of comment. The first is the long, slow march of the Italian *seicento* back from the slough of despond to which 'Ruskin terrorism' had consigned it.[137] Alice Corkran's 1908 guide to the Gallery for young people was typical in approaching the *seicento* room with a shudder: 'I shall not keep you long over this room,' she reassured her readers, 'the pictures are painful to look at.'[138] *Apollo* editor Denys Sutton was an admirer of the period, as well as one of the first, along with Francis Haskell, to study the history of taste and collecting in Britain. He and

Denis Mahon sought to reengage scholarship with Guercino, Reni and Caravaggio through a bevy of publications and exhibitions. As a Trustee Mahon was indefatigable in support of this school. Although there was no doubting his belief in its importance, he urged the school's representation in terms that sought a return to the Eastlake approach which had been forgotten for so long.[139] In 1957 the Gallery acquired a Guido *Adoration of the Shepherds*. As the editor of the *Burlington* noted at the time, only six *seicento* works had been acquired since 1846 – two of them by accident, one being misattributed to Velázquez and the other thought to be nineteenth-century French.[140] Since 1987 Mahon's generosity in lending *seicento* works from his highly important collection to the Gallery has done much to address this neglect.

In the nineteenth century the Gallery had acquired very little eighteenth-century French art, believing that the Wallace Collection's holdings of Boucher and his contemporaries relieved them of responsibility in this area. When a Treasury-appointed committee met in 1897 to consider how the collection bequeathed to the nation by Lady Wallace should be housed Poynter argued that it should be displayed in an annexe to the National Gallery. 'If that is not done,' he told the committee, 'I think that fifty or a hundred years hence, when all the people who knew Sir Richard Wallace and Hertford House are dead and gone, those living then will say what a great opportunity was missed of bringing the pictures down to Trafalgar Square.'[141] Although in 1935 Clark had proposed offering to loan Turners to the Hermitage in exchange for works by Hubert Robert, this idea did not come off, and Hendy's focus on Renoir and Cézanne only made the eighteenth-century French 'gap' more conspicuous.[142] As a scholar and a Paterian Levey had been drawn to eighteenth-century masters such as Watteau and Tiepolo and as Director he was particularly eager to improve the Gallery's holdings. In 1969, while he was still Keeper the Gallery acquired Tiepolo's *Allegory with Venus and Time* for £409,500 - £220,000 of this a special grant. The price was felt to be high, and together with the record-breaking sale of the Earl of Radnor's Velázquez *Juan de Pareja* (£2.31m) the

Opposite: At the National Gallery politics and acquisitions have always gone together, and in this respect Giovanni Battista Tiepolo's **Allegory with Venus and Time** (c. 1754-8) was no exception. At the time of its acquisition in 1969 it hung on the ceiling of a room in the Egyptian Embassy, and some would-be donors were not keen at the idea of funds going to the United Arab Republic. It was acquired thanks to a donation from the Pilgrim Trust, as well as a special Treasury grant.

In 1970 this Velázquez portrait of **Juan de Pareja** from the Earl of Radnor's collection was sold to New York's Metropolitan for a record £2.31m. Although it had been on a 1930 'Paramount List' and was one of thirteen 'essential' works on a 1968 list prepared by Gallery staff, Heath's government felt unable to act. Today five of the thirteen works from the 1968 list hang in the Gallery, two of them on loan.

following year it confirmed Eccles' belief that such money was better spent on improving visitor facilities.[143] As Director Levey acquired the Gallery's first Fragonard (1978) and David (1984).

Taking a step back to consider a century and a half of acquisitions, it becomes possible to distinguish three phases in the numerical growth of the collection. For the first thirty years the Gallery had no regular purchase grant. Combined with the unsatisfactory accommodation and doubts surrounding the Gallery's purpose, this kept acquisitions (whether by purchase or donation) low. The introduction of a purchase grant in 1855 as well as Eastlake's annual buying expeditions brought about a step change. A phase of rapid growth began which lasted for approximately forty years, with Directors taking advantage of their independent buying powers and the absence of serious foreign competition or export restrictions to acquire works intended to constitute an encyclopaedia of European art history. The Salting and Mond Bequests were belated echoes of this.

A final change in pace and approach was triggered by the Rosebery Minute (1894), the Lansdowne Resolutions (1902) and the establishment of the NACF (1903). Directors ceased to tour abroad, their powers and pretensions to expertise undermined by Trustees determined to focus all their resources on saving a short list of masterpieces from export. Although the list of masters represented on this list grew, generally speaking the view of the collection as an 'anthology' rather than an 'encyclopaedia' remained. As the *Saturday Review* put it in 1898, the Gallery 'is not a mere museum or repository, where pictorial documents of all kinds are to be preserved, irrespective of their value, but it is a gallery of the great masters, to which artistic excellence, and artistic excellence alone, should procure the right of admission.'[144]

It could be argued that the Trustees had no choice but to adopt a defensive approach, in view of the fact that the Treasury repeatedly refused to increase the annual purchase grant in line with inflated market prices and increased rivalry from German museums and American millionaires. In the 1880s the grant was reduced from the ten thousand pound level set in 1855. It was a mere £7,000 (£209,000 today) in

1924 and only returned to the 1855 level in 1954 – without any adjustment for inflation. Only under Hendy did it rise to any significant extent, reaching £125,000 by 1962 (£1.9m today). It would be difficult to come up with a 'purchasing power parity' exchange rate such as would allow one to make reliable comparisons across long historical periods. Nonetheless, it seems safe to argue that no pre-1974 Director ever came close to having the means Eastlake enjoyed.

To suggest that the Treasury simply forgot about the Gallery, was ignorant of shifts in the art market or staffed with philistines would be unfair. The history of special grants amply demonstrates their ongoing commitment to the growth of the Gallery. A statistical analysis of acquisitions over the hundred-and-fifty-year period does not suggest that changes in tax policy such as legacy or estate duties or Capital Transfer Tax had any appreciable impact on donations or bequests. It is, of course, impossible to calculate how many 'extra' would-be donors might have been put off by such taxes – but it can be demonstrated that they did not cause the number of donations to decline. What clearly did change in the 1890s was the Treasury's willingness to trust the 'arm's length principle' and give the Gallery a market-adjusted purchase grant to spend independently or save for future purchases.

Put simply, they did not trust the Trustees. Meanwhile the alternative – entrusting a 'professional' Director with extensive purchasing powers – had been sullied by the vicious three-way struggle for the post between a rising generation of professional art experts and critics, painters and connoisseur Trustees. It thus became all too easy for Chancellors such as William Harcourt to call a plague on all their houses. In 1893 he wrote that he and the Prime Minister didn't have a clear idea of who should be Director – but they were sure of their 'profound distrust' of both artists and the 'new' critics.[145] The Trustees' repeated failure to back up their Directors (with the exception of Clark) also frustrated their efforts to secure improved funding.

A 1909 memo by a Treasury mandarin named Armitage Smith surveyed the history of acquisitions funding since 1824,

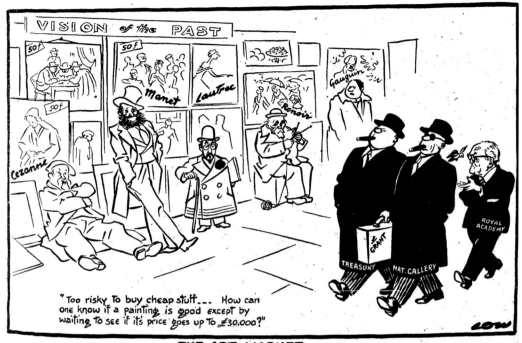

"Too risky to buy cheap stuff... How can one know if a painting is good except by waiting to see if its price goes up to £30,000?"

THE ART MARKET

David Low's target in this 1953 cartoon was those diehards at the Royal Academy and National Gallery who opposed Philip Hendy's acquisition of Cézannes and Renoirs, including *Old Lady With a Rosary* (at left). Academy Secretary Gerald Kelly (at right) was a particularly outspoken opponent. The arguments advanced by the cartoonist's cigar-smoking Trustee echoed those deployed in all seriousness by Alfred de Rothschild, Robert Witt and other Trustees earlier in the century.

arguing that the recently-adopted system of low annual purchase grants and the odd large special grant represented a happy compromise between the two approaches adopted hitherto (Treasury control up to 1855, and Director control thereafter):

The Trustees of the National Gallery seem to regard it as beyond their province to buy the works of any Master however eminent until he is old i.e. universally recognised and valued – in the market – accordingly. This explains (but scarcely justifies) the absence from all our public Galleries of specimens of such masters as e.g. Manet, Millet or Puvis de Chavannes. As we are always a generation or more behind cultivated opinion elsewhere we have to pay £5,000 for a picture which might have been got for £500... It seems worth considering whether in the interests of future taxpayers if not of the national art collections something might not be done to give an impulse to a broader view.[146]

Sadly, this 'broader view' was a long time coming. Although a 1922 concordat saw Treasury and Gallery come to an agreement on long-term priorities, the Paramount Lists it spawned only seemed to muddy the waters further.

Paramount Lists were schedules of specific paintings of heritage value which the Treasury had supposedly promised to purchase if they were ever threatened with export. The idea of such a list was to some extent a development of Albert's 1853 *Plan* – except that it targeted specific works rather than artists and focussed exclusively on paintings already in Britain. The NACF had first formulated such lists by 1909, and the 1913 Curzon Report included similar ones (prepared by Herbert Cook and Benson) in an appendix. The first Treasury commitment came in June 1922, with further lists being negotiated in 1927 and 1930. The Treasury's undertaking with respect to these ten-strong Paramount Lists was valued at £780,000. As Director Clark thought them 'inelastic', and he successfully renegotiated first for a longer list (20 works) and then for a massively expanded series of lists, one for each school.[147]

The 1922 Paramount list consisted of the following works:

H. Memling, *The Donne Triptych*, c. 1475 (National Gallery,
 acquired 1957)
A. van Dyck, *The Balbi Children*, c. 1625 (National Gallery, Getty
 Fund, acquired 1985)
Titian, *An Allegory of Prudence*, c. 1565, (National Gallery, gift, 1966)
The Wilton Diptych, c. 1395, (National Gallery, Special Grant/private
 sources/NACF, 1929)
Gainsborough, *The Morning Walk*, c. 1785 (National Gallery, with
 NACF, 1954)
H. van Eyck, *The Three Maries*, Boijmans van Beuningen Museum,
 Rotterdam
Titian, *The Vendramin Family*, c. 1545, 1929 (National Gallery,
 Special Grant/Courtauld/ Duveen/NACF)
Rembrandt, *Self-Portrait*, c. 1665 (Iveagh Bequest, Kenwood, 1927)
Holbein, *Henry VIII*, c. 1535, Thyssen-Bornemisza Collection, Madrid

Estimated cost: £780,000 (revised 1927 figure)

Paramount Lists were a hang-over from the heady pre-First World War years, when the NACF had rallied support for their

early rescue campaigns by arguing that there was a highly lim-
ited number of paintings left in the country worth saving. Fry
told the Curzon Committee that there were less than twenty
paintings worth saving – secondary works were unimportant.
'Let us make a supreme last effort, and then we will wind up the
whole affair... and not bother any more.'[148] Once they had sold
the Treasury on the notion, however, the Gallery appeared
unable or unwilling to question it, even as its disadvantages
became painfully obvious. The lists left no room for changes in
taste or market value – and soon became public knowledge. It
was unclear whether works on the list could be 'bumped' for
others, or whether the gaps opened by acquisition of works on
the list could be back-filled. By the late 1940s and 1950s both
Treasury and Gallery were uncomfortable with this curious
combination of rigidity and ambiguity.

Yet instead of demanding a rethink of acquisitions funding,
the Trustees welcomed the 'convenient ambiguity,' arguing in
1954 that the List 'still remained to some extent a bargaining
point'.[149] Thus if the Treasury stubbornly refused to entrust the
Gallery with a decent annual purchase grant, it was partly
because the Trustees and the NACF had made it hard to imagine
what they would need it for – once a short list of named works
had been taken care of. And even in those cases the Treasury
quickly grew suspicious of the tendency to take public 'clam-
our' as confirmation of a purchase's necessity. Paramount Lists
were still aways off in 1909, but a Treasury mandarin could
nonetheless wearily observe

that a good deal of nonsense is talked about pictures in private hands
being 'lost to the nation' if sold out of the country. The enjoyment to
be got from a work of art is got by looking at it, not by the sense of pos-
session; a good many more English people would see Rembrandt's
'Mill' if it were at the Louvre than do actually see it at Bowood.

Care should be taken, he continued, to avoid the wiles of 'a
Bond Street dealer with a real or imaginary American million-
aire in the background.'[150]

There are risks in focussing our attention too rigidly on the

Treasury, however. To do so is to neglect the extent to which the National Gallery was intended from its very foundation to be the recipient of donations and bequests. Admittedly, there were two areas in which people felt the Treasury had a responsibility to encourage generosity on the part of private individuals. The first was in taxation policy: the state should not sap the public-spiritedness of the wealthy by taxing them heavily, or should encourage donations through tax relief, or at least accept works of art in lieu of taxation. Although legislation passed in 1910 saw the Revenue concede the principle that heritage objects could be accepted in lieu of estate duty, in practice this only became possible after the 1956 Finance Act, which allowed works of art to be accepted and allocated to national museums.

In terms of tax policy, therefore, the Treasury did not deliver. But there remained another way for the Treasury to encourage generosity: by funding the construction of a Gallery whose pleasant site, grand interiors and generous wall-space would inspire collectors to donate works to put inside it. It is to this project that we must turn next.

MR. PUNCH'S DESIGNS FOR THE NEW NATIONAL GALLERY.

No. 1.—SUGAR-TONGS PATTERN.

Not by Owen Jones.

No. 2.—STEARINE ORDER.

Borrowed by Brodrick.

No. 3.—GOTHIC HORSE-SHOE STYLE.

A Suggestion for Street.

No. 4.—CROQUET STYLE.

How do you Like this for a Dome, Mr. Barry?

No. 5.—THE TELESCOPIC STYLE,

Or how to get "Top Lights" for Pictures, Mr. Digby Wyatt, if you Please.

No. 6.—THE BOTTLE AND GLASS,

[Or Convivial Period—which might have Happened if Banks had Dined with Barry.

Six: A much loved and elegant friend

Plans illustrating the development of the National Gallery can be found on pp. 467-472

In October 1825 the architect Charles Cockerell wrote an entry in his diary, noting promising recent developments in the world of British art and learning. Like John Soane and his near-contemporary William Wilkins, Cockerell was as much a scholar of classical antiquity as a practising architect. Indeed, at times he seems to have felt that his devotion to the former prevented him from fully exploring his creativity, leaving him 'a good artist spoilt'.[1] As a youth Cockerell had travelled through Europe to tour Sicily and the southern coast of Anatolia. In partnership with the great German scholar-architect Haller von Hallerstein Cockerell discovered a remarkable set of temple sculptures in 1811. He had hoped to acquire these Aegina Marbles for the British Museum, only to be outwitted by his Bavarian rivals. He was more fortunate with the Phigaleian Marbles which he discovered shortly afterwards at Bassae.

Cockerell clearly believed that great museums were an invaluable resource for the advancement of European classical scholarship and specifically the education of British artists and architects. But, as he noted in his diary, there was a limit to what scholarship, travel and collections could achieve if the creative will required to release their full potential was lacking:

Opposite: Published at the time of the 1866-7 **architectural competition for a new National Gallery**, this *Punch* cartoon perfectly captures the confusion born of Victorian eclecticism. Thanks to advances in archaeology, architectural history and building materials Victorian architects had a wide range of styles from which to choose. The facility with which they could swap one for the other may, this cartoon suggests, have been a weakness rather than a strength.

Comparing modern architecture with the remains of all former times we find the art stript of all imaginative beauties, neither sculpture nor painting contribute to it – it is a dry adaptation of proportions without ornament in which the great end in view seems to have been attainment of the negative merit of avoiding errors. To what purpose have the Elgin and Grecian discoveries, the purchases of fine paintings for the ornament of our country and the travels of individuals tended if we are to be quakers in architecture?[2]

Cockerell's comment is particularly useful, as it identifies three key problems surrounding the attempt to create grand public architecture in Britain, and specifically to create what Robinson had referred to in his 1824 budget speech as a gallery

'worthy of the nation'. Since at least the time of Voltaire's *Letters on England* Quakers had been seen as exemplary of British Protestantism and religious toleration. They made themselves conspicuous by the simplicity of their dress (modelled on seventeenth-century precedents), by their thrift and by their remarkable success in business. As a sect set apart from the community around them, the Quaker concept of a public sphere did not extend beyond the marketplace. In warning of Britons becoming 'Quakers in architecture' Cockerell was therefore referring to the popularity of a stripped-down Greek style, which clothed public monuments in a style which paid exaggerated deference to rules extrapolated from fifth-century Greek temples – a style whose simplicity lent it the additional merit of being cheap. He seems to suggest that, left unchecked, Quaker tendencies in British patronage would spawn an architecture that somehow managed to combine antiquarian rearrangement of disjointed architectural elements with a new Utilitarian emphasis on economy. The result would be buildings that could only exist in England, but did not in any way contribute to a national style or identity.

Eight years later construction began of a National Gallery which seemed to fulfill all these anxieties. Indeed, Pugin's 1836 polemic, *Contrasts*, echoed Cockerell's concerns in citing William Wilkins' unfinished Gallery as the epitome of a debased and demoralised architecture. Completed in 1838, the building has never enjoyed much of a reputation among architects or architectural historians. Despite the dome and 'pepperpots' its façade is, like the 'needless Alexandrine' of Pope's *Essay on Criticism*, one 'That, like a wounded snake, drags its slow length along.' Given its unpopularity and the number of alternative sites and designs proposed, its survival is one of the most remarkable aspects of the Gallery's history. Much of the blame or credit must rest with a decidedly Quaker desire for economy. By retaining the Trafalgar Square site and expanding to the north over ground originally occupied by St George's Barracks and St. Martin's parish workhouse the gallery slowly colonized an island site that had only one 'public' side.

Decimus Burton, Robert Smirke and John Soane are among the architects whose designs Pugin targets in this, the frontispiece from his 1836 manifesto for the Gothic style, **Contrasts**. But the place of honour (top) is accorded William Wilkins for his National Gallery, which was still being constructed at the time.

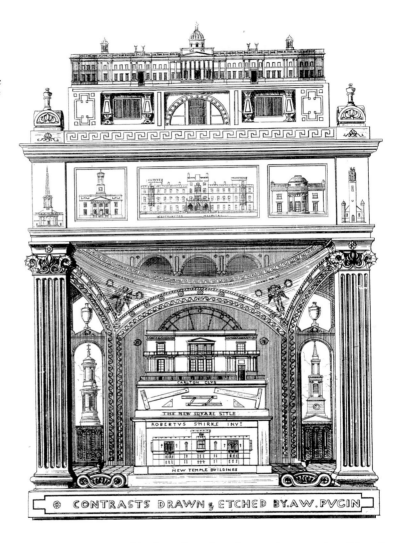

Expansion could therefore be done piecemeal without incurring embarrassment or, it was thought, controversy. The housing of the Royal Academy in Wilkins' East Wing put paid to that hope. This marriage of inconvenience was dissolved in

1869, when the Academy moved to Burlington House. Even before that, however, the Gallery was flirting with the idea of incorporating another partner on the site: the National Portrait Gallery. An itinerant institution that had drifted from one temporary home to another for years, the Portrait Gallery finally moved into purpose-built quarters on the northeast corner of the site in 1895. By the 1960s, however, a juxtaposition which had originally been proposed a century before as a preliminary to total union had become decidedly unhappy. Under Roy Strong the Portrait Gallery seemed only too eager to leave the entire island site to the National Gallery. It remained, sulkily, but only after helping to ensure that plans for a massive redevelopment of the site prepared in 1964 would never be realized. Throughout all this the thin (one-room deep) Wilkins screen which masked this Potemkin village aged into beauty, eventually becoming the 'much loved friend' which Prince Charles so memorably defended in his May 1984 speech at Hampton Court.

The debate over the Sainsbury Wing design is still recent in historical terms, and as such is discussed here in the epilogue. This chapter considers the story of the building up to the opening of the Northern Extension in 1975, a story with four broad phases. The first involves the creation of a new public square at Charing Cross by George IV's architect, John Nash, and the process by which Wilkins won the commission to design a building that at various points was intended to house not merely the Gallery but also the Royal Academy, the Public Record Office, and extra accommodation for the barracks. Wilkins' building and its abortive plan of sculptural decoration suggest that it is best understood in the context of the arches and other monumental designs (most of them never built) intended to celebrate the victories of 1815. The next phase was heralded by the Great Exhibition of 1851 and the 1853 Select Committee, which saw a violent reaction against the Trafalgar Square site. This led Cockerell and other architects to come up with designs for a new building to be constructed on land at South Kensington purchased in 1852 by the Exhibition

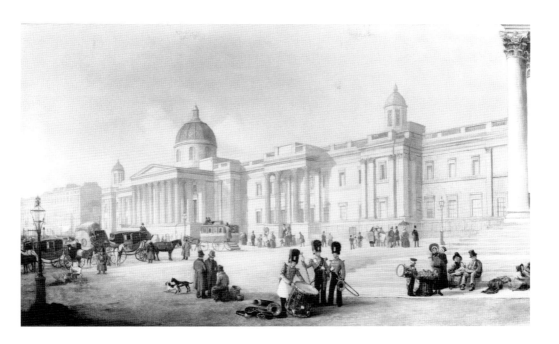

This **View of the National Gallery** by Henry Gritten records the Gallery as it looked on completion, shortly before it was officially opened by a young Queen Victoria. At this point William Railton's column had yet to be built, although the Nelson Monument Committee held a design competition that year. As it turned out, the Committee fell short of funds, and the square was still a building site ten years later, when Chartist rioters set fire to the contractors' sheds.

Commissioners and Disraeli's government. As documented in chapter two, resistance from Lord Elcho and his 'National Gallery Reform Association' led to retention of the existing site.

This was not a stay of execution for Wilkins' pepperpots, however, and in 1867 a public competition was held for a total rebuild. Gladstonian economy meant that the 'winner,' E. M. Barry, was only able to build a sequence of rooms (still known as the Barry Rooms) behind Wilkins' east wing. Even without the grand Neo-Roman façade and great hall that formed part of his original plans, the Barry Rooms represented a radical departure in interior decoration: palatial marble and gilding combined with a vaguely church-like Greek cross plan. This enrichment continued through a third phase of development that lasted from the completion of the Barry Rooms in 1874 until 1945. Facilitated by the departure of the barracks from the western half of the site in 1901, this phase saw the

reconstruction of the entrance hall by Sir John Taylor (1889) and the construction of a more restrained suite of rooms (1911) behind Wilkins' west wing, as well as various smaller projects funded by private donors like Duveen and the Estate of Ludwig Mond. These created a more or less symmetrical floor plan that eased circulation.

The idea of a separate extension linked to a corner of the main complex was proposed by William Delano's 1940 design for the Gulbenkian Annexe, which would have stood roughly where the Northern Extension is now. This plan was halted by the war, which also damaged several galleries in the west wing that were slowly reconstructed one-by-one and reopened, with much simpler décor, from 1950 onwards. Only with the government's acquisition of the site of Hampton's department store to the west of the Gallery in 1957 did the Gallery once again turn its attention outwards, cooperating with the National Portrait Gallery in ambitious plans that would have relocated the latter to a multi-storey block on the Hampton Site. What with plans for new traffic arteries to the north, this scheme would have involved reorienting the Gallery entirely, adding new approaches and entrances while simultaneously marooning the institutions on a glorified traffic island. The Northern Extension was one phase in this four-phase plan. The other phases were never realized.

Like the Barry Rooms, the Northern Extension was to have formed a beachhead, from which a new understanding of museum architecture and décor would conquer the older building. In both cases the Gallery had to reach a plan of internal decoration and hanging that would somehow ease the transition across stylistic battlefronts. Under Hendy and Levey the results could bear an uncomfortable resemblance to a demilitarized zone. Although new additions always involved some changes to the unaltered core of the building, these post-war years were characterized by a disdain for the Victorian gallery that, in hindsight, can appear almost vindictive. Only in the 1980s did a consciousness of the Gallery as a historic document appear. Whether this represented a laudable sensitivity to

past visions of the Gallery or a happy coincidence between Barry's gilding and a broader cultural shift in Gallery administration back to pre-war magnificence is as yet unclear.

It is important to place these various plans for the construction, demolition, alteration and extension of the Gallery in the context of architectural history, and in particular the evolution of the museum 'building type' from eighteenth-century galleries in private houses to the art museum of today.[3] As a site of national and international pilgrimage, but one where veneration is paid to objects traditionally commissioned by kings and princes, the museum can be understood as a hybrid between the church and the palace. In both types of building light and understanding are carefully controlled in ways that sometimes seem to suppress the visitor even as their chiaroscuro helps him to orientate. Some scholars have even related the museum type to that of the prison, suggesting that museum architecture deliberately overwhelms and intimidates the viewer. Relevant parallels with less threatening building types, notably the department store, have been sidelined.[4] Grandeur could therefore be seen by some as an obstacle to proper appreciation. Hendy in particular believed that he was improving visitors' experience by lowering ceilings and doorways so as to make galleries more neutral.

Any discussion of Gallery design thus involves a discussion of how the institution positions the viewer relative to the art on display. Depending on the gallery's site, hang, exterior and interior decoration Old Masters can be made to appear remote from everyday existence, to 'belong' in a particular period setting associated with a distant country or class, and to require solitary veneration as the price of true understanding. Another site and building might by contrast present Old Masters as an everyday luxury, as creative statements easily translated into other times and idioms, best enjoyed socially and explored in conversation. A single room's effect can be altered depending on whether walls are hung with two or three rows of paintings, or with just a few isolated works hung in a single line.

The first carbuncle

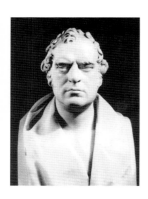

E. M. Baily's bust of **William Wilkins** (1830) captures the architect's stern manner. A noted classical scholar, Wilkins could betray little tolerance for those who lacked his deep understanding of classical precepts. In such a public commission as the National Gallery his tendency to adopt a pompous tone with his critics was a serious handicap.

Until the opening of Wilkins' new building by a young Queen Victoria in 1839 the Gallery had been housed in a Pall Mall townhouse: until 1834 in Angerstein's former home at number 100, and thereafter in number 105. The move had been necessitated by the creation of a new street between Pall Mall and St James's Square – number 105 was itself demolished in 1838. 100 and 105 formed part of a series of townhouses erected in the late eighteenth century, when the street was a popular address for minor nobility and the upwardly mobile. Several were altered by notable architects, including Soane and Henry Holland, who made alterations to 105 for Mrs. Fitzherbert in 1787.[5] Apart from minor alterations, there was little attempt to adapt either house for use as a gallery. A crowded hang combined with the original plasterwork ceilings must have lent the Gallery a rich if cramped feel. Even after the introduction of new skylights many paintings would doubtless have been difficult to see.

As we saw in chapter two, the idea of the museum as commemorative monument to military success had been picked up from the rhetoric surrounding the Revolutionary and Napoleonic Louvre, and was reflected in the Royal Academy's design competition for a 'Dome of National Glory'. In addition to Thomas Hardwick's relatively modest Greek 'national museum' (exhibited at the RA in 1805), Thomas Harrison's 'national building to record by painting and sculpture the Victories of the Marquess of Wellington' (1814) and Joseph Gwilt's memorial-wall-cum-gallery (1809) are examples of this concept. There were great hopes that such plans might be realized after 1815, as parliament earmarked large sums for monuments, voting half a million pounds for a Waterloo monument in 1818. It was hoped that such monuments and associated improvements to the approaches to London would go some way to rival Napoleonic Paris. By widening streets and demolishing buildings the 1826 Charing Cross Improvement Act had enabled Nash to clear a site around Charing Cross that seemed

full of promise, a site he felt would be ideal for a National Gallery.

Decimus Burton came closest to realising such fantasies of 'municipal improvement': a pupil of Soane, Burton cut his teeth designing two terraces for Nash around Regent's Park (1821-3) before going on to design the Colosseum on its southern edge – a much-admired Greek version of the Pantheon run by a private entrepreneur as a sort of pleasure garden. He went on to design the Hyde Park Screen, the Wellington Arch and the Athenaeum, all of which enjoyed prominent positions in the new public spaces created by Nash using Crown Estate land. As the architect of both the buildings of the Zoo and the Royal Botanic Society's buildings in Regent's Park, Burton was well qualified when it came to coming up with designs to house temples of 'improvement'. Whereas it stood to reason that the new Whig administration did not consider the 'Tory' architect of the British Museum, Robert Smirke, one might have expected Burton to play a role in the Gallery's conception.[6]

Instead Burton was compromised by Nash's fall in 1828, when the full extent of the latter's corrupt dealing in Crown lands was revealed. Nonetheless, Burton's chaste Greek Revival style probably helped pave the way for Wilkins' success in the 1832 National Gallery commission. Wilkins had first reached public notice by designs for monuments to Nelson and Wellington in 1817, the latter a public competition for a monument that was never erected. By 1832 he had built the first portions of the campus complex at Downing College Cambridge as well as University College, London. Both were characterized by long façades, enlivened in the latter case by a dome and ten-columned portico, London's first. As a scholar he was also noteworthy for his many published accounts of Greek temples and for his translation of part of Vitruvius. Gallery Trustee Aberdeen was a close friend who had written an anonymous preface to the latter work. In stark contrast to Cockerell, Wilkins' scholarship was not devoid of pedantry. For the 54-year-old architect, the Gallery commission represented the chance of a lifetime: to create an imposing yet correct Greek

This late eighteenth-century coloured etching by Thomas Malton shows the relationship of William Kent's **King's Mews** to James Gibbs' church of St Martins-in-the-Fields. Objections by parishioners forced Wilkins to push back the façade of his National Gallery so as to allow views of Gibbs' portico. This was hardly fair – the portico had been entirely hemmed in by buildings until John Nash cleared away buildings to create what we now know as Trafalgar Square.

building at the centre of London. Instead the project was a failure. Although both were in a sense his right, Wilkins was not allowed to design the square in front of his building, and was not knighted on its opening. He died the following year. Greek Revival in Britain effectively died with him, although the style enjoyed an afterlife in Scotland, in buildings such as W. H. Playfair's National Gallery of Scotland (1850-4) in Edinburgh.

Wilkins' design was in many ways a victim of circumstance, but his own failure of nerve clearly had a role to play.[7] When he first proposed the site for a Gallery in 1831 the government had already decided to let the north side of the square for shops. Wilkins knew that for his project to be realized he had to stress the economy and adaptability of the structure. Hence his initial suggestion that the building be brick faced with cement, that the Public Record Office be accommodated in the ground floor of the west wing, and a partial basement used as overspill accommodation for the barracks. He mutely accepted the need to allow public rights of way through the building at ground-floor level, to allow access to the barracks behind the west wing and Castle Street behind the east. He even agreed to reuse Corinthian columns left over from the demolished Carlton House (Henry Holland, 1783-96), despite the fact that their architect's French Classicism was totally at odds with his own. Complaints from St Martin's parishioners that the building would block the view of their church, exacerbated by Wilkins own arrogant response in the press, forced him first to push the entire façade back and then to recess the two wings. This forced the building into an unhappy argument with the Baroque Classicism of Gibbs' church on one side and the town houses of Pall Mall East on the other. Both were taller than Wilkins' original design. This obliged him to make other alterations in an attempt to make his façade more imposing.

Raising his façade by nine feet was expensive, if uncontroversial. By deciding to add columns in front of the central segments of each wing, however, and superimpose on them an intricate programme of sculptural decoration Wilkins arguably betrayed his own design. Here he was able to call on a supply of

Millions of National Gallery visitors pass through the portico entrance each year, but few notice this group of **Europe and Asia Exalting Wellington** located immediately above the central door. Carved by Charles Rossi, it is one of several sculptural elements originally intended for the Marble Arch. When that project was scaled back, Wilkins jumped in to secure them to enrich his Gallery façade. Wellington's head was removed from the central shield, and now hangs above the reception area of the Gallery offices in the West Wing.

ready-carved sculpture which had been rendered homeless when work on Nash's Marble Arch was halted in 1830 on George IV's death. Construction on Nash's Arch had begun in 1827, with a rich programme of sculptural decoration – half naval, half military – sketched out by the sculptor John Flaxman. When the Whig First Commissioner of Woods and Forests, Viscount Duncannon, invited Wilkins to view the unused sculptures, the latter's imagination took fire immediately. 'I am no advocate for the introduction of sculpture into buildings unless it be of excellent design and good execution,' he wrote in June 1834, '[these sculptures] are of this description and may be made not only conducive to a certain degree of richness in the exterior but by breaking the horizontal *sky-line* greatly improve the general effect.'[8]

Adding this recycled sculpture to his earlier plan for two quadrigae Wilkins now proposed that the side gateways should be viewed as '*Propylea* or Entrances which partake, in some degree, of a monumental character. Nor is it at all necessary that the accessories of this building should have relation to the arts only. The entrance to the barracks may, without impropriety, assume the appearance of a military memorial, and that from Castle Street into Trafalgar Square, that of a naval testimonial.'[9] Charles Rossi's *Europe and Asia exalting Wellington* was placed above the main door, minus Wellington's head. The winged victories which were to have stood on top of the arch were placed in the niches beneath the gateways and either side of the main door. Their weapons were either replaced with artistic implements, or removed entirely. Wilkins wanted to add Westmacott's friezes to the gateways as well: 32 feet of *Nelson Inspecting a Captured Ensign* and *A Naval Battle Scene* on the east gateway, and a matching lengths illustrating *The Meeting of Wellington and Blücher* and *The Capture of Napoleon's Carriage* on the west. He only just managed to put the former on the east façade before the Treasury caught up with him, rightly pointing out that these sculptural additions had not been approved.[10]

Censure of Wilkins' failure to keep his Grecian cool might be considered unfair, in so far as there was, until the recent

rediscovery of lost sketches, little evidence of any better con-
temporary designs. Soane's Dulwich Picture Gallery (1811-14)
provided an excellent model for interior arrangement of rooms
and lighting, but offered little in the way of a grand façade.
Indeed, it is best understood as part of a collegiate architectur-
al tradition, in so far as Soane's plans were originally to have
placed the gallery as part of a closed quadrangle. Robert
Smirke's British Museum façade of the 1820s was certainly
imposing, but plans to house the paintings in his building
(which never went very far) would have placed them in gal-
leries above the King's Library. This would have meant quite a
climb – and connoisseurs were already weary from years of
having to climb up three flights to reach the Royal Academy's
exhibition rooms in Somerset House.[11]

The corruption scandal which had discredited Nash fuelled
a desire to fight 'Old Corruption' in all areas of the public serv-
ice. It was now necessary to ensure that public architectural
commissions were seen to be fairly awarded. But the 1832 com-
petition organized by Duncannon and his 'Committee of
Gentlemen' was clearly an *ex post facto* attempt to provide cover
for a decision in Wilkins' favour that had already been made.
The other architects who took part (Nash, Sydney Smirke and
Cockerell) were not provided with much of a brief, and their
designs had disappeared without trace. If his earlier plan for
Charing Cross is any guide, Nash planned to have a line of
Corinthian columns running the full length of his 450' façade,
a scheme that would have chimed with Schinkel's Berlin
Museum (1823-1830).[12]

The present author discovered two sketches for Cockerell's
design on the flyleaf of his diary for 1832, in which he also
recorded meeting with Wilkins and Gallery Trustees. This
design seems much stronger than Wilkins'. The central portico
is similar, but is surmounted by a respectable dome which not
only relates better to the scale of the building, but which would
presumably have been reflected in the interior arrangement of
the building. This unlike Wilkins' dome, which guiltily slips
from view as one enters, like the deranged aunt locked in the

Although it is hard not to see the Gallery commission as a stitch-up, designs were solicited by the Whig government from a few architects other than Wilkins, perhaps to make the process seem less like a 'job'. **Charles Cockerell's drawings** for the project do not survive, apart from this sketch on the flyleaf of the architect's diary for 1832.

attic whenever polite company visits. The unapologetically grand side arches are topped with what would appear to be obelisks, with a hint of Hawksmoor's Christchurch, Spitalfields of 1723. Cockerell estimated his design as costing £60,000. The ground floor was to comprise shops, whose prime location had, Cockerell claimed, led one contractor to offer to build a 400' long Gallery for free, provided that the government allowed him 'to appropriate the shops and mezzanines, and the wings at either extremity of the design – and that government will give him the ground at peppercorn rent for 99 years'.[13] This scheme, though abortive, would not be the last public-private partnership proposed for Trafalgar Square.

In 1832 Cockerell had little experience on such projects. He had, however, drawn up designs for the Cambridge University Library, for which a competition was held in 1829. Indeed, in so far as the library was also intended to include gallery space, the Cambridge competition can be seen as a dry-run for Trafalgar Square. Here again Wilkins and Cockerell were rivals, the former producing a design with what would appear to be pepperpots, unhappy progenitors of those on the Gallery. Had Cockerell won the 1832 competition there is little doubt that

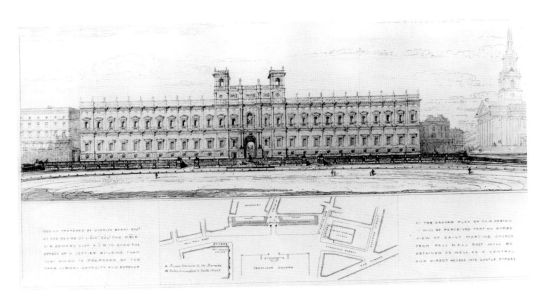

Charles Barry was not one of the architects asked to submit designs for a Gallery in 1832, but nonetheless drew up this Italian palazzo design and had it engraved. Wilkins and Cockerell followed the brief closely, incorporating ground-level access to the barracks and the streets behind the site halfway along each wing of their designs. Barry proposed to have a central opening. Although he failed to secure the commission, he was commissioned to lay out the square – much to Wilkins' despair.

such a façade would have afforded him plenty of opportunity to display that masterful handling of surfaces demonstrated at his University Library at Cambridge, executed in 1837-40, and at his Ashmolean Museum and Taylorian Institution in Oxford of 1841-5.

If Cockerell's design hints at genius, it was the rogue entry by the 37-year-old Charles Barry which showed the course British architecture was taking: towards a heavier Renaissance classicism modelled on Florentine or Roman palazzi, a style which Leo von Klenze had adopted for his highly influential Pinakothek in Munich (1826-1836). In so far as *palazzo* museums such as the Uffizi were constructed in tightly-developed cities where buildings did not have to hold the approaching visitor's attention over long vistas, they had a two-dimensionality which rendered them modular in a way that Greek or Roman classical structures involving domes and porticoes could never be. Their cellular interiors were also conducive to a more rigorous classified hang.

Barry had not in fact been invited to submit a design in

1832. Instead his design was commissioned by Sir Edward Cust, a retired Colonel who spent much of the 1830s advocating reform of state architectural patronage. Barry's design placed the entrance to the barracks around one edge, and reserved a high central arch for access to Castle Street. Just two years later Cust clearly leaned on this Barry design when he produced what he called 'A Volunteer Design for the Fitzwilliam Museum with a view to recommend the Italian style of architecture...'[14] Manchester finally gave Barry his chance to build in this style when it commissioned its Athenaeum from him in 1837. Even if he was excluded from the 1832 competition, Barry triumphed over Wilkins in the end. In a final insult, Wilkins' design for the square was rejected and the commission awarded to Barry. Like Railton's column commemorating Nelson, erected in 1843 thanks in large part to a private subscription, Barry's fountains (now in Ottawa) and terrace (1842-3) did the Gallery few favours. In so far as Barry had a scheme to improve Wilkins' façade by raising the façade and adding columns, this may have been deliberate.[15]

If Wilkins failed to provide an equivalent to the great German museums constructed in the same period by Leo von

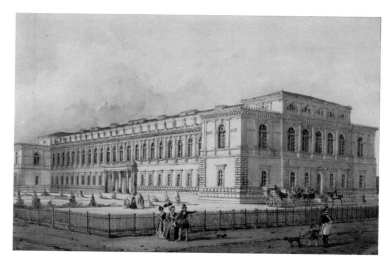

Commissioned by King Ludwig I of Bavaria, Leo von Klenze's Munich **Pinakothek** (now Alte Pinakothek) opened in 1836. Heavy war damage means that we can no longer enjoy the ornate interior frescoes designed by Wilhelm von Kaulbach, which illustrated episodes from the lives of great *altdeutsch* and Italian Renaissance artists. The museum could only be visited as part of a guided tour – as its Director Georg von Dillis pointed out in 1838, 'the lowest classes of the nation' could not otherwise be trusted to visit without vandalizing the paintings.

William Wilkins' hall and staircases were probably the best parts of his otherwise much maligned National Gallery (1834-8), although it must be said that they took up a lot of much needed space. The **west staircase** pictured here served as the entrance to the Gallery; a matching staircase on the east served the Royal Academy. Both disappeared in 1860 when James Pennethorne's new gallery was built.

Klenze and Schinkel, at least he largely managed to avoid charges of 'jobbery' and waste while providing the nation's pictures with much improved accommodation. His Gallery provided some compensation for the failure of so many commemorative projects to come to fruition, a failure partly rooted in the economic stagnation of the late 1820s. *Contrasts*, Pugin's landmark polemic of 1836, took a much less positive view, however. It suggested that connoisseur devotion to the Antique had entered into an unholy alliance with profit-hungry developers. It retold the story of a Regency revival of state architectural patronage not so much as a triumph, but as a tragi-comic farce. It lambasted the products of the New Church Competition, the Regent's Park developments, Marble Arch and other improvements as so many tired reworkings of design elements each of which had been torn from its original context. Greek Revival and the watery Gothic practised by Smirke and Wilkins was a vernacular, Pugin suggested, in which fluency was easily achieved – but in which nothing profound could be said.

Confusing 'chaste' design with cheap construction and mere custodianship of antique relics with cultural leadership, developers and connoisseurs had demoralized British society. Instead of guarding a native tradition, museums and the architectural profession had literally led the public to worship foreign gods. Seeking for a building to place at the centre of his hall of shame, Pugin chose the National Gallery. In condemning Wilkins' building as both overloaded and aesthetically bankrupt, Utilitarian yet cumbersome, Pugin's critique set the tone for the next century. This made it possible for plans for the flooring-over of Wilkins' central hall (arguably the Gallery's finest space) to be drawn up as early as 1845. In the same year Eastlake published his pamphlet criticizing the building's shortcomings.[16] Office of Works architect James Pennethorne's plans to create a new 120' gallery over the central hall were shelved when alternative overspill accommodation was found for the Vernon and Turner pictures at Marlborough House. These plans were eventually realized in 1860, the new gallery being opened the following year.[17]

'A pinakothek at Kensington Gore'

Although a consensus had been reached that Wilkins' building was an embarrassment, it was only after 1851 that serious discussion of rehousing the Gallery started. As with the original foundation, the main spur here was a windfall: the profits accrued by the runaway success of the Great Exhibition, whose popularity even led some to propose reusing the empty Crystal Palace as a National Gallery.[18] These profits had been used to purchase a large site at South Kensington which Prince Albert proposed to transform into a Munich-style science-and-art park with a relocated National Gallery at its core. The exploratory designs he commissioned in 1853 were not published or widely distributed, but were clearly considered promising enough for Aberdeen's cabinet to sanction relocation of the Gallery to South Kensington in 1853. Of these, C. R. Cockerell's Greenwich-style arrangement was probably the most impressive – although it should be noted that, given the way the site slopes, the earth-bound visitor would only have

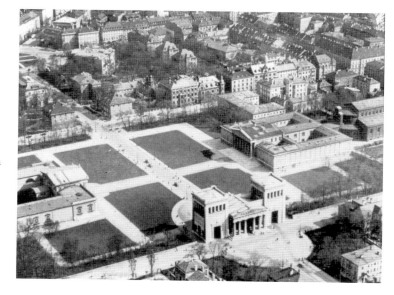

This aerial view shows how Leo von Klenze's **Königsplatz** in Munich looked in its undamaged, pre-war state. Visitors reached his classical museum or Glyptothek (1830) by passing through an arch, called a 'Propylea' after the gateways which marked the entry to the precincts of Greek temples. In the 1850s Prince Albert planned to have such a Propylea at South Kensington, marking the divide between the world of the everyday and the hallowed realm of art.

discovered its charms gradually. His was the only design to leave the central area open, and stylistically it represented a happy medium between the exhibition-hall functionality of Cole and Redgrave's design, and the overblown Late Italian palace proposed by Thomas L. Donaldson, which included a massive 'Dome of Glory' and triumphal staircases.

Such a site would, it was felt, create a proper distance between the worlds of everyday commerce and of art, allowing both the visitors and the art to escape the fumes which had supposedly been damaging the paintings, necessitating controversial cleaning. In so far as South Kensington was Henry Cole's fief, such plans suggested a gallery that would combine fine and applied arts in a highly didactic way, that would classify visitors so as to distill and separate those elements in society deemed fit and able for improvement. The fierceness of the debate between Albert and Cole on the one hand and those resisting the move to Kensington on the other is best explained as a conflict over such distinctions. Elcho and the 'National Gallery Reform Association' believed that Old Master paintings were precious treasures that belonged in a palace, and that it was demeaning to lump them together with other, lesser forms of design. At one point Elcho even proposed that the Gallery literally be housed in a new royal palace, with galleries able to double as reception rooms on state occasions.[19]

Elcho and his allies believed it was disrespectful to display fine paintings in structures like those spartan, if well-lit, iron warehouses at Cole's South Kensington Museum; the so-called 'Brompton Boilers' of 1855-6, designed by C. D. Young & Co. and William Dredge. The type of massive, modular and infinitely expandable museum implied by the 'Boilers' would, they believe, confuse rather than inspire visitors. Albert and Cole, by contrast, believed that it was unscientific and demeaning to display Old Master paintings as a 'priceless' hoard, and that the educational role of the museum was compromised by refusing to classify audiences so as to limit or exclude casual visitors. Ruskin clearly shared this view when he lampooned 'the popular idea of a national gallery' as 'that of a magnificent palace,

Victoria's Prince Consort, Albert of Saxe-Coburg-Gotha, had to overcome many obstacles in his attempts to improve British design and emulate the grand museums erected by fellow German princelings. In this 1856 *Punch* cartoon, **H.R.H.F.M.P.A. AT IT AGAIN!!** he is caught in the act of trying to move the Nation's paintings to South Kensington by Mr. Punch's policeman, who sternly tells him to put them back where he found them. Albert was a keen advocate of the Gallery's relocation to Hyde Park, and deeply disappointed when his plan failed to come off.

Designed by the firm of C. D. Young and Co., the 'iron museums' at South Kensington (1855-6) were remarkable for their low cost, as well as for the speed with which they were erected. Dubbed the **'Brompton Boilers,'** they became the symbol of Henry Cole's Department of Science and Art. Although a large section was dismantled and rebuilt in the East End to house the Bethnal Green Museum, parts remained in service at South Kensington until 1899.

whose walls must be decorated with coloured panels, every one of which shall cost £1000 and be discernible, through a telescope, for the work of a mighty hand.'[20]

Somewhere between these camps were the architects of the Institute of British Architects, which Donaldson had helped establish in 1834, and which became 'Royal' in 1866. The IBA was the last in a series of no fewer than eleven separate organizations set up since 1791 in an attempt to secure the profession an identity independent of the Royal Academy. By 1852 it was impatient to raise its profile, and saw resistance to the Gallery's relocation as one way of doing so. Its willingness to join Elcho's camp is striking, as the Kensington site obviously offered much more creative freedom. Professional pride provides an explanation, however. By opposing Kensington the architects were seeking to ensure that the design of a new National Gallery would be the product of a proper public competition, rather than that secretly-prepared design which supposedly lay 'cut and dried' somewhere in the Treasury – or Prince Albert's back-pocket.[21]

For them, Kensington was also associated with Francis

Fowke. As an officer in the Royal Engineers who came to South Kensington in 1856, Fowke had not been trained in an architect's office. His published 1860 proposal for reconstruction of Wilkins' gallery, the massive hall he built for the 1862 Exhibition and his triumph in the competition for a new Natural History Museum were so many challenges to the IBA's professional identity and self-respect. The architect Alfred Waterhouse, who was appointed to supervise the construction of the Museum according to Fowke's plans (Fowke having died), refused to do so – and was allowed to draw up his own design instead. Such disdain probably explains why Fowke's use of combined skylights and diffusing laylights at South Kensington's Sheepshanks Gallery (1855-6) was not widely followed until the 1920s. Although such a lighting system was incorporated in Barry's extension, otherwise Wilkins and Taylor's galleries stuck to the traditional 'monitor' lighting, necessitating a system of blinds to keep out direct sunlight.[22]

With the help of allies like the IBA, by 1857 the Elcho camp had apparently won. Although they succeeded in holding the Trafalgar Square site, the endless Committees and Commissions had wearied many, and nobody seemed to have any energy left to debate whether Wilkins' building should be demolished and a new Gallery built, or whether the Royal Academy should first be ejected. Eastlake feared that the new gallery Pennethorne built over Wilkins' central hall (1860-1) presumed that the Gallery would be given the entire building; in this matter at least, his duty as President of the Academy came before his responsibility as Gallery Director.[23] Pennethorne gave the Gallery a large new room decorated to a more ornate finish than the original rooms. In 1869 the Royal Academy did move out. The west wing was now dedicated to British pictures, which for the first time included the Turners, which had returned from their temporary quarters at South Kensington. The east wing held the Flemish, French and Spanish Schools. The new gallery provided a climactic setting for the Later (post-Raphael) Italian works. Paintings were still hung in two rows, as well as above doorways. The new gallery

The idea of creating more space by flooring over Wilkins' central staircases and hall had first been proposed by Prime Minister (and Trustee) Sir Robert Peel in 1845, when he instructed Office of Works architect James Pennethorne, a pupil of John Nash, to prepare designs. **Pennethorne's gallery** was only built in 1860. It had no exterior façade, but its interior was noteworthy for being much more richly decorated than Wilkins' galleries had been.

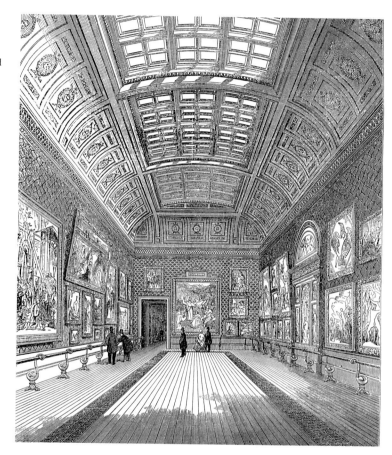

greatly reduced the sense of drama on entering the building, despite the efforts of Cockerell to enliven his friend's design. Pennethorne's gallery would disappear when his pupil, Sir John Taylor, redesigned the hall in the 1880s.[24]

The year 1857 also saw the first of a series of public competitions for government buildings that would extend over a decade and result in George Gilbert Scott's Government Offices (competition 1856-7, built 1863-75), Waterhouse's Natural History Museum (comp. 1864, built 1873-91), George Edmund

Architect and outspoken 'Goth' **George Edmund Street** is shown here as a latter-day Veronica. Instead of the image of Christ, however, it is the façade of his Royal Courts of Justice that miraculously appears on his hankerchief.

Street's Royal Courts of Justice (comp. 1866-7, built 1874-1882) and Barry's design for a new National Gallery at Trafalgar Square (comp. 1866-7, built 1869-1874). Together with the construction of the Embankment, underground railways and Joseph Bazalgette's sewer system, these buildings supposedly heralded a step-change in London planning. Haussmann's massive public work projects in Paris, begun in 1853, as well as the formation of Vienna's Ringstrasse in the following decade had set the pace. The creation of the Metropolitan Board of Works under First Commissioner Benjamin Hall in 1855, and the appointment of Layard to the post in 1859 simplified and centralized lines of control over planning decisions. 'For the first time since the Great Fire,' Layard later wrote, 'an opportunity presented itself of making London a metropolis worthy of this great Empire... The Government had to decide upon the erection of a larger number of important buildings than had probably ever been raised in any capital at one time.'[25] This new London would be rebuilt not by a Regent and his favourites, as a monument to what had happened in 1815, but by professional architects and wise statesmen, as a monument to what had not happened in 1848.

The exiled Saxon architect Gottfried Semper was to some extent a victim of this optimism, which did not survive much beyond Layard's resignation of the First Commissionership in 1868. Before realizing the vanity of such hopes and leaving London to take up a Professorship in Zürich Semper produced a startlingly innovative museum design for Albert, a design for a model cemetery for Edmund Chadwick and further plans for a government office complex centred around Inigo Jones' Banqueting House. Although Cole and Donaldson gave Semper some opportunities to lecture at South Kensington and the IBA, neither engaged with Semper's theories on the development of architectural ornament, which offered a path out of the embarrassment and confusion felt by so many mid-nineteenth-century architects in Britain and elsewhere at the gamut of different styles open to them.[26] The succession of Gothic, Italian and 'Byzantine' designs produced by Scott for the Government

An erstwhile court architect who fled Saxony after helping the 1848 revolutionaries design a better barricade, Gottfried Semper came to London a political exile. In 1855 Prince Albert commissioned him to produce a **design for a gallery at South Kensington**. He produced this drawing of a 500' long U-shaped gallery with a court-yard covered by a massive glass roof. This was to have been crossed by a vast prosce-nium arch, for concerts and other performances.

Offices suggested that these could be interchangeable, and, worse still, that architects were there to play whichever tune their masters – in this case, the anti-Gothic Palmerston – demanded.[27] Semper's London years were a missed opportuni-ty. A glance at his 1855 museum design and at the museums he designed in Dresden and Vienna suggests that this was a missed opportunity for the National Gallery as well.

In addition to forcing Scott to change his Government Offices design when he returned to office as Prime Minister in 1859, Palmerston also decided to shake up plans for the National Gallery by declaring in 1863 that the Academy should take over all of Wilkins' building in return for £70,000, which would then help fund a new National Gallery on the Burlington House site that the government had acquired back in 1854. 'The general opinion about the National Gallery I take to be that the best general arrangement would be to erect an un-pretentious building in Burlington Gardens between the present house [Colen Campbell, 1718-9] and Savile Row, with no ornament except towards Savile Row...'[28] The commission

could furthermore be given to Banks and Charles Barry (Jr.; brother of E. M. Barry) as compensation for failing to secure the Government Offices commission despite coming first in the public competition. In January 1864 the architects met with Keeper Ralph Wornum to discuss the Gallery's requirements, and apparently produced plans (lost) a short time later.[29]

When Palmerston's First Commissioner (and, it was rumoured, illegitimate son), William Cowper moved later that year for funds to start construction, however, the vote was defeated (174-122) in the Commons. This despite the fact that Elcho was now behind the Burlington site, which, Cowper promised, could eventually provide an area 'larger than the Galleries of Berlin or Munich, and [with] more floor space than the Louvre'.[30] Key trustees, including Layard and Thomas Baring clearly regretted this and supported a later, unsuccessful attempt by the MP A. J. Beresford Hope to revive the plan. The following January Cowper quietly moved to purchase the workhouse site behind the Gallery's east wing for £82,800. He now favoured Pennethorne's plans to build a new gallery extension to the north, a structure partially supported by pillars so as to keep the barracks yard open. Pennethorne's plan respectfully avoided altering Wilkins' building, which the architect admired for the 'picturesque effects of light and shade' of its façade, effects which would be lost if it was transformed from a 'classic gallery' into an 'Italian palace'.[31]

'Where are our architects?'

Cowper was clearly nervous about such piecemeal additions, and therefore welcomed Elcho's suggestion in June 1865 that a competition be held, with the leading architects all invited to propose suggestions. In launching the competition in February 1866 Cowper was careful to invite participation from a wide range of architects, including the Goth G. G. Scott, who subsequently withdrew, however, to be replaced by George Edmund Street. Little was given by way of a brief. Competing architects were requested to submit two designs: one for an extension over

the recently-acquired workhouse site to the northeast, and one for a total rebuild of the Gallery, for which licence was granted to include the space occupied by St George's Barracks. They were to include 'the largest possible extent of wall space for the hanging of pictures that may be consistent with grand architectural effects', and include smaller galleries for the display of 'cabinet pictures and original drawings,' which could be side-lit. After Palmerston's government fell the new Commissioner of Works was Lord John Manners, whose speech in the 1864 debate had played a crucial role in securing the defeat of the Burlington House scheme. In consultation with Wornum he issued the competitors with a second, more detailed brief identifying the Gallery's specific needs: these included 'retiring rooms for ladies' and a 'picture store-room for pictures not exhibited'. The attention to visitors' needs, and the challenge to the unwritten dogma that every single painting had to be displayed are nonetheless striking. Waterhouse's Natural History Museum would be the first the one in Britain to have separate study and exhibition collections planned from the start.[32] At Trafalgar Square a reference section and lavatories only came in the 1910s.

The limited number of drawings that survive from the 200-300 entries submitted in time for the competition's extended deadline of January 1, 1867 suggest just how far perceptions of the ideal gallery had shifted from the early 1850s. At the time of the 1853 select committee Eastlake, Waagen, Ruskin, Fowke and other commentators had sneered at the tendency for architects to sacrifice practical needs on the altar of grand effects. Donaldson's Italianate palace design of 1853 must have seemed positively quaint, typical of the favourite architect of the decidedly old-fashioned Palmerston. By 1867 opulence and in particular Neo-Roman concatenations of domes, colonnades, loggias, and mammoth staircases were back.

That the 1867 designs publicly exhibited at the Palace of Westminster seemed unlikely examples of the museum building type was a testament to the extent to which the leading architects of the period – William Tite, Cuthbert Brodrick, but

also Cockerell – had developed their styles primarily through commissions for banks and town-halls. E. M. Barry's original design was ponderous and fussy, sacrificing acres of wall space to its grand staircase and domes. His staircase hall would have been filled with statues of great British and Old Master painters, intended to lead the public 'to form correct ideas as to the past history of art'.[33] Interestingly Barry's original design also included room for the National Portrait Gallery, established in 1856, which was still housed in cramped quarters at 29 Great George Street.

The only references to German museums were the landscape galleries and the loggias, which, like those at Klenze's Pinakothek, would have allowed visitors to make their way to the school they wished to visit without passing through others. It was hard not to agree with the anonymous critic of the *Westminster Gazette*, who wrote:

This impression of the central staircase of **G. E. Street**'s 1866 design for a National Gallery indicates his skill at using light and changes of level to create a noumenal space. Only with the construction of Alfred Waterhouse's Natural History Museum (1873-91) would this sort of vision become reality.

On viewing these designs one is simply tempted to ask – where are our architects? For it is impossible to concede the merit of true architecture in any of them... They may be palaces, banks, clubs, coach manufactories, mortuary memorials, athenaeums, scenes in grand opera, or fancy examples for a new edition of "Pugin's Contrasts;" but picture-galleries for modern, dirty London, they are not... There are the same useless features... the same eccentric recesses and semi-domes and makeshifts...sham domes only calculated to produce draughts and store up wind; the same absurdities of detail, vases, and pots,... and marvellous vegetable productions – the same want of feature where it is required, and the same amount of distorted features without necessity, like wens and bunions which disfigure the human form.[34]

Punch's wonderful lampoon of the competing designs reflected the widespread impression that the competition had produced little other than a collection of 'wens' – that is, carbuncles.

George Edmund Street's design and the pamphlet he published justifying it invite discussion of why the Victorian Gothic Revival never came close to influencing the Gallery design – why the national 'Teutonic' style promoted by Pugin, Scott and historians such as E. A. Freeman was not chosen for the

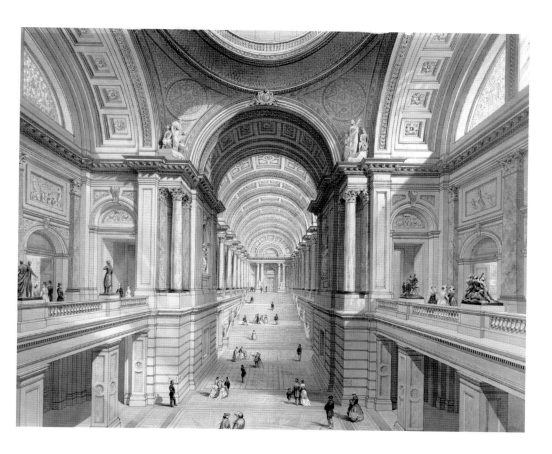

The massive central hall from **E. M. Barry**'s 1866 Gallery competition entry was accused of sacrificing acres of useful space to achieve grand architectural effects. Although it was never built, it seems to foreshadow the hall of the Fifth Avenue Wing at New York's Metropolitan Museum (Richard Morris Hunt and Richard Howland Hunt, completed 1902).

National Gallery.[35] As a style for town halls Gothic enjoyed some popularity in the 1860s and 1870s, at Northampton, Wakefield and Rochdale, for example.[36] Street's design, in a North Italian or Lombardic Gothic, perhaps suffered from being overly symmetrical. But at least he already had experience of designing a Gothic museum-cum-library at Adderley Park in Birmingham. His mentor, G. G. Scott, had also designed Fitzroy Museum and Library at Lewes (1862) in Gothic. Ultimately the latent Italocentrism of the Old Master canon and belief that Gothic was synonymous with 'poorly-lit' were simply too

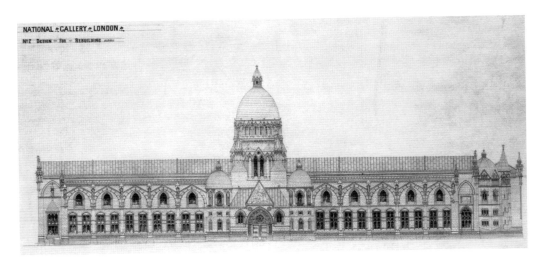

NATIONAL · GALLERY · LONDON ·
N° 2 DESIGN · FOR · REBUILDING

Although many admired his Gothic design for the Royal Courts of Justice (1866-8), **G. E. Street**'s entry for the 1866 National Gallery competition was anathema to many. 'In short,' Street wrote, 'it was asserted that I was sure to design a Gothic gallery and that as a Gothic gallery must needs be a failure, it was wrong to waste time obtaining any plans from me.'

strong for this alternative to have been a viable one.

Several architects noted the difficulties of fitting their designs around the Square. In his accompanying statement Matthew Digby Wyatt argued that Railton's column rendered any symmetrical design unworkable, by blocking out the centre of any such structure. Such views had been shared by the members of the Select Committee convened to discuss the monument's design in 1840 – but Wyatt was the first to suggest such a radical riposte.[37]

The judges initially decided to recommend none of the designs, before fear of the scandal such an insult to the architectural profession would unleash led them to reconsider. They picked out Barry's new gallery and J. Murray's extension as having the greatest merit. It took over a year for Barry to be appointed 'Architect for the New National Gallery,' on the strength less of his designs than of the perceived debt owed him after he was summarily taken off the Royal Courts of Justice project, having been joint winner (with Street) in that separate competition. Barry was given a *Confidential Report* of the Gallery Trustees and Director outlining their requirements. Layard had published his own views of the competition in a

1867 pamphlet, and as Commissioner he clearly encouraged Barry to adapt his design to reflect the less wasteful 'skeletal' plan he himself had proposed.[38] In order to create more hanging space the Greek cross plan Barry had originally proposed

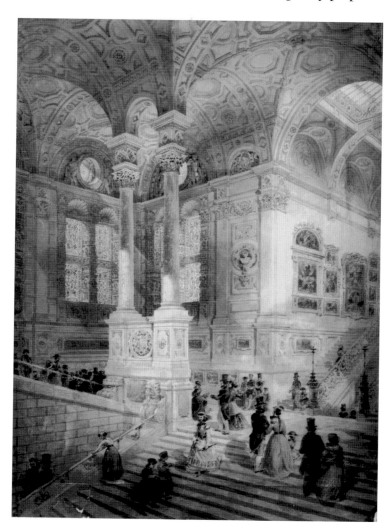

Matthew Digby Wyatt's entry in the 1866 National Gallery competition was in an ornate Late Renaissance style, with a wide central loggia. This wash drawing shows his staircase, where the paintings on display would have been overwhelmed by sculptured relief work, ornate pilasters and a coffered ceiling. Wyatt had contributed essays on 'Renaissance' and 'Italian decoration' to Owen Jones' *Grammar of Ornament* (1850). His staircase might have served as one of the plates.

Ths gallery level floor plan is from Barry's amended design (1869). It includes accommodation for the National Portrait Gallery and the Raphael Cartoons. First Commissioner of Works A. H. Layard was also an active Trustee. When the commission was massively curtailed he urged Barry to retain the three parallel galleries seen here (just east of the staircase), so as to maximize hanging space. Instead Barry adopted his Greek cross plan for his suite of rooms, a decision with many repercussions for subsequent developments.

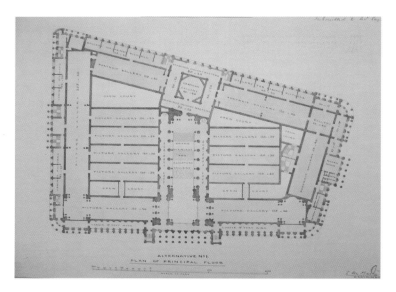

for the northeast corner was replaced with three parallel galleries running latitudinally.

When Layard's tragically short Commissionership ended a year later, Barry restored the grander, Greek-cross plan – a decision that shaped the subsequent development of the Gallery. Unfortunately Layard's replacement as Commissioner, Acton Ayrton, was a scrappy self-made lawyer with little knowledge of art or architecture, perhaps the only man ever to have been transferred out of the Treasury for being too much of an economiser. Ayrton treated Barry and his design with contempt, even threatening to bar the architect from future work if he did not agree to simplify his design, lowering doorways and dispensing with marble flooring.[39] With Layard's departure Barry had lost touch with the Trustees, who in several respects agreed with Ayrton that the new rooms were over-ornamented. E. W. Wyon's lunette bas-reliefs in the apses off the octagon and the decoration (by Crace and Sons) of the east gallery ceiling with painted panels commemorating great British painters had little relevance to the Gallery. The choice of

subjects for the former – which included *Pericles and Aspasia visiting the studio of Phidias* and *Michelangelo giving the model of St. Peter's to Pope Paul III* – was a throwback to superceded ideas of a super-National Gallery combining painting and sculpture. As for the east gallery, it was initially hung with late fifteenth- and sixteenth-century Italian paintings. A century passed before it housed any British works. The Joshua Reynolds inscription Barry wrapped around the inside of the dome was also perceived as embarrassing – and later removed.[40] Ayrton's replacement as First Commissioner in 1873 with the more congenial W. P. Adam allowed Barry to restore several such elements to his design – the entrance hall he completed in 1875 for the Fitzwilliam Museum in Cambridge shows just what dramatic effects he was capable of producing.

With the single exception of the north doorway of the octagon, which he conceived as a frame for a vista of Sebastiano's *Raising of Lazarus*, which was indeed hung on the north wall of the northern Gallery, Barry paid little attention to how the rooms would be hung, and in practice Burton's rehang for the opening of the new rooms on August 9, 1876 could achieve

E. M. Wyon's lunette of **Pericles and Aspasia Visiting the Studio of Phidias** is one of a set of four decorating the Barry Rooms (1876). Twenty years before the idea of displaying 'pagan' sculpture and 'Christian' paintings together had been considered, then abandoned. Wyon's lunette thus seemed out of place. 'Burton's account of the decoration of the new rooms is that it is vulgar and overdone and consequently injurious to the pictures,' Trustee A. H. Layard wrote, 'which I can easily believe.'

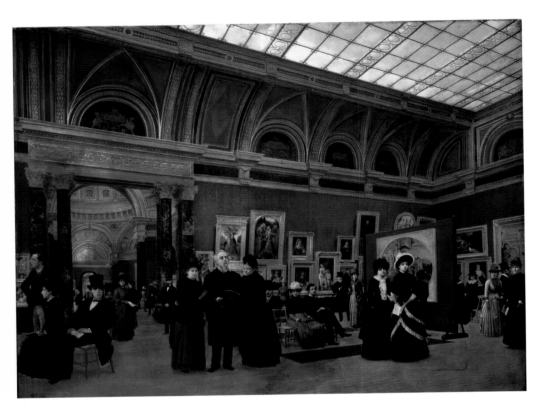

E. M. Barry does not seem to have liaised with Gallery Director Frederick Burton over the Barry Rooms' decorative programme. The **'New Italian Room'** depicted in this painting by Gabrielli, for example, had a stencilled frieze commemorating great British artists – yet British paintings were not hung in it for almost a century. The laylights were, however, a vast improvement on the 'monitor' system previously adopted in the Gallery, diffusing a more even wash of light.

little by way of a chronological 'path', even if he now had twenty rooms at his disposal. The British School now occupied the entire west wing and two galleries of the East, which were followed by a French gallery, and (in the easternmost room) the Italian, French and Dutch works of the Wynn-Ellis Bequest, which had to be hung together. Turning to the Barry Rooms, the Italian pre-Raphaelites were shown in the small northeast room, flanked by larger galleries, each of which contained later Italian works.

The domed octagon housed the Peel Collection (Dutch) on one apse, the Spanish school in another, 'earliest Italian' in the third and a combination of selected fifteenth- and sixteenth-

century Italian and Van Eycks in the last. In other words, the potential value of the dome as a church-like setting for altarpieces was not explored. The inclusion of a black marble dado below the pictures and covering of the walls with a dark maroon embossed wallpaper was a radical departure from the paler colours of the Wilkins galleries. In 1875 the latter had been papered in a similar maroon and had their doorways painted black and gold in order to lessen the contrast.[41]

As if he hadn't already suspected, Barry was officially informed in 1877 that the Treasury had dropped plans to carry out the rest of his scheme. Remarkably, he was paid £5,000 compensation. On his 1873 plan for the rooms Barry had directed that no fewer than five blank doorways to be left hidden in the walls, intended to provide access to future extensions – three of them assuming further construction to the north, and, most curiously, the east. He would have been pleased to know that the two doorways in the west walls of the west apse and north gallery were indeed opened when Sir John Taylor built his extension in 1889. Barry's ventilation and lighting system was also advanced for its time. His design included a tall Italianate campanile (easily visible today) which drew air through a series of vents distributed around the galleries. Although the laylights greatly reduced the disruptive reflections created elsewhere in the galleries by the combination of 'monitor' lighting and glazed pictures, at the time their diffused light was felt by some to be insufficient.[42]

Marble halls

Taylor was an official Works achitect who had worked under Pennethorne. The decision to return to the pre-1832 concept of an official architect rather than hold a competition was a reaction to the fiascos of the 1850s and 1860s. Although Taylor's new domed hall with its three staircases necessitated the destruction of Pennethorne's gallery, in so far as the design borrowed heavily from the latter's 1865 design for a northern extension it was in some ways a joint effort. Taylor's additions

also created two new galleries to the north, opening up two new circulation routes into the Barry Rooms. Like Barry, Taylor chose John Dibblee Crace to decorate his dome.

John Dibblee Crace was one of a dynasty of interior decorators who had made their reputation decorating the interiors of Brighton Pavilion and Carlton House for the Prince Regent earlier in the century. In the 1830s J. D.'s father, John Gregory, had successfully reorganized the firm and its activities to appeal to a broader, less courtly clientele. In 1843 he travelled to Munich, where the bold stencilled decoration of Leo von Klenze's museums and Königsbau inspired him to depart from the French-influenced pastels that had previously characterized the firm's output. German theorists of design, especially Semper, helped him justify his adventurous combinations of colour, notably in his decorative scheme for Fowke's 1862 Exhibition building. John Gregory worked closely with his son until his death in 1889, by which time polychromy was becoming less fashionable.[43] Thereafter J. D. lost interest in the firm's work, and it ceased operations ten years later. Even with the four corner landings, the staircase's proportions have never quite succeeded in making it a place for visitors to pause and gaze at the decorations (recently restored) or at other visitors.

The lighting scheme incorporated into the Taylor rooms was also old-fashioned. As already noted, Barry's precedent in adopting daylight-diffusing laylights was not followed. Neither was the opportunity taken to follow Henry Cole's example at South Kensington and install gaslight, a common feature in the new municipal galleries built in Liverpool, Birmingham and other cities in this period. Indeed, the Gallery ripped out the gaslight fittings it found when it took over the Academy's half of Wilkins' building in 1869. Burton and the Trustees considered evening opening in 1886. Like their predecessors in the 1860s, they chose to ignore the findings of Faraday's 1859 investigation into the effects of gas on paintings. Although the famed chemist had concluded that gas was safe, the Trustees insisted that unconsumed particulates made artificial lighting a 'very hazardous evil' for the paintings. Given the hundreds of

E. M. B. Warren's water-colour shows how Crace's decorative scheme fitted in with Office of Works architect Sir John Taylor's **new central hall** (1889).The fresco above the central stair was not realized and the space remained empty until the 1990s, when Director Neil MacGregor borrowed Lord Leighton's *Cimabue's Celebrated Madonna is carried in Procession through the Streets of Florence* (1853-5) to hang there.

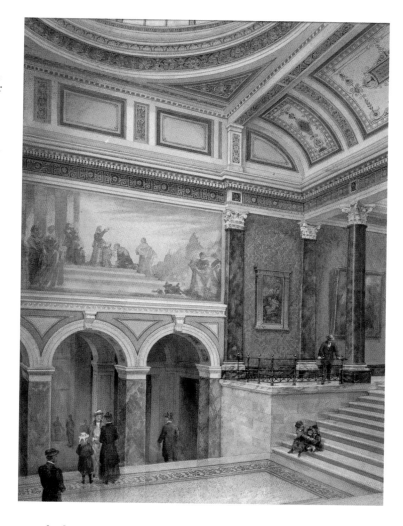

rough sleepers that gathered nightly in the Square at this time, there was also the concern that the Gallery might become a doss-house. Long-term illumination by gas in other galleries was in fact dogged with problems: gas was expensive and damaged paintwork and other fittings. Admittedly, the electric

lighting introduced in parts of the British Museum in 1879 and 1882 did not have such deleterious effects. But in a period which (as noted in chapter four) saw a loss of faith in the museum's power to 'save' the working man, the social expectations of evening opening diminished even as new technologies made artificial light cheaper and safer than ever before. Several museums that adopted evening opening with great fanfare in the 1860s and 1870s found by the 1890s that poor attendances did not justify its continuation.[44]

The prominence of the Crace decorations in both the Barry and Taylor extensions reflects the degree to which attention narrowed from ambitious architectural visions of lofty new palaces to a focus on the interior design of the Gallery. In stark contrast to the years before and after, the long period between 1876 and the 1959 *Sunday Times* competition for a Gallery extension on the Hampton Site saw discussions of Gallery design limited to the Trustees and museum professionals.[45] None of the extensions erected during this period had any exterior façades, which obviously lessened public interest. But even when progress towards the ideal of an 'island' gallery suggested the opening up of new façades, a nervous respect for the Wilkins building seems to have discouraged the Trustees and the Office of Works from taking the opportunity to reconsider the overall layout, let alone contemplate the demolition of the Wilkins façade.

At this point the shops on Pall Mall East still abutted directly on to the western edge of Wilkins' building. In 1901 the Trustees took the outbreak of a fire in one of these shops as the cue to demand that a fire break be opened up on this side. Their response to the idea (first raised in 1890) of pushing through a new street north to Orange Street was lukewarm, however.[46] Henry Tanner's 1911 designs for a new façade running the length of this new street were hardly adventurous – consisting of a pastiche of Wilkins' façade. Nonetheless, the Trustees got their way, and the new area to the west was left as a railed-in area of grass.[47] The same period saw the gradual retreat of the War Office from the barracks site according to a 'Memorandum

The area behind the portico is an architectural palimpsest. Wilkins, Pennethorne, Taylor, Hawks and several other architects have all left traces here. This wash drawing (c. 1895) shows how muddled the results could be. It features **James Pennethorne's east staircase**, built in 1860 when he floored over Wilkins' hall. Taylor's 1889 alterations replaced that gallery with a new central hall (with three sets of stairs), but for some reason Pennethorne's two earlier sets were retained until 1911.

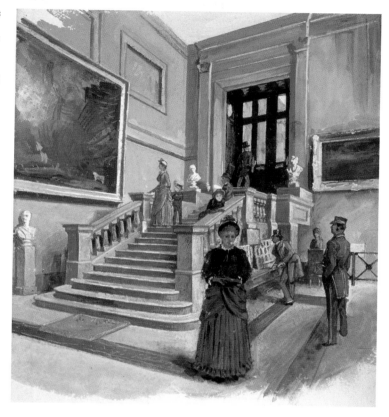

of Arrangement' drafted in September 1895. That it took so long to prise them out is a testament to the long shadow cast by an 1848 memorandum by Wellington highlighting its supposed importance in quelling would-be revolutionaries in the Square. Although Grenadier Guards had indeed surprised demonstrators on 'Bloody Sunday' (8 November 1887) by suddenly appearing from behind the Gallery, as long-term accommodation the site's disadvantages had been acknowledged for some time.[48] The barracks were fully vacated in 1911. In a similar fashion the British Museum had also started buying up surrounding properties from 1895 in a similar search for an 'island

site'. They, however, commissioned a master-plan from John James Burnet in 1903, and opened a large extension – the Edward VII Galleries – in 1914.

Although the master-plan, which included a new Kingsway-style 'British Museum Avenue' extending to the north, was not realized, the contrast with the Gallery's blinkered perspective is interesting.[49] The Glaswegian Burnet's British Museum Galleries were typical of the heavy Neo-Baroque and Neo-French Classicist blocks that embodied the Edwardian heyday of Empire. What with the construction of Admiralty Arch, the further enrichment of Nelson's Column and the concentration of large blocks housing the diplomatic representations of Canada, Rhodesia and other dominions in the immediate vicinity, the National Gallery was at risk of being eclipsed. Although such buildings were the product of a new wave of monumental planning that in some ways echoed the 1820 'improvements' that framed the original building, stylistically their classicism was much less chaste. Their focus on London as an imperial centre did not sit well with the nation-focussed Gallery.[50]

The only traces left by this style of architecture were on the interiors of the suite of five galleries (1909-11) designed by Works architect H. N. Hawks, who died before their completion. Typically of the period they combined the new technique of reinforced concrete with massive door surrounds, made up of blocks of green Tinos marble weighing more than three tons apiece. That said, compared to the Crace-decorated galleries and central hall Hawks' fittings were much less colourful. The small domed octagon of the central gallery had no polychromy, no inscriptions, and no sculpture other than a French frosting of tightly-bunched plasterwork. Far from being a crossing point for circulation, this gallery originally had a radiator island surrounded by benches (since removed) at its centre. The plans are the first to indicate the presence of a Ladies' lavatory.

As reviews and photographs taken at the opening indicate, the Hawks rooms finally afforded enough space to exhibit works – in the case of the largest, western gallery, these were

In 1909 work started on a **range of galleries behind the west wing** of Wilkins' building. Completed in 1911, these mirrored the layout of the Barry Rooms in the east, but their décor was much more restrained. Architect Henry Hawks took the opportunity to install the Gallery's first public lavatories at the same time. The archipelago of 'radiator islands' shown here was a less felicitous feature.

British 'Old Masters' – with a certain amount of space between the frames. This exposed more of the wall covering, in this case a painted and embossed William Morris-designed canvas; dull gold in the west gallery, Cordova red in the octagon and green in the final three rooms. Under the influence of Arts and Crafts designers like Morris the red velvet hangings, gilding and stencilling were now considered vulgar.[51] By 1910 Poynter's rich damask coverings at the Tate were felt to smack of a Bond Street gallery. Holroyd and Holmes' approach to the décor represented a halfway house between the red plush demanded by what Clive Bell dismissively called 'the art-treasurers' and the white-wall austerity which was considered progressive by 1931 – not least thanks to Alfred Barr's interiors at New York's Museum of Modern Art (1929).[52] Even if he admitted that it could sometimes be taken too far, the V&A Director Eric MacLagan concluded a 1931 lecture on museum décor by observing that minimalism was at worst 'a fault in the right direction'.[53]

MacLagan's lecture to the RIBA on 'Museum Planning' was a rare attempt to assess trends in museum design, and nicely encapsulated the shift from palatial opulence – excused, where possible, as 'period' setting — to the post-war 'porridge vernacular' (as Lord Rothschild would later call it) of Hendy and Levey.[54] At the V&A MacLagan and his immediate predecessor Sir Cecil Harcourt Smith had turned their backs on the heavy ornamentalism introduced by the museum's founder, Henry Cole, who had resigned in 1873. The complex allegories and rich decorative schemes laboriously realized in terracotta, tile, frescoes and stained glass had been panelled over, covered in linoleum, painted over or simply removed. In a 1910 memo Smith had stated that 'the decoration of a museum should be as unobtrusive as possible, and should in no way overpower the effect of the objects exhibited.'[55] MacLagan for his part regretted 'a general tendency to be too palatial'.

'Period' settings, he added, were 'the worst mistake of all.'[56] While at the Portrait Gallery Holmes had introduced some stained panelling 'to give the galleries a far-off resemblance to

panelled rooms in a Tudor mansion'.[57] He also hung the Gallery's primitives against white walls in an attempt to evoke a church setting, but this appears to have been regarded as an 'unfortunate experiment'.[58] Von Ihne's Neo-Baroque Kaiser-Friedrich-Museum in Berlin and New York's Metropoli-tan were just two examples of pre-First World War museums with large internal 'basilicas' for the exhibition of sculpture and paintings.

The gilt comes off

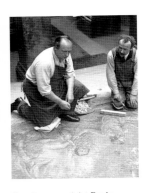

Russian mosaicist **Boris Anrep** is shown here working on the mosaic 'Profane Love,' part of a larger scheme illustrating *The Pleasures of Life* (1929) that decorated the east vestibule of the central hall. Anrep later added *The Awakening of the Muses* (1933) and finally *The Modern Virtues* (1952). Paid for by Trustee Samuel Courtauld and Mrs. Gilbert Russell, Anrep's mosaics brought a ludic irreverence to the opulent formality of Taylor's hall, and featured portraits of Greta Garbo, Winston Churchill, Kenneth Clark – as well as a small panel dedicated to mud pies.

Harvard's Fogg Art Museum was now held to be the model for museum interiors. Coolidge, Shepley, Bulfinch and Abbott's first-floor galleries at the Fogg were noteworthy for their white walls, minimalist doorways and suspended laylights. These last concealed a large upper space filled with a battery of daylight-filtering louvres and electric lamps designed to ensure a constant level of illumination throughout the day. Behind the scenes the Fogg was also noteworthy for pioneering a system by which much of its collection was relegated to a reserve, in which the paintings were hung on sliding racks. Although a suspended ceiling was retro-fitted to Hawks' large western gallery after the war, the full Fogg system was only fully realized in Trafalgar Square when the Northern Extension and Sainsbury Wing were built. When artificial (electric) light was introduced in 1935, the arrangement consisted of a series of suspended lanterns.

In 1929 the second, larger and more figurative mosaic series by the Russian emigré Boris Anrep, *The Pleasures of Life*, had been unveiled at the Gallery. Although the liveliness and whimsy of vignettes celebrating dance, the seaside and other pleasures might have been welcome elsewhere in the building, they did not fit in well with the earlier Crace decorations in the central hall. Extending over thirty years, Anrep's later pavements in the Taylor rooms included an *Awakening of the Muses* (1933) featuring Clive Bell as Bacchus, Osbert Sitwell as Apollo and Virginia Woolf as Clio. This was a witty Bloomsbury satire on

The **Mond Room** (1928) housed the collection bequeathed by chemical magnate Sir Ludwig Mond, a collection the Mond family wanted displayed together. Located off the main circulation route, the room became a favourite retreat. In 1974 a visitor wrote complaining that it was full of idlers: 'all seats occupied – 4 asleep, 1 doing a crossword, 1 reading a newspaper, 1 reading his mail.'

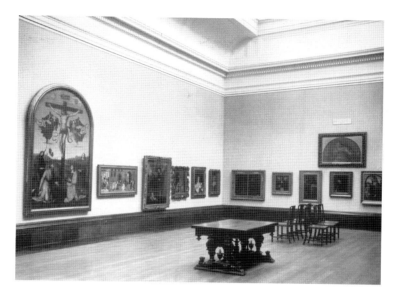

the Pantheons conspicuous on the Albert Memorial and almost all other Victorian public buildings – except, that is, the National Gallery itself.[59]

MacLagan admired American museums with large interiors that could be rearranged by the use of temporary screens. He also praised the new Marlay Gallery extension to the Fitzwilliam Museum in Cambridge (1924), which used projecting bays to break up a larger space. These were also admired by Holmes, who asked that they be included in the large Venetian Gallery (1927, opened 1930) Duveen funded at the Gallery. This extended west from Taylor's north gallery, but did not as yet connect with Hawks' suite until 1937, when two small linking galleries were built.[60] As with the Mond Gallery (1928), such private benefactions came at a price: in both cases the donor or his heirs sought the inclusion of *cassone*, carpets and other touches intended to make the space more suggestive of a well-appointed home. Such involvement in the design process could exacerbate the usual difficulties of easing the transition between the décor of 'new' and 'old' galleries.[61]

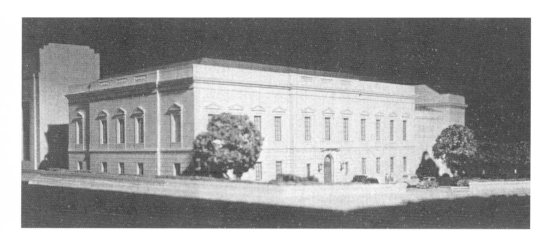

When Armenian oil magnate Calouste Sarkis Gulbenkian decided to endow the Gallery with his collection and Iraqi oil interests he chose American architect Walter Delano to design a suitable **annexe** (1939-40). This building would have stood behind the west wing, roughly where the Northern Extension is today, and housed all of Gulbenkian's art, not just his paintings. The model illustrated above survived the perilous trip across the Atlantic in 1942, only to be thrown out by the Gallery in a fit of absent-mindedness. This grainy photograph is all that remains.

Hendy's opposition to the Gulbenkian Annexe may well have derived from precisely this concern. Walter Delano's Annexe (designed 1939-40) would have been redolent of an American millionaire's home-museum. With its separate fore-court, garden court, grand staircase and mingling of different schools and media it would have provided a London equivalent for the Frick Collection, linked to both the Duveen Gallery and the westernmost gallery of Hawks' suite by a bridge. Situated where the Northern Extension is now, it would not have been visible from the Square. In addition to seven galleries on the same level as the main rooms (four of them with windows) it would have included a 'Reception or Lecture Gallery,' two lifts, four offices and more than adequate lavatories.

The partnership of Delano and Aldrich had been formed in 1903 and first established a reputation designing a series of clubhouses and country houses for New York's elite in the 1910s. By the 1930s, however, they were almost exclusively occupied with large scale public projects, including airports, the extension of the White House and temporary structures for the 1939 World's Fair – which included a spire-like 'Trylon' remarkably similar to the 'Skylon' exhibited at the Festival of Britain twelve years later. The firm's very first project had been

the Walters Art Gallery in Baltimore (1904-9), commissioned by the railway magnate Henry Walters. It is the Cushing Memorial Art Gallery (1919-20) in Newport, Rhode Island, however, that best hints at what the Gulbenkian Annexe might have been like. Its intimate scale and minimal exterior, relieved with tight mouldings, show the characteristic Neo-Georgian restraint which Delano and Aldrich sought to substitute for the monumental classicism of their close rival, John Russell Pope, who designed Washington's National Gallery. Gulbenkian was an admirer of their U. S. Government Building in Paris (1929-32), which had been designed in the purified neo-classical style of Ange-Jacques Gabriel, as befitted its location on the Place de la Concorde, which Gabriel had laid out in 1769. The oil magnate particularly admired the staircase, which rose behind a screen of columns from a vaulted entrance hall. Delano's Annexe design repeated this scheme.[62]

Before his appointment as Director Hendy had headed Leeds City Art Gallery. There he had done little to disguise his impatience with the existing Victorian accommodation, and had

All parts of the Gallery suffered during **wartime** Luftwaffe raids. Glass roofs were patched with corrugated iron; the resulting leaks damaged the floors. One west wing gallery suffered a direct hit on the night of 12 October 1940, another bomb hit five nights later, but failed to explode. Sadly the disposal crew arrived too late to prevent it detonating the following day. Heavy raids in February and March 1944 caused more serious damage.

been a noisy advocate of a huge new City Hall and Gallery complex intended to replace it. John C. Procter's design lent heavily on the work of Charles Holden, and like the latter's Senate House for the University of London (1932) was in a style a later generation has come to associate with totalitarian 'Palaces of Culture'. Although this project was rejected on grounds of cost, Hendy was unfazed, and when the City took over nearby Temple Newsam as a museum in 1939 he rearranged many period interiors. These provided a congenial setting for temporary exhibitions of works by Paul Nash, Jacob Epstein, Ben Nicholson and Henri Gaudier Brzeska – artists hitherto little seen in London, let alone Leeds.[63]

Compared to the resources being devoted to housing, new towns and schools in the same period, there was little enthusiasm for developing museum designs in Britain for the two decades following 1945. Mies van der Rohe's 1942 'Museum for a Small City' (later realized in Berlin as the Neue Nationalgalerie) had, however, advanced the straightforward concept of a 'hangar' museum, whose 'rooms' could be created at will by shifting screens around a geometric grid formed by thin columns holding up a flat roof. Both the screens and the roof itself floated in space, suggesting a giddy freedom from oppressive opulence and a rigid enfilade. The latter's suggestion of a fixed 'path' was increasingly perceived as an imposition in an educational context where child-centred pedagogic methods had placed a new emphasis on exploratory play. In order to encourage more interactive use of the museum Miesian galleries such as the new wing at Amsterdam's Stedelijk (1954) and Le Havre's Maison de la Culture (1961) devoted unprecedentedly large areas to education and club rooms, lecture rooms and shops.

For Hendy, struggling to work with limited resources inside a bomb-damaged and museologically 'retrograde' building, Franco Albini and Carlo Scarpa's highly-influential work refitting the interiors of Italian museums such as the Palazzo Bianco (Genoa) and Castelvecchio (Verona) must have seemed particularly inspiring. Here historic old façades were restored,

while inside rooms were radically altered. Paintings were hung at wide intervals against white walls (in some cases without frames) and with unobtrusive labels. Sculpture and other objects were displayed on black steel supports. Although using a modified car-lift as a plinth for Renaissance sculpture groups seems deranged today, in 1965 such an approach was widely admired for its 'simplicity and humility of approach in respect of a great work of art'.

Another passage from the same book on *The New Museum* by Michael Brawne seems to sum up the 1950s 'new museography' approach Hendy sought to follow at Trafalgar Square:

Large collections have a considerable programme of renovation and remodelling as well as of a certain amount of expansion ahead of them so that their enormous collections may be arranged in a way which will again allow each particular item to communicate its message. In the case of museum design a focussing of attention on the particular has brought with it a further and important contribution: the ability to come to terms with some of greatest examples of the past without in any way compromising the present.[64]

The view of past greatness as something troubling and even morally suspect has obvious parallels with the concerns Berger later addressed in *Ways of Seeing*. In Hendy's case such views were mainly a throwback to pre-war positions.

When confronted with the Ministry of Work's 1948 proposals for the décor of the refurbished (and now air-conditioned) west wing galleries, Hendy maligned them as reminiscent of 'drawings for a proposed furniture showroom in the Tottenham Court Road made some fifty years ago'. As he explained to Crawford, 'I would rather have clinical functionalism than what the Ministry have produced.'[65] Crawford disagreed, and used his position on the Royal Fine Arts Commission to have Hendy's revised designs stopped, confirming the Treasury's impression that the overall situation at the Gallery was 'preposterous'.[66] Under Hendy, Davies and Levey the integrity of the Gallery's interiors suffered from a new penchant for suspended ceilings, oatmeal Hessian wall coverings

and attempts to insert changes of level with platforms that
obliged the visitor to walk up a few stairs onto a dais, pass
through a doorway, and descend the other side.[67] Projecting
bays were added to break up the three largest galleries. Under
the decentralized administration of Levey individual curators
were given considerable leeway to decide how they wished their
School to be displayed. Terracotta-like floor tiles and other
'period' effects were adopted in order to create the effect of a
Renaissance palazzo in the Italian rooms, for example. Even
allowing for the spirit of the age, the disdainful attitude shown
towards framing until the arrival of MacGregor can also seem
insensitive.

Yet such décor was clearly driven by a sincere desire to make
the individual visitor's engagement with the art more intimate
and moving. Suspended laylights also reflected a heightened
awareness of the potential damage daylight could inflict on
paintings, a concern raised by one of the Gallery's own scien-
tists, Gary Thomson, in a highly influential paper published in
1961. Squaring the circle of controlled daylight above and flex-
ible gallery space below could be very difficult. Unhappy com-
promises at the Hayward and Tate extension (1970-9) could
end up being expensive and ultimately self-defeating. A desire

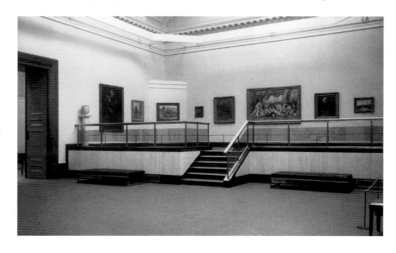

Director Michael Levey
sought to render the Galleries
more intimate by installing
suspended ceilings, screens
and blocking off enfilades.
He also sought to introduce
changes of level through
daises, which struck many
as pointless and seriously
hampered handicapped
visitors' movement.

The **carpet, laylights and projecting panels** introduced here make it difficult to identify quite which gallery it is. The panelling enabled visitors to interact with a particular altarpiece, such as Raphael's *Ansidei Madonna* (right) in relative isolation, without being disturbed by neighbouring works. Carpeting kept noise levels low, suggesting a fugitive Gallery, abdicating its role as a public space.

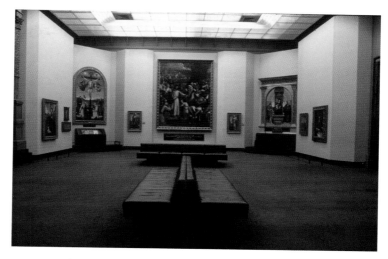

to control light levels and ensure a measured daily 'dose' of light led to the installation of complex daylight-filtering machinery, only for artificial light to be preferred in practice as a safer and less fiddly alternative.[68]

The Hampton Site

As noted above, the Barry Rooms had been followed by a long period in which questions of site and large-scale extensions were not discussed much. The purchase by the government of the site of Hampton's department store in 1957 ended all that. Spurred on by an unofficial competition for designs organized by *The Sunday Times* in June 1959, the question of what a Gallery on the site might look like and how it should relate to Wilkins' building got a full airing many years before Prince Charles' famous intervention. When the site was considered for purchase the Treasury had been highly sceptical, noting that the Gallery had not mentioned any need for more space, correctly suspecting that once acquired the Trustees would break their promise not to agitate for any Gallery extension on the site for 25 years.[69]

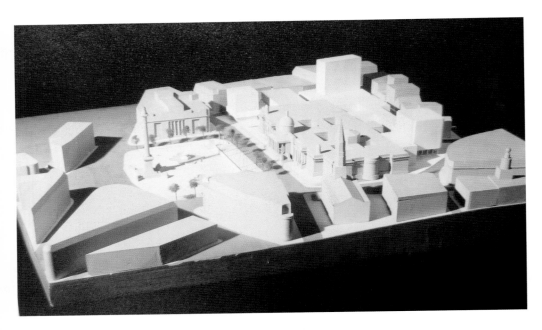

Ministry of Public Building and Works architect William Kendall's **masterplan for Trafalgar Square** (1964-5) would have demolished Ewan Christian's National Portrait Gallery and moved that institution to a squat tower on the Hampton Site, linked to the National Gallery by a bridge. This would have created space for the National Gallery to build a new complex of galleries and offices running right across the back, with a new entrance on to St. Martin's Place. Once again, this photograph is all that survives of the model.

In 1961 a new Chancellor decided to invite both the National Gallery and the National Portrait Gallery to assess their needs for the next twenty years with a view to drawing up plans for a rethink of the entire 'island' site. According to a concordat reached back in October 1915, the National Gallery only had a claim on approximately half of the land extending back from Wilkins' west wing – the Portrait Gallery had been allocated a strip running right across the rear of the Gallery. It was now decided that it was more sensible to reallocate this land to the National Gallery and build a new National Portrait Gallery on the Hampton Site in four or five years' time. Christian's old Portrait Gallery would then either be altered for use by the National Gallery or (the favoured option) demolished entirely. This, at least, was the plan which Macmillan approved privately in September 1961. At that time it was thought unwise to go public, however, and time was bought by referring the whole question to the Museum and Galleries Commission.[70]

But the general scheme was agreed by the Trustees of both Galleries in a formal treaty signed in 1964.

The treaty spurred the Ministry of Public Building and Works to have one of its architects, William Kendall, draw up plans between August 1964 and June 1965.[71] This four-phase plan relocated the Portrait Gallery to an L-shaped, plain three-storey block on the Hampton Site, built out over a piazza to connect with the Gallery. In lieu of Christian's building the northeast corner would have housed a secondary entrance with a short tower above for offices. All the east Wing galleries, including the Barry Rooms, were also to be remodelled, Hendy being keen on 'the abolition of large-scale "palace" marble door-architectraves [sic]'.[72] At the rear a suite of galleries would link the northeast block with one at the northwest, which would house accommodation for the Reference Collection underneath more galleries on the main level. This block was the only phase to be completed (in a somewhat altered form), as the Northern Extension. In contrast to Barry's grandiloquent scheme, Kendall's was attentive to the service needs of the institution and broadly in harmony with Wilkins' building. The proposed new piazzas and entrances to the north east and to the relocated Portrait Gallery were particularly well-designed. In contrast to contemporary projects that were realized, such as Denys Lasdun's National Theatre (1967-76), it was low-key.[73]

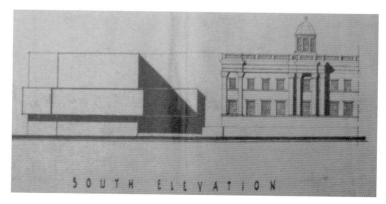

This 1964 plan shows one of the façades proposed by architect William Kendall for the **National Portrait Gallery**, which was to have been relocated to the Hampton Site, where the Sainsbury Wing stands today. Ewan Christian's NPG was to have been demolished, had Roy Strong not succeeded in having the rather un-distinguished building listed.

Kendall's design also had the advantage of accommodating a pedestrian link between Leicester and Trafalgar Squares. In William Suddaby's design of the same period, this potential was realized more fully, with elevated walkways above a sunken garden dotted with trees and tables.[74] Although the Sainsbury Wing has left space for pedestrian traffic along this route, in practice this is little used. That said, 1960s planning could also prove remarkably deaf to the Gallery's requirements, as the plans prepared in June 1966 by Greater London Council to drive large traffic arteries right round the back and sides of the Gallery indicate. This scheme would have marooned the Gallery on a traffic island accessible by foot-tunnels, much as the GLC did to Burton's Wellington Arch and Nash's Marble Arch in the same period (1961-2).[75] It was not only suggested that the old Portrait Gallery be demolished, but that the Hampton Site be largely given over to roadway. Both institutions were to be accommodated by taking in more land on the northern side of Orange Street, although detailed plans were not prepared.

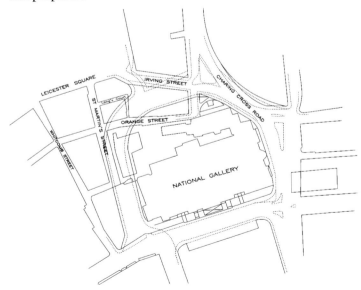

Discussion of new buildings on the Hampton Site almost became academic when the Greater London Council proposed in June 1966 to run a traffic artery right round the back of the Gallery, covering the Site in tarmac and marooning the institution on a **traffic island**.

Louis Hellman's 1970
**lampoon of the Northern
Extension design** appeared
in the *Architects' Journal*.
It features a grateful Martin
Davies, who expresses his
relief at the Ministry of
Public Buildings and Works'
inventive solution to his
space problems.

Such planning epitomizes that school of car-friendly urbanism associated with Sir Colin Buchanan, who had worked on planning in London since 1946, first for the Ministry of Town and Country Planning and then for the Ministry of Transport, for whom he wrote a landmark report on *Traffic in Towns* (1963). Although far from his intention, Buchanan's book inspired a welter of traffic schemes that blighted many town centres – of which the Trafalgar Square could have been an egregious example.[76] Fortunately the traffic island plan was dropped by February 1967. Yet the inter-departmental wrangling it caused, exacerbated by both Westminster City Council and Ministry of Housing objections to Kendall's proposed Portrait Gallery, tied the project up for a further two years. Kendall retired in 1970 and so was not able to see the project through to completion five years later.[77] Without altering the interior arrangements, his successors added the prominent cantilevered upper storey, 'slit' windows and opted for black stone cladding below. Intended to reflect Wilkins' architrave, it drew fire from the Royal Fine Art Commission (to whom

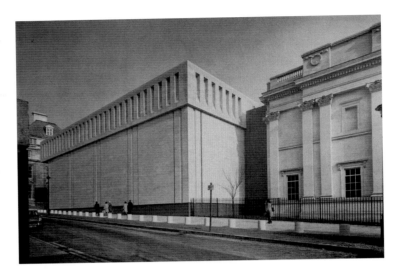

Westminster had referred the project), who insisted that the lower storey be clad in white Portland stone instead.

It was at this point (July 1970), precisely when the design for the extension had been settled and unveiled to the public in a temporary exhibition, that the Portrait Gallery's new Director, Roy Strong, decided to weigh in. In 1964, as indeed during the 1867 competition, the Portrait Gallery had been perfectly willing to let masterplans for the site be drawn up, and had been happy to go along with the National Gallery's plans. Strong saw such positions as supine, and worked hard to undermine the treaty negotiated between the two institutions three years before his appointment – 'something mysteriously referred to as the 1964 Agreement,' as he called it. Strong began campaigning to preserve Christian's building, which was eventually listed. Unfazed, the National Gallery and the Ministry of Works took a stand 'that the Christian site is required in order to complete the [National] Gallery as one entity with a rationalised circulation even if Christian is retained as a false façade.'[78] A feasibility study commissioned from Casson Conder and Partners in 1970 found that even with three

Taken in February 1975, this picture shows one of the **Northern Extension** galleries before completion, with two technicians admiring the electronically-controlled louvres that controlled the level of natural light entering the galleries. The 'white cube' aesthetic was a world away from the interiors of E. M. Barry and Taylor, and has since fallen out of favour. Sadly, so too has the use of natural light to illuminate galleries.

sub-basements and a 90' tower block the needs of the Portrait Gallery could not be met on the Hampton Site footprint. But Strong knew that already: he had deliberately overloaded the brief to ensure this result. Although his 1970-2 campaign was successful, he vowed he would 'never forgive those BEASTS, the National Gallery' as long as he lived.[79]

Strong can only claim part of the credit for destroying the 1964 scheme and leaving the Gallery with another annexe-by-default. As with the much more dramatic collapse in 1967 of plans to build an extension to the British Museum (Leslie Martin and Colin St. John Wilson, 1962-4) shows, identifying a single cause is probably impossible.[80] Other ministries played their part, as did the great caesura of charging – a policy which Eccles saw as the *quid pro quo* for such large-scale extension schemes.

The Northern Extension's ground-floor Reference Galleries were considered a successful innovation for the Gallery, and upstairs the main suite enjoyed Fogg-style lighting control and one room deliberately not hung with paintings. Under Levey this feature, which had originally been conceived in 1969 as a

The original design of the **Northern Extension galleries** was open, airy, and suffused with light. Without cornices or dados, the partition walls seemed to float. This was felt to be a suitable setting for the Gallery's Renaissance works, including Holbein's *Ambassadors*.

'room for teenagers' – a sop to Jennie Lee – was invested with a broader role, as a space in which the visitor could take time to relax away from the paintings, enjoying them at one remove through recollection and introspection.[81] The Northern Extension also allowed temporary exhibitions on a scale previously impossible.

Fourteen years after opening the Northern Extension was largely dismissed as 'irredeemable,' thanks to 'its grid of boring, badly lit, box-like galleries and its lack of any coherent architectural relationship with the old block'. The same 1989 *Apollo* article also critiqued the rest of the Gallery's décor in neo-Victorian terms – even arguing that the existing wall treatments (which it described as 'heterogeneous in the extreme') should be replaced with 'red damask for the whole building'.[82] Despite subsequent privately-funded renovation presumably intended to render the contrast between the main galleries and the Northern Extension less conspicuous, the rooms remain curiously displaced within the building. It will doubtless take many more years before the style of display originally intended here has aged sufficiently for the scheme to be accorded the

On paper the **open plan of the Northern Extension** suggested a space in which visitors could roam at will. At times of heavy circulation, however, it could be difficult to enjoy the pictures without being disturbed by a steady stream of visitors heading for the main galleries.

same respect accorded to those of Wilkins, Barry, Taylor and Crace.

In 1833, as debate over Wilkins' proposed design raged in the press, the architect Charles Purser wrote a pamphlet pointing to the many challenges afforded by the site, not least by the Barracks and the Workhouse:

> Between this Scylla and Charybdis we are about to launch as rich and promising a freight as ever hope consigned to the ocean of time!... On the one hand, what bounds can imagination set to the probable glories of our *English Louvre*! – on the other, it needs not, – with the assistance of past experience, – the gift of prophecy to foretell, that, left to its own direction, our National Gallery will become another National Blunder... erected in one reign, to be abandoned in the next![83]

Purser echoed Cockerell's comments on 'Quaker architecture' by claiming that Britons were too preoccupied with money and business to concern themselves with the project of designing a worthy Gallery. Given their tendencies to jobbery, however, he intimated that neither the Crown nor the government could be trusted, either.

With all major stylistic developments (apart from Gothic and Edwardian classicism) represented, the Gallery is to be congratulated on affording a microcosm of British architectural history since 1830 – on having failed to realise Purser's gloomy prediction of successive unhappy reinventions of itself. It is to be hoped that subsequent refurbishment respects this history. Nonetheless, the actual building remains a disappointment to many. One of the most impressive studies of gallery architecture and design in Britain has described its building history as 'an extended and dismal story'.[84] It is certainly no 'English Louvre.' What prevented the Trustees, Treasury, Parliament, the Office of Works and private benefactors from achieving a grand unified scheme?

The fact that great public buildings and museums were built in this period, even in periods of Gladstonian economy, indicates the extent to which the Gallery was simply unlucky in the circumstances which prevented more impressive schemes from being carried out. The pugnacious personalities of Wilkins, Elcho, Ayrton, Hendy and Strong cannot be overlooked here. In addition, a tendency to fuss, to conflate distinct (if ultimately related) issues of site, style, audience, lighting and décor dragged out discussion for far too long, wearying key advocates and the allies they needed to convince of their case. At most municipal galleries and at South Kensington Museum decision making was made relatively straightforward by the fact that funding and design decisions were the preserve of private benefactors or the museum's own officials. The National Gallery, by contrast, inhabited an unhappy limbo, which any number of self-appointed authorities were only too happy to fill. Thus the very aspect which makes the Gallery's history so revealing a witness to broader political events also condemned it to architectural mediocrity.

Economising doubtless played an important role. A simple, inexpensive, multi-purpose building was the price Wilkins paid to save the site from commercial development in 1832. Until 1945 several redevelopments suffered cut-backs from the Treasury placing them behind armaments in its list of priorities

News of Robert Vernon's generous gift of his collection of modern British art in 1847 turned minds to considering how Wilkins' Gallery might be altered, expanded or replaced so as to accommodate such gifts. This 1848 **Punch cartoon** shows 'a design to be studiously avoided,' warning that if the 'cruet example' of Wilkins was followed, the result would be a 'a terrible smash.'

(A DESIGN TO BE STUDIOUSLY AVOIDED FOR THE PROPOSED GALLERY.)

– from the 1850s, when the South Kensington scheme was delayed by the Crimean War at a crucial planning stage, to the 1930s, when the introduction of air-conditioning lost out to re-armament in face of the Nazi threat (it was only installed, gradually, twenty years later). After 1945 the Gallery was out-prioritized by welfare spending, limited building supplies and man-power being focussed on community and school construction. Even when budgetary commitments were secured for work on the Gallery, post-war Trustees were eager (perhaps overly so) to view them as 'chips' to be traded in for special grants needed to rescue specific works of art. From at least 1934 up to Eccles, the government's view had usually been that 'it is more important to display the pictures they have got than to buy new ones.'[85] This fundamental conflict in priorities may have encouraged the Treasury and various Prime Ministers from Gladstone to Macmillan to see the Gallery as incapable of planning long-term – and hence to discount Trustee arguments in favour of extensions.

But did anybody actually want a 'British Louvre'? In the nineteenth century the great European museums and the grand planning schemes they ornamented had strong associations with revolution, rapine, bureaucratic despotism, atheism and, perversely, Catholicism. Above all they were associated with a court-centred culture. George IV and Albert both sought to change the face of London, and each had schemes that assigned the National Gallery an important role. Doubts surrounding the corrupt financing behind Nash's developments and the constitutional propriety of the Prince Consort's

activities prevented them being fully realized, however. Last but not least, the relative under-representation of London until the Third Reform Act meant that it was easy for MPs to play the Robin Hood card: to argue that expenditure on a Gallery building involved robbing the poor provincial in order to subsidize a lounge for Londoners.[86]

Deep down, many clearly felt that noisy discussion and slow, piecemeal development were the most appropriate way for a *British* National Gallery to grow – even that they were the price paid for political and social stability. Allied to this was a suprising affection, infrequently acknowledged, for Wilkins' low building.[87] Wilkins' Gallery, a correspondent to *The Builder* wrote as early as 1867, had 'become historical; we like to see its dear familiar face, and most of us have invested more or less of our affection in it. It suits the situation admirably, and is in harmony with its surroundings.'[88] Even if was, as the architectural historian Sir John Summerson famously put it, a mantelpiece, it was the nation's mantelpiece, and few were those who would have those pepperpots arranged any other way.

Epilogue

425

Epilogue

The 150th anniversary of the Gallery fell in 1974. The recent defeat of admission charging gave further cause for celebration. The anniversary was marked with a special exhibition entitled, somewhat inelegantly, *The Working of the National Gallery*. This offered visitors the opportunity to learn about the activities of the National Gallery's numerous specialized staff. The tendency of architects to overlook the service requirements of museums meant that much of this work went on in ground floor quarters that were ill-suited and constantly shifting. Fortunately the Northern Extension was nearing completion, and would provide purpose-built accommodation for such staff. The Education, Scientific and Conservation Departments in particular benefitted from a new, generously-proportioned secondary entrance and top-lit studios. Gradually the practice of having individual curators take on secondary roles (as Education or Press Officer, for example) was giving way to the appointment of staff with specialized expertise. The Gallery's first full-time Press Officer, for example, was appointed in 1975. Meanwhile the refurbishment of the East Wing of Wilkins' building began. The annual purchase grant was almost doubled, from £480,000 to £990,000.

During the following thirty years the number of staff working at the Gallery increased as more departments were added, encompassing new areas of activity, such as Development. Visitor numbers increased from two million to over five One wonders if Hendy, let alone Eastlake, would recognize the institution they ran with much smaller staffs, in an age when the funding landscape was much simpler. Excluding warders, in 1955 the Gallery had a staff of 25. By 1975 this had risen to 38, rising to 83 in 1985 and 198 in 1995. The growth of Gallery departments, of visitor numbers and the range of activities and events which bring them all together are well documented in the Gallery's annual reports and other publications, and it is not the aim here to duplicate or even offer a précis of such

Previous page:
A **sketch** by architect Robert Venturi for his Sainsbury Wing gallery enfilade.

Opposite: The **Sainsbury Wing staircase** features a frieze recording the names of some of the artists whose works hung in the galleries behind. Its permanence recalls a Victorian confidence that the greatest artists could be identified and should be immortalized by those designing public monuments and museums. To a latter-day age at once more sceptical and more 'knowing', such deeply incised initials could seem a superficial allusion.

In 1970 Richard Rogers and Renzo Piano won the competition to design the Centre Pompidou in Paris (1971-7). **Richard Rogers Partnership**'s entry for the 1981 competition for a National Gallery annexe seems more redolent of the designs then being prepared for Lloyd's Register of Shipping, a project completed in 1986.

material. It is still too soon to attempt a thorough chronicle of events and debates that remain current in the museum 'world' – still a small and in some ways involuted one.

In keeping with this book's attempt to relate the insider perspective to broader social and political trends, this short epilogue will instead describe what I consider to be the five most important changes to affect the Gallery in the last thirty years. The first of these is the most concrete: the construction of Robert Venturi and Denise Scott Brown's Sainsbury Wing, which opened in 1991.[1] This was itself related to a shift in the relationship between Director and Trustees, as both responded to the challenges posed by Thatcherite arts policy. Thanks in no small part to Director Neil MacGregor, the Gallery managed to accommodate new ways of marketing the Gallery to visitors and sponsors while at the same time reinvesting the paintings with emotional and spiritual value. Combined with MacGregor's strong stance against admission charges, it seemed as if the faith that underpinned the Gallery's social mission in the previous century had returned. A final change – the development of links between the Gallery's Old Masters and contemporary artists - can also be seen as a restatement of one of the Gallery's original aims.

As we saw in the previous chapter, the Hampton Site located to the west of Wilkins' building had already excited ambitious plans for the reorganization of the entire Trafalgar Square site, only for these to be scuppered by Roy Strong's refusal to honour the 1964 agreement brokered between the Gallery and the NPG. Economic difficulties and the coming to power of Margaret Thatcher in 1979 meant that when the Chairman of the Trustees, Noel Annan, addressed the Hampton Site question again in 1981, the parameters of the brief were rather tighter: an annexe to be built on public land by private developers, who would combine top-lit galleries with offices in a mixed-use structure. The former were to be linked to the Wilkins building via a link, the latter rented out.

If the Trustees had left themselves little room for manoeuvre, they were sidelined entirely by Secretary of the Environment Michael Heseltine and the architectural establishment, both of

which spotted an opportunity to further their own agendas. The professional architectural lobby which had nervously weighed in during the 1850s debates over the Gallery's proposed relocation to South Kensington was now much more self-confident. Annan was on the committee appointed to judge the architectural competition held in May 1982, but clearly felt that the Gallery's interests were being squeezed between fellow committee member and architect Hugh Casson and developers such as Trafalgar House. The former wanted to use the high profile site to make a stylistic statement, while the latter simply wished to maximize the office space available for rent. Casson vetoed the Trustees' preferred design, by the large American firm Skidmore Owings and Merrill, then largely known for designing office towers.[2] Although the winning firm of Ahrends Burton Koralek were willing to make changes to their design, the revised plan featured a glass tower which the Prince of Wales (a Trustee of the Gallery) dubbed 'a monstrous carbuncle on the face of a much loved and elegant friend' in a

The Gallery Trustees were impressed with the amount of gallery space SOM's design had squeezed out of the site, and asked ABK to make a number of amendments that the architects felt weakened their design. These included **a new tower** housing a staircase and a cafeteria. The tower earned the design the honour of being called a 'monstrious carbuncle' by the Prince of Wales.

Denise Scott Brown and her husband, **Robert Venturi**, were the architects chosen in January 1986 to design the Sainsbury Wing. 'We will work for a building that grows out of its context', Venturi promised, 'that of this William Wilkins fabric and the square itself – take off from what's here and at the same time, and in the end, enhance what's here.'

controversial speech at the RIBA in May 1984. Heseltine refused the ABK design planning permission. The Gordian knot was finally cut with the Sainsbury brothers' announcement in 1985 that they would fund the construction of a Sainsbury Wing.

Twenty years have now passed since the announcement of the Sainsbury gift. The resulting building has remained popular, and the fierce comments the design originally elicited from critics and the architectural press are almost entirely forgotten. 'We are to be given a vulgar American piece of post-modern mannerist pastiche,' The *Architectural Review* promised in 1987. Venturi and Scott Brown's building was viewed by the profession as insubstantial, yet somehow ponderously knowing and insistent at the same time. Its relationship to its neighbour was memorably described by the *Review*'s E. M. Farrelly as that of 'the National's clever kid brother, who insists on being around, but who will not shut up.' The broadsheets were kinder, Simon Jenkins stating in *The Times* that the building was 'a marvel... a building which both sustains a presence across a large square and fits comfortably into the adjacent streetscape.'[3]

The design certainly satisfied the requirement, first laid down in a 1982 brief, that the galleries have a 'basilica-like' feel, as befitted rooms intended to house paintings commissioned for

Trustees John Sainsbury and Jacob Rothschild (second and third from left) join Robert Venturi, Margaret and Dennis Thatcher in front of the **newly-unveiled model of the Sainsbury Wing.**

Announced in April 1985, **Simon, John and Timothy Sainsbury**'s generous offer to build an annexe brought almost thirty years of wrangling over the Hampton Site to a close. They joined Director Michael Levey, Noel Annan and other Trustees and staff on the select committee charged with finding a suitable architect.

churches or monastic foundations. Venturi's gallery floor plan was in keeping with the mid-nineteenth century idea that museums should make an attempt to replicate the artwork's original surroundings. The frieze of artist's names running down the side of the main staircase could also be considered a throwback to a Victorian penchant for compiling lists of great men and displaying their names or images on public buildings. Such 'directions to Fame in letters of stone,' as the pre-Victorian Hazlitt described them, seemed presumptious to the Victorians' successors.[4] As noted above, Boris Anrep's mosaics represent Bloomsbury's satire of such roll-calls of eminents. One suspects the Sainsbury Wing frieze (actually, strictly speaking, not a frieze at all) may be equally pointed.

The 1982 competition for a National Gallery annexe on the Hampton Site was won by the firm of Ahrends Burton Koralek. Despite a challenging brief that stipulated a mixed-use building combining gallery and leasable office space, **ABK** produced a worthy design that might have realized long held hopes of linking Leicester and Trafalgar Squares.

'Contextual borrowings should never deceive,' Denise Scott Brown insisted, 'you should know what the real building consists of beneath the skin. For this reason our allusions are representations rather than copies of historic precedents. The deceit is only skin deep.'[5] There is surely room to question whether the Sainsbury Wing's façade does enough to suggest the interior structure, and whether the drawn curtain of Corinthian columns does in fact 'sustain a presence' across the square. The interior affords visitors little opportunity to situate themselves relative to the square or even Canada House, the large exterior windows on the south side having been blocked up at the Trustees' request. The basement temporary exhibition rooms were felt by many to be oppressive and struggled to cope with blockbuster crowds such as that drawn by the 2001 Vermeer exhibition.

For an architect whose other works, notably the Seattle Art Museum (1984-1991), show a fascination for running 'symbolic streets' through public buildings, neither the grand staircase nor the confined walkway between the two buildings provided

Of the designs entered in the 1982 competition the Gallery's Trustees thought this design by **Skidmore Owings Merrill** the best. Unlike the ABK design, it had traditional rooms with skirting boards, cornices and architraves.

much opportunity for *flânerie* or public autovoyeurism. The need to make more of the Jubilee Walk linking Leicester and Trafalgar Squares had been recognized by the Ministry of Public Works' 1960s plan for the Hampton Site. Even with the pedestrianization of the north side of Trafalgar Square, the Walk is little used today. The embracing curve of the ABK design would have created a welcoming space in an otherwise somewhat forbidding square, a space that could have served both as an antechamber to the Gallery and as a pedestrian thoroughfare. Although the Trustees thought their ceilings 'oppressively' low, the curved gallery wrapped round this piazza and the other, rectilinear galleries would have had an interesting contrapuntal relationship. For all the obtrusiveness of its tower (a relatively late addition, to be fair), which Prince Charles likened to that of a 'municipal fire station,' the cafeteria at its top would also have enjoyed spectacular views.[6]

In 1998 Robert Venturi produced a sketch outline of the previous forty years of architecture, one which reached a climax with his own 'Iconographc – Generic' style, described as a

'fanfare "on", not "as" building'.[7] The most admired architects of museums and similar structures do not seem to have followed Venturi's scheme. Daniel Libeskind's unrealized 'Spiral' for the V&A, Frank Gehry's Guggenheims (Bilbao and that proposed for Manhattan) and Rem Kolhaas's Palace of Music in Porto suggest that the Sainsbury Wing may in time come to represent a stylistic cul-de-sac. At least, it might have left itself open to that possibility, had the conservative backlash championed by the Prince in his speech and subsequent series *A Vision of Britain* (1988) not led Venturi and Scott Brown to leave out or tone down many of the signature features of their style.[8] The free-standing Corinthian column they originally intended to stand in front of their entrance was removed, for example.The ribs suspended from the ceiling above the staircase are grey steel. A common motif in Venturi's designs, they usually appear in vibrant colours, rendered in plastic or even neon. Only the multicoloured Egyptian columns hidden on the southwest corner of the façade hint at what one might have expected.

The critics' frustration with their design may well have been a function of this: the design was insufficiently Venturian for them to attack it properly. Although, as the previous chapter showed, Wilkins faced much heavier criticism when his design was leaked to the press in 1833, he, too, was obliged to tone down his design. He was made to bow to Gibbs' St. Martin-in-the-Fields in the same way as Venturi did to him. 'We think of our building as separate from the Wilkins building,' the latter observed, 'but also inflecting towards it, almost as you bow towards somebody, it is acknowledging it and dependent on it.'[9] Both architects 'bowed' in full awareness of the other structure's weaknesses. Venturi borrowed Wilkins' columns, but, as we have seen, these were themselves borrowed from Henry Holland's Carlton House. Wilkins' long façade looked grand, but was only one room deep. It had a dome on the outside, but not on the inside – both deception. Seen in this way, Wilkins and Venturi fit together extremely well. In both cases the buildings can seem slightly insubstantial when contrasted with the important architectural debates that surrounded them,

Although the architects agreed to remove the free standing column intended for the **Sainsbury Wing exterior** (centre left), they successfully fought to keep a much wider pillar located inside the ground floor entrance – even though the Trustees pointed out that it blocked light and was structurally unnecessary. Appealing to posterity, one Trustee had a statement of his objections put into a time capsule and sealed in the pillar's foundations.

debates that cast long shadows over British architectural history.

With its grand staircase, enfilades, *pietra serena* columns and Mannerist conceits, Venturi and Scott Brown's building reflected a new approach to gallery decor that was also expressed in changes to the main building. There Hendy and Levey had endeavoured to subdivide large spaces and block off enfilade views in pursuit of the fleeting moment of carpeted, private intimacy with works of art. They had, admittedly, introduced a restaurant and shop. Installed at the top of Taylor's central hall, the latter seemed an unhappy, temporary guest. It was as if the marble and the moneychangers had been allowed to stay on sufferance – at least until such time as both could be swept

Venturi and Scott Brown's Wing is linked to William Wilkins' block by an underground tunnel as well as by this **bridge at gallery level**. When Wilkins' building was originally built it abutted directly onto a row of townhouses, with no west façade. At various points in time pastiche frontages have therefore been put up here.

out entirely. The Venturi building by contrast included a large shop and celebrated the public aspects of the building, seeking to elide the separation between 'inside' and 'outside' on the staircase and providing grand 'architectural' paths for visitors to follow and orientate themselves by.

Even before the Sainsbury Wing opened the relatively new Director, Neil MacGregor, had himself reoriented the hang according to a 'Wing System': instead of suites of rooms tracking a single School (French, Netherlandish, etc), paintings of different schools were hung in contiguous galleries arranged so as to group works of similar date together. Instead of the 'period' touches described in chapter six, a process was soon started by which many galleries had their wooden floors, generous doorways and high ceilings re-exposed. This was only possible

The Sainsbury Wing was part of a massive rehang of the collection along the so-called 'Wing System', by which the previous arrangement of separate suites for each school (Netherlandish, Italian, etc.) was replaced with a more chronological arrangement highlighting European exchange in different historical eras. Here Director **Neil MacGregor** (centre) discusses the Sainsbury Wing hang with (l to r) **Michael Wilson, Susan Foister, Nick Penny** and **Dillian Gordon.**

thanks to the Gallery taking over management of the building in 1988, when it 'untied' itself from the Property Services Agency, the branch of the Department of the Environment formerly charged with upkeep. Up until that point the PSA had sole responsibility for carrying out any work on the fabric or decor of the National Gallery, tying up even quite minor repairs in red tape.

The hessian wall coverings, fluorescent lights, wall panels, dais and suspended ceilings went, in a spirit of returning the galleries to their original splendour.[10] Although the return to opulence was otherwise in tune with Tim Clifford's much-discussed 'country-house' hangs at Manchester and Edinburgh, MacGregor pointedly excluded the sculpture which Levey had borrowed from the V&A and Burrell Collection. Private sponsorship played a key role, and can only have encouraged the enrichment process. Indeed, in some galleries gilding and marble were added where they had never been part of the original

The original decor of the **Northern Extension** featured carpeting and suspended laylight ceilings. The open plan suite was divided up by partitions without cornices or dados.

decorative scheme. In the case of the pastiche Victorian galleries created (with the help of sponsors like Yves Saint Laurent) in the renovated Northern Extension in the late 1990s, things may have got out of hand.

In the 1980s, however, the synergies of high art and consumerism seemed to be everywhere: Thatcherites like Luke Rittner at the Arts Council, Strong's cheekily commercial regime at the V&A and 'shopping-mall museums' by I. M. Pei and, indeed, Venturi himself. The 'heritage boom' led many cultural commentators to see amalgams of old and new as evidence of national decline. Britons were supposedly escaping into a theme-park England divorced from any reality, past or present.[11] The ambiguity of this state in turn encouraged museologists to follow the lead set by the *Ways of Seeing* series by John Berger discussed in chapter four. They plumbed new depths of cynical despair, refusing to believe that there was a typical audience which the museum could address, or that art

Little remained of Levey's decor after **the 1990s refurbishment**, sponsored by a number of private benefactors, as well as corporate sponsors such as Yves Saint Laurent. MacGregor retrofitted the Galleries to the point where they are difficult to distinguish from the 1913 Hawks rooms in the west wing. Polished hardwood floors and patterned silk replaced carpeting and hessian. High ceilings and marble door surrounds were also inserted. Only the paintings remain recognisably the same.

objects had anything meaningful to say.[12] There seemed no way forward or back.

Fortunately the new cohort of Trustees that arrived on the board in the late 1970s and early 1980s could see a way forward. Noel Annan, Jacob Rothschild and John Sainsbury were the most important in this regard. Academics, bankers and businessmen had long sat on the board, so on the surface the appointments were not surprising. What was new was the impression they all shared that the Gallery needed them to intervene, to spruce up the interiors and in particular to teach the institution new skills they felt it had to learn if it was to remain one of the world's leading museums. As we saw in chapters two and three, the fifty years from about 1890 to 1940 had seen Trustees such as Curzon and Duveen dominate the institution to an extent never seen before or since. Their influence had mainly been felt in the area of acquisitions, however, and the years after 1940 saw Clark and Hendy use a mixture of

charm and stiff-necked resistance to contain the Trustees. Under Levey it seemed that most business was settled by the Chairman and Director immediately before board meetings, leaving the rest of the Trustees with little input. With Annan's Chairmanship in 1978 that soon changed, and by 1982 friction between the board and staff had become particularly painful, with profound disagreements over voluntary charging and even the colour of the walls. Business methods were in the air, Annan wrote to the Director in May, 'we cannot ignore what is happening in the country at large.'[13]

It would be unhelpful and insensitive to go into such disputes in detail. What institution does not experience them? As Trustees Lords Rothschild and Sainsbury were more conspicuous by their extraordinary generosity. The £30m pound gift of Simon, John and Timothy Sainsbury announced in 1985 stands out here. In leading by example, they in turn were able to make a more compelling case for supporting the Gallery to non-Trustees. The Sainsburys' generosity was matched by the £50m endowment presented by John Paul Getty Jr. that same year. Coming in the year the government froze the Gallery's grant, this unprecedentedly large gift enabled the Gallery to make a number of important acquisitions, such as Caravaggio's *Boy Stung by a Serpent*. Such largesse brought the Director as close as the holder of that post is ever likely to get to matching the buying power enjoyed by Eastlake in the 1850s. Thanks to Sainsbury's expertise, the shop was turned from a loss-making venture into a significant revenue stream.

The fact that similar Trustee/staff friction was occurring at Tate and the Arts Council, however, suggests that something more significant than a clash of personalities was at work.[14] To some members of staff it seemed that the Trustees were, wittingly or unwittingly, acting in concert with a Thatcherite political agenda. While Trustees and staff had previously disagreed on occasions, they normally closed ranks when dealing with government. 'Tory drift,' as Levey described it, seemed to suggest a much more complex scenario, one that must have been genuinely unsettling to those familiar with the arm's length principle, which, for all its faults, at least protected

Opposite: John Paul Getty, Jr.'s 1985 gift of a £50m endowment enabled the Gallery to purchase this Caravaggio **Boy Bitten by a Lizard** (c. 1595-1600) the following year. Among the other works acquired through the endowment was Anthony van Dyck's *The Balbi Children* (c. 1625-7).

scholarship and technical aspects of gallery administration from outside influences.[15] There were several areas in which the synergies of Thatcherite arts policy and Trustee initiatives were close enough to make it difficult to see which impulse came first. In the case of the shop, for example, merchandizing only became a meaningful exercise when Thatcher agreed to let institutions keep the proceeds, rather than deducting profits from their annual grant.

Behind business sponsorship, more aggressive courting of private donors and merchandizing lay the realization that central government funding of the arts would at best remain level while salaries and service costs continued to rise. In 1981 Directors of the national museums were willing to acknowledge the need to attract sponsors: that year Levey secured a £1.5m donation from the Sunley Foundation to build temporary exhibition galleries in one of the Gallery's internal courtyards. But this if anything made them more keen to rally against cuts. The British Museum's David Wilson, for example, threatened to close galleries, suggesting that the government might be shamed into more generous funding.[16] Such a tactic lay behind Roy Strong's axing of the Circulation Department at the V&A. Yet the powers-that-be refused to blink. The arrival in 1983 at the Arts Council of Luke Rittner, founder of the Association for Business Sponsorship in the Arts, was ominous. By 1985 it was clear that, in the words of the Arts Minister Grey Gowrie, 'the limits of hospitality have been reached'.[17]

Thatcherite arts policy could be hard to predict, and occasionally counter-productive. The Arts Council's 1984 report, *The Glory of the Garden*, was the first of several successive attempts to package cuts as a regional arts renaissance, as a reaction against an elitist, London-centred culture.[18] While museums in Liverpool were the recipients of special urban regeneration funds that would create the National Museums and Galleries of Merseyside, down south Thatcher's abolition of the Greater London Council ended a series of successful arts initiatives organized by Tony Banks. Untying from the PSA in 1988 showed the Gallery's willingness to run the building on its

own. Yet instead of receiving encouragement the Gallery was penalized to the tune of many millions in the form of deferred maintenance liabilities for which they received no compensation. Within four years of receiving the power to allocate their government grant according to their own set of priorities the Gallery was asking to return to the old system. Here again 'empowerment' seemed to offer the government a way of evading a duty to increase grants in line with a rising art market, a duty which the old, ring-fenced purchase grant made difficult to dodge.[19]

Meanwhile that same year there were rumours that Thatcher was considering spending £100m bringing the Thyssen Collection to London, as if desperate to upstage Mitterand with her own *grand projet* the year before the bicentenary of 1789. Noting the contrast with cuts in museum funding, Levey wrote to *The Independent* that 'not even the yuppiest child would treat its old toys thus on catching sight of potential new ones in a shop window.'[20] The funding bonanza unleashed by the National Lottery established in 1993 led some museum insiders to question whether the government's commitment to the arts was deep enough to ensure that the support for routine costs would be there when the shine came off all the new buildings and other capital projects.

Even while government urged museums to look to private donors, they refused to reform the tax code to facilitate this, by broadening the range of taxes in lieu of which artworks could be accepted by the Treasury or, more importantly, introducing US-style tax relief. Enabling donors to offset the gross value of pre-eminent artworks donated to national collections against income before assessment for tax would represent a major step towards building a culture of philanthropy. It was one of several changes proposed by Sir Nicholas Goodison in his 2004 report for the Treasury.[21]

Although this book has consistently sought to avoid periodizing the Gallery's history according to the 'reigns' of its successive Directors, it would be impossible to explain developments over the past twenty years without addressing the persona of Neil MacGregor. 'Persona' because of the remarkable

444

success with which he managed to appear on millions of television screens while keeping the focus on the paintings rather than himself. He thus avoided the 'personality' status his predecessors had occasionally courted.[22] Much remained unspoken – his Christian faith in particular. For all his work popularizing the gallery, he never ceased to point out that 'looking is hard work'.[23] 'The dignity of the thing can be taken on by the looker,' he observed in a 1992 interview, 'people take themselves seriously when they look at something of supreme quality.'[24] This clearly echoes Charles Kingsley's 1848 account (quoted in chapter four) describing how the street 'ruffian' learns to value himself by looking at the Gallery's paintings.

MacGregor tapped into a broader reaction against the 1980s commodification of culture and heritage. The heritage boom had largely passed the Gallery by. If anything, the stress on the country house as a complete package (architecture plus contents) suggested that the last place paintings 'saved' from export belonged was in a centrally-located collection. The following decade saw a renewed focus on the emotional and spiritual consolations of art. Art was about authentic objects to be approached and communed with reverentially, rather than images to be replicated, broadcast and consumed in numerous playful yet ultimately 'valid' ways. Sister Wendy Beckett, who presented a 1991 television series devoted to Gallery paintings, played an important role here. The spiritual element she highlighted offered a contrast to Pamela Tudor-Craig's 1986 BBC series *The Secret Life of Paintings*, which shrouded a series of religious paintings from the Gallery's collection in special effects and 'misty worlds'.[25]

MacGregor's temporary exhibitions and the unprecedented success of *Seeing Salvation* in 2000 brought the Gallery's paintings to national prominence to a degree never seen before. 350,000-odd visitors saw the show during its three-month run For 84,000 of them this was the first time they had visited the Gallery.[26] Many more read the accompanying book or watched the television series. In stark contrast to the hand-wringing of the 'heritage boom,' there was no question here of identity, either national or class. It was the renaissance of a Kingsleyan

faith in the ability of great art to provide a place for all people to experience powerful representations of shared emotions. Although the type of visiting he most valued as Director consisted of repeated casual visits, alone or in the company of others, for the most part he was not following the trend towards museum visiting as a stroll past pretty pictures on the way from the shop to the 'ace caff' to which the museum happened to be attached.

He was equally out of tune with the late 1990s focus on museums as a means of combating 'social exclusion', a focus which saw the government department responsible for culture demand that museums achieve quotas for racial minorities.[27] As he noted in a 2004 interview:

Museums are still happy to talk about gender issues or race issues but what they are much less happy about is what it tells you about your own experience of jealousy or fulfillment or bereavement to look at great works of art and that ultimately is why the thing is there in the first place. I think we've got trapped in the second order questions.[28]

The success of his shows arguably helped government overlook the extent to which his way of seeing differed from theirs. Identified as 'Centres for Social Change' in a 2000 government report, museums were instructed to 'consult people at risk of social exclusion about their needs and aspirations,' the fostering of community identity in particular.[29]

MacGregor's 1996 show, *At Home with Constable's "Cornfield"* arguably did the same trick with museological expectations. The exhibition began with an advertisement placed in a South London newspaper that reproduced the painting and asked anyone who had the image in their home to write in to an address in Wimbledon. The plates, prints and wallpaper patterns quoting the painting that subsequently emerged from a range of private homes across London were then put on display, with the owners invited to comment on what the image meant to them individually. In a way this was a development of a point Berger had made in *Ways of Seeing*, when he had noted how paintings shown on television became

part of the viewer's sitting room. Such museologists, drawing on Walter Benjamin's famed 1936 essay on the mechanical reproduction of images, argued that such replication robbed the work of art of its original 'aura'. One might therefore have expected the *At Home* exhibition to highlight the commodification of the *Cornfield*, knowingly implying how ridiculous it was for the National Gallery to 'privilege' an 'original' work. MacGregor's message was the opposite: that the different meanings applied to the *Cornfield* by those who owned objects featuring it actually increased the value and significance of the original.

It is all the more striking to recall that when he was named as Levey's successor in 1986, MacGregor was viewed as an inexperienced outsider, an unhappy second-best to Edward Pillsbury, the monied Director of the Kimball Art Gallery who the Trustees had originally approached. At the last minute Pillsbury balked at the low salary and high bureaucracy, which required that the Director be a civil servant. Dismay had been expressed outside the Gallery at the prospect of an American leading the Gallery, a remarkably parochial response for the time. Although his position as editor of the *Burlington Magazine* had given him opportunities to comment on museum policy, at the time of his appointment MacGregor had never worked in a museum. To Denys Sutton (MacGregor's counterpart at *Apollo*), and indeed to the mainstream media it appeared that the board had deliberately chosen an outsider in order to give themselves more of a free hand. At a press conference Lord Rothschild explained that, given the growth of the Gallery's activities, the role of Director had changed into that of co-ordinator, with a lighter touch.[30] In fact MacGregor was closely involved in a wide range of initiatives, combining his work rearranging and proselytizing for the Gallery with the introduction of a new series of standardized wall labels, better framing and the publication of a new series of catalogues. Art historical scholarship was thus defended during a period when the rise of exhibition auteurs had suggested a crisis of confidence in curators as bearers of knowledge.[31]

MacGregor's return to what he perceived as the nineteenth-

In 2001 the government finally agreed to end **museum admission charges**. Although the Gallery's position on the issue had seemed less than clear when charges were introduced in the early 1970s, Neil MacGregor's Directorship saw the Gallery become a bastion of opposition to charging, as this poster of 1998 demonstrates.

century values underpinning the Gallery was also implicated in the next important development: the establishment of a firm position against admission charges. As we saw in chapter three, in 1971-4 neither the Director nor the majority of the Trustees felt the issue important enough to jeopardize government support required for special acquisition grants, extensions and other projects deemed to be of greater importance than access. Although the return of Labour in 1974 curtailed the Tories' first experiment with charges, there was little sense that the ideological war had been won. If the charging debate had been a Pyhrric victory for the Conservative government, it had also been their 'ideological resurrection,' as one MP had indeed noted at the time.[32] With the return of the Conservatives charging was again being considered by 1981, when the Commons Education, Science and Arts Committee discussed it. Within the Gallery Levey came under pressure from Noel Annan and other trustees to introduce voluntary charges the following year. A large tronc for voluntary donations was duly placed near the entrance, one which Levey clearly felt might prove a 'Trojan tronc' for involuntary charges.[33] As the Metropolitan Museum in New York demonstrated, there were ways of making 'voluntary' charges pay: by obliging all visitors to queue for a badge, for example, in front of a large board indicating the level of 'recommended donation' incurred by different types of visitor.

Thatcherite freezes in their grants forced many national museums to introduce charging in the mid-1980s. This was one of the savage ironies of a policy that trumpeted decentralization, empowerment and increased responsibility. The adoption of grants-in-aid (1986), untying from the PSA (1988), giving the Gallery greater control over its budget (1993) and further tweaks to accounting arrangements gave the National Gallery much more room to manoeuvre financially. Organizations like the Association for Business Sponsorship with the Arts (established 1976) offered new sources of income. In so far as frozen grants represented a cut in state aid in real terms, however, such freedom meant the right to choose between whether to introduce charges or cut services.

As the National Maritime, Natural History, Science, Imperial War and Victoria and Albert Museums each gave in to charging, Levey and MacGregor worked hard to avoid this choice. Capitalizing on his legal training, in 1989 MacGregor turned the witness chair at the Commons Arts committee's next, more serious discussion of charges into a bully-pulpit for free admission. The Director refused to accept the precedent of France, where museum charges were seen as *de rigueur*. 'The culture in France has traditionally been the province of the prince,' he observed. 'It is what the state does as part of its own promotion. In this country the pictures at the National Gallery belong to the people.'[34] The committee nonetheless recommended that all museums introduce compulsory charges. In 2001, four years after the arrival of New Labour, funds were promised to allow all national museums and galleries to offer free admission. A debate the Gallery initially seemed chary of entering has now been won.[35]

A final change has been the introduction of temporary exhibitions, artist residencies and other activities intended to invite dialogue between new and old masters. As we saw in chapter one, John Wilkes' 1777 speech in support of a gallery was partly based on the belief that such a collection was a prerequisite for the establishment of a British School of painting. As it happened, the leading artists of the Royal Academy initially opposed the establishment of a national gallery in the early nineteenth century precisely because they feared such a gallery might discourage patronage of living art. And yet the two managed (just) to cohabit in Wilkins' building for over thirty years, allowing easy comparison between art old and new. The two Artists' Days a week that remained in force from 1824 to 1939 showed the Gallery's commitment to special access for young artists. By 1900 this was a dead letter, however, and after such a long time in abeyance it was easy to see the revival of the Gallery's original role as an inspiration to native artists as something entirely fresh and new.

Levey started the trend with the first of a series of *Artist's Eye* shows in 1977, which gave one visiting artist a year the opportunity to curate a small exhibition of works chosen from

Previous pages:
When Neil MacGregor was appointed Director in 1987 the collection was still weak in nineteenth-century works, with the notable exception of the French masters, which Hendy had made his special focus. Caspar David Friedrich's **Winter Landscape** (c. 1811) was bought in 1987. MacGregor would later acquire works by other nineteenth-century German and Danish masters, including Max Liebermann, Ludwig Gaertner and Kristen Købke.

the permanent collection. Paintings by different masters from different periods were thus temporarily freed from the classificatory hang observed in the rest of the Gallery and reappraised in the context of the artist's own comments. In 1982 the first Artist-in-Residence, Jock McFadyen, was appointed and allocated a studio at the top of the Northern Extension to which the public were granted access on Fridays. For many visitors this would have been their first interaction with a living artist. Later artists included Paula Rego and Frank Auerbach, both of whom donated works that decorate the Gallery today. Particularly impressive was the show *Encounters*, put on in 2000, consisting of pairings of works by modern artists, each one shown next to the Gallery painting that had inspired it. Turner would have been pleased. As we saw in chapter five, when the artist left his paintings to the nation in 1857 his will stipulated that the Gallery stage a permanent encounter between two of his paintings and a pair of Claudes.

The thirty years from 1974 thus saw the Gallery embellish and expand its galleries, construct links with contemporary artists, establish a firm position on admission charges and reinvest visiting with the emotional charge it had lost sometime in the late nineteenth century. At the same time it managed to

Sponsored by American Express, the **Microgallery** opened on the Sainsbury Wing mezzanine level in 1991. It allowed visitors to use a series of interactive computer workstations to find out more about the collection, including those works not actually displayed in the Gallery. Here they could plan which particular works they wished to see or just rest their legs, printing out a personal itinerary or information sheets to take home.

Appointed Associate
Artist in 1990, Paula
Rego produced a series of
paintings entitled
Crivelli's Garden, which
were initially hung in
the Sainbury Wing cafe.
Rego relished the oppor-
tunity her residency gave
her to borrow ideas from
Mantegna, Jan Steen,
Hogarth and other
artists whose work hung
in the Gallery. 'I creep
upstairs and snatch at
things, and bring them
down with me to the
basement,' she noted,
'where I can munch
away at them.'

limit the impact of a 1980s consumerist heritage boom that threatened to turn museums like the V&A into brands – and which, thanks to 1990s 'Cool Britannia' and the persistent appeal of 'signature' museum structures, continues to throw into question the public trust invested in the Guggenheim and Tate franchises. Although the Gallery now put on regular temporary exhibitions, their programme resisted absorption into what Andrew McClellan has called 'the steady diet of Impressionism, mummies, and anything with "gold" in the title'.[36] By inviting in modern artists it provided its visitors with a window onto contemporary art.

But it wasn't a shop window. Unlike the Tate or Royal Academy, the Gallery did not give the impression of being the victim of manipulation by sponsors, collectors or the artists themselves. This is not to say that corporate sponsorship and merchandising did not lead the Gallery to produce innovative products and resources. Quite the reverse. Microsoft's *Art Gallery*, the website and the American Express-sponsored Microgallery (1991) placed the National Gallery ahead of its peers: the first national museum to package itself as a CD-ROM, the first (in 2001) to have its entire collection on the worldwide web, and the first to introduce interactive, on-site gallery guides.[37] But there were limits. The Gallery, unlike the Tate, did not create its own line of house paints available from B&Q.

In 2001 *New York Times* critic Michael Kimmelman wrote that 'Museums must re-assert their authority on what beauty really is, thereby reclaiming the idea of quality in art.'[38] As chapter four suggested, notions of authority and quality underwent severe questioning in the decades after World War II. In the 1980s and after government and museums themselves have found it much easier to support and justify great collections in terms of national heritage and social inclusion. Both may pay dividends in the short term, yet prove expensive in the long. A century on from the foundation of the NACF, there is evidence that the British public may be growing less responsive to rescue appeals. 'Because otherwise it will leave' may not be enough of a justification. As the Trustees observed in 1982, 'it is the duty of the Gallery to buy paintings which do

Opposite: George Stubbs' portrait of the 2nd Marquis of Rockingham's horse **Whistlejacket** (1762) was purchased in 1997 with the help of the Heritage Lottery Fund. It was sent on a tour of provincial galleries timed to coincide with nearby race meetings and was even projected nightly onto the Sainsbury Wing façade – until the police intervened.

not form part of the heritage'. Growing dependence on the National Heritage Fund (now the National Heritage Lottery Fund) was, they felt, restricting the pool of paintings they could realistically fight for.[39]

Even measured by their own criteria, a focus on inclusion has yet to produce much by way of results. New initiatives intended to widen participation in the arts, both geographically and in social terms have had little or no effect in changing the distribution of arts expenditure across the country or the class makeup of national museums' audiences. This may be because such outreach projects, whether state- or privately-supported, only enjoy short-term funding and are inevitably deemed successes, despite or because of the absence of the criteria needed to make such judgments. It may also reflect a fundamental failure to perceive the needs of the non-visitor. Perhaps because museum professionals themselves do not require such guidance, it is assumed that those they wish to address do not require them either, or find a clear narrative path 'patronizing'.

'We want the paintings to do the signing' MacGregor announced when unveiling the new British Rooms in 1994, which placed Stubbs' *Whistlejacket* at the end of a long vista through the building.[40] Yet, to translate 'leaping horse' into 'eighteenth-century British paintings over here' assumes a fluency in art history the 'excluded' do not possess. What surveys we possess indicate that they appreciate, rather than resent, a greater degree of support, and are confused by measures that suggest multiple routes without privileging a master narrative.[41] Although one detects hesitation at times, the Gallery has for the most part persisted in telling 'the history of western painting as the history of great artists,' and not allowed itself to become distracted by a 'social exclusion' agenda.[42] There is even evidence to suggest that the government may have realized that it is time, in one Culture Secretary's words, 'to stop apologizing for [culture] by speaking only of it in terms of other agendas'.[43]

For the historian of modern Britain, it is precisely this tendency to apologize that makes the Gallery's history so fascinating. For most of its history the Gallery has been fought

Opposite: As an art historian Sir Denis Mahon's work has helped rescue the Italian Seicento masters maligned by the later Victorian critics and their followers – especially Guercino. Mahon acquired his **Elijah fed by Ravens** (1620) from the Barberini family in 1936, and lent it to the Gallery in 1987. The generosity of Mahon's loan of his collection (27 works in all) reflects his many years of service to the Gallery, as a volunteer 'Attaché' in 1930s and later as a Trustee from 1957-64 and 1966-73.

With the **pedestrianisation** of the north side of Trafalgar Square the Gallery was more strongly integrated into this heart of national life. The construction of the wide range of steps in front of the Gallery created a more impressive approach, and indeed was redolent of Wilkins' original, unrealised design for the north side of the Square. Remodellings and redecorations inside the Gallery entrances reflected this new-found grandeur.

over by competing agendas: educational, social, artistic and political. Denied the cover afforded its peers by close royal or state supervision, its position at 'arm's length' kept it well within the reach of politicians, journalists, connoisseurs and normal citizens. To those on the inside, eager to preserve the discipline of art history, it could be easy to perceive this as 'meddling' by 'Philistines'. This book has tried to resist that tendency. The Gallery was, is and will remain more than an institution. It is an ongoing project that all these stakeholders have pursued, together.

Is it still helpful, or possible, to speak of it as a *national*

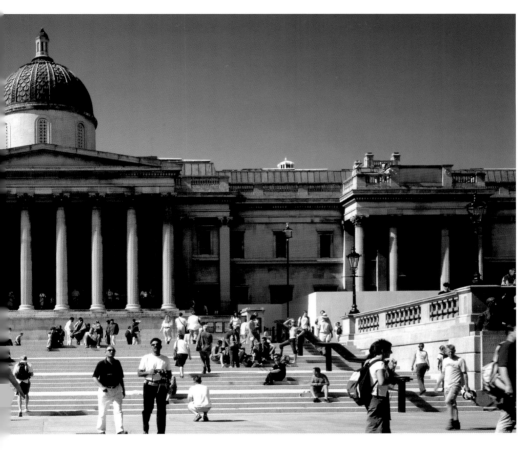

Gallery, however? A recent outbreak of citizenship classes notwithstanding, the Gallery's nation seems squeezed between devolution and a supra-national community, a vice called 'a Europe of the regions'. It is surely too soon to do anything more than raise this question here. Perhaps the last word should go to fifteen-year-old Jerome from Leytonstone, an enthusiastic participant in 'Painting the Line,' one of the Gallery's outreach programmes working with children in care. He suggested that the Gallery should swap its 'National' moniker for something simpler and more direct. His suggestion?

"They should call it 'Our Gallery'."

Directors and Trustees of the National Gallery

Directors

Up until 1855 the head of the Gallery held the title of Keeper. With the creation of the post of Director (on a renewable, five-year term), the title of Keeper devolved onto the second-in-command, who also served as Secretary to the Board. In 1916 the terms of the appointment were brought into line with Civil Service regulations. Directors were now appointed until the retirement age.

William Seguier (1772-1843), 1824-43
Sir Charles Lock Eastlake (1793-1865), 1843-7
Thomas Uwins RA (1782-1857), 1847-55
Sir Charles Lock Eastlake PRA, 1855-65
Sir William Boxall RA FRS (1800-79), 1866-74
Sir Frederick William Burton RHA FRSA (1816-1900),
 1874-94
Sir Edward John Poynter PRA, later 1st Bt (1836-1919),
 1894-1904

[Post vacant, January 1905-June 1906]

Sir Charles Holroyd (1861-1917), 1906-1916
Sir Charles John Holmes KCVO (1868-1936), 1916-28
Sir Augustus Moore Daniel (1866-1950), 1929-33
Sir Kenneth Mackenzie Clark KCB FBA CH OM, later Lord
 Clark (1903-83), 1934-45
Sir Philip Anstiss Hendy (1900-80), 1945-1967
Sir Martin Davies FBA CBE (1908-75), 1968-73
Sir Michael Vincent Levey (1927-), 1974-86
Robert Neil MacGregor (1946-), 1987-2002
Charles Saumarez Smith (1954-), 2002-

Thomas Lister, 4th Baron Ribblesdale of Gisburne Park was among those Trustees who supported a focus on big name masterpieces in the Edwardian period. He thus joined Alfred de Rothschild and Redesdale in opposing the acquisition of Masaccio's *Virgin and Child* in 1916, for example. He was, however, able to admit to Curzon that their printed 'memos make us – as a body – rather ridiculous.' He presented his portrait by John Singer Sargent (1902) to the Gallery in 1916 in memory of his two sons, who both died in the Great War.

Trustees 1824-1974

The National Gallery Board emerged from the British Museum Trustees' sub-committee of the Department of Paintings, Prints and Drawings. In 1828 the Prime Minister (Canning) appointed Peel and Agar Ellis to this 'Committee of Superintendence' – as neither was a British Museum Trustee, this represented in one sense the birth of the Gallery as an independent institution. Thereafter all Trustees were appointed by the Prime Minister, although they tended to call themselves 'Directors' until the reforms of the 1850s clarified their status as Trustees in the proper, legal sense of the term.

Until 1855 the President of the Royal Academy, the First Lord of the Treasury (Prime Minister) and Chancellor of the Exchequer were Trustees ex officio. In practice, however, this rule was only fitfully implemented. Charles Eastlake was the last PRA to be appointed Trustee ex officio (in 1850). Practising artists did not appear on the Board until 1948; since that time there has usually been one 'Artist Trustee'.

Trustees were appointed for life until 1916, and thereafter for renewable terms of seven years. The 1855 Treasury Minute decreed that the number of Trustees sitting on the board should be allowed to decline to six. This number was raised to eight in 1897, then ten in 1909. From 1955 the Tate Trustees have had the right to appoint an eleventh Trustee from among their number.

The office of Chairman was first proposed by Curzon in 1918, but only seems to have been implemented in 1922. Until that point meetings were chaired by the senior Trustee present.

* = Ex officio
† = Tate Representative
C = Chairman

George James Welbore Agar-Ellis, later 1ˢᵗ Baron Dover, 1827-33
Sir George Beaumont, 7ᵗʰ Bt, 1824-7
Roberts Banks Jenkinson*, 2ⁿᵈ Earl of Liverpool, 1824-8

Sir Thomas Lawrence* PRA, 1824-30
Charles Long FRS FSA, later Baron Farnborough, 1824-38
Frederick John Robinson*, later 1st Viscount Goderich and 1st
 Earl of Ripon, 1824-59
George Hamilton-Gordon, 4th Earl of Aberdeen, 1824-60
Sir Robert Peel, 2nd Bt., 1827-50
Charles, 2nd Earl Grey, 1831-45
Sir Martin Archer Shee PRA*, 1831-50
Nathaniel William Ridley-Colborne, later Baron Colborne of
 West Harling, 1831-54
Samuel Rogers, 1834-55
Henry Petty-Fitzmaurice PC, 3rd Marquess of Lansdowne,
 1834-63
William Wells, 1835-47
Alexander Baring, 1st Lord Ashburton of Ashburton, 1835-48
Sir Charles Bagot GCB, 1835-43
Francis Egerton DCL PC, 1st Earl of Ellesmere, 1835-57
Sir James Robert George Graham Bt, 1835-61
George Granville Leveson-Gower, 2nd Duke of Sutherland,
 1835-61
Thomas Spring Rice FRS FGS, later 1st Baron Monteagle of
 Brandon, 1835-66
Spencer Joshua Alwyne Compton PRS, 2nd Marquess of
 Northampton, 1839-51
William Bingham Baring, 2nd Lord Ashburton of Ashburton,
 1850-64
Sir Charles Lock Eastlake PRA*, 1850-5
William Russell, 1850-84
Thomas Baring, 1850-73
Samuel Jones Loyd, 1st Baron Overstone, 1850-71
Charles Compton, 3rd Marquess of Northampton, 1851-77
Sir Austen Henry Layard DCL PC, 1866-94
Sir William Henry Gregory, 1867-92
Walter Charles James, later 1st Baron Northbourne, 1871-93
Charles Stewart Hardinge, 2nd Viscount Hardinge of Lahore,
 1874-94
William Ward, 1st Earl of Dudley, 1877-82

George James Howard, 9th Earl of Carlisle, 1881-1911
William Graham, 1884-5
Sir Richard Wallace KCB, Bt., 1884-90
John Savile, 1st Baron Savile of Rufford PC GCB, 1890-96
Alfred de Rothschild, 1892-1918
John Postle Heseltine, 1893-1929
Henry Charles Keith Petty-Fitzmaurice KG, 5th Marquess of
　Lansdowne, 1894-1927 (C: 1922-3)
Sir Charles Tennant, 1st Bt, 1894-1906
Sir Henry Tate, 1st Bt, 1897-99
Sir John Murray Scott, 1st Bt, 1897-1912
Adelbert Wellington Brownlow Cust, 3rd Earl Brownlow,
　1897-1921
Robert George, Baron and Viscount Windsor, 1st Earl of
　Plymouth, 1900-23
Thomas David Gibson KCMG GCIE GCSI , 1st Baron Carmichael of
　Skirling, 1906-08, 1923-1926
Algernon Bertram Freeman-Mitford, 1st Baron Redesdale,
　1908-16
Thomas Lister, 4th Baron Ribblesdale, 1909-23
Sir Edgar Vincent , Viscount D'Abernon, 1909-35
George Nathaniel Curzon, 1st Marquess of Curzon of
　Kedlestone, 1911-25 (C: 1924)
Robert Henry Benson, 1912-29
Sir Robert Clermont Witt FSA CBE, 1916-23, 1923-31, 1933-40
　(C: 1930)
David Alexander Edward Lindsay, 27th Earl of Crawford and
　10th Earl of Balcarres GBE, 1918-25, 1925-32 (C: 1925-9)
Sir Philip Albert Gustave David Sassoon GBE CMG, 3rd Bt, 1921-
　28, 1929-36, 1936-9 (C: 1933-35)
Sir Herbert Cook FSA, 3rd Bt, 1923-30
Sir Augustus Moore Daniel KBE, 1925-29
Arthur Hamilton Lee GCB GBE, 1st Viscount Lee of Fareham,
　1926-33, 1941-47 (C: 1931-2)
William George Arthur Ormsby-Gore GCMG, 4th Baron Harlech,
　1927-34, 1936-41
James Ramsay MacDonald, 1928-35

Sir Joseph Joel Duveen, later Lord Duveen of Millbank, 1929-36

Stanley Baldwin, 1930-3

HRH Edward KG KT KP, Prince of Wales, 1930-6

Samuel Courtauld, 1931-8, 1939-46 (C: 1936-37, 1940-41)

Sir Evan Charteris KC, 1932-39

Sir Samuel Henry William Llewellyn GCVO PRA, 1933-40

Henry Harris, 1934-41

David Alexander Robert Lindsay GBE, Lord Balniel, later 28th Earl of Crawford & 11th Earl of Balcarres, 1935-41, 1945-52, 1953-60 (C: 1938-9, 1946-8)

Anthony Eden MC, Earl of Avon, 1935-42, 1942-9

Walter Horace Samuel MC, 2nd Viscount Bearsted, 1936-43, 1947-48 (C: 1942-3)

Paul Ayshford Methuen, 4th Baron Methuen, 1938-45

The Hon Sir Jasper Ridley KCVO OBE, 1939-46

William Allen Jowitt, later Baron, Viscount and Earl Jowitt, 1946-53

John Maynard Keynes CB, 1st Baron Keynes of Tilton, 1941-46

Viscount Massey PC, 1941-46 (C: 1943-46)

Sir Muirhead Bone, 1941-48

Capt Lord Sidney Charles Herbert CVO, later Earl of Pembroke & Montgomery, 1942-1949, 1953-60

Capt Edward George Spencer Churchill MC, 1943-50

Thomas Sherrer Ross Boase MC, 1946-53 (C: 1951-53)

Andrew Sydenham Farrar Gow FBA, 1947-54

Sir James Alan Barlow GCB KBE, 2nd Bt., 1948-55 (C: 1949-51)

Professor Sir William Menzies Coldstream CBE, 1948-55, 1956-63†

Sir Wallace Alan Akers FRS, 1949-54

Professor Alan Francis Clutton-Brock, 1949-56

Sir Williams Emrys Williams CBE, 1949-56

Lt Col Gerald Wellesley, 7th Duke of Wellington KG, 1950-57 (C: 1953-4)

Professor Lionel Charles Robbins, Baron Robbins CH CB FBA, 1952-59, 1960-7, 1967-74 (C: 1954-9, 1962-7)

Sir Richard Brinsley Ford, 1954-61

Brendan Rendall Bracken PC, Viscount Bracken of
 Christchurch, 1955-1958
Sir Thomas Ralph Merton DSc FRS, 1955-62
Sir John Clermont Witt FSA, 1955-62, 1965-72 (C: 1960-2,
 1967-72)
Henry Spencer Moore OM CH FBA, 1956-63†, 1964-71, 1971-
 1986
Sir John Denis Mahon CBE, FBA, 1957-64, 1966-73
Oliver Lyttelton, 1ˢᵗ Viscount Chandos of Aldershot, KG DSO MC,
 1958-65
Robert Arthur James Gascoyne-Cecil KG PC, 5ᵗʰ Marquess of
 Salisbury, 1959-66
Andrew Robert Buxton Cavendish Devonshire MC, 11ᵗʰ Duke of
 Devonshire, 1960-67
Robert Ivor Windsor Clive, 3ʳᵈ Earl of Plymouth, 1960-67
Sir Reginald Patrick Linstead CBE DSc FRS, 1962-66
Sir Karl T Parker CBE, 1962-69
Dame C. Veronica Wedgwood OM DBE, 1962-76
Sir Colin Anderson†, 1963-67
Sir William Johnston Keswick, 1964-71
Professor William Valentine Mayneord CBE FRS, 1966-71
Andrew Forge†, 1967-71
Sir Edward Wilder Playfair KCB, 1967-74 (C: 1972-74)
John Egerton Christmas Piper CH, 1967-74, 1975-
Mary Woodall CBE FSA, 1969-76
Stewart Carlton Mason CBE†, 1971-73
Gordon William Humphreys Richardson MBE, 1971-73
Sir Gordon Brims Black McIvor Sutherland FRS, 1971-78
Professor Martin Froy, 1972-79
Professor John Rigby Hale FBA FSA, 1973-80 (C: 1974-80)
Oliver Brian Sanderson Poole, 1ˢᵗ Baron Poole CBE TD, 1973-80
Professor Basil Selig Yamey CBE FBA, 1974-81
Howard Hodgkin, 1974-1980

Plans

The National Gallery has grown from Wilkin' shallow frontage onto what would become Trafalgar Square (essentially one room deep and masking the barracks and workhouse behind) to a rambling concatenation of rooms covering four times the area. It has now managed to take over almost all of the island site apart from the thin ribbon of the National Portrait Gallery, which is expertly turned around the north-eastern corner to give the impression of much greater size. The piecemeal addition of gallery space meant that after Wilkins there was no central architectural focus. The situation was exacerbated by the creation in the 1970s of the Northern Extension, but has to some extent been overcome in recent years by imposing a unity of decoration and circulation in the main section, while creating with the Sainsbury Wing an annexe with a highly distinct yet more overtly deferential identity.

1838

William Wilkins's Gallery (1834-8) was also the home of the Royal Academy. Two pedestrian passages ran under both wings, that in the west or Gallery wing led to the yard of St George's Barracks, that in the east, Academy wing to Castle Street. The ground floor of the west wing housed the Gallery Keeper until 1871. There were only five galleries, the semicircular room at the rear being used by the Academy for sculpture displays.

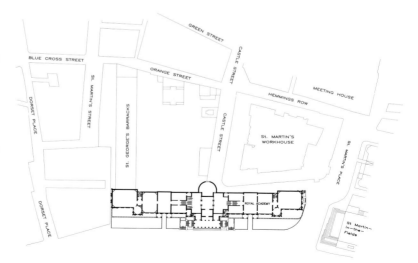

1861

James Pennethorne floored over Wilkins' central hall to create a new long gallery. To compensate for the loss of Wilkins' he created two new, somewhat cramped stairs, one for the Gallery and one for the Academy. Eight years later the Academy finally left for Burlington House.

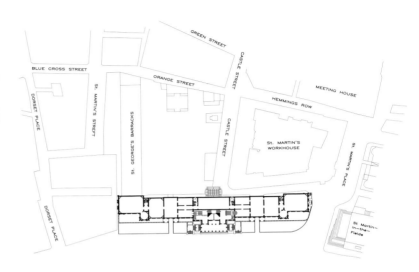

1876

The removal of the Workhouse allowed the construction of E. M. Barry's suite (1868-76), seven galleries grouped around a richly-decorated dome. Barry's suite had no visible exterior elevations, though he did include a tall Italianate campanile as part of his ventilation system.

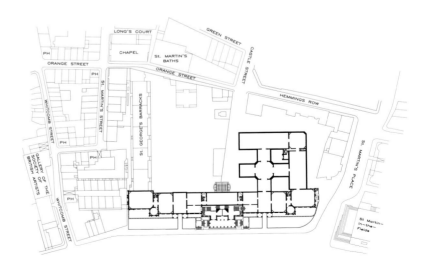

1887

John Taylor's additions
(1884-7) improved circula-
tion around the Barry Rooms
and provided a central spine
of three new galleries, partly
built on pillars so as not to
incommode the soldiers
drilling below. This com-
pensated somewhat for the
creation of a Central Hall,
which replaced Penne-
thorne's long gallery of 1860.
J. D. Crace's ornate decora-
tions were completed in 1889

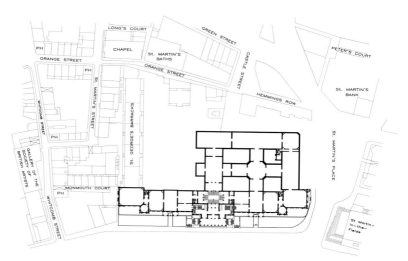

1913

The removal of the barracks
in 1901 allowed Henry
Hawks to design a suite of
five galleries in the west wing
(1909-11). Hawks also
removed the stairs introduced
by Pennethorne in 1860, and
installed the first public lava-
tories. In the meantime Ewan
Christian's National Portrait
Gallery (1891-5) had gone up,
masking Barry's east eleva-
tion with a Wilkins pastiche.
To the west of Wilkins' build-
ing a firebreak was created –
the Gallery had opposed
plans to run a street here.

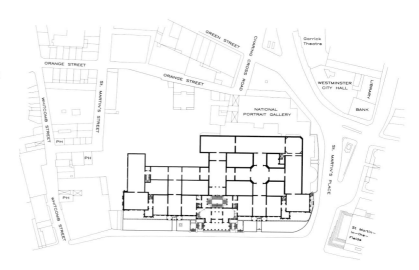

1938

Private benefactions enabled the addition of the Mond (1928) and Duveen (1930) Rooms. The latter included projecting bays, and was later linked to the Hawks Galleries by the construction of a third new gallery. Hampton's Furniture Stores to the west gave its name to the site later occupied by the Sainsbury Wing.

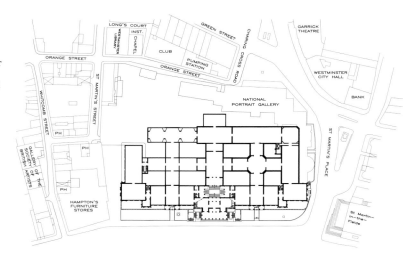

1955

Bombs destroyed one of the Hawks Galleries. The installation of air conditioning in the east wing was seen as more important than reconstruction.

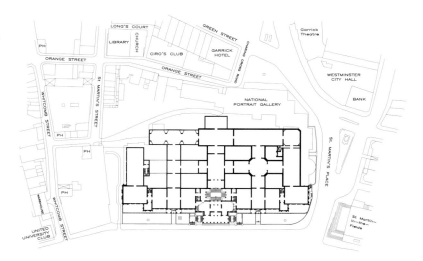

pre-1975

Hendy had projecting bays or partitions added to five galleries, seeking to break up larger spaces. Circulation through the Mond Room was improved by replacing the original single, central doorway with two lower ones.

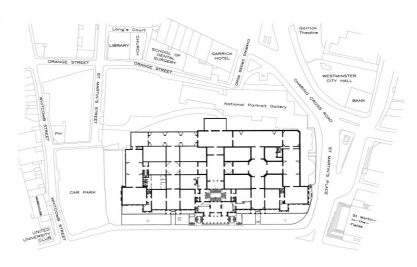

1975

Based on a design by William Kendall, the Northern Extension provided a new entrance on to Orange Street for school parties, as well as conservation studios. The eleven main galleries were a marked contrast to the rest of the Gallery, despite continuing efforts to block off sightlines with more partitions and now daises (not shown). Three galleries finally linked the Duveen and Hawks suite, with a pastiche Wilkins' façade looking out on to St Martin's Place.

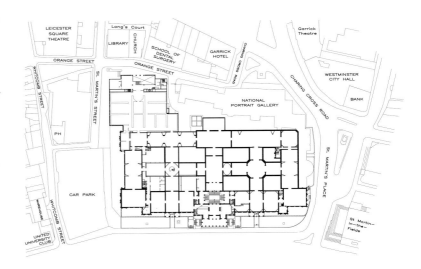

1991

Venturi and Scott Brown's Sainsbury Wing opened in 1991 on the Hampton Site, which had been used as a car park. It added sixteen rooms on gallery level, linked to Hawks' west gallery by a bridge. The Sunley Room had earlier been built in one of the internal courts. For the most part, however, these have been filled in for use as storage and other facilities not open to the public.

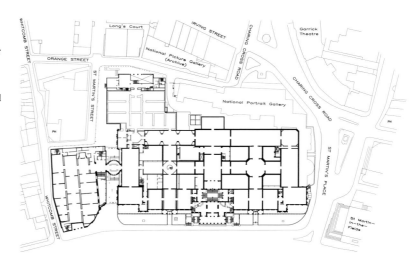

1997

Apparently minor changes in fact transformed some major areas of the Gallery. Most notable was the reorganization of the rooms in the Northern Extension, where the narrow corridors and pinch points had proved extremely uncomfortable for displaying and enjoying paintings. The distracting circular staircase that occupied the western octagon was relocated to a passageway next to the main hall.

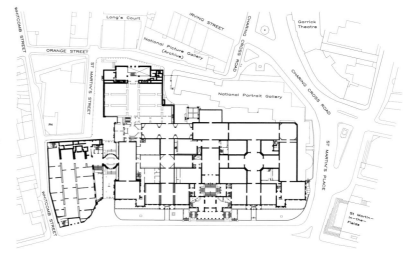

Table 1. Visitor numbers

Note the sudden increases on the opening of Wilkins' new Gallery in 1838. The one million mark was first reached during the Great Exhibition of 1851. Thereafter it was only surpassed once (1877, after the Barry Rooms opened) before 1949. The healthy upward trend that started with Victoria's reign appears to have peaked around 1880 and then gone into decline, matching that broader loss of faith in the Gallery's social mission discussed in chapter four. The picture is even starker in the inset table, of visitor numbers as a percentage of the population of London. Subsequent twentieth-century rallies were successively quashed by wars and the Crash. Only in the 1950s did attendances begin a second sustained upward trend, which started from a floor that tallies neatly with the level reached at the peak of the Victorian period. Since 1974 this upward trend has continued, recently breaking the 5 million mark (and 70% of the population of London). Under Director Charles Saumarez-Smith the Gallery became the UK's most popular visitor attraction
Source: Parliamentary Papers, Annual Reports. Figures for 1857-9 and 1940-6 are unavailable.

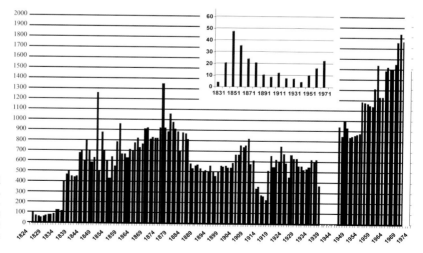

Visitors to the National Gallery (in thousands), 1826-1974. Inset: visitor numbers as a percentage of the population of London

Table 2. Most Frequently Copied Paintings, 1865-1890

	'Foreign and Old Masters'	'Modern Masters'
1865	Van Dyck, *Cornelis van der Geest* del Sarto, *Portrait of a Young Man* Sassoferrato, *The Virgin in Prayer* Raphael, *Madonna and Child with Infant Baptist* [Follower of] Greuze, *Portrait of a Girl*	Reynolds, *The Age of Innocence* Turner, *The Fighting Téméraire* William Collins, *Happy as a King* Reynolds, *The Infant Samuel* Josephus Dyckmans, *The Blind Beggar,*
1870	Van Dyck, *Cornelis van der Geest* Rembrandt, *Portrait of Aechje Claesdr.* Rembrandt, *Self-portrait at the age of 34* Velázquez, *Philip IV* Guido Reni, *Ecce Homo*	Turner, *The Fighting Téméraire* Thomas Uwins (Keeper), *Chapeau de Brigand* C. M. Dubufe, *The Surprise* John Frederick Herring, *The Frugal Meal* Reynolds, *The Age of Innocence*
1880	[Follower of] Greuze, *Portrait of a Girl* Murillo, *Peasant Boy* Velázquez, *Philip IV* Greuze, *A child with an apple* Greuze, *Portrait of a Girl*	Landseer, *The Cavalier's Pets* Romney, *The Parson's Daughter* Reynolds, *Angels* Reynolds, *The Age of Innocence* Romney, *Lady Hamilton as a figure in 'Fortune Telling'*
1890	Van de Velde, *Calm: Two Dutch Vessels* Greuze, *A child with an apple* Greuze, *Portrait of a Girl* Van Dyck, *Cornelis van der Geest* Frans Hals, *Portrait of A Man in his thirties*	Landseer, *Dignity and Impudence* Romney, *The Parson's Daughter* Turner, *The Fighting Téméraire* Romney, *Lady Hamilton as a figure in 'Fortune Telling'* Constable, *Gillingham Bridge, Dorset*

Source: Parl. Papers 1866, 27; 1871, 24; 1881, 37; 1890-1, 32.

Sources and Select Bibliography

I. Sources

a. Archives

In the National Gallery Archives
 Boxall Papers
 Burton/Gregory Correspondence
 Davies Papers
 Eastlake Notebooks and Correspondence
 Hendy Papers
 History Files
 Isherwood Kay Papers
 Subject Files
 Trustee Files
 R. N. Wornum Papers
In the Public Record Office
 Department of the Environment
 Office of Works
 Prime Minister's Office
 Treasury
In other repositories (in London, unless otherwise stated)
 Aberdeen Papers (British Library)
 Agar Ellis Papers (Northamptonshire CRO)
 Annan Papers (King's College, Cambridge)
 Ashburton Papers (National Library of Scotland)
 Barings Papers (ING Barings, Plc)
 Beaumont (Coleorton) Papers (Pierpont Morgan Library, New York)
 Bedford (8th Duke) Papers (Woburn Abbey, uncatalogued)
 T. S. R. Boase Papers (Magdalen College, Oxford)
 British Institution Archive (National Art Library)
 British Museum Archive
 Brougham Papers (University College, London)
 R. A. B. Butler (Courtauld) Papers (Trinity College, Cambridge)
 Kenneth Clark Papers (Tate)
 Cockerell Papers (RIBA)
 Henry Cole Papers (National Art Library)

W. G. Constable Papers (St. John's College, Cambridge)
Conway Papers (University Library, Cambridge)
Crawford Papers (Balcarres and the National Library of Scotland)
Curzon Papers (British Library, Oriental and India Office Library)
D'Abernon Papers (British Library)
Augustus Daniel Diaries (in Crawford Papers, National Library of Scotland, 97/42-43)
Dennistoun Papers (National Library of Scotland)
Disraeli Papers (Bodleian Library, Oxford)
William Dyce Papers (Aberdeen City Art Gallery)
Edward Edwards Papers (Manchester Central Library)
Elcho Papers (Gosford)
Ellesmere Papers (Northamptonshire CRO)
Getty Research Institute, Provenance Index and Collectors Files (Los Angeles)
Gladstone Papers (British Library and Flintshire CRO)
Graham Papers (British Library)
Gulbenkian Papers (Gulbenkian Foundation, Lisbon)
Harcourt Papers (Bodleian Library, Oxford)
Holmes Diaries (National Portrait Gallery)
Howard (9th Earl of Carlisle) Papers (Castle Howard)
Keynes Papers (King's College, Cambridge)
Lansdowne Papers (British Library, uncatalogued)
Lawrence Papers (Royal Academy)
Layard Papers (British Library)
Lee of Fareham Papers (Courtauld Institute)
MacColl Papers (Glasgow University)
Mass Observation Archive (University of Sussex)
Monkton Milnes (Houghton) Papers (Triniy College, Cambridge)
Monteagle Papers (National Library of Ireland, Dublin)
Otto Mündler Notebooks (Zentralarchiv der SMPK, Berlin)
Mure of Caldwell Papers (National Library of Scotland)
National Art Collections Fund Archive (Tate)
National Gallery of Ireland Archives (Dublin)
Overstone Papers (University of London)
Peel Papers (British Library and Fitzwilliam Museum, Cambridge)
Pennethorne Papers (RIBA)
Redesdale Papers (Gloucestershire CRO)
Ridley Papers (Northumberland CRO)
Ripon Papers (British Library)
David Roberts Papers (National Library of Scotland)
Samuel Rogers Papers (University College, London)
Rosebery Papers (National Library of Scotland)
Rothschild Archive

Royal Academy Archive
Royal Institute of British Architects Drawings Collection (National Art
 Library)
Royal Commission for the 1851 Exhibition Archive
Royal Society of Arts Archive
Russell Papers (Public Record Office)
Society for the Diffusion of Useful Knowledge Archive (University College)
Sutherland Papers (National Library of Scotland)
Tennant of the Glen Papers (National Archives of Scotland)
Robert Vernon (Jenkyns) Papers (Balliol College, Oxford)
Wallace Collection Archive

b. Official Papers (in chronological order)

Hansard
National Gallery Annual Reports

Report and minutes of the select committee on the Elgin Marbles (Parl. Papers,
 1816, 3)
*Report and minutes of the select committee on the Office of Works and Public
 Buildings* (Parl. Papers, 1828, 4)
Report and minutes of the select committee on the observance of the Sabbath day
 (Parl. Papers, 1831-2, 7)
Report and minutes of the select committee on public walks (Parl.Papers, 1833,11)
Report and minutes of the select committee on drunkenness (Parl. Papers, 1834, 8)
Report and minutes of the select committee on arts and manufactures (Parl.
 Papers, 1836, 9)
Report of the select committee on the British Museum (Parl. Papers, 1836, 10)
Report and minutes of the select committee on Trafalgar Square (Parl. Papers,
 1840, 12)
Report and minutes of the select committee on national monuments (Parl.
 Papers, 1841, 6)
Report and minutes of the select committee on the promotion of fine arts (Parl.
 Papers, 1841, 16)
Second report of the fine arts commission (Parl. Papers, 1843, 29)
Report and minutes of the select committee on art unions (Parl. Papers, 1845, 7)
Report and minutes of the select committee on works of art (Parl. Papers, 1847-
 8, 16)
Report and minutes of the select committee on the School of Design (Parl.
 Papers, 1849, 18)
*Report and minutes of the select committee on the accommodation of the
 National Gallery* (Parl. Papers, 1850, 15)
Report of the royal commission on the British Museum (Parl. Papers, 1850, 24)

Report of commissioners [for] the site for a new National Gallery (Parl. Papers, 1851, 22)

Report and minutes of the select committee on the management of the National Gallery (Parl. Papers, 1852-3, 35)

Report and minutes of the royal commission on the site of the National Gallery (Parl. Papers, 1857, 24)

Report and minutes of the select committee on public institutions (Parl. Papers, 1860, 16)

Explosions (London, Trafalgar Square, and etc.) (1884, Cmnd. 3972 and 4077)

Report of the committee of the Trustees of the National Gallery [on] the retention of important pictures ('Curzon Committee', 1914-6, 29)

Interim and final reports and minutes of the royal commission on national museums and galleries ('D'Abernon Commission', 1928-9, 8; 1929-30, 16)

Report of a committee [on] the export of works of art ('Waverley Committee', 1942)

Report of a committee [on] the functions of the National Gallery ('Massey Committee', 1945-6, 13)

Enquiry into security at the National Gallery (Parl. Papers, 1961-2, 18)

A Policy for the Arts: the first steps (1964, Cmnd. 2601).

Future policy for museums and galleries (1971, Cmnd. 4676)

c. Pamphlets and Essays

Anon., *A letter to the members of the Society for the Encouragement of Arts...* (London, 1761)

Anon., *Consideration respecting the pictures in the National Gallery* (London, 1850)

Anon., *Observations on the interest of the fine arts in Great Britain* (London, 1823)

Beresford Hope, Alex James, *Public offices and metropolitan improvements* (3rd ed., London, 1857)

Boydell, Josiah, *Suggestions towards forming a plan for the encouragement, improvement, and benefit, of the arts and manufactures in this country* (London, 1802)

Carey, William, *The national obstacle to the national public style considered* (London, 1825)

Coningham, William, *The picture cleaning in the National Gallery* (London, 1847)

Coningham, William, *Strictures on the minutes of the Trustees of the National Gallery* (London, 1847)

Coningham, William, *The National Gallery in 1856* (London, 1859)

Davis, J. P., *The Royal Academy, and the National Gallery.* (London, 1858)

Dennistoun, James, 'The National Gallery', *Edinburgh Review* 97 (April 1853)

Desenfans, Noel, *A Plan... to preserve... the portraits of the most distinguished characters of England, Scotland and Wales* (London, 1799)

Dyce, William, *The National Gallery, its formation and management* (London, 1853)

Eastlake, Charles Lock, *The National Gallery* (London, 1845)

Eastlake, Charles Lock, *Contributions to the literature of the fine arts* (London, 1848 and 1870)

Edwards, Edward, *The fine arts in England* (London, 1840)

Fergusson, James, *Observations on the British Museum, National Gallery and National Record Office* (London, 1849)

French, George Russell, *The Palace, the National Gallery, and the Royal Academy* (London, 1846)

Gwilt, John Sebastian and Joseph, *Project for a National Gallery* (London, 1838)

Haydon, Benjamin Robert, *Some enquiry into the causes which have obstructed the advance of historical painting for the last seventy years in England* (London, 1829)

Hoare, Prince, *An inquiry into the requisite cultivation and present state of the arts of design in England* (London, 1806)

Hoare, Prince, *Epochs of the Arts* (London, 1813)

Layard, Austen Henry, *Suggestions for a new National Gallery* (London, 1867)

Long, Charles, *A letter to the Right Hon. Sir Charles Long* (London, 1825)

Long, Charles, *Short remarks, and suggestions, upon improvements now carrying on or under consideration* (London, 1826)

MacColl, Dugald S., 'The National Gallery: its problems, resources and administration', *The nineteenth century* 71 (1912)

National Gallery Reform Association, *Protest and counter-statement* (1855)

National Gallery Reform Association, *The National Gallery, no. II* (1856)

Purser, Charles, *The prospects of the nation in regard to its National Gallery* (London, 1833)

Pye, John, *Patronage of British art* (London, 1845)

Rawdon, William, *A letter to the trustees of the National Gallery* (London, 1851)

Robinson, J. C., *The National Gallery considered in reference to other public collections* (London, 1867)

[Ruskin, John], *The National Gallery. Two letters to the Editor of* The Times (London, 1852)

Shee, Martin Archer, *A letter to Joseph Hume, MP* (London, 1838)

Street, George Edmund, *Some remarks in explanation of his designs* (London, 1867).

Wilkins, William, *A letter to Lord Viscount Goderich* (London, 1832)

Yapp, G. W., *Art-education... [and] the National Gallery...* (2nd ed., London, 1853)

II. Select Bibliography

Allen, Brian (ed.), *Towards a modern art world* (New Haven, 1995)

Altick, Richard, *The shows of London* (London, 1978)

Amery, Colin, *The National Gallery Sainsbury Wing: a celebration of art and architecture* (London, 1991)

Ames, Winslow, *Prince Albert and Victorian taste* (London, 1967)

Anderson, Benedict, *Imagined communities: reflections on the origin and spread of nationalism* (London, 1983).

Anderson, Patricia, *The printed image and the transformation of popular culture* (Oxford, 1991)

Annan, Noel, *Our age* (London, 1990)

Armstrong, Walter, *The Peel collection and Dutch school of painting* (London, 1904)

Auerbach, Jeffrey A., *The Great Exhibition of 1851. A nation on display* (New Haven, 1999)

Bailey, Peter, *Leisure and class in Victorian England* (London, 1978)

Barlow, Paul and Colin Trodd (eds.), *Governing cultures: art institutions in Victorian London* (Aldershot, 2000)

Barrell, John, *The political theory of painting from Reynolds to Hazlitt* (London, 1986)

Barrell, John (ed.), *Painting and the politics of culture* (Oxford, 1992)

Bell, Alan, 'Colvin vs. Poynter: the directorship of the National Gallery, 1892-4', *Connoisseur* (Dec. 1975), 278-83

Bennett, Tony, *The birth of the museum. History, theory, politics* (London, 1995)

Berenson, Bernard, *Aesthetics and history* (London, 1948)

Berger, John, *Ways of seeing* (London, 1977)

Blanning, T. C. W., *The culture of power and the power of culture* (Oxford, 2002)

Bodkin, Thomas, *Hugh Lane and his pictures* (London, 1956)

Bonython, Elizabeth and Anthony Burton, *The great exhibitor: the life and work of Henry Cole* (London, 2003)

Boothroyd-Brooks, Hero, 'Practical developments in English easel-painting conservation, c. 1824-1968, from written sources' (University of London/Courtauld Institute of Art doctoral thesis, 1999)

Borland, Maureen, *D. S. MacColl: painter, poet, art critic* (Harpenden, 1995)

Bourdieu, Pierre, *Distinction. A social critique of the judgment of taste* (trans. Richard Nice, Cambridge, MA, 1984)

Bourdieu, Pierre and Alain Darbel, *The love of art: European art museums and their public* (trans. Nick Merriman, Oxford, 1991).

Braham, Allan, *The working of the National Gallery* (London, 1974)

Braham, Allan, 'Towards a National Gallery', NACF *Review* 86 (1989), 78-92

Brawne, Michael, *The new museum: architecture and display* (London, 1965).

Brigstocke, Hugh, *William Buchanan and the nineteenth-century art trade* (London, 1982)

Brockwell, M, W,, *The National Gallery Lewis Bequest* (London, 1909)

Brown, David Blayney and Felicity Owen, *A collector of genius: a life of Sir George Beaumont* (London, 1988)

Brown, David Blayney, Felicity Owen and John Leighton, *'Noble and patriotic' the Beaumont Gift 1828* (London, 1988)

Buchanan, Brian, Graham Hulme and Kenneth Powell, *The National Portrait Gallery: an architectural history* (London, 2000)

Burton, Anthony, *Vision and accident: the story of the Victorian and Albert Museum* (London, 2000)

Cannadine, David, *The decline and fall of the British aristocracy* (London, 1990)

Casteras, Susan P. and Colleen Denney (eds.), *The Grosvenor Gallery. A palace of art in Victorian England* (New Haven, 1996)

Caygill, Joanna, *The story of the British Museum* (London, 1981)

Chancellor, Valerie, *The political life of Joseph Hume 1777-1855* (London, 1986)

Clark, Alan (ed.), *'A good innings': The papers of Viscount Lee of Fareham* (London, 1974)

Clark, Kenneth, *Another part of the wood* (London, 1974)

Clark, Kenneth, *The other half* (London, 1977)

Cole, Alan S., *Henry Cole: fifty years of public work* (2 vols., London, 1884)

Collini, Stefan (ed.), *English pasts: essays in history and culture* (Oxford, 1999)

Collini, Stefan, *Absent minds. Intellectuals in Britain* (Oxford, 2006)

Colls, Robert, *Identity of England* (Oxford, 2002)

Colvin, Howard (ed.), *The history of the King's Works* (5 vols., London, 1976)

Conlin, Jonathan, 'A new perspective on John Wilkes', *Huntington Library Quarterly* 36.4 (2001)

Conlin, Jonathan, 'The origins and history of the National Gallery, c.1753-1860', (Cambridge University doctoral thesis, 2002)

Conlin, Jonathan, 'At the expense of the public: the 1762 Signpainters' Exhibition and the public sphere', *Eighteenth-century Studies* 36.1 (2002)

Conlin, Jonathan, 'Gladstone and Christian Art, 1832-54', *Historical Journal* 46.2 (2003)

Conlin, Jonathan, 'Butlers and boardrooms: Alfred de Rothschild as collector and connoisseur', *Rothschild Archive Annual Review* (2006)

Conn, Stephen, *Museums and American intellectual life, 1876-1926* (Chicago, 1998)

Courtauld, Samuel, *Ideals and industry* (Cambridge, 1949)

Cunningham, Hugh, *Leisure in the industrial revolution c. 1780-1880* (London, 1980)

Cuno, James (ed.), *Whose muse? Art museums and the public trust* (Princeton, 2004)

Daunton, Martin, *Trusting Leviathan: the politics of taxation in Britain, 1799-1914* (Cambridge, 2001)

Daunton, Martin, *Just taxes: the politics of taxation in Britain, 1914-1979* (Cambridge, 2002)

Desmond, Adrian, *The politics of evolution* (Chicago, 1989)

Duncan, Carol and Alan Wallach, 'The universal survey museum', *Art History*, 3.4 (1980), 448-69

Duncan, Carol, *Civilizing rituals: inside public art museums* (London, 1995)

Elias, Norbert, *The civilising process* (trans. Edmund Jephcott, Oxford, 1994)

Fenton, James, *School of genius: a history of the Royal Academy* (London, 2006)

Foucault, Michel, *Discipline and punish* (trans. Alan Sheridan, London, 1977)

Foucault, Michel, 'Of other spaces', *Diacritics* 16.1 (1986), 22-27.

Fowler, Rowena, 'Why did Suffragettes attack works of art?', *Journal of Women's History* 2.3 (1991), 109-25

Fox, Celina (ed.), *London – world city, 1800-1840* (New Haven, 1992)

Fry, Roger, *Last lectures* (Cambridge, 1939)

Fyfe, Gordon, *Art, power and modernity: English art institutions, 1750-1950* (London, 2000)

Garnett, Oliver, 'The letters and collection of William Graham', *Walpole Society* 62 (2000), 145-57

Geddes Poole, Andrea, 'Conspicuous presumption: the Treasury and the Trustees of the National Gallery, 1890-1939', *Twentieth Century British History* 16.1 (2005), 1-28

Gilmour, David, *Curzon* (London, 1994)

Golby, J. M. and A. W. Purdue, *The civilisation of the crowd* (London, 1984)

Goldgar, Anne, 'The British Museum and the virtual representation of culture in the eighteenth century', *Albion* 32.2 (2000), 195-231

Goldman, Lawrence, *Science, reform and politics in Victorian Britain: the Social Science Association, 1857-1886* (Cambridge, 2002)

Gould, Cecil, *Trophy of conquest: the Musée Napoleon and the creation of the Louvre* (London, 1965)

Gould, Cecil, *Failure and success: 150 years of the National Gallery* (London, 1974)

Green, Christopher, *Art made modern: Roger Fry's vision of art* (London, 1999)

Green, Jonathan, *All dressed up: the sixties and the counter-culture* (London, 1998)

Habermas, Jürgen, *The structural transformation of the public sphere* (trans. Thomas Burger, London, 1989)

Harrison, Brian, 'Religion and recreation in nineteenth-century England', *Past & Present* 38 (1967), 98-125

Harrison, Brian, *Drink and the Victorians* (London, 1971)

Haskell, Francis, *Rediscoveries in art: some aspects of taste and collection in France and Britain 1750-1900* (London, 1976)

Haskell, Francis, *Past and present in art and taste: selected essays* (New Haven, 1987)

Haskell, Francis, 'William Coningham and his collection', *Burlington Magazine* (Oct. 1991), 676-81

Haskell, Francis, *The ephemeral museum. Old master paintings and the rise of the art exhibition* (New Haven, 2000)

Haydon, Benjamin Robert, *The diary of Benjamin Robert Haydon* (ed. Willard Bissell Pope, 5 vols., Cambridge, MA, 1960)

Heleniak, Kathryn Moore, 'Victorian collections and British nationalism: Vernon, Sheepshanks and the National Gallery of British Art', *Journal of the History of Collections* 12.1 (2000), 91-107

Hemingway, Andrew and William Vaughan, *Art in bourgeois society, 1790-1850* (Cambridge, 1998)

Herring, Sarah, 'The National Gallery and the collecting of Barbizon paintings in the early twentieth century', *Journal of the History of Collections* 13.1 (2001), 77-89

Hewison, Robert, *Culture and consensus. England, art and politics since 1940* (London, 1995)

Hilton, Boyd, *The age of atonement. The influence of evangelicalism on social and economic thought, 1795-1865* (Oxford, 1988)

Hollis, Patricia, *Jennie Lee. A life* (Oxford, 1997)

Holmes, Charles and C. H. Collins Baker, *The making of the National Gallery* (London, 1924)

Holmes, Charles, *Self and partners (mostly self)* (New York, 1936)

Hoock, Holger, 'Old masters and the English school. The Royal Academy of Arts and the notion of a national gallery at the turn of the nineteenth century', *Journal of the History of Collections* 16.1 (2004), 1-18

Hoock, Holger, *The King's artists: the Royal Academy of Arts and the politics of British culture, 1760-1840* (Oxford, 2003)

Hooper-Greenhill, Eilean, *Museums and the shaping of knowledge* (London, 1992)

House, John, *Impressionism for England: Samuel Courtauld as patron and collector* (London, 1994)

Jones, Arthur, *Britain's heritage. The creation of the National Heritage Memorial Fund* (London, 1985)

Kehoe, Elisabeth Sara, 'The British Museum: the cultural politics of a national institution, 1906-39' (University of London doctoral thesis, 2001)

Kelly, Anne, 'The Lane Bequest', *Journal of the History of Collections* 16.1 (2004), 90-110

King, Lyndel Saunders, *The industrialization of taste. Victorian England and the Art Union of London* (Ann Arbor, 1985)

Klonk, Charlotte, 'Mounting vision: Charles Eastlake and the National Gallery of London', *Art Bulletin* 82.2 (2000), 331-347

Korn, Madeleine, 'Collecting paintings by Matisse and Picasso in Britain before the Second World War', *Journal of the History of Collections*, 16.1 (2004), 111-129

Korn, Madeleine, 'Exhibitions of modern French art and their influence on collectors in Britain, 1870-1918: the Davies Sisters in context', *Journal of the History of Collections*, 16.2 (2004), 191-218

Kultermann, Udo, *Geschichte der Kunstgeschichte: der Weg einer Wissenschaft* (Vienna, 1966)

Lago, Mary, *Christiana Herringham and the Edwardian art scene* (London, 1996)

Le Mahieu, D. L., *A culture for democracy: mass communication and the cultivated mind in Britain between the wars* (Oxford, 1988)

Leventhal, F. M., ' "The best for the most": CEMA and state sponsorship of the arts in wartime, 1939-45', *Twentieth Century British History* 1.3 (1990), 289-317

Levey, Michael, 'A little known Director: Sir William Boxall', *Apollo* (May 1975), 354-9

Levey, Michael, *The case of Walter Pater* (London, 1978).

Levey, Michael, *The chapel is on fire* (London, 2000)

Liscombe, R. W., *William Wilkins 1778-1839* (Cambridge, 1980)

Lowenthal, David, *The heritage crusade and the spoils of history* (London, 1997)

Mace, Rodney, *Trafalgar Square: emblem of empire* (London, 1976).

MacGregor, Neil, *The purpose of public pictures* Eighth Leverhulme Memorial Lecture (University of Liverpool, 1993)

MacGregor, Neil, '"To the happier carpenter" Rembrandt's war-heroine Margaretha de Geer, the London public and the right to pictures', Eighth Gerson Lecture (University of Groningen, 1995)

Macleod, Diana Sachko, *Art and the Victorian middle class* (Cambridge, 1996)

Mallett, Donald, *The greatest collector: Lord Hertford and the founding of the Wallace Collection* (London, 1979)

Mandler, Peter, *Aristocratic government in the age of reform. Whigs and Liberals, 1830-1852* (Oxford, 1990)

Mandler, Peter, *The fall and rise of the stately home* (New Haven, 1997)

Mandler, Peter, 'Art, death and taxes: the taxation of works of art in Britain, 1796-1914', *Historical Research* 74 (2001), 271-97

Markham, S. F., *The museums and art galleries of the British Isles* (Carnegie UK Trustees, 1938)

Martin, Gregory, 'Wilkins and the National Gallery', *Burlington Magazine*, 113 (1971), 318-29

Martin, Gregory, 'The founding of the National Gallery in London', series of articles in *Connoisseur* 189 (1974)

McCamley, N. J., *Saving Britain's art treasures* (Barnsley, 2003)

McClellan, Ian, *Inventing the Louvre* (Cambridge, 1994)

Merriman, Nicholas, *Beyond the glass case* (London, 1991)

Miers, Henry, *A report on the public museums of the British Isles* (Carnegie UK Trustees, 1928)

Minihan, Janet, *The nationalization of culture: the development of state subsidies to the arts in Great Britain* (London, 1977)

von Moos, Stanislaus, *Venturi Scott Brown and Associates, 1986-1998* (New York, 1999)

Nead, Lynda, *Victorian Babylon. People, streets and images in nineteenth-century London* (New Haven, 2000)

Office International des Musées, *Muséographie. Architecture et aménagement des musées d'art* (Madrid, 1934)

Oliver, Lois, *Boris Anrep: the National Gallery mosaics* (London, 2004)

Pearce, S. M., *Museums, objects and collections: a cultural study* (Leicester, 1992)

Pearson, Nicholas M., *The state and the visual arts: a discussion of state intervention in the visul arts in Britain, 1760-1981* (Milton Keynes, 1982)

Perdigao, Jose di, *Calouste Gulbenkian, collector* (Lisbon, 1969)

Pevsner, Nikolaus, *A history of building types* (Washington, DC, 1976)

Physick, John, *The Victoria and Albert Museum* (Oxford, 1982)

Plagemann, Volker, *Das deutsche Kunstmuseum, 1790-1870* (Munich, 1967)

Pointon, Marcia (ed.), *Art apart: art institutions and ideology across England and North America* (Manchester, 1994)

Pomeroy, Jordana, 'The National Gallery's origins in the British Institution', *Apollo* 148 (1998), 41-49

Pope-Hennessy, John, *Learning to look* (New York, 1991)

Port, M. H., *Imperial London. Civil government building in London, 1850-1915* (New Haven, 1995)

Prettlejohn, Elizabeth (ed.), *After the Pre-Raphaelites* (Manchester, 1999)

Reitlinger, Gerald, *Economics of taste: the rise and fall of the picture market, 1760-1960* (New York, 1961)

Richter, J. P., *Lectures on the National Gallery* (London, 1898)

Robertson, David, *Sir Charles Eastlake and the Victorian art world* (Princeton, 1978)

Rosman, Doreen M., *Evangelicals and culture* (Aldershot, 1992)

Salmon, Frank, 'British architects and the foundation of the RIBA', *Architectural History* 39 (1996), 77-113

Saumarez Smith, Charles, *Ludwig Mond's bequest: a gift to the nation* (London, 2006)

Secrest, Meryle, *Kenneth Clark: a biography* (London, 1984)

Secrest, Meryle, *Duveen: a life in art* (London, 2004)

Shaw, Roy, *The arts and the people* (London, 1987)

Sheehan, James, *Museums in the German art world* (Oxford, 2000)

Skidelsky, Robert, *John Maynard Keynes* (London, 2003)

Solkin, David, *Painting for money: the visual arts and the public sphere in eighteenth-century England* (London, 1992)

Spalding, Francis, *The Tate: a history* (London, 1998)

Stansky, Peter, *Sassoon: the worlds of Philip and Sybil* (New Haven, 2003)

von Stockhausen, Tillmann, *Gemäldegalerie Berlin: die Geschichte ihrer Erwerbungspolitik* (Berlin, 2000)

Strong, Roy, *The Roy Strong diaries, 1967-1987* (London, 1997)

Sutton, Denys, [series of articles on the history of British collecting], *Apollo* (1985)

Swinney, Geoffrey N., 'Gas lighting in British Museums and Galleries', *Museums Management and Curatorship* 18.2 (1999), 113-143

Tate, *Robert Vernon's gift. British art for the nation, 1847* (London, 1993)

Taylor, Brandon, *Art for the nation. Exhibitions and the London public, 1747-2001*, (London, 1999).

Thomas, Peter D. G., *John Wilkes: a friend to liberty* (Oxford, 1996)

Tomkins, Calvin, *Merchants and masterpieces: the story of the Metropolitan Museum of Art* (New York, 1970)

Tyack, Geoffrey, '"A gallery worthy of the British people": James Pennethorne's designs for the National Gallery, 1845-67', *Architectural History* 33 (1990), 120-34

Uwins, Sarah, *A memoir of Thomas Uwins*, RA (2 vols., London, 1858).

Vergo, Peter (ed.), *The new museology* (London, 1989)

Vincent, David, *Bread, knowledge and freedom: a study of working-class autobiography* (London, 1981)

Vincent, John (ed.), *The Crawford papers: the journals of David Lindsay* (Manchester, 1984)

Wardleworth, Dennis, 'The "friendly" battle for the Mond Bequest', *British Art Journal* 4.3 (2004)

Walker, John, *Self-portrait with donors* (New York, 1974)

Walker, John A., *Arts TV: a history of arts television in Brtiain* (London, 1993)

Walsh, Kevin, *The representation of the past* (London, 1992)

Ward, Marianne C., 'Preparing for the National Gallery: the art criticism of William Hazlitt and P. G. Patmore', *Victorian Periodicals Review* 23.3 (1990), 104-114

Warner, Malcolm, 'The Pre-Raphaelites and the National Gallery', *Huntington Library Quarterly* 55.1. (1992), 1-11

Waterfield, Giles, *Rich summer of art: a regency picture collection seen through Victorian eyes* (London, 1988)

Waterfield, Giles, *Palaces of art: art galleries in Britain 1790-1990* (London, 1991)

Weight, Richard, *Patriots: national identity in Britain, 1940-2000* (Basingstoke, 2002)

Weston-Lewis, Aidan, *A poet in paradise: Lord Lindsay and Christian art* (Edinburgh, 2000)

Whitehead, Christopher, *The public art museum in nineteenth-century Britain: the development of the National Gallery* (Aldershot, 2005)

Wilson, David M., *The British Museum: a history* (London, 2002)

Witt, Robert, *The nation and its art treasures* (London, 1911)

Wittlin, Alma, *The museum: its history and its tasks in education* (London, 1949)

Wittlin, Alma, *Museums: in search of a useable future* (London, 1970)

Witts, Richard, *Artist unknown: an alternative history of the Arts Council* (London, 1998)

Wolff, Janet and John Seed, *The culture of capital: art, power and the nineteenth-century middle class* (Manchester, 1998).

Notes

Abbreviations used in the notes:

ArchH	*Architectural History*
BL	British Library
BLO	British Library, Oriental and India Office Library
Burl.	*Burlington Magazine*
Cmnd.	Command Paper
CR	'Curzon Report', (Parl. Papers 1914-6, 29)
GRI	Getty Research Institute, Provenance Index
GUL	Glasgow University Library
H3 (H4)	*Hansard*, 3rd series (4th series, etc.)
JHC	*Journal of the History of Collections*
NAL	National Art Library
Minutes	Minutes of the National Gallery Board, 1828-2006
NFTA	National Film and Television Archive, British Film Institute
NG	National Gallery Archive
NLS	National Library of Scotland
NSA	National Sound Archive, British Library
PP	Parliamentary Papers
PRO	National Archives, Kew
RC	Royal Commission for the 1851 Exhibition
RCMG	Royal commission on national museums and galleries, Interim Report (Parl. Papers, 1928-9, 8) Final Report (Parl. Papers, 1929-30, 16)
RCNG	Report and minutes of the royal commission on the site of the National Gallery (Parl. Papers, 1857, 24)
SCAM	Report and minutes of the select committee on arts and manufactures (Parl. Papers, 1836, 9).
SCNG	Report and minutes of the select committee on the management of the National Gallery (Parl. Papers, 1852-3, 35)
TA	Tate Archive
UCL	University College London

Chapter One: Origins

1. Arthur Macgregor, ed., *The late King's goods: collections, possessions and patronage of Charles I in the light of the Commonwealth Sale inventories* (Oxford, 1989), p. 227.
2. Stephen Gleissner, 'Reassembling a royal art collection for the restored King of Great Britain', *JHC* 6 (1994), 103-115.
3. John Shearman, *Raphael's cartoons* (London, 1972), pp. 146-52.
4. John Gwynn, *An essay on design* (London, 1749), p. 13.
5. Andrew McClellan, *Inventing the Louvre* (Cambridge, 1994), pp. 8, 61, 87.
6. Robert Hurd, *Dialogues on the uses of foreign travel considered as part of an English gentleman's education* (London, 1764), pp. 59-60.
7. *Horace Walpole Correspondence*, ed. Wilmarth S. Lewis (48 vols., New Haven, 1932-83), 24: 240.
8. Carol Duncan, 'Putting the "Nation" in the National Gallery' in Gwendolyn Wright, *The formation of national collections of art and archaeology* (Washington, DC, 1996), pp. 101-112.
9. Gwynn, *An essay on design*, pp. 2, 46, 70-1.
10. Kathleen Wilson, *The sense of the people: politics, culture and imperialism 1715-1785* (Cambridge, 1995).
11. Anthony Ashley Cooper, 3rd Earl of Shaftesbury, *Characteristics of men, manners, opinions, times*, ed. Lawrence E. Klein (Cambridge, 1990), p. 402.
12. Linda Colley, *Britons: forging the nation, 1707-1837* (London, 1992), pp. 86-7.
13. 6 Geo II, c.22
14. Anne Goldgar, 'The British Museum and the virtual representation of culture in the eighteenth century', *Albion* 32.2 (2000), 195-231.
15. Anon. [A. Thomson], *Letters on the British Museum* (London, 1766), p. 37.
16. Anon., *A letter to the members of the Society for the Encouragement of Arts...* (London, 1761), pp. 46-54.
17. Henry Fielding, *An inquiry into the late increase in robbers*, ed. Malvin R. Zirker (Oxford, 1998).
18. John Brown, *An estimate of the manners and principles of the times* (2 vols., London, 1757-8), 1:63.
19. Cited in Donna T. Andrew, *Philanthropy and police. London charity in the eighteenth century* (Princeton, NJ, 1989), p. 63.
20. Benedict Nicolson, *The treasures of the Foundling Hospital* (Oxford, 1972).
21. Cited in John Barrell, *The political theory of painting from Reynolds to Hazlitt* (London, 1986), p. 20. See also David Solkin, *Painting for money: the visual arts and the public sphere in eighteenth-century England* (London, 1992), pp. 157-213.
22. London, Royal Society of Arts. Committee Minute Book (1758-60), f. 127.
23. Barrell, *The political theory of painting*, p. 136.
24. Joseph Highmore, *Essays moral, religious and miscellaneous* (2 vols., London, 1766), 2:89.
25. Reprinted in *St. James' Chronicle*, 22-24 April 1762.
26. For a fuller discussion, see Jonathan Conlin, '"At the expense of the public": the Signpainters' Exhibition and the public sphere', *Eighteenth-century Studies* 36.1 (2002), 1-21.
27. Museum of London. Warwick Wroth Collection, Vauxhall scrapbook, v.3, f. 38.
28. Shaftesbury, *Characteristics*, p. 31.
29. Abbé Coyer, *Nouvelles observations sur l'Angleterre* (Paris, 1774), pp. 109-110.
30. Anon., *A description of Vauxhall Gardens* (London, 1762), pp. 24-6.
31. London, Royal Society of Arts. Committee Minute Book (1760-1), f. 32 (27 February 1761).
32. John Almon, ed., *The speeches of John Wilkes* (3 vols., London, 1777), 2:56-69.
33. David Watkin, *The architect King: George III and the culture of Enlightenment* (London, 2004), pp. 83, 99, 132-3; Holger Hoock, 'Old masters and the English School', *JHC* 16.1 (2004), 1-18 (3).

34. Horace Walpole to Mann, 11 Feb. 1779, *Walpole Correspondence* 24:441.
35. *The European Magazine*, Feb. 1782; see also *Gentleman's Magazine*, 49 (1779), 270-271 and 469-470. Andrew Moore, ed., *Houghton Hall, the Prime Minister, the Empress and the Hermitage* (Norwich, 1996).
36. Jonathan Conlin, 'High art and low politics: a new perspective on John Wilkes', *Huntington Library Quarterly* 64.3-4 (2001), 356-82.
37. See the essays 'On civil liberty' and 'Of the rise and progress of the arts and sciences' in David Hume, *Political essays*, ed. Knud Haakonssen (Cambridge, 1994).
38. 'L'histoire visible de l'Art'. Chrétien de Mechel, *Catalogue des tableaux de la Galerie Impériale et Royale de Vienne* (Basel, 1784), xv.
39. Shaftesbury, *Characteristics*, p. 50.
40. See Thomas Crow, *Painters and public life in eighteenth-century France* (London, 1985), pp. 4-10. John Goodman, '"Altar against altar": the Colisée, Vauxhall utopianism and symbolic politics in Paris, 1767-77', *Art History* 15.4 (1992), 434-469; M. Dussausoy, *Le citoyen désintéressé* (2 vols., Paris, 1768), 2:203, 222.
41. Wilkes to Jean-Baptiste-Antoine Suard, 21 June 1768. Ann Arbor, MI, William L. Clements Library. Wilkes Papers, v.3, f. 23.
42. *The Middlesex Journal*, 20-22 June 1769. See also Robert Strange, *The conduct of the Royal Academicians* (London, 1771); Holger Hoock, *The King's artists: the Royal Academy of Arts and the politics of British culture, 1760-1840* (Oxford, 2003), pp. 19-23.
43. Joshua Reynolds, *Discourses on art*, ed. Robert Wark (New Haven, 1997), pp. 139-40 (7th discourse, 1776), 247 (14th discourse, 1788).
44. William Hogarth, *The analysis of beauty*, ed. Ronald Paulson (New Haven, 1997), pp. 32-3.
45. Ann Bermingham, 'Landscape-o-rama: the exhibition landscape at Somerset House and the rise of popular

landscape entertainments' in David Solkin, ed., *Art on the line: the Royal Academy exhibitions at Somerset House, 1780-1836* (London, 2001), pp. 127-144; K. D. Kriz, *The idea of the English landscape painter* (New Haven, 1997), pp. 86-98.
46. James Barry, *A letter to the Dilettanti Society* (London, 1798), p. 14. See also James Barry, *Works* (2 vols., London, 1809), 2:499. As Holger Hoock has noted, Barry may have been the first to use the term. Hoock, 'Old masters and the English School', 3.
47. See Joseph Wilton's comments in London, Royal Academy Archive. C/3, ff.15-17 (16).
48. Hoock, *The King's artists*, p. 49.
49. Noel Desenfans, *A plan... to preserve among us, and transmit to posterity, the portraits of the most distinguished characters of England, Scotland and Ireland...without any expence to government* (London, 1799), pp. 40-1, 49.
50. The Truchsess Gallery was also offered to the British state at around this time. Morton D. Paley, 'The Truchsessian Gallery revisited', *Studies in Romanticism* 16.2 (1977), 165-178.
51. Pers. comm. of West to Farington, 21 July 1805. K. Garlick, A. Macintyre and K. Cave, eds, *The Diary of Joseph Farington* (16 vols., New Haven, 1978-84), 7: 2592. For reaction to the Desenfans plan, see ibid., 4:1133, 1136-7, 1145, 1150, 1157, 1160, 1161.
52. Hoock, *The King's artists*, p. 196.
53. Linda Colley, 'The apotheosis of George III: loyalty, royalty and the British nation, 1760-1820', *Past & Present* 102 (1984), 94-129; Colley, *Britons*, p. 176.
54. To quote an observation made during the 1805 revival of the Garter ceremony, cited in Watkin, *The architect King*, p. 156.
55. Holger Hoock, 'The British military pantheon in St Paul's Cathedral: the state, cultural patriotism, and the politics of national monuments, c.1795-1820', in Matthew Craske and Joanna Innes,

eds, *Rethinking the age of reform: Britain 1780-1850* (Cambridge, 2003), pp. 254-70.

56. Elizabeth K. Helsinger, 'Land and national representation in Britain', in Rosenthal, Payne and Wilcox, eds, *Prospects for the nation: recent essays in British landscape, 1750-1880* (New Haven, 1997), pp. 13-36 (23).

57. McClellan, *Inventing the Louvre*, p. 121 and Fig. 5 (p. 9). Helen Rosenau, *Social purpose in architecture: Paris and London compared, 1760-1800* (London, 1970), ch. 6.

58. The exhibition drawings for the Hardwick and Gwilt buildings are in the RIBA Drawings Collection. For similar exhibition drawings, see *Catalogue of the exhibition of the Royal Academy* (1798) No. 925; *Catalogue* (1800) Nos. 946, 954, 1028, 1065; *Catalogue* (1802) No. 919; *Catalogue* (1804) No. 858; *Catalogue* (1805) Nos. 677, 679, 714. William Woods, *An essay on national and sepulchral monuments* (London, 1808).

59. Holger Hoock, *The King's Artists*, pp. 276-82.

60. Hoock, *The King's artists*, p. 192.

61. Hoock, *The King's artists*, Ch. 8, pp. 263-9.

62. Entry for 8 October 1806. *Farington Diary*, 8:2882.

63. Anon., 'Sir F. Bourgeois and the Dulwich Picture Gallery', *Library of the Fine Arts* 3 (1832), 425; *Farington Diary*, 10:3822.

64. Prospective visitors had to be 'known to some member of the family, or otherwise produce a recommendation from some distinguished person, either of noble family or of known taste in the arts'. In wet weather, they were advised to make sure they came in their carriages, so as not to track mud into the Gallery. This hardly suggests a wide audience. Charles M. Westmacott, *British galleries of painting and sculpture* (London, 1824), p. 176.

65. Gregory M. Rubinstein, 'Richard Earlom and Boydell's "Houghton Gallery"', *Print Quarterly* 8.1 (1991), 1-27.

66. Josiah Boydell, *Suggestions towards forming a plan for the encouragement, improvement, and benefit, of the arts and manufactures in this country, on a commercial basis* (London, 1802). Sven Bruntjen, *Josiah Boydell* (New York, 1985), pp. 113-7 and T. S. R. Boase, 'Macklin and Bowyer', *Journal of the Warburg and Courtauld Institutes* 26 (1963), 148-176.

67. Prince Hoare, *An inquiry into the requisite cultivation and present state of the arts of design in England* (London, 1806), p. 21; Prince Hoare, *Epochs of the Arts* (London, 1813), pp. 112, 213, 271. See also Morris Eaves, 'Inquiry into the real and imaginary obstructions to the acquisition of the arts in England: the comedy of the English school of painting', *Huntington Library Quarterly* 52.1 (1989), 125-39.

68. This premium was first proposed on 1 March 1807. NAL, British Institution Papers, RC.V.II, v.1, ff. 193, 206.

69. Francis Haskell, *The ephemeral museum. Old master paintings and the rise of the art exhibition* (New Haven, 2000), p. 52.

70. William Hazlitt, 'On Patronage and Puffing' in *Table-Talk* (London, 1821), pp. 300-301.

71. C. R. Leslie, *Memoirs of the life of John Constable* (Ithaca, NY, 1980), p. 114.

72. David Blayney Brown and Felicity Owen, *A collector of genius: a life of Sir George Beaumont* (London, 1988), p. 180.

73. Beaumont to Bowles, 21 February 1808. New York, Pierpont Morgan Library. Misc. Artists Papers (William Lisle Bowles).

74. Martin Archer Shee, *A letter to the president and directors of the British Institution* (London, 1809), p. 8.

Chapter Two: Possessed by the People

1. See Liverpool to Castlereagh, 15 July 1815. Charles William Vane, ed., *Correspondence, dispatches, and other papers of Viscount Castlereagh* (3rd ser., 4 vols., London, 1853), 3:429. John Gurwood, *The dispatches of Field Marshal the Duke of Wellington* (12 vols., London,

1928), 12:634-5, 639-40; Cecil Gould, *Trophy of conquest* (London, 1965), pp. 116-30.

2. For a rare attempt to resist the tendency to locate the museum in Foucault's 'carceral archipelago', see Stephen Conn, *Museums and American intellectual life, 1876-1926* (Chicago, 1998), p. 12.

3. Charles Long, *A letter to the Right Hon. Sir Charles Long* (London, 1825); *Short remarks, and suggestions, upon improvements now carrying on or under consideration* (London, 1826).

4. The Royal Academy's attitude towards the idea of a national gallery is discussed more fully in Chapter One.

5. 23 February 1824. *H3*, 10, c. 311 (loan) 316 (quote).

6. Treasury to Seguier, 8 April 1824, NG5/4/1824.

7. Diary entry. Northamptonshire CRO, Annaly (Holdenby) Papers, X.1384/29.

8. Seguier to Treasury, 3 January 1825. PRO, T 1/4028.

9. Fellow Tory MP Thomas Baring argued that Beaumont had given his pictures not 'to a building [the British Museum]; but to the nation'. 29 March 1824. *H3*, 10, c.1474.

10. G. J. W. Agar Ellis, 'The Angerstein Collection of Pictures', *Quarterly Review*, 31 (April 1824), 210-4 (213).

11. Treasury minute, 29 June 1824. PRO, T 1/4028. Treasury to Seguier, 2 July 1824. NG5/4/1824.

12. A legal defence plan was drawn up at an Extraordinary General Meeting of the British Museum trustees held on 23 May 1826, to be used in case of demands for the sculptures' removal. British Museum Archive, General Meeting Minute Book 2.

13. Sarah Uwins, *A memoir of Thomas Uwins* (2 vols., London, 1858), 1:129.

14. *Fifth report of the Commissioners of HM Woods, Forests, and Land Revenues* (PP, 1826, 14), Plates 2, 3.

15. *Select Committee on the Office of Works and Public Buildings* (PP, 1828, 4), p. 10. Robinson, Peel (then Home

Secretary), Long and Agar Ellis were present at this meeting, held on 15 July 1828. NG1/1, f. 6.

16. For what would appear to be his 'Questions on a National Gallery', together with Wilkins' peeved reaction, see PRO, WORKS 17/10/1/51 and 17/10/1/59. In 1837 Cust published a pamphlet entitled *Thoughts on the expedience of a better system of control and supervision over buildings erected at public expense.*

17. William Wilkins, *A letter to Lord Viscount Goderich* (London, 1832), pp. 14-15, 67, 71.

18. *The Literary Gazette and Journal of Belles Lettres* 277 (16 February 1833), 104-6; 279 (2 March 1833), 135-6.

19. 13 April and 23 July 1832. *H3*, 12, c.467-7 and 14, c.645.

20. 12 August 1833. *H3*, 20, c.619, 624.

21. Charles Eastlake, *Contributions to the literature of the fine arts* (2nd ser., London, 1870), p. 153.

22. For an example, see the Commons debate of 30 July 1839. *H3*, 49, c. 1007-1038.

23. A full list of these Select Committees can be found in the bibliography.

24. See Hume to Chadwick, 1 April 1833 and 11 November 1841. UCL, Chadwick Papers, MSS 1066/8-11 and 60.

25. Diary entry for 19 January 1833. Willard Russell Pope, ed., *The diary of Benjamin Robert Haydon* (5 vols., Cambridge, MA, 1960), 4:30.

26. 31 December 1839. *Haydon Diary*, 4:600.

27. *SCAM*, Part I, x.

28. For a fuller discussion, see Lara Kriegel, 'Culture and the copy: calico, capitalism, and design copyright in early Victorian Britain', *Journal of British Studies* 43.2 (April 2004), 233-265.

29. 7 April 1843. *H3*, 68, c.733

30. *The Builder*, 6 November 1858.

31. 6 March 1845. *H3*, 78, c.386 and 391.

32. 'Parson Lot' [Charles Kingsley], 'The National Gallery No. 1' and 'The National Gallery No. 2', *Politics for the*

People, 6 and 20 May 1848.

33. George Godwin, *Town swamps and social bridges* (London, 1859), p. 18.

34. William Gladstone, *The state in its relations with the church* (4th ed., 2 vols., London, 1841), 1:154-5, 308.

35. 16 April 1844. *H3*, 74, c.38.

36. Anna Jameson, *A handbook to the public galleries of art in and near London* (London, 1842), p. 387.

37. *SCNG*, Q5307.

38. Peel to Eastlake, 13 May 1844. BL, AddMSS 40544, f. 105.

39. *SCNG*, Q5396

40. William Coningham's *Strictures on the minutes of the Trustees of the National Gallery* was published on 4 February 1847. For Hume, see *H3*, 89, c.498.

41. This was reported to the Commons by Gladstone on 14 April 1853. *H3*, 125, c.1117.

42. Minutes, 3 April and 18 December 1854.

43. Gladstone to Lansdowne, 13 January 1854, BL, AddMSS 44529, f. 33. Gladstone to Aberdeen, 4 September 1854, ibid., f.141.

44. PP, 1854-5, 53, pp. 311-21.

45. *The Athenaeum*, 10 June 1854, p. 720; a denial even had to be issued in the Commons on 3 July 1854. *H3*, 134, c.1061.

46. James Dennistoun, 'The National Gallery', *Edinburgh Review* 97 (April 1853), 390-420; William Dyce, *The National Gallery, its formation and management* (London, 1853).

47. See Eastlake to Wornum, 6 May 1856, NG32/71.22.

48. 19 and 20 Vict., c. 29. For the text, see PP, 1856, 5: 241-9. The bill passed all readings without debate, and received the Royal Assent on 23 June 1856. *H3*, 142, c.1771. For the sale, see 'Return relating to the National Gallery (Mr. Coningham)', Cmnd. 275.

49. Eastlake to Gladstone, July 1858, BL, AddMSS 44589, f. 187.

50. For the bribery accusations made by A. J. Otway and William Coningham on 14 March 1856 and 2 July 1857 see *H3*,

141, c.150 and 146, c.823, 844. For the Travelling Agent see ibid., c.816-846; 151, c.1386-1391. See also Wornum to Elcho, 4 July [1857], NG32/68.7.

51. Jaynie Anderson, 'The first cleaning scandal at the National Gallery 1846-1853' in Peter Booth, ed., *Appearance, opinion, change: evaluating the look of paintings* (London, 1990), pp. 3-7.

52. 6 December 1852. *H3*, 123, c.1024.

53. *SCNG*, Q8036.

54. *SCNG*, Q7505.

55. Transcript of Granville to Albert, 16 November 1853. RC, Box 12, 30.

56. Philip Guedalla, *The Queen and Mr. Gladstone* (2 vols., London, 1933), 1:107.

57. RC, Box 16, 149.

58. The words are those of Liberal Chancellor George Cornewall Lewis. *RCNG*, Q2787.

59. Francis Richard Charteris-Wemyss-Douglas (1818-1909) was a Trustee of the NPG from 1856 to 1866. For his art collection, see National Gallery of Scotland, *Pictures from Gosford House lent by the Earl of Wemyss and March* (Edinburgh, 1957); Sheilagh Wemyss, 'Francis, Lord Elcho (10th Earl of Wemyss) as a collector of Italian Old Masters', *Journal of the Scottish Society for Art History* 8 (2003), 73-6.

60. Anon., *Protest and counter statement against the report of the Select Committee on the National Gallery* (London, 1855), pp. 78-9.

61. Anon. ['National Gallery Reform Association'], *The National Gallery No. II*, (London, 1856), p. 30.

62. Gustav von Waagen, 'Thoughts on the new building to be erected for the National Gallery', *Art Journal*, n.s., 5 (April-May, 1853), 101-3, 121-5. See also Ian Jenkins, *Archaeologists and aesthetes in the sculpture galleries of the British Museum* (London, 1992), pp. 48-9 (Ch. 3).

63. Walter Bagehot, *The English constitution*, ed. Paul Smith (Cambridge, 2001), p. 37.

64. Dyce to Henry Cole, 14 January 1853. Aberdeen City Art Gallery, Dyce Papers, 1311.

65. The Portrait Gallery would be 'temporarily' housed at South Kensington from 1869 to 1885, when it was moved to Bethnal Green, where it was housed in the original 1857 'iron museum', which had been transferred from its original location at South Kensington. Graham Hulme, Brian Buchanan and Kenneth Powell, *The National Portrait Gallery: an architectural history* (London, 2000), p. 28.

66. NG1/4, f. 202.

67. Kathryn Moore Heleniak, 'Victorian collections and British nationalism: Vernon, Sheepshanks and the National Gallery of British Art', *JHC* 12.1 (2000), 91-107.

68. Richard Redgrave, 'On the gift of the Sheepshanks Collection', [1857] *Introductory addresses on the Science and Art Department* (London, 1887), p. 30 (quotation). Francis Fowke, 'The National Gallery difficulty solved', *Cornhill Magazine* 1 (May 1860), 346-55.

69. William Russell to Overstone, 7 January 1860. University of London Library, MS 804, 1211.

70. Michael Levey, 'A little-known Director: Sir William Boxall', *Apollo*, May 1975, pp. 354-9.

71. Trustee William Gregory's support of the grant was only opposed by the Tory George Bentinck, who noted that 'it was a new fact in natural history to say that they could feed a starving man by showing him pictures'. 20 March 1871. *H3*, 205, c.310-5.

72. Layard claimed to have the support of Lord Overstone, William Russell and Boxall. 23 July 1866. *H3*, 184, c.1303-22. See also M. H. Port, *Imperial London: civil government building in London, 1851-1915* (New Haven, 1995), p. 92; Jeffrey Tyack, '"A gallery worthy of the British people": James Pennethorne's designs for the National Gallery, 1845-67', *ArchH* 33 (1990), 120-34.

73. George Edmund Street, *Some remarks in explanation of his designs for (1) rebuilding and (2) enlarging the National Gallery* (London, 1867).

74. Such insularity also prevented them from taking any real advantage of Semper's presence as a political exile in London post 1848. For this see Wolfgang Herrmann, *Gottfried Semper im Exil: Paris, London 1849-55* (Basel, 1978), pp. 45, 83-8.

75. Gordon Waterfield, *Layard of Nineveh* (London, 1963), pp. 311-3.

76. For a fuller account of the history of the 1866 competition and the Barry Rooms, see Christopher Whitehead, *The public art museum in nineteenth-century Britain: the development of the National Gallery* (London, 2005).

77. Burton to William Gregory, 2 March 1888. NG, Burton/Gregory correspondence, Letter 9.

78. See *SCAM*, Part II, Q36-40; *SCNG*, Q5815-6, Q6530, Q7486-7, Q7940; *RCNG*, Q2467, Q2825. Copies had been an important element in Charles I's collection. See Susan Bracken, 'Copies of Old Master paintings in Charles I's collection', *British Art Journal* 3.2 (Spring 2002), 28-31.

79. Gregory to George Howard, 7 November 1889. Castle Howard, J22/78/1. For similar reactions see Richard Wallace to Charles Locke Eastlake, 9 November 1889 and William Gregory to Austen Henry Layard, n.d.. NG7/110/1889.

80. NG7/121/1889.

81. Frances Spalding, *Tate: a history* (London, 1998).

82. *Select Committee on Public Institutions* (PP, 1861, 16), Q1596.

83. Walter Besant, 'How can a love and appreciation of art be best developed among the masses of the people?', *Social Science Association Transactions* (London, 1885), pp. 724-37 (726).

84. Lawrence Goldman, *Science, reform, and politics in Victorian Britain: the Social Science Association 1857-1886* (Cambridge, 2002), p. 152ff.

85. Sheilagh Wilson, '"The highest art for the lowest people": the Whitechapel and other philanthropic art galleries, 1877-1901' in Colin Trodd and Paul

Barlow, eds., *Governing cultures* (London, 2000), pp. 172-86.

86. Rodney Mace, *Trafalgar Square: emblem of empire* (London, 1976), p. 189. Burton took the precaution of instructing police on duty at the Gallery to keep fire hoses at the ready 'to play upon any mob that might choose to pay their addresses to the N. G.' Burton to William Gregory, 14 November 1887. NG, Burton/Gregory correspondence, Letter 2.

87. 20 July 1885. *H3*, 295, c.1329.

88. 5 March 1885. *H3*, 294, c.215.

89. "Explosions", Cmnd. 4077 (PP, 1884, 17), 753-64. See also E. W. Henderson to Burton, 26 January 1885. NG7/68/1885.

90. NG7/69/1885. The extra plain-clothes policemen were removed in June 1888.

91. NG7/103/1888 (Gregory). Treasury (Jackson) to NG Trustees, 26 June 1888. NG7/104/1888. See also Minutes, 16 May 1888.

92. As this statement makes no allowance for inflation, one could argue that in 1954 it *still* hadn't reached the pre-Blenheim level.

93. 'Some questions concerning the National Gallery', *The Times*, 18 August 1869. See also 'GHM' [G. H. Murray], 'National Gallery', 30 March 1894 and Rosebery to Poynter, 19 April 1894. NLS, ACC 8365, 10150, f. 186 and 101030, f. 15.

94. See also 'GHM' [G. H. Murray], 'National Gallery', 30 March 1894 and Rosebery to Poynter, 19 April 1894. NLS, ACC 8365, 10150, f. 186 and 101030, f. 15.

95. Niall Ferguson, *The world's banker: the history of the House of Rothschild* (London, 1998), pp. 748-50.

96. J. Mordaunt Crook, *The rise of the nouveaux riches: style and status in Victorian and Edwardian architecture* (London, 1999), pp. 64-5, 238-40.

97. Ferguson, *The world's banker*, p. 744.

98. David Cannadine, *Decline and fall of the British aristocracy* (New Haven, 1990), p. 579.

99. Ibid., pp. 217, 293, 466.

100. For a different view, see Andrea Geddes Poole, 'Conspicuous

presumption: the Treasury and the Trustees of the National Gallery, 1890-1939', *Twentieth Century British History* 16.1 (2005), 1-28.

101. 'The Directorship of the National Gallery', *The Spectator*, 17 February 1894, 233-235 (234). See also Alan Bell, 'Colvin vs. Poynter: the directorship of the National Gallery, 1892-4', *Connoisseur* (December 1975), 278-83.

102. John E. Millais, 'Thoughts on our art of to-day', *Magazine of Art* (1888), 289-92 (290).

103. Allen Staley, 'The Grosvenor Gallery winter exhibitions' in Susan P. Casteras and Colleen Denney, eds., *The Grosvenor Gallery: a palace of art in Victorian England* (New Haven, 1996).

104. Maureen Bowland, *D. S. MacColl: painter, poet, art critic* (Harpenden, 1995), pp. 139-50.

105. For the Poynter/Howard correspondence see Castle Howard, J22/57; Minutes, February 4 1896.

106. Telegram of 28 February 1896, read at a meeting held 3 March.

107. Minutes, 4 May 1897. 5th Marquis of Lansdowne to George Howard, 28 April [n.d.], Castle Howard, J22/78/1.

108. See Carlisle's dissent from the resolution of the Trustees. Minutes, 10 June 1902.

109. Charles J. Holmes, *Self and partners (mostly self)* (New York, 1936), p. 313

110. The idea that the NPG would eventually become a subsidiary or subsection of the National Gallery was not part of the Earl of Stanhope's plan in moving for its establishment in 1856, and seems rather to have been developed by the cabinet as a means of silencing Spooner, Coningham and other critics who opposed the creation of any more boards or any new museums requiring their own housing and budget. As Chancellor of the Exchequer George Cornewall Lewis claimed that rooms would be set aside for the NPG in the new National Gallery, and that its collection would be under the care of the latter's officials and trustees. His successor Gladstone

advocated eventual union. See 10 August 1857. *H3*, 147, c.1318. Even after the 1857 royal commission had scuppered the idea of a new Gallery, Gladstone was still writing to Eastlake in 1859 arguing that the idea of having two separate establishments for the NPG and National Gallery was 'indefensible' and referred to 'the promise of future union'. Gladstone to Eastlake, 17 September 1859. BL, AddMSS 44530, f. 79.

111. As part of the NPG's Millennium Project this range did indeed become part of the National Gallery, part of a land swap that enabled the former to create the Ondaatje Wing. Hulme, Buchanan and Powell, *The National Portrait Gallery*, pp. 105 (walls), 109 (tower), 224-5 (land swap).

112. Gerald Reitlinger, *The economics of taste: the rise and fall of the picture market, 1760-1960* (New York, 1961), pp. 181, 202.

113. Cannadine, *British aristocracy*, p. 113.

114. 7 March 1877. *H3*, 232, c.1542.

115. Reitlinger, *The economics of taste*, pp. 189, 192.

116. 2 July 1894. *H4*, 26, c.731.

117. Peter Mandler, *The fall and rise of the stately home* (New Haven, 1997), pp. 126, 207. Cannadine, *British aristocracy*, p. 516.

118. 2 July 1894. *H4*, 26, c.729-30.

119. 7 July 1896. *H4*, 42, c.997.

120. Peter Mandler, 'Art, death and taxes: the taxation of works of art in Britain, 1796-1814', *Historical Research* 74.185 (August 2001), 272-296 (284).

121. 'Friends of the National Gallery', *Saturday Review* 90 (15 December 1900), 751-2.

122. D.S. MacColl, 'The National Gallery: its problems, resources and administration', *The Nineteenth Century*, 71 (January 1912), 24-39 (38).

123. Mary Lago, *Christiana Herringham and the Edwardian art scene* (London, 1996), pp. 75, 97, 125 (quote).

124. Borland, *D.S. MacColl*, p. 131.

125. D. S. MacColl to 27th Earl of Crawford, 12 May 1909. NLS, ACC9769, 97/29, f. 2145.

126. *CR*, p. 11

127. Joseph Conrad, *The secret agent*, ed. Bruce Harkness and S. W. Reid (Cambridge, 1990), p. 30.

128. The paintings damaged were NG730, NG1213, NG812, NG280, NG726.

129. See Joynson-Hicks' comments in the Commons, 11 March 1914. *H5*, 59, c.1228. Rowena Fowler, 'Why did Suffragettes attack works of art?', *Journal of Women's History* 2.3 (Winter 1997), 109-25 (113).

130. *The Suffragette*, 20 March 1914, p. 516.

131. Mary Richardson, *Laugh a defiance* (London, 1953), p. 165.

132. Dario Gamboni, *The destruction of art: inconoclasm and vandalism since the French Revolution* (London, 1997), pp. 93-7, 259.

Chapter Three: Opulence and Austerity

1. The portrait, by Herkomer, had been donated by a Mr. Ralli. Minutes of 13 March 1917.

2. Charles Holroyd to Curzon, 16 October 1914. BLO, MS EUR F112/56.

3. Benson to Curzon, 19 December 1912. BLO, MS EUR F112/62. See also, PRO, T1/11995; 'The Report of the National Gallery Trustees', *Contemporary Review*, August 1915, 229-236.

4. The Treasury Minute of 3 August 1916 that established these changes was framed without consulting the Trustees, who duly protested to the Prime Minister. Trustees to Asquith, 30 November 1916. BLO, MS EUR F112/58. The account given by Holmes in his autobiography neglects to mention that he and D. S. MacColl had initially discussed a plan whereby Witt would serve for a few years before handing the reins to Holmes. See Holmes letters to Charles F. Bell tipped in to p. 245 of the latter's copy of Holmes' *Self and Partners* in

NPG, Holmes Papers; GUL, MacColl Papers, H283-5, H291, H316-8.

5. Robert Witt to Curzon, 12 July 1917. BLO, MS EUR F112/57.

6. Holmes to Curzon, 21 January 1924. BLO, MS F112/60. NG16/159.1; Minutes, 11 January, 8 February 1927; *RCMG*, Q2276.

7. Berenson to I. S. Gardner, 15 September 1923. Rollin van N. Hadley, ed, *The letters of Bernard Berenson and Isabella Stewart Gardner, 1887-1924* (Boston, 1987), p. 663.

8. A private member's bill banning the export of certain works of art was proposed in 1926, but did not get past its first reading.

9. Ramsay MacDonald to Curzon, 17 April 1924. BLO, MS EUR F112/60.

10. For the Sale Bill see BLO, MS EUR, F112/72. See also the letters in NG26/35.

11. Curzon, 'Confidential note on the Bridgewater Titians', 8 June 1916, ibid.

12. 21 November 1916. *H5*, 23, c.539ff (539-42, 553).

13. Holmes to William Lever, 9 December 1916. NG26/35.

14. Henry James, *The Outcry* (New York, 2002), pp. 63, 164, 166, 170.

15. Philip Sassoon, 3 August 1922. *H5*, 157, c.1857-8.

16. Northumberland to Lansdowne, 11 November 1916. NG26/60. Muir Mackenzie speaking in the Lords, 28 November 1916. *H5*, 28, c.701.

17. Van den Bergh: Robert Witt to Curzon, 18 November 1924. BLO, F112/60. Ellerman: C. H. Collins Baker to Lansdowne, 2 September 1916. NG26/60. Davis: Robert Witt to Curzon, 9 December 1918. BLO, MS EUR F112/58 and MS EUR F112/70.

18. Clive Bell, 'Save the Old Masters from their friends', *Vanity Fair*, October 1922, p. 67.

19. 'Memorandum on a proposed society of "Friends of Arts"', n.d. [1916?]. BLO, MS EUR F112/77. For Sassoon's speech see 3 August 1922, *H5*, 157, c.1858.

20. Curzon, 'Memorandum by Lord Curzon on the relations of the Director and the Trustees', 14 March 1914. BLO, MS EUR F112/64.

21. Redesdale to Curzon, 2 February 1914. BLO, MS EUR F112/56.

22. Margot Asquith to Curzon, n.d. [Nov 1913?]. BLO, MS EUR F112/56.

23. D'Abernon to Holmes, 6 August 1923. BL, AddMSS 48930, f.163.

24. See John House, *Impressionism for England: Samuel Courtauld as patron and collector* (London, 1994), pp. 10-12.

25. Duveen to D'Abernon, 8 August 1916. BLO, MS EUR F112/70.

26. Holroyd to Curzon, 14 September 1915. BLO, MS EUR F112/58.

27. For the cultural origins of Irish repatriation debates, see Jordanna Bailkin, *The culture of property: the crisis of Liberalism in modern Britain* (Chicago, 2004), Ch. 1. For the Layard dispute, see BLO, MS EUR F112/67-8; David B. Elliott, *Charles Fairfax Murray* (Lewes, 2000), p. 191.

28. Minutes, 21 March 1917. Dennis Wardleworth, 'The "friendly" battle for the Mond Bequest', *British Art Journal* 4.3, 87-93.

29. Thomas Bodkin, *Hugh Lane and his pictures* (Dublin, 1956); Anne Kelly, 'The Lane Bequest', *JHC* 16.1 (2004), 89-110.

30. Robert Skidelsky, *John Maynard Keynes, 1883-1946* (London, 2003), p. 212.

31. Clive Bell, *Civilisation* (London, 1928), pp. 127-30.

32. Barstow to Trustees, 23 October 1922. Transcribed in Minutes, 13 June 1922.

33. Martin Daunton, *Just taxes: the politics of taxation in Britain, 1914-1979* (Cambridge, 2002), p. 82.

34. Committee on National Expenditure, (PP, 1922, 9), 89.

35. Muirhead Bone, 'The public and the national gallery', *Burl.*, May 1923, 252. See also Bone to MacColl, n.d. [1923?]. GUL, MacColl Papers, B446.

36. The Fees (Increase) Bill debates of 7 and 26 March 1923 mainly focussed on the other clauses of the bill, which

related to shipping. *H5*, 161, c.555-608; 162, c.138-167. Minutes, 11 November 1924. *RCMG*, Q1836.

37. *RCMG*, Interim Report, 726. See also Beresford (Secretary to the Commission) to D'Abernon, 18 May 1928. PRO, T105/1.

38. *RCMG*, Q12-4, Q51-4. Calvin Tomkins, *Merchants and masterpieces: the story of the Metropolitan Museum of Art* (New York, 1970), pp. 62, 68, 70, 79, 87.

39. Minutes, 13 February 1917. *RCMG*, Q1767.

40. *RCMG*, Final Report, 484.

41. Wynford Dewhurst, *Wanted: a Ministry of Fine Arts* (London, 1913).

42. *RCMG*, Final Report, 445; *The Times*, 2 August 1928. The Museums and Galleries Commission had few powers and little idea of whom it was to report to. Esmé, Countess of Carlisle, *A history of the Museums and Galleries Commission* (London, 1988).

43. *RCMG*, Final Report, 453.

44. Minutes, 15 October 1929, 11 February and 17 July 1930.

45. Lords debates of 2 March 1931, 1 January 1935, 14 February 1935. The bill passed its third reading on 19 February. *H5*, 79, c.57-94; 95, c.711-723, 776-778, 930-935, 999.

46. 27th Earl of Crawford to Collins Baker, 10 May 1928. NG26/24.

47. Apart from his diaries for 1930-3, which he left to the 28th Earl of Crawford, and which are at NLS, ACC 9769, 97/42-3, Daniel appears to have left no papers. The fact that there is no GRI Collector File for him suggests that he was not a well-known collector.

48. For a typical example of Trustee correspondence on this subject see Evan Charteris to Balniel, 26 December 1937. NLS, ACC 9769, 101/16(5). Kenneth Clark, *Another part of the wood: a self-portrait* (London, 1974), pp. 264-5.

49. He was enthusiastic enough a Trustee to explore the possibility of continuing to attend meetings after his coronation. PRO, PREM5/134.

50. David Lindsay (1900-1975) was known as Lord Balniel (or simply 'Bal') until he succeeded as the 28th Earl of Crawford and Balcarres in 1940.

51. Balcarres, Notebooks of the 28th Earl of Crawford, 2, f. 5. For D'Abernon's links to Duveen, see the former's file at the GRI and S. N. Behrman, *Duveen* (New York, 1972), pp. 24, 105.

52. For Daniel's concerns, see Daniel to Ormsby-Gore, 31 December 1929. NG26/74.

53. William St Clair, 'The Elgin Marbles: questions of stewardship and accountability', *International Journal of Cultural Property*, 8.2 (1999), 391-521 (418).

54. Balcarres, Diaries of the 27th Earl of Crawford, 44, 1 October 1928. For the export duty proposal, see Austen Chamberlain memo, 2 May 1919, BLO, MS EUR F112/58. For D'Abernon's opposition, see D'Abernon to Curzon, 3 October 1921, BL, AddMSS 48933, f. 93. For his dealings with Duveen, see BL, AddMSS 48932, ff. 1, 2, 66, 132, 217, 244.

55. See Ramsay MacDonald to Curzon, 26 September 1924; Holmes to Curzon, 3 October 1924. BLO, MS EUR F112/60.

56. Martin Conway, *Art treasures of Soviet Russia* (London, 1925), pp. 147, 250, 262. Robert Witt, 'Report on Visit to the Hermitage, Leningrad, in July 1931'. NG16/133.1.

57. Elena Solomacha, 'Verkäufe aus der Eremitage, 1926-1933' in Waltraud Bayer, ed., *Verkaufte Kultur: die sowjetischen Kunst- und Antiquitätenexporte, 1919-1938* (Frankfurt am Main, 2001), 41-62 (50).

58. For the history and provenance of the painting see Jaynie Anderson, *Tiepolo's Cleopatra* (Melbourne, 2003).

59. Stamfordham to Lee, 2 February 1931. NG16/133.1.

60. 27th Earl of Crawford to Daniel, 19 January 1931. NG26/27. See also 'Breaking up the Hermitage' (Editorial), *Burl.* 63 (August 1933), 53.

61. Daniel, account of 17 February 1933 meeting with Gutekunst and Meyer. NG16/133.1. For Daniel's and Davies'

reports on the painting, dated 29 and 31 January 1933, as well as similar reports by Isherwood Kay and Ellis Waterhouse, see Ibid. Daniel's diaries record the various visits of Trustees to see the Tiepolo, and their comments on it. NLS, ACC9769, 97/43. See also Roger Fry, 'Cleopatra's Feast', *Burl.* 63, September 1933, 131.

62. Solomacha, 'Verkäufe aus der Eremitage', p. 56. For the Stroganoff Rembrandt, see Daniel's diary for February and March 1933. NLS, ACC9769, 97/43. For post-1934 proposals to purchase from the Hermitage and Clark's 1935 trip to Russia see Minutes, 29 October 1935.

63. Horace Rumbold (British Embassy, Berlin) to Arthur Henderson, 11 March 1931. PRO, FO 371/15213. Schleicher and his wife were executed on Hitler's orders three years later, in the so-called 'Night of the Long Knives'.

64. PRO, PREM 1/137.

65. Elizabeth Kehoe, 'The British Museum: the cultural politics of a national institution 1906-1939' (unpublished DPhil thesis, University of London, 2001), p. 161ff.

66. PRO, T162/287. See also the minutes of a Cabinet meeting of 3 April 1933. PRO, T172/1802.

67. The Keepership also came open at about this time, and was given to Isherwood Kay thanks to Daniel's support. Ellis Waterhouse and Martin Davies were both candidates for this appointment. See the Waterhouse letters to Isherwood Kay, NG36/88/6, /7 and /10; Daniel diary, NLS, ACC 9769, 97/43, entries for 11 April and 19 July 1932.

68. Lee made his threat to J. A. Barlow at the Treasury on 12 July 1933. His forcefulness may explain why Clark was appointed instead of Ellis Waterhouse – the Trustees' favoured candidate. Other candidates included Roger Fry (seen as too old and temperamental), Herbert Read (too likely to be bullied by the Trustees), Max Friedländer (too German), Thomas Bodkin, H. C. Kaines

Smith, Muirhead Bone, S. Cursiter and A. P. Oppé (Principal Asst. Secretary at the Board of Education). For the Treasury and Prime Minister's deliberations, see PRO, PREM 5/92. See also Clark, *Another part of the wood*, pp. 208-9.

69. For one example of such behaviour see Daniel to Evan Charteris, 19 December 1932. NG26/17 and especially C. H. Collins Baker's 'Reflections and conclusions as regards the N.G.'. GUL, MacColl Papers, B18.

70. Clark, *Another part of the wood*, p. 211.

71. Robert Witt attended, and 'took some delightful little parties round the English rooms, mostly from Yorkshire and so intelligent and keen'. Robert Witt to Clark, 30 April 1934. NG26/123.

72. Minutes, 13 April 1937. Electricity had been introduced to the ground floor offices in 1914.

73 Committee of Public Accounts, session of 25 February 1937 (PP, 1936-7, VI), Q1289-1486. The whole episode bears an eerie similarity to a similar one that confronted Henry Cole at the South Kensington Museum in May 1872. Elizabeth Bonython and Anthony Burton, *The great exhibitor: the life and work of Henry Cole* (London, 2003), pp. 256-7.

74. Clark to Balniel, 25 February 1938. NLS, ACC11533, 101/16(1). Clark, *Another part of the wood*, pp. 263-4.

75. For sale idea, see Clark to Balniel, 27 July 1939. NLS, ACC11533, 101/16(1). For purchase grant 'snare', see Clark to Keynes, 2 January 1945. NG26/59.

76. Clark to MacColl, n.d. [Paris], GUL, MacColl Papers, C165. Compare Clark to 28th Earl of Crawford, n.d.. NLS, ACC11533, 101/16(5). Clark, *Another part of the wood*, pp. 209, 225, 261-3; *The other half: a self portrait* (London, 1977), p. 77.

77. For this episode, see NLS, ACC11533, 101/17; Balcarres, Notebooks of 28th Earl of Crawford, 2, f. 56; Clark, *Another part of the wood*, p. 262.

78. Balniel, memo, 30 March 1938. NLS, ACC11533, 101/17.

79. Kenneth Clark, 'On visiting picture galleries', lecture delivered 22 June 1939. TA, 8812.2.2.334. Clark later became more hostile to the 'incantation' of Fry. Clark, 'The Work of Bernard Berenson' in *Moments of Vision* (London, 1981), p. 124.

80. Kenneth Clark, *One hundred details from pictures in the National Gallery* (2nd ed., London, 1990), viii. Clark, *Another part of the wood*, p. 259.

81. Edward Bruce, head of the Federal Art Plan, had proposed the idea. For Clark's response, see Clark to Balniel, 26 October 1939. NG26/29. For Churchill, see Clark, *The other half*, p. 5 where he regrets subsequently destroying the document. Other sources have Churchill using slightly different language.

82. 28th Earl of Crawford to Ormsby-Gore, 11 May 1942. NLS, ACC9769, 101/4(1). See also Neil MacGregor, 'Rembrandt's war-heroine Margaretha de Geer, the London public and the right to pictures', Gerson Lecture (Groningen, 1995).

83. Francis Haskell, *The ephemeral museum: Old Master paintings and the rise of the art exhibition* (New Haven, 2000).

84. Cited in Brian Foss, 'Message and medium: government patronage, national identity and national culture in Britain, 1939-1945', *Oxford Art Journal* 14.2 (1991), 52-72 (57).

85. Cited in Foss, 'Message and medium', 65.

86. Balniel to Clark, 10 November 1939. NLS, ACC9769, 101/16(2).

87. Ellis Waterhouse described Davies' work as forging 'a new kind of weapon of scholarship' in his 'Martin Davies', *Proceedings of the British Academy* 61 (1975), 561-5 (563). See also 'Sir Martin Davies, 1908-75', NG16/59.11. For a detailed account of the Gallery evacuation and the conversion of Manod Quarry for use as a storage facility, see N. J. McCamley, *Saving Britain's art treasures* (Burnsley, 2003), ch. 7.

88. Charles Wheeler to the Editor, *The Times*, 1 January 1942. Wheeler later served as President of the Royal Academy (1956-66). Minutes, 10 October 1939, 21 January 1942.

89. The monthly figures were released as part of the P. I. D. Intelligence Series on 29 April 1944. NG16/11.1.

90. For the wartime gallery in propaganda films see Central Office of Information, 'Britain can take it'; ditto, 'Listen to Britain'. NFTA. Nonetheless, Clark hardly mentions the One Picture shows in his memoirs. Clark, *The other half*, p. 54.

91. See the reports from 1940-2 of Humphrey Pease, 'FA', 'DH' and 'PJ' (quote). University of Sussex, Mass Observation Archive. 'Art 1938-42' Box 2/E, 'Art 1938-49' Box 3/A and /C. See also 'NM', 'General impression of the Children's Concert', 30 August 1940; 'London Survey 1940', Box 3/H.

92. In addition to Gallery archives, the following account is based on Clark's papers at TA, 8812.1.4.165a-c; 28th Earl of Crawford's papers at NLS, ACC6769, 101/19a(2); state papers at PRO, FO 371/40215; Gulbenkian's papers at the Gulbenkian Foundation, Lisbon, 'Clark', 'Crawford and Balcarres' and 'National Gallery 1939-1950' files. For a fuller account see Conlin, 'Oil and Old Masters', *TLS*, 31 October 2003.

93. Clark to Delano, 1 September 1942. TA, 8812.1.4.165b.

94. Clark to Gulbenkian, 17 April 1943. TA, 8812.1.4.165b.

95. Hacobian (Gulbenkian's London agent) to Clark, 10 July 1941. Ibid.

96. Mynors (Treasury) to K. M. Crump (Ministry of Economic Warfare), 13 March 1944. PRO, FO 371/40215, E1692.

97. E. P. Fitzgerald, 'The Iraq Petroleum Company, Standard Oil of California, and the contest for eastern Arabia, 1930-3', *International History Review* 13.3 (August 1991), 441-465.

98. Clark to Eden, n.d.; Mynors to E. F. Q. Henriques (Trading with the Enemy

Department), 8 May 1944. PRO, FO 371/40215, E1301 and 2875.

99. PRO T273/43. See also James Lees-Milne, *Diaries, 1946-1949* (London, 1998), p. 275.

100. 'In short,' Hendy observed, 'the establishment of the Gulbenkian Institution would appear to put an end to the history of the National Gallery.' Hendy, 'Proposed Gulbenkian institute', memo [December 1947]. NG35/10.

101. 28th Earl of Crawford to Hendy, 11 July 1946. NG26/30. See also Lord Radcliffe, 'The Gulbenkian I knew', *Sunday Times*, 28 July 1957; John Walker, *Self-portrait with donors: confessions of an art collector* (Boston, 1974), Ch. 11; Clark, *The other half*, 99-102.

102. Survey cited in Beth Breeze, 'The return of philanthropy', *Prospect* 106 (January 2005).

103. J. M. Keynes, 'Art and the State'. Cambridge, King's College. Keynes Papers, A36/60-70.

104. J. M. Keynes, 'The Arts Council: its policy and hopes', *The Listener* 12 July 1945, 1.

105. Jill Craigie (Writer/Director) and Sydney Box (Producer), *Out of Chaos* (Two Cities Films, 1944). NFTA.

106. F. M. Leventhal, 'The best for the most: CEMA and state sponsorship of the arts in wartime, 1939-1945', *Twentieth-century British History* 1.3 (1990), 289-317 (308).

107. Cecil Gould, 'Tosca's Creed' (unpublished memoir, 1992), p. 78.

108. Hendy to 28th Earl of Crawford, 30 April 1948. NG26/31. See also Hendy, memo on building, 1 January 1949. NG26/6.

109. Hendy to Wellington, 26 November 1953. NG16/112. Hendy, 'National Gallery. Staff and constitution', memo for 10 Downing Street [1947]; Hendy, memo, 17 November 1966. Both at NG35/6. Gould, 'Tosca's Creed', p. 89.

110. National Gallery, *An exhibition of cleaned pictures, 1936-1947* (London, 1947). For Trustee concern at the tone of the catalogue see 28th Earl of Crawford

to Hendy, 1 and 10 April 1947. NG26/30.

111. Hendy, 'Towards an improved National Gallery', *Britain To-Day* 139 (November 1947), 14-18 (18). See also Editorial, *Burl.*, December 1947, 329.

112. For a more critical view, see H. Granville Fell, 'The National Gallery of cleaned pictures', *Connoisseur* 119 (1947), 122-5.

113. 28th Earl of Crawford to Hendy, 30 October 1946; to William Gibson, 26 November 1947. NG26/30. Boase to Hendy, 10 March 1947, NG26/10. Clark to William Gibson, 8 May 1941. NG16/268.4. Herbert Lank, pers. inf. (2004).

114. For Buck's report see Minutes, 14 July 1949 and 9 February 1950. Herbert Lank, pers. inf. (2004).

115. Minutes, 8 November 1951. Hendy to Wellington, 18 September 1953. NG26/112. Herbert Lank, pers. inf. (2004). For Hendy's response to Trustee concerns, see Hendy to Boase, 21 January and 6 February 1952. NG35/6.

116. *Select committee on the functions of the National Gallery and Tate Gallery* (PP, 1945-6, 13), 10.

117. John Rothenstein to Hendy, 4 October 1957; Tate Trustees, memo, 29 March 1961. NG26/118. Rothenstein was, given recent scandals at the Tate, not in a strong position. Spalding, *Tate*, pp. 116-124.

118. *H5*, 186, c.796 (Strabolgi), 1155 (Methuen). 1158 (Crawford).

119. And even his appointment had been contentious, because RAs were felt to be 'uneducated', and because it might set a precedent. See Daniel's comments in his diary, NLS, ACC9769, 97/43, entries for 26 and 30 January 1933.

120. John Piper may be an exception, given the role he played in encouraging the Board to take a firmer stance against admission charges in the early 1970s. See Minutes, 1 June 1972; Piper to John Witt, 9 June 1971, NG16/2.3. For artist trustees in general, see John Witt to [Hendy?], 18 August 1967. NG16/59.12. Muirhead Bone predates Coldstream on

the board, but was no longer a practising artist when he was appointed.

121. For Feather, see Eddie Playfair to Levey, 10 June 1974; List of Trustee candidates, October 1974. The latter list also included Germaine Greer and Iris Murdoch. Both at NG16/445.1.

122. Treasury memo, 28 June 1960. PRO, T227/1960.

123. See Henry Hookway (DES) to M Widdup, 16 July 1971. PRO, T227/3400.

124. 'Export of Works of Art' (Treasury Report, 1952), 24.

125. In practice this timeframe was extended. Ibid., 57.

126. For regional vs. national priorities, see the panel discussion between David Piper, John Witt and others. BBC for *For the nation*, 'How much?' (1971). NFTA.

127. He also gave them valuations suggesting that paintings acquired by special grant two years before had depreciated. Philip Hendy to Sir Ronald Harris, 11 November 1963; K. E. Couzens, Treasury memo, 2 December 1963; Mary Loughnane, Treasury memo, 7 April 1964. All at PRO T227/2492.

128. *Halifax Courier and Guardian*, 9 November 1955.

129. *Daily Express*, 10 November 1955. See also Alfred Madel to Treasury, 27 October 1955. PRO T227/359.

130. Speech of 6 June 1955. For press reaction to the 'economist-cum-dictator', see *Evening Standard*, 9 June 1955.

131. Robbins to W. E. Williams, 8 July 1955. NG26/85. For admission charges, see Michael Levey, 'Memorandum on entrance fees', October 1955. NG16/2.1.

132. Denis Mahon to John Witt, 29 September 1970. NG26/117.

133. R. C. Griffiths, Treasury memo, 5 April 1960; Prime Minister's minute, 26 December 1960; Treasury memo, 16 January 1961. PRO T218/552.

134. Geoffrey Keynes to John Witt, 26 August 1961. NG26/119. Lord Bridges and Sir John Ferguson, *Enquiry into Security at the National Gallery* (PP, 1961-2, 18).

135. NG16/411.

136. The loophole was subsequently tightened, if not entirely closed. Humphrey Wine, 'The missing Goya: Section 11 of the Theft Act 1968', *Art Antiquity and Law* 6.4 (December 2001).

137. 'The story of the Leonardo Cartoon Appeal' (unpub. typescript, n.d.), p. 24. Balcarres, Papers of the 28th Earl of Crawford. Andrew Forge had recently reignited debate over Gallery cleaning policy. Forge, 'Mortal Masterpieces' and 'Cleaning', *New Statesman* n.s. 61 (26 May and 2 November 1961), 845 and 663.

138. Kempton Bunton, 'Com 4'. NG16/411.

139. 28th Earl of Crawford, 'The story of the Leonardo Cartoon Appeal', p. 13.

140. For records of the campaign see NG16/134.1; TA, 9328.14.10.1.9, 9328.14.10.1.1, 9328.14.10.5.1.

141. 'The story of the Leonardo Cartoon Appeal', pp. 22-3, 34. Gregory Martin, pers. inf. (2004).

142. Hendy in *Daily Telegraph*, 11 November 1958.

143. Treasury memo, 28 June 1960, see also J. Gibson, Treasury memo, 9 May 1960. PRO, T227/1950.

144. The decision was quickly criticized by the Cabinet Home Affairs Committee, for raising unrealistic hopes that construction would begin within five years PRO, T227/1950-1.

145. Gould, 'Tosca's creed', p. 102. Roy Strong, *The Roy Strong diaries, 1967-1987* (London, 1997), pp. 22-23.

146. Earlier opening on Sundays was stymied by the Civil Service Union's objections. Minutes, 3 June 1965, 3 February and 7 April 1966. Martin Davies to John Witt, 28 January 1969. NG26/115. Levey to Playfair, 13 February 1974. NG26/79.

147. Clipping from unidentified newspaper, NG16/59.12. Even well-disposed journalists felt that the need for 'showmanship' could not be ignored. Michael Dixon, 'New Director of the National Gallery', *Guardian*, 9 January 1968, 11b.

148. Martin Davies, 'Admission charges

at the National Museums and Gallery',
speech given 9 July 1971. NG16/2.3.
For Davies' television manner, see
BBC/Patria Pictures for *Omnibus*, 'A
fortune in pictures' (1970), directed
Michael Gill. NFTA.
149. Minutes, 9 March 1937, 18
November and 13 December 1945.
150. Eccles, 9 July 1971 speech to
Museums Association (reissued as Press
Release). NG16/2.3.
151. Edward Playfair, notes from meet-
ing with Eccles, 9 July 1972. NG16/2.4.
152. Archer at first said he would
abstain, but he did in fact enter a lobby –
with the 'nays'. *H5*, 829, c.1316-7
(Williams), 843, c.376 (Archer).
153. Davies, memo, 11 November 1970.
NG16/2.2.
154. Cited in Playfair, 'Entrance
charges', memo, 6 July 1972. NG16/2.3.
155. *H5*, 843, c.360.
156. See draft of Edward Playfair to
Eccles, December 1973. NG16/2.5.
157. Robbins, 'Unsettled questions in the
political economy of the arts', *Three
Banks Review* 91 (September 1971), 3-19.
See also *NG Report* (1969-1978), pp. 14-
5; Minutes, 5 November 1970.
158. 6 December 1971. *H5* 326, c.601-2.
For Heath and the Titian, see PRO,
T227/3400.
159. NG16/2.6.
160. Alistair Smith, pers. inf. (2004).

Chapter Four: The Experiment

1. G. J. W. Agar Ellis, 'The Angerstein
Collection of pictures', *Quarterly Review*
31 (April 1824), 210-4 (213). Diary
entry. Northamptonshire CRO, Annaly
(Holdenby) Papers, X.1384/29.
2. *SCNG*, Q7505.
3. Sir Henry Miers, *A report on the public
museums of the British Isles*, Carnegie
Trust Report (Edinburgh, 1928), p. 69.
4. Matthew Arnold, *Culture and anarchy*,
ed. Samuel Lipman (New Haven, 1994),
p. 5.
5. Raymond Williams, *Culture and

society, 1780-1950 (London, 1958), p. 226.
6. *Report of the Commissioners on Fine
Art* (PP, 1842, 25), App. 2. pp. 14-5.
7. For a typical example, see Sue
Braden, *Artists and people* (London,
1978), pp. 171-2, 179.
8. *RCMG*, Q1765.
9. Gustav von Waagen, 'Thoughts on
the new building to be erected for the
National Gallery', *Art Journal*, n.s., 5
(April-May, 1853), 101-3, 121-5 (124).
10. Hugh Cunningham, *Leisure in the
industrial revolution* (London, 1980), p.
90.
11. 13 April 1832. *H3*, 12, c.469.
12. 'The National Gallery', *Penny
Magazine* 5 (11 November 1836), 466;
'Hogarth and his works', *Penny Magazine*
3 (28 February 1834), 125.
13. David Vincent, *Bread, knowledge and
freedom: a study of working-class auto-
biography* (London, 1981), p. 146.
14. 16 April 1844. *H3*, 74, c.32-33. For
the committee itself, see *Select Committee
on National Monuments and Works of Art*
(PP, 1841, 6).
15. Minutes of 11 October 1932.
16. *SCAM* Pt. 2, Q1790
17. Charles Dickens, 'Please to leave
your umbrella', *Household Words*, 1 May
1858. David Pascoe, ed., *Charles Dickens.
Selected journalism 1850-70* (London,
1997), pp. 586-90.
18. 'Felix Summerly' [Henry Cole],
Hand-book for the National Gallery
(London, 1842), n.p.
19. *Select Committee on Public Institutions*
(PP, 1860, 16), Q313, Q364 (visitors);
Select Committee on National Monuments
(PP, 1841, 6), Q1849 (Cunningham);
SCNG, Q5018 (Monteagle).
20. *Select Committee on the
Accommodation of the National Gallery*
(PP, 1850, 15), Q82 (Uwins); *Select
Committee on National Monuments* (PP,
1841, 6), Q2672 (Wildsmith).
21. After renovation, Charles Morton's
Canterbury Hall in Lambeth reopened in
1854 with a new picture gallery contain-
ing works by W. P. Frith, Rosa Bonheur,
and Daniel Maclise. Surrey Music Hall

had a picture gallery by 1853. See Elizabeth Stokes, 'Class and the civilising process: social factors in the organization of museums in the nineteenth century' (unpublished PhD diss., Keele University, 1987), pp. 163-4.

22. John Landseer, *A descriptive, explanatory and critical catalogue of fifty of the earliest pictures contained in the National Gallery* (London, 1834), xii-xiii.

23. 14 April 1834. *H3*, 22, c.746-7.

24. 'Parson Lot' [Charles Kingsley], 'The National Gallery, No. 1', *Politics for the people*, 1 (May 6 1848), 6 (both quotations).

25. Edward Norman, *The Victorian Christian Socialists* (Cambridge, 1987), p. 6.

26. *SCNG*, Q5400.

27. To quote Baring Wall's proposed amendment to the report of the 1850 Select Committee on the Accommodation of the National Gallery. His proposed text was voted down 4-2, but not on account of any disagreement with this part of Wall's suggested text. *Select Committee on the Accommodation of the National Gallery* (PP, 1850, 15), viii.

28. *Select Committee on Public Institutions* (PP, 1860, 16), Q322-3.

29. Walter Stanley Jevons, 'The use and abuse of museums' in *Methods of social reform* (London, 1883), pp. 55, 58. See also Walter Besant, 'How can a love and appreciation of art be best developed among the masses of the people?', *Social Science Association Transactions* (London, 1885), pp. 724-37 (728).

30. Besant, 'Art for the people', pp. 726, 728.

31. Besant, 'Art for the people', p. 730.

32. *RCNG*, Q2504.

33. Elisabeth Helsinger, *Ruskin and the art of the beholder* (Cambridge, MA, 1982), pp. 206, 221, 245; Norman, *Victorian Christian Socialists*, pp. 135-6.

34. Jordanna Bailkin, *The culture of property: the crisis of Liberalism in modern Britain* (Chicago, 2004) pp. 19, 26.

35. Dunraven, 'Opening national institutions on Sunday', *The Nineteenth Century* 15 (March 1884), 416-434. In the United States, which faced the same issue at roughly the same time, unions were not opposed to Sunday opening. Calvin Tomkins, *Merchants and masterpieces: the story of the Metropolitan Museum of Art* (New York, 1970), pp. 75-8.

36. 21 March 1883. *H3*, 286, c.434. He had made his earlier speech in the Commons under his former courtesy title, as Lord Ashley.

37. 11 August 1885. *H3*, 300, c.1719.

38. *Resolutions passed by the Trustees of the National Gallery with reference to opening the same* (PP, 1880, 15), p. 2. (quote). Burton to Layard, 19 August 1885. BL, AddMSS 39039, f. 49; J. C. Robinson to Layard, 12 and 15 March 1886, AddMSS 39040, ff. 70, 72 (quote).

39. Walter Pater, *The Renaissance* (London, 1910), p. 80.

40. Introduction to the Fontana Library edition of Walter Pater, *The Renaissance*, ed. Kenneth Clark (London, 1961), p. 21. Michael Levey, *The case of Walter Pater* (London, 1978).

41. Susan D. Pennybacker, *A vision for London, 1889-1914: labour, everyday life and the LCC experiment* (London, 1995), p. 243.

42. S. F. Markham, *A report on the museums and art galleries of the British Isles* Carnegie Trust Report (Edinburgh, 1938), pp. 9, 140.

43. Charles Hanbury-Tracy, 2nd Baron Sudeley, 'The public utility of museums', *The Nineteenth Century* 90 (July 1921), 73-4.

44. Sudeley, 'The public utility of museums, picture galleries, and botanical gardens' (1914), quoted in Elisabeth Kehoe, 'The British Museum: the cultural politics of a national institution, 1906-1939' (Univ. of London DPhil diss., 2001), p. 129.

45. Minutes, 9 April 1935.

46. S. C. Kaines Smith, *Looking at pictures* (2nd ed., London, 1921), p. 21.

47. *RCMG*, Q2309.

48. Muirhead Bone, 'The public and the

national gallery', *Burl.* 42 (May 1923), 252.

49. 7 and 26 March 1923. *H*5, 161, c.603 (Viscount Wolmer); 162, c.143 (MacDonald).

50. F. W. Thomas, 'Low and I at the National Gallery', *The Star*, 19 January 1925, p. 3.

51. *RCMG*, Q1647.

52. *RCMG*, Q2301; Minutes, 19 June 1934.

53. *RCMG*, Final Report, pp. 470, 472.

54. 2 March 1932. *H*5, 249, c.67-8.

55. Sudeley, 'Public utility of museums', 74.

56. *RCMG*, x.

57. Eastlake to Wornum, 12 March 1856. NG5/205/1856.

58. Erika Rappaport, *Shopping for pleasure: women in the making of London's West End* (Princeton, 2000), pp. 74-107.

59. Minutes, 19 February and 19 May 1931; Clark, 'Notes on post-war plans for National Gallery', n.d. TA, 8812.1.4.244; Minutes, 19 June 1934; Barlow to Hendy, 7 July 1950, NG26/6.

60. Unfazed, Clark then teamed up with other London museums to ask the Treasury for a joint appointment. Minutes of 10 August 1934.

61. D. L. LeMahieu, *A culture for democracy: mass communication and the cultivated mind in Britain between the wars* (Oxford, 1988), pp. 162-3.

62. Richard Cork, *Art beyond the gallery in early twentieth-century England* (New Haven, 1985), p. 29.

63. 'National Gallery Publicity', memo, 27 June 1934. NG16/181.1

64. Minutes, 9 March 1937. Eight years earlier, in response to a query from the Museum and Galleries Commission the Trustees had, admittedly, stated their support for the abolition of paying days. Nothing came of this private statement, however. Minutes, 12 November 1929. For temporary exhibitions, see Clark, 'The National Gallery: growth of a great collection', *The Times*, 8 April 1938.

65. John A. Walker, *Arts TV: a history of arts television in Britain* (London,

1993), p. 21.

66. Dartington Hall Trustees, *The arts enquiry: the visual arts* (Oxford, 1946), p. 170.

67. LeMahieu, *A culture for democracy*, p. 149.

68. Clive Bell, *Civilisation* (London, 1928), p. 127.

69. F. R. Leavis, *Mass civilisation and minority culture* (Cambridge, 1930).

70. Richard Hoggart, *The uses of literacy: aspects of working-class life with special reference to publications and entertainments* (London, 1959), pp. 177-8, 238; Arnold, *Culture and anarchy*, p. 97.

71. Kenneth Clark, 'Art and democracy', *Cornhill Magazine* 161 (July 1945), 371.

72. F. M. Leventhal, 'The best for the most: CEMA and state sponsorship of the arts in wartime, 1939-45', *Twentieth-century British history* 1.3 (1990), 289-317 (305). See also Brian Foss, 'Message and medium: government patronage, national identity and national culture in Britain, 1939-45', *Oxford Art Journal* 14.2 (1991), 52-72.

73. William Emrys Williams, 'Are we building a new British culture?', *Picture Post*, 2 January 1943, 27.

74. Mary C. Glasgow, 'State aid for the arts', *Britain To-day* 182 (June 1951), 10.

75. C. A. R. Crosland, *The future of socialism* (London, 1956), p. 524.

76. Aneurin Bevan, *In place of fear* (London, 1952), p. 50.

77. Bevan, *In place of fear*, p. 6.

78. A. MacLaren, 26 May 1944. *H*5, 400, c.1170-1.

79. Sir Herbert Williams, 25 May 1943. *H*5, 389, c.1389.

80. Richard Weight, *Patriots: national identity in Britain, 1940-2000* (Basingstoke, 2002), p. 165.

81. Cited in Robert Hewison, *In anger: culture in the Cold War, 1945-60* (London, 1981), p. 62.

82. CEMA, *Plans for an art centre* (London, 1945).

83. 'Moreover, I was not impressed by some of the things community artists said about working-class life.' Roy Shaw,

The arts and the people (London, 1987), p. 93.

84. Weight, *Patriots*, p. 189.

85. Lawrence Black, *The political culture of the Left in affluent Britain, 1951-1964* (Basingstoke, 2003), pp. 74, 79-80 (quote), 81, 86, 101, 106.

86. Bevan, *In place of fear*, p. 48; Shaw, *The arts and the people*, p. 20. For an admiring response to Fascist musem practice see Alma S. Wittlin, *The Museum: its history and its tasks in education* (London, 1949), p. 187.

87. The Education Committees of Kent and Essex had published guides to 'school pictures' in the 1930s, so this was rather belated. Dartington Hall Trustees, *The arts enquiry*, p. 159.

88. Hans Unger, 'London's Art Galleries', London Transport Museum, Image Y3800.

89. R. Scanlon, 'Enjoy your London. No. 3 The Art Galleries', London Transport Museum, Image Y1033A.

90. Jennie Lee, *A policy for the arts: the first steps*, Cmnd. 2601, pp. 5, 12, 20.

91. Roy Strong, *Diaries 1967-87* (London, 1997), pp. 23, 72.

92. NSA, Museums Oral History Project, interview (2003) with Frederick Dunning, 1CDR0023739, track 13. Strong, *Diaries*, p. 78.

93. Minutes, 3 March 1966, 7 April 1966 (girls) 6 April 1967; Alistair Smith, pers. comm. (2004); R. H. Mitchem to P. H. Philpott (Race Relations Board), 10 May 1968. PRO, CK 2/58.

94. Broadcast 8 October 1970. Contrast the much more reverential treatment of Michael Gill's BBC *Omnibus* documentary, *A fortune in pictures*. Both NFTA.

95. Alistair Smith, pers. comm. (2004).

96. Loic Tallon, 'I'm a celebrity: get me an audio tour', *Museums Journal* 106.4 (April 2006), 26-7.

97. Dartington Hall Trustees, *The Arts enquiry*, p. 159.

98. John Berger, *Ways of seeing* (London, 1972), pp. 23, 29

99. Walker, *Arts TV*, p. 99.

100. Berger, *Ways of seeing*, p. 32.

101. Richard Weight is one of the few scholars who appears to have noticed this. Weight, *Patriots*, p. 470.

102. David Attenborough, *Life on air: memoirs of a broadcaster* (London, 2002), pp. 212-4.

103. Kenneth Clark, 'Art and Society', in Clark, *Moments of vision* (London, 1981), p. 79.

104. 25 January 1972. H5, 829, c.1323-4.

105. For this argument, see Geraldine Norman's interview of Eccles. *Times*, 12 November 1971, 12a.

106. Pierre Bourdieu, *Distinction: a social critique of the judgment of taste*, trans. Richard Nice (Cambridge, MA, 1984); Pierre Bourdieu and Alain Darbel, *The love of art: European art museums and their public*, trans. Nick Merriman (Oxford, 1991).

107. 'We live in a culture based on buying and selling,' she wrote, 'and a comparison with societies in which museums are state-supported has to include a reference to the loss of individual freedom that often is a part of the package.' She also argued that visitors who paid would be more attentive and critical, another point Eccles would later make. Wittlin, *Museums*, p. 214.

108. 6 and 14 December 1971. H5, 326, c.596, 1079.

109. 14 December 1971. H5, 326, c.1076.

110. 6 December 1971. H5, 326, c.590.

111. Neil MacGregor, 'Rembrandt's war-heroine Margaretha de Geer, the London public and the right to pictures', the Gerson Lecture (Groningen, 1995), pp. 40, 42.

Chapter Five: A Special Feast

1. Insisting on the representative nature of the collection could sometimes descend to the level of 'scoring' the Gallery's holdings of key masters in order to compare them with other leading museums. Cecil Gould, *Failure and success. 150 years of the National Gallery,*

1824-1974 (London, 1974), p. 93. For an earlier example, more alarming in its rigour, see M. W. Brockwell, *The National Gallery Lewis Bequest* (London, 1909).
2. Eastlake to Gladstone, memo of July 1859. BL, AddMSS 44589, f. 137v.
3. 'The National Gallery', *Art Journal*, n.s., 3 (February 1851), 37.
4. Minutes, 7 February 1887 and 16 May 1888 (Peel). Treasury to Trustees, 10 March 1890. NG7/121/1890.
5. Calvin Tomkins, *Merchants and masterpieces: the story of the Metropolitan Museum of Art* (New York, 1970), p. 73.
6. The paintings were NG215-6, wings of an altarpiece now attributed to Lorenzo Monaco. William Coningham, *Strictures on the minutes of the Trustees of the National Gallery* (London, 1847), p. 7.
7. Sidney Colvin to George Howard, 15 March 1893. Castle Howard, J22/31.
8. 'The National Gallery', *Burl.* 63 (October 1933), 145. Ellis Waterhouse confessed that until 1945 he had felt uneasy using the term 'art historian,' due to 'a nagging feeling that it was a neologism which might not necessarily be understood!' Waterhouse, *British art and British studies: remarks by Ellis Waterhouse at the inauguration of the Yale Center for British Art* (New Haven, 1979), p. 5.
9. Tillmann von Stockhausen, *Gemäldegalerie Berlin: die Geschichte ihrer Erwerbungspolitik* (Berlin, 2000), pp. 54, 60.
10. Unfortunately, there is still no adequate history of either, although the lectures and articles of Francis Haskell and Denys Sutton offer insightful contributions. The best sustained account of the development of art history in Britain (seen in a European context) is that contained in Udo Kultermann's *Die Geschichte der Kunstgeschichte: der Weg einer Wissenschaft* (Munich, 1990). But even this was originally published almost forty years ago.
11. Contemporary accounts suggest that Angerstein could appear ill-at-ease in the company of the elite. K. Garlick, A.

Macintyre and K. Cave, eds, *The diary of Joseph Farington* (16 vols., New Haven, 1978-84), 6:2059 (19 June 1803); Anon. *Public characters* (London, 1803-4), pp. 385-402 (402).
12. Francis Haskell, *Rediscoveries in art: some aspects of taste, fashion and collecting in England and France* (Oxford, 1976), pp. 46-7.
13. Jordana Pomeroy, 'Sebastiano del Piombo's "Raising of Lazarus" comes to England', *British Art Journal* 2.3 (2001).
14. Graham to Peel, 3 August 1840. BL, AddMSS 40318, f. 212. Hugh Brigstocke, *William Buchanan and the nineteenth-century art trade* (London, 1982), pp. 111 (papers), 70 (Gallery offer), 77, 82 (Perino).
15. See for example Aberdeen to Lawrence, 21 November 1824. London, Royal Academy, LAW/4/272.
16. SCNG, Q5307; Claire Smith, 'The 4th Earl of Aberdeen as a collector of Italian old masters', *Journal of the Scottish Society for Art History* 8 (2003), 47-52; *SCNG*, p. 358.
17. Constable to John Fisher, 6 December 1822. C. R. Leslie, *Memoirs of the life of John Constable* (Ithaca, NY, 1980), p. 97.
18. Leslie, *Constable*, p. 273.
19. Wilkie to Lady Beaumont, 12 March 1827. New York, Pierpont Morgan Library, Coleorton Papers, 31.
20. William Carey, *Variae. Historical observations on anti-British and anti-contemporarian prejudices* (London, 1822), p. 89. Selby Whittingham, 'A most liberal patron: Sir John Fleming Leicester', *Turner Studies* 6.2 (1986), 24-35 (27).
21. Liverpool to Leicester, 27 March 1823. Cited in Douglas Hall, 'The Tabley House Papers', *Walpole Society* 38 (1960-2), 59-122 (111).
22. Hall, 'Tabley house papers', 63. For another view, see Whittingham, 'Leicester', 33.
23. R. B. Beckett, *John Constable's correspondence* (6 vols., Ipswich, 1962-8), 6: 216-7.
24. Mark Evans, 'Constable's paintings

of "Dedham Vale" and Claude's "Landscape with Hagar and the Angel"', *British Art Journal* 3.3 (2002), 43-7 (46). The two Turners were hung next to the Claudes in December 1852. Minutes, 6 and 9 December 1852.

25. Eastlake to Gladstone, 8 July 1859. BL, AddMSS 44392, f. 34. See also Boxall to Trustees, n.d. [June 1869?], NG14/29.

26. Minutes, 3 July 1835 (first mention), 5 July 1852. By 1889 some Trustees were willing to acknowledge privately that this rule was 'unwritten'. Gregory to George Howard, 7 November 1889. Castle Howard, J22/78/1.

27. Julie F. Codell, 'Righting the Victorian artist: the Redgraves' "A century of painters of the British School" and the serialization of art history', *Oxford Art Journal* 23.2. (2000).

28. Diane Sachko Macleod, *Art and the Victorian middle class* (Cambridge, 1996), pp. 14, 21.

29. For a much fuller discussion, see the Introduction to Judy Egerton, *National Gallery Catalogues.The British School* (London, 1998).

30. Ford Madox Brown, 'Our National Gallery', *Magazine of Art* (1890), 133-136 (136); RCMG, Q1765.

31. Gladstone to Aberdeen, 17 April 1854. BL, AddMSS 44529, f. 83.

32. Jonathan Conlin, 'Gladstone and Christian Art, 1832-54', *Historical Journal* 46.2 (2003), 341-374.

33. Susanna Avery-Quash, 'The growth of interest in early Italian painting in Britain with particular reference to pictures in the National Gallery' in Dillian Gordon, *National Gallery Catalogues. The fifteenth-century Italian paintings* volume one (London, 2003), xxv-xliv; Hugh Brigstocke, 'Lord Lindsay as a collector', *Bulletin of the John Rylands Library* 64 (Spring 1982), 287-333 (330).

34. Anna Jameson, *Sacred and legendary art* (2 vols., London, 1848), 1:xxi.

35. Haskell, *Rediscoveries in art*, p. 174.

36. Anna Jameson, *Visits and sketches at home and abroad* (3rd ed., 2 vols., London, 1839), 1: 267-8; Elizabeth Eastlake,

'Treasures of art in Great Britain [review]', *Quarterly Review* 94 (March 1854), 467-508 (481).

37. 14 August 1834. NG32/10/Vol. 1.

38. M. J. Joseph, 'Charles Aders', *Auckland University College Bulletin* 43: 6 (1953), 1-44.

39. The 'Holbein' (NG195) is catalogued today as 'Style of Nicholas de Neufchâtel', but a dendrochronological analysis conducted in 1993 by Dr Peter Klein of the University of Hamburg revealed that the work's panels were from a tree that was still growing in the year of Holbein's death, suggesting a date for the painting of around 1560. I am grateful to Dr Klein for sharing his results with me.

40. Dyce to Gladstone, 22 June 1854. BL, AddMSS 44381, f. 173.

41. Gladstone to Uwins, 15 June 1854. BL, AddMSS 44529, f. 108.

42. David Robertson, *Sir Charles Eastlake and the Victorian art world* (Princeton, 1978), p. 137. The first scholarly attempt to recreate the altarpiece from which the Liesborn panels came was published as Michael Levey, 'Reconstruction of a Westphalian altar-piece', *Burl.* 100 (Sept. 1958), 304-6.

43. Minutes, 17 November 1856. Unfortunately Friedrich-Wilhelm IV objected to the rather enlightened idea of international cooperation in this case. Stockhausen, *Gemäldegalerie Berlin,* p. 79. Many of the Krüger paintings that were formally accessioned later went to the South Kensington Museum/V&A and National Gallery of Scotland on long-term loan, from 1862 to 1906. The altarpiece was reconstructed for a special exhibition held in June 1966.

44. Lorne Campbell, 'Introduction' to *National Gallery Catalogues. The fifteenth-century Netherlandish Schools* (London, 1998) p. 16.

45. Minutes, 5 February 1844.

46. Doris Strack, 'Boisserées Projekt der "Beiträge zur Geschichte der Christlichen Malerei"', in Annemarie Gethmann-Seifert, ed., *Kunst als Kulturgut* (Bonn,

1995), pp. 42-62.

47. Charles Eastlake, *Contributions to the literature of the fine arts*, 2nd ser. (London, 1870), pp. 358-9.

48. Adrian Desmond, *The politics of evolution* (Chicago, 1989), pp. 145-151.

49. 'Life of Raphael', *Quarterly Review* 131 (June 1840), reprinted in Eastlake, *Contributions*, 2nd ser., p. 200; Lady Eastlake cited in Christopher Whitehead, *The public art museum in nineteenth-century Britain: the development of the National Gallery* (London, 2005), p. 17; 'Editor's preface' to Franz Kugler, *A handbook of the history of paintings from the age of Constantine the Great to the present time*, trans. 'A Lady' [Eleanor Eastlake] (2 vols., London, 1841), 1: xvii.

50. Sutton is typical in this regard in writing that 'little need be said' of the philosophical framework of Lindsay's *Sketches*. Denys Sutton, 'From Ottley to Eastlake', *Apollo*, August 1985, 90.

51. Bernard Berenson, *Aesthetics and history* (London, 1948), p. 99.

52. E. K. Waterhouse, 'Some notes on William Young Ottley's collection of Italian Primitives' in *Italian studies presented to E. R. Vincent* (Cambridge, 1962), pp. 272-280.

53. Robyn Cooper, 'The growth of interest in early Italian painting in Britain: George Darley and the "Athenaeum", 1834-1846', *Journal of the Warburg and Courtauld Institutes* 42 (1980), 201-220.

54. Francis Haskell, 'William Coningham and his collection of Old Masters', *Burl.* 133 (October 1991), 676-681 (676).

55. Edmund Walker Head, 'Eastlake's "Materials for a history of oil painting"', *Edinburgh Review* 86 (July 1847), 188-214 (212). For Head, see *Proceedings of the Royal Society* 103 (1868), lxxi-lxxviii.

56. Given the extent to which books such as Langbehn's foreshadowed Nazi rhetoric, Udo Kultermann is understandably eager to draw a distinction between this *Pseudowissenschaft* and the 'real' sort. Kultermann, *Geschichte der Kunstgeschichte*, pp. 122-9. See also

Francis Haskell, *The Ephemeral Museum: Old Master paintings and the rise of the art exhibition* (New Haven, 2000), Chs. 6-7; Otto Kurz, 'On the sale of art by German museums', undated memo [1950s]. NLS, ACC6769, 101/19A.

57. Minutes, 22 June and 6 July 1857.

58. Anna Jameson, *A companion to the most celebrated private galleries of art in London* (London, 1844), p. 341

59. Frank Herrmann, 'Peel and Solly', *JHC* 3.1 (1991), 89-96 (91).

60. Anna Jameson, *A handbook to the public galleries of art in and near London* (2 vols., London, 1842), 1: 11.

61. Layard to Gregory, 2 February 1870. BL, AddMSS 38949, f. 12. See also Boxall to Layard, n.d. [March 1869], NG14/28/1869.

62. Peter C. Sutton, *Pieter de Hooch* (London, 1980), p. 54.

63. Hermann, 'Peel and Solly', 92.

64. Harcourt to Poynter, 4 August 1894; Poynter to Harcourt, 11 July 1894. Oxford, Bodleian Library, MS Harcourt dep. 224, f. 11. See also his comments in Minutes, 10 June 1902.

65. See Claude Phillips, D. S. MacColl and Reginald Grundy's letters, *Daily Telegraph*, 23, 25 and 28 November 1916; MacColl to Lansdowne, 4 April 1916. GUL, MacColl Papers, L56. For the sale lists, see Minutes, 22 June, 17 November 1916.

66. Minutes, 10 July 1917.

67. Treasury minute, 21 March 1871.

68. Layard to Gregory, 13 June 1872. BL, AddMSS 38949, f. 106. For Dillwyn, see Elizabeth Bonython and Anthony Burton, *The great exhibitor: the life and work of Henry Cole* (London, 2003), pp. 236-8.

69. For Eastlake's notebooks and the abolition proposal, see Elizabeth Eastlake and Charles Locke Eastlake to Gladstone, 5 May and 31 August 1893. NLS, Rosebery MS 10150, ff. 52, 58. For Mündler and his notebooks see Sidney Colvin to Sir Algernon West, 31 July 1893, ibid, f. 62; Stockhausen, *Gemäldegalerie Berlin*, p. 142; Rolf

Kultzen, 'Otto Mündler', *Jahrbuch der Berliner Museen* 38 (1996); C. T. Dowd, ed., 'The travel diaries of Otto Mündler, 1855-1858', *Walpole Society* 51 (1985). These are an edited and abridged English version of the original diaries in Berlin, Zentralarchiv der SMPK, Nachlass Mündler.

70. Haskell, *The Ephemeral Museum*, pp. 83, 85.

71. Stockhausen, *Gemäldegalerie Berlin*, p. 87. Monteagle, by contrast, justified the purchase to Peel by citing its 'great use to our portrait painters'. 3 April 1844. BL, AddMSS 40542, f. 68.

72. From 1830-70 the Gallery was only open to the 'decently dressed' general public (as opposed to 'Amateure') between 9-2pm on Mondays. Stockhausen, *Gemäldegalerie Berlin*, pp. 75, 76 (donations), 87, 97, 129, 132 (quotation), 203 (opening hours and regulations).

73. Manfred Ohlsen, *Wilhelm von Bode. Zwischen Kaisermacht und Kunsttempel* (Berlin, 1995), p. 122. See also Jeremy Warren, 'Bode and the British', *Jahrbuch der Berliner Museen* 38 suppl. (1996), 121-40.

74. Stockhausen, *Gemäldegalerie Berlin*, pp. 64, 145-6.

75. Wilhelm von Bode, *Mein Leben* (2 vols., Berlin, 1930), 2: 85-6.

76. Viscount Hardinge, a Trustee, had proposed that such a list be drawn up and displayed in the Gallery to inspire donations. Minutes, 20 May 1889 and 2 December 1890.

77. Previously catalogued as NG1268, now British Museum, Dept. of Ancient Egypt and Sudan, EA 74715.

78. Cosmo Monkhouse, *In the National Gallery* (London, 1895), p. 4. Thirty-five years later they were still on the north vestibule, and still being mentioned in guides. Trenchard Cox, *The National Gallery: a room to room guide* (London, 1930), pp. 18-19.

79. W. M. Flinders Petrie, *Hawara, Biahmu and Arsinoe* (London, 1889). For his correspondence regarding the National Gallery, see NG7/105/1888.

80. Account of meeting taken from Burton to Gregory, 6 July 1888. NG, Burton-Gregory Correspondence, letter 18.

81. Burton to Gregory, 10 July 1888. NG, Burton-Gregory Corr., letter 19.

82. For icons, see [Holmes] to Robert Witt, 3 October 1924 and Robert Witt to Holmes, 7 February 1926, both NG26/122. Minutes, 10 December 1929. Offers to present icons met with a chilly reception from Clark and the Trustees in 1942 (Minutes, 16 June 1942) and do not appear to have been discussed again. NG4163 is noted as being on display in 1930 (Cox, *The National Gallery*, p. 22).

83. George Howard to Gladstone, 19 February 1894. Castle Howard, J22/78/1.

84. Kultermann, *Geschichte der Kunstgeschichte*, p. 340.

85. J. C. Robinson, 'Art connoisseurship in England', *The Nineteenth Century* 38 (November 1895), 838-49 (840).

86. Robinson, 'Art connoisseurship', 844.

87. Robinson, 'Art connoisseurship', 843.

88. Haskell, *Rediscoveries in art*, pp. 203-4 (note 75); Ann Sumner, 'Sir John Charles Robinson', *Apollo* 130 (October 1989), 226-30; Elizabeth Bonython and Anthony Burton, *The great exhibitor: the life and work of Henry Cole* (London, 2003), pp. 213, 220-1.

89. Brigstocke, *William Buchanan*, pp. 12 (Wemyss), 18; William Buchanan, *Memoirs of painting* (2 vols., London, 1824), 2: 229 (Wallis).

90. Hugh Brigstocke, 'Richard Ford in Spain', *British Art Journal* 5.2 (2004), 91-94 (92). See also Jonathan Brown, *Images and ideas in seventeenth-century Spanish painting* (Princeton, 1978), pp. 3-20.

91. Richard Doyle, *Dick Doyle's diary* (London, 1840), p. 91. Alice Corkran's 1908 guide notes that Murillo's painting, though 'stagey' is still very popular with copyists. Alice Corkran, *The National*

Gallery. *Treasure house series* (London, 1908), p. 121. By 1930, it had become a work that gave pleasure to 'those who are not embarrassed by cloying sentiment' – and visitors had to be warned not to consider 'all these pictures worthless, for many, though over-sweet, are works of great technical distinction.' Cox, *The National Gallery*, p. 163.

92. As it has turned out, almost none of the Velázquez on show at the Gallery are now accepted as works by the master.

93. Minutes, 9 May 1853. Ford and Stirling to the Editor, *Times*, 12 May 1853; Haskell, *Rediscoveries in art*, p. 160 (Zurbarán). NG7/103/88 (Savile copies). A Dr Longton gave another set of copies after works in Spanish galleries in 1886. Minutes, 16 May 1888.

94. Frank Rutter, *Since I was twenty-five* (London, 1927), p. 151; R. A. M. Stevenson, *Velasquez*, rev. Theodore Crombie (London, 1962), p. 36.

95. Stevenson, *Velasquez*, p. 17. Michael Levey, 'Botticelli and nineteenth-century England', *Journal of the Warburg and Courtauld Institutes* 23 (1990), 291-306 (304)

96. For a typical account of the Gallery as 'late', see Sarah Herring, 'The National Gallery and the collecting of Barbizon paintings in the early twentieth century', *JHC* 13.1 (2001), 77-89 (77). I am grateful to Madeleine Korn for providing me with the information regarding dates of entry into public collections. For a useful corrective to the 'late' view, see her 'Exhibitions of modern French art and their influence on collectors in Britain, 1870-1918: the Davies Sisters in context', *JHC* 16.2 (2004), 191-218 and her 'Collecting paintings by Matisse and Picasso in Britain before the Second World War', *JHC* 16.1 (2004), 111-129.

97. John House, *Impressionism for England: Samuel Courtauld as patron and collector* (London, 1994), pp. 28-9, 227-8.

98 Quoted by Sutton in Stevenson, *Velasquez*, p. 25.

99. See Keynes to his mother, 3 March 1918. Cambridge, King's College. Keynes Papers, PP45/168/9/85.

100. Keynes outlines his plan in a memo of 20 March 1918. PRO, T/1/12190. Undeterred, in 1943 Keynes tried to persuade Export Control to use the same means to acquire Henri de Rothschild's Chardins. Keynes to Rowe-Dutton, 12 July 1943. Cambridge, King's College. Keynes Papers, PP/77/22.

101. See C. J. Holmes, *Self and partners* (New York, 1936), pp. 335-344; Roger Fry, 'The Sale of the Degas Collection', *Burl.* 32 (March 1918), 118; Denys Sutton, 'The Degas Sale in England', *Burl.* 131 (April 1989). NG16/60 and NG26/121. Curzon to Bonar Law, 3 May 1918. PRO, T172/803. Holmes to Keynes, 30 April 1918. Cambridge, King's College. Keynes Papers. T/1/145.

102. For Holmes' attempts to set the record straight, see Holmes to Editor of the "New Statesman", 9 November 1918. NG16/60.

103. Skidelsky refers to this as Keynes' 'absolution'. Robert Skidelsky, *John Maynard Keynes, 1883-1946* (London, 2003), p. 212.

104. The unnamed 'clever friend' referred to in Holmes' account of a visit to 'a private collection in the Avenue du Bois' is clearly Keynes, identifiable by the 'charming work by Cézanne' (*Still-life with apples*, c. 1878, now on loan to the Fitzwilliam), which he says has cleared him out of available funds. Holmes, *Self and partners*, p. 339; David Scrase and Peter Croft, *John Maynard Keynes* (Cambridge, 1983), No. 7.

105. Holmes to Curzon, 2 May 1918. BLO, MSS EUR F112/57.

106. 'I might have paid my contemporaries the compliment of consulting them more often', Holmes noted. Holmes, *Self and partners*, p. 343.

107. Holmes to Curzon, 4 May 1918. BLO, MSS EUR F112/58. See the catalogue to Tate Britain's 2003 exhibition *Constable to Delacroix: British Art and the French Romantics*, No. 52.

108. Letter to the Editor, *Burl.* 6 (1908), p. 375.

109. Fry, 'The Sir Hugh Lane Pictures at the National Gallery' (April 1917). Quoted in House, *Impressionism for England*, p. 230-232 (231). The to us rather surprising pre-eminence given at the time to Puvis de Chavannes should be seen in this context. Holmes believed Puvis' *Beheading of John the Baptist* 'challenge[d] comparison with the work of the great Italians of the cinquecento'. For notices of Puvis see ibid., pp. 228 (Holmes), 229 (Claude Phillips), 230 (Lionel Cust).

110. Charles Holmes, *Notes on the Post-Impressionist painters – Grafton Galleries, 1910-11* (London, 1910), pp. 14 (Van Gogh), 12 (Cézanne), 21 (*Dame au Chapelet*).

111. Interestingly, in 1934 Clark still felt it necessary to glaze Cézanne's *Mont Saint-Victoire* (on loan from Courtauld), as he felt some 'deranged die-hard' might attack it. Clark to Courtauld, 19 February 1934. NG26/21.

112. Philip Hendy, 'Cézanne's "La Vieille au Chapelet"', *The Listener*, 15 December 1960, pp. 1108-9.

113. Christopher Green, ed., *Art made modern: Roger Fry's vision of art* (London, 1999), p. 116. The hang is described in a ten-page memo on Hendy's shortcomings written by the 28th Earl of Crawford at NLS, ACC9769, 101/19.

114. In 1947 Hendy even attempted to wrest control of the Knapping Fund back to the Gallery. The Tate fought hard to keep the Seurat, but it returned to the Gallery in 1961. See 28th Earl of Crawford to Ridley, 28 March 1947, and his memo 'French 19th-century pictures in the National Gallery', 19 April 1951. NLS, ACC9769, 101/19; Minutes, 13 October 1955. For Wellington's opposition, see his memo, October 1953. PRO, T227/359.

115. Daniel to Balniel, 3 December 1932. NLS, ACC9769, 101/16(3).

116. For a full account of the Settlement, see Ann Kelly, 'The Lane bequest: a British-Irish cultural conflict revisited', *JHC* 16.1 (2004), 90-110.

117. Robbins to Macmillan, 20 October 1958. NLS, ACC9769, 101/18(2).

118. Indeed, he even let them see figures showing that earlier French purchases had declined in value. See the Treasury memos of K. E. Couzens, 2 December 1963, and Mary Loughnane, 7 April 1964. PRO, T227/2492.

119. Hendy criticized this policy as tantamount to 'an abandonment of [the Gallery's] position as a developing entity.' *National Gallery Report* (1938-54), p. 9.

120. Minutes, 14 February 1946. Macmillan's comments came in response to reading Ronald Harris' Treasury memo of 13 December 1960. Prime Ministerial minute, 26 December 1960. Both PRO, T218/552.

121. Dennis Farr, 'A student at the Courtauld Institute', *Burl.* 147 (August 2005), 539-547 (547).

122. Clark to Balniel, 25 February 1938. NLS, ACC9769, 101/16(1).

123. Poynter did acquire NG1849, a *Nativity with Saints* ascribed to Pacchiarotto, in 1901. Benson names Sassetta as a desideratum in his 'Sketch of deficiencies' of May 1914. NG7/445/1914. See also Avery-Quash, 'Early Italian painting in Britain', xxxv.

124. Kenneth Clark, 'Sassettas for the National Gallery', *Burl.* 6 (April 1935), 153-4; Edward Hutton, *The Sienese School in the National Gallery* (London, 1925); Denys Sutton, *Robert Langton Douglas: a connoisseur of art and life* (London, 1979), pp. 26-30, 42-6, 170; Edward Fowles, *Memories of Duveen Brothers* (London, 1976), p. 110.

125. Meryle Secrest, *Duveen: a life in art* (London, 2004) p. 489; Colin Simpson, *The partnership: the secret association of Bernard Berenson and Joseph Duveen* (London, 1987), p. 245; Lord Balniel comments extensively on the effects of Duveen's restorations in his notebook entry for 1 December 1932. Balcarres, Notebooks of the 28th Earl of Crawford, 1, f. 14.

126. Minutes of 10 July 1934 (and following four meetings); PRO, TS27/1108; Kenneth Clark, *Another part of the wood* (London, 1974), p. 228; Secrest, *Duveen*, p. 187; Balcarres, Notebooks of the 28th Earl of Crawford, 2, ff. 4-5 (Charteris); Clark memo, 9 July 1934, NG16/268.1. That Clark knew more than he was prepared to discuss openly is clear from Clark to Courtauld, 6 July 1936 and Clark to Ormsby-Gore, 17 November 1934. NG26/21 and NG26/75.

127. Indeed, there is a suggestion that this was not the first time Duveen had done this. See D'Abernon to Holmes, 16 January 1925 and Holmes to D'Abernon, 19 January 1925. BL, AddMSS 48930, ff. 193, 195.

128. Benson's collecting was partly modelled on that of a former Trustee, William Graham, 15 of whose paintings Benson purchased in 1886. See Robert Benson, *Catalogue of Italian pictures... collected by Robert and Evelyn Benson* (London, 1914), v-vi; Oliver Garnett, 'The letters and collection of William Graham', *Walpole Society* 62 (2000), 152-7; Charles Sebag-Montefiore, 'R. H. Benson as a collector', in Jehanne Wake, *Kleinwort Benson: the history of two families in banking* (Oxford, 1997), App. 3; David B. Elliott, *Charles Fairfax Murray* (Lewes, 2000), pp. 105-6 (Duccio panels), 117 (Benson).

129. In the Duveen scout book entry for Benson the Correggio was placed in the second class, 'Very fine and important pictures'. See Benson's Collector's File in the GRI. Secrest, *Duveen*, p. 293; 27th Earl of Crawford, memo of conversation with Warren Fisher, 15 May 1928, PRO, T105/5. Diary entry for 12 July 1927, Balcarres, Diaries of the 27th Earl of Crawford, v.43.

130. Clark to Balniel, 3 August 1936. NLS, ACC9769, 101/16(5).

131. 'Thus he became the prince of weeders, and always had something to exchange. To him Art was litle more than a craft.' Benson, *Catalogue of... Benson*, vii.

132. Holmes to Curzon, 21 March 1921. BLO, MSS EUR F112/58.

133. Unfortunately the paintings had already been sold for £30,000. Minutes, 15 March 1904.

134. Robert Witt to Daniel, 2 February 1933. NG15/133.1. For similar statements by Daniel and Lee, as well as Ormsby-Gore's lonely resistance, see Daniel, 'Note on the policy of purchase', n.d. [March 1931?], NG26/38; Lee, 'Desiderata', 12 March 1931, NG26/61; Ormsby-Gore, 'On the policy of the Board in regard to new acquisitions', 11 February 1931, NG26/74.

135. Rothschild, memo on Curzon Report, n.d. BLO, F112/64. For C. H. Collins Baker's tragi-comic reminiscences of just how far Rothschild's disdain could take him, see his 'Reflections and conclusions as regards the N.G.'. GUL, MacColl Papers, B18.

136. Charles Sebag-Montefiore, 'Three lost collections of London', *NACF Magazine*, December 1988, 50-6; 'Sir Herbert Cook: an amateur of the old school', *Gazette des Beaux-Arts*, 4th ser. 114 (December 1989), 301-304; Clark, Crawford and Witt's lengthy correspondence on the matter is at NLS, ACC6769, 101/16(2). Clark considered selling 'redundant' pictures to fund the purchase of Cook's *Three Maries*. Clark to 28th Earl of Crawford, 27 July 1939. NG26/29.

137. The phrase is that of the 27th Earl of Crawford. 'N/G Desiderata, October 1927', NG26/25.

138. Corkran, *National Gallery*, p. 109.

139. See John Witt, note of conversation with Mahon, 8 January 1970. NG26/117. Philip Hendy, note of conversation with Mahon, 18 August 1961, NG26/67.

140. Editorial, *Burl.* 100 (February 1958), 39-40.

141. *Report of the committee [on] the collection of Lady Wallace* (1897, Cmnd. 8445), Q252. See also Poynter to George Howard, 3, 8 and 23 March 1897. Castle Howard, J22/57; RCMG, Q1242.

142. Minutes, 29 October 1935. The *lacunae* do not seem to have been noticed, at least until 1930. Cox, *The National Gallery*, pp. 184-7.

143. The Tiepolo had been part of the fixtures of the Egyptian Embassy, and was sold by the United Arab Republic. J. D. Brierley (DES) to Jordan Moss (Treasury), 17 June 1969; P. Mountfield, Treasury memo, 21 October 1970. PRO, T227/3400.

144. 'The state of the National Gallery', *Saturday Review*, 26 February 1898, 275-279 (278).

145. Harcourt to George Howard, 3 March 1893. Castle Howard, J22/78/1. This seems to confirm the point made by Janet Minihan in her *The nationalisation of culture* (London, 1977), pp. 161, 166.

146. Armitage Smith, 'NG: purchase of pictures', 2 September 1909. PRO, T 1/11183.

147. *CR*, pp. 5, 19; Paramount List discussions appear frequently in Gallery Minutes, but for a sample see 13 June 1922, 8 March 1927, 17 June, 8 July and 14 October 1930, 13 December 1945, 10 April 1947. [Clark], 'Memorandum on the Paramount List', n.d. [1945?], NG16/268.1 (quotation).

148. *CR*, Q632. For similar comments, see Q166 (Charles Aitken)

149. Minutes, 10 June 1954. For earlier confusion, see Daniel to D'Abernon, 20 June 1931. NG26/62.

150. The Treasury had worked this out as early as 1909. Mr. Barstow, Treasury memo, 30 December 1909. PRO, T/11183.

Chapter Six: A much loved and elegant friend

1. David Watkin, *The life and works of C. R. Cockerell* (London, 1974), p. xxi.

2. Watkin, *Cockerell*, p. 61.

3. Nikolaus Pevsner, *A history of building types* (London, 1976), Ch. 8.

4. Tony Bennett, *The birth of the Museum. History, theory, politics* (London, 1995); Tony Bennett, 'The

exhibitionary complex' in Reesa Greenberg, Bruce W. Ferguson and Sandy Nairne, eds, *Thinking about exhibitions* (London, 1996). For museums and retail outlets, see Charlotte Klonk, 'Mounting vision: Charles Eastlake and the National Gallery', *Art Bulletin* 82.2 (2000), 331-347.

5. F. H. W. Sheppard, *Survey of London*, 29, Part 1 (1960), 323-4, 349-350.

6. Guy Williams, *Augustus Pugin versus Decimus Burton: a Victorian architectural duel* (London, 1990), chs. 6-7.

7. For more detailed accounts, see Gregory Martin, 'Wilkins and the National Gallery', *Burl.* 113 (1971), 318-329; M. H. Port, 'The National Gallery' in H. M. Colvin, ed., *The history of the King's Works* (6 vols., London, 1973), 6:461-471.

8. Wilkins to Alex Milne, 16 June 1834. PRO, WORKS 17/13/6/1.

9. Wilkins to Duncannon, 17 July 1834. PRO, WORKS 17/13/6/5.

10. Treasury to Woods and Forests, 6 March 1835 and Wilkins to Woods and Forests, 13 March 1835. PRO, WORKS 17/13/6/15 and 17. These friezes were inserted by Blore into the garden front of Buckingham Palace instead.

11. Martin, 'Wilkins', 318.

12. *Fifth report of the Commissioners of HM Woods, Forests, and Land Revenues* (PP, 1826, 14), Plate II.

13. Cockerell to Duncannon, 14 May 1832. PRO, WORKS 17/10/1/10.

14. David Watkin, *The triumph of the classical. Cambridge architecture, 1804-1834* (Cambridge, 1977), p. 44 and Pl. 13.

15. M. H. Port, 'Trafalgar Square', in Colvin, *King's Works*, 6:491-4; Rodney Mace, *Trafalgar Square: emblem of empire* (London, 1976), p. 70.

16. Charles Eastlake, *The National Gallery, observations on the unfitness of the present building for its purpose in a letter to the Right Hon. Sir Robert Peel* (London, 1845).

17. Geoffrey Tyack, 'James Pennethorne's designs for the National Gallery, 1845-1867', *ArchH* 33 (1990),

120-134 (122, 126-7).

18. Spiridione Gambardella, *What shall we do with the glass palace?* (London, 1851).

19. Christopher Whitehead, 'Museum interiors in London, 1850-76', (Scuola Normale Superiore di Pisa PhD thesis, 1999), p. 152.

20. Cited in Christopher Whitehead, *The public art museum in nineteenth-century Britain: the development of the National Gallery* (London, 2005), p. 14.

21. For the fascinating debates on the Gallery site question (to which Foggo and Donaldson themselves contributed) see *Papers read at the Institute of British Architects* (sess. 1852-3, 2, 1ff). See also Frank Salmon, 'British architects, Italian fine arts academies and the foundation of the RIBA, 1816-1843', *ArchH* 39 (1996), 77-113.

22. Michael Compton, 'The architecture of daylight' in Giles Waterfield, ed., *Palaces of art: art galleries in Britain, 1790-1990* (London, 1991), pp. 37-47 (42).

23. Whitehead, *The public art museum*, pp. 179, 188.

24. Ibid., pp. 178-9, 183, Fig. 29.

25. Quoted in M. H. Port, 'A contrast in styles at the Office of Works', *Historical Journal* 27.1 (1984), 159. For a fuller account, see his *Imperial London: civil government building in London, 1850-1915* (New Haven, 1995).

26. Martin Fröhlich, *Gottfried Semper. Zeichnerischer Nachlass* (Basel, 1974), pp. 84-9; Wolfgang Herrmann, *Gottfried Semper im Exil* (Basel, 1978); Harry Francis Mullgrave, *Gottfried Semper* (New Haven, 1996), pp. 85, 100, 176-217.

27. David B. Brownlee, 'G. G. Scott's design for the government offices', *ArchH* 28 (1985), 159-182.

28. Quoted in Port, *Imperial London*, p. 91.

29. Whitehead, *The public art museum*, pp. 192-5.

30. 6 June 1864. H3, 175, c.1297-1332 (1302).

31. Port, *Imperial London*, p. 91; Tyack, 'James Pennethorne's designs', 129-130;

Whitehead, *The public art museum*, p. 196 (quote).

32. Whitehead, *The public art museum*, pp. 205, 207; J. Mordaunt Crook, *The British Museum* (London, 1972), p. 207.

33. Barry quoted in Anon., 'The Designs for the new National Gallery', *The Builder*, 2 February 1867, 71-3.

34. Anon., 'The Exhibition of Designs for the New National Gallery (from the *Westminster Gazette*)', *The Building News*, 18 February 1867, p. 72.

35. George Edmund Street, *Some remarks in explanation of his designs for the (1) rebuilding and (2) enlarging the National Gallery* (London, 1867). For architecture, Teutonism and national identity in this period see G. Alex Bremner, 'Nation and empire in the government architecture of mid-Victorian London: the Foreign and India Office reconsidered', *Historical Journal* 48.3 (2005), 703-742 (714-6).

36. Colin Cunningham, *Victorian and Edwardian town halls* (London, 1981), pp. 132-8; James S. Curl, *Victorian architecture* (London, 1990), p. 169.

37. Anon., 'The designs for the new National Gallery', *The Builder*, 2 February 1867, 72-3; Mace, *Trafalgar Square*, pp. 71-2, 76, 84. How Railton's column secured approval despite such opposition has yet to be ascertained.

38. A. H. Layard, *Suggestions for a new National Gallery* (London, 1867).

39. Port, 'A contrast in styles', 151-176.

40. The artists' names were restored in 1994, after a suspended ceiling added after the Second World War was removed. The Reynolds inscription around the dome was not replaced even when the Barry rooms were restored in 1986.

41. Whitehead, *The public art museum*, pp. 238-41.

42. For laylights, see Compton, 'The architecture of daylight', p. 42.

43. Megan Aldrich, ed., *The Craces: royal decorators, 1768-1899* (Brighton, 1990). Sadly, this book does not mention the Crace decorations at the National Gallery.

44. The disruption caused by the Great War only confirmed this trend. See Geoffrey N. Swinney, 'Gas lighting in British museums and galleries', *Museum Management and Curatorship* 18.2 (2000), 113-143 (117-8, 130-5). For rough sleepers, see Mace, *Trafalgar Square*, pp. 171-3.

45. An exception is the attempt by the editor of *The Builder* to advance his own proposals for a remodelling in the issue of 2 July 1904.

46. 5th Marquis of Lansdowne to George Howard, 13 February [1890]. Castle Howard, J22/78/1.

47. PRO, WORKS 17/76.

48. The 'Memorandum' basically consisted of a land swap compensating the War Office with land elsewhere – mainly on the site of the Tate. PRO, WORKS 17/50. Mace, *Trafalgar Square*, pp. 159, 190.

49. Crook, *The British Museum*, pp. 214-5.

50. See G. Alex Bremner, 'Westminster Abbey and the commemoration of Empire, 1854-1904', *ArchH* 47 (2004), 251-282 (273-4); 'Architecture, symbolism, and the ideal of Empire in late Victorian Britain, 1887-1893', *Journal of the Society of Architectural Historians* 62.1 (March 2003), 49-73.

51. Anon., 'National Gallery Extension', *Architectural Review*, April 1911, pp. 226-231. The colour scheme in the new galleries was still too intrusive for some. See Anon., 'The National Gallery' and 'The New Rooms at the National Gallery', *The Builder* 17 March (p. 328) and 21 July 1911 (p. 61).

52. Clive Bell, 'Save the Old Masters from their friends', *Vanity Fair,* October 1922, p. 67.

53. Eric MacLagan, 'Museum Planning', *Journal of the RIBA*, 6 June 1931, pp. 527-543 (531).

54. Jacob Rothschild, 'The NG: the last three years and the next three years', Trustee memo, 29 March 1988. NG27/102.2.

55. John Physick, *The Victoria and Albert Museum*, pp. 252-3, 254 (quote), 255-7.

56. MacLagan, 'Museum planning', 528, 530.

57. Quoted in Waterfield, *Palaces of Art*, p. 62.

58. Clive Bell, 'Save the Old Masters from their friends', *Vanity Fair,* October 1922, p. 67. For Holmes' use of white, see the comments by Charles Bell in his annotated copy of Charles Holmes, *Self and partners* (New York, 1936). National Portrait Gallery Archive, p. 197.

59. Réné MacColl, 'Modern Life in Mosaic: Boris Anrep at the National Gallery', *Studio* 99 (1930), 128-135. Anrep's mosaics had been related to Cézanne's paintings by Roger Fry in his 'Modern Mosaic and Mr. Boris Anrep', *Burl.* 42 (June 1923), 272-278. Lois Oliver, *Boris Anrep: the National Gallery mosaics* (London, 2006).

60. Minutes, 3 April and 12 June 1928. For the 1930s additions, see PRO, T219/615. The link between the Duveen Gallery and Hawks' suite was destroyed in WW2, and rebuilt in 1961.

61. For Duveen's demands, see Daniel to 27th Earl of Crawford, 13 July 1929. NG26/26. See also Alfred Mond to 27th Earl of Crawford, 18 June 1927. NG26/25.

62. 'We have kept the building very simple', Delano wrote to Clark, '– you may think too simple – but in any case it is "Gabrielish".' Delano to Clark, 22 November 1939. TA, 8812.1.4.165a. Peter Pennoyer and Anne Walker, *The architecture of Delano and Aldrich* (New York, 2003), pp. 61- 66, 76, 196. I am indebted to Dr Nuno Grande of Porto University for helping me locate the photographs of the model for this project, the original model having been misplaced some time after its arrival at the Gallery.

63. My thanks to Kitty Ross, Curator of Social History at Leeds Museum, for providing me with photographs of Procter's model, and to Anthony Wells-Cole for showing me Hendy's work at Temple Newsam. See the *Annual Reports of the Sub-Libraries and Arts Committee* (Leeds

Corporation, 1940-1942), for references to both projects.

64. Michael Brawne, *The new museum: architecture and display* (London, 1965), p. 16.

65. Hendy to 28th Earl of Crawford, 30 April 1948. NG26/31.

66. Treasury memo, 8 September 1948. PRO, T219/615.

67. Minutes, 2 December 1965, 7 April 1966.

68. Compton, 'The architecture of daylight', pp. 45-6; Herbert Lank, 'The display of paintings in public galleries', *Burl.* 134 (1992), 165-171.

69. K. E. Couzens, Treasury memo, 3 December 1957. PRO, T219/616. For Treasury cynicism at the Gallery's change of tack see J. Gibson, Treasury memo, 9 May 1960. PRO, T227/1950. The Treasury was concerned that delays in letting the site for a short- or medium-term commercial use were playing into the Gallery's hands, especially as the Gallery was felt to have overly cordial relations with the Ministry of Works. See the two anonymous Treasury memos of 6 June, Ibid.

70. Hesitation was advisable, as the Cabinet's Home Affairs Committee had objected to the timing and phasing proposed for the project in their meeting of 12 May 1961. See Michael Reed, Cabinet Office memo for Home Secretary, 27 June 1961. PRO, PREM11/3382.

71. For Kendall's plans, and related correspondence, see PRO, WORKS 17/502 and 17/748.

72. 'Personally,' he wrote to Kendall, 'I believe the Dome, as such, will disappear altogether one day...' Hendy to Kendall, 16 March 1964. PRO, WORKS 17/502. In June 1966 Hendy asked Kendall to come up with a plan to alter Taylor's central hall. Although plans were drawn up the following year, funds were lacking. See 'Proposed Alterations to Entrance Hall', August 1967. PRO, WORKS, 17/749. Two rows of pilasters were removed from the foot of the main vestibule in 1969.

73. Kendall did see his designs realized at the V&A, where his new medieval galleries opened in 1967. See John Physick, *The Victoria and Albert Museum*, p. 275.

74. PRO, WORKS 17/748, plan <8>.

75. Andrew Saint, 'The Marble Arch', *Georgian Group Journal* 7 (1997), 75-93 (91).

76. PRO, WORKS 17/748.

77. The Ministry of Housing and Local Government objected that Kendall's design was 'out of scale, in its main features, with the National Gallery building'. L. A. J. Glyde to Kendall, 28 May 1965. PRO, WORKS 17/502. The MPBW appealed against the GLC's plan in letters to Barbara Castle and Jennie Lee. See Reginald Prentice to Barbara Castle, 14 June 1966. PRO, WORKS 17/748.

78. Strong, *Diaries*, p. 72. R. I. Greatrex, MPBW memo 'NPG', 2 April 1970. For this and other gambits see PRO, WORKS 17/485.

79. See Strong to Leslie Potts (MPBW), 8 January 1970. PRO, WORKS 17/748. It is striking that Strong's shopping-list (which included a crèche and roof garden) went unchallenged. For the various designs considered, see PRO, WORKS, 17/723. For Strong's inferiority complex as regards Hendy, Robbins, and the National Gallery, see Strong, *Diaries*, pp. 52, 53, 72, 73, 74, 75 (quoted), 98, 119, 120, 384, 385.

80. As with the National Gallery scheme, objections by the local authority played an important role, however. See Crook, *The British Museum*, pp. 219-225.

81. Martin Davies to John Witt, 28 January 1969. NG26/115 (quote). For Levey's views on the need for such a space, 'A future for the National', NSA, M5202W. For an abortive 'Children's Centre' conceived in 1969 (as part of alterations to the Central Hall), see PRO, WORKS 17/749.

82. Admittedly, the piece did concede in passing that filling the Extension with 'pastiche Victorian interiors' (or with offices, its alternative proposal) would be inconsistent with the 'respectful

treatment of the older rooms'. John Martin Robinson, 'Reviving the splendour of the National Gallery', *Apollo*, January 1989, 48-51.

83. Charles Purser, *The prospects of the nation in regard to its National Gallery* (London, 1833), pp. 40, 76.

84. Giles Waterfield, 'Palaces of Art', in Waterfield, *Palaces of Art*, p. 17.

85. Treasury memo, 5 September 1934. PRO, T219/615.

86. A point ably made by M. H. Port in his *Imperial London*, p. 12.

87. Port, *Imperial London*, p. 16.

88. H. C. Barlow, MD to Editor, 'The National Gallery'. *The Builder*, 19 January 1867, p. 50.

Epilogue

1. For a full account of the Hampton Site competition and Sainsbury Wing commission, see Colin Amery, *A celebration of art and architecture: the National Gallery Sainsbury Wing* (London, 1991); Emma Barker and Annabel Thomas, 'The Sainsbury Wing and beyond: the National Gallery today', in Emma Barker, ed., *Contemporary cultures of display* (New Haven, 1999), pp. 73-101.

2. Albert Bush-Brown, *Skidmore, Owings and Merrill: architecture and urbanism, 1973-1983* (New York, 1984).

3. Amery, *A celebration*, p. 83.

4. William Hazlitt, *Complete works*, ed. P. P. Howe (21 vols., London, 1934), 18: 39.

5. Citied in Stanislaus von Moos, *Venturi Scott Brown and Associates, 1987-1998* (New York, 1999), p. 48.

6. Annan to Levey, 11 October 1984, NG26/3. For the design and Peter Ahrends' response to the episode, see Peter Blundell-Jones, *Ahrends Burton Koralek* (London, 1991), pp. 10, 15-19, 134-7.

7. Van Moos, *Venturi Scott Brown and Associates*, p. 8.

8. HRH Charles, Prince of Wales, *A vision of Britain: a personal view of architecture* (London, 1989), p. 7.

9. Quoted in *The much loved friend? A portrait of the National Gallery* Nicholas Rossiter producer, broadcast BBC2, 8 July 1991. NFTA.

10. John Martin Robinson, 'Reviving the splendour of the National Gallery', *Apollo* (January 1989), 48-51.

11. Patrick Wright, *On living in an old country* (London, 1985); Raphael Samuel, *Theatres of memory* (2 vols., London, 1994-9).

12. For a typical example, see Philip Wright, 'The quality of visitors' experiences in art museums', in Vergo, ed., *New Museology* (London, 1989), p. 119-148.

13. Annan to Levey, 19 May 1982. NG26/2.

14. Compare Lord Palumbo's role at the Tate, discussed in Spalding, *The Tate: a history* (London, 1998), pp. 218-9.

15. Levey to Annan, 21 May 1982. Cambridge, King's College. Annan Papers, NGA/5/1/598.

16. Education, Science and Arts Committee, *Public and private funding of the arts* (Evidence), PP, 1981-2, 49-III, Q1324-5.

17. Cited in Robert Hewison, *Culture and consensus: England, art and politics since 1940* (London, 1995), p.251. Unlike most of the publications produced by the entity it chronicles, Richard Witts, *Artist unknown: an alternative history of the Arts Council* (1998) is truly remarkable for its concision and wit.

18. As Arts Council Chairman William Rees-Mogg put it in the foreword, there were 'two artistic nations' in Britain. Arts Council of Great Britain, *The Glory of the garden: the development of the arts in England. A strategy for a decade* (1984), v.

19. Trustees' Foreword, *National Gallery Annual Report* (1992), p. 5.

20. *The Independent*, 22 June 1998. The Thyssen Collection had been the focus of a temporary exhibition at the Gallery in March/April 1961.

21. Sir Nicholas Goodison, *Securing the best for our museums: private giving and government support*, January 2004.

22. Hunter Davies, 'Match of the Day',

Sunday Times Magazine, 10 March 1974.

23. Education, Science and Arts Committee, *Should museums charge?* (1st Report), PP, 1989-1990 sess., 1.

24. Patricia Morrison, 'An invitation to loiter with intent', *Financial Times*, 3 October 1992.

25. Quote from 'St. George and the Dragon', *The Secret Life of Paintings*, Dick Foster director, broadcast BBC1, 11 October 1986. NFTA.

26. *National Gallery Annual Report* (1999-2000), p. 58.

27. Martin Darley, 'Ethnic targets for UK museums', *The Arts Newspaper* 11.105 (July-August 2000), p. 10.

28. Neil MacGregor, pers. comm. (2004).

29. DCMS, *Centres for social change: museums, galleries and archives for all* (May 2000), 5.

30. Denys Sutton, 'The National Gallery imbroglio', *Apollo* (September 1986), p. 230. See also Edward Pearce, 'Our nationalistic gallery', *Sunday Telegraph*, 3 August 1986; Pearson Phillips, 'Job for an image restorer', *Times*, 31 July 1986.

31. M. Pollak and N. Heinich, 'From museum curator to exhibition auteur' in Reesa Greenberg, Bruce W. Ferguson and Sandy Nairne, eds, *Thinking about exhibitions* (London, 1996); Simon Tait, 'Curatosaurus ex?', *Financial Times*, 6 June 1999, 34.

32. Bethell, 11 November 1971. H5, 325, c.851.

33. Levey to Annan, 21 May 1982. Cambridge, King's College. Annan Papers, NGA/5/1/598.

34. Education, Science and Arts Committee, *Should museums charge?* (1st Report), PP, 1989-1990, Q10.

35. There remains a tendency to rewrite the Gallery's own history slightly in claiming (as in the 2001-2 *Annual Report*, p.17) that the Gallery has always 'steadfastly' upheld the principle of free entry, that the Gallery was 'always free',

etc. In fact fees were charged at least two days a week from 1880 to 1939. There also remains a reluctance to admit the force of the evidence, advanced first by Pierre Bourdieu and more recently by Nick Merriman, suggesting that charges play almost no role in determining whether underrepresented socio-economic groups visit museums. Nick Merriman, 'Museum visiting as a cultural phenomenon', in Peter Vergo, ed., *The new museology* (London, 1989), pp. 149-171; *Beyond the glass case* (London, 1991). That government has noted this is suggested by DCMS, 'National Museums and Galleries: funding and free admission' (February 2003), Cmnd. 5772.

36. Andrew McClellan, *Art and its publics: museum studies in the millennium* (Oxford, 2003), p. 33.

37. Admittedly, the Gallery had not been in the vanguard in introducing Acoustiguides in 1995. See Loic Tallon, 'I'm a celebrity: get me an audio tour', *Museums Journal* 106.4 (April 2006), pp. 26-7.

38. Cited in James Cuno, ed., *Whose muse? Art museums and the public trust* (Princeton, 2004), p. 104.

39. Trustees' Foreword, *National Gallery Report* (January 1982-December 1984), p. 11. Tate Director Nicholas Serota made a similar point in his speech to the NACF Centenary Conference. Caroline Bugler, ed., *Saving art for the nation: a valid approach to 21st-century collecting?* (London, 2003), pp. 13-22.

40. Interview, *Country Life*, 3 November 1994, p. 91.

41. Pierre Bourdieu and Alain Darbel, *The love of art: art museums and their public*, trans. Nick Merriman (Oxford, 1991), pp. 49-60.

42. Neil MacGregor, pers. comm. (2004).

43. Tessa Jowell, *Government and the value of culture* (DCMS, 2004), p. 17

Picture Credits

Many thanks to the National Gallery for their generosity in providing so many images at greatly reduced price, without which this book and its author would have been much the poorer. The author would also like to thank the Avery Library (Columbia University), the Huntington (San Marino), Neue Pinakothek (Munich), Paula Rego, the Rothschild Archive, the 1851 Royal Commission, and SOM London for waiving their licensing fees. The National Portrait Gallery, Tate and Victoria and Albert kindly agreed to charge reduced fees. Richard Ingrams and Private Eye, Foster and Partners and Venturi Scott Brown very kindly made images available.

All reasonable effort has been made to contact the owners of copyright in the images featured in this book. Owners not credited below are invited to inform the publishers, who will be pleased to rectify any such oversights in future editions.

Half-title, ii-iii,iv-v, vi-vii, viii-ix, xii-xiii, xiv, xvii, xviii, 2, 7, 26/7, 30, 34, 42, 46, 50, 53, 54/5, 59, 64/5, 70, 74/5, 78, 83, 84, 85, 88, 89, 90, 96/7, 104/5, 110, 112/3, 120, 124/5, 130, 132, 136/7, 142/3, 149, 157, 158, 160, 166/7, 180, 182, 188, 191, 193, 194, 195, 204, 210, 215, 217, 220/1, 223, 226/7, 229, 240/1, 258/9, 267, 269, 272, 274, 278, 281, 282/3, 286/7, 288, 289, 290, 294/5, 298, 301, 302, 304, 305, 306, 311, 314/5, 317, 318, 321, 329, 332, 335, 336, 338/9, 343, 344, 346, 349, 353, 355, 356, 369, 374, 380, 394, 399, 407, 409, 410, 417, 424, 434, 436, 437, 439, 442/3, 447, 451, 455, 456, 448/9 © The National Gallery, London; 141, 146, 155, 161, 165, 168, 176, 192, 207, 208, 244, 378, 390, 392, 405 Courtesy of the National Gallery, London.

9, 52, 57, 69, 80, 86, 100, 102, 122, 123, 129, 147, 152, 154, 163, 255, 327, 280, 313 © National Portrait Gallery, London.

Crown copyright material is reproduced with the permission of the Controller of HMSO and Queen's Printer for Scotland.

Cover/jacket and x-xi: courtesy Nigel Young/Foster and Partners; Author photograph © Ethne Conlin; 1 © Sarah Quill; 4, 54/5, 81, 82, 383, V&A Images/Victoria and Albert Museum; 12, 41, 51 © Yale Center for British Art, Paul Mellon Collection, USA/Bridgeman Art Library; 11, 325 © The Trustees of the British Museum; 15, 16, 22, 375, 414 © The Author; 19, 33, 61, 235, 402 © Guildhall Library, City of London; 23 Hermitage, St. Petersburg, Russia/Bridgeman Art Library; 38 © BNF; 39, 377, 393 © RIBA; 48 © Bayerische Staatsgemäldesammlungen, Neue Pinakothek; 79, 387 With the permission of the Royal Commission for the Exhibition of 1851; 99 © Rothschild Archive; 101, 206, 233, 238 © ILN Picture Library; 118 © Mirrorpix; 127 Courtesy of the Huntington Library, Art Collections, and Botanical Gardens, San Marino, California; 151 Giambattista Tiepolo Italian 1696–1770, The Banquet of Cleopatra 1743–44, oil on canvas, 250.3 x 357.0 cm, Felton Bequest, 1933, National Gallery of Victoria, Melbourne, Australia; 170 © Gulbenkian Foundation, UK Branch; 174, 184 © Photographs by Snowdon, Camera Press London; 178-9 © Private Eye, courtesy Richard Ingrams; 199 © Telegraph Group Syndication; 213, 265 © BBC; 214, 291 © Tate, London 2006; 246, 360 © Solo Syndication; 251, 252, 262 © Transport for London; 293 © National Trust Picture Library; 372 © Fitzwilliam Museum, Cambridge; 393 © Queen's Printer and Controller of HMSO, 2006. UK Government Art Collection; 404 © Topfoto; 406 © Avery Library, Columbia University; 415, 416 © Crown copyright; 423, 428, 433 Courtesy Venturi, Scott Brown and Associates, Inc.; 426, 430 © RIBA John Donat/RIBA Library Photographs Collection; 427, 431 © SOM London; 452/3 © Marlborough Fine Art; 455 © NI Syndication Ltd., 1991; 458 G. Jackson/Arcaid

Index

SOOTHING EFFECT
OF HIGH ART

Illustrations pp. i-xviii

p. i This painting of c. 1520 was probably painted as part of a larger altar-piece commissioned for the church of S Maria in Stelle, near Verona, and may depict members of the **Giusti Family**. When Eastlake saw the complete altarpiece in 1864 he recorded that the main upper panels were ruined. He only bought this part from the heirs of Andrea Monga because it came as a package with Gerolamo da Libri's *Virgin and Child with Saint Anne.*

pp. ii-iii Claude Monet was one of several French Impressionists who moved to London to escape the Franco-Prussian War and the Commune (1870-1). He painted this scene of **The Thames Below Westminster** in 1871. Bought in 1936 by J. J. Astor, it was bequeathed to the Gallery by Lord Astor of Hever in 1971, the sixth Monet to enter the collection.

pp. iv-v Dutch artist Willem Duyster normally painted small scale portraits and genre. His **Soldiers fighting over booty in a barn** (1623-4) is unique in his oeuvre. It was bought in 1913 from a descendant of Colonel Wolfgang Romer, who had accompanied William III to England in 1688.

pp. vi-vii Painted on vellum, this **Adoration of the Kings** by Jan Breughel the Elder of 1598 was presented by the merchant and shipping magnate Alfred de Pass in 1920, along with a motley collection of other works, including a Guardi and a *Madonna and Child* attributed to Catena. Alfred de Pass also presented works by British artists to the Tate, and the Royal Cornwall Museum, as well as several others in South Africa, where he lived for many years.

pp. viii-ix: Ugolino di Nerio, **Two Angels** of about 1324-5, presented by Henry Wagner in 1918. A fragment originally placed above a figure of St Francis (lost), from the altarpiece of S Croce, Florence.

pp. x-xi: This view of the Gallery from Canada House shows the results of the **Trafalgar Square redevelopment,** co-ordinated by Norman Foster and Partners, which has reintegrated the Gallery in the vigorous life of the Square. The pedestrianisation of the north side of the square had originally been proposed in the early 1970s, but Director Martin Davies had opposed it, arguing that it would inconvenience handicapped or elderly visitors arriving by car. In practice the Gallery now seems both grander and more inviting; internally this has been reflected by improved access via the restored entrance vestibule or the new Sir Paul Getty Entrance and Annenberg Court at ground level. Cool white walls and richly-veined black marble greet the visitor where MDF and noisome smells once predominated.

pp. xii-xii: The thousands who queued up to pay their respects to Leonardo da Vinci's **cartoon** comprised just a fraction of the many more who helped raise money to buy it off the Royal Academy in 1962, a campaign led by the 28th Earl of Crawford. They did not share the Goya thieves' view of it as 'a scruffy piece of cardboard'.

p. xiv: When this **Portrait of a Young Man** (c. 1510) went on sale in 1882 at the Hamilton Palace Sale it was catalogued as a Leonardo da Vinci. Noted art expert Bernard Berenson attributed it to Vincenzo Catena, an attribution which is still held today.

p xvii: The Victorian revival of interest in *quattrocento* art did not pay the Sienese School much attention. Only in the 1930s did the Gallery take steps to address this. When Giovanni di Paolo's **St John the Baptist Retiring to the Desert** (c. 1453) was acquired along with three other works by the same master in 1944, it was the Gallery's first purchase in six years – a reflection of the impact the War had on the growth of the collection.

The Nation's Mantelpiece: A History of the National Gallery
© Jonathan Conlin 2006

The right of Jonathan Conlin to be identified as the Author of this
Work has been asserted by him in accordance with the Copyright
Designs and Patents Act 1988.

Supported by:

 CALOUSTE
GULBENKIAN
FOUNDATION

First published 2006 by Pallas Athene (Publishers) Ltd,
42 Spencer Rise, London NW5 1AP
If you would like further information about
Pallas Athene publications, please write to
the address above, or visit our website:
www.pallasathene.co.uk

Editor: Alexander Fyjis-Walker
Design: Harold Bartram
Plans: Peter Fotheringham
Index: Veronica Stebbing

Special thanks to Charles Saumarez-Smith, and to Lars Kiel
Bertelsen, Stephanie Black, Suzie Burt, Robert Cripps, Margaret
Daly, Philip France, Barbara Fyjis-Walker, Clare Gough, Richard
Ingrams, Stephen Lennon, Sarah Quill and Belinda Ross

Printed in China

1 84368 018 1/978-1 84368-018-5 hardback
1 84368 020 3/978-1 84368-020-8 paperback